BAROQUE

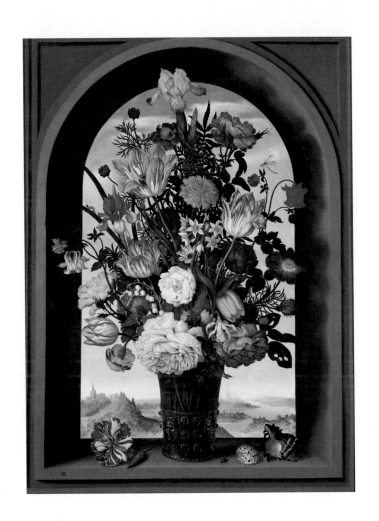

EDITED BY KRISTINA MENZEL

BAROQUE

LE BAROQUE

BAROCK

EL BARROCO

BAROCCO

BAROK

CONTENTS SOMMAIRE INHALT

ÍNDICE INDICE INHOUD

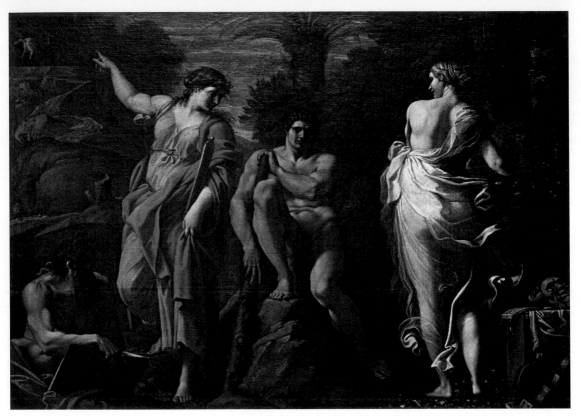

The Choice
of Hercules

Le Choix d'Hercule

Herakles am
Scheideweg

Heracles en la
encrucijada

Ercole al Bivio

Hercules op
een kruispunt

ANNIBALE CARRACCI
(1560–1609)
c. 1596, Oil on
canvas/Huile sur
toile, 167 × 237 cm,
Museo Nazionale di
Capodimonte, Napoli

The Baroque: A European Style with Many Faces

The baroque period spanned the whole of Europe from 1600 to 1780. Beginning with Italian artists such as Carracci and Caravaggio, who brought drama to painting through dynamic compositions and pronounced contrasts between light and dark, the baroque was later exported by countless artists to their own countries, where the new style developed in very different ways. The Catholic Church of the Counter-Reformation, in reaction to the Protestant Reformation, sought to captivate the senses and emotions of the faithful through sacred art, leading the baroque to become the dominant style in all the Catholic countries of Europe. The monarchs of that time were absolutist rulers, or at least saw themselves as such, and the baroque style, with its monumental historical paintings and magnificent portraits, catered to sovereign desires for splendour and demonstrations of power, and became the court art par excellence. The latest phase of the baroque style, known as rococo, began in about 1720 and was characterised by an increased sense of playfulness and intimacy.

Le baroque : un style européen aux multiples visages

Entre 1600 et 1780 environ, le style baroque gagna toute l'Europe. Aux origines de la peinture baroque, on trouve des artistes italiens comme les Carrache et Le Caravage, qui par la composition dynamique de leurs tableaux et l'utilisation prononcée du clair-obscur introduisirent une véritable intensité dramatique dans la peinture. De nombreux artistes exportèrent ensuite ce style nouveau vers leurs pays respectifs, où il se développa de différentes manières. Les commanditaires jouèrent un rôle déterminant : l'Église catholique de la Contre-Réforme (dans sa réaction à la Réforme protestante) voulait, grâce à l'art sacré, toucher les sens et les émotions des fidèles, et le baroque devint ainsi un style dominant dans tous les pays catholiques. Les souverains de l'époque étaient des monarques absolus, ou du moins se percevaient comme tels. Avec ses tableaux historiques ou ses portraits grandioses, le baroque se prêtait parfaitement à leur volonté d'afficher leur magnificence et leur pouvoir, et devint ainsi un style de cour par excellence. Le baroque tardif, à partir de 1720 environ, porte le nom de rococo, et se caractérise par des éléments frivoles et d'une plus grande intimité.

Der Barock: Ein europäischer Stil mit vielen Gesichtern

Der Barock erfasste von etwa 1600 bis 1780 ganz Europa. Am Anfang der barocken Malerei standen italienische Künstler wie die Carracci und Caravaggio, die durch dynamische Bildkompositionen oder ausgeprägte Hell-Dunkel-Kontraste Dramatik in die Malerei brachten. Zahllose Künstler exportierten diesen neuen Stil in ihre Heimatländer, wo er ganz unterschiedlich weiterentwickelt wurde. Hierbei kam den Auftraggebern eine wesentliche Rolle zu: Die katholische Kirche der Gegenreformation (als Reaktion auf die protestantische Reformation) wollte mittels der sakralen Kunst die Sinne und Emotionen der Gläubigen ergreifen – wodurch der Barock zum dominierenden Stil in allen katholischen Ländern wurde. Die Monarchen jener Zeit waren absolutistische Herrscher oder sahen sich zumindest als solche. Als Stil, der mit monumentalen Historienbildern oder großartigen Porträts alle Wünsche nach herrscherlicher Prachtentfaltung und Machtdemonstration erfüllte, avancierte der Barock zur Hofkunst par excellence. Seine Spätphase war ab etwa 1720 das Rokoko, das durch mehr spielerische Elemente und größere Intimität bestimmt ist.

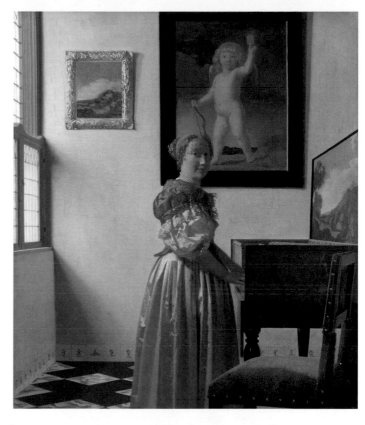

Lady Standing at a Virginal

Une dame debout au virginal

Stehende Virginalspielerin

Jugador virginal de pie

Giovane donna in piedi vicono al virginale

Staande klavecimbelspeelster

JOHANNES VERMEER (1632–1675)

c. 1670–72, Oil on canvas/Huile sur toile, 51,7 × 45,2 cm, The National Gallery, London

El Barroco: un estilo europeo con muchas caras

El periodo barroco abarcó toda Europa desde aproximadamente el 1600 hasta 1780. La pintura barroca comenzó con artistas italianos como Carracci y Caravaggio, que aportaron dramatismo a la pintura a través de composiciones dinámicas o pronunciados contrastes claro-oscuro. Innumerables artistas exportaron este nuevo estilo a sus países de origen, donde se desarrolló de maneras muy diferentes. La Iglesia Católica de la Contrarreforma (en reacción a la Reforma Protestante) quiso apoderarse de los sentidos y emociones de los fieles a través del arte sagrado, por lo que el barroco se convirtió en el estilo dominante en todos los países católicos. Los monarcas de esa época eran gobernantes absolutistas o al menos se veían a sí mismos como tales. El estilo barroco, con sus monumentales pinturas históricas o magníficos retratos, cumplió todos los deseos de desarrollo del esplendor soberano y demostración de poder, convirtiéndose así en el arte de la corte por excelencia. Su fase tardía fue la del rococó a partir de aproximadamente el año 1720. Una fase caracterizada por elementos más lúdicos y de mayor intimidad.

Il barocco: uno stile europeo con numerose sfaccettature

Il periodo barocco ha attraversato tutta l'Europa dal 1600 al 1780 circa. La pittura barocca inizia con artisti italiani come Carracci e Caravaggio, che portano il dramma nella pittura attraverso composizioni dinamiche o forti contrasti chiaro-scuri. Numerosi artisti hanno, in modi molto differenti, divulgato e sviluppato questo nuovo stile nei loro paesi. La Chiesa Cattolica della Controriforma (come reazione alla Riforma Protestante) ha voluto cogliere i sensi e le emozioni dei fedeli attraverso l'arte sacra - per cui il barocco è diventato lo stile dominante in tutti i paesi cattolici. I monarchi dell'epoca erano reggenti assolutisti o almeno si consideravano tali. Lo stile barocco, con le sue monumentali pitture storiche o con i suoi magnifici ritratti, soddisfaceva i desideri di sfoggio della sovranità e della dimostrazione del potere, diventando l'arte di corte per eccellenza. A partire dal 1720 circa, la sua fase più avanzata fu il Rococò, caratterizzato da elementi più ludici e da una maggiore intimità.

De barok: een Europese stijl met veel gezichten

De barok had tussen circa 1600 en 1780 heel Europa in zijn greep. Aan de wieg van de barokke schilderkunst stonden Italiaanse kunstenaars zoals Carracci en Caravaggio, die door dynamische composities of uitgesproken licht-donkercontrasten dramatiek in de schilderkunst brachten. Talloze kunstenaars exporteerden deze nieuwe stijl naar hun eigen land, waar ze op heel verschillende manieren verder werd ontwikkeld. De katholieke kerk van de Contrareformatie (als reactie op de protestantse Reformatie) wilde de zinnen en emoties van de gelovigen aanspreken door middel van sacrale kunst, waardoor de barok de dominante stijl werd in alle katholieke landen. De monarchen van die tijd waren absolute heersers of zagen zichzelf in elk geval zo. De barokke stijl, die met zijn monumentale historiestukken en grootse portretten alle verlangens naar een soevereine ontplooiing van pracht en praal en machtsvertoon vervulde, werd de hofkunst bij uitstek. De late fase was vanaf circa 1720 het rococo, dat gekenmerkt werd door meer speelse elementen en meer intimiteit.

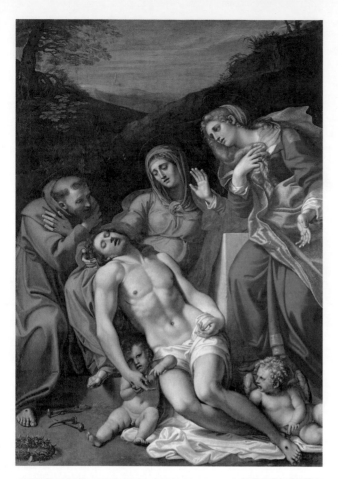

Pietà with St Francis and Mary Magdalene

Pietà avec saint François et sainte Marie-Madeleine

Pietà mit den Heiligen Franziskus und Maria Magdalena

Piedad con San Francisco y María Magdalena

Pietà con San Francesco e Maria Maddalena

Pïèta met Franciscus en Maria Magdalena

ANNIBALE CARRACCI (1560–1609)

c. 1602–07, Oil on canvas/Huile sur toile, 277 × 186 cm, Musee du Louvre, Paris

Baroque in Italy:
Between Naturalism and Classicism

Rome was the undisputed centre of the Italian baroque. The residence of the Pope resided and the highest clergy, the city contained countless churches that were constantly in need of decoration. The nobility, too, offered artists ever more commissions, and often even permanent positions at their courts.

After the end of the Renaissance and the Mannerist period, Italian baroque painting developed between the antipodes of Michelangelo Merisi Caravaggio and Annibale Carracci. The former took a naturalistic, often even extreme approach to his subjects, while the latter painted in a classicist, idealizing manner. Caravaggio, unlike Carracci, had no students, but was nevertheless enormously influential, even far beyond the borders of his country.

In the 18th century, the Italian cultural centre shifted to Venice, where the vedute of Canaletto and Guardi were most admired.

Le baroque en Italie :
entre naturalisme et classicisme

Rome fut le centre incontesté du baroque italien. C'était là que résidaient le Pape et le haut clergé et on y bâtissait sans cesse de nouvelles églises, qu'il fallait décorer. La noblesse fortunée passait également de plus en plus de commandes aux artistes, voire les employait directement à la cour.

Après la Renaissance et le courant du maniérisme, la peinture italienne baroque se développa autour de deux artistes très différents : Le Caravage et Annibale Carrache. Le premier se caractérisait par une approche naturaliste voire radicale de ses sujets, tandis que le second peignait d'une manière plus classique et idéaliste. Contrairement à Carrache, Le Caravage n'avait pas d'élèves, mais il jouissait d'une influence considérable, et ce par-delà les frontières.

Au XVIIIe siècle, le centre culturel se déplaça à Venise, où les vedute de Canaletto – ou encore de Guardi – furent particulièrement admirées.

Barock in Italien:
Zwischen Naturalismus und Klassizismus

Das unbestrittene Zentrum des italienischen Barocks war Rom. Hier residierte der Papst samt oberstem Klerus, zahllose Kirchen wurden gestiftet, die dekoriert werden wollten. Auch der reiche Adel bot den Künstlern immer mehr Aufträge, vielen sogar feste Anstellungen an ihren Höfen.

Nach dem Ende der Renaissance und der Phase des Manierismus entwickelte sich die italienische Barockmalerei zwischen den Antipoden Michelangelo Merisi Caravaggio und Annibale Carracci. Ersterer mit einem naturalistischen, oft gar drastischen Zugang zu seinen Sujets, Letzterer in klassizistischer, idealisierender Weise malend. Caravaggio hatte im Gegensatz zu Carracci keine Schüler, doch war er enorm einflussreich, und das weit über die Grenzen des Landes hinaus.

Im 18. Jahrhundert sollte sich das kulturelle Zentrum nach Venedig verlagern, wo vor allem die Veduten Canalettos oder Guardis bewundert wurden.

Boy Bitten by a Lizard

Garçon mordu par un lézard

Knabe, der von Eidechse gebissen wird

Chico mordido por una lagartija

Ragazzo morso da un ramarro

Jongen die gebeten wordt door een hagedis

MICHELANGELO MERISI KNOWN AS CARAVAGGIO (1571–1610)

c. 1595, Oil on canvas/Huile sur toile, 65 × 52 cm, Fondazione Longhi, Firenze

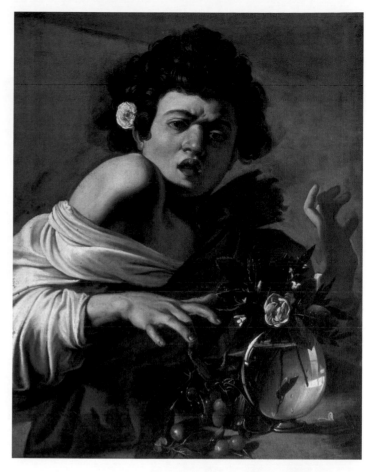

El barroco en Italia:
entre el naturalismo y el clasicismo

El centro indiscutible del barroco italiano fue Roma. Aquí residió el Papa junto con el más alto clero, se donaron innumerables iglesias que querían ser decoradas. La rica nobleza también ofrecía a los artistas más y más encargos, muchos de ellos ofrecían incluso puestos de trabajo fijos en sus cortes.

Después del final del Renacimiento y del Manierismo, la pintura barroca italiana se desarrolló entre las antípodas de Miguel Ángel Merisi Caravaggio y Annibale Carracci. El primero con un enfoque naturalista, a menudo incluso drástico, y el segundo pintando de manera clasicista e idealizadora. Caravaggio, a diferencia de Carracci, no tenía estudiantes, pero era enormemente influyente, mucho más allá de las fronteras del país.

En el siglo XVIII, el centro cultural se trasladaría a Venecia, donde se admiraban más las Vedutas de Canaletto o Guardi.

Barocco in Italia:
tra naturalismo e classicismo

Il centro indiscusso del barocco italiano era Roma. Qui risiedeva il Papa insieme con il più alto clero, furono donate numerose chiese che dovevano anche essere decorate. La ricca nobiltà offriva inoltre agli artisti sempre più incarichi, molti dei quali anche permanenti presso le loro corti.

Dopo la fine del Rinascimento e il periodo manierista, la pittura barocca italiana si sviluppò tra gli antipodi Michelangelo Merisi detto Caravaggio e Annibale Carracci. Il primo con un approccio naturalistico, spesso anche drastico, verso i suoi soggetti, il secondo dipingendo in modo classicistico, idealizzante. Caravaggio, a differenza del Carracci, non aveva allievi, ma ha avuto un'influenza enorme, anche all'estero. Nel XVIII secolo il centro culturale si trasferì a Venezia, dove si potevano ammirare soprattutto le Veduta del Canaletto o del Guardi.

Barok in Italië:
tussen naturalisme en classicisme

Het onbetwiste centrum van de Italiaanse barok was Rome. Hier resideerde de paus samen met de hoogste geestelijkheid, hier werden talloze kerken opgericht die gedecoreerd moesten worden. Ook de rijke adel gaf kunstenaars steeds meer opdrachten en veel kunstenaars kregen zelfs een vaste aanstelling aan hun hof.

Na het einde van de renaissance en de periode van het maniërisme ontwikkelde de Italiaanse barokke schilderkunst zich tussen de tegenvoeters Michelangelo Merisi Caravaggio en Annibale Carracci. De eerste met een naturalistische, vaak zelfs onkiese toegang tot zijn onderwerpen, de tweede met een classicistische, idealiserende schilderstijl. Caravaggio had, in tegenstelling tot Carraci, geen leerlingen, maar was toch enorm invloedrijk, en dat tot ver over de grenzen van zijn land.

In de 18e eeuw zou het culturele centrum zich verplaatsen naar Venetië, waar de vedute van Canaletto of Guardi het meest bewonderd werden.

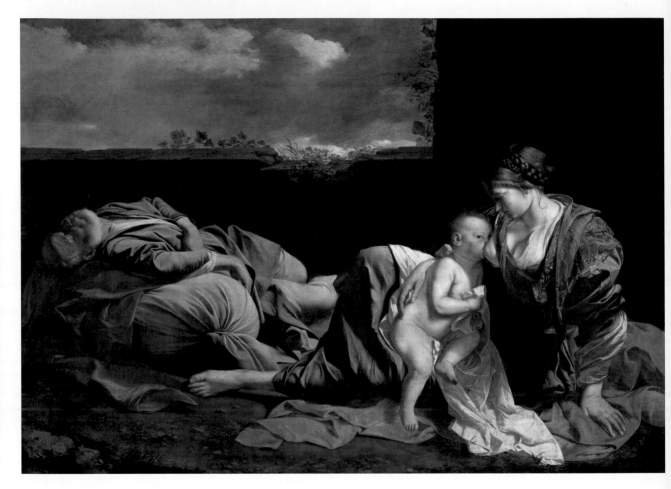

Rest on the Flight into Egypt

An interesting example of the early baroque, influenced by Caravaggio, but which soon develops different emphases. The figures' great physicality and the extraordinary lighting are particularly striking.

Le Repos de la Sainte Famille pendant la fuite en Égypte

C'est un représentant intéressant du baroque primitif, chez lequel on sent l'influence du Caravage mais qui propose rapidement ses propres orientations. Dans cette œuvre, on est frappé par le relief des corps et les effets de lumière impressionnants.

ORAZIO GENTILESCHI (1563-1639)

c. 1628, Oil on canvas/Huile sur toile, 157 × 225 cm, Musée du Louvre, Paris

Ruhe auf der Flucht nach Ägypten

Ein interessanter Vertreter des Frühbarock, von Caravaggio beeinflusst, doch schon bald andere Akzente setzend. Hier sticht die große Körperhaftigkeit und die außergewöhnliche Lichtwirkung heraus.

Descanso de la huida de Egipto

Un interesante representante del barroco temprano, influenciado por Caravaggio, pero que pronto introdujo diferentes acentos. Aquí es donde destaca la gran fisicalidad y el extraordinario efecto luminoso.

Riposo durante la fuga in Egitto

Interessante rappresentante del primo barocco, influenzato dal Caravaggio, ma che ben presto pone accenti diversi. Qui spiccano la grande fisicità e lo straordinario effetto luminoso.

Rust tijdens de vlucht naar Egypte

Een interessante, door Caravaggio beïnvloede vertegenwoordiger van de vroege barok, die al snel andere accenten zette. Hier vallen de grote lichamelijkheid en het buitengewone lichteffect op.

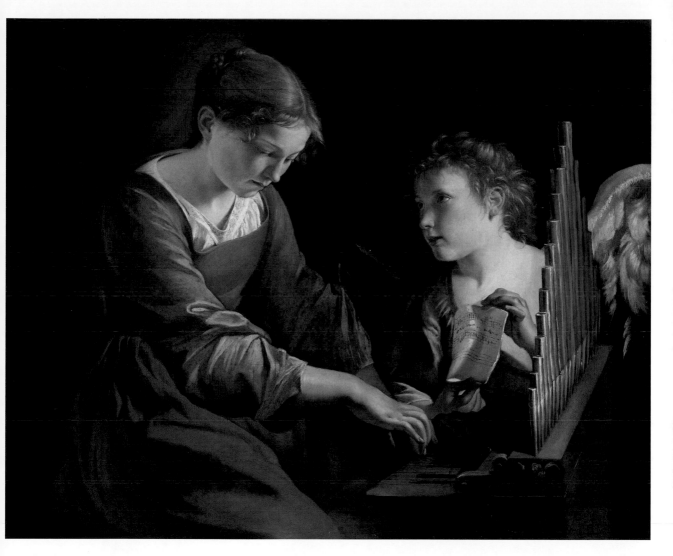

St Cecilia and an Angel

Sainte Cécile avec un ange

Die Heilige Cäcilie und ein Engel

Santa Cecilia y un ángel

Santa Cecilia e un angelo

De heilige Cecilia en een engel

ORAZIO GENTILESCHI (1563–1639)

c. 1617/18, Oil on canvas/Huile sur toile, 87,5 × 108 cm, National Gallery of Art, Washington, D.C.

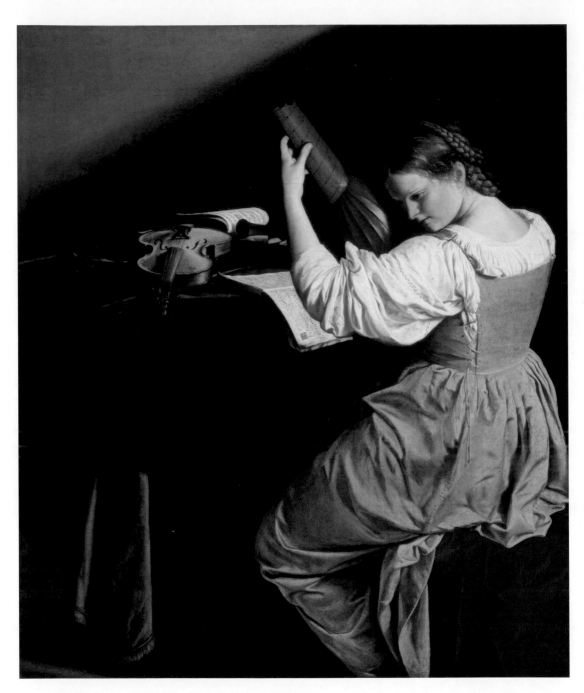

The Lute Player

La Joueuse de luth

Der Lautenspieler

El laudista

Suonatrice di luito

De luitspeelster

ORAZIO GENTILESCHI (1563–1639)
c. 1612–20, Oil on canvas/Huile sur toile, 143,5 × 129 cm, National Gallery of Art, Washington, D.C.

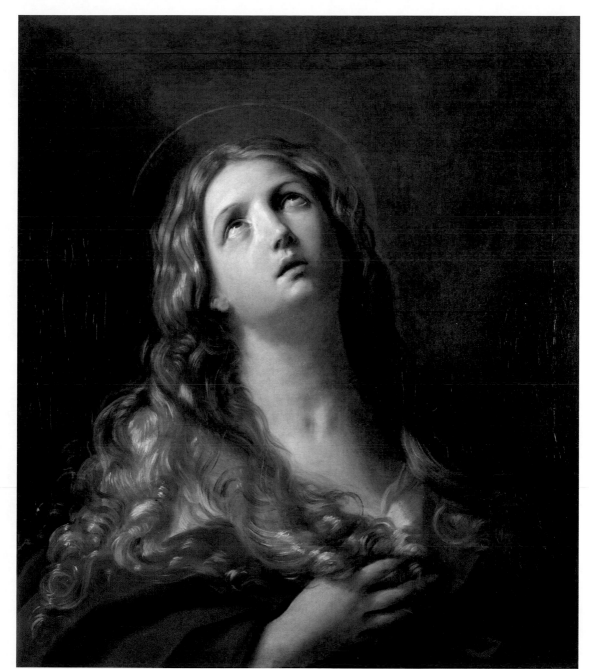

Mary Magdalene

Sainte Marie-
Madeleine

Maria Magdalena

María Magdalena

Maria Maddalena

Maria Magdalena

GUIDO RENI
(1575–1642)
c. 1634/35,
Oil on canvas/
Huile sur toile,
79,3 × 68,5 cm,
The National
Gallery, London

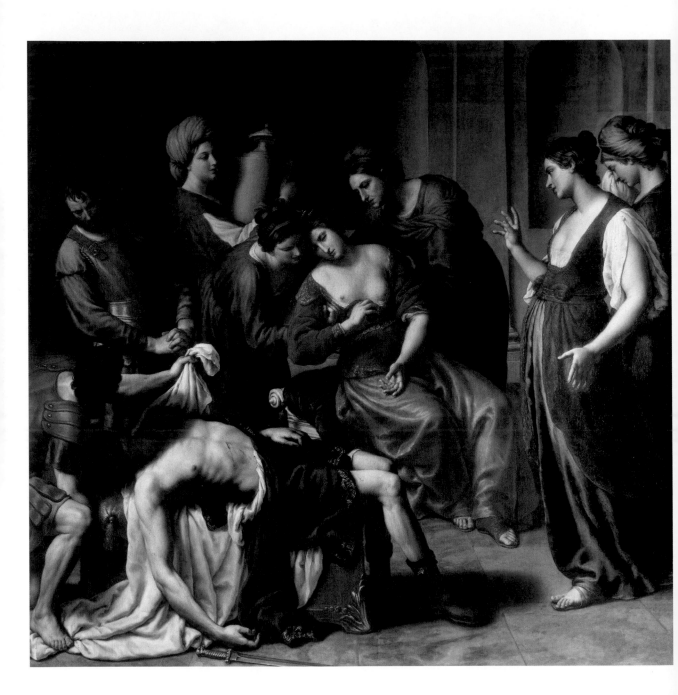

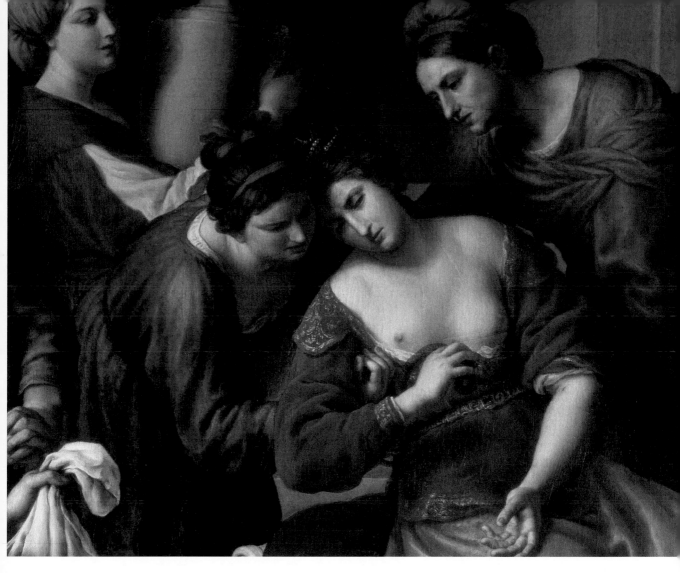

Death of Cleopatra

Turchi shows the last moments in the life of the Egyptian pharaoh. Cleopatra's tragic fate was as if made for the baroque period, as countless operatic adaptations attest.

La Mort de Cléopâtre

Turchi montre les deux derniers moments de la vie de la reine d'Égypte. Le destin tragique de cette souveraine était parfaitement indiqué pour l'époque baroque, comme en témoignent également d'innombrables opéras.

ALESSANDRO TURCHI (1578-1649)

c. 1640, Oil on canvas/Huile sur toile, 255 × 267 cm, Musée du Louvre, Paris

Tod der Kleopatra

Turchi zeigt die beiden letzten Momente im Leben der ägyptischen Pharaonin. Das tragische Schicksal der Herrscherin war wie geschaffen für die Barockzeit, wovon auch unzählige Opernbearbeitungen zeugen.

La muerte de Cleopatra

Turchi muestra los dos últimos momentos de la vida de la faraona egipcia. El trágico destino de la gobernante fue como si se hubiese creado para el Barroco, tal y como lo atestiguan las innumerables adaptaciones de la ópera.

Morte di Cleopatra

Turchi mostra gli ultimi due momenti della vita della regina egiziana. La tragica sorte della sovrana si adattava alla perfezione al periodo barocco, come testimoniano gli innumerevoli adattamenti operistici.

De dood van Cleopatra

Turchi toont de laatste twee momenten in het leven van deze vrouwelijke farao. Het tragische lot van de heerseres was als gemaakt voor de barok, waar ook de talloze operabewerkingen van getuigen.

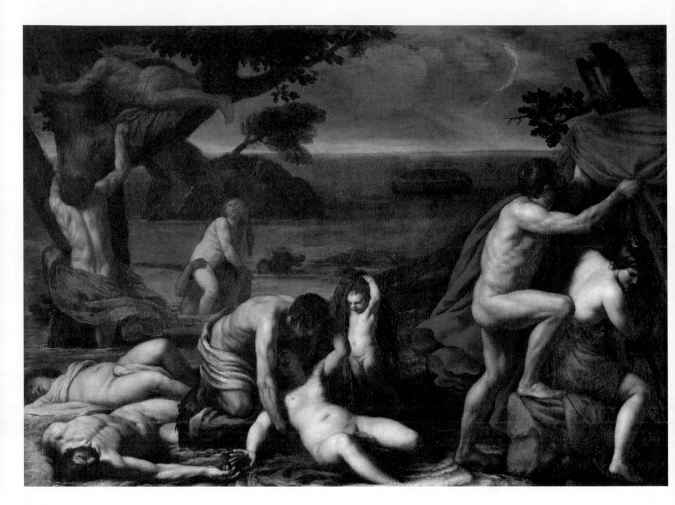

The Deluge

Le Déluge

Die Sintflut

El diluvio

Il diluvio

De zondvloed

ALESSANDRO TURCHI (1578- 1649)

c. 1614/15, Oil on canvas/Huile sur toile, 74 × 96 cm, Musée du Louvre, Paris

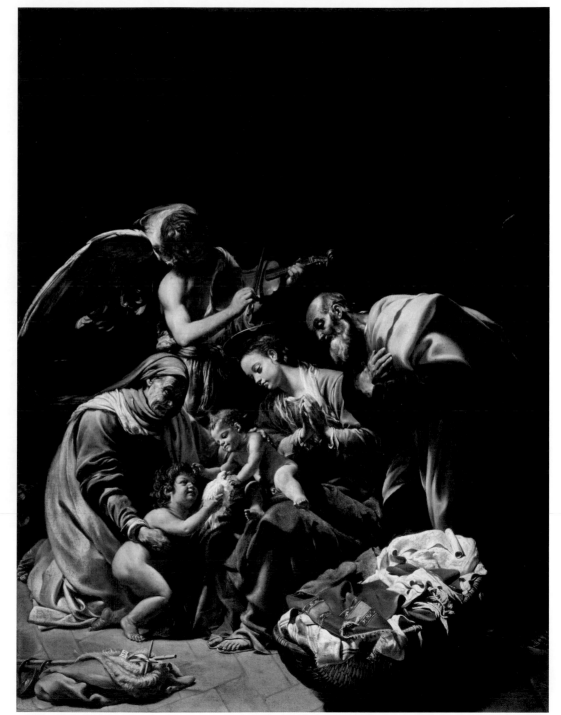

The Holy Family

La Sainte Famille

Die Heilige Familie

La Sagrada Familia

La Sacra Famiglia

De Heilige Familie

ORAZIO BORGIANNI
(1578–1616)

1615, Oil on canvas/Huile
sur toile, 226 × 173,5 cm,
Galeria Nazionale, Roma

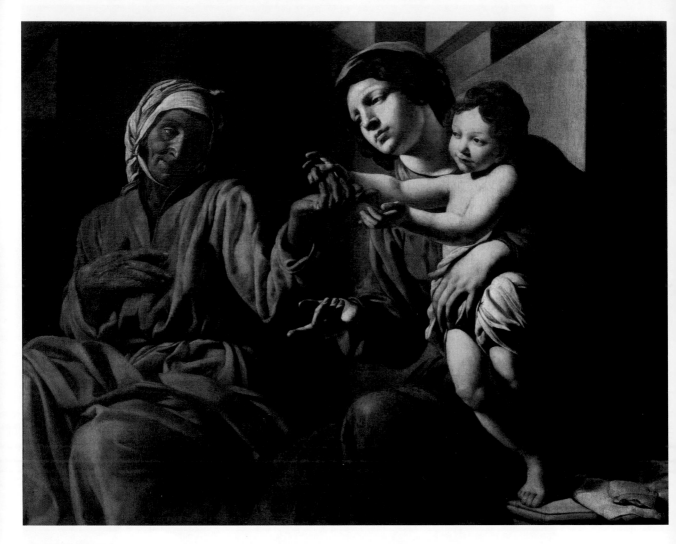

St Mary with Child and St Anne

La Vierge à l'Enfant avec sainte Anne

Maria mit dem Kind und der Heiligen Anna

María con el Niño y Santa Ana

Maria con il Bambino e Sant'Anna

Maria met Kind en de heilige Anna

GIOVANNI BATTISTA CARACCIOLO (1578–1635)

c. 1633, Oil on canvas/Huile sur toile, 119 × 152 cm, Kunsthistorisches Museum, Wien

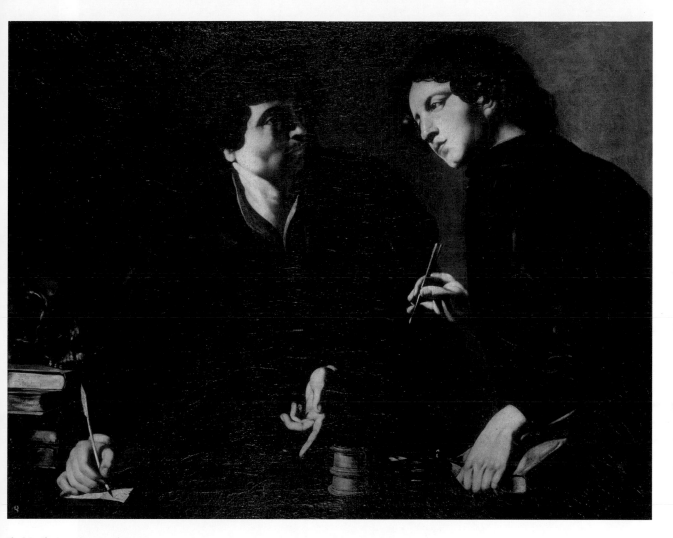

The Saint Physicians Cosmas and Damian

Portrait de deux médecins en saint Côme et saint Damien

Doppelporträt zweier Ärzte als Heilige Cosmas und Damian

Doble retrato de los Santos médicos Cosmas y Damián

Doppio ritratto di due medici come Santi Cosma e Damiano

Dubbelportret van twee artsen als de heiligen Cosmas en Damianus

GIOVANNI BATTISTA CARACCIOLO (1578–1635)

1620–30, Oil on canvas/Huile sur toile, 96 × 121 cm, Museo del Prado, Madrid

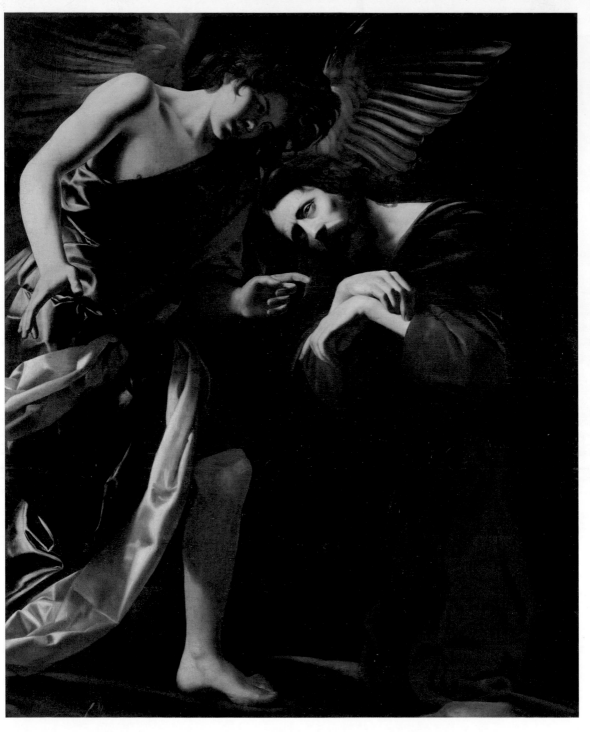

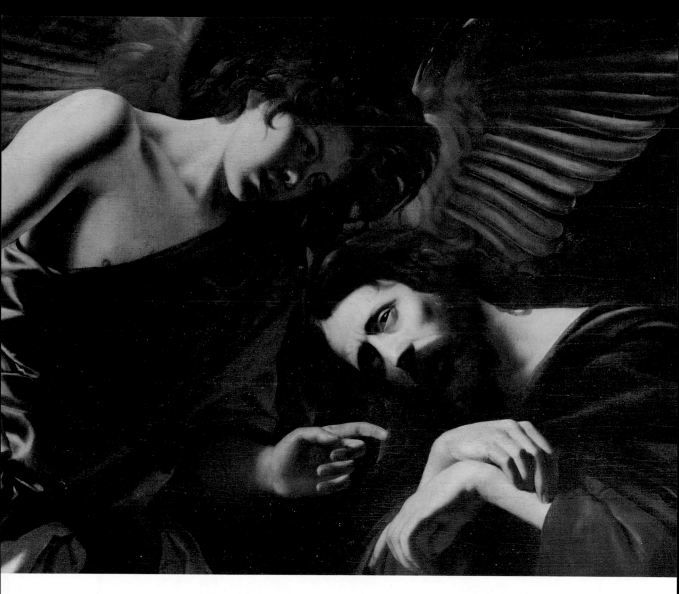

Christ on the Mount of Olives

More than almost any other of Caravaggio's successors, Caracciolo was able to prompt immediate emotional responses in the viewer – as with this Christ, who finds comfort in the angel.

Le Christ et l'ange dans le Jardin ou L'Agonie du Christ

Parmi les successeurs du Caravage, Caracciolo n'avait pas son pareil pour susciter des émotions immédiates chez le spectateur. C'est le cas avec ce Christ consolé par un ange.

Christus am Ölberg

Wie kaum einem zweiten unter den zahlreichen Nachfolgern Caravaggios gelang es Caracciolo, beim Betrachter unmmittelbare, direkte Emotionen hervorzurufen. So auch bei diesem Christus, der Trost durch den Engel erfährt.

Cristo en el Monte de los Olivos

Como casi ningún otro de los muchos sucesores de Caravaggio, Caracciolo fue capaz de evocar emociones directas e inmediatas en el espectador. También con este Cristo, que experimenta la consolación del ángel.

Cristo sul Monte degli Ulivi

Come quasi nessun altro dei tanti successori di Caravaggio, Caracciolo ha saputo suscitare emozioni immediate e dirette nello spettatore. Così anche con questo Cristo, che sperimenta il conforto attraverso l'angelo.

Christus op de Olijfberg

Als een van de weinige navolgers van Caravaggio kon Caracciolo bij de toeschouwer directe emoties oproepen. Zo ook met deze Christus, die troost ervaart door de engel.

GIOVANNI BATTISTA CARACCIOLO (1578–1635)

c. 1615–17, Oil on canvas/Huile sur toile, 148 × 124 cm, Kunsthistorisches Museum, Wien

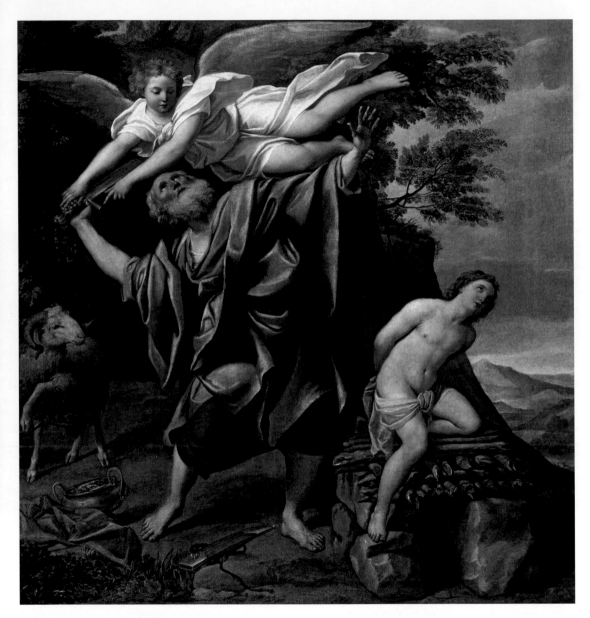

The Sacrifice of Isaac **Die Opferung Isaaks** **Il sacrificio di Isacco**

Le Sacrifice d'Abraham **El sacrificio de Isaac** **De offering van Izaäk**

DOMENICHINO (1581–1641)

1627/28, Oil on canvas/Huile sur toile, 147 × 140 cm, Museo del Prado, Madrid

**Landscape with Tobias
Laying Hold of the Fish**
Of all the Italian painters,
Domenichino is considered to have
most developed landscapepainting,
in many ways anticipating
Lorrain and Poussain.

L'Archange Raphaël avec Tobie
Parmi les peintres italiens baroques,
Le Dominiquin est considéré à
raison comme celui qui a le plus
fait avancer la peinture de paysages,
préfigurant même dans une large
mesure les paysages de Lorrain ou
de Poussin.

Landschaft mit Tobias
Unter den italienischen Malern
gilt Domenichino als derjenige, der
am meisten für die Entwicklung
der Landschaftsmalerei tat
und der in vielem schon die
Landschaften Lorrains oder
Poussains vorwegnahm.

Paisaje con Tobias
Entre los pintores italianos,
Domenichino es considerado
como el que más ha contribuido al
desarrollo de la pintura paisajística y
como el que en muchos sentidos ya
se anticipó a los paisajes de Lorrain
o Poussain.

Paesaggio con Tobias e l'angelo
Tra i pittori italiani, Domenichino è
considerato quello che è riuscito a
portare maggiore sviluppo alla
pittura paesaggistica e che per molti
versi ha già anticipato i paesaggi di
Lorrain o di Poussain.

Landschap met Tobias
Onder de Italiaanse schilders
wordt Domenichino beschouwd
als degene die het meest heeft
gedaan voor de ontwikkeling van
de landschapschilderkunst. Hij
liep in veel opzichten al vooruit
op de landschappen van Lorrain
en Poussain.

DOMENICHINO (1581–1641)
c. 1610–13, Oil on copper/Huile sur
plaque de cuivre, 45,1 × 33,9 cm,
The National Gallery, London

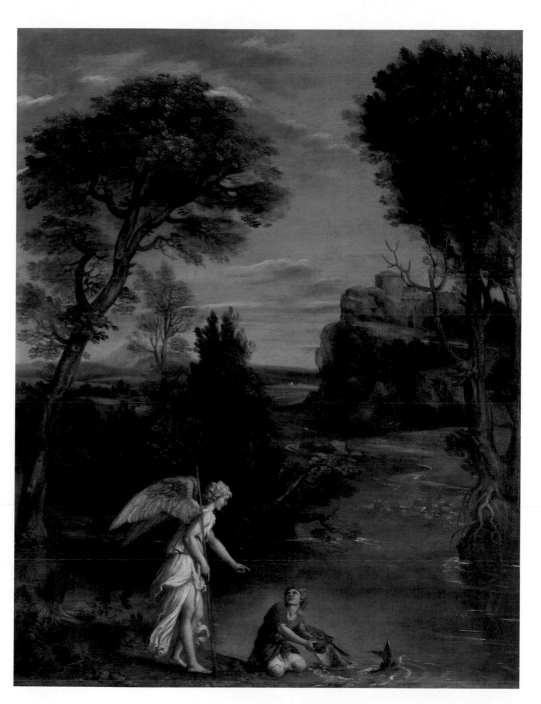

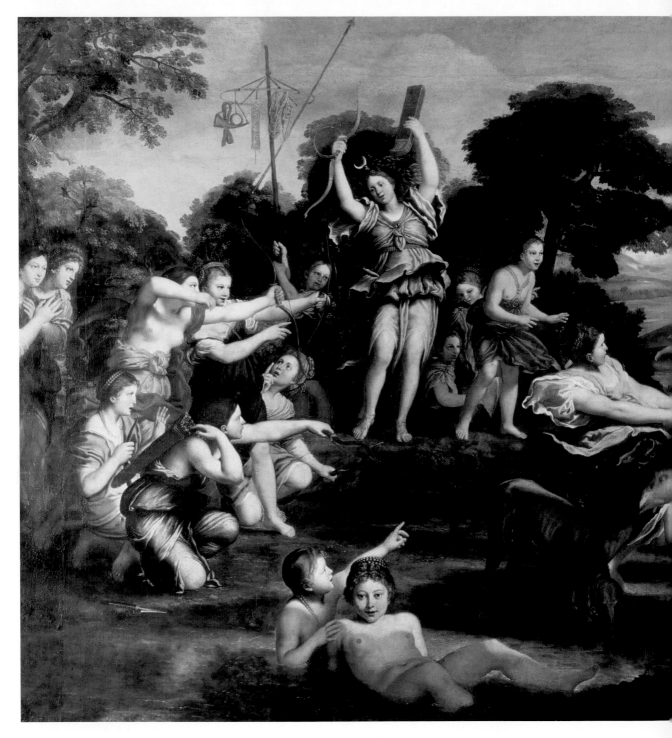

The Hunt of Diana

A monumental work, not least due to its breadth of more than three meters. Beginning with the two nymphs in the foreground, the viewer explores the picture, ever discovering new, surprising details.

Diane et ses nymphes

Une œuvre colossale symboliquement mais également par son envergure, de plus de trois mètres. En partant des deux nymphes situées au premier plan, le spectateur peut balayer tout le tableau en découvrant sans cesse de nouveaux détails inattendus.

Jagd der Diana

Ein monumentales Werk, nicht nur, weil es mehr als drei Meter breit ist. Ausgehend von den beiden Nymphen im Vordergrund sucht der Betrachter das Bild ab und entdeckt dabei immer neue, überraschende Details.

La caza de Diana

Una obra monumental, no sólo porque tiene más de tres metros de ancho. A partir de las dos ninfas en primer plano, el espectador busca la imagen y descubre detalles siempre nuevos y sorprendentes.

La caccia di Diana

Un'opera monumentale, non solo perché larga più di tre metri. Partendo dalle due ninfe in primo piano, lo spettatore esplora il dipinto e scopre dettagli sempre nuovi e sorprendenti.

De jacht van Diana

Dit is een monumentaal werk, niet alleen omdat het meer dan 3 meter breed is. Vanaf de twee nimfen op de voorgrond dwaalt de blik van de kijker over het schilderij en ontdekt daarbij steeds nieuwe, verrassende details.

DOMENICHINO (1581–1641)

1616/17, Oil on canvas/Huile sur toile, 225 × 320 cm, Galleria Borghese, Roma

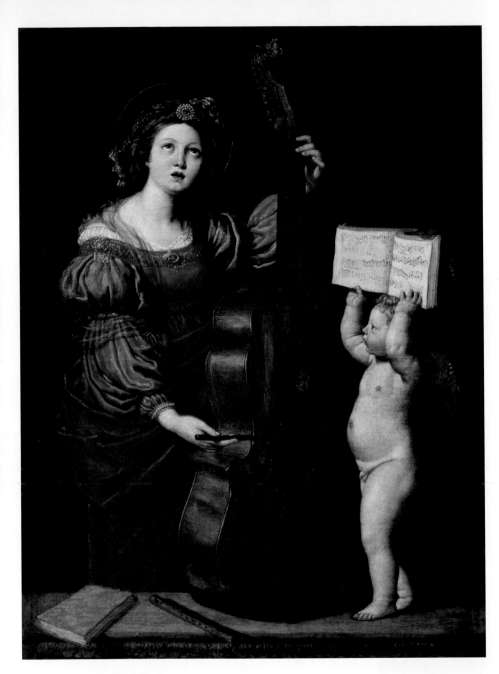

St Cecilia Die Heilige Cäcilie Santa Cecilia

Sainte Cécile La Santa Cecilia De heilige Cecilia

DOMENICHINO (1581–1641)

c. 1617/18, Oil on canvas/Huile sur toile, 160 × 120 cm, Musée du Louvre, Paris

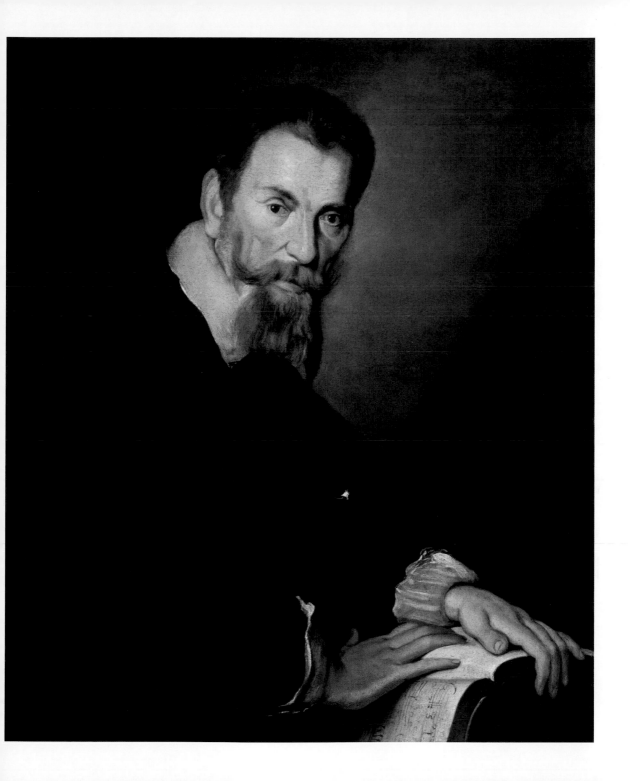

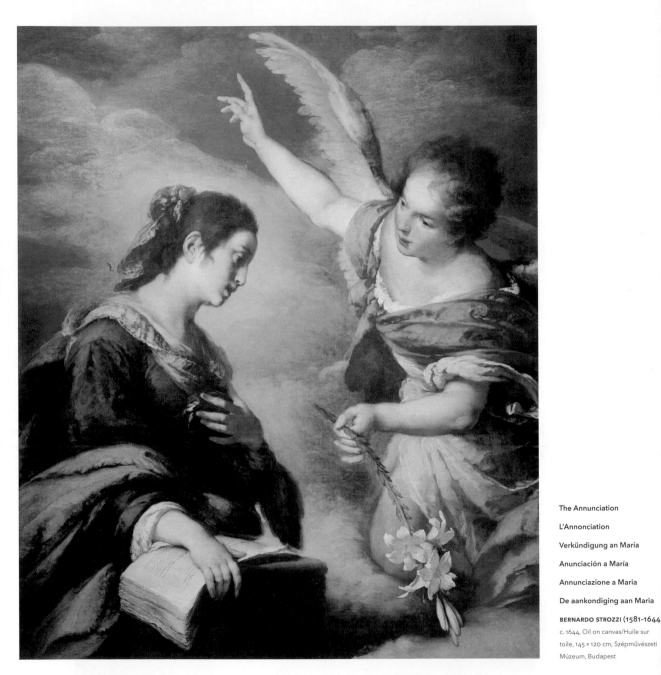

The Annunciation

L'Annonciation

Verkündigung an Maria

Anunciación a María

Annunciazione a Maria

De aankondiging aan Maria

BERNARDO STROZZI (1581–1644)

c. 1644, Oil on canvas/Huile sur toile, 145 × 120 cm, Szépművészeti Múzeum, Budapest

The Viola da Gamba Player

Strozzi was something of a secular priest in Venice, where he became one of the founders of the local baroque style. He managed to develop his own artistic language out of a wide variety of styles.

La Joueuse de viole de gambe ou La Joueuse de violoncelle (Portrait de Barbara Strozzi)

Strozzi était prêtre diocésain à Venise, où il devint l'un des fondateurs du style baroque vénitien. Il réussit à combiner les différentes influences en présence pour développer un langage artistique propre.

Die Gambenspielerin

Strozzi wirkte als Weltpriester in Venedig, wo er zu einem der Begründer des dortigen Barockstils wurde. Es gelang ihm, aus den verschiedensten Stilen eine eigene künstlerische Sprache zu entwickeln.

La intérprete de viola de gamba

Strozzi fue sacerdote mundial en Venecia, donde se convirtió en uno de los fundadores del estilo barroco. Consiguió desarrollar su propio lenguaje artístico a partir de una gran variedad de estilos.

Ritratto di Barbara Strozzi

Strozzi fu sacerdote universale a Venezia, dove divenne uno dei fondatori dello stile barocco. Egli è riuscito a sviluppare il proprio linguaggio artistico da una grande varietà di stili.

De violiste

Strozzi werkte als wereldgeestelijke in Venetië, waar hij een van de grondleggers van de barok werd. Hij slaagde erin zijn eigen artistieke taal te ontwikkelen uit een grote verscheidenheid aan stijlen.

BERNARDO STROZZI (1581–1644)
c. 1640, Oil on canvas/Huile sur toile, 126 × 99 cm, Gemäldegalerie Alte Meister, Dresden

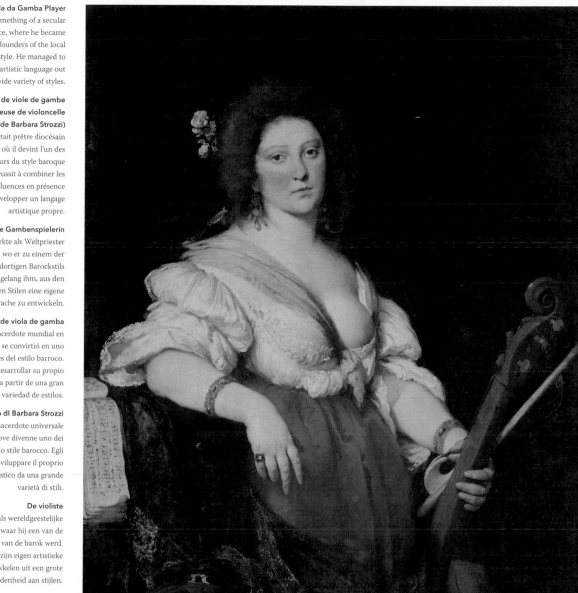

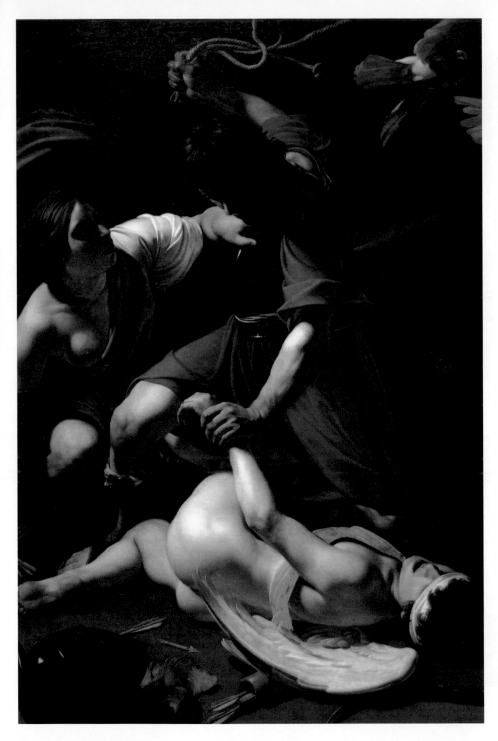

Cupid Chastised

Mars châtiant Cupidon

Mars züchtigt Amor

Marte castigando a Cupido

Marte castiga Cupido

Mars geselt Amor

BARTOLOMEO MANFREDI (1582–1622)
1613, Oil on canvas/Huile sur toile, 175,3 × 130,6 cm,
Art Institute of Chicago, Chicago

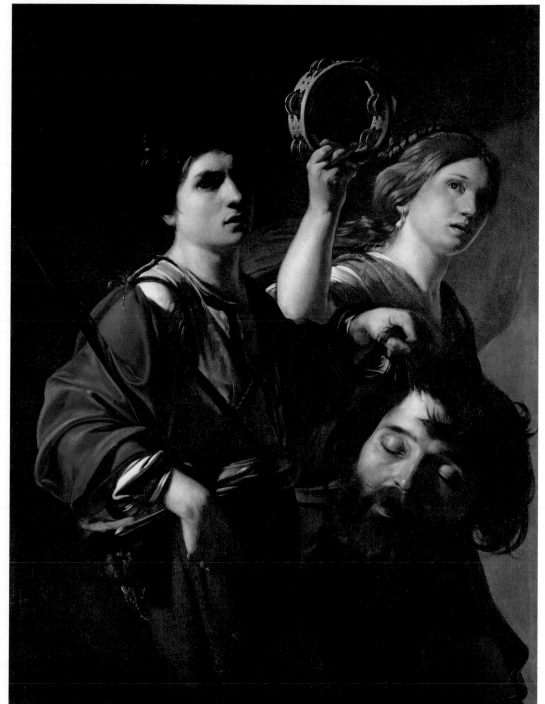

The Triumph of David

Le triomphe de David

Triumph Davids

El triunfo de David

Il trionfo di Davide

Triomf van David

**BARTOLOMEO MANFREDI
(1582–1622)**

c. 1615, Oil on canvas/
Huile sur toile, 128 × 97 cm,
Musée du Louvre, Paris

Judith and Holofernes

Judith et Holopherne

Judith und Holofernes

Judith y Holofernes

Giuditta e Oloferne

Judith en Holofernes

BARTOLOMEO MANFREDI (1582-1622)

n.d., Oil on canvas/Huile sur toile, 117,6 × 169,3 cm, Alte Pinakothek, München

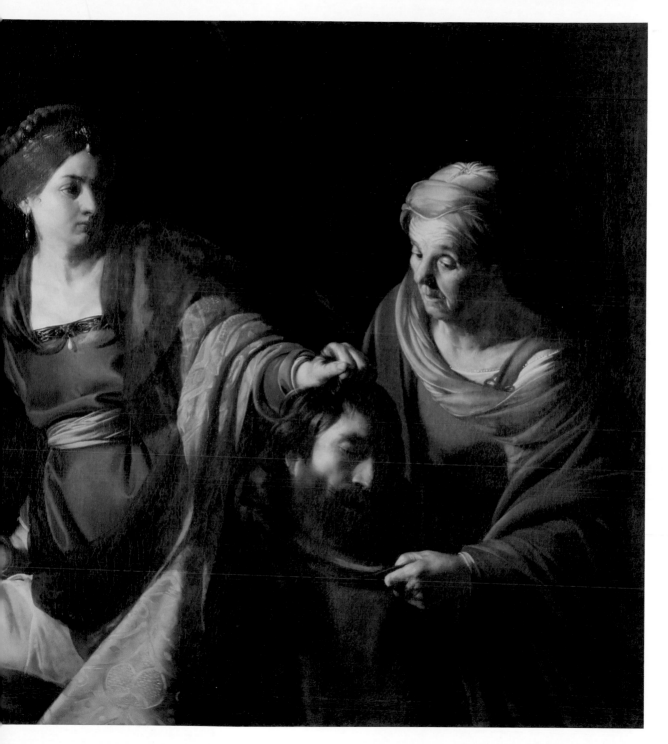

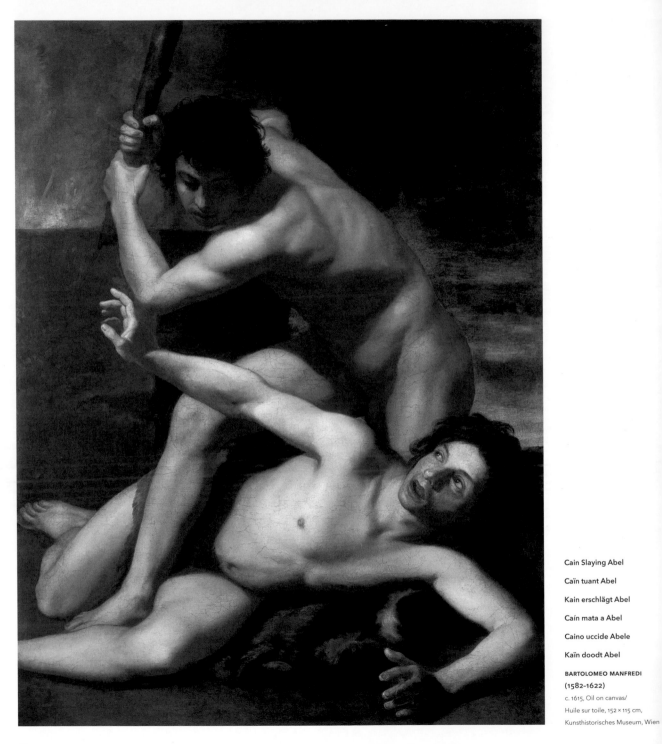

Cain Slaying Abel

Caïn tuant Abel

Kain erschlägt Abel

Caín mata a Abel

Caino uccide Abele

Kaïn doodt Abel

BARTOLOMEO MANFREDI
(1582–1622)

c. 1615, Oil on canvas/
Huile sur toile, 152 × 115 cm,
Kunsthistorisches Museum, Wien

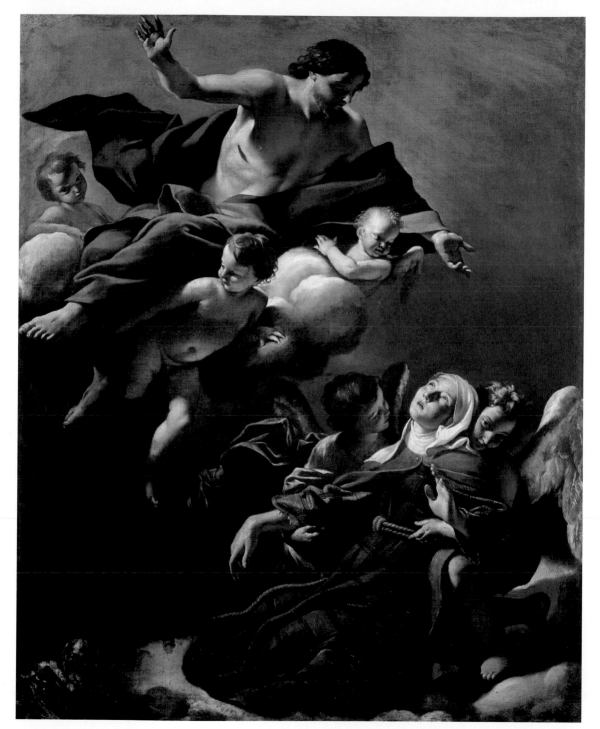

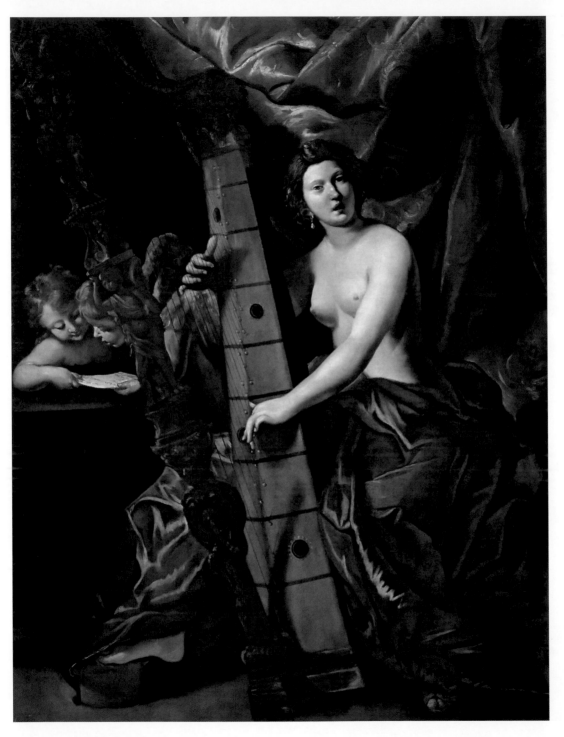

Venus Playing the Harp

Vénus jouant de la
harpe ou La Musique

Venus spielt die Harfe

Venus toca el arpa

Venere suona l'arpa

Venus speelt harp

**GIOVANNI LANFRANCO
(1582–1647)**
n.d., Oil on canvas/Huile
sur toile, 214 × 150 cm,
Galleria Nazionale, Roma

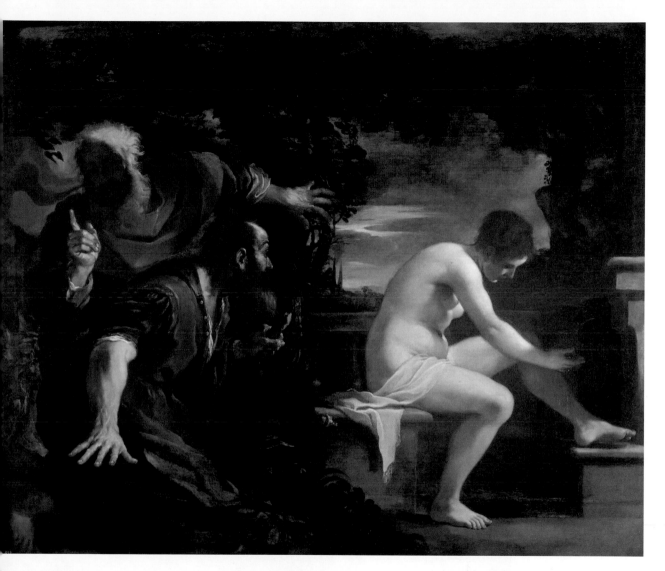

Susanna and the Elders

Rarely has the motif of the oppressed Susanna been depicted with greater internal tension. One only has to consider the contrast between the incensed old men and the tranquil young woman.

Suzanne et les vieillards

Le personnage tourmenté de Suzanne a rarement été représenté avec une tension aussi palpable : l'attention se focalise sur le fort contraste entre les vieillards furieux et la jeune femme plongée dans ses pensées.

GUERCINO (1591–1666)

1517, Oil on canvas/Huile sur toile, 176 × 208 cm, Museo del Prado, Madrid

Susanna und die beiden Alten

Selten wurde das Motiv der bedrängten Susanna mit größerer innerer Spannung dargestellt als hier. Man achte nur auf den starken Kontrast zwischen den aufgebrachten Alten und der in sich ruhenden jungen Frau.

Susanna y los viejos

Rara vez se ha representado el motivo de la oprimida Susana con mayor tensión interior que aquí. Sólo hay que prestar atención al fuerte contraste entre los viejos y la joven en reposo.

Susanna e i Vecchioni

Raramente il motivo della Susanna calunniata è stato raffigurato con maggiore tensione interiore come in questo dipinto. Basti pensare al forte contrasto tra gli anziani agitati e la tranquillità della giovane donna.

Susanna en de twee oude mannen

Zelden is het motief van de belaagde Susanna met meer innerlijke spanning afgebeeld dan hier. Dat is alleen al te zien aan het sterke contrast tussen de opgehitste oude mannen en de in zichzelf gekeerde jonge vrouw.

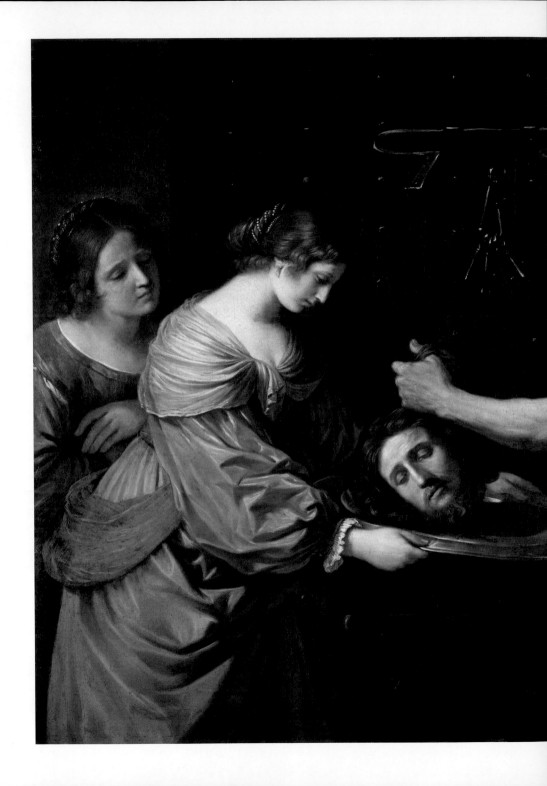

Salome Receiving the Head of John the Baptist

Salomé recevant la tête de saint Jean-Baptiste

Salome empfängt Haupt Johannes' des Täufers

Salomé recibe la cabeza de Juan el Bautista

Salomè riceve la testa di Giovanni Battista

Salomé ontvangt het hoofd van Johannes de Doper

GUERCINO (1591–1666)

1637, Oil on canvas/Huile sur toile, 139 × 175 cm, Musée des Beaux-Arts, Rennes

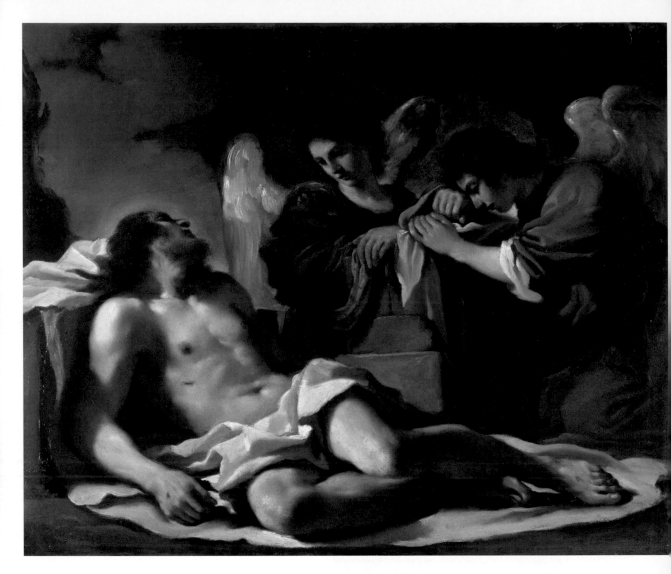

The Dead Christ Mourned by Two Angels

Le Christ mort pleuré par deux anges

Der tote Christus von zwei Engeln betrauert

El Cristo muerto llorado por dos ángeles

Il Cristo morto compianto dagli angeli

De dode Christus beweend door twee engelen

GUERCINO (1591–1666)

c. 1617/18, Oil on copper/Huile sur plaque de cuivre, 36,8 × 44,4 cm, The National Gallery, London

Et in Arcadia ego (The Arcadian Shepherds)

Et in Arcadia ego *ou* Les Bergers d'Arcadie

Schäfer in Arkadien

Pastor en Arcadia

Et in Arcadia Ego

Herders in Arcadië

GUERCINO (1591–1666)

1618–22, Oil on canvas/Huile sur toile, 81 × 91 cm, Galleria Nazionale, Roma

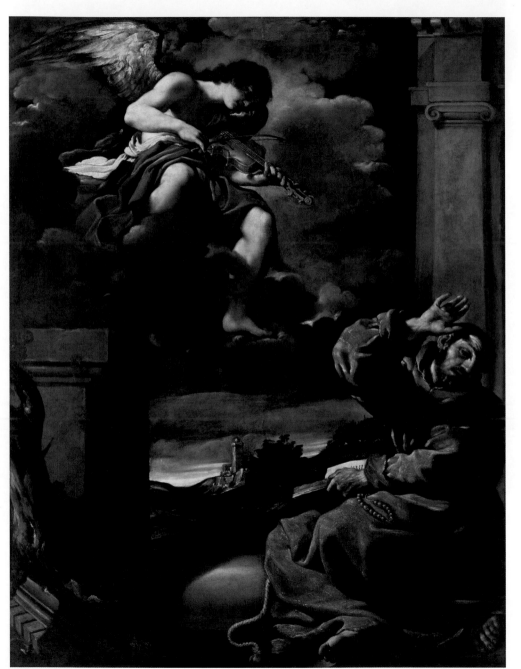

St Francis in Ecstasy with St Benedict and an Angel

Baroque depictions of St Francis focused less on stories such as the sermon to the birds, and more on the saint's immediate experience of God and his contemplative life.

L'Extase de saint François

Autre spécificité : les représentations baroques de saint François montrent rarement l'épisode où il parle aux oiseaux, préférant mettre au premier plan son expérience directe de Dieu et sa vie contemplative.

Ekstase des Heiligen Franziskus

Im Barock ging es beim Heiligen Franziskus seltener um Geschichten wie die Vogelpredigt, stattdessen rückten die unmittelbare Gotteserfahrung und sein kontemplatives Leben in den Vordergrund.

Éxtasis de San Francisco

En el periodo barroco, San Francisco trataba menos temas como el sermón del pájaro, y se centraba más en la experiencia inmediata de Dios y su vida contemplativa salieron a la luz.

Estasi di San Francesco

Nel periodo barocco, San Francesco veniva rappresentato meno spesso negli episodi come la predica degli uccelli, ma invece veniva messa in evidenza l'esperienza immediata di Dio e la sua vita contemplativa.

Extase van de heilige Franciscus

In de barok ging het bij Franciscus minder om verhalen zoals die over zijn vogelpreek, maar in plaats daarvan traden zijn directe ontmoeting met God en zijn contemplatieve leven op de oorgrond.

GUERCINO (1591–1666)
c. 1623, Oil on canvas/Huile sur toile,
162,5 × 127 cm, Gemäldegalerie
Alte Meister, Dresden

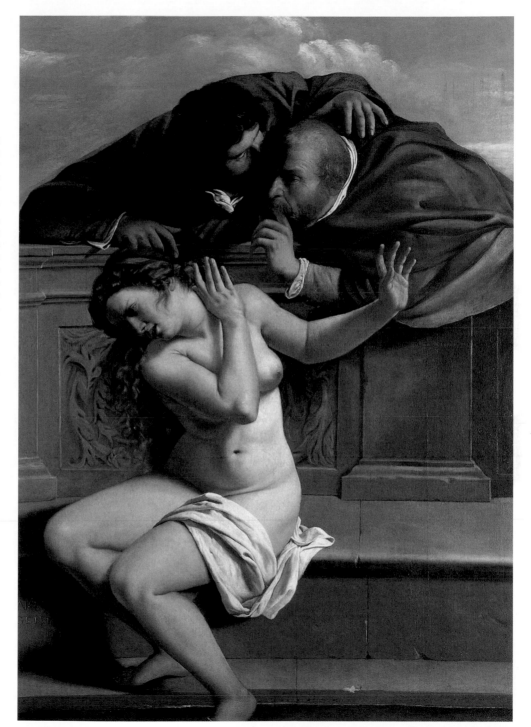

Susanna and the Elders

The fact that Gentileschi, as a woman artist, often took on erotically charged subjects made her works all the more attractive to her largely aristocratic clients.

Suzanne et les vieillards

Pour ses commanditaires souvent issus de la noblesse, le charme de beaucoup de tableaux de Gentileschi résidait dans le fait que cette peintre femme s'attaquait souvent à des sujets empreints d'érotisme. Cela vaut sans doute pour cette interprétation du motif de Suzanne.

Susanna und die Alten

Der Reiz vieler Gemälde Gentileschis bestand für viele ihrer meist adligen Kunden sicher darin, dass es eine Frau war, die sich den oft erotisch aufgeladenen Sujets annahm.

Susana y los viejos

El atractivo de muchas de las pinturas de Gentleeschi para muchos de sus clientes, en su mayoría aristocráticos, consistía precisamente en que era una mujer la que normalmente aparecía en los temas cargados eróticamente.

Susanna e i vecchioni

L'interesse di molti dipinti della Gentileschi per molti dei suoi clienti, per lo più aristocratici, consisteva certamente nel fatto che era una donna a dipingere i soggetti spesso carichi di erotismo.

Susanna en de ouderlingen

De aantrekkingskracht van veel van Gentileschi's schilderijen lag voor veel van haar veelal aristocratische opdrachtgevers zeker in het feit dat het een vrouw was die de vaak erotisch geladen onderwerpen aandurfde.

ARTEMISIA GENTILESCHI (1593-C. 1653)
c. 1610, Oil on canvas/Huile sur toile,
170 × 121 cm, Private collection

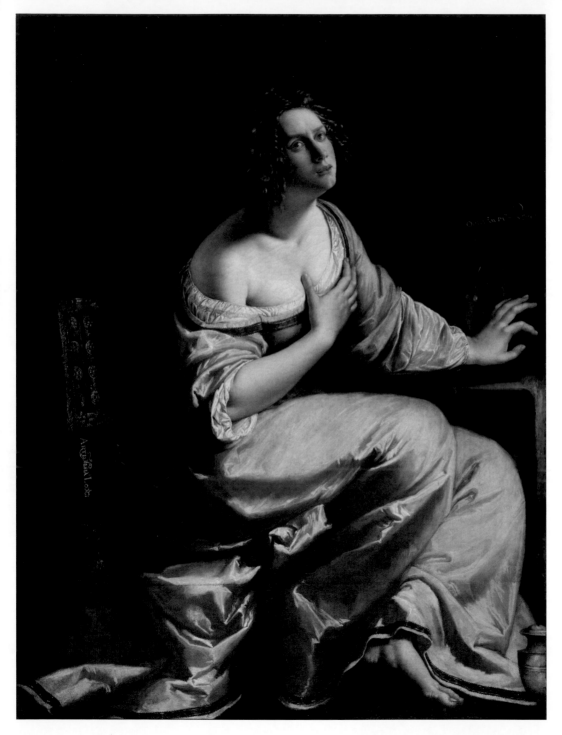

Mary Magdalene

La Conversion de Madeleine

Maria Magdalena

María Magdalena

Maria Maddalena

Maria Magdalena

ARTEMISIA GENTILESCHI (1593–C. 1653)
c.1620, Oil on canvas/Huile sur toile, 146,5 × 108 cm, Palazzo Pitti, Firenze

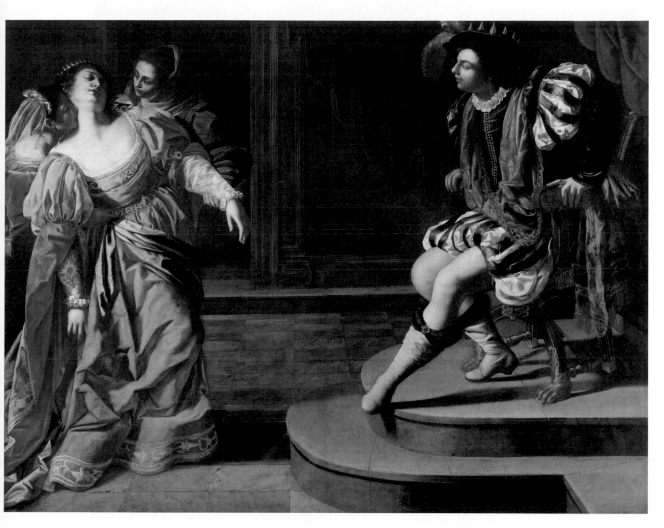

Esther Before Ahasuerus

Esther et Assuérus

Esther vor Ahasver

Esther frente a Ahasver

Ester e Assuero

Ester voor Ahasveros

ARTEMISIA GENTILESCHI (1593–C. 1653)
c. 1628–35, Oil on canvas/Huile sur toile, 208,3 × 273,7 cm, Metropolitan Museum of Art, New York

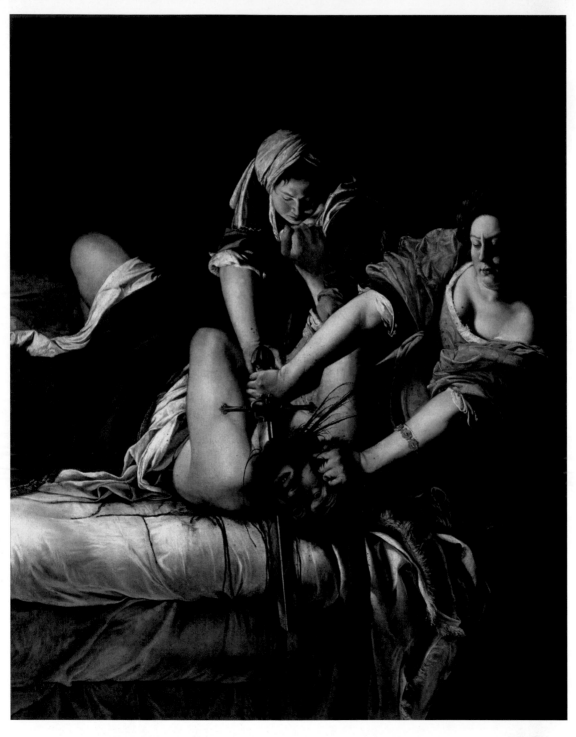

Judith Beheading
Holofernes

Judith décapitant
Holopherne

Judith und
Holofernes

Judith y Holofernes

Giuditta che
deacpita Oloferne

Judith en
Holofernes

**ARTEMISIA
GENTILESCHI**
(1593–C. 1653)
c. 1620, Oil on canvas/
Huile sur toile,
162,5 × 199 cm, Galleria
degli Uffizi, Firenze

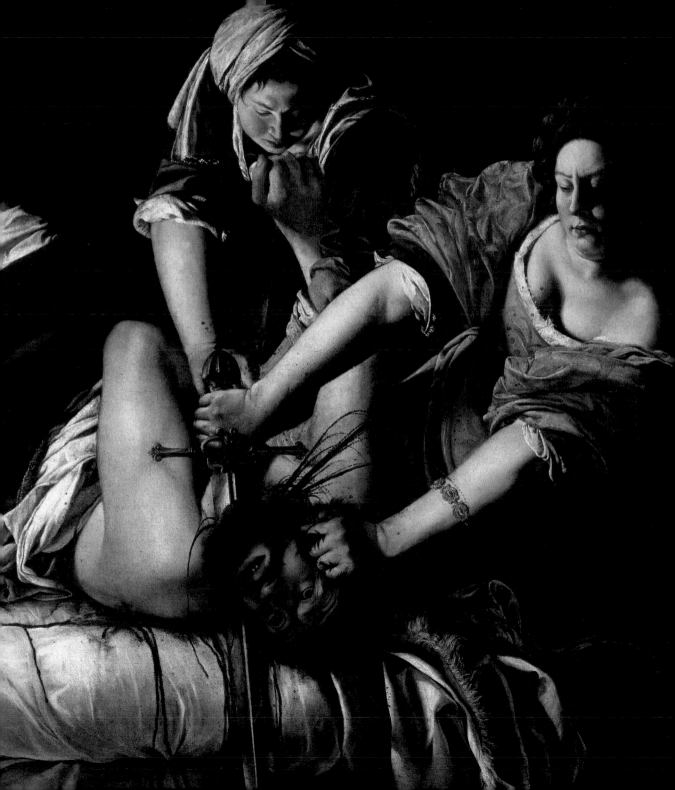

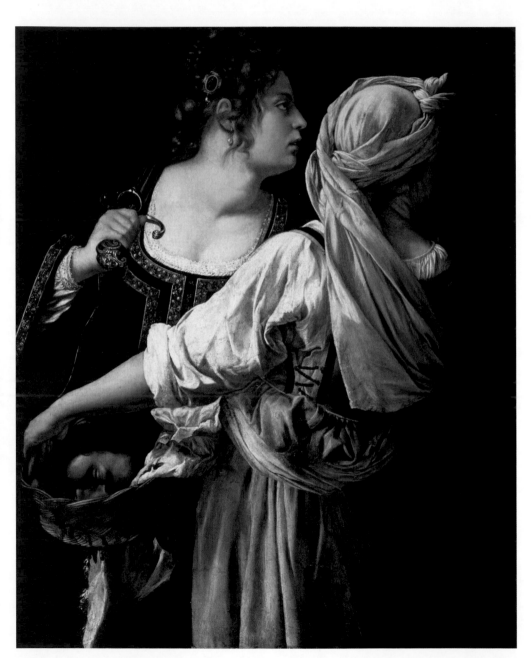

Judith and Her Maidservant

The story of Judith and Holofernes was a popular theme in the baroque period. Artemisia Gentileschi, one of the few female painters of the time, made the drama particularly tangible.

Judith et sa servante

L'histoire de Judith et Holopherne a été fréquemment représentée à l'époque baroque. Artemisia Gentileschi, l'une des rares femmes peintres de son temps, s'y entendait particulièrement bien pour rendre palpable la tension dramatique.

Judith mit dem Haupt des Holofernes

Die Geschichte um Judith und Holofernes wurde im Barock oft interpretiert. Artemisia Gentileschi, eine der wenigen weiblichen Maler der Zeit, verstand sich besonders gut darauf, die Dramatik spürbar zu machen.

Judith con el jefe de Holofernes

La historia de Judith y Holofernes fue interpretada a menudo en el periodo barroco. Artemisia Gentileschi, una de las pocas pintoras de la época, era particularmente buena haciendo tangible el drama.

Giuditta con la sua ancella

La storia di Giuditta e Olofene venne interpretata spesso in epoca barocca. Artemisia Gentileschi, una delle poche pittrici dell'epoca, fu particolarmente brava a rendere il dramma tangibile.

Judith met het hoofd van Holofernes

Het verhaal van Judith en Holofernes werd in de barok vaak vertolkt. Artemisia Gentileschi, een van de weinige vrouwelijke schilders van die tijd, slaagde er bijzonder goed in de dramatiek voelbaar te maken.

ARTEMISIA GENTILESCHI (1593–C. 1654)
c. 1620, Oil on canvas/Huile sur toile, 146,5 × 108 cm, Palazzo Pitti, Firenze

Philosophy

Autoportrait

Philosophie

Filosofía

Filosofia

De filosofie

SALVATOR ROSA
(1615–73)
c. 1645, Oil on
canvas/Huile sur
toile, 116,3 × 94
cm, The National
Gallery, London

The Return of Astraea

Rosa painted this allegory shortly before the end of the Thirty Years War:
Astraea, goddess of justice, appears accompanied by a lion and announces to
the peasants the dawn of the Golden Age.

Astrée enlevé par les anges

Peu avant la fin de la guerre de Trente Ans, Rosa peignit cette belle allégorie :
Astrée, déesse de la justice, apparaît accompagnée d'un lion et raconte aux
paysans les débuts de l'âge d'or.

Wiederkehr der Astraea

Kurz vor Ende des Dreißigjährigen Krieges malt Rosa diese Allegorie: Astraea,
Göttin der Gerechtigkeit erscheint in Begleitung eines Löwen und kündet den
Bauern vom Anbruch des Goldenen Zeitalters.

Regreso del Asträa

Poco antes del final de la Guerra de los Treinta Años, Rosa pinta esta alegoría:
Asträa, diosa de la justicia, aparece acompañada de un león y anuncia a los
campesinos el amanecer de la Edad de Oro.

Il ritorno di Astrea

Poco prima della fine della Guerra dei Trent'anni, Rosa dipinge questa allegoria:
Astrea, dea della giustizia, appare accompagnata da un leone e annuncia ai
contadini l'alba dell'Età dell'Oro.

De terugkeer van Astrea

Kort voor het einde van de Dertigjarige Oorlog schilderde Rosa deze allegorie:
Astrea, godin van de gerechtigheid, verschijnt samen met een leeuw en kondigt
aan de boeren het begin van de gouden eeuw aan.

SALVATOR ROSA (1615–73)

c. 1640–45, Oil on canvas/Huile sur toile, 139,5 × 209 cm, Kunsthistorisches Museum, Wien

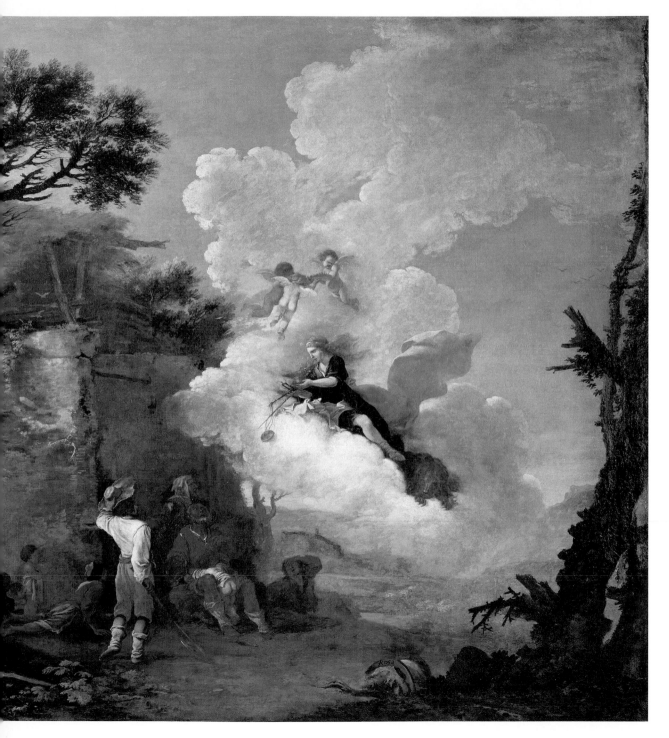

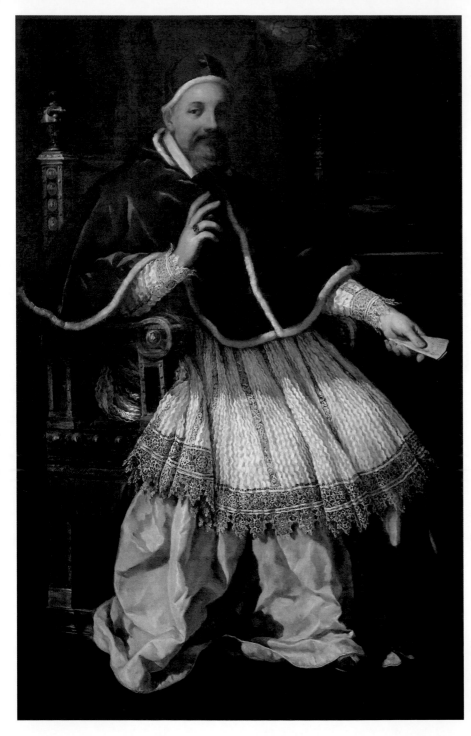

Pope Urban VIII

Portrait du pape Urbain VIII

Urban, der VIII.

Urbano, el VIII.

Urbano VIII

Urbanus VIII

PIETRO DA CORTONA (1597–1669)

1627, Oil on canvas/Huile sur toile,
199 × 128 cm, Musei Capitolini, Roma

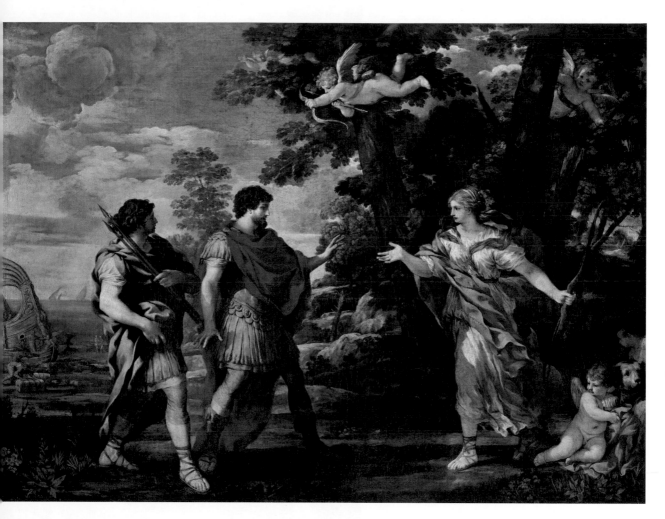

Venus as Huntress Appears to Aeneas

A scene derived from Virgil's Aeneid: Aeneas, founder of the city of Rome and son of the Trojan Anchises and Venus, encounters his mother in the form of a huntress.

Vénus apparaissant à Énée

Cet épisode est inspiré de l'Énéide de Virgile : Énée, futur fondateur de la ville de Rome et fils du Troyen Anchise et de Vénus, rencontre sa mère sous les traits d'une chasseresse.

Venus erscheint Aeneas als Jägerin

Vergils Aeneis entstammt die Vorlage für diese Episode: Aeneas, der spätere Gründer der Stadt Rom und Sohn des Trojaners Anchises und der Venus, trifft seine Mutter in der Gestalt einer Jägerin.

Venus se aparece a Eneas como cazadora

Vergils Aeneis es el modelo para este episodio: Eneas, el posterior fundador de la ciudad de Roma e hijo de los Troyanos Anquisas y Venus, conoce a su madre en la forma de una cazadora.

Venere appare ad Enea come una cacciatrice

L'Eneide di Virgilio è il modello di questo episodio: Enea, il più tardi fondatore della città di Roma e figlio del troiano Anchise e di Venere, incontra sua madre nelle sembianze di una cacciatrice.

Venus verschijnt als slaaf voor Aeneas

Uit Vergilius' Aeneis komt het voorbeeld voor deze episode: Aeneas, de latere stichter van de stad Rome en zoon van de Trojaan Anchises en Venus, ontmoet zijn moeder in de gedaante van een slaaf.

PIETRO DA CORTONA (1596–1669)

c. 1630–35, Oil on canvas/Huile sur toile, 127 × 176 cm, Musée du Louvre, Paris

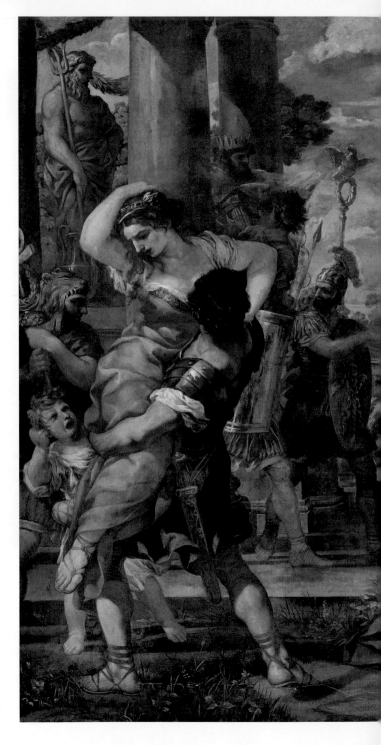

The Rape of the Sabines

L'Enlèvement des Sabines

Raub der Sabinerinnen

Rapto de las Sabinas

Ratto delle Sabine

De Sabijnse maagdenroof

PIETRO DA CORTONA (1596–1669)
1629, Oil on canvas/Huile sur toile, 280,5 × 426 cm, Protomoteca Capitolina, Rom

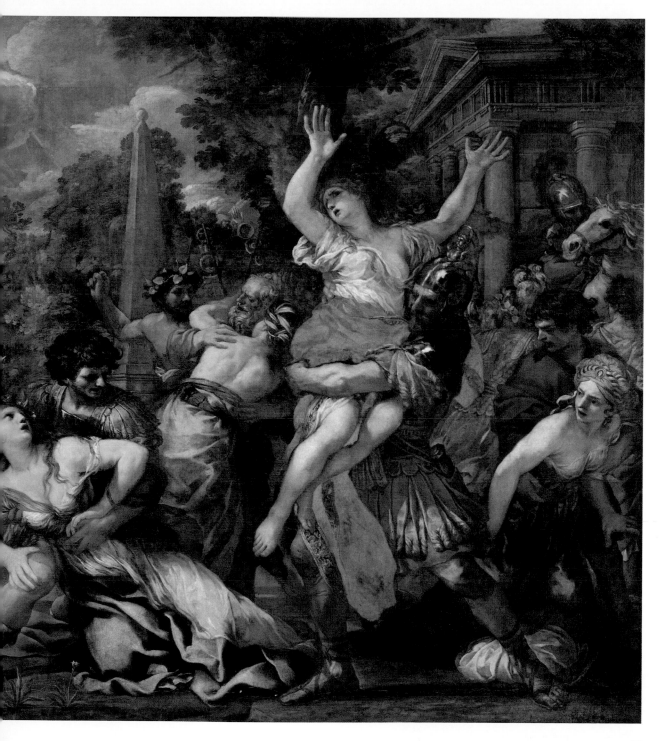

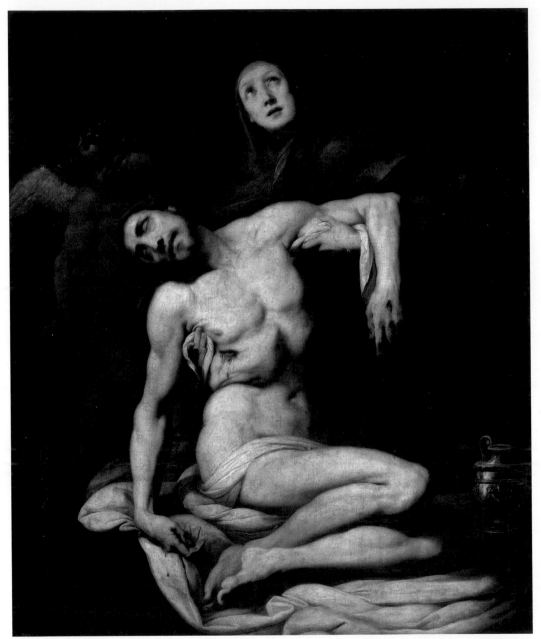

Pietà

Originally commissioned by the Spanish envoy in Rome, this painting survived the fire in the Royal Palace of Madrid in 1734. Later, it was transferred to the Prado.

Pietà

Commandé par l'ambassadeur espagnol à Rome, futur vice-roi de Naples, ce tableau alla jusqu'à Madrid, où il survécut en 1734 à l'incendie du palais royal. Il fut plus tard transféré au Prado.

Pietà

In Auftrag gegeben vom spanischen Gesandten in Rom, gelangte das Bild nach Madrid, wo es den Brand im Königlichen Palast im Jahr 1734 überstand. Später wurde es in den Prado überführt.

Pietà

Por encargo del enviado español en Roma, la pintura llegó a Madrid, donde sobrevivió al incendio del Palacio Real en 1734. Posteriormente fue trasladado al Prado.

Pietà

Commissionato dall'emissario spagnolo a Roma, il dipinto giunse a Madrid, dove sopravvisse all'incendio del Palazzo Reale nel 1734. In seguito, fu trasferito al Prado.

Piëta

In opdracht van de Spaanse gezant in Rome kwam het schilderij naar Madrid, waar het in 1734 de brand in het koninklijk paleis overleefde. Later werd het overgebracht naar het Prado.

DANIELE CRESPI (1598–1630)

1626, Oil on canvas/
Huile sur toile, 154 × 128 cm,
Museo del Prado, Madrid

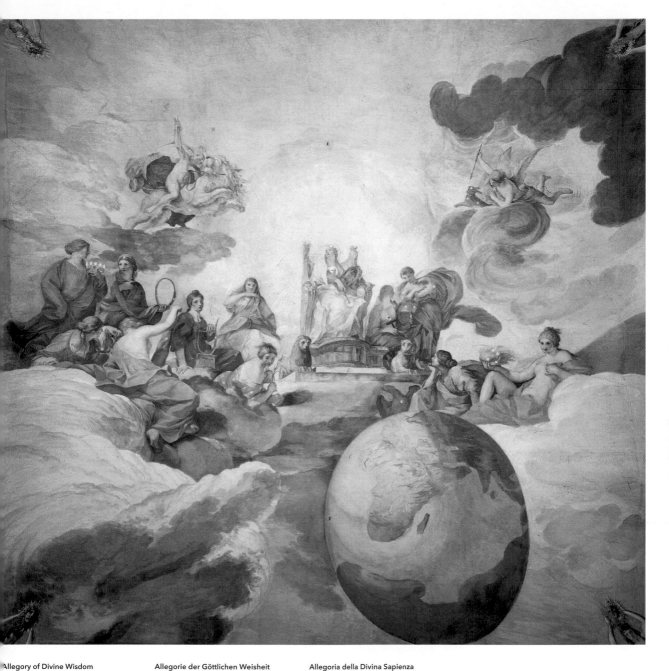

Allegory of Divine Wisdom	Allegorie der Göttlichen Weisheit	Allegoria della Divina Sapienza
Triomphe de la Sagesse divine	Alegoría de la Sabiduría Divina	Allegorie van de goddelijke wijsheid

ANDREA SACCHI (1599–1661)

629–31, Fresco/Fresque, 130 × 140 cm, Palazzo Barberini, Roma

The Vision of St Romuald

The founder of the Camaldolese Order is said to have had a vision of a ladder on which white-clad monks climbed to heaven. For this reason, he choose white robes for his order's habit.

La Vision de saint Romuald

Dans sa vision, le fondateur de l'ordre des Camaldules aurait rêvé d'une échelle sur laquelle des moines habillés de blanc montaient jusqu'au ciel. Plus tard, il fit du blanc la couleur de l'habit de son ordre.

Die Vision des Heiligen Romuald

In seiner Vision soll der Gründer des Camaldulenserordens von der Leiter geträumt haben, auf denen die weißgekleideten Mönche zum Himmel kletterten. Aus diesem Grund übernahm er die weißen Gewänder als Ordenstracht.

La visión de San Romualdo

En su visión, se dice que el fundador de la Orden Camaldulense soñó con la escalera por la que los monjes vestidos de blanco subían al cielo. Por esta razón tomó la túnica blanca como hábito.

La visione di san Romualdo

Nella sua visione, il fondatore dell'Ordine Camaldolese avrebbe sognato la scala su cui i monaci, vestiti di bianco, salivano al cielo. Per questo motivo come per l'abito religioso è stato scelto il colore bianco.

Het visioen van de heilige Romualdus

In zijn visioen zou de stichter van de camaldulenzenorde gedroomd hebben over een ladder waarop in het wit geklede monniken naar de hemel klommen. Daarom werden witte habijten de kleding van de orde.

ANDREA SACCHI (1599–1661)

c. 1631, Oil on canvas/Huile sur toile, 310 × 175 cm, Musei Vaticani, Roma

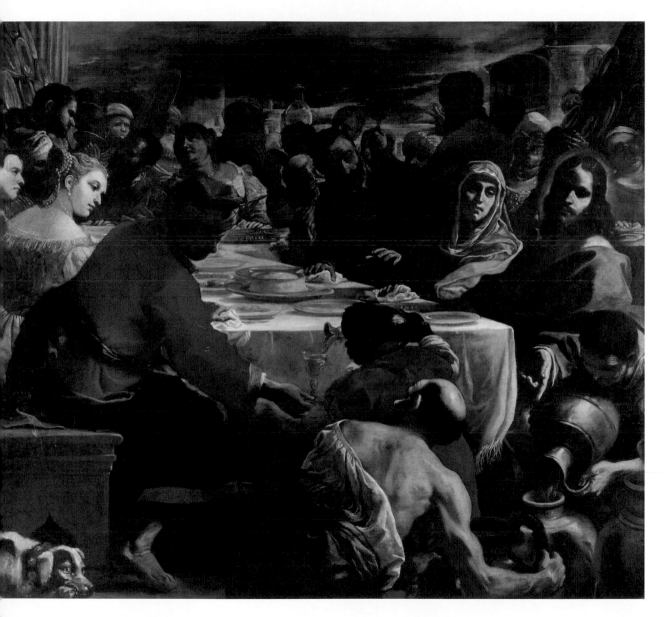

The Marriage at Cana Die Hochzeit von Kanaa Il matrimonio di Kanaa

Les Noces de Cana La boda de Kanaa De bruiloft te Kana

MATTIA PRETI (1613–99)

c. 1655–60, Oil on canvas/Huile sur toile, 203,2 × 226 cm, The National Gallery, London

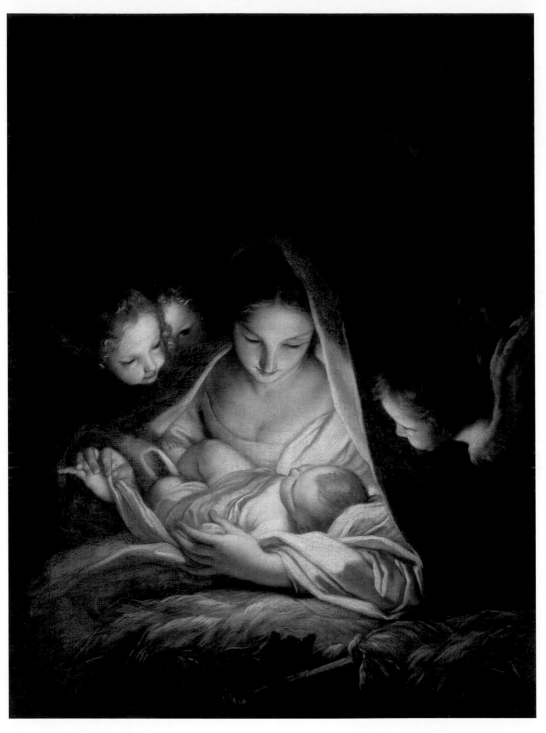

The Holy Night (The Nativity)

La Sainte Nuit

Die Heilige Nacht

La Nochebuena

La Santa Notte

De heilige nacht

CARLO MARATTA (1625–1713)
c. 1650, Oil on canvas/Huile sur
toile, 99 × 75 cm, Gemäldegalerie
Alte Meister, Dresden

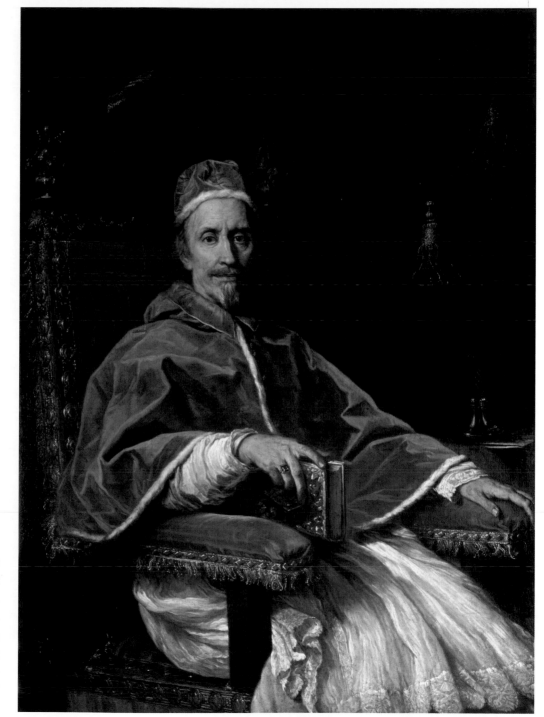

Portrait of Pope Clement IX

Portrait de Clément IX

Papst Clemens IX.

El Papa Clemente IX.

Papa Clemente IX

Paus Clemens IX

CARLO MARATTA (1625-1713)
c. 1669, Oil on canvas/Huile sur
toile, 123 × 170 cm, State Hermitage
Museum, St. Petersburg

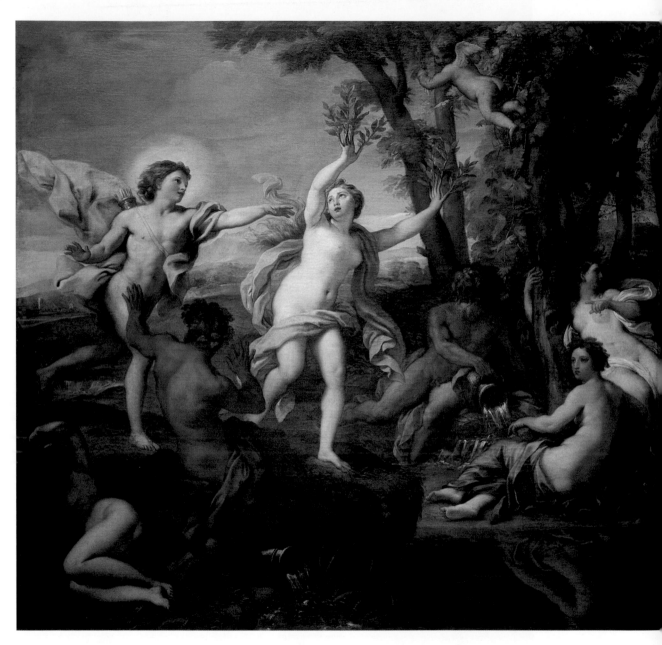

Apollo and Daphne

Apollo und Daphne

Apollo e Dafne

Apollon à la poursuite de Daphné

Apolo y Dafne

Apollo en Daphne

CARLO MARATTA (1625–1713)

1681, Oil on canvas/Huile sur toile, 221,1 × 224 cm, Musée Oldmasters Museum, Bruxelles

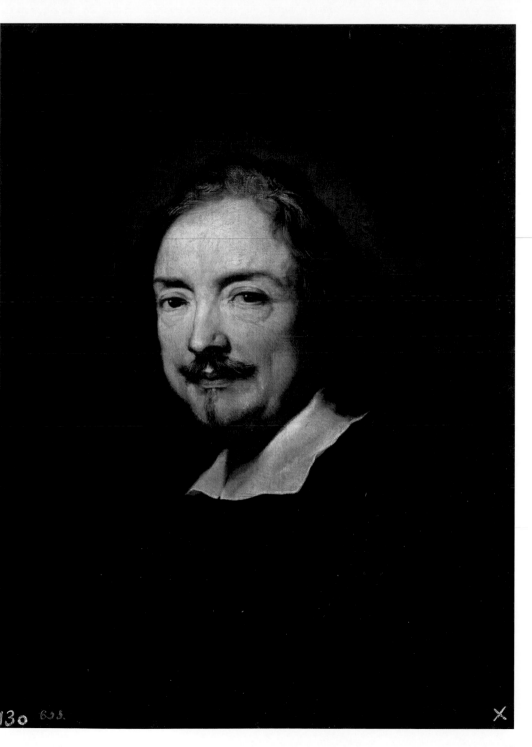

Andrea Sacchi

The enormously productive Carlo Maratta became a student of the then-famous Roman painter Andrea Sacchi at a young age. This portrait of his first teacher was painted shortly before the latter's death in 1661.

Le Peintre Andrea Sacchi

Extrêmement productif, Carlo Maratta fut dès ses jeunes années l'élève du célèbre peintre romain Andrea Sacchi. Il réalisa ce portrait de son premier maître peu avant la mort de celui-ci, en 1661.

Andrea Sacchi

Der enorm produktive Carlo Maratta wurde schon in jungen Jahren Schüler des damals sehr bekannten römischen Malers Andrea Sacchi. Dieses Porträt seines ersten Lehrers entstand kurz vor dessen Tod im Jahre 1661.

Andrea Sacchi

El enormemente productivo Carlo Maratta se convirtió en un estudiante del entonces famoso pintor romano Andrea Sacchi a una edad muy temprana. Este retrato de su primer maestro fue pintado poco antes de su muerte en 1661.

Andrea Sacchi

Carlo Maratta, estremamente produttivo, divenne allievo fin da giovanissimo dell'allora famosissimo pittore romano Andrea Sacchi. Questo ritratto del suo primo maestro fu realizzato poco prima della sua morte, avvenuta nel 1661.

Andrea Sacchi

De uiterst productieve Carlo Maratta werd al op jonge leeftijd leerling van de toen zeer beroemde Romeinse schilder Andrea Sacchi. Dit portret van zijn eerste leermeester werd kort voor diens dood in 1661 geschilderd.

CARLO MARATTA (1625–1713)
c. 1661, Oil on canvas/Huile sur toile,
7 × 50 cm, Museo del Prado, Madrid

63

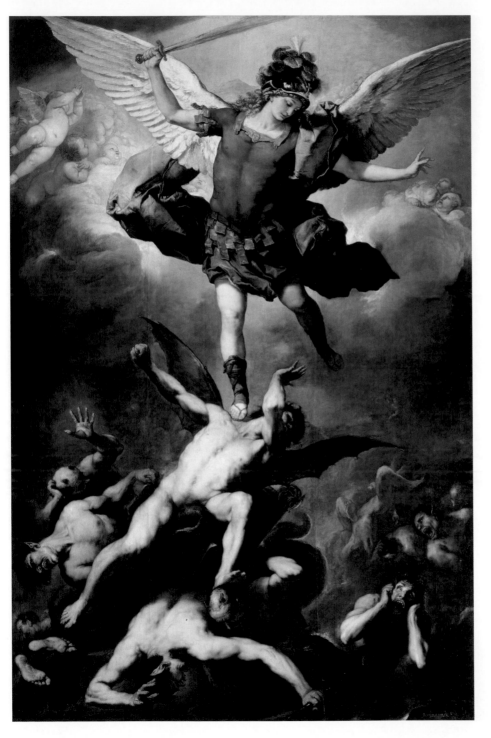

The Fall of the Rebel Angels

Few other baroque painters had such a large stylistic repertoire as the Neapolitan Luca Giordano. This work was originally commissioned for the Minoritenkirche in Vienna.

L'Archange saint Michel rejette les anges rebelles en enfer

Peu de peintres baroques disposaient d'un éventail de styles aussi large que celui de Luca Giordano, originaire de Naples. Cette œuvre fut initialement réalisée pour l'église des Minimes de Vienne.

Erzengel Michael stürzt die abtrünnigen Engel

Wenige andere Barockmaler verfügten über eine ähnlich große stilistisches Repertoire wie der in Neapel geborene Luca Giordano. Dieses Werk wurde ursprünglich für die Wiener Minoritenkirche gestiftet.

El Arcángel Miguel derriba a los ángeles renegados

Pocos otros pintores barrocos tenían un repertorio estilístico tan amplio como Luca Giordano, nacido en Nápoles. Esta obra fue donada originalmente para la Minoritenkirche de Viena.

San Michele sconfigge gli angeli ribelli

Pochi altri pittori barocchi avevano un repertorio stilistico così vasto come Luca Giordano, nato a Napoli. Quest'opera è stata donata originariamente per la Minoritenkirche di Vienna.

De aartsengel Michaël stort zich op de afvallige engelen

Maar weinig barokschilders hadden zo'n groot stilistisch repertoire als de in Napels geboren Luca Giordano. Dit werk werd oorspronkelijk geschonken voor de Minoritenkirche in Wenen

LUCA GIORDANO (1632-1705)

c. 1660-65, Oil on canvas/Huile sur toile, 419 × 283 cm, Kunsthistorisches Museum, Wien

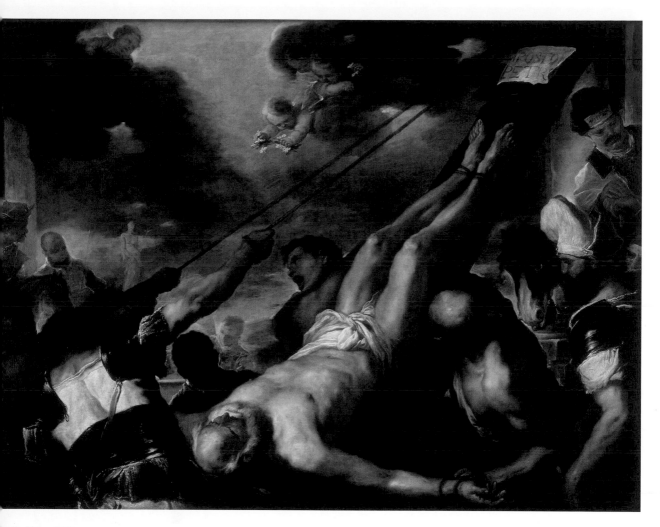

The Crucifixion of St Peter

Le Crucifiement de saint Pierre

Kreuzigung Petri

Crucifixión de Pedro

Crocifissione di San Pietro

Kruisiging van Petrus

LUCA GIORDANO (1634–1705)

1660, Oil on canvas/Huile sur toile, 196 × 258 cm, Gallerie dell'Accademia, Venezia

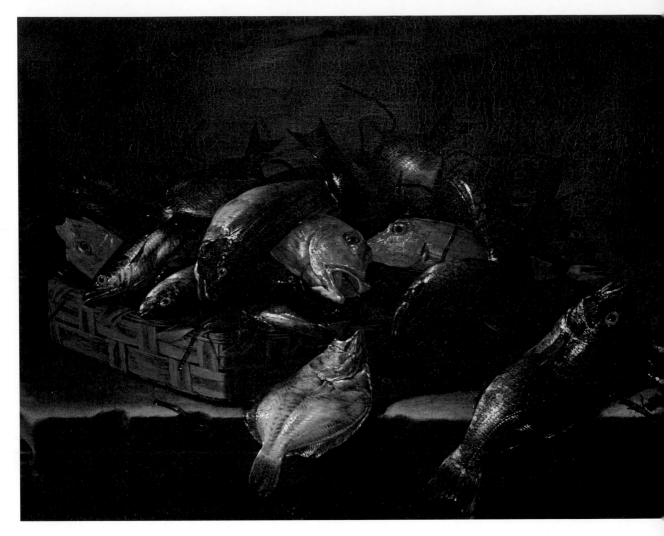

Still Life with Fish

Nature morte aux poissons

Stillleben mit Fischen

Naturaleza muerta con peces

Natura morta con pesce

Stilleven met vissen, oesters en garnalen

GIUSEPPE RECCO (1634–95)

17th century, Oil on canvas/Huile sur toile, 92 × 116 cm, Musée du Louvre, Paris

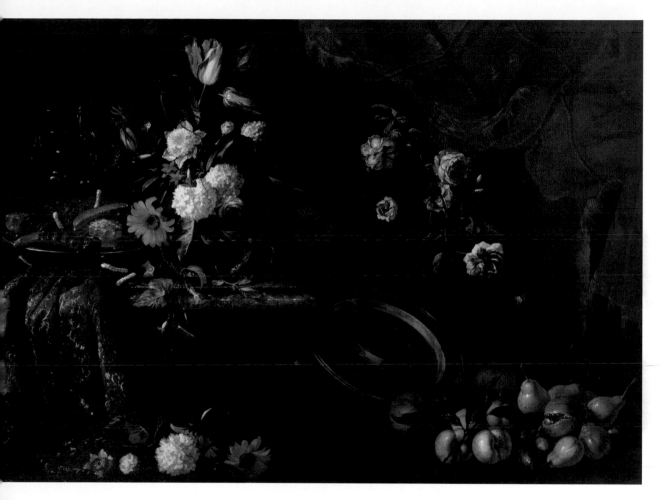

Flowers, Fruits, and Sweets

Nature morte aux fleurs, fruits et friandises

Blumen, Früchte und Süßwaren

Flores, frutas y dulces

Fiori, frutti e dolciumi

Bloemen, fruit en zoetigheden

GIUSEPPE RECCO (1634–95)

17th century, Oil on canvas/Huile sur toile, Private collection

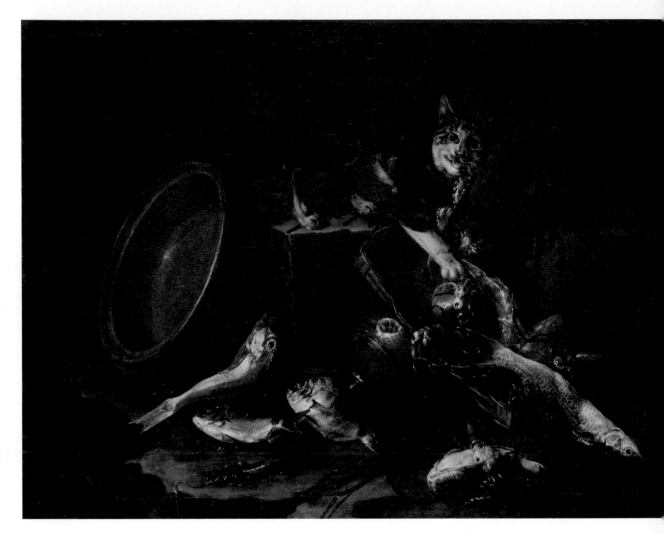

A Cat Stealing Fish

Chat volant un poisson

Eine Katze stiehlt Fisch

Un gato robando pescado

Un gatto ruba il pesce

Een kat steelt vis

GIUSEPPE RECCO (1634–95)
c. 1667–69, Oil on canvas/Huile sur toile, 96,5 × 128,3 cm, Metropolitan Museum of Art, New York

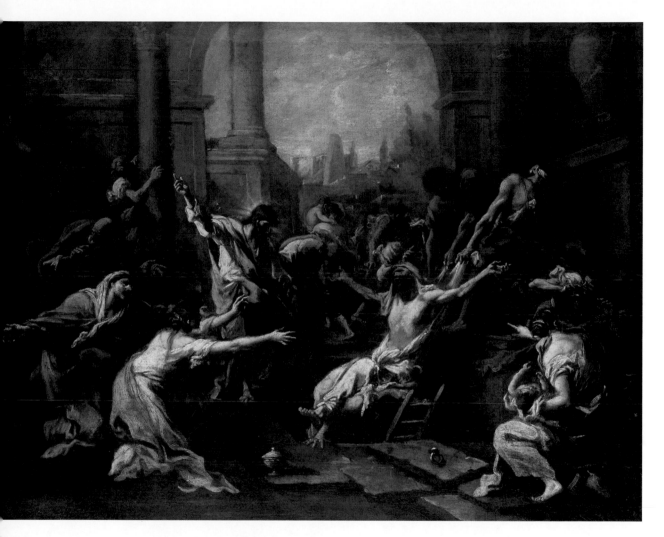

The Raising of Lazarus

Magnasco is notable among the painters of his time for his highly dramatic scenes. His interpretation of the Lazarus story features numerous amazed spectators and bold gestures by Christ and other figures.

La Résurrection de Lazare

Avec ses scènes à la tension dramatique extrême, Magnasco acquit une place particulière parmi les peintres de son époque. C'est le cas dans cette représentation de Lazare, avec ses nombreux spectateurs émerveillés et son Christ aux bras levés.

Die Auferstehung des Lazarus

Magnasco nahm mit seinen hochdramatischen Szenen unter den Malern seiner Zeit eine Sonderstellung ein. So auch in dieser Lazarus-Interpretation mit den vielen staunenden Zuschauern und Christus mit erhobenem Arm.

La Resurrección de Lázaro

Magnasco ocupó un lugar especial entre los pintores de su época con sus escenas de gran dramatismo, también en esta interpretación de Lázaro con los muchos espectadores asombrados y Cristo con el brazo levantado.

La risurrezione di Lazzaro

Magnasco occupa un posto speciale tra i pittori del suo tempo grazie alle sue scene altamente drammatiche. Anche per questa interpretazione di Lazzaro con i tanti spettatori stupiti e Cristo con il braccio alzato.

De opwekking van Lazarus

Magnasco nam met zijn uiterst dramatische scènes een bijzondere positie in onder de schilders van zijn tijd. Zo ook in deze Lazarusinterpretatie met zijn schare verbaasde toeschouwers en Christus met opgeheven arm.

ALESSANDRO MAGNASCO (1667-1749)

1715-40, Oil on canvas/Huile sur toile, 65,5 × 83,5 cm, Rijksmuseum, Amsterdam

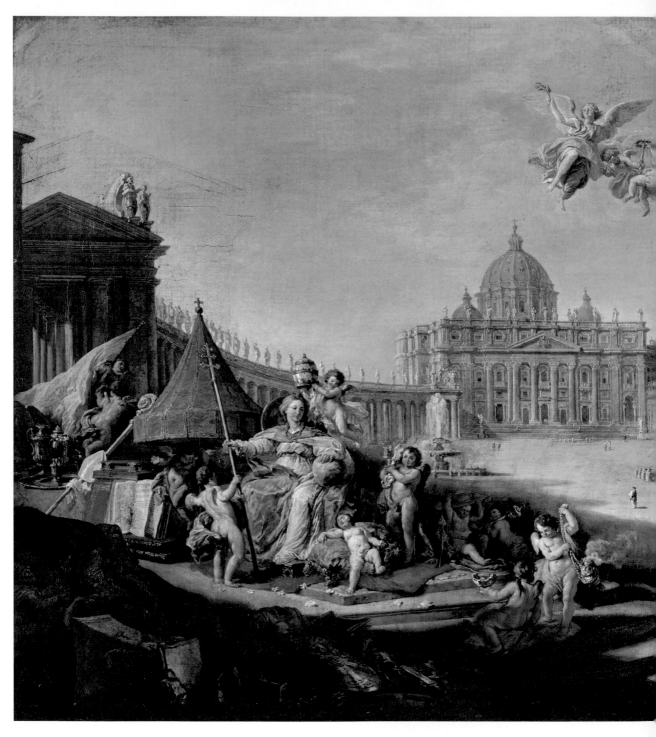

St Peter's Square with the Triumph of the Papacy

La Place Saint-Pierre avec l'allégorie du triomphe de la papauté

Petersplatz mit Triumph des Papsttums

Plaza de San Pedro con el triunfo del pontificado

Piazza San Pietro con una allegoria del trionfo del papato

Sint-Pietersplein met de triomf van het pausdom

GIOVANNI PAOLO PANNINI (1691/92–1765)

1757, Oil on canvas/Huile sur toile, Musée du Louvre, Paris

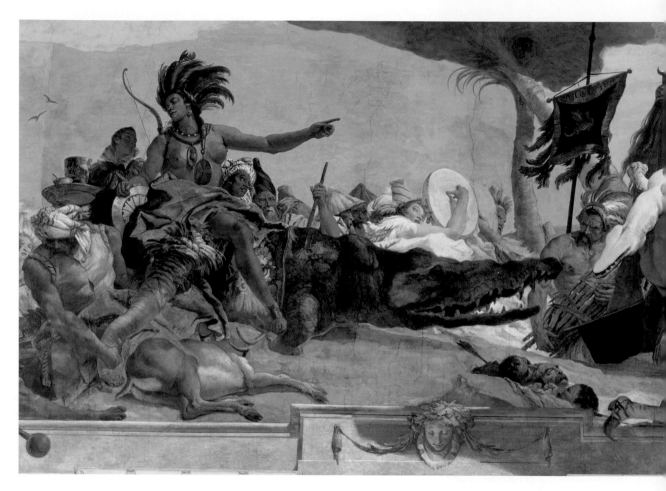

Apollo and the Continents, *detail of America*

L'Amérique, *détail d'Apollon et les Continents*

Apollo und die Kontinente, *Detail mit Amerika*

Apolo y los continentes, *detalle con América*

Apollo e i continenti, *dettaglio con l'America*

Apollo en de continenten, *detail met Amerika*

GIOVANNI BATTISTA TIEPOLO (1696-1770)

1752/53, Fresco/Fresque, Fürstbischöfliche Residenz, Würzburg

The Adoration of the Magi

After 1750, Tiepolo remained in Franconia, where he decorated the grand staircase of the Prince-Bishop's residence in Würzburg. He painted this adoration of the Magi for the monastery church in Schwarzach.

L'Adoration des mages

Dans les années 1750, Tiepolo résida en Franconie, où il décora à Wurtzbourg le grand escalier de la résidence du prince-évêque. Il peignit cette Adoration pour l'église du monastère de Schwarzach

Anbetung der Heiligen Drei Könige

In den Jahren nach 1750 hielt sich Tiepolo in Franken auf, wo er das große Treppenhaus der Fürstbischöflichen Residenz in Würzburg ausschmückte. Diese Anbetung der Könige malte er für die Klosterkirche in Schwarzach.

Adoración de los Reyes Magos

En los años posteriores a 1750 Tiepolo se alojó en Franconia, donde decoró la gran escalera de la residencia del Príncipe Obispo en Würzburg. Pintó este culto de los reyes para la iglesia monasterio en Schwarzach.

Adorazione dei Magi

Negli anni successivi al 1750 Tiepolo soggiornò in Franconia, dove decorò l'ampia scalinata della residenza del Vescovo Principe di Würzburg. Egli dipinse l'Adorazione dei Magi per la chiesa conventuale di Schwarzach.

Aanbidding der koningen

In de jaren na 1750 verbleef Tiepolo in Franken, waar hij het grote trappenhuis van de prins-bisschoppelijke residentie in Würzburg decoreerde. Deze Aanbidding der koningen schilderde hij voor de kloosterkerk in Schwarzach.

GIOVANNI BATTISTA TIEPOLO (1696–1770)

1753, Oil on canvas/Huile sur toile, 408 × 210,5 cm, Alte Pinakothek, München

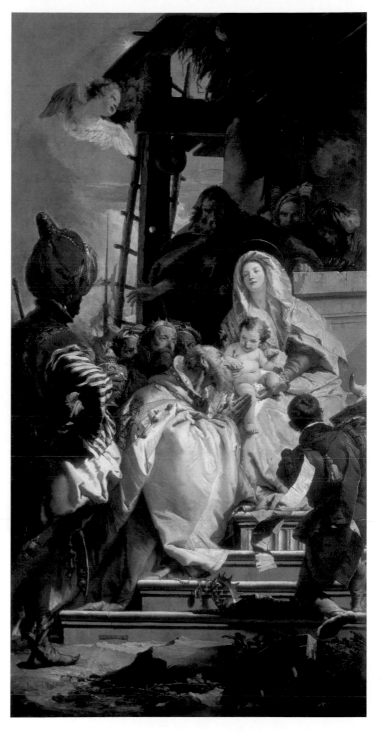

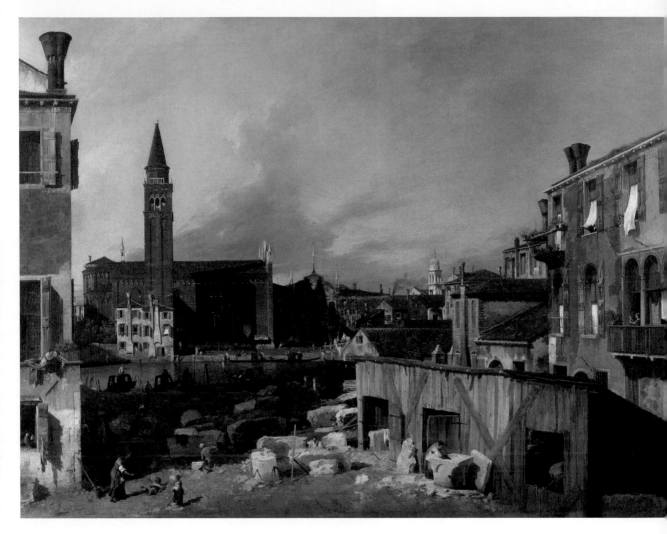

The Stonemason's Yard

La Cour du tailleur de pierre

Kirche und Scuola della Carità von der Marmorwerkstatt am Campo S. Vitale aus

Iglesia y Escuela de la Caridad del taller de mármol del Campo S. Vitale

Chiesa e Scuola della Carità del laboratorio dei marmi in campo San Vidal

Kerk en Scuola della Carità uit de marmerwerkplaats op Campo S. Vitale

CANALETTO (1697–1768)

c. 1725, Oil on canvas/Huile sur toile, 123,8 × 162,9 cm, The National Gallery, London

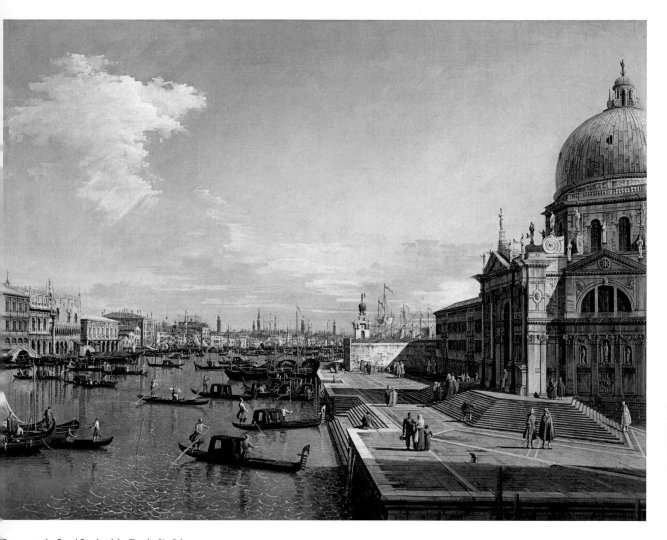

Entrance to the Grand Canal and the Church of La Salute

L'Église de la Salute

Venedig, Santa Maria della Salute

Venecia, Santa Maria della Salute

Venezia, Santa Maria della Salute

Venetië, Santa Maria della Salute

CANALETTO (1697–1768)

1735–40, Oil on canvas/Huile sur toile, 119 × 153 cm, Musée du Louvre, Paris

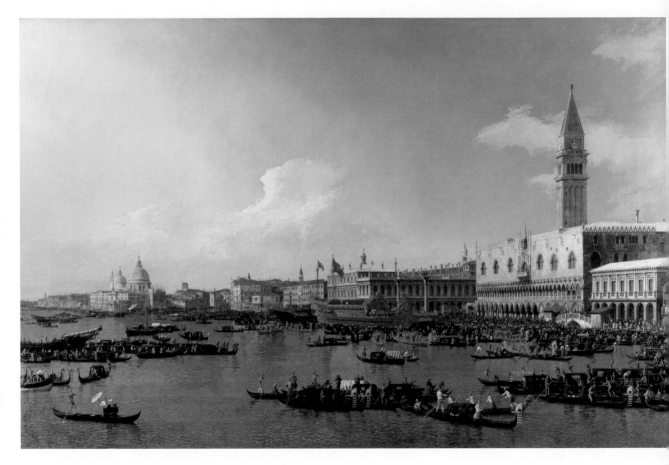

Venice: The Basin of San Marco on Ascension Day
One of the most magnificent views of the city and at the same
time a document of a very special holiday: on Ascension
Day, the city of Venice traditionally celebrated its wedding
to the sea.

Le Bassin de San Marco le jour de l'Ascension
C'est à la fois l'une des vues les plus grandioses de la ville et un
témoignage d'une fête très particulière : le jour de l'Ascension,
on célébrait le mariage de la ville de Venise avec la mer.

Venedig: Das Becken von San Marco am Himmelfahrtstag
Eine der großartigsten Ansichten der Stadt überhaupt und
zugleich ein Dokument eines ganz besonderen Feiertages:
Am Himmelfahrtstag wurd traditionell die Hochzeit der Stadt
Venedig mit dem Meer zelebriert.

Venecia: La cuenca de San Marco en el Día de la Ascensión
Una de las vistas más magníficas de la ciudad y, al mismo
tiempo, un documento de una fiesta muy especial: en el día
de la Ascensión se celebraba tradicionalmente la boda de la
ciudad de Venecia con el mar.

Venezia: il bacino di San Marco nel giorno dell'Ascensione
Uno dei panorami più belli della città e allo stesso tempo un
documento di un giorno festivo molto speciale: nel giorno
dell'Ascensione di Cristo si celebrava tradizionalmente il
matrimonio della città di Venezia con il mare.

Venetië: het bekken van San Marco op Hemelvaartsdag
Een van de mooiste uitzichten op de stad en tegelijkertijd
een document van een heel bijzondere feestdag: op
Hemelvaartsdag werd traditioneel de bruiloft van de stad
Venetië met de zee gevierd.

CANALETTO (1697-1768)
c. 1740, Oil on canvas/Huile sur toile, 121,9 × 182,8 cm, The National Gallery, London

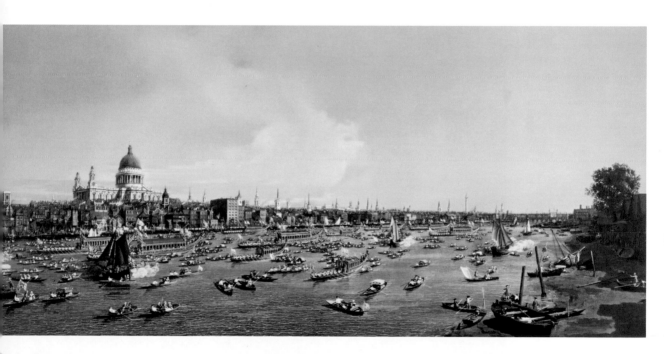

**London, Thames with a View of the
City and St Paul's Cathedral**
Canaletto spent the years between 1746 and 1756 in London,
where his views of the city met with great approval, mainly
thanks to the support of collector Joseph Smith.

La Tamise et la City
Entre 1746 et 1756, Canaletto séjourna à Londres, où ses
nombreuses vues de la ville rencontrèrent un franc succès,
en particulier grâce au soutien financier de Joseph Smith,
marchand et collectionneur.

CANALETTO (1697-1768)
1746/47, Oil on canvas/Huile sur toile, 118 × 238 cm, Národní Galerie, Praha

**London, Themse mit Blick auf die
Stadt und St. Paul's Cathedral**
Von 1746 bis 1756 lebte Canaletto in London, wo seine
Ansichten von der Stadt großen Anklang fanden, vor allem
wegen der Förderung durch den Sammler Joseph Smith.

**Londres, Támesis con vistas a la ciudad
y a la Catedral de San Pablo**
Canaletto pasó los años entre 1746 y 1756 en Londres,
donde sus vistas de la ciudad recibieron gran aprobación,
principalmente por el apoyo del coleccionista Joseph Smith.

Il Tamigi con la Cattedrale di St. Paul
Canaletto trascorse gli anni tra il 1746 e il 1756 a Londra,
dove le sue numerose vedute della città riscossero un grande
successo, soprattutto grazie al sostegno del mercante e
collezionista Joseph Smith.

**Londen, Theems met uitzicht op de
stad en St. Paul's Cathedral**
Canaletto verbleef tussen 1746 en 1756 in Londen, waar zijn
gezichten op de stad op veel bijval konden rekenen, vooral
dankzij de steun van de verzamelaar Joseph Smith.

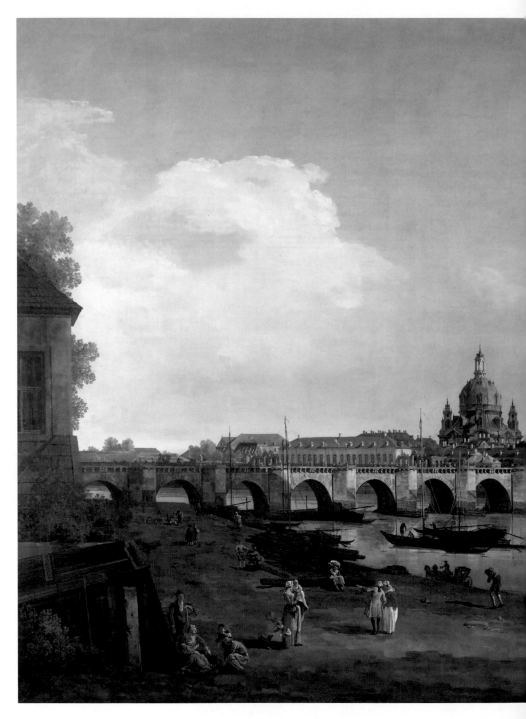

Dresden from the Right Bank of the Elbe above the Augustus Bridge

Bellotto caused confusion (which persists until today) by taking over his uncle's nickname of Canaletto. Here we see one of his numerous vedute of the Saxon royal capital.

Vue de Dresde depuis la rive droite de l'Elbe avec le pont Auguste

Bellotto en déconcerta plus d'un en reprenant à son oncle ce surnom de Canaletto. Nous voyons ici l'une de ses nombreuses vedute, réalisée dans sa ville de résidence saxonne.

Dresden vom rechten Elbufer unterhalb der Augustusbrücke

Bellotto verwirrte bis heute nicht wenige, indem er den Beinamen Canaletto von seinem Onkel übernahm. Hier sehen wir eine seiner zahlreichen Veduten, die er von der sächsischen Residenzstadt anfertigte.

Dresde desde la orilla derecha del Elba bajo el puente Augusto

Bellotto ha confundido a muchos hasta el día hoy al tomar el apodo de Canaletto de su tío. Aquí vemos uno de sus numerosas vedutas, que hizo de la ciudad sajona de residencia.

Veduta di Dresda dalla riva destra dell'Elba con il ponte di Augusto

Bellotto confondeva molti fino ad oggi prendendo il soprannome di Canaletto dallo zio. Qui vediamo una delle sue numerose vedute create della città di residenza della Sassonia.

Dresden gezien van de rechteroever van de Elbe onder de Augustusbrug

Bellotto brengt menigeen tot op heden in verwarring doordat hij de bijnaam Canaletto overnam van zijn oom. Hier zien we een van zijn talrijke vedute die hij van de Saksische residentie maakte.

BERNARDO BELLOTTO (1721–80)
1748, Oil on canvas/Huile sur toile,
133 × 237 cm, Gemäldegalerie
Alte Meister, Dresden

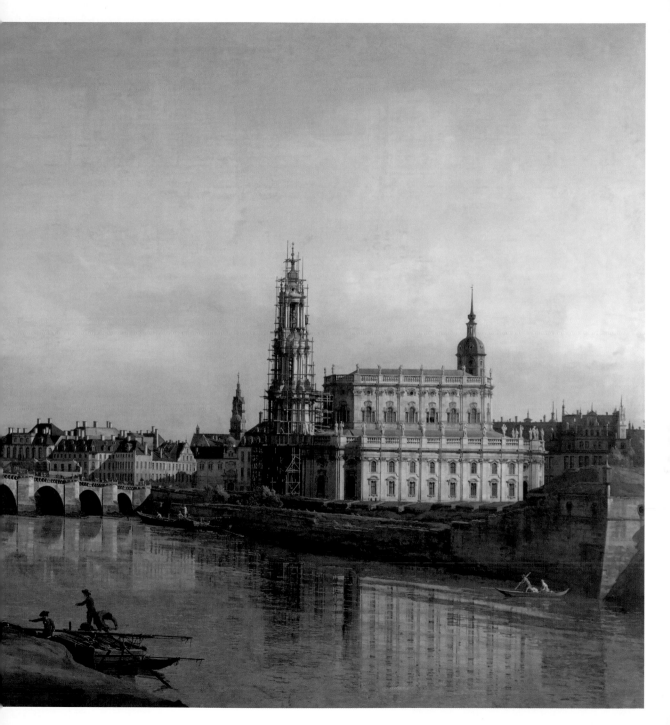

View of Warsaw

In 1768, Bellotto became court painter to the Polish king. His depictions of Warsaw were so exact that they were used to aid reconstruction after the Second World War.

Vue de Varsovie depuis la terrasse du Château royal

En 1768, Bellotto devint peintre à la cour du roi de Pologne. Ses représentations de la ville de Varsovie étaient tellement précises qu'elles furent utilisées après la Seconde Guerre mondiale lors de la reconstruction de la ville.

Blick auf Warschau

Im Jahre 1768 wurde Bellotto Hofmaler des polnischen Königs. So genau waren seine Darstellungen der Stadt Warschau, dass sie beim Wiederaufbau nach dem Zweiten Weltkrieg herangezogen werden konnten.

Vista de Varsovia

En 1768 Bellotto se convirtió en pintor de la corte del rey polaco. Sus representaciones de la ciudad de Varsovia eran tan precisas que podían utilizarse para la reconstrucción después de la Segunda Guerra Mundial.

Vista di Varsavia

Nel 1768 Bellotto divenne pittore di corte del re polacco. Le sue raffigurazioni della città di Varsavia erano così precise da poter essere utilizzate per la ricostruzione dopo la Seconda guerra mondiale.

Gezicht op Warschau

In 1768 werd Bellotto hofschilder van de Poolse koning. Zijn afbeeldingen van de stad Warschau waren zo nauwkeurig dat ze konden worden gebruikt voor de wederopbouw na de Tweede Wereldoorlog.

BERNARDO BELLOTTO (1721-80)
1773, Oil on canvas/Huile sur toile, 166 × 269 cm, Muzeum Narodowego, Warszawie

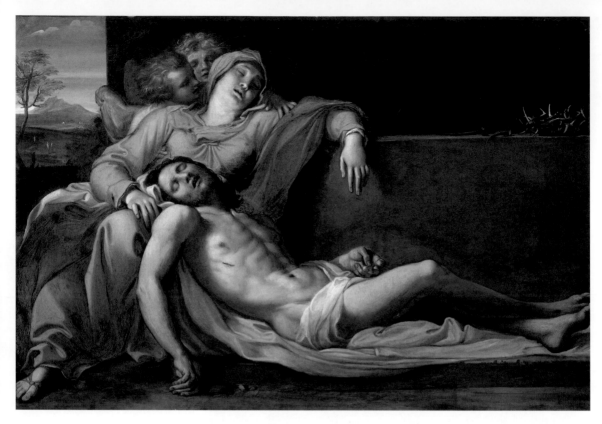

ANNIBALE CARRACCI (1560-1609)
c. 1603,
Oil on canvas/
Huile sur toile,
41,3 × 60,7 cm,
Kunsthistorisches
Museum, Wien

The Carracci: Pioneers of the Baroque

Agostino and Annibale Carracci, the sons of a tailor, and their cousin Ludovico Carracci, saw themselves as the heirs of the great artistic tradition of the Renaissance. The Carracci rejected the artificiality of Mannerist painting and sought a return to nature, combined with the study of the great Northern Italian masters of the Renaissance, especially Correggio, Titian, and Veronese—a move perceived at the time as having saved the art world. In the 1580s, the Carracci—especially Annibale, the most talented of them—produced some of the most radical and innovative images in Europe. Annibale not only drew from nature, but also invented a new technique of interrupted brushstrokes to capture movement and the effects of light on form. He became the most admired artist of his time and had a decisive influence on the emergence of the baroque.

Les Carrache : précurseurs du baroque

À l'instar de leur cousin Ludovico, Agostino et Annibale Carrache – fils de tailleur – se voyaient comme les héritiers de la grande tradition artistique de la Renaissance. Les Carrache rejetèrent le caractère artificiel de la peinture maniériste, aspirant à un retour à la nature, en lien avec l'étude des grands maîtres de la Renaissance d'Italie du Nord, en particulier Le Corrège, Titien et Véronèse ; à leur époque, cela fut considéré comme une véritable planche de salut. Dans les années 1580, ils peignirent les tableaux les plus radicaux et les plus innovants de toute l'Europe, en particulier Annibale, le plus talentueux d'entre eux. Annibale ne se contentait pas de peindre la nature, il mit également au point une nouvelle manière de manier le pinceau, par touches, pour saisir le mouvement et les effets de lumière sur les volumes. Il devint l'un des artistes les plus admirés de son temps et influença considérablement la naissance du baroque.

Die Carracci: Wegbereiter des Barocks

Zwei Söhne eines Schneiders, Agostino und Annibale, sowie deren Cousin Ludovico Carracci sahen sich als Erben der großen künstlerischen Tradition der Renaissance. Die Carracci lehnten die Künstlichkeit der manieristischen Malerei ab und strebten eine Rückkehr zur Natur an, verbunden mit dem Studium der großen norditalienischen Meister der Renaissance, insbesondere Correggios, Tizians, Veroneses – was zu ihrer Zeit in der Kunstwelt als Rettung empfunden wurde. In den 1580er-Jahren malten sie, allen voran Annibale, der talentierteste von ihnen, die radikalsten wie innovativsten Bilder ganz Europas. Annibale zeichnete nicht nur nach der Natur, er schuf auch eine neue, unterbrochene Art der Pinselführung, um Bewegung und die Auswirkungen von Licht auf die Form zu erfassen. Er stieg zum meist bewunderten Künstler seiner Zeit auf und beeinflusste die Entstehung des Barocks maßgeblich.

The Annunciation

L'Annonciation

Verkündigung

La proclamación

Annunciazione

De aankondiging

**LUDOVICO CARRACCI
(1555–1619)**

c. 1585, Oil on
canvas/Huile sur
toile, 178 × 218 cm,
Pinacoteca Nazionale,
Bologna

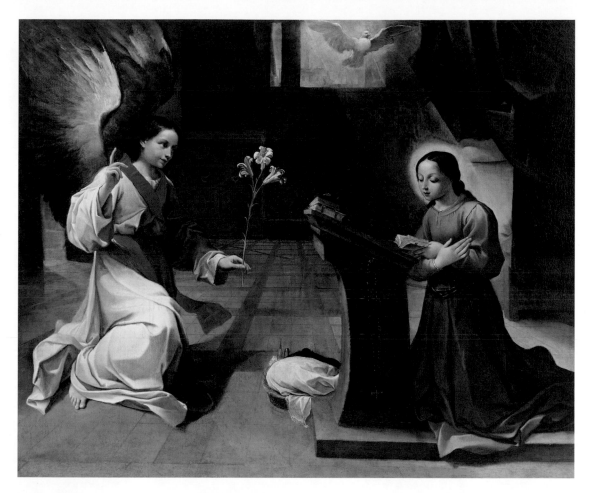

Los Carracci: pioneros del Barroco

Dos hijos de sastre, Agostino y Annibale, y su primo Ludovico Carracci se consideran herederos de la gran tradición artística del Renacimiento. Los Carracci rechazaron la artificialidad de la pintura manierista y buscaron un retorno a la naturaleza, combinado con el estudio de los grandes maestros del Renacimiento del norte de Italia, especialmente Correggios, Tizianos, Veroneses— hecho que fue percibido como una salvación en el mundo del arte de su tiempo. En la década de 1580 pintaron, sobre todo Annibale, el más talentoso de ellos, las imágenes más radicales e innovadoras de Europa. Annibale no sólo se inspiró en la naturaleza, sino que también creó una nueva forma interrumpida de pincelada para capturar el movimiento y los efectos de la luz sobre la forma. Se convirtió en el artista más admirado de su tiempo e influyó decisivamente en la aparición del barroco.

I Carracci: Pionieri del Barocco

Due figli di un sarto, Agostino e Annibale, e il loro cugino Ludovico Carracci si considerarono eredi della grande tradizione artistica del Rinascimento. I Carracci rifiutavano l'artificialità della pittura manierista e cercano un ritorno alla natura, unito allo studio dei grandi maestri del Rinascimento del Nord Italia, in particolare di Correggi, Tiziano, Veronese – che allora, nel mondo dell'arte, veniva percepito come salvezza. Intorno al 1580 dipinsero, soprattutto Annibale, il più talentuoso tra loro, le opere più radicali e innovative d'Europa. Annibale non solo ha tratto ispirazione dalla natura, ma ha anche creato un nuovo, ininterrotto modo di eseguire la pennellata per catturare il movimento e gli effetti della luce sulla forma. Egli divenne l'artista più ammirato del suo tempo e ha avuto un'influenza decisiva sulla nascita del barocco.

De Carraci's: wegbereiders van de barok

Twee zonen van een kleermaker, Agostino en Annibale, en hun neef Ludovico Carracci zagen zichzelf als de erfgenamen van de grote artistieke traditie van de renaissance. De Carraci's keerden zich af van de kunstmatigheid van de maniëristische schilderkunst en streefden naar een terugkeer naar de natuur, die ze gepaard lieten gaan met de bestudering van de grote Noord-Italiaanse renaissanceschilders, met name Correggio, Titiaan en Veronese – wat in die tijd als een redding van de kunst werd gezien. Rond 1580 schilderden ze – vooral Annibale, de meest getalenteerde van de drie – de meest radicale en vernieuwende doeken van heel Europa. Annibale tekende niet alleen naar de natuur, maar creëerde ook een nieuwe, onderbroken penseelvoering om beweging en de effecten van licht op vormen vast te leggen. Hij werd de meest bewonderde kunstenaar van zijn tijd en had een beslissende invloed op het ontstaan van de barok.

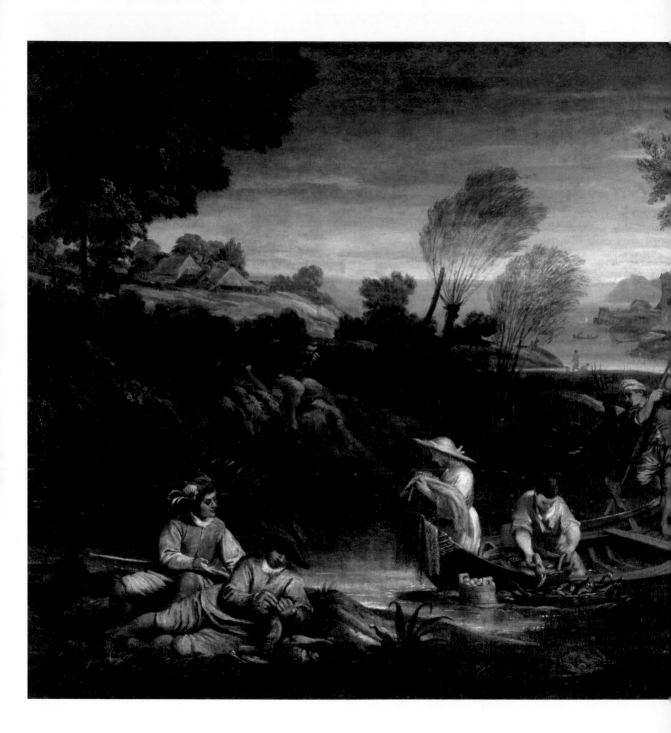

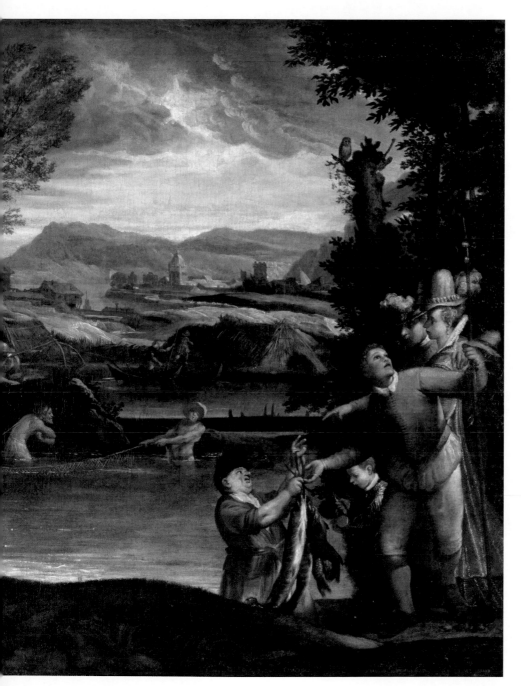

Fishing

Naturalism of figure and landscape – this combination represents the guiding principle of the Carracci's theory of art, which they taught in Bologna at the academy founded around 1585.

La Pêche

Le naturel des personnages, comme des paysages : c'est la conjonction de ces deux principes qui constitue la ligne directrice de l'enseignement des Carracci – tel qu'ils le dispensèrent dans l'académie qu'ils créèrent à Bologne, autour de 1585.

Der Fischfang

Natürlichkeit von Figur und Landschaft – die Verbindung beider Prinzipien stellt die zentrale Leitlinie der Kunstlehre der Carracci dar, die sie in ihrer um 1585 in Bologna eröffneten Akademie vertraten.

La pesca

La naturalidad de la figura y el paisaje - la combinación de ambos principios representa la pauta central de la teoría del arte de Carracci, la cual representó en su academia inaugurada en Bolonia alrededor de 1585.

La pesca

La naturalezza della figura e del paesaggio - la combinazione di entrambi i principi rappresenta la linea guida centrale della teoria dell'arte dei Carracci, che essi rappresentarono nella loro accademia inaugurata a Bologna intorno al 1585.

De visvangst

De natuurgetrouwheid van figuur en landschap – de combinatie van beide principes geeft de centrale richtlijn van de kunsttheorie van Carracci weer. Zij werden vertegenwoordigden in de rond 1585 geopende academie in Bologna.

ANNIBALE CARRACCI (1560–1609)

c. 1585-88, Oil on canvas/Huile sur toile, 136 × 255 cm, Musée du Louvre, Paris

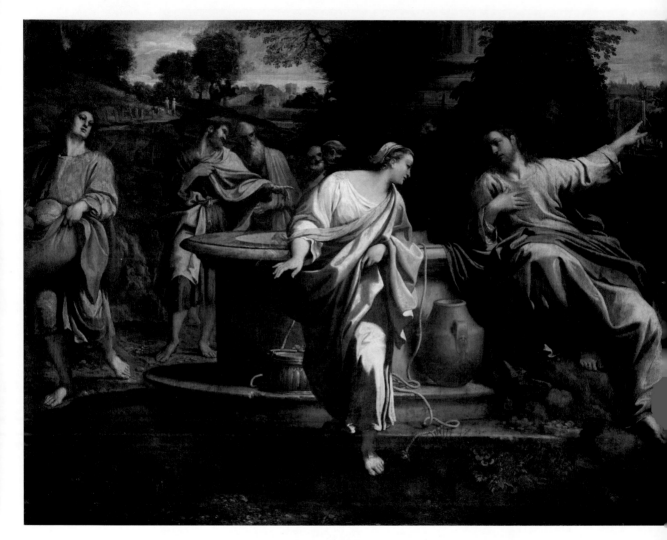

Christ and the Samaritan Woman

Jesus asks a Samaritan woman for water, thus breaking a social taboo: the Jews and Samaritans were bitter enemies at the time.

Le Christ et la Samaritaine au puits

Jésus demande de l'eau à une Samaritaine, brisant ainsi l'un des tabous de son époque, car une hostilité farouche régnait alors entre Juifs et Samaritains – une histoire toujours d'actualité.

Christus und die Samariterin am Jakobsbrunnen

Jesus bittet eine Samariterin um Wasser und bricht damit ein gesellschaftliches Tabu seiner Zeit, denn zwischen Juden und Samaritern herrschte bittere Feindschaft.

Jesús y la samaritana en la fuente de Jacob

Jesús pide agua a una mujer samaritana, rompiendo así un tabú social de su tiempo, ya que la enemistad amarga reinaba entre judíos y samaritanos.

Cristo e la Samaritana

Gesù chiede acqua a una samaritana, rompendo un tabù sociale del suo tempo, perché tra ebrei e samaritani prevaleva un'amara inimicizia.

Jezus spreekt met de Samaritaanse vrouw bij de Jacobsput

Jezus vraagt een Samaritaanse vrouw om water en doorbreekt daarmee een sociaal taboe van zijn tijd, want er heerste een bittere vijandschap tussen de Joden en Samaritanen.

ANNIBALE CARRACCI (1560–1609)
1593/94, Oil on canvas/Huile sur toile, 170 × 225 cm, Pinacoteca di Brera, Milano

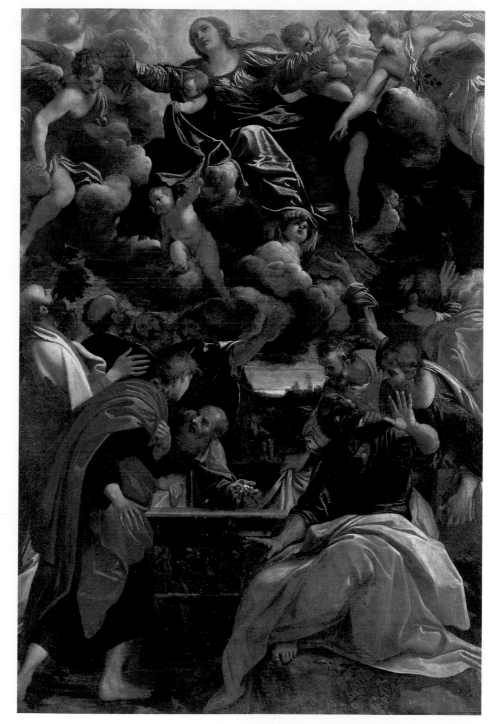

The Assumption of the Virgin

L'Assomption de la Vierge

Himmelfahrt Mariens

Asunción de la Virgen

Assunzione della Vergine

Hemelvaart van Maria

ANNIBALE CARRACCI (1560–1609)
1592, Oil on canvas/Huile sur toile, 260 × 177 cm,
Pinacoteca Nazionale, Bologna

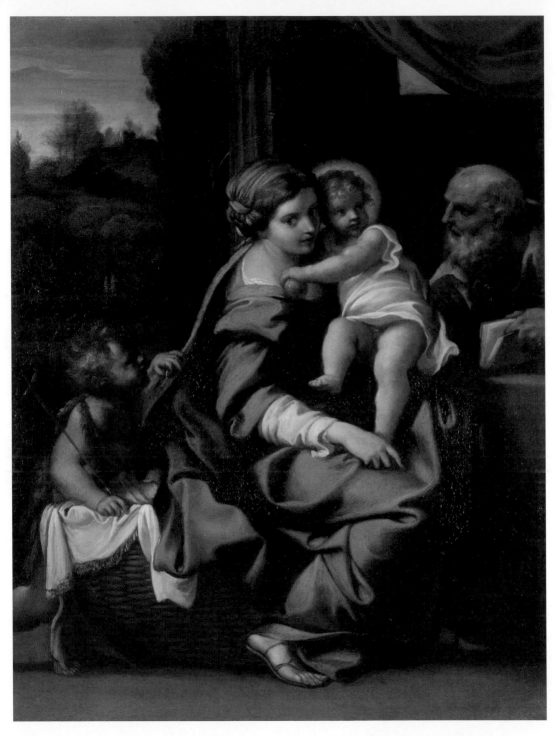

The Holy Family with
St John the Baptist
(The Montalto Madonna)

La Sainte Famille avec
saint Jean-Baptiste enfan

Die Heilige Familie mit
dem Johannesknaben
(Montalto-Madonna)

La Sagrada Familia con
San Juan Bautista

La Sacra Famiglia
con San Giovannino
(Madonna Montalto)

De Heilige Familie met
Johannes de Doper
(Montalto-Madonna)

ANNIBALE CARRACCI
(1560–1609)
c. 1600, Oil on Copper/
Huile sur plaque de cuivre,
35 × 27,5 cm,
The National Gallery, London

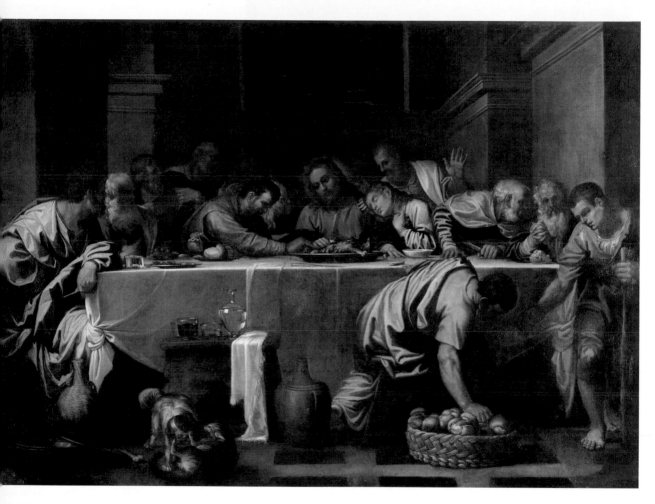

e Last Supper

Cène

s Letzte Abendmahl

Última Cena

ltima cena

t laatste avondmaal

OSTINO CARRACCI (1557-1602)

3/94, Oil on canvas/Huile sur toile, 172 × 237 cm, Museo del Prado, Madrid

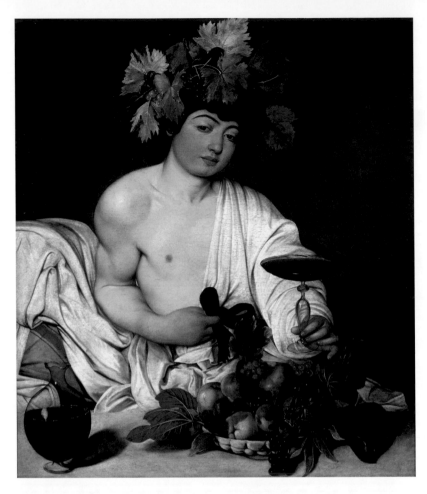

Caravaggio: Trailblazer of Italian Painting

Realism, light, and drama—Caravaggio was a master of effects. Born in 1571 as the son of a craftsman, he became the star of the Roman art world thanks to his extraordinary talent. His short and tragic life—he died under mysterious circumstances in 1610—was, like his art, characterised by uncompromising resolve and absolutism. He possessed a gift for self-perception that both enabled him to depict extreme emotionality and brought disaster to his private life. During the day he consorted with the Roman financial elite and the Pope; at night he dived into the shady world of the 'real' Rome with its prostitutes, gamblers, and thugs. Though no more than fifty works can be definitively attributed to him, they brilliantly reflect the painter's eccentricity. His use of chiaroscuro influenced Dutch and Flemish painting and, alongside Annibale Carracci, Caravaggio can be considered one of the most important pioneer of the baroque.

Le Caravage : l'enfant terrible de la peinture

Réalisme, lumière et tension dramatique : Le Caravage était un maître des effets. Grâce à son talent hors du commun, ce fils d'artisan né en 1571 devint l'étoile montante de la scène artistique romaine. Sa vie aussi courte que tragique (il trouva la mort en 1610 dans des circonstances mystérieuses) fut à l'image de son art : sans compromis et à la recherche de l'absolu. Il disposait d'une très grande sensibilité, qui lui permettait de peindre des tableaux empreints d'une émotion extrême, mais qui dans sa vie privée lui fut fatale. Le jour, il côtoyait le pape et les cercles financiers de Rome, et la nuit, il plongeait dans la Rome interlope, la « véritable » Rome, avec ses prostituées, ses flambeurs et ses malfrats. Les œuvres qui nous sont parvenues, une cinquantaine seulement, reflètent l'excentricité du peintre : avec ses effets de clair-obscur, il influença la peinture hollandaise et flamande et fut, aux côtés d'Annibale Carrache, l'un des précurseurs du baroque.

Caravaggio: Grenzgänger der Malerei

Realismus, Licht und Dramatik – Caravaggio war ein Meister der Effekte. Der 1571 geborene Sohn eines Handwerkers stieg dank seines außergewöhnlichen Talents zum Shootingstar der römischen Kunstwelt auf. Sein kurzes wie tragisches Leben – er kam bereits 1610 unter mysteriösen Umständen zu Tode – war ebenso wie seine Kunst geprägt von Kompromisslosigkeit und Absolutheit. Er besaß eine Gabe zur Selbstwahrnehmun die ihn zu Darstellungen äußerster Emotionalität befähigte und ihm im Privatleben zum Verhängnis wurd Am Tag verkehrte er mit der römischen Hochfinanz und dem Papst, nachts tauchte er ab in das zwielichtige „ech Rom mit seinen Prostituierten, Spielern und Schlägern. Seine nicht mehr als 50 gesicherten Werke spiegeln die Exzentrik des Malers: Mit seinen Hell-Dunkel-Effekten beeinflusste er die holländische wie flämische Malerei und war neben Annibale Carracci wichtiger Wegbereite des Barocks.

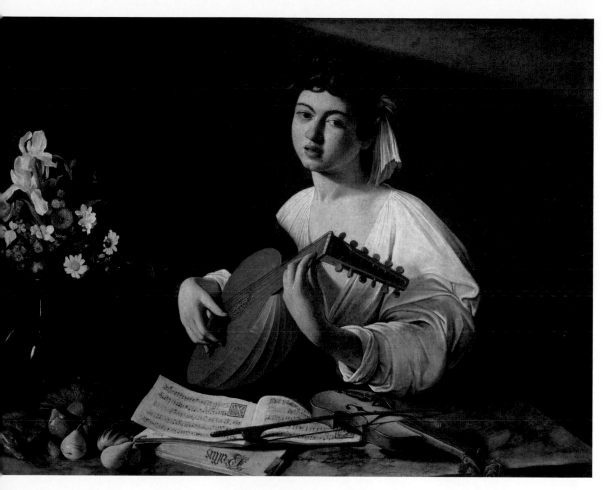

Caravaggio: pintor fronterizo

Realismo, luz y drama– Caravaggio fue un maestro de los efectos. Nacido en 1571, hijo de un artesano, se convirtió en una estrella del mundo del arte romano gracias a su extraordinario talento. Su corta y trágica vida –murió en circunstancias misteriosas en 1610– así como su arte se caracterizaron por la inflexibilidad y la absolutidad. Poseía un don para la autopercepción que le permitió representar una emotividad extrema y se convirtió en su perdición en su vida privada. Durante el día se relacionaba con las altas finanzas romanas y con el Papa, por la noche se zambullía en la "auténtica" Roma, ensombrecida con sus prostitutas, jugadores y matones. Sus no más de 50 obras aseguradas reflejan la excentricidad del pintor: con sus efectos claros oscuros influyó en la pintura holandesa y flamenca y, junto con Annibale Carracci, fue un importante pionero del barroco.

Caravaggio: Attraversare il confine della pittura

Realismo, luce e dramma – Caravaggio era un maestro degli effetti. Nato nel 1571, figlio di un artigiano, divenne un emblema nel mondo dell'arte romana grazie al suo straordinario talento. La sua breve e tragica vita – morì in circostanze misteriose già nel 1610 – e la sua arte furono caratterizzate dall'assolutezza e dall'intransigenza. Possedeva un dono per la percezione di sé che gli ha permesso di descrivere l'emotività estrema e che gli fu fatale nella vita privata. Di giorno frequentava l'alta finanza romana e il Papa, di notte invece si perdeva nella Roma "vera", quella equivoca, con le sue prostitute, i suoi giocatori e i suoi malviventi. Le sue non più di 50 opere riconosciute, riflettono l'eccentricità del pittore: con i suoi effetti chiaro-scuri influenzò la pittura olandese e fiamminga e, insieme ad Annibale Carracci, fu un importante pioniere del barocco.

Caravaggio: grensganger van de schilderkunst

Realisme, licht en dramatiek – Caravaggio was een meester in effecten. De in 1571 geboren zoon van een ambachtsman werd dankzij zijn buitengewone talent de rijzende ster van de Romeinse kunstwereld. Zijn korte en tragische leven – hij stierf in 1610 al onder mysterieuze omstandigheden – werd net als zijn kunst gekenmerkt door compromisloosheid en absoluutheid. Hij bezat een gave voor zelfobservatie, die hem in staat stelde extreme emotionaliteit af te beelden, maar die hem privé noodlottig zou worden. Overdag ging hij om met de Romeinse geldadel en de paus, 's nachts stortte hij zich in het duistere 'echte' Rome met zijn prostituees, gokkers en vechtersbazen. Zijn niet meer dan 50 zekere werken weerspiegelen de excentriciteit van de schilder: met zijn licht-donkereffecten beïnvloedde hij de Nederlandse en Vlaamse schilderkunst en was hij naast Annibale Carracci een belangrijke wegbereider van de barok.

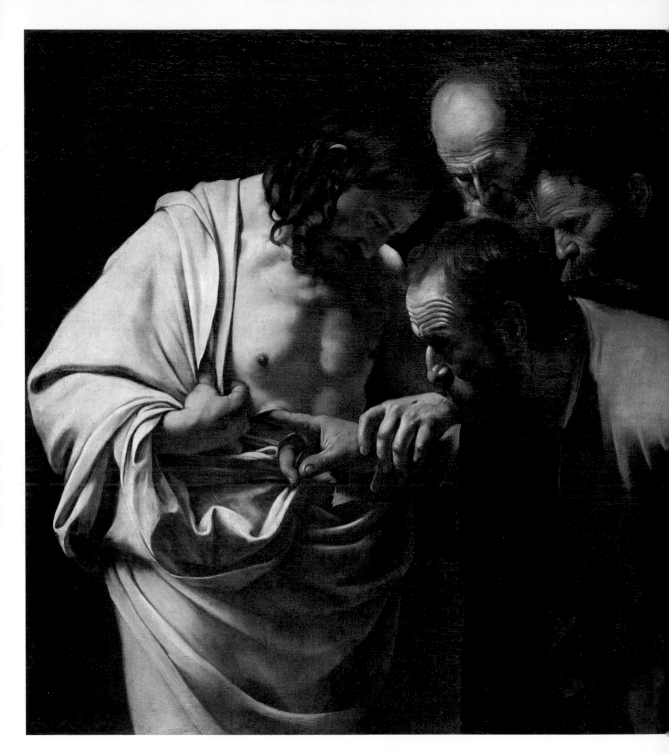

The Incredulity of St Thomas

The story of doubting Thomas appears only in the Gospel of St John. The text, however, does not mention any touching of the wound – pure artistic license on the part of Caravaggio.

L'Incrédulité de saint Thomas

L'Évangile selon Jean décrit l'incrédulité de saint Thomas. Il ne mentionne toutefois pas que ce dernier ait touché la plaie, il s'agit ici d'une pure licence artistique.

Der ungläubige Thomas

Das Evangelium des Johannes schildert als einziges die Ungläubigkeit des Thomas. Allerdings ist von einer Wundberührung darin keine Rede, diese erweist sich hier als reiner Ausdruck künstlerischer Freiheit.

El incrédulo Tomás

El Evangelio de Juan es el único que describe la incredulidad de Tomás. Sin embargo, en él no se menciona el contacto con las heridas, que aquí resulta ser una expresión pura de la libertad artística.

Incredulità di san Tommaso

Il Vangelo di Giovanni è l'unico che descrive l'incredulità di Tommaso. Tuttavia, non vi è alcuna menzione di un contatto con le stigmate, che qui si rivela essere una pura espressione di libertà artistica.

De ongelovige Thomas

Het evangelie van Johannes beschrijft als enige het ongeloof van Thomas. Er wordt echter met geen woord gerept over wonden aanraken, wat hier een zuivere uiting van artistieke vrijheid blijkt te zijn.

CARAVAGGIO (1571-1610)

c. 1595-1600, Oil on canvas/Huile sur toile, 107 × 146 cm, Bildergalerie, Potsdam

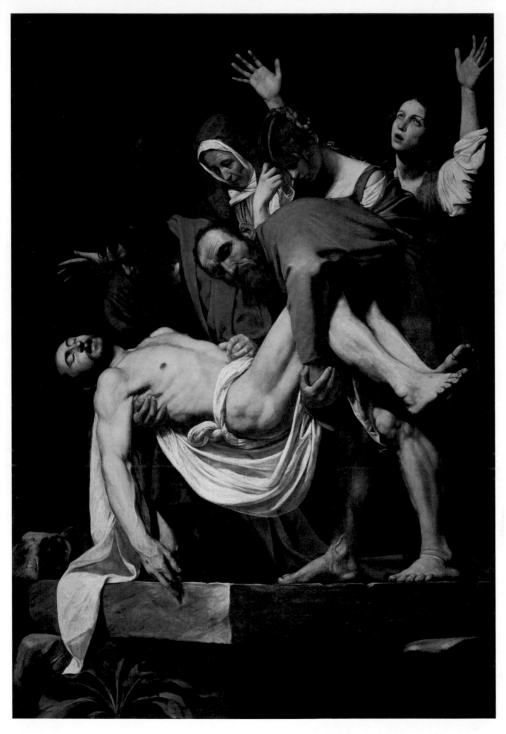

The Entombment of Christ

La Mise au tombeau

Grablegung Christi

Sepultura de Cristo

Deposizione

De graflegging van Christus

CARAVAGGIO (1571–1610)

c. 1602–4, Oil on canvas/Huile sur toile,
300 × 203 cm, Musei Vaticani - Pinacoteca, Rom

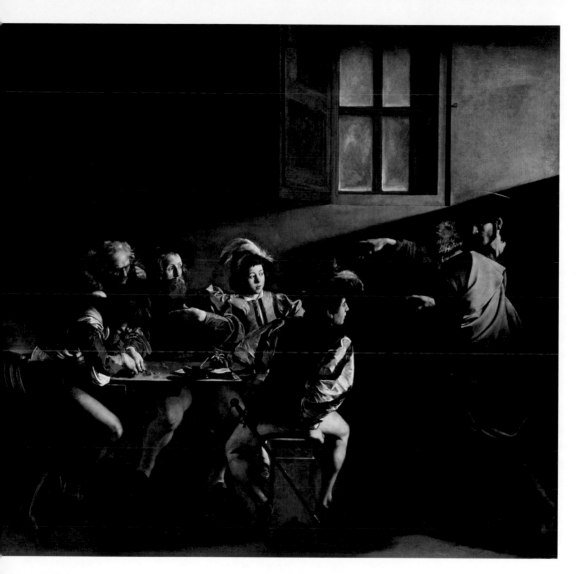

The Calling of St Matthew
1599, Caravaggio received his first important public
commission to decorate the Cappella Contarelli in Rome. He
created a magnificent ensemble of paintings that remain on
view to this day.

Vocation de saint Matthieu
1599, Le Caravage obtint sa première commande officielle
de grande envergure : la décoration de la chapelle Contarelli
à Rome. Vit ainsi le jour un ensemble de tableaux de grand
format, qui s'y trouve encore aujourd'hui.

Die Berufung des Heiligen Matthäus
1599 erhielt Caravaggio mit der Ausstattung der Cappella
Contarelli in Rom seinen ersten wichtigen öffentlichen
Auftrag. Es entstand ein großartiges Gemäldeensemble, das
sich noch heute an derselben Stelle befindet.

La vocación de San Mateo
En 1599 Caravaggio recibió su primer encargo público
importante para decorar la Cappella Contarelli en Roma.
Se creó un magnífico conjunto de pinturas, que aún hoy se
encuentra en el mismo lugar.

Vocazione di san Matteo
Nel 1599 Caravaggio ricevette la sua prima importante
commissione pubblica per arredare la Cappella Contarelli a
Roma. Un magnifico insieme di dipinti, che si trova ancora
oggi nello stesso luogo.

De roeping van Matteüs
In 1599 ontving Caravaggio met de decoratie van de Cappella
Contarelli in Rome zijn eerste belangrijke publieke opdracht.
Er ontstond een prachtig schilderijenensemble, dat zich nog
altijd op dezelfde plaats bevindt.

CARAVAGGIO (1571–1610)
1599–1600, Oil on canvas/Huile sur toile, 323 × 343 cm, Chiesa di San Luigi dei Francesi, Roma

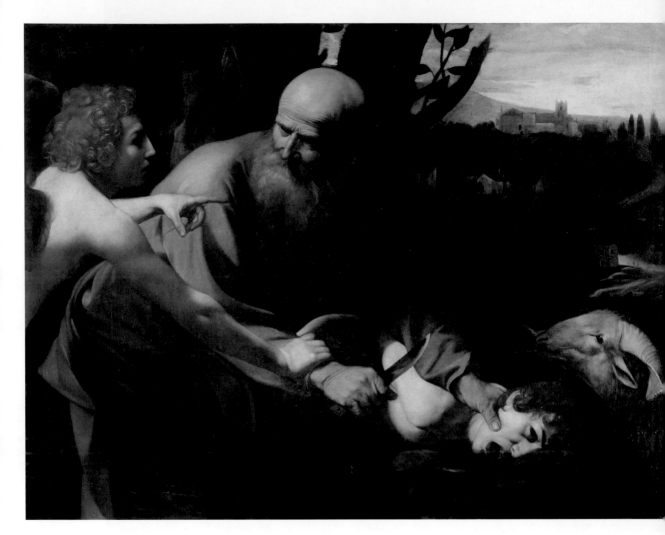

The Sacrifice of Isaac

Le Sacrifice d'Isaac

Die Opferung Isaaks

El sacrificio de Isaac

Il sacrificio di Isacco

De offering van Izaäk

CARAVAGGIO (1571–1610)

c. 1601/02, Oil on canvas/Huile sur toile, 104 × 135 cm, Galleria degli Uffizi, Firenze

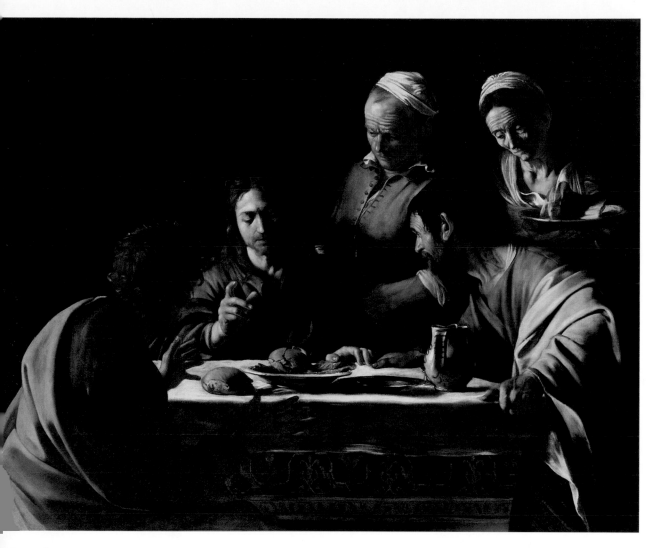

e Supper at Emmaus

Souper à Emmaüs

as Emmausmahl

na de Emaús

ena in Emmaus

e maaltijd te Emmaüs

RAVAGGIO (1571-1610)

06, Oil on canvas/Huile sur toile, 141 × 175 cm, Pinacoteca di Brera, Milano

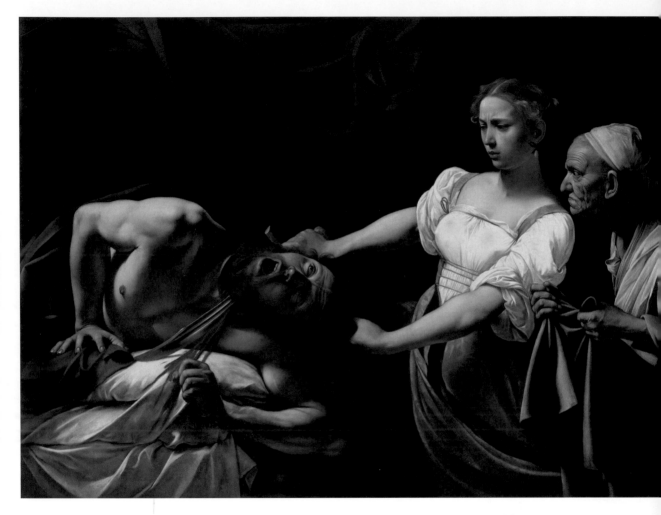

Judith Beheading Holofernes

The model for the resolute, disgusted, beautiful face of Judith was the prostitute Fillide Melandroni, who can be recognised in other of Caravaggio's female biblical figures.

Judith décapitant Holopherne

C'est une prostituée, Fillide Melandroni, qui servit de modèle pour le beau visage de Judith, empreint de détermination et de dégoût ; Le Caravage s'inspira également d'elle pour d'autres personnages bibliques féminins.

CARAVAGGIO (1571–1610)

c. 1598, Oil on canvas/Huile sur toile, 145 × 195 cm, Palazzo Barberini, Roma

Judith und Holofernes

Modell für das Entschlossenheit und Abscheu zeigende, schöne Gesicht der Judith stand die Dirne Fillide Melandroni, deren Gestalt sich ebenso in anderen biblischen Frauenfiguren Caravaggios wiederfindet.

Judith y Holofernes

La modelo para la determinación y la aversión del hermoso rostro de Judit fue la prostituta Fillide Melandroni, cuya figura también se encuentra en otras figuras femeninas bíblicas de Caravaggio.

Giuditta e Oloferne

Modello per il volto deciso e disgustoso e bello di Giuditta fu la cortigiana Fillide Melandroni, la cui figura si ritrova anche in altre figure femminili bibliche del Caravaggio.

Judith en Holofernes

Model voor het vastberadenheid en weerzin uitstralende, knappe gezicht van Judith was de prostituee Fillide Melandroni, wier gestalte ook in andere Bijbelse vrouwenfiguren van Caravaggio terug te zien is.

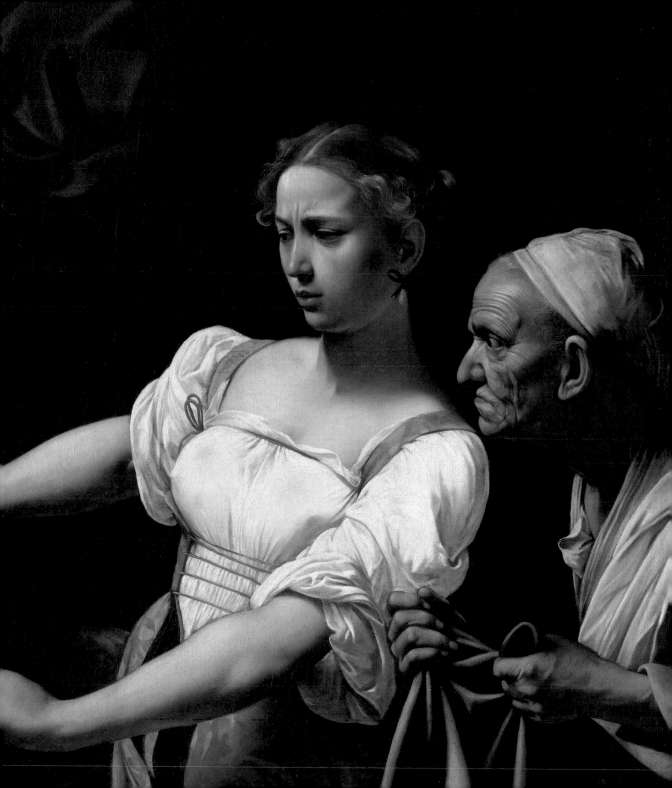

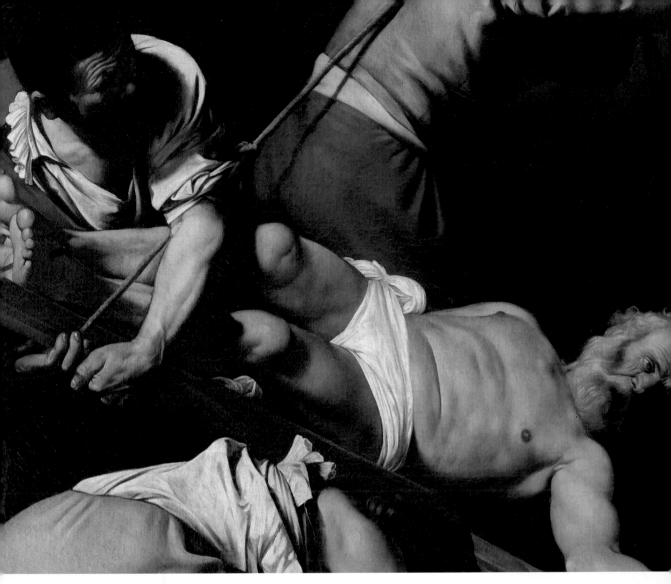

The Crucifixion of St Peter

Caravaggio painted this crucifixion scene with almost unsurpassable drama, his realism brushing against the limits of the tolerable. In doing so, he created one of the most revolutionary images of sacred art of his time.

Le Crucifiement de saint Pierre

Le Caravage peignit cette scène de crucifixion avec une tension difficilement égalable, son réalisme est à la limite du supportable. Il signa ainsi l'un des tableaux les plus révolutionnaires de l'art sacré de l'époque.

Die Kreuzigung des Heiligen Petrus

Caravaggio malte diese Kreuzigungsszene in kaum zu überbietender Dramatik, sein Realismus berührt die Grenze des Erträglichen. Er schuf damit eines der revolutionärsten Bilder der damaligen Sakralkunst.

La Crucifixión de San Pedro

Caravaggio pintó esta escena de la crucifixión en un drama casi insuperable, su realismo toca los límites de lo tolerable. Al hacerlo, creó una de las imágenes más revolucionarias del arte sagrado de la época.

Crocifissione di San Pie

Caravaggio dipinse questa scena della crocifissione con dramma quasi insuperabile, il suo realismo tocca i lim della tollerabilità. Così facendo crea una delle immagini rivoluzionarie dell'arte sacra dell'epo

De kruisiging van Pet

Caravaggio schilderde deze kruisigingsscène met een bi onovertroffen dramatiek en zijn realisme raakt de grenzen v wat nog verdraagbaar is. Daarmee schiep hij een van de me revolutionaire sacrale kunstwerken van die t

CARAVAGGIO (1571-16

1601, Oil on canvas/Huile sur toile, 230 × 175 cm, Basilica di Santa Maria del Pop

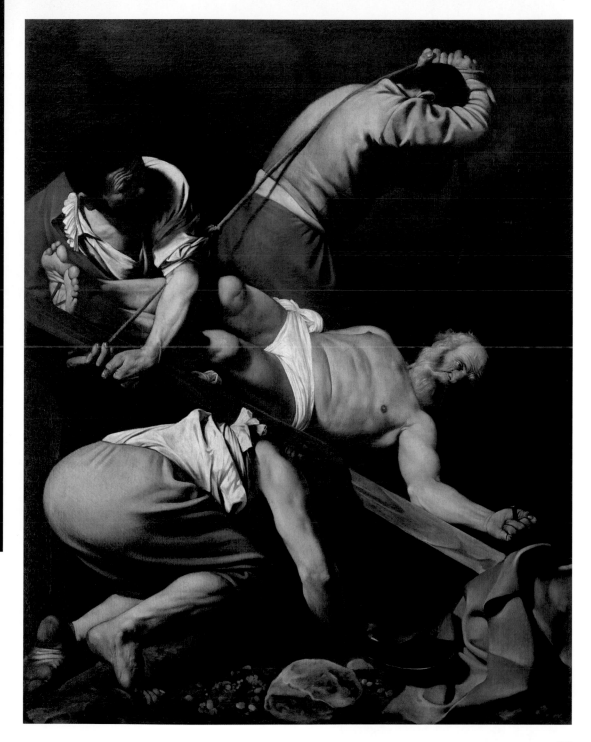

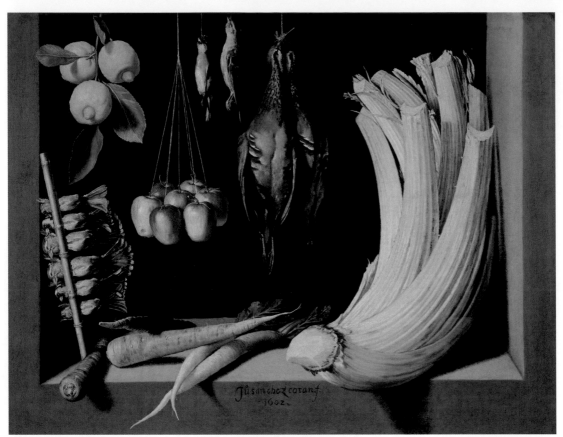

Still Life with Game,
Vegetables, and Fruit

Nature morte aux
gibiers, légumes
et fruits

Jagdstillleben

Bodegón de caza

Natura morta di cacci

Jachtstilleven

JUAN SÁNCHEZ COTÁN
(1561–1627)

1602, Oil on canvas/Huile
sur toile, 68 × 88,2 cm,
Museo del Prado, Madrid

Baroque in Spain: Art as a Weapon against Protestantism

Spanish baroque painting developed against the backdrop of the strong religious zeal imposed on the country by the Habsburgs. The Inquisition mercilessly hunted down all kinds of heresy and served the Catholic Church in enforcing orthodoxy.

Art, consequently, concentrated on the sacred sphere, with religious subjects largely replacing profane ones. Painting now functioned not only to depict the spiritual, but to make it sensually perceptible. Altarpieces and ceiling paintings, portraits of the Virgin Mary and the saints—they all aimed at the emotional overpowering of the viewer.

Since, in contrast to Italy, there was almost no noteworthy class of aristocratic clients outside of the capital, the entire cultural elite was concentrated at the court of Philip IV in Madrid, among them the three most important Spanish painters of the century: Jusepe de Ribera, Francisco de Zurbarán, and above all, Diego Velázquez.

Le baroque en Espagne : l'utilisation de l'art comme arme contre le protestantisme

La peinture baroque espagnole se développa dans un contexte de zèle religieux extrême, imposé au pays par les Habsbourg. L'Inquisition traquait impitoyablement les hérésies de toutes sortes, aidant ainsi l'Église catholique à imposer une orthodoxie parfaite.

Dans les domaines artistiques, on se concentra de plus en plus sur les thèmes sacrés, qui évincèrent largement les sujets profanes. En peinture, il ne s'agissait plus seulement de représenter la spiritualité religieuse, mais aussi de la rendre perceptible par les sens. Retables et peintures sur plafonds, portraits de Marie ou des saints, toutes les œuvres visaient principalement à submerger émotionnellement le spectateur.

Contrairement au cas italien, il n'y avait pas hors de la capitale de véritable noblesse d'où puissent émerger des commanditaires réguliers, et toute l'élite intellectuelle se concentra donc à Madrid, à la cour de Philippe IV – notamment les trois plus grands peintres du siècle : José de Ribera, Francisco de Zurbarán et surtout Diego Vélasquez.

Barock in Spanien: Kunst als Waffe gegen den Protestantismus

Die spanische Barockmalerei entwickelte sich vor dem Hintergrund eines starken religiösen Eifers, den die Habsburger dem Land auferlegten. Die Inquisition jagte alle Arten von Ketzerei gnadenlos und diente der katholischen Kirche bei der Durchsetzung der Orthodoxie.

Für die Kunst bedeutete dies eine Konzentration auf den sakralen Bereich, welcher profane Sujets weitgehend verdrängte. In der Malerei ging es nun darum religiöse Spiritualität nicht nur abzubilden, sondern sinnlich erfahrbar werden zu lassen. Altarbilder und Deckenmalereien, Marienbildnisse und Heiligenporträts sie alle zielten vor allem auf die emotionale Überwältigun des Betrachters.

Da es im Gegensatz zu Italien abseits der Hauptstadt kaum eine nennenswerte Schicht adliger Auftraggeber gab, konzentrierte sich die gesamte kulturelle Elite am Hofe Philipps IV. in Madrid, darunter die drei wichtigste Maler des Jahrhunderts: Jusepe de Ribera, Francisco de Zurbarán und allen voran Diego Velázquez.

Christ and St Bernard

Le Christ prenant dans ses bras saint Bernard

Christus und der Heilige Bernhard

Cristo y San Bernardo

Cristo e San Bernardo

Christus en de heilige Bernardus

FRANCISCO RIBALTA (1565–1628)

1625-27, Oil on canvas/Huile sur toile, 158 × 113 cm, Museo del Prado, Madrid

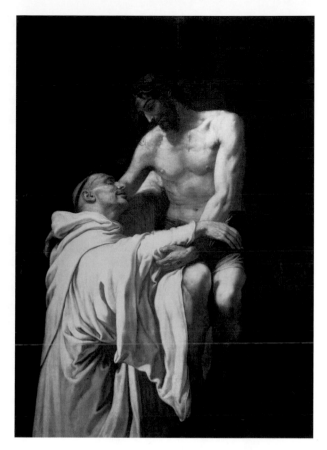

El barroco en España: el arte como arma contra el protestantismo

La pintura barroca española se desarrolló en el contexto de un fuerte celo religioso impuesto al país por los Habsburgo. La Inquisición cazó despiadadamente todo tipo de herejías y sirvió a la Iglesia Católica en la aplicación de la ortodoxia.

Para el arte, esto significaba una concentración en la esfera sagrada, que sustituía en gran medida a los sujetos profanos. La pintura no sólo representaba la espiritualidad religiosa, sino que la hacía sensualmente perceptible. Retablos y pinturas de techo, retratos de la Virgen María y retratos de santos, todos ellos dirigidos sobre todo a abrumar emocionalmente al espectador.

Dado que, a diferencia de Italia, fuera de la capital apenas había clientes aristocráticos dignos de mención, toda la élite cultural se concentró en la corte de Felipe IV en Madrid, entre ellos los tres pintores más importantes del siglo: Jusepe de Ribera, Francisco de Zurbarán y, sobre todo, Diego Velázquez.

Barocco in Spagna: l'arte come arma contro il protestantesimo

La pittura barocca spagnola si sviluppò sullo sfondo di un forte zelo religioso imposto al paese dagli Asburgo. L'Inquisizione perseguiva senza pietà ogni tipo di eresia e serviva la Chiesa cattolica imponendo l'ortodossia.

Per l'arte significava concentrarsi sulla sfera sacra, che in gran parte soppiantava i soggetti profani. Dipingere non significava solo rappresentare la spiritualità religiosa, ma anche renderla sensualmente percepibile. Pale e dipinti del soffitto, ritratti della Vergine Maria e ritratti di santi – tutti miravano soprattutto a travolgere emotivamente lo spettatore.

Poiché, a differenza dell'Italia, non c'era quasi nessuno degno di nota tra i clienti aristocratici fuori dalla capitale, l'intera élite culturale si concentrò alla corte di Filippo IV a Madrid, tra cui i tre pittori più importanti del secolo: Jusepe de Ribera, Francisco de Zurbarán e soprattutto Diego Velázquez.

De barok in Spanje: kunst als wapen tegen het protestantisme

De Spaanse barokschilderkunst ontstond tegen de achtergrond van een sterke geloofsijver die de Habsburgers het land oplegden. De inquisitie joeg genadeloos op alle vormen van ketterij en diende de katholieke kerk bij het doordrijven van de orthodoxie.

Voor de kunst betekende dit een concentratie op religie, die profane onderwerpen verregaand verdrong. In de schilderkunst ging het er nu om religieuze spiritualiteit niet alleen af te beelden, maar ook zinnelijk waarneembaar te maken. Altaarstukken en plafondschilderingen, portretten van de Maagd Maria en heiligenportretten – ze waren vooral gericht op de emotionele overweldiging van de toeschouwer.

Omdat er buiten de hoofdstad, in tegenstelling tot in Italië, nauwelijks een noemenswaardige laag van adellijke opdrachtgevers was, concentreerde de hele culturele elite zich aan het hof van Filips IV in Madrid, onder wie de drie belangrijkste schilders van de eeuw: Jusepe de Ribera, Francisco de Zurbarán en vooral Diego Velázquez.

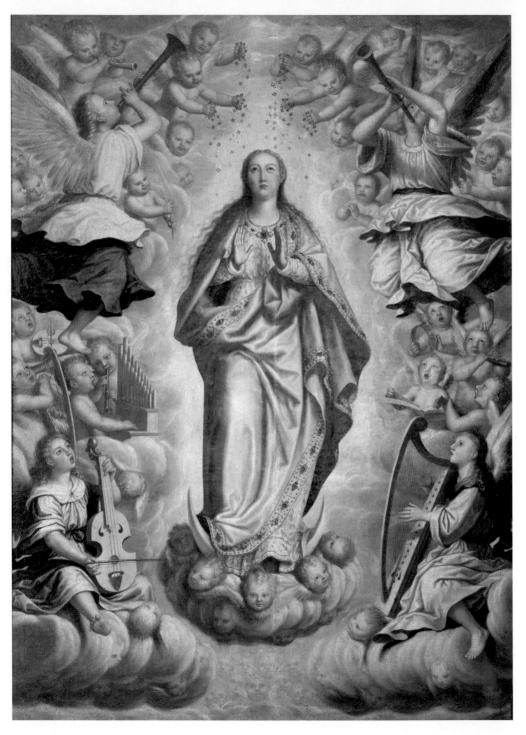

The Assumption of the Virgin

L'Assomption de Marie

Mariä Himmelfahrt

Día de la Asunción

Assunzione della Vergine

Maria-Hemelvaart

JUAN SÁNCHEZ COTÁN (1561–1627)
c. 1603-27, Oil on canvas/Huile
sur toile, 207 × 183 cm, Museo
de Bellas Artes, Granada

Hortensio Félix Paravicino
In addition to his expressive religious paintings, it was portraits that secured the Cretan painter's fame. Paravicino was an important theologian and close friend of El Greco's.

Portrait de frère Hortensio Félix Paravicino
Outre ses tableaux religieux si expressifs, c'est surtout à ses nombreux portraits que le peintre venu de Crète dut sa notoriété. Paravicino, théologien de renom, était aussi un ami proche du Greco.

Hortensio Félix Paravicino
Neben den ausdrucksstarken religiösen Gemälden sind es vor allem Porträts, die den Ruhm des auf Kreta geborenen Malers begründeten. Paravicino war ein bedeutender Theologe und enger Freund El Grecos.

Hortensio Félix Paravicino
Además de las pinturas religiosas expresivas, son principalmente los retratos los que fundaron la fama del pintor nacido en Creta. Paravicino fue un importante teólogo y amigo cercano de El Greco.

Hortensio Félix Paravicino
Oltre ai dipinti religiosi espressivi, sono soprattutto i ritratti a edificare la fama del pittore cretese. Paravicino è stato un importante teologo e amico intimo di El Greco.

Hortensio Félix Paravicino
Naast expressieve religieuze schilderijen zijn het vooral de portretten die de op Kreta geboren schilder beroemd hebben gemaakt. Paravicino was een belangrijke theoloog en een goede vriend van El Greco.

EL GRECO (1541–1614)
1609, Oil on canvas/Huile sur toile, 112,1 × 86,1 cm, Museum of Fine Arts, Boston

A Cardinal (The Grand Inquisitor Fernando Niño de Guevara)

Niño de Guevara was the Grand Inquisitor of Spain when this portrait was painted. It is considered one of El Greco's most striking portraits, not least due to the unusual direction of the sitter's gaze.

Le Cardinal Fernando Niño de Guevara

Ce portrait fut réalisé autour de 1600, alors que Niño de Guevara était Grand Inquisiteur d'Espagne. On le considère comme l'un des portraits les plus pénétrants du Greco, notamment grâce à la direction inhabituelle du regard du cardinal.

Ein Kardinal (der Großinquisitor Fernando Niño de Guevara)

Das Porträt wurde gemalt, als Niño de Guevara Großinquisitor von Spanien war. Es gilt als eines der eindringlichsten Porträts El Grecos, nicht zuletzt wege der ungewöhnlichen Blickrichtung des Dargestellten.

Un Cardenal (el Gran Inquisidor Fernando Niño de Guevara)

El retrato fue pintado cuando Niño de Guevara era el Gran Inquisidor de España. Es considerado uno de los retratos más llamativos de El Greco, sobre todo por la inusual dirección de visión de la niñera.

Un cardinale (il Grande Inquisitore Fernando Niño de Guevara)

Il ritratto è stato realizzato quando Niño de Guevara era il Grande Inquisitore di Spagna. È considerato uno dei ritratti più suggestivi di El Greco, non da ultimo pe l'insolita direzione dello sguardo del soggetto.

Een kardinaal (de grootinquisiteur Fernando Niño de Guevara)

Het portret werd geschilderd toen Niño de Guevara de grootinquisiteur van Spanje was. Het wordt beschouwd als een van de indringendste portretten va El Greco, niet in de laatste plaats vanwege de ongewor kijkrichting van de geportretteerde.

EL GRECO (1541–1614)
c. 1600, Oil on canvas/Huile sur toile, 170,8 × 108 cm,
Metropolitan Museum of Art, New York

St Bruno Prays in La Torre, Calab

Bruno le Chartreux en prière
l'ermitage de La Torre, en Calab

Der Heilige Bruno betet in La Torre, Kalabri

San Bruno reza en La Torre, Calab

San Bruno prega a La Torre, Calab

De heilige Bruno bidt in La Torre, Calab

VICENTE CARDUCHO (1576–163
1626-32, Oil on canvas/Huile sur to
337 × 297,5 cm, Museo del Prado, Mad

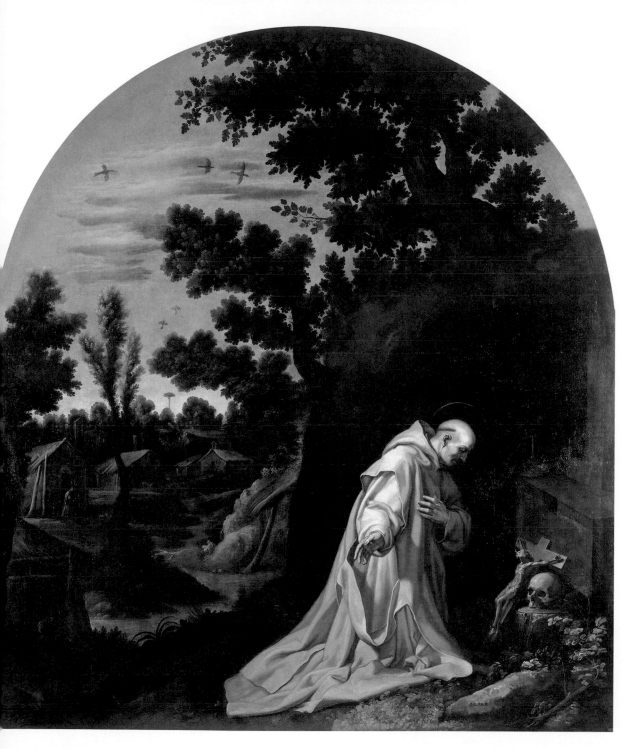

The Relief of Constance

Though born in Florence, Vicente Carducho worked at the Spanish court. This painting depicts a scene from the Thirty Years War, when Lake Constance became highly desirable for its strategic location.

Le Secours de la forteresse de Constance

Vicente Carducho vit le jour à Florence, mais travailla à la cour d'Espagne. La scène représentée ici est un épisode de la guerre de Trente Ans, vers la fin de laquelle le lac de Constance fut âprement disputé en raison de sa position stratégique.

Einnahme von Konstanz

In Florenz geboren, wirkte Vicente Carducho am spanischen Hof. Dargestellt ist eine Episode aus dem Dreißigjährigen Krieg, an dessen Ende der Bodensee wegen seiner strategischen Lage stark umkämpft war.

Llevando a Constance

Nacido en Florencia, Vicente Carducho trabajó en la corte española. Representa un episodio de la Guerra de los Treinta Años, al final de la cual el lago de Constanza era muy competitivo por su ubicación estratégica.

I soccorsi di Costanza

Nato a Firenze, Vicente Carducho ha lavorato alla corte spagnola. Si tratta di un episodio della Guerra dei Trent'anni, al termine della quale il Lago di Costanza era molto conteso per la sua posizione strategica.

Inname van Konstanz

De in Florence geboren Vicente Carducho werkte aan het Spaanse hof. Afgebeeld is een episode uit de Dertigjarige Oorlog, aan het einde waarvan het Bodenmeer vanwege zijn strategische ligging hevig bevochten werd.

VICENTE CARDUCHO (1576–1638)

1634, Oil on canvas/Huile sur toile, 297 × 374 cm, Museo del Prado, Madrid

St John the Evangelist in Patmos

Paysage avec saint Jean l'Évangéliste

Landschaft mit Johannes dem Evangelisten

Paisaje con Juan Evangelista

Paesaggio con Giovanni Evangelista

Landschap met Johannes de Evangelist

JUAN BAUTISTA MAÍNO (1578–1614)

1612-14, Oil on canvas/Huile sur toile, 74 × 163 cm, Museo del Prado, Madrid

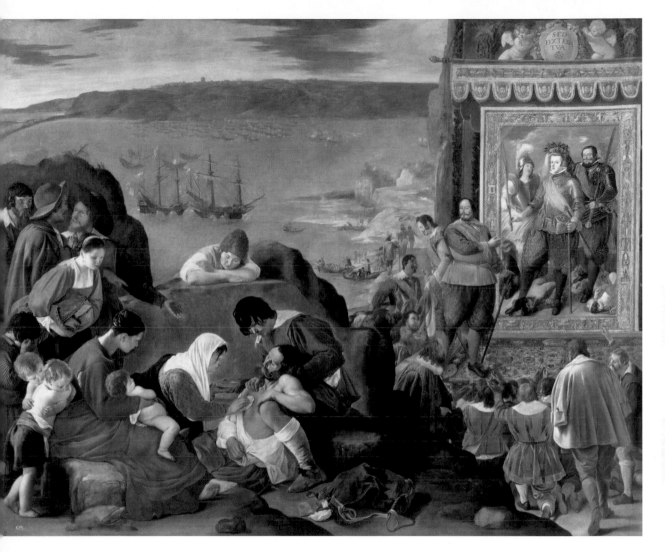

The Recapture of Bahía de Todos los Santos

Salvador de Bahia, then the largest city in the southern hemisphere, was reconquered by the Dutch in 1624. At that time, the Portuguese, who had founded Bahia, were under Spanish rule.

Reconquête de la baie de Tous les Saints

Salvador de Bahia, alors la plus grande ville de l'hémisphère sud, fut reprise en 1624 par les Hollandais. À cette époque, les Portugais, qui avaient fondé Bahia, étaient sous domination espagnole.

Rückeroberung der Stadt Bahia durch die Spanier

Salvador de Bahia, damals größte Stadt der südlichen Hemisphäre, wurde 1624 von den Holländern zurückerobert. Zu dieser Zeit standen die Portugiesen, die Bahia gegründet hatten, unter der Herrschaft der Spanier.

La recuperación de Bahía de Todos los Santos

Salvador de Bahía, entonces la ciudad más grande del hemisferio sur, fue reconquistada por los holandeses en 1624. En ese momento, los portugueses, que habían fundado Bahía, estaban bajo dominio español.

Riconquista di Bahia da parte degli spagnoli

Salvador de Bahia, allora la più grande città dell'emisfero meridionale, fu riconquistata dagli olandesi nel 1624. A quel tempo, i portoghesi, che avevano fondato Bahia, erano sotto il dominio spagnolo.

Herovering van de stad Bahia door de Spanjaarden

Salvador de Bahia, de destijds grootste stad op het zuidelijk halfrond, werd in 1624 terugveroverd op de Nederlanders. In die tijd stonden de Portugezen, die Bahia hadden gesticht, onder Spaanse heerschappij.

JUAN BAUTISTA MAÍNO (1578–1614)

1634/35, Oil on canvas/Huile sur toile, 309 × 381 cm, Museo del Prado, Madrid

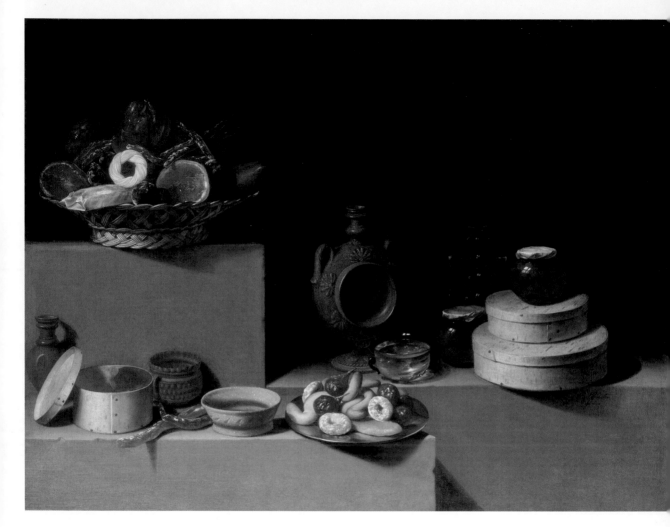

Still Life with Sweets and Pottery

Nature morte avec friandises et poterie

Stillleben mit Süßigkeiten und Töpferwaren

Naturaleza muerta con dulces y cerámica

Natura morta con dolci e ceramiche

Stilleven met zoetigheden en aardewerk

JUAN VAN DER HAMEN Y LÉON (1596-1631)

1627, Oil on canvas/Huile sur toile, 84,5 × 112,7 cm, National Gallery of Art, Washington, D.C.

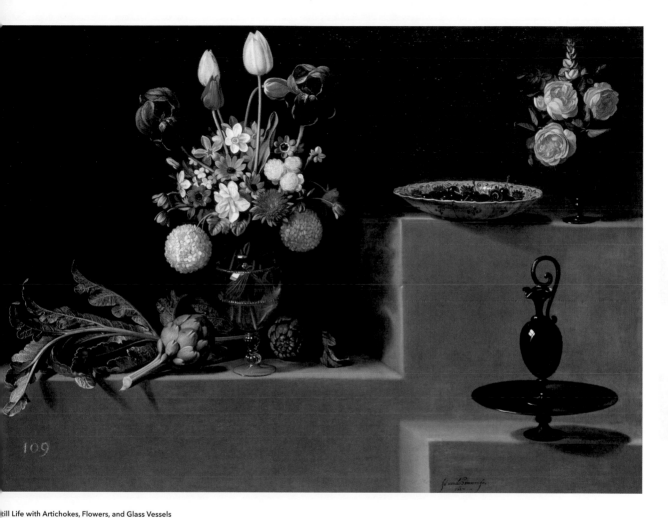

Still Life with Artichokes, Flowers, and Glass Vessels

Nature morte aux artichauts, fleurs et vases en verre

Stillleben mit Artischocken, Blumen und Glasgefäßen

Bodegón con alcachofas, flores y vasos de vidrio

Natura morta con carciofi, fiori e vasi di vetro

Stilleven met artisjokken, bloemen en glaswerk

JAN VAN DER HAMEN Y LÉON (1596–1631)

1627, Oil on canvas/Huile sur toile, 81 × 110 cm, Museo del Prado, Madrid

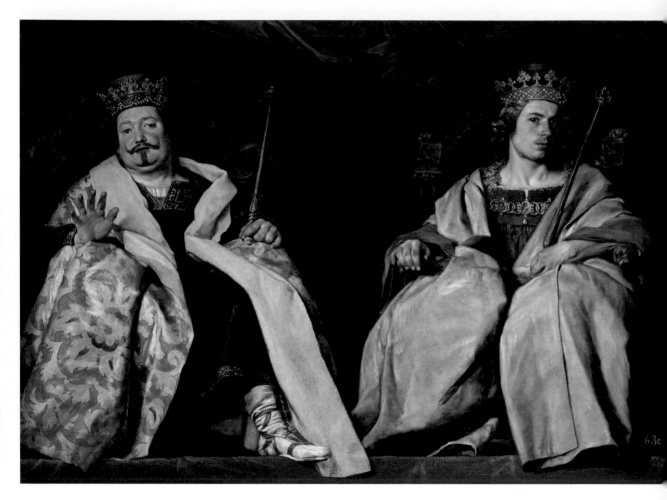

Two Kings of Spain

Portrait de deux rois d'Espagne

Zwei spanische Könige

Dos reyes españoles

Due re di Spagna

Twee Spaanse koningen

ALONSO CANO (1601–67)

c. 1641, Oil on canvas/Huile sur toile, 165 × 227 cm, Museo del Prado, Madrid

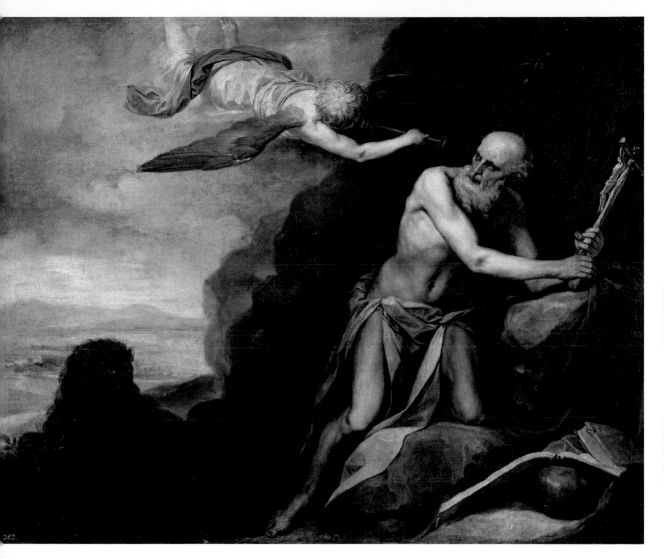

252.

The Penitent St Jerome

Two distinguishing characteristics of Cano's painting stand out in this work: his ability to depict perspective in a natural way, as seen in the angel, and his interest in landscape painting.

Saint Jérôme pénitent dans le désert

On retrouve dans ce tableau deux des principales caractéristiques de l'œuvre de Cano : son aptitude à représenter fidèlement les différences de taille dues à la perspective, comme on le voit chez l'ange, et son intérêt pour les paysages.

Der büßende Heilige Hieronymus

Zwei besondere Merkmale der Malkunst Canos stechen bei diesem Werk ins Auge: Seine Fähigkeit zur naturgetreuen Abbildung der perspektivischen Verkürzung, wie beim Engel zu sehen; und Canos Interesse für die Landschaftsmalerei.

San Jerónimo penitente

Dos características especiales de la pintura de Cano se destacan en esta obra: su habilidad para representar la perspectiva de una manera natural, como se ve en el ángel; y el interés de Cano en la pintura de paisajes.

San Girolamo penitente

Due particolarità della pittura di Cano spiccano in questo lavoro: la sua capacità di rappresentare la prospettiva in modo naturale, come si vede nell'angelo, e l'interesse di Cano per la pittura paesaggistica.

Boetende Hiëronymus

Twee bijzondere kenmerken van Cano's schilderkunst vallen op in dit werk: zijn vermogen om het perspectief natuurlijk weer te geven, zoals te zien is bij de engel, en zijn belangstelling voor de landschapschilderkunst.

ALONSO CANO (1601-67)
1660, Oil on canvas/Huile sur toile, 177 × 209 cm, Museo del Prado, Madrid

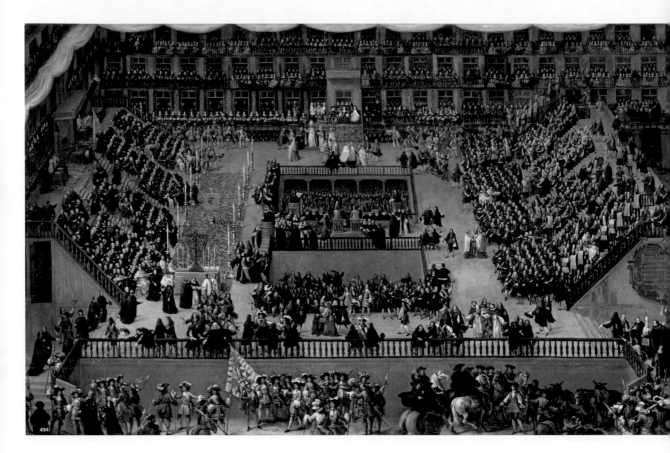

Auto-da-fé in the Plaza Mayor of Madrid

Autodafé sur la Plaza Mayor de Madrid

Autodafé auf der Plaza Mayor in Madrid am 30. Juni 1680

Auto de Fe en la Plaza Mayor de Madrid el 30 de junio de 1680

Autodafé nella Plaza Mayor a Madrid il 30 giugno 1680

Autodafe op het Plaza Mayor van Madrid op 30 juni 1680

FRANCISCO RIZI (1608–85)

1683, Oil on canvas/Huile sur toile, 277 × 438 cm, Museo del Prado, Madrid

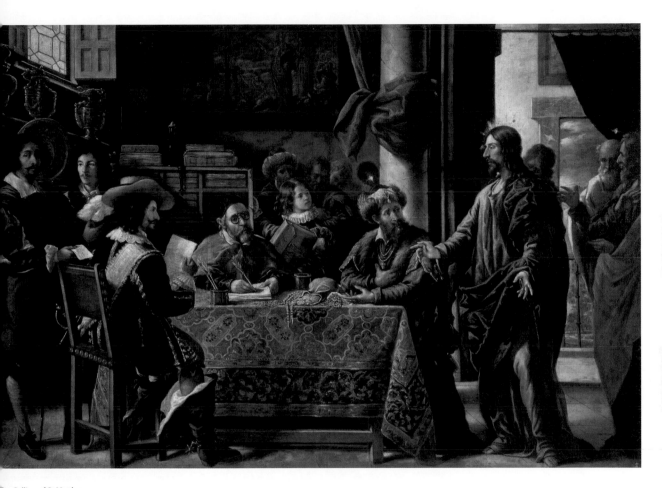

The Calling of St Matthew

La Vocation de saint Matthieu

Berufung des Heiligen Matthäus

Vocación de San Mateo

Vocazione di san Matteo

De roeping van Matteüs

JAN DE PAREJA (1610-70)

1661, Oil on canvas/Huile sur toile, 225 × 325 cm, Museo del Prado, Madrid

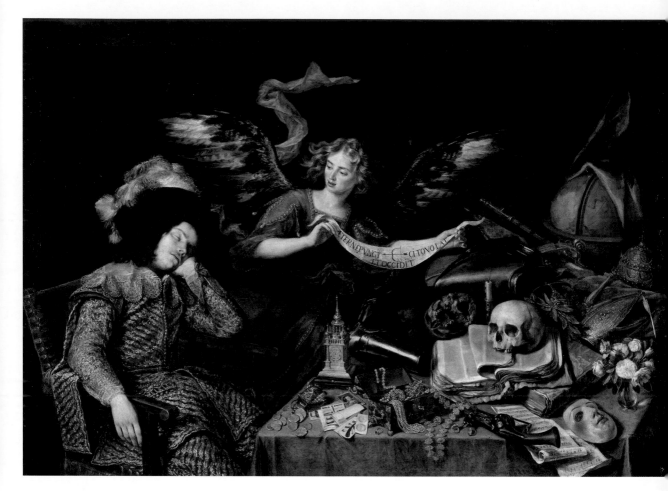

The Knight's Dream

Le Songe du chevalier

Der Traum des Kavaliers

El sueño del caballero

Il sogno del cavaliere

De droom van de cavalier

ANTONIO DE PEREDA Y SALGADO (1611– 78)

c. 1650, Oil on canvas/Huile sur toile, 152 × 217 cm, Academia de San Fernando, Madrid

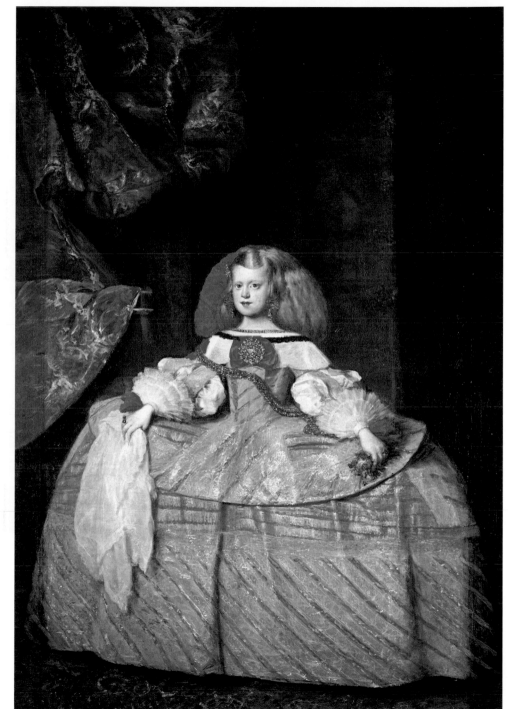

Margarita de Austria, Infanta of Spain

Portrait de l'infante Marguerite

Die Infantin Margarete

La Infanta Margarete

L'Infanta Margherita

De infante Margaretha

JUAN BAUTISTA MARTÍNEZ DEL MAZO
(1611–67)

c. 1665, Oil on canvas/Huile sur toile,
212 × 147 cm, Museo del Prado, Madrid

Still Life with Fruits

Nature morte aux fruits

Stillleben mit Früchten

Naturaleza muerta con frutas

Natura morta con frutta

Stilleven met fruit

JUAN DE ARELLANO (1614–76)
c. 1660, Oil on canvas/Huile sur toile, 28,5 × 37 cm, Museo del Prado, Madrid

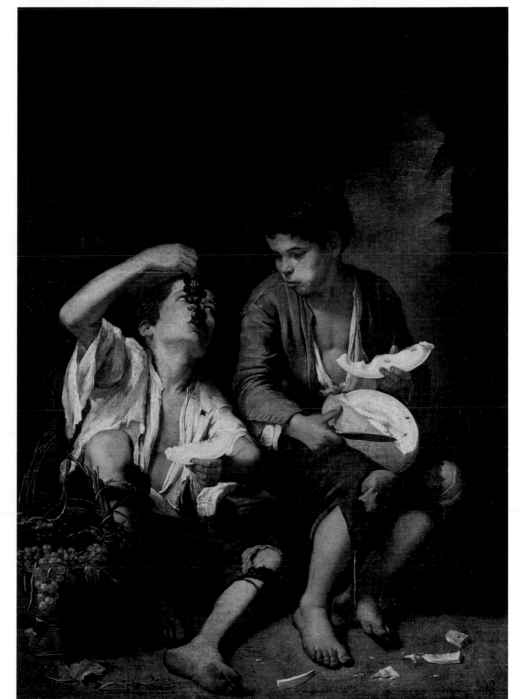

Two Boys Eating Melon and Grapes
Murillo had one of the greatest thematic ranges of all Spanish baroque painters. Today his genre paintings can be found all over Europe, having already been traded internationally during his lifetime.

Les Mangeurs de melon et de raisin
Parmi les peintres baroques espagnols, Murillo s'est illustré par la grande diversité de ses thèmes. On trouve aujourd'hui ses scènes de genre, comme celle-ci, aux quatre coins de l'Europe, car es étaient déjà vendues à l'international de son vivant.

Trauben- und Melonenesser
Murillo gehörte sicher zu den thematisch vielseitigsten Malern des spanischen Barocks. Seine Genrebilder sind heute in ganz Europa zu finden, da sie schon zu seinen Lebzeiten international gehandelt wurden.

Comedor de uvas y melones
Murillo fue sin duda uno de los pintores más diversos temáticamente del Barroco español. Sus pinturas de género se pueden encontrar hoy en día en toda Europa, ya que durante su vida fueron objeto de comercio internacional.

Mangiatore di uva e melone
Murillo è stato certamente uno dei pittori più tematicamente diversi del Barocco spagnolo. I suoi quadri di genere si trovano oggi in tutta Europa, dal momento che erano già commercializzati a livello internazionale durante la sua vita.

Jongens die druiven en meloen eten
Murillo was zeker wat betreft thematiek de meest veelzijdige schilder van de Spaanse barok. Zijn genrestukken zijn nu in heel Europa te vinden, omdat ze tijdens zijn leven al internationaal verhandeld werden.

BARTOLOMÉ ESTEBAN MURILLO (1618–82)
c. 1645, Oil on canvas/Huile sur toile, 145,9 × 103,6 cm, Alte Pinakothek, München

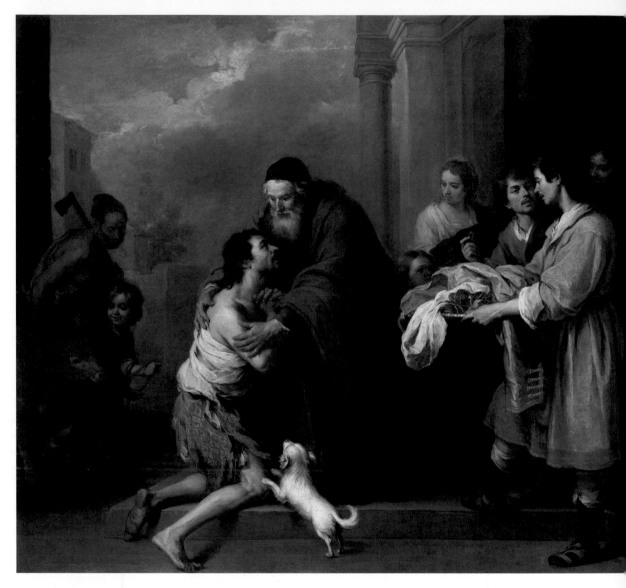

The Return of the Prodigal Son

Le Retour du fils prodigue

Die Rückkehr des verlorenen Sohnes

El regreso del hijo pródigo

Il ritorno del figliuol prodigo

De terugkeer van de verloren zoon

BARTOLOMÉ ESTEBAN MURILLO (1618–82)

1667–70, Oil on canvas/Huile sur toile, 236,3 × 261 cm, National Gallery, Washington, D.C.

The Infant St John the Bapt

Saint Jean-Baptiste enfa

Johannes der Täufer als Ki

Juan el Bautista de ni

Giovanni Battista da bambi

Johannes de Doper als ki

BARTOLOMÉ ESTEBAN MURILLO (1618–8

c. 1670, Oil on canvas/Huile sur toile, 121 × 99 cm, Museo del Prado, Mad

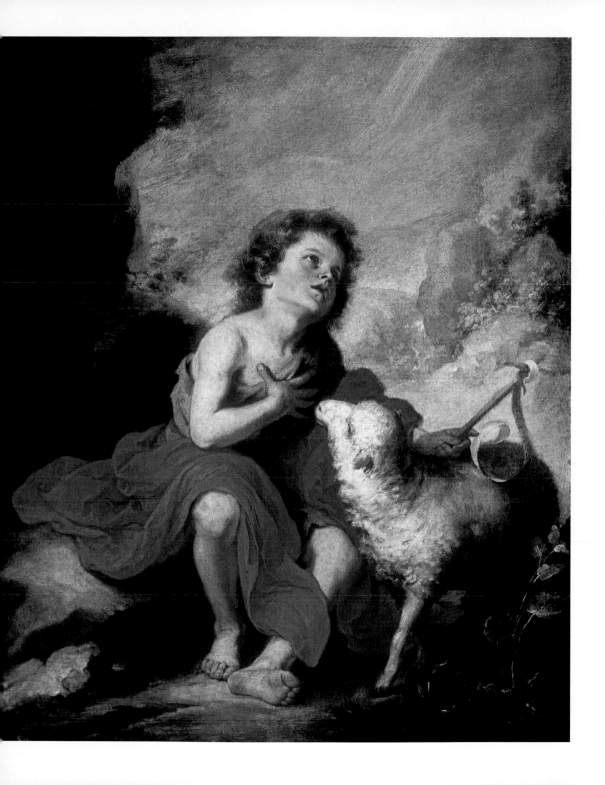

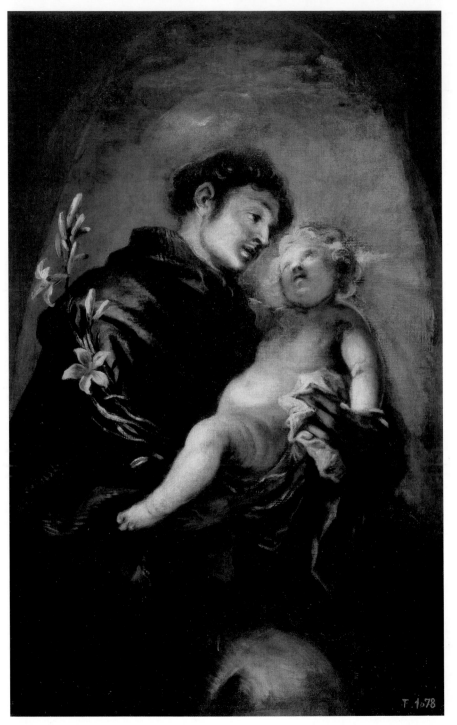

T.1078

St Anthony of Padua

St Anthony of Padua, a favourite subject of the Counter-Reformation, appears here as a beardless Franciscan. The strong contrasts in light stand out next to the lily branch, symbol of his purity.

Saint Antoine de Padoue

Saint Antoine de Padoue, l'un des personnages les plus prisés de la Contre-Réforme, apparaît ici sous les traits d'un Franciscain imberbe. Les contrastes de lumière ressortent autour de la branche de lys, symbole de pureté.

Der Heilige Antonius von Padua

Der Heilige Antonius von Padua, ein Lieblingssujet der Gegenreformation, erscheint hier als bartloser Franziskaner. Neben dem Lilienzweig als Symbol seiner Reinheit, stechen die starken Lichtkontraste hervor.

San Antonio de Padua

San Antonio de Padua, tema predilecto de la Contrarreforma, aparece aquí como un franciscano sin barba. Junto a la rama de lirio como símbolo de su pureza, destacan los fuertes contrastes de luz.

Sant'Antonio da Padova

Sant'Antonio da Padova, soggetto prediletto della Controriforma, appare qui come un francescano senza barba. Accanto alla ninfea, simbolo della sua purezza, spiccano i forti contrasti di luce.

De heilige Antonius van Padua

De heilige Antonius van Padua, een geliefd onderwerp tijdens de Contrareformatie, verschijnt hier als een baardeloze franciscaan. Naast de lelietak als symbool van zijn zuiverheid springen de sterke lichtcontrasten in het oog.

FRANCISCO DE HERRERA EL MOZO (1622–85)
n.d., Oil on canvas/Huile sur toile, 166 × 105 cm,
Museo del Prado, Madrid

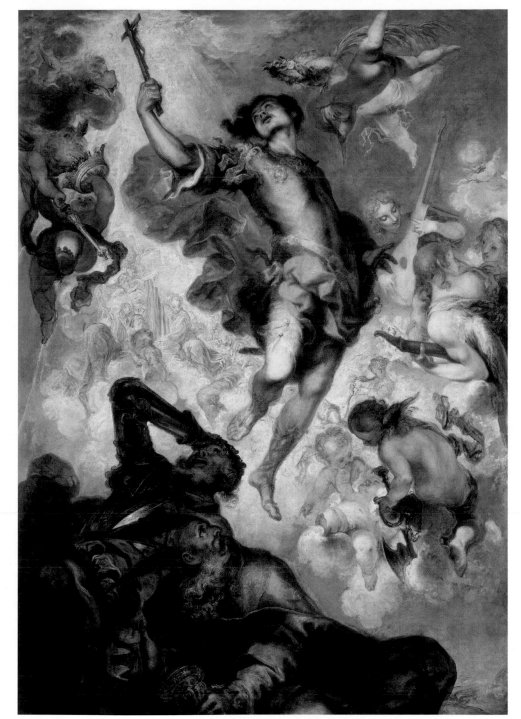

Triumph of St Hermenegild

Le Triomphe de saint Herménégilde

Triumph des Heiligen Hermenegild

Triunfo del Santo Hermenegildo

Trionfo di Sant'Ermeneggilio

Triomf van de heilige Hermenegilde

FRANCISCO DE HERRERA EL MOZO
(1622–85)

1654, Oil on canvas/Huile sur toile,
326 × 228 cm, Museo del Prado, Madrid

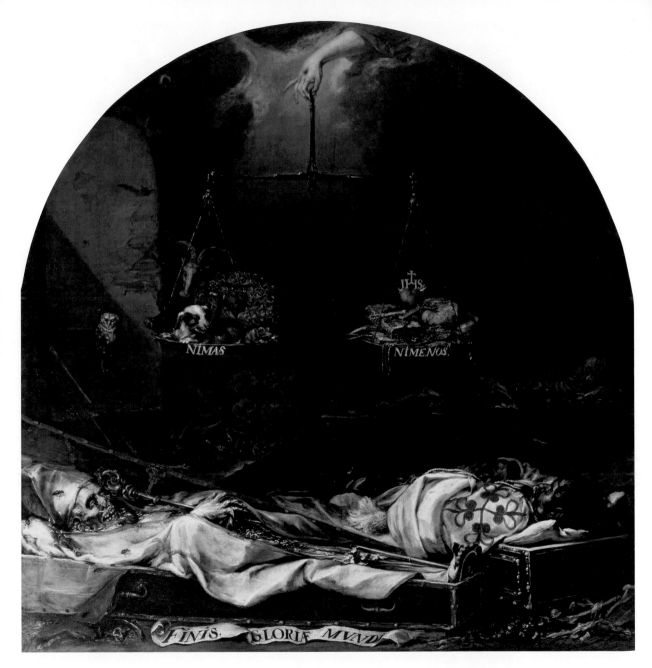

Finis Gloriae Mundi

JUAN DE VALDÉS LEAL (1622–90)

c. 1670-72, Oil on canvas/Huile sur toile, 220 × 216 cm, Hospital de la Caridad, Sevilla

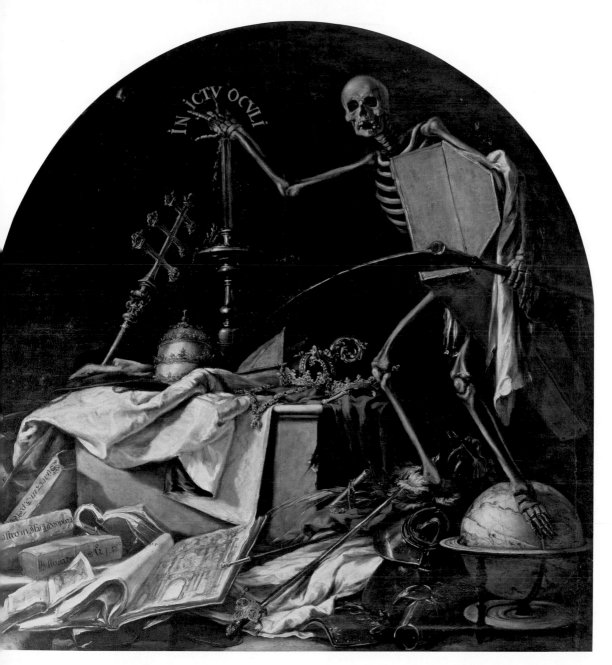

Allegory of Death Allegorie des Todes Allegoria della morte
In ictu oculi Alegoría de la Muerte Allegorie van de dood

JUAN DE VALDÉS LEAL (1622–90)

1670–72, Oil on canvas/Huile sur toile, 220 × 216 cm, Hospital de la Caridad, Sevilla

Portrait of a Young Girl

José Antolínez is considered [o]ne of the most interesting painte[rs] in Madrid in the second half [of] the 17th century. From humb[le] origins, he acquired an excell[ent] clientele, including the Spanis[h] court.

Portrait d'une petite fille

José Antolínez est considéré comme l'un des peintres les p[lus] intéressants du Madrid de la seconde moitié du XVIIᵉ siècl[e.] Issu d'un milieu modeste, il s[u] conquérir une clientèle exige[ante] à la cour d'Espagne entre aut[res.]

Porträt eines Mädchens

José Antolínez gilt als einer der interessantesten Maler in Madrid der zweiten Hälfte d[es] 17. Jahrhunderts. Aus einfach[en] Verhältnissen stammend erarbeitete er sich einen ausgezeichneten Kundenstam[m,] auch am spanischen Hof.

Retrato de una chica

José Antolínez es considerad[o] uno de los pintores más interesantes de Madrid de la segunda mitad del siglo XVII[.] orígenes sencillos, adquirió u[na] clientela excelente, también e[n] corte española.

Ritratto di ragazza

José Antolínez è considerato uno dei pittori più interessar[ti] di Madrid nella seconda met[à] del 17 ° secolo. Da umili origi[ni] acquisì una clientela eccellen[te,] anche alla corte spagnola.

Portret van een meisje

José Antolínez wordt besch[ouwd] als een van de interessantste schilders van Madrid in de tweede helft van de 17e eeuw[.] Met zijn eenvoudige achterg[rond] verwierf hij een uitstekende clientèle, ook aan het Spaans[e]

JOSÉ ANTOLÍNEZ (1635–75)
c. 1660, Oil on canvas/Huile sur
58 × 46 cm, Museo del Prado, M[adrid]

The Death of Mary Magdalene

Le Ravissement de
Marie-Madeleine

Der Tod Maria Magdalenas

a muerte de María Magdalena

La morte di Maria Maddalena

e dood van Maria Magdalena

JOSÉ ANTOLÍNEZ (1635-75)
1670-75, Oil on canvas/
Huile sur toile, 205 × 163 cm,
Museo del Prado, Madrid

Assumption of the Virgin

L'Assomption de la Vierge

Himmelfahrt Mariä

La Asunción de la Virgen María

Assunzione della Vergine Maria

Hemelvaart van Maria

JUAN MARTÍN CABEZALERO (1637-6⟨

c. 1665, Oil on canvas/Huile sur toile,
237 × 169 cm, Museo del Prado, Madrid

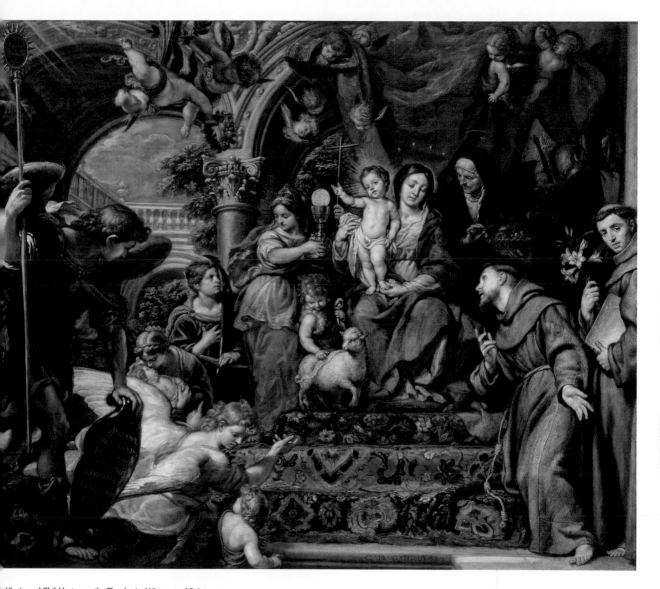

Virgin and Child between the Theological Virtues and Saints

rge à l'Enfant avec les Vertus théologales, entourée de saints

Jungfrau mit dem Kinde zwischen den christlichen Tugenden und Heiligen

Virgen con el Niño entre las Virtudes Teologales y santos

Vergine con il Bambino tra le Virtù Cristiane e i Santi

Maagd met het Kind tussen de christelijke deugden en heiligen

UDIO COELLO (1642–93)

, Oil on canvas/Huile sur toile, 232 × 273 cm, Museo del Prado, Madrid

St Dominic

St Dominic of Guzmán, the founder of the
Dominican Order, represented the defence of
Catholic orthodoxy and, as such, was a very
popular subject in Spanish baroque painting.

Saint Dominique de Guzman

Dominique de Guzman, fondateur de l'ordre d
dominicains, fut l'un des saints les plus à mêm
de représenter la défense de la foi catholique.
Cela lui conféra une place de choix dans la
peinture baroque espagnole.

Der Heilige Dominikus

Der Heilige Dominikus von Guzmán stand
als Gründer des Dominikanerordens für die
Verteidigung der katholischen Rechtgläubigke
Dies machte ihn zu einem sehr beliebten Suje
der spanischen Barockmalerei.

Santo Domingo

Santo Domingo de Guzmán, el fundador de la
Orden Dominicana, representaba la defensa d
ortodoxia católica. Esto lo convirtió en un ter
muy popular en la pintura barroca española.

San Domenico

San Domenico di Guzmán, il fondatore
dell'ordine domenicano, ha difeso l'ortodossia
cattolica. Questo lo ha reso un soggetto molt
popolare nella pittura barocca spagnola.

De heilige Dominicus

Dominicus Guzmán stond als stichter van
de dominicaanse orde voor de verdediging
van de katholieke leer. Dit maakte hem tot
een zeer populair onderwerp in de Spaanse
barokschilderkunst.

CLAUDIO COELLO (1642–93)

c. 1685, Oil on canvas/Huile sur toile,
240 × 160 cm, Museo del Prado, Madrid

e Parasol

mbrelle

r Sonnenschirm

sombrilla

arasole

parasol

NCISCO DE GOYA (1746–1828)

, Oil on canvas/Huile sur toile, 104 × 152 cm, Museo del Prado, Madrid

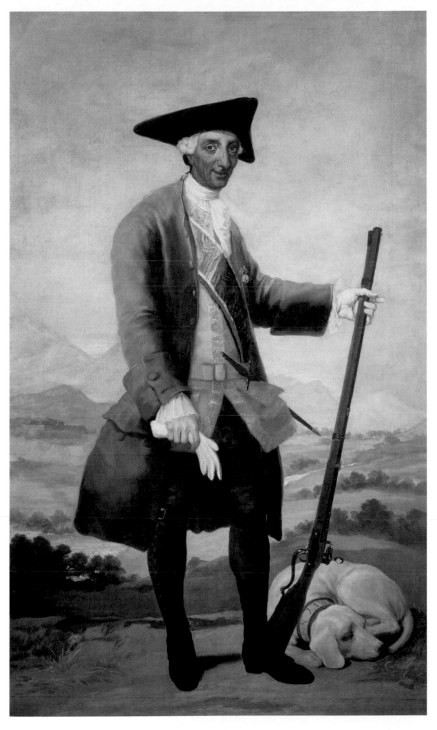

Charles III of Spain in Hunting Dress

Portrait de Charles III d'Espagne en costume de chasse

Karl III. von Spanien in Jagdkleidung

Carlos III de España en traje de caza

Carlo III di Spagna in abiti da caccia

Karel III van Spanje in jachtkleding

FRANCISCO DE GOYA (1746-1828)

c. 1786, Oil on canvas/Huile sur toile,
207 × 126 cm, Museo del Prado, Madrid

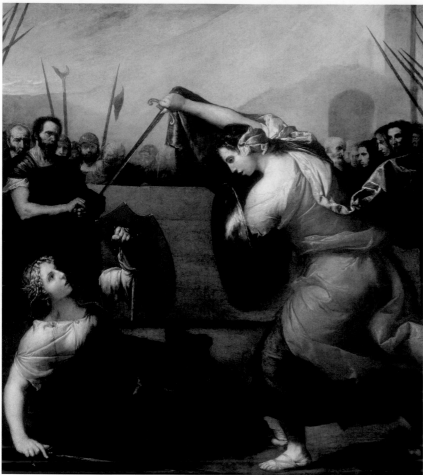

Women Gladiators

Combat de femmes

Zweikampf der Frauen

Combate de mujeres

Duello tra due donne

Gevecht tussen twee vrouwen

JUSEPE DE RIBERA (1591–1652)
1636, Oil on canvas/Huile sur toile, 235 × 212 cm,
Museo del Prado, Madrid

Jusepe de Ribera: Career in Italy

Of the three most important Spanish baroque painters, Jusepe de Ribera was the one who could least deny Caravaggio's influence. His pronounced chiaroscuro paintings with their intense colours were enthusiastically received in Spain, fitting in well with the gloomy realism of the time.

At the age of 20, Ribera went to Italy, where he travelled and studied extensively: beginning in Northern Italy, where he worked with Correggio and Veronese, via Rome, where he was particularly impressed by Raphael's frescoes in the Vatican, he was finally drawn to Naples, where he worked until his death. The city at the foot of Mount Vesuvius, at that time under Spanish rule, was an important cultural centre, and Ribera earned a high reputation. Nevertheless, he died there a pauper in 1652.

José de Ribera : une carrière en Italie

Parmi les trois peintres les plus importants du baroque espagnols, José de Ribera fut celui qui pouvait le moins nier l'influence du Caravage, avec ses couleurs intenses, fut reçue avec enthousiasme en Espagne, où elle se mariait parfaitement avec le réalisme obscur des nombreuses œuvres de cette époque.

Ribera arriva en Italie à 20 ans et entreprit de parcourir tout le paysage artistique local et de l'étudier en profondeur : de l'Italie du Nord, où il s'attela au Corrège et à Véronèse, il partit à Rome, où les fresques de Raphaël, au Vatican, l'impressionnèrent particulièrement, avant de s'installer à Naples, où il travailla jusqu'à sa mort. Alors sous domination espagnole, cette ville au pied du Vésuve était un centre culturel important et Ribera y acquit une grande considération. Il y mourut pourtant dans la pauvreté en 1652.

Jusepe de Ribera: Karriere in Italien

Von den drei wichtigsten Malern des spanischen Barocks war Jusepe de Ribera derjenige, der den Einfluss Caravaggios am wenigsten verleugnen konnte. Dessen ausgeprägte Hell-Dunkel-Malerei mit ihrer intensiven Farbigkeit wurden in Spanien begeistert aufgenommen, passte sie doch gut zu dem ohnehin schon düster gestimmten Realismus vieler Werke dieser Zeit.

Mit 20 Jahren ging Ribera nach Italien, wo er die dortige Kunstlandschaft gründlich bereiste und studierte. Von Oberitalien aus, wo er sich mit Correggio und Veronese beschäftigte, über Rom, wo ihn besonders Raffaels Fresken im Vatikan beeindruckten, zog es ihn schließlich nach Neapel, wo er bis zu seinem Tod wirken sollte. Die Stadt am Fuße des Vesuv, zu dieser Zeit unter spanischer Herrschaft, war ein wichtiges kulturelles Zentrum und Ribera gelangte zu hohem Ansehen. Dennoch war er verarmt, als er 1652 ebendort verstarb.

St Paul the Hermit

Saint Paul Ermite

Der Heilige Paulus Eremita

San Pablo Eremitaño

San Paolo Eremita

Paulus de Heremiet (Paulus Eremita)

JUSEPE DE RIBERA (1591–1652)

c. 1652, Oil on canvas/Huile sur toile, 197 × 153 cm, Musée du Louvre, Paris

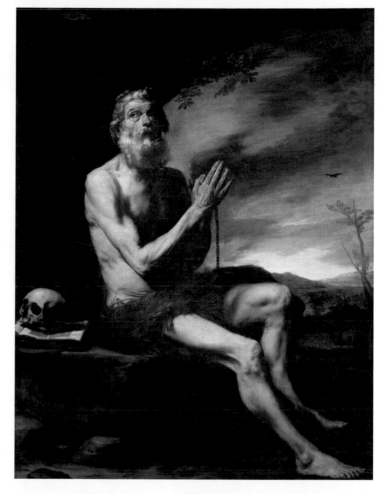

sepe de Ribera: carrera en Italia

los tres pintores barrocos españoles más importantes, epe de Ribera fue el que menos pudo negar la luencia de Caravaggio. Su pronunciada pintura ra-oscura, con su intenso colorido, fue recibida con usiasmo en España, ya que encajaba bien en el ya nbrío realismo de muchas obras de la época.

A la edad de 20 años, Ribera fue a Italia, donde viajó studió a fondo el paisaje artístico italiano: desde el rte de Italia, donde trabajó con Correggio y Veronese, sando por Roma, donde quedó particularmente presionado por los frescos de Rafael en el Vaticano, finalmente atraído a Nápoles, donde trabajó hasta su erte. La ciudad a los pies del Vesubio, entonces bajo minio español, era un importante centro cultural y era alcanzó una gran reputación. Sin embargo, murió pobre en 1652.

Jusepe de Ribera: Carriera in Italia

Tra i tre più importanti pittori barocchi spagnoli, Jusepe de Ribera è quello che meno ha potuto negare l'influenza di Caravaggio. La sua spiccata pittura in chiaro-scuro, con i suoi colori intensi, fu accolta con entusiasmo in Spagna, in quanto si adattava bene al realismo già cupo di molte opere di quel tempo.

A 20 anni, Ribera si reca in Italia, dove viaggia e studia a fondo il paesaggio artistico italiano: dal Nord Italia, dove collabora con il Correggio e il Veronese, passando per Roma, dove rimane particolarmente colpito dagli affreschi di Raffaello in Vaticano, per giungere infine a Napoli, dove lavora fino alla sua morte. La città ai piedi del Vesuvio, a quel tempo sotto il dominio spagnolo, era un importante centro culturale e Ribera godé lì di grande stima. Tuttavia, morì povero nel 1652.

Jusepe de Ribera: carrière in Italië

Van de drie belangrijkste Spaanse barokschilders was Jusepe de Ribera degene die de invloed van Caravaggio het minst kon verloochenen. Zijn schilderijen met uitgesproken licht-donkercontrasten en intensieve kleuren werden enthousiast ontvangen in Spanje, omdat ze goed aansloten bij het toch al somber gestemde realisme van veel werken uit die tijd.

Op 20-jarige leeftijd reisde Ribera naar Italië, waar hij het Italiaanse kunstlandschap grondig bestudeerde en bereisde: vanuit Noord-Italië, waar hij zich bezighield met Correggio en Veronese, via Rome, waar hij bijzonder onder de indruk was van Rafaëls fresco's in het Vaticaan, reisde hij uiteindelijk naar Napels, waar hij tot zijn dood zou werken. De stad aan de voet van de Vesuvius, destijds onder Spaanse heerschappij, was een belangrijk cultureel centrum en Ribera bouwde een goede reputatie op. Toch was hij een arm man toen hij daar in 1652 stierf.

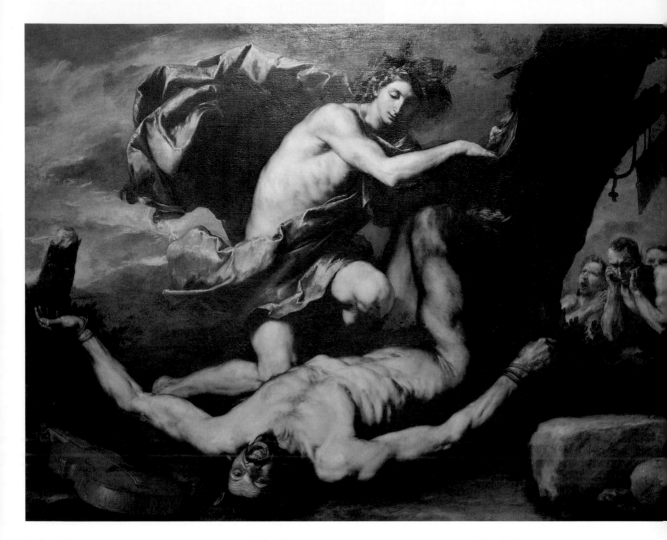

Apollo and Marsyas

A work animated by strong colors and a refined composition. The dynamic Marsyas, who seems to jut out of the picture, contrasts strikingly with the gentle features of the god Apollo, who flays him.

Apollon et Marsyas

Les couleurs puissantes et la composition raffinée de cette œuvre lui donnent vie. Marsyas, qui semble presque jaillir du tableau, offre un net contraste avec les traits délicats du dieu Apollon en train de l'écorcher.

Apoll und Marsyas

Ein Werk, das von seinen starken Farben und von seiner raffinierten Komposition lebt. Der aus dem Bild herausragende Marsyas kontrastiert auffällig mit den sanften Zügen des ihn schindenden Gottes Apoll.

Apolo y Marsyas

Una obra que vive de sus colores fuertes y de su refinada composición. Marsias que sobresale de la imagen contrasta notablemente con los suaves rasgos del Dios Apolo que lo oprime.

Apollo e Marsia

Un'opera che vive dei suoi colori forti e della sua raffinata composizione. Il Marsia che merge in questo dipinto e che vuole scuoiare Apollo, contrasta sorprendentemente con la tranquillità della divinità.

Apollo en Marsyas

Een werk dat leeft door zijn sterke kleuren en verfijnde compositie. De uit het doek naar voren stekende Marsyas contrasteert opvallend met de zachte gelaatstrekken van de god Apollo die hem afbeult.

JUSEPE DE RIBERA (1591–1652)

1637, Oil on canvas/Huile sur toile, 182 × 232 cm, Galleria Nazionale di Capodimonte, Napoli

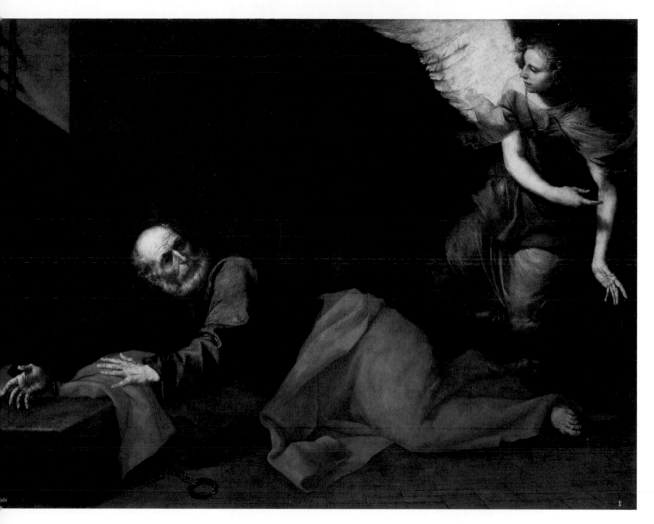

Peter Freed by an Angel

int Pierre délivré par un ange

trus, von einem Engel befreit

dro, liberado por un ángel

tro, liberato da un angelo

trus bevrijd door een engel

SEPE DE RIBERA (1591–1652)

9, Oil on canvas/Huile sur toile, 177 × 232 cm, Museo del Prado, Madrid

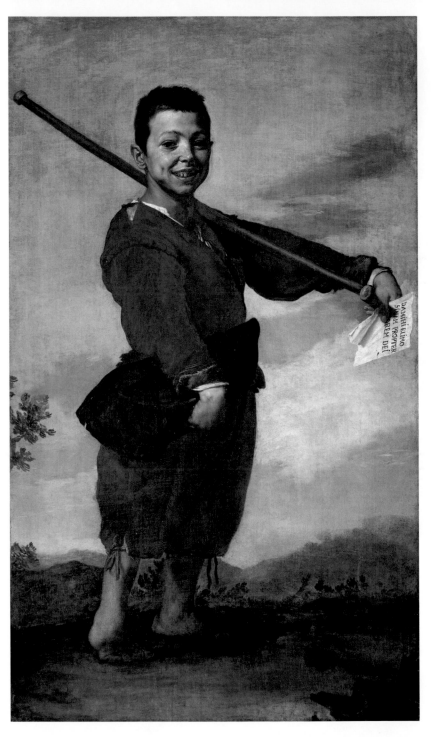

The Clubfoot

A picture of touching contrasts: the beggar's physical deformity and the plea for alms in his hand is juxtaposed with his cheery disposition and the dignified perspective from which the painter shows him.

Le Pied-Bot

Ce tableau nous touche aujourd'hui encore par ses contrastes : ce mendiant physiquement handicapé, avec à la main son morceau papier demandant l'aumône, semble serein. La perspective choisie par Ribera lui laisse sa dignité.

Der Klumpfuß

Ein Bild, das durch seine Kontraste berührt: der körperlich entstellte Bettler mit der Bitte um Almosen in der Hand, der gute Mutes zu sein scheint und aus einer Perspektive gemalt wurde, d ihm seine Würde lässt.

El pie varo

Un cuadro que emociona por sus contrastes: el mendigo físicamente desfigurado con el saco de limosnas en la mano, que parece estar de buen humor y pintado desde una perspectiva que muestra su dignidad.

Storpio

Un quadro che tocca attraverso i suoi contrasti: il mendicante sfigurato fisicamente che chiede l'elemosina con la mano, sembra di buon umore, viene dipinto da una prospettiva che gli lascia la sua dignità.

De klompvoet

Dit schilderij raakt door zijn contrasten: de fysiek verminkte bedelaar met het verzoek om aalmoezen in zijn hand ziet er blij uit en is geschilderd vanuit een perspectief dat hem in zijn waarde laat.

JUSEPE DE RIBERA (1591–1652)

1642, Oil on canvas/Huile sur toile, 164 × 94 cm, Musée du Louvre, Paris

Penitent St Peter

Ribera's talent for portraying mental and physical suffering evident in this picture, which focuses on St Peter's emotional anguish in his moment of repentance.

Saint Pierre pénitent

Le talent tout particulier de Ribera pour représenter les souffrances physiques et psychiques se retrouve également dans cette représentation de Pierre en pénitence. Il s'agit ici surtout e tourments de l'âme, que l'on peut lire sur le visage du saint.

Reuiger Petrus

Riberas Talent zur Darstellung psychischen und physischen Leidens zeigt sich auch bei dieser Darstellung. Hier geht es vor allem um die seelische Qual, die sich im Gesicht des Heiligen zeigt.

repentimiento de San Pedro

El talento de Ribera para retratar el sufrimiento mental físico también es evidente en te retrato. Se trata sobre todo de la agonía emocional que aparece en el rostro del santo.

Pentimento di San Pietro

l talento di Ribera nel ritrarre la sofferenza fisica e mentale è evidente anche in questa rappresentazione. Si tratta oprattutto dell'agonia emotiva che appare sul volto del santo.

De berouwvolle Petrus

Ribera's talent voor het schilderen van geestelijk en lichamelijk lijden is ook zichtbaar in deze afbeelding. Het gaat hier vooral om de emotionele pijn, die af te lezen is van het gezicht van de heilige.

USEPE DE RIBERA (1591-1652)
.d., Oil on canvas/Huile sur toile, 116 × 88 cm, Kunsthistorisches Museum, Wien

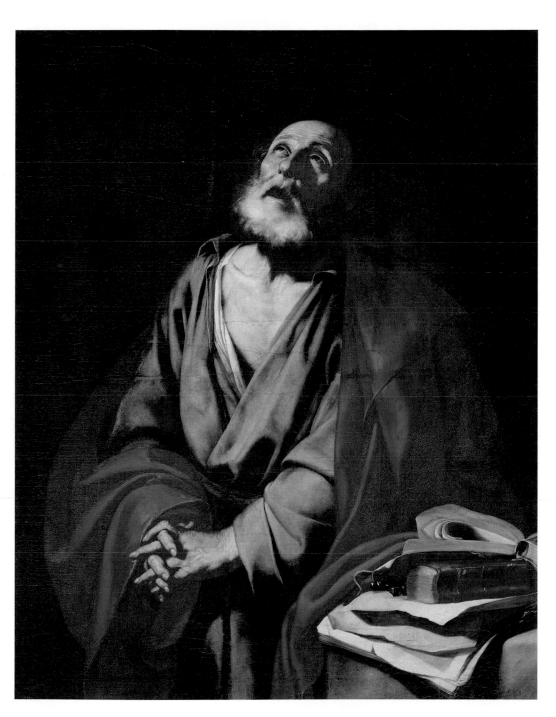

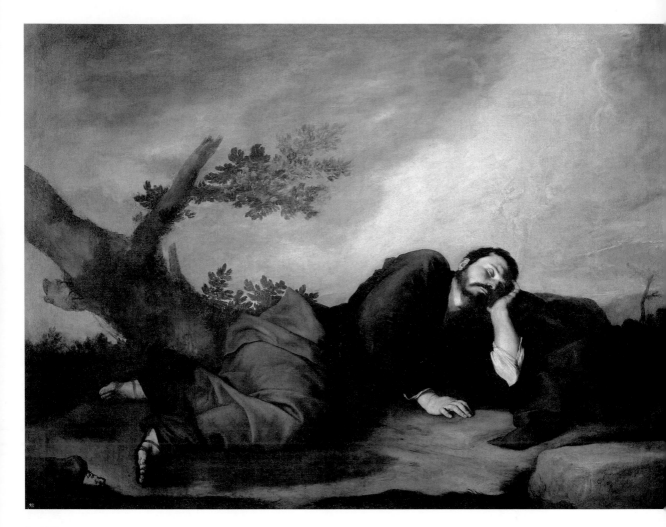

Jacob's Dream

Le Songe de Jacob

Jakobs Traum

El sueño de Jacob

Sogno di Giacobbe

Jacobs droom

JUSEPE DE RIBERA (1591–1652)

1639, Oil on canvas/Huile sur toile, 179 × 233 cm, Museo del Prado, Madrid

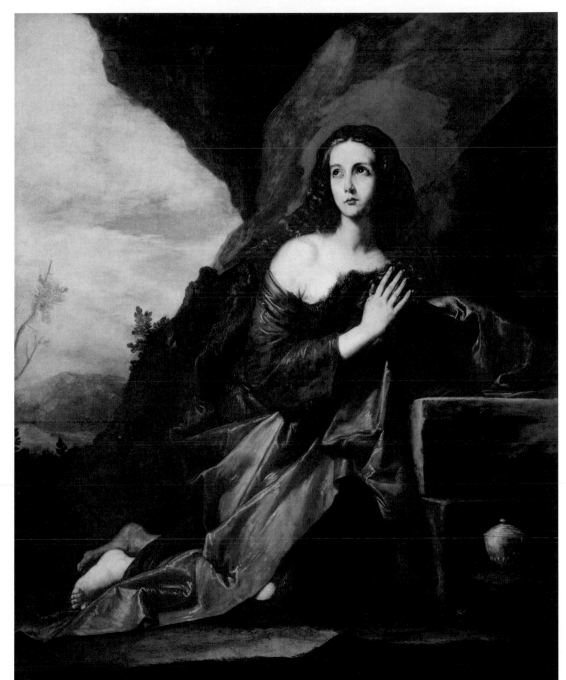

Penitent Magdalene

Marie-Madeleine
au désert

Die büßende
Magdalena

Magdalena penitente

Maddalena penitente

De boetende Maria
Magdalena

JUSEPE DE RIBERA
(1591–1652)
1641, Oil on canvas/Huile
sur toile, 182 × 149 cm,
Museo del Prado, Madrid

143

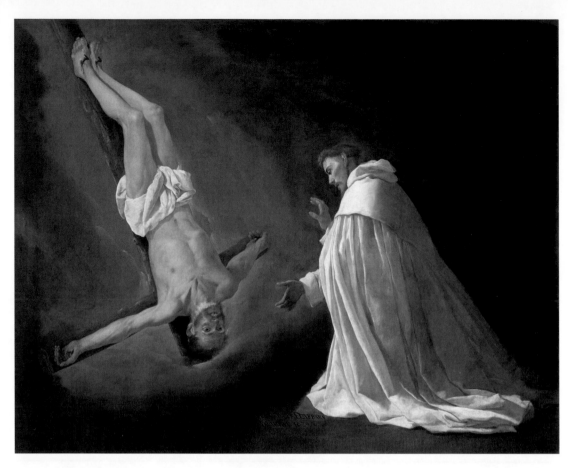

The Apparition
of St Peter to
St Peter Nolasco

Apparition de
saint Pierre à saint
Pierre Nolasque

Der Apostel Petrus
erscheint dem Heilige
Petrus Nolascus

Aparición del apóstol
San Pedro a San
Pedro Nolasco

Apparizione di
San davanti a San
Pietro Nolasco

De apostel Petrus
verschijnt aan de
heilige Peter Nolascus

FRANCISCO DE ZURBARÁ
(1598–1664)
1629, Oil on canvas/Huile
sur toile, 179 × 223 cm,
Museo del Prado, Madrid

Francisco de Zurbarán:
Painting as Worship

Although Zurbarán's life almost exactly corresponded
to that of his compatriot Velázquez—he was born in
1598 and died in 1664—the deeply felt religiosity of his
works may feel more foreign to us today than Velázquez's
intellectual approach.

Zurbarán, a native of Extremadura, began making
votive panels and altarpieces after his training in Seville,
until the move from Velázquez to Madrid gave him
the opportunity to become a city painter in Seville.
Towards the middle of the century, however, his local
popularity declined, perhaps due the rising star of
Murillo, Zurbarán's junior by twenty years. In those years,
Zurbarán's style also changed, his naturalism giving way to
more delicate tones.

In 1658, Zurbarán went to Madrid, where he later died.
To this day he remains a symbol of the deep religious
feeling of his epoch.

Francisco de Zurbarán :
la peinture vue comme une messe

Bien qu'il fut contemporain de son compatriote
Vélasquez, puisque né en 1598 et mort en 1664, la
profonde religiosité qui s'exprime dans ses œuvres peut
nous sembler plus étrangère que l'approche intellectuelle
de Vélasquez.

Originaire d'Estrémadure, Zurbarán commença son
apprentissage à Séville en peignant des ex-voto et des
retables, jusqu'à ce que le départ de Vélasquez pour
Madrid lui permette de devenir le peintre de la ville de
Séville. Vers le milieu du siècle, sa popularité commença
à baisser à l'échelle locale, peut-être parce que celle de
Murillo, de 20 ans son cadet, était en plein essor. Le style
de Zurbarán évolua à cette époque, son naturalisme
revêtant des teintes plus claires.

En 1658, il s'installa à Madrid, où il resta jusqu'à
sa mort. Il symbolise aujourd'hui encore la profonde
sensibilité religieuse de cette période.

Francisco de Zurbarán:
Malen als Gottesdienst

Auch wenn seine Lebensspanne in etwa der seines
Landsmannes Velázquez entsprach – geboren im
Jahr 1598, gestorben 1664 –, so mag uns Heutigen die
tief empfundene Religiosität, die aus seinen Werken
spricht, doch fremder erscheinen als der intellektuelle
Ansatz Velázquez'.

Der aus der Estremadura stammende Zurbarán begar
nach seiner Ausbildung in Sevilla mit der Herstellung vo
Votivtafeln und Altarbildern, bis ihm die Übersiedelung
von Velázquez nach Madrid die Gelegenheit bot,
Stadtmaler in Sevilla zu werden. Gegen Mitte des
Jahrhunderts ließ seine lokale Popularität jedoch nach,
was damit zu tun haben könnte, dass zu dieser Zeit der
Stern des etwa 20 Jahre jüngeren Murillo aufging. In jen
Jahren wandelte sich auch der Stil Zurbaráns, dessen
Naturalismus nun zarteren Tönen wich.

1658 ging Zurbarán nach Madrid, wo er später verstar
Bis heute steht er für das tiefe religiöse Empfinden
dieser Epoche.

St Elisabeth of Portugal

Sainte Isabelle du Portugal

Die Heilige Elisabeth von Portugal

Santa Isabel de Portugal

Sant'Elisabetta di Portogallo

De heilige Elizabeth van Portugal

FRANCISCO DE ZURBARÁN (1598-1664)

c. 1635, Oil on canvas/Huile sur toile, 184 × 98 cm, Museo del Prado, Madrid

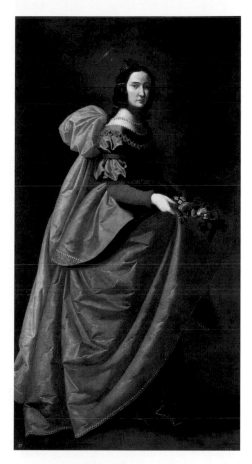

Francisco de Zurbarán: la pintura como servicio divino

Aunque fue contemporáneo de su compatriota Velázquez —nacido en 1598, fallecido en 1664—, la religiosidad profundamente sentida que habla de sus obras nos puede parecer hoy más extraña que el enfoque intelectual de Velázquez.

Zurbarán, extremeño, comenzó a hacer paneles votivos y retablos después de su formación en Sevilla, hasta que el traslado de Velázquez a Madrid le dio la oportunidad de convertirse en pintor de ciudad en Sevilla. Hacia mediados de siglo, sin embargo, su popularidad local declinó, lo que podría tener algo que ver con el hecho de que Murillo, unos 20 años más joven, estaba ganando reconocimiento en ese momento. En esos años también cambió el estilo de Zurbarán, cuyo naturalismo dio paso a tonos más delicados.

En 1658 Zurbarán se trasladó a Madrid, donde murió. Hasta el día de hoy representa el profundo sentimiento religioso de esta época.

Francisco de Zurbarán: La pittura come ufficio divino

Anche se la sua vita somigliava approssimativamente a quella del suo connazionale Velázquez - nato nel 1598, morto nel 1664 - la religiosità profondamente sentita che parla dalle sue opere può sembrare oggi più strana dell'approccio intellettuale di Velázquez.

Zurbarán, originario dell'Estremadura, ha iniziato a realizzare pannelli votivi e pale d'altare dopo la sua formazione a Siviglia, fino a quando il trasferimento di Velázquez a Madrid gli dette l'opportunità di diventare il pittore della città di Siviglia. Verso la metà del secolo, tuttavia, la sua popolarità locale diminuì, il che potrebbe avere a che fare con il fatto che la stella nascente Murillo, circa 20 anni più giovane, stava sorgendo in quel momento. In quegli anni cambiò anche lo stile di Zurbarán, il cui naturalismo cedette il passo a toni più delicati.

Nel 1658 Zurbarán si recò a Madrid, dove morì più tardi. A tutt'oggi egli è sinonimo del profondo sentimento religioso di quest'epoca.

Francisco de Zurbarán: schilderen als godsdienst

Hoewel zijn levensloop grofweg overeenkwam met die van zijn landgenoot Velázquez – geboren in 1598, gestorven in 1664 –, komt de diepgevoelde religiositeit die uit zijn werken spreekt nu vreemder op ons over dan de intellectuele benadering van Velázquez.

De uit Extremadura afkomstige Zurbarán begon na zijn opleiding in Sevilla met het maken van votiefpanelen en altaarstukken, totdat de verhuizing van Velázquez naar Madrid hem de kans gaf om stadsschilder te worden in Sevilla. Tegen het midden van de eeuw nam zijn lokale populariteit echter af, wat iets te maken zou kunnen hebben met het feit dat de ster van de ongeveer 20 jaar jongere Murillo op dat moment rijzende was. In die jaren veranderde ook de stijl van Zurbarán, wiens naturalisme nu plaatsmaakte voor zachtere tinten.

In 1658 ging Zurbarán naar Madrid, waar hij later stierf. Tot op heden staat hij voor het diep religieuze gevoel van dit tijdperk.

Agnus Dei

Francisco de Zurbarán was a master of textures. This Lamb of God captivates the viewer not only by its humility, but also by its incredible closeness to life.

Agnus Dei

Francisco de Zurbarán était un maître des textures. Cet agneau de Dieu attendant le sacrifice frappe l'observateur non seulement par sa résignation mais aussi par son incroyable réalisme.

FRANCISCO DE ZURBARÁN (1598-1664)

1635-40, Oil on canvas/Huile sur toile, 37,3 × 62 cm, Museo del Prado, Madrid

Agnus Dei

Francisco de Zurbarán war ein Meister der Texturen. Dieses Lamm Gottes zieht den Betrachter nicht nur durch seine Ergebenheit in den Bann, sondern auch durch seine unglaubliche Lebensnähe.

Agnus Dei

Francisco de Zurbarán fue un maestro de las texturas. Este Cordero de Dios cautiva al espectador no sólo por su devoción, sino también por su increíble cercanía a la vida.

Agnus Dei

Francisco de Zurbarán era un maestro della texture. Questo Agnello di Dio affascina lo spettatore non solo per la sua umiltà, ma anche per la sua incredibile aderenza alla realtà.

Agnus Dei

Francisco de Zurbarán was een meester in texturen. Dit Lam Gods boeit de toeschouwer niet alleen door zijn berusting, maar ook door zijn ongelooflijke levensechtheid.

St Apollonia

In one hand a palm leaf, in the other a pair of tongs—St Apollonia carries the insignia of her torments. According to legend, her teeth were ripped out.

Sainte Apolline

Dans une main, une feuille de palmier, dans l'autre, une paire de tenailles : sainte Apolline porte avec elle les symboles de son martyre. La légende veut que l'on lui ait arraché les dents, ce qui fait qu'elle est aujourd'hui – entre autres – la patronne des dentistes.

Die Heilige Apollonia

der einen Hand ein Palmenblatt, in der anderen eine Zange – die Heilige Apollonia trägt die Insignien ihrer Qualen bei sich. Der Legende nach wurden ihr die Zähne ausgerissen.

Santa Apolonia

En una mano una hoja de palma, en la otra unas pinzas - Santa Apolonia lleva la insignia de sus tormentos. La leyenda dice que le arrancaron los dientes.

Sant'Apollonia

Da una parte una foglia di palma, dall'altra le tenaglie - nt'Apollonia porta i simboli del suo martirio. Secondo la leggenda le furono strappati tutti i denti.

De heilige Apollonia

In de ene hand een palmblad, in de andere een tang – de heilige Apollonia draagt de tekens van haar kwellingen. Volgens de legende werden haar tanden eruit getrokken.

FRANCISCO DE ZURBARÁN (1598-1664)

1636, Oil on canvas/Huile sur toile, 134 × 67 cm, Musée du Louvre, Paris

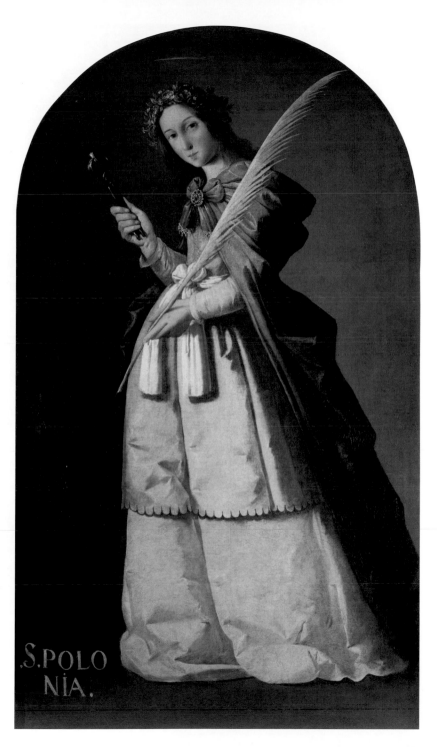

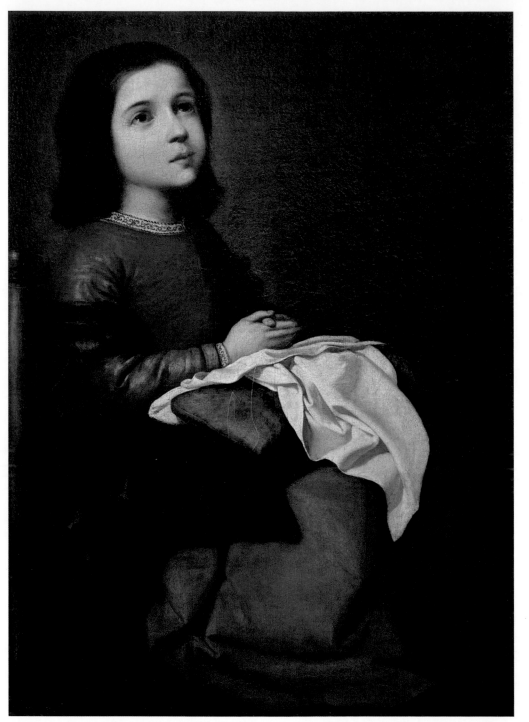

Childhood of the Virgin

Marie enfant

Jugend der Mutter Gottes

Juventud de la Madre de Dios

Madre di Dio da giovinetta

Jeugd van de Moeder Gods

FRANCISCO DE ZURBARÁN
(1598–1664)
1658–60, Oil on canvas/Huile sur
toile, 73,5 × 53,5 cm, State Hermitage
Museum, St. Petersburg

The Ecstasy of St Franc

Saint François en exta

Der Heilige Franziskus in Eksta

San Francisco en éxtas

Estasi di San Frances

De heilige Franciscus in exta

FRANCISCO DE ZURBARÁ
(1598–166
c. 1660, Oil on canvas/Huile sur to
64,7 × 53,1 cm, Alte Pinakothek, Münch

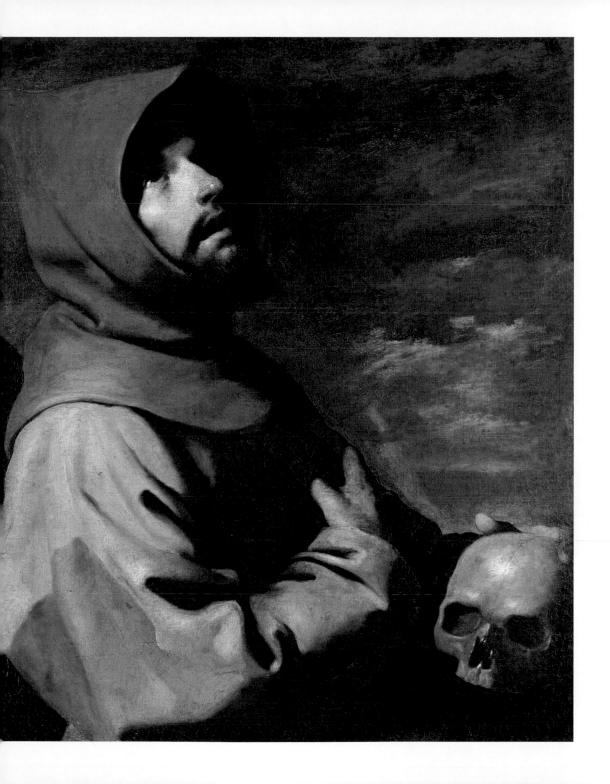

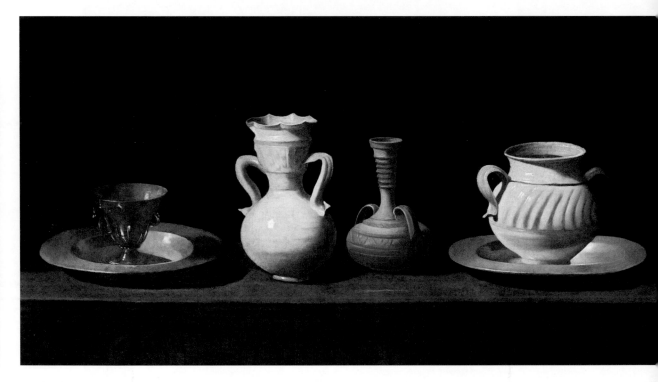

Still Life with Vessels

Tasses et vases

Stillleben mit Gefäßen

Bodegón con vasijas

Natura morta con vasi

Stilleven met kruiken

FRANCISCO DE ZURBARÁN (1598–1664)

c. 1650, Oil on canvas/Huile sur toile, 46 × 84 cm, Museo del Prado, Madrid

The Crucified Christ with a Pain

Saint Luc en peintre devant la Crucifixi

Der Heilige Lukas als Maler vor dem Gekreuzigt

San Lucas como pintor ante Cristo en la Cr

San Luca pittore davanti al Crocifis

De heilige Lucas als schilder voor de gekruisig

FRANCISCO DE ZURBARÁN (1598–166

c. 1650, Oil on canvas/Huile sur toile, 105 × 84 cm, Museo del Prado, Mad

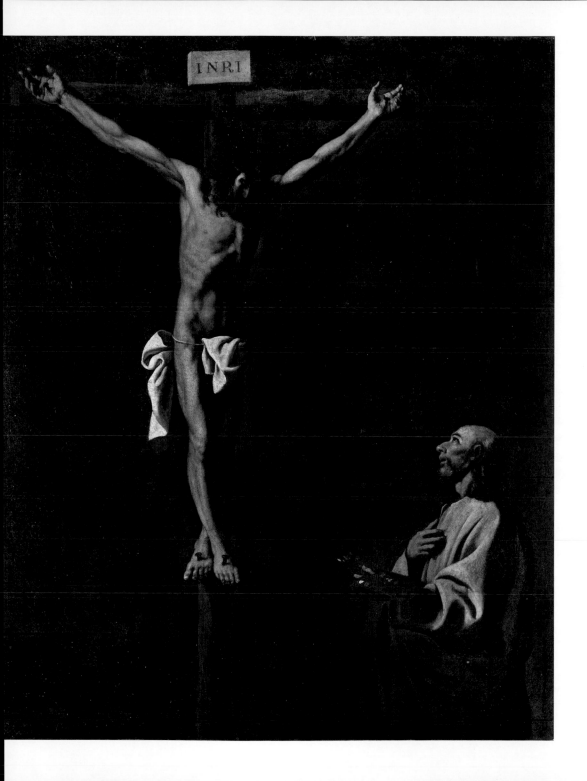

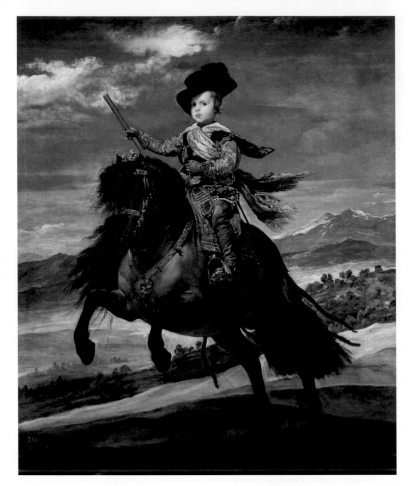

Portrait of Prince Baltasar Carlos

Le Prince Baltasar Carlos à cheval

Reiterbildnis Prinz Baltasar Carlos

Retrato del Príncipe Baltasar Carlos

Ritratto del principe Baltasar Carlos

Portret van prins Baltasar Carlos te paard

DIEGO VELÁZQUEZ (1599-1660)

1635, Oil on canvas/Huile sur toile, 211,5 × 177 cm, Museo del Prado, Madrid

Diego Velázquez:
The Tamed Wilderness of Spain

What sets Diego Rodríguez de Silva y Velázquez most
clearly apart from his contemporaries Ribera and
Zurbarán is his moderation of temperament. Where
the others let their emotions run free in their quest to
overwhelm the viewer, Velázquez focused more on the
intellect, painting complex pictures that invited the viewer
to discover their many allusions. This made Velázquez the
most modern of the Spanish baroque painters.

But it was not only his novel themes and mastery of
composition that led Édouard Manet, among others, to
esteem Velázquez so much. The painter's late style, the
climax of his work, attracted many admirers, not least due
to the more delicate colour palette. These gentle tones are
still associated with Velázquez and ensure his fame.

Diego Vélasquez :
l'impétuosité espagnole domestiquée

Diego Rodríguez de Silva y Velázquez, dit Vélasquez en
français, se distinguait surtout de ses contemporains
Ribera et Zurbarán par son tempérament modéré. Là
où les autres laissaient libre cours à leurs émotions
pour submerger de spectateur, lui préférait d'autres
voies : il misait surtout sur l'intellect, peignant des
images complexes où regorgeant d'allusions à découvrir.
Vélasquez devint ainsi le plus moderne des peintres
baroques espagnols.

Pourtant, ce ne furent pas seulement ses thèmes
novateurs et sa maîtrise parfaite de la composition de
ses tableaux qui lui valurent par exemple l'admiration
d'Édouard Manet, mais plutôt son style tardif,
aboutissement de son art, caractérisé notamment par
une palette de couleurs plus tendres. Ces tons doux, que
l'on associe aujourd'hui encore au nom de Vélasquez, lui
assurèrent la renommée.

Diego Velázquez:
Die gezähmte Wildheit Spaniens

Was Diego Rodríguez de Silva y Velázquez am
deutlichsten von seinen Zeitgenossen Ribera und
Zurbarán abhebt, ist die Mäßigung des Temperaments.
Dort, wo die anderen ihren Emotionen freien Lauf ließe
um den Betrachter zu überwältigen, ging er andere Weg
Er setzte stärker auf den Intellekt, malte komplexe Bilde
bot dem Betrachter an, viele Anspielungen zu entdecker
Damit avancierte Velázquez zum modernsten unter den
spanischen Barockmalern.

Doch waren es nicht nur die neuartigen Themen und
die souveräne Beherrschung der Bildkomposition, die da
führten, dass zum Beispiel Édouard Manet Velázquez so
bewunderte. Hierfür verantwortlich war wohl am meiste
der Spätstil des Malers, der Höhepunkt seines Schaffens,
nicht zuletzt in Bezug auf eine zartere Farbpalette. Diese
sanften Töne sind es, die man bis heute mit Velázquez in
Verbindung bringt und die seinen Ruhm sichern.

Pope Innocent X

Portrait du pape Innocent X

Papst Innozenz X.

Papa Inocencio X.

Papa Innocenzo X

Paus Innocentius X

DIEGO VELÁZQUEZ (1599-1660)

c. 1650, Oil on canvas/Huile sur toile, 141 × 119 cm, Galleria Doria Pamphilij, Roma

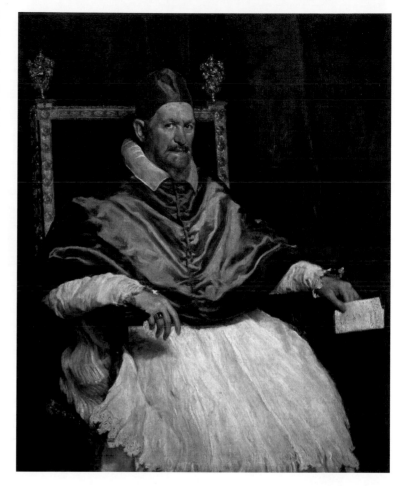

ego Velázquez:
salvajismo domado de España

que distingue a Diego Rodríguez de Silva y Velázquez
sus contemporáneos Ribera y Zurbarán es la
deración de temperamento. Donde los otros dejaban
e sus emociones corrieran libres para abrumar al
ectador, él siguió otros caminos: se centró más en el
electo, pintó cuadros complejos, ofreció al espectador
cubrir muchas alusiones. Esto convirtió a Velázquez en
intor más moderno del barroco español.

Pero no fueron sólo los temas novedosos y el
ninio soberano de la composición pictórica lo que
ó a Édouard Manet, por ejemplo, a admirar tanto a
ízquez. El estilo tardío del pintor, el clímax de su obra,
probablemente el responsable de ello, sobre todo
o que respecta a una paleta de colores más delicada.
os tonos suaves todavía se asocian con Velázquez y
guran su fama.

Diego Velázquez:
La furia domata di Spagna

Ciò che distingue Diego Rodríguez de Silva y Velázquez
dai suoi contemporanei Ribera e Zurbarán è la
moderatezza del temperamento. Dove gli altri lasciavano
scorrere le loro emozioni per sopraffare lo spettatore,
lui andava per altre vie: si concentrava di più sull'intelletto,
dipingeva quadri complessi, offriva allo spettatore
la possibilità di scoprire le allusioni. Questo ha reso
Velázquez il più moderno dei pittori barocchi spagnoli.

Ma non sono stati solo i temi innovativi e l'abile
padronanza della composizione pittorica a portare tanta
ammirazione nei confronti di Édouard Manet Velázquez.
Il tardo stile del pittore, culmine della sua attività, ne è
probabilmente il motivo, anche per quanto riguarda una
più delicata scelta nei colori. Questi toni delicati sono
ancora associati a Velázquez e ne garantiscono la fama.

Diego Velázquez:
de getemde wildheid van Spanje

Wat Diego Rodríguez de Silva y Velázquez het duidelijkst
onderscheidt van zijn tijdgenoten Ribera en Zurbarán
is zijn gematigde temperament. Waar de anderen
hun emoties de vrije loop lieten om de toeschouwer
te overweldigen, bewandelde hij andere wegen: hij
richtte zich meer op het intellect, schilderde complexe
schilderijen, liet de toeschouwer veel toespelingen
ontdekken. Velázquez was daarmee de modernste van de
Spaanse barokschilders.

Maar niet alleen zijn nieuwerwetse thema's en
soevereine beheersing van de beeldcompositie leidden
ertoe dat bijvoorbeeld Édouard Manet Velázquez zo
bewonderde. De late stijl van de schilder, het hoogtepunt
van zijn werk, was daar waarschijnlijk verantwoordelijk
voor, niet in de laatste plaats vanwege het zachtere
kleurenpalet. Deze zachte tonen worden nog steeds
geassocieerd met Velázquez en stellen zijn roem veilig.

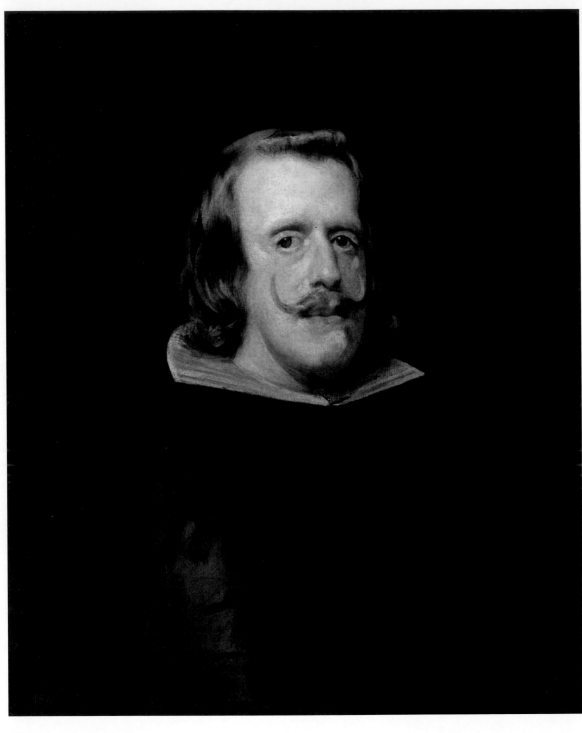

Philip IV
of Spain

Philippe IV
d'Espagne

Philipp IV.
von Spanien

Felipe IV de
España

Filippo IV
di Spagna

Filips IV van
Spanje

**DIEGO
VELÁZQUEZ
(1599–1660)**
c. 1653, Oil
on canvas/
Huile sur toile
69,3 × 56,5 cm
Museo del
Prado, Madrid

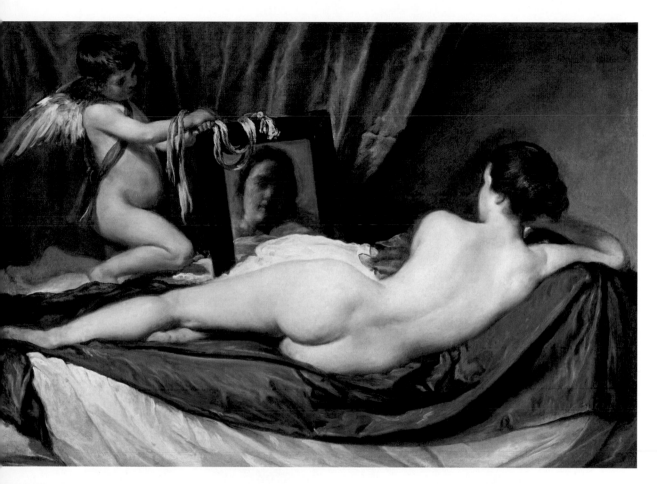

nus at her Mirror (The Rokeby Venus)

lections have always played a major role in Velázquez's
ntings. In this work, which was fiercely attacked by the
urch, Venus looks at us as much as she looks at herself
ough the mirror held by her son Cupid.

Vénus au miroir

 jeux de miroirs ont toujours joué un rôle important
s l'œuvre de Vélasquez. Dans ce tableau, violemment
qué à l'époque par l'Église, Vénus nous regarde tout en
templant son propre reflet dans le miroir – que lui tient
. fils Cupidon.

Venus mit dem Spiegel

Spiegelungen spielten in Velázquez' Bildern immer eine große
Rolle. In diesem damals von der Kirche scharf angegriffenen
Werk schaut Venus uns ebenso an wie sie sich selbst
betrachtet in dem von ihrem Sohn Amor gehaltenen Spiegel.

Venus del espejo

Las reflexiones siempre han jugado un papel importante en la
pintura de Velázquez. En esta obra, fuertemente atacada por
la Iglesia de entonces, Venus nos mira tanto como se mira a sí
misma en el espejo que sostiene su hijo Cupido.

Venere allo specchio

Le immagini riflesse hanno sempre avuto un ruolo importante
nei dipinti di Velázquez. In quest'opera, aspramente criticata
dalla Chiesa di allora, Venere ci guarda come guarda sé stessa
nello specchio tenuto da suo figlio Cupido.

Venus voor de spiegel

Spiegelbeelden hebben altijd een grote rol gespeeld in
Velázquez' schilderijen. Venus kijkt in dit werk, dat destijds
scherp werd aangevallen door de kerk, evenzeer naar ons als
naar zichzelf in de spiegel van haar zoon Amor.

GO VELÁZQUEZ (1599-1660)
7-51, Oil on canvas/Huile sur toile, 122,5 × 177 cm, The National Gallery, London

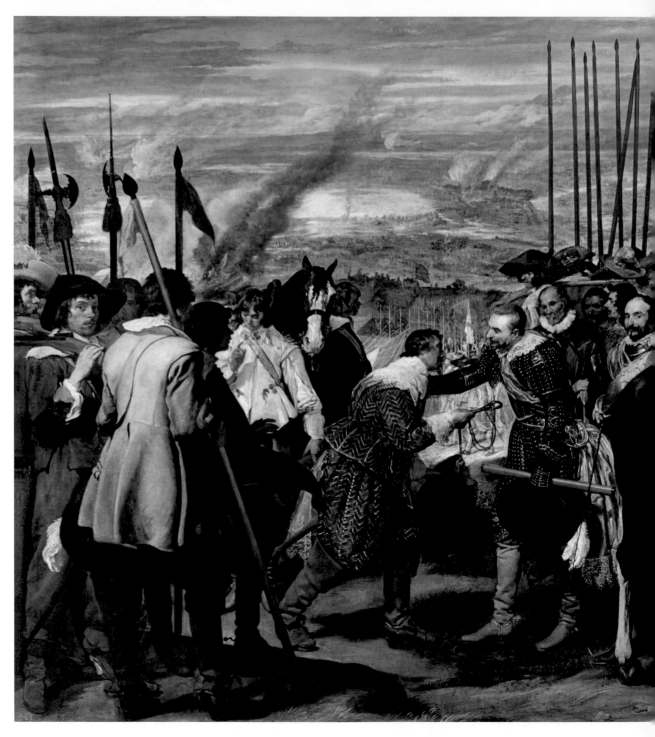

The Surrender of Breda

The capture of Breda Fortress was an important military achievement for the Spaniards after a long battle against the defeated Netherlands. This painting, made ten years later, was destined for the Buen Retiro pleasure palace.

La Reddition de Breda ou Les Lances

Pour l'Espagne, la prise de la place forte de Breda fut une victoire militaire d'une grande importance, après un long combat contre les Pays-Bas. Ce tableau, peint dix ans plus tard, était destiné au palais du Buen Retiro.

DIEGO VELÁZQUEZ (1599–1660)

c. 1635, Oil on canvas/Huile sur toile, 307 × 367 cm, Museo del Prado, Madrid

Übergabe von Breda

Für die Spanier war die Einnahme der Festung Breda eine wichtige militärische Leistung nach langem Kampf gegen die abgefallenen Niederlande. Das zehn Jahre später entstandene Bild war für das Lustschloss Buen Retiro bestimmt.

La rendición de Breda

Para los españoles, la toma de la Fortaleza de Breda fue un importante logro militar después de una larga batalla contra los caídos Países Bajos. La pintura, realizada diez años después, era para el Palacio del Buen Retiro.

Presa di Breda

Per gli spagnoli, la presa della fortezza di Breda fu un'importante conquista militare dopo una lunga battaglia contro i Paesi Bassi. Il quadro, dipinto dieci anni dopo, era destinato al Palazzo del Buen Retiro.

De overgave van Breda

Voor de Spanjaarden was de inname van de vestingstad Breda een belangrijke militaire prestatie na een lange strijd tegen het afvallige Nederland. Het schilderij, dat tien jaar later werd gemaakt, was bestemd voor het lustslot Buen Retiro.

Triumph of Bacchus

Le Triomphe de Bacchus

Triumph des Bacchus

El triunfo de Baco

Trionfo di Bacco

Triomf van Bacchus

DIEGO VELÁZQUEZ (1599-1660)
1628/29, Oil on canvas/Huile sur toile, 165 × 225 cm, Museo del Prado, Madrid

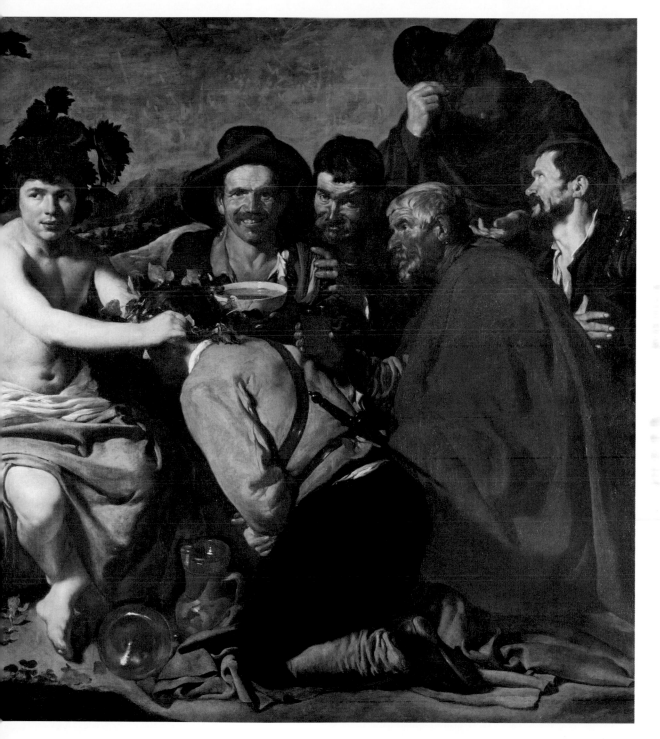

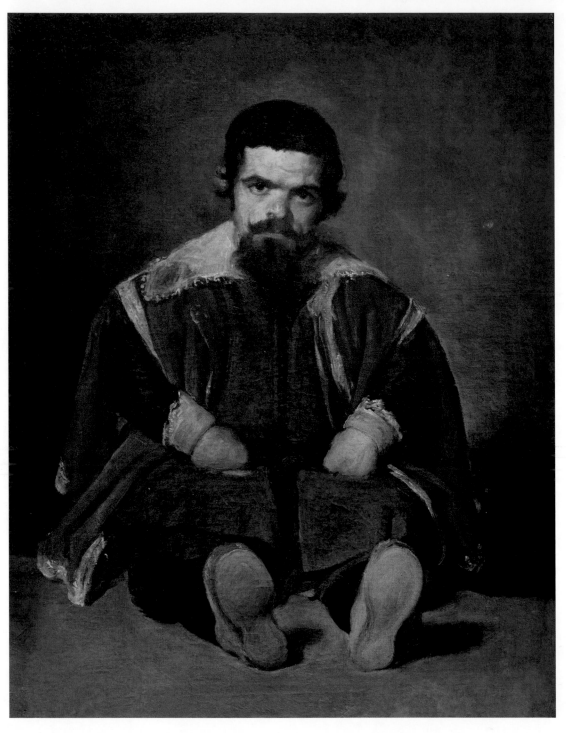

The Court Jester
Sebastián de Morra

Sebastián de Morra

Der Hofnarr
Sebastián de Morra

El bufón Sebastián
de Morra

Ritratto di Sebastiár
de Morra

De hofnar Sebastiár
de Morra

DIEGO VELÁZQUEZ
(1599–1660)

1644, Oil on canvas/Hu
sur toile, 106,5 × 82,5 cr
Museo del Prado, Madr

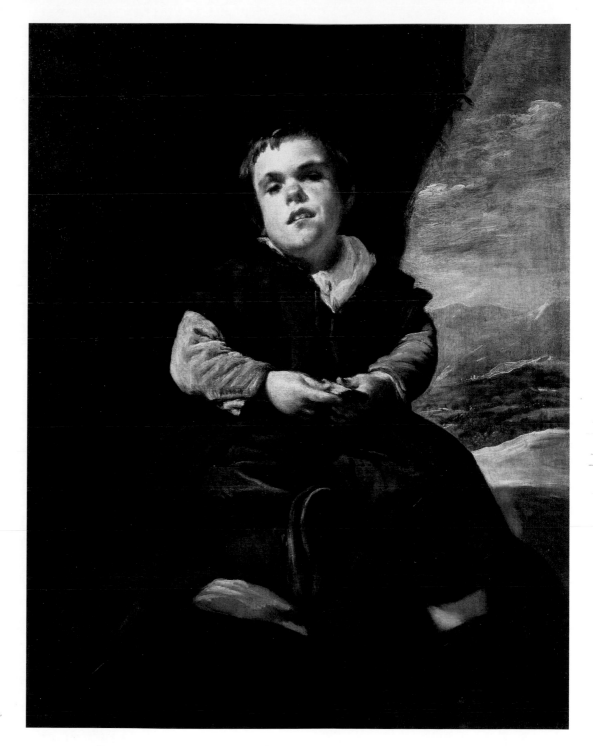

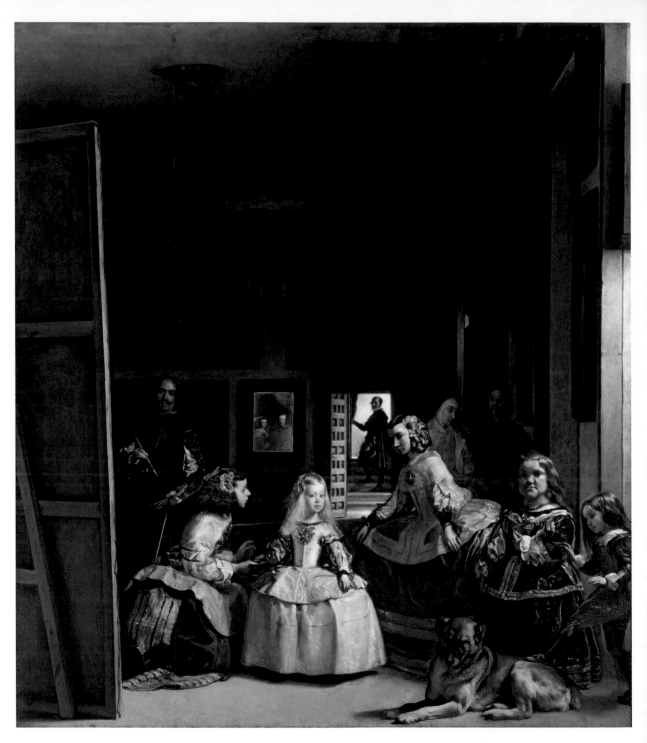

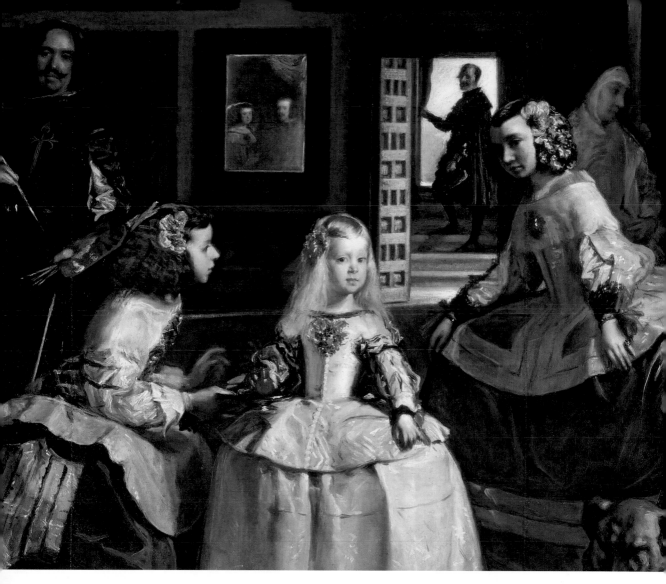

Meninas

…y work of Western art history that cleverly plays with …elationship between reality and illusion. A dense web …eanings makes the painting very complex, yet there is …ing artificial about it.

Ménines

…e œuvre phare de l'histoire des arts met en scène avec …hement un jeu extrêmement imbriqué entre illusion et …té. Malgré ses multiples niveaux de signification, elle n'a …tant en rien l'air artificiel ou factice.

Las Meninas

Ein Schlüsselwerk der Kunstgeschichte. Es spielt raffiniert mit der Wechselbeziehung zwischen Realität und Illusion. Ein dichtes Netz an Bedeutungen macht es zwar sehr komplex, aber es haftet ihm nichts Künstliches an.

Las Meninas

Una obra clave de la historia del arte. Juega inteligentemente con la interrelación entre realidad e ilusión. Una densa red de significados la hace muy compleja, pero no tiene nada de artificial.

Las Meninas

Un'opera chiave della storia dell'arte. Gioca abilmente con l'interrelazione tra realtà e illusione. Una fitta rete di significati la rende molto complessa, ma in essa non c'è nulla di artificiale.

Las Meninas

Een topstuk uit de kunsthistorie. Het speelt slim met de wisselwerking tussen realiteit en illusie. Een dicht web van betekenissen maakt het erg complex, maar er zit niets kunstmatigs aan.

…O VELÁZQUEZ (1599–1660)

Oil on canvas/Huile sur toile, 520,5 × 281,5 cm, Museo del Prado, Madrid

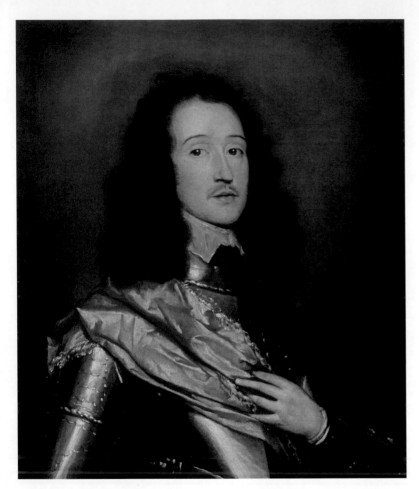

Richard Lovelace

WILLIAM DOBSON (1611–46)

c. 1645/46, Oil on canvas/Huile sur toile, 74,9 × 63,5 cm,
Dulwich Picture Gallery, London

Great Britain: The Path to the "Golden Age" of British Painting

Due to religious turmoil and civil war, the Renaissance and baroque arrived somewhat late to the British Isles. Although there were talented British baroque painters like Dobson and Wright in the 17th century, the court preferred foreign masters who were familiar with current continental trends, such as the Dutchmen Mytens and van Dyck and the German-born Lely and Kneller. In the 18th century, political consolidation and the ascendance of the House of Hanover to the throne led to an economic upswing, after which the arts flourished more consistently. Hogarth painted modern life (often satirically), and a heyday of portraiture followed shortly thereafter with painters such as Gainsborough, Reynolds (the first president of the Royal Academy of Arts, founded in 1768) and the Scotsman Ramsay—the beginning of the "golden age" of British painting.

La Grande-Bretagne : vers un « âge d'or » de la peinture britannique

Entre troubles religieux et révolution, la Renaissance et le baroque arrivèrent sur les iles britanniques avec un certain retard. Il y eut certes des peintres baroques britanniques talentueux au XVIIᵉ siècle, mais la cour leur préféra des maîtres étrangers plus familiers des tendances artistiques du continent, comme les néerlandais Mytens, van Dyck et Lely, ou encore Kneller – d'origine allemande pour sa part. Au XVIIIᵉ siècle, la consolidation politique et l'arrivée de la maison de Hanovre sur le trône entraînèrent un véritable essor économique, permettant aux arts de prospérer. Hogarth entreprit de peindre (souvent de manière satirique) la vie moderne, puis des peintres comme Gainsborough, Reynolds (premier président de la Royal Academy of Arts, créée en 1768) ou l'Écossais Ramsay apportèrent ses lettres de noblesse à l'art du portrait, marquant ainsi le début de « l'âge d'or » de la peinture britannique.

Großbritannien: Der Weg zum „goldenen Zeitalter" der britischen Malerei

Durch religiöse Wirren und Bürgerkrieg wurden Renaissance und Barock auf den britischen Inseln erst verzögert wirksam. Zwar gab es im 17. Jahrhundert begabte britische Barockmaler wie Dobson und Wright, der Hof aber bevorzugte ausländische Meister, die mit den aktuellen kontinentalen Stilströmungen vertraut waren – etwa die Niederländer Mytens und van Dyck sowie die deutschstämmigen Lely und Kneller. Im 18. Jahrhundert führten die politische Konsolidierung und die Ankunft des Hauses Hannover auf dem Thron zu wirtschaftlichem Aufschwung, weshalb die Künste nun konstanter gediehen. Hogarth malte (häufig satirisch) moderne Leben, und kurz darauf begann mit Malern wie Gainsborough, Reynolds (der erste Präsisdent der 1768 gegründeten Royal Academy of Arts) sowie dem Schotten Ramsay eine Blütezeit der Porträtkunst – der Anfang des „goldenen Zeitalters" der britischen Malerei.

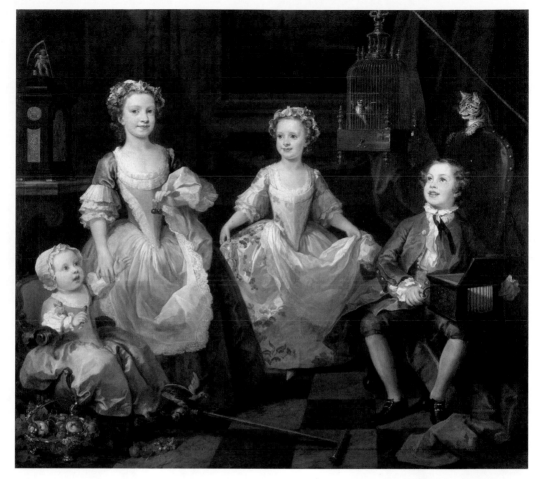

The Graham Children

Les Enfants Graham

e Kinder der Familie Graham

s niños de la familia Graham

I figli della famiglia Graham

De kinderen van de
familie Graham

WILLIAM HOGARTH (1697–1764)
1742, Oil on canvas/
Huile sur toile, 160,5 × 181 cm,
The National Gallery, London

n Bretaña: el camino hacia la
lad de Oro" de la pintura británica

ido a la confusión religiosa y a la guerra civil, el
acimiento y el Barroco se hicieron notar en las Islas
ánicas con cierta demora. Aunque en el siglo XVII
a talentosos pintores barrocos británicos como
son y Wright, la corte prefería maestros extranjeros
estuvieran familiarizados con las tendencias actuales
estilo continental, como los holandeses Mytens y van
k y los alemanes Lely y Kneller. En el siglo XVIII, la
solidación política y la llegada de la Casa de Hannover
ono condujeron a un auge económico, razón por
al las artes florecieron de manera más consistente.
arth pintó (a menudo satíricamente) la vida moderna,
co después comenzó un apogeo del arte del retrato
pintores como Gainsborough, Reynolds (el primer
idente de la Royal Academy of Arts fundada en 1768)
escocés Ramsay– el comienzo de la "Edad de Oro" de
ntura británica.

Gran Bretagna: la strada verso
"l'età dell'oro" della pittura britannica

A causa dei disordini religiosi e della guerra civile, il
Rinascimento e il Barocco nelle Isole Britanniche furono
attivi solo con un certo ritardo. Sebbene nel XVII secolo
vi fossero pittori di talento del barocco britannico come
Dobson e Wright, la corte preferì maestri stranieri che
conoscevano le attuali correnti di stile continentale, come
i Mytens e van Dyck olandesi e i Lely e Kneller, tedeschi.
Nel XVIII secolo, il consolidamento politico e l'arrivo sul
trono del Casato degli Hannover portarono ad una ripresa
economica, motivo per cui le arti fiorirono in modo più
consistente. Hogarth dipinse (spesso in modo satirico)
la vita moderna, e poco dopo un periodo di massimo
splendore dell'arte ritrattistica, iniziò con pittori come
Gainsborough, Reynolds (il primo presidente della Royal
Academy of Arts fondata nel 1768) e lo scozzese Ramsay –
l'inizio dell'"età dell'oro" della pittura britannica.

Groot-Brittannië: de weg naar de 'gouden
eeuw' van de Britse schilderkunst

Door religieuze onlusten en burgeroorlog traden de
renaissance en barok op de Britse eilanden slechts met
enige vertraging in werking. Hoewel in de 17e eeuw al
getalenteerde Britse barokschilders waren zoals Dobson
en Wright, gaf het hof de voorkeur aan buitenlandse
meesters die bekend waren met de gangbare stijlen en
stromingen van het continent – zoals de Nederlanders
Mytens en Van Dyck en de in Duitsland geboren Lely en
Kneller. In de 18e eeuw leidde de politieke consolidatie
en de troonsbestijging van het Huis van Hannover tot
een economische opleving. Hogarth schilderde (vaak
satirisch) het moderne leven, en kort daarna begon een
bloeiperiode van de portretschilderkunst met schilders
als Gainsborough, Reynolds (de eerste voorzitter van de
in 1768 opgerichte Royal Academy of Arts) en de Schot
Ramsay – het begin van de 'gouden eeuw' van de Britse
schilderkunst.

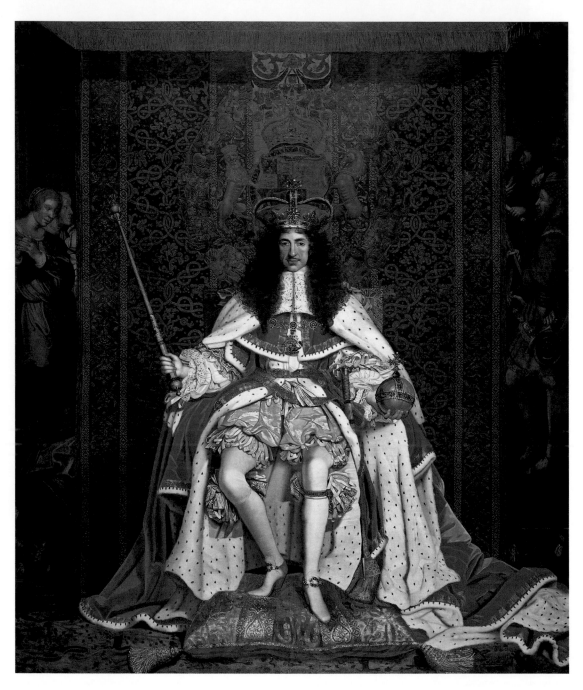

Charles II

Charles II, roi
d'Angleterre,
en habits de
couronnement

Charles II.

Carlos II.

Carlo II

Karel II

**JOHN MICHAEL
WRIGHT (1617–94)**
c. 1671–76, Oil on
canvas/Huile sur toil
281,9 × 239,2 cm, Ro
Collection, London

Endymion Porter

William Dobson, one of the first well-
known portraitists in the country, painted
many of Charles I's followers during
the English Civil War. This portrait
of a courtier was painted at the Exile
Court in Oxford.

Endymion Porter

William Dobson, l'un des portraitistes
les plus renommés du pays, peignit
pendant la première révolution anglaise
de nombreux partisans de Charles Ier. Ce
portrait, celui d'un courtisan, fut réalisé à
Oxford lorsque la cour y était en exil.

Endymion Porter

William Dobson, einer der ersten
namhaften Porträtisten des Landes, malte
während des englischen Bürgerkriegs
viele Anhänger von Charles I. Dieses
Bildnis eines Höflings entstand am
Exilhof in Oxford.

Endymion Porter

William Dobson, uno de los primeros
retratistas conocidos en el país, pintó a
muchos seguidores de Carlos I durante
la Guerra Civil Inglesa, este retrato de
un cortesano fue pintado en la Corte del
Exilio en Oxford.

Endymion Porter

William Dobson, uno dei primi noti
ritrattisti del paese, durante la guerra
civile inglese dipinse molti seguaci di
Carlo I. Questo ritratto di un cortigiano fu
dipinto alla Corte di Oxford.

Endymion Porter

William Dobson, een van de eerste
bekende portretschilders van het land,
schilderde tijdens de Engelse burgeroorlog
veel aanhangers van Karel I. Dit portret
van een hoveling werd geschilderd aan het
hof in ballingschap in Oxford.

WILLIAM DOBSON (1611–46)

c. 1642–45, Oil on canvas/Huile sur toile,
149,9 × 127 cm, Tate Britain, London

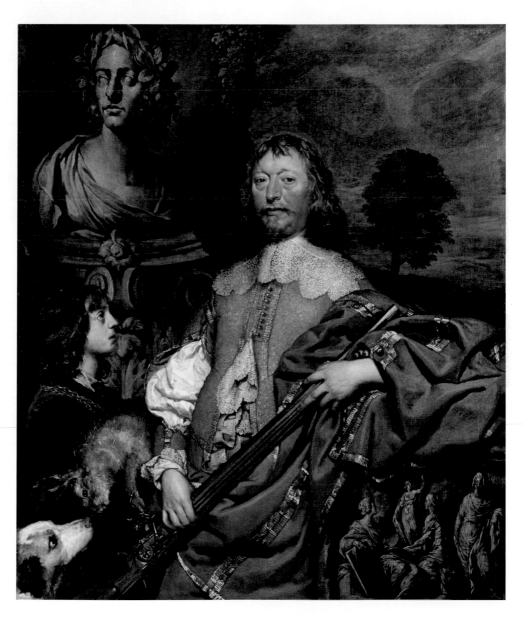

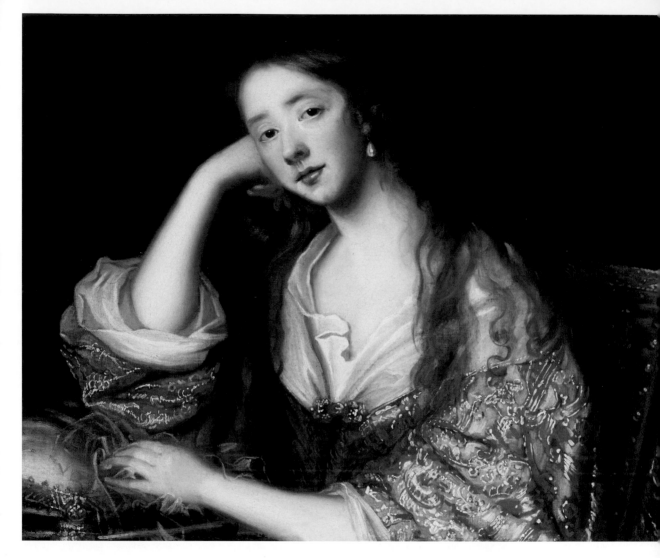

Lady Joanna Thornelow

After a long time abroad, especially in Italy, Wright returned to England, where he painted highly realistic portraits of royalty and nobility, ultimately becoming court painter to Kings Charles II and James II.

Lady Joanna Thornelow

Après avoir longtemps voyagé, notamment en Italie, Wright rentra en Angleterre où il devint peintre à la cour de Charles II et de James II, réalisant des portraits très réalistes des membres de la maison royale et de la noblesse.

JOHN MICHAEL WRIGHT (1617–94)
p. 1656, Oil on canvas/Huile sur toile, 63 × 75 cm, Private collection

Lady Joanna Thornelow

Nach langer Zeit vor allem in Italien kehrte Wright nach England zurück, wo er Mitglieder des Königshauses und Adels sehr realistisch porträtierte und Hofmaler der Könige Charles II. und James II. wurde.

Lady Joanna Thornelow

Después de mucho tiempo fuera, especialmente en Italia, Wright regresó a Inglaterra, donde pintó retratos muy realistas de la realeza y la nobleza y se convirtió en pintor de la corte de los reyes Carlos II y Jaime II.

Lady Joanna Thornelow

Dopo molto tempo trascorso soprattutto in Italia, Wright tornò in Inghilterra, dove dipinse ritratti molto realistici di regnanti e della nobiltà, e dove divenne pittore di corte per re Carlo II e Giacomo II.

Lady Joanna Thornelow

Na lange tijd, vooral in Italië, keerde Wright terug naar Engeland, waar hij zeer realistische portretten van de koning en adel schilderde en hofschilder werd van de vorsten Karel en Jacobus II.

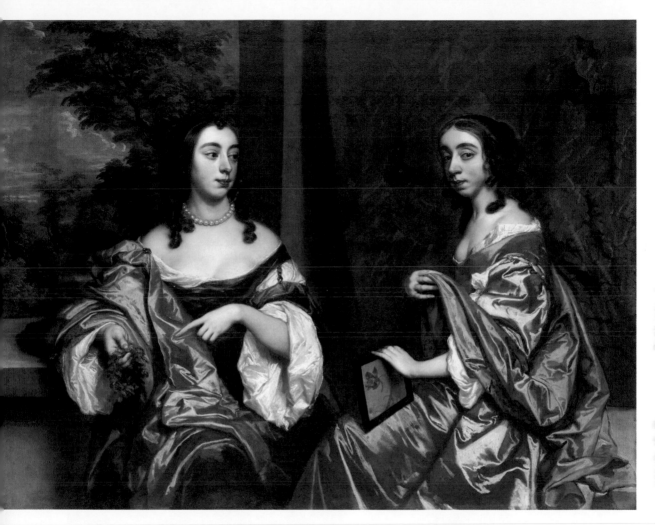

...ry Capel and her sister Elizabeth, Countess of Carnarvon

...y became England's leading portraitist after van Dyck,
...ose influence is unmistakable. With the help of a large
...rkshop, Lely made numerous portraits of members of the
...ish court and high nobility.

...trait de Mary Capel, plus tard duchesse de Beaufort,
...a sœur Elizabeth, comtesse de Carnarvon

...y devint le portraitiste à la mode en Angleterre après la
...rt de van Dyck, dont l'influence sur son propre travail
...te indéniable. Son grand atelier lui permit de réaliser
...nombreux portraits des membres de la cour et de la
...te noblesse.

Mary Capel und ihre Schwester
Elizabeth, Gräfin von Carnarvon

Lely folgte als führender Porträtist Englands auf van Dyck,
dessen Einfluss unverkennbar ist. Mithilfe einer großen
Werkstatt entstanden zahlreiche Porträts von Angehörigen
des britischen Hofes und Hochadels.

Mary Capel y su hermana Isabel, Condesa de Carnarvon

Lely siguió a van Dyck como el mejor retratista de Inglaterra,
cuya influencia es inconfundible. Con la ayuda de un gran
taller, se crearon numerosos retratos de miembros de la corte
británica y de la alta nobleza.

Mary Capel e sua sorella Elisabetta, contessa del Carnarvon

Lely seguì a van Dyck come primo ritrattista in Inghilterra,
la cui influenza è evidente. Con l'aiuto di un'ampia bottega,
sono stati realizzati numerosi ritratti di membri della corte
britannica e dell'alta nobiltà.

Mary Capel en haar zus Elizabeth, gravin van Carnarvon

Lely volgde Van Dyck, wiens invloed onmiskenbaar is, op
als dé portrettist van Engeland. Met de hulp van zijn grote
werkplaats maakte hij talrijke portretten van leden van het
Britse hof en de hoge adel.

PETER LELY (1618-80)

...0-60, Oil on canvas/Huile sur toile, 130,2 × 170,2 cm, Metropolitan Museum of Art, New York

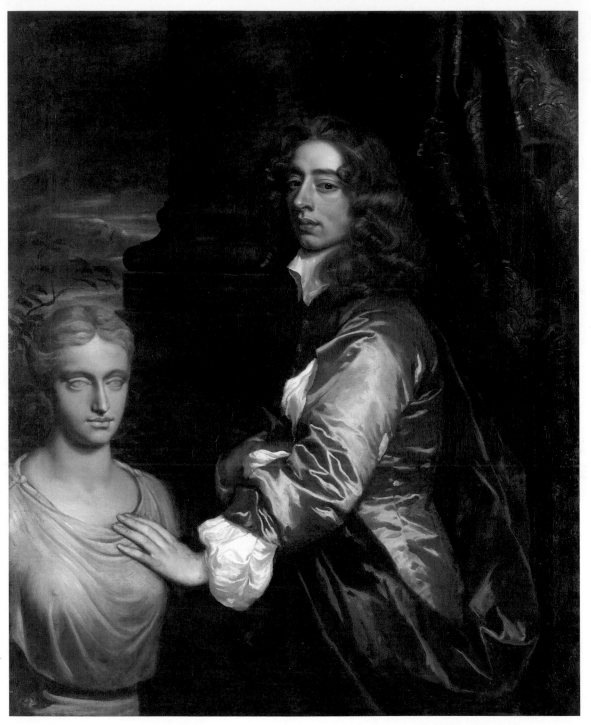

Sir Henry Ca

SIR PETER LEL
(1618–80)

c. 1660, Oil
on canvas/
Huile sur toile,
126,4 × 102,9 cr
Metropolitan
Museum, New

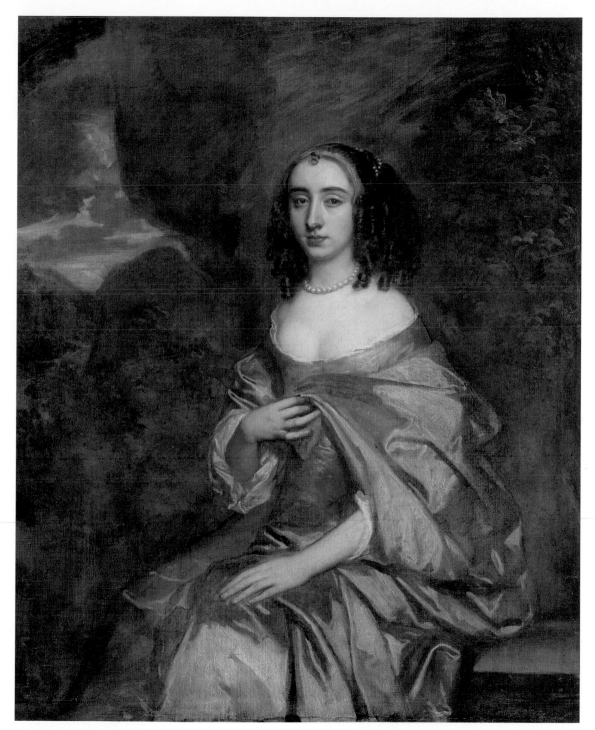

Portrait of a Lady
with Blue Drape

Portrait d'une
femme au
châle bleu

Porträt einer
Dame mit
blauem Tuch

Retrato de una
dama con un
vestido azul

Ritratto di donna
con telo blu

Portret van
een dame met
blauwe draperie

SIR PETER LELY
(1618–80)

c. 1660, Oil
on canvas/
Huile sur toile,
126,7 × 102,5 cm,
Dulwich Picture
Gallery, London

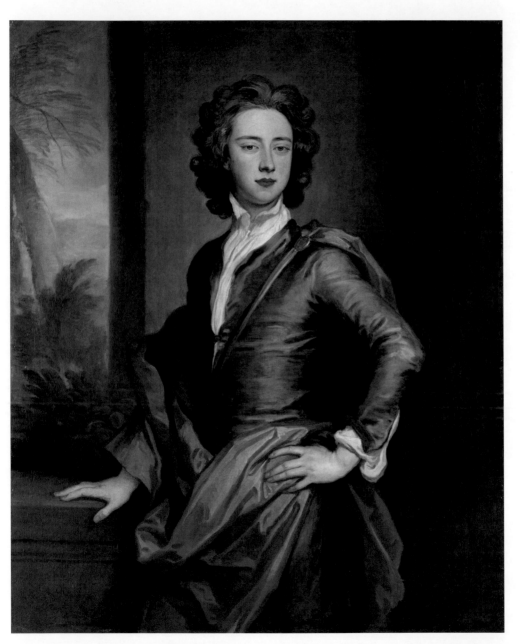

Charles Beauclerk, Duke of St Alban
Kneller succeeded Lely as court painte
Born in Lübeck, he studied in Leiden
and Amsterdam (with Rembrandt,
among others) and travelled to Italy.
The sitter here is an illegitimate son
of Charles II.

**Charles Beauclerk,
1ᵉʳ duc de Saint-Albans**
Kneller succéda à Lely à la cour. Né
à Lübeck, il avait étudié à Leyde et
à Amsterdam (y compris auprès de
Rembrandt), puis voyagé en Italie.
Charles Beauclerk était un fils illégitir
de Charles II.

**Charles Beauclerk, Herzog
von St Albans**
Kneller folgte Lely als Hofmaler nach.
Der gebürtige Lübecker hatte in Leide
sowie Amsterdam (auch bei Rembrar
gelernt und Italien bereist. Der
Porträtierte war ein unehelicher Sohr
von Charles II.

Charles Beauclerk, Duque de St Alb
Kneller siguió a Lely como pintor de
la corte. Nacido en Lübeck, estudió
en Leiden y Amsterdam (también con
Rembrandt) y viajó a Italia. La person
retratada era hijo ilegítimo de Carlos

Charles Beauclerk, duca di Sant'Alb
Kneller seguì a Lely come pittore di
corte. Nato a Lubecca, studiò a Leida
ad Amsterdam (anche da Rembrandt
e si recò in Italia. Il soggetto ritratto e
un figlio illegittimo di Carlo II.

**Charles Beauclerk, hertog
van St Albans**
Kneller volgde Lely op als hofschilder
De in Lübeck geboren schilder
studeerde in Leiden en Amsterdam (
bij Rembrandt) en reisde naar Italië.
geportretteerde was een onwettige zo
van Karel II.

SIR GODFREY KNELLER (1646–1723)
c. 1690–95, Oil on canvas/Huile sur
toile, 126,7 × 102,9 cm, Metropolitan
Museum of Art, New York

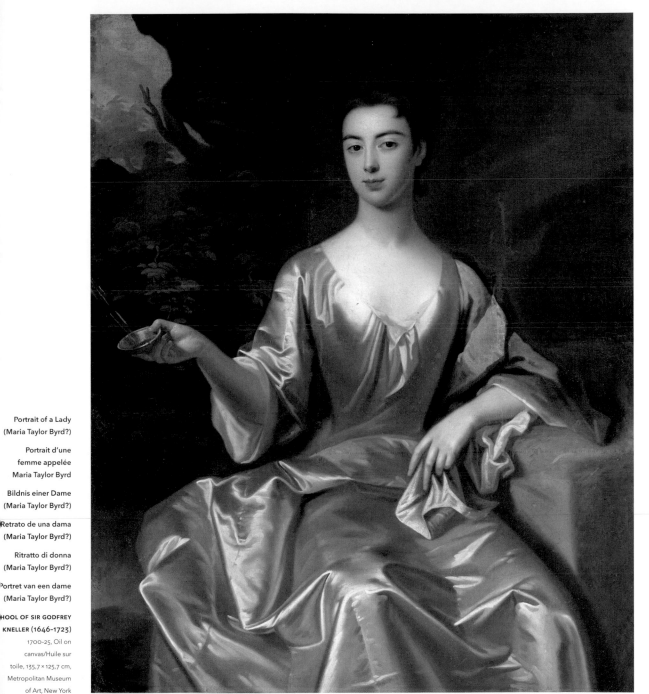

Portrait of a Lady
(Maria Taylor Byrd?)

Portrait d'une
femme appelée
Maria Taylor Byrd

Bildnis einer Dame
(Maria Taylor Byrd?)

Retrato de una dama
(Maria Taylor Byrd?)

Ritratto di donna
(Maria Taylor Byrd?)

Portret van een dame
(Maria Taylor Byrd?)

**SCHOOL OF SIR GODFREY
KNELLER (1646-1723)**
1700-25, Oil on
canvas/Huile sur
toile, 135,7 × 125,7 cm,
Metropolitan Museum
of Art, New York

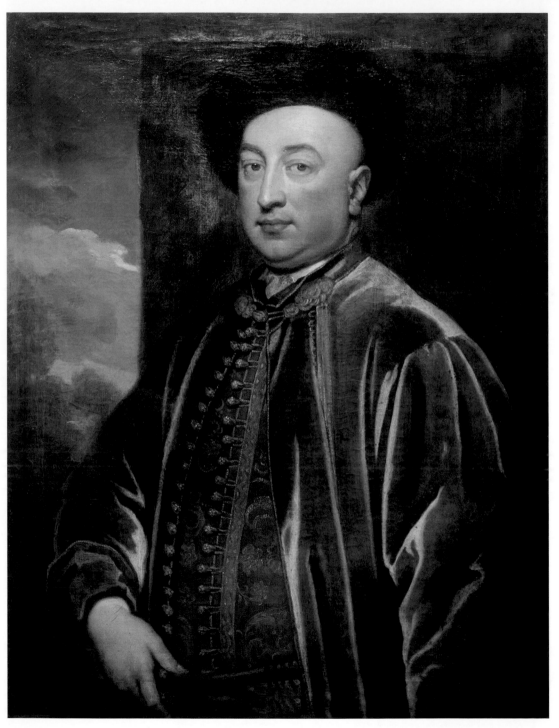

Ludwig Maximilian
Mehmet von Königst

SIR GODFREY KNELLER
(1646–1723)

1714, Oil on canvas/
Huile sur toile, 92 × 71 cm
Kloster Barsinghausen,
Barsinghausen

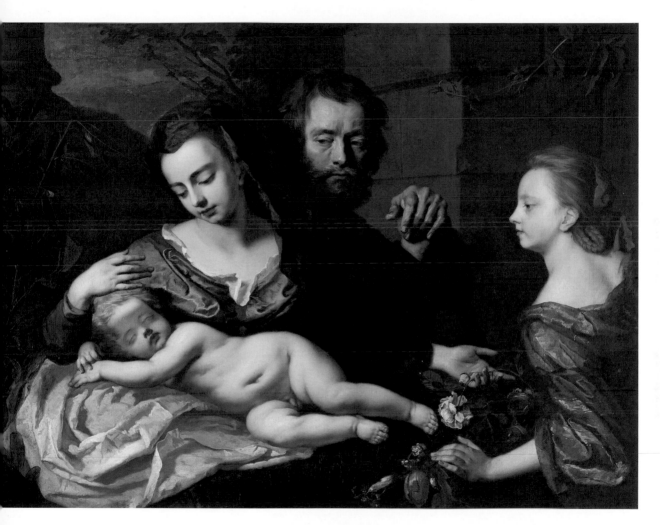

The Holy Family

Sainte Famille

Heilige Familie

Sagrada Familia

Sacra Famiglia

Heilige Familie

MICHAEL DAHL (1659–1743)

1, Oil on canvas/Huile sur toile, 103 × 138 cm, Nationalmuseum, Stockholm

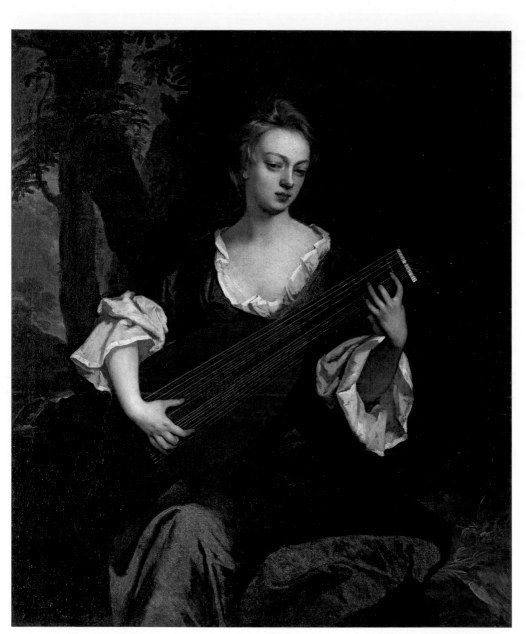

Françoise Leijoncrona

The Swedish portraitist Dahl worked in London, but also travelled to Paris and Rome. He painted members of the royal house and the high nobility; the sitter here is the wife of the Swedish envoy.

Françoise Leijoncrona

Ce portraitiste suédois travaillait à Londres, mais voyagea également à Paris et à Rome. Il peignit les membre de la maison royale et de la haute noblesse ; on voit ici la femme de l'ambassadeur suédois.

Françoise Leijoncrona

Der schwedische Porträtmaler Dahl arbeitete in London, reiste aber ebenso nach Paris und Rom. Er malte Mitglieder des Königshauses und des Hochadels; die Dargestellte war die Frau des schwedischen Gesandten.

Françoise Leijoncrona

El retratista sueco Dahl trabajó en Londres, pero también viajó a París y Roma. Pintó a miembros de la casa real y de la alta nobleza; la mujer representada era la esposa del enviado sueco.

Françoise Leijoncrona

Il pittore ritrattista svedese Dahl ha lavorato a Londra, ma si è anche reca a Parigi e a Roma. Dipingeva membr della casa reale e dell'alta nobiltà; la donna raffigurata era la moglie dell'emissario svedese.

Françoise Leijoncrona

De Zweedse portretschilder Dahl werkte in Londen, maar reisde ook naar Parijs en Rome. Hij schilderde leden van het koninklijk huis en de hoge adel; de geportretteerde was de echtgenote van de Zweedse gezant.

MICHAEL DAHL (1659–1743)

c. 1700, Oil on canvas/
Huile sur toile, 128,5 × 107,5 cm,
Nationalmuseum, Stockholm

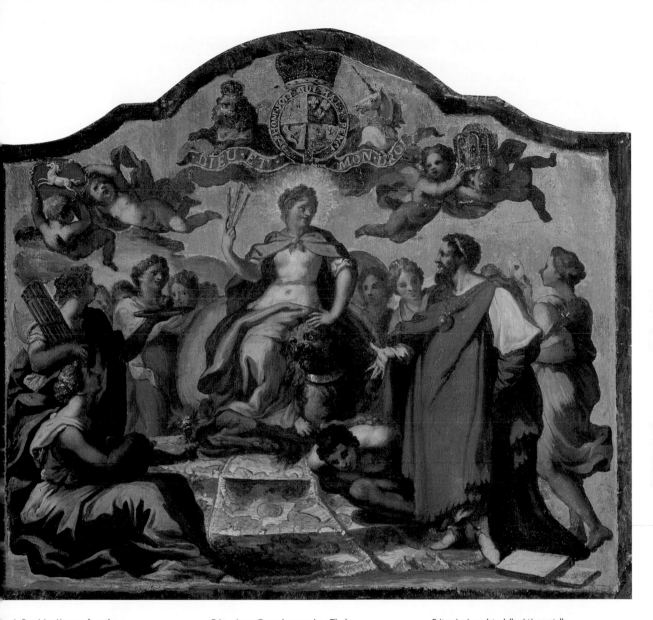

annia Receiving Homage from the
tinents, panel for a royal stage coach

annia intrônisée, entourée de la Concorde, le
oir et la Religion triomphant du vice. Décor
a porte du carosse royal de George I^{er}

Britannia von Tugenden umgeben, Tür der
Staatskarosse von König George I

Britania rodeada de virtudes, puerta de la
carrocería del estado del Rey Jorge I

Britannia circondata dalle virtù, sportello
della carrozza di stato del re Giorgio I

Britannia omgeven door deugden, deur van
de staatskoets van koning George I

MAMES THORNHILL (1675–1734)

8, Oil on wood/Huile sur bois, 54 × 60,2 cm, Victoria and Albert Museum, London

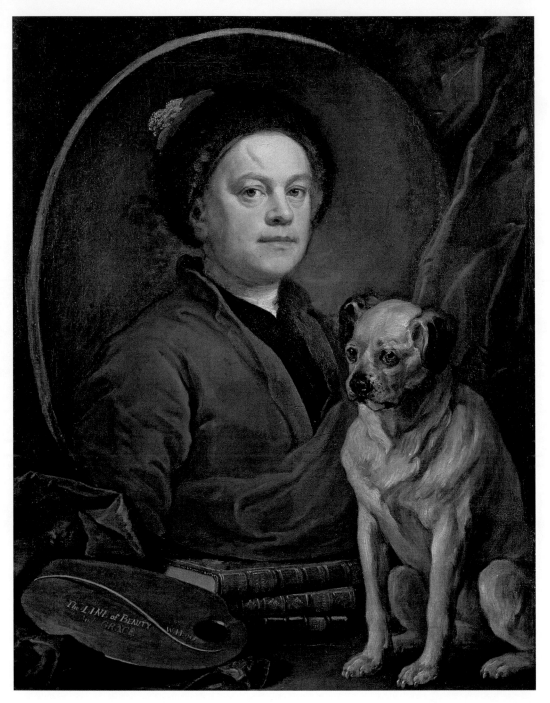

The Painter and His Pug

Self-portrait with an agenda: the authors of the books inspired Hogarth's paintings, the "line of beauty" on the palette refers to his theory of art, and the pug to his combative character.

Le Peintre et son chien

Un autoportrait programmatique : les auteurs des livres présentés inspiraient sa peinture, la « ligne de beaut[é] sur la palette fait référence à sa théorie artistique et le chien à son caractère tenace.

Der Maler und sein Mops

Selbstbildnis mit Programm: Die Autoren der Bücher inspirierten Hogarths Bilder, [d]ie „Schönheitslinie" auf der Pale[tte] verweist auf seine Kunsttheor[ie] und der Mops auf seinen kampflustigen Charakter.

El pintor y su doguillo

Autorretrato con programa: los autores de los libros inspiraron las pinturas de Hogarth, la "línea de belleza" en la paleta se refiere a su teoría del arte y el doguillo a s[u] carácter combativo.

Il pittore e la sua carlino

Autoritratto con programma: gli autori dei libri hanno ispirato i dipinti di Hogarth, la "linea di bellezza" sulla tavolozza fa riferimento alla s[ua] teoria dell'arte e il carlino al s[uo] carattere combattivo.

De schilder en zijn mopshon[d]

Zelfportret met programma: de auteurs van de boeken inspireerden Hogarths schilderijen, de 'schoonheidsl[ijn] op het palet verwijst naar zij[n] kunsttheorie en de mopshond[e] naar zijn strijdlustige karakte[r]

WILLIAM HOGARTH (1697–176[4])
1735–45, Oil on canvas/
Huile sur toile, 90 × 69,9 cm,
Tate Britain, London

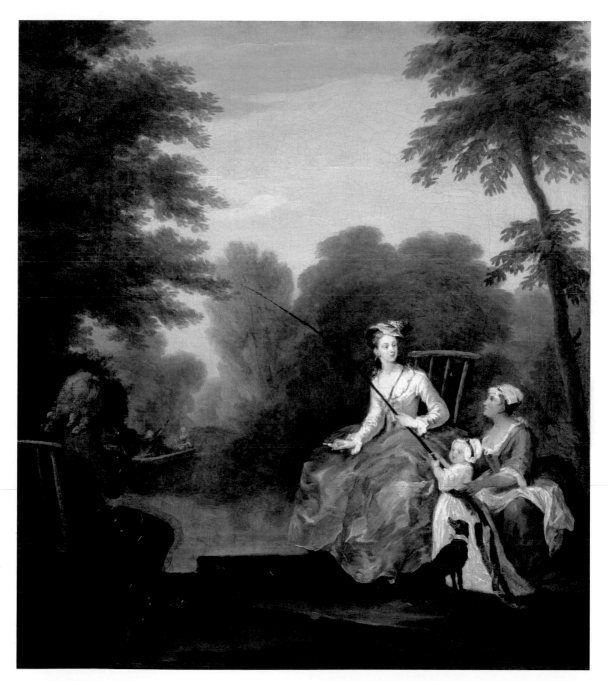

The Fishing
Party

Partie de
pôche

Eine
Angelpartie

Un juego
partida de
pesca

La pesca

Een
hengelfeestje

**WILLIAM
HOGARTH
(1697–1764)**
c. 1730/31, Oil
on canvas/
Huile sur toile,
9 × 48,1 cm cm,
Dulwich Picture
Gallery, London

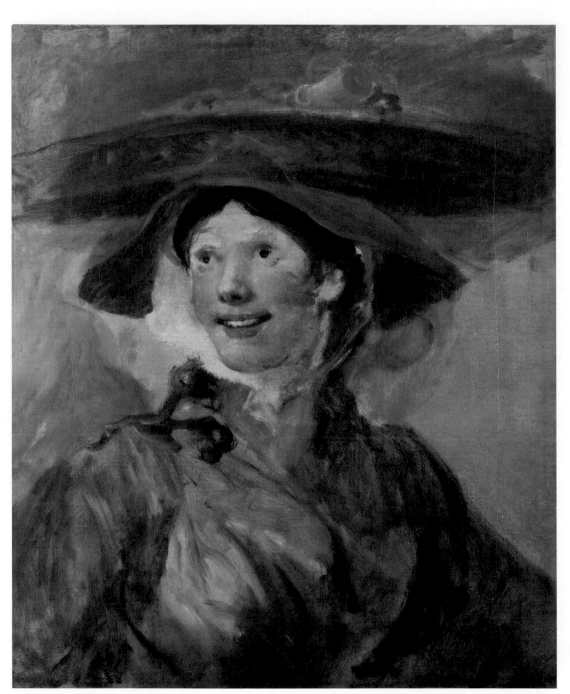

The Shrimp Girl

La Marchande
de crevettes

Das Krabbbenmädch

La vendedora de
camarones

Venditrice di gamber

De garnalenverkoops

**WILLIAM HOGARTH
(1697-1764)**
c. 1740-45, Oil on
canvas/Huile sur toile,
63,5 × 52,5 cm, The
National Gallery, London

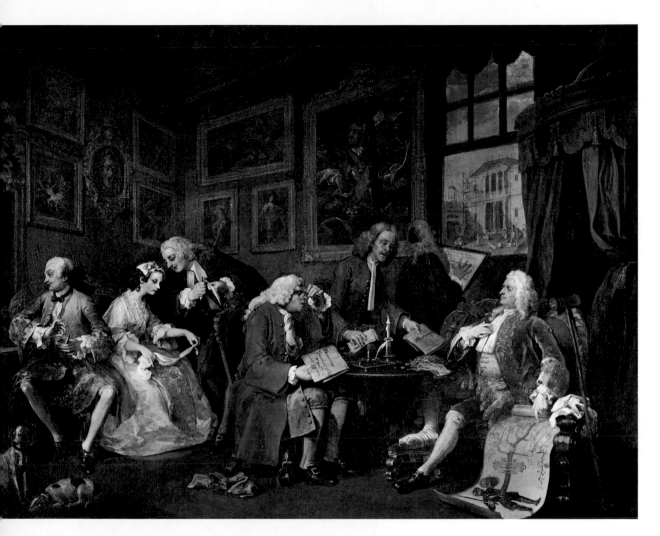

Marriage à la mode, picture 1: The Marriage Settlement
Hogarth portrayed "modern moral themes" in satirical series—like the disastrous marriage of a poor nobleman a rich bourgeoise. Engravings of these series spread all cross Europe.

Mariage à la mode, 1. « Le contrat de mariage »
Hogarth utilisait les « sujets moraux modernes » pour en re des séries de tableaux ; ici, on voit le mariage désastreux tre un jeune noble ruiné et la fille d'un riche bourgeois. s séries inspirèrent des gravures qui se répandirent dans te l'Europe.

Marriage à la mode, Bild 1: Der Ehevertrag
Hogarth setzte „moderne moralische Themen" in satirischen Serien ins Bild – wie die desaströse Ehe eines armen Adligen mit einer reichen Bürgerstochter. Stichfolgen nach diesen Serien waren in ganz Europa verbreitet.

Matrimonio a la moda, foto 1: El contrato matrimonial
Hogarth retrató "temas morales modernos" en series satíricas, como el desastroso matrimonio de un pobre noble con una rica hija burguesa. Secuencias basándose en estas series se extendieron por toda Europa.

Matrimonio à la mode, figura 1: accordo
Hogarth ritraeva "temi morali moderni" in serie satiriche – come il disastroso matrimonio di un povero nobile con una ricca figlia borghese. Serie di ritratti dopo queste erano diffuse in tutta Europa.

Marriage à la mode, schilderij 1: De huwelijksvoltrekking
Hogarth portretteerde "moderne morele thema's" in satirische reeksen, zoals het rampzalige huwelijk van een arme edelman met een rijke burgerdochter. Etsenseries naar deze reeks waren wijdverbreid in heel Europa.

ILLIAM HOGARTH (1697-1764)
743, Oil on canvas/Huile sur toile, 69,9 × 90,8 cm, The National Gallery, London

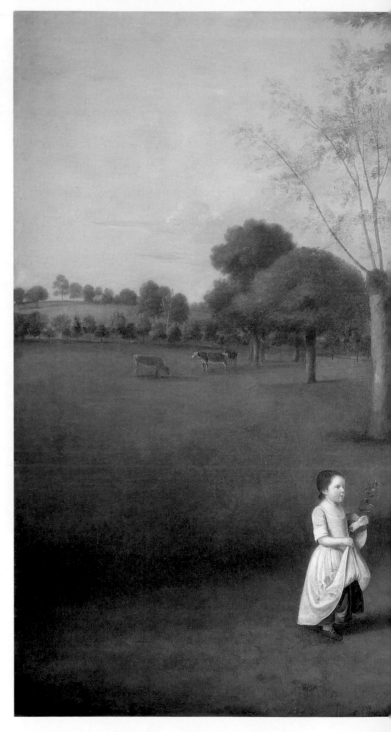

Members of the Maynard Family in the Park at Waltons

Membres de la famille Maynard au parc à Walton

Mitglieder der Familie Maynard im Park von Waltons

Miembros de la familia Maynard en Waltons Park

Membri della famiglia Maynard nel parco Waltons

Leden van de familie Maynard in het park van Waltons

ARTHUR DEVIS (1712–87)

c. 1755-62, Oil on canvas/Huile sur toile, 138,5 × 195,6 cm,
National Gallery of Art, Washington, D.C.

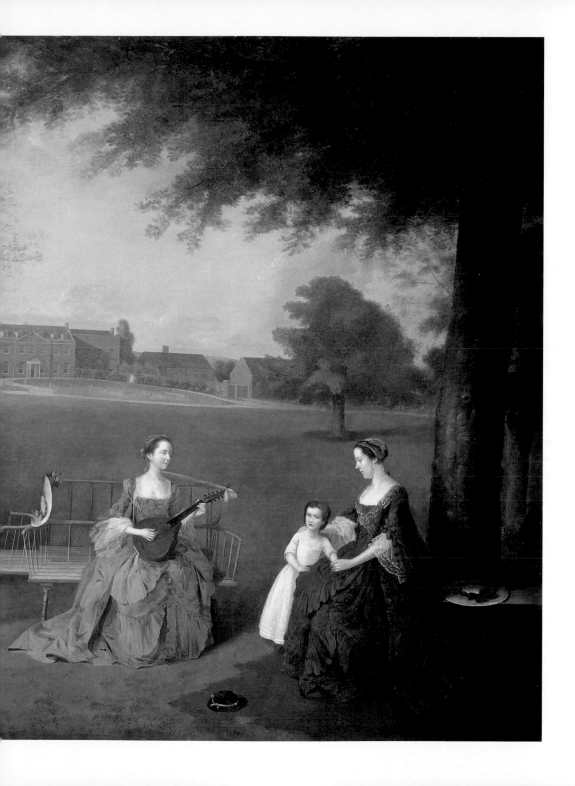

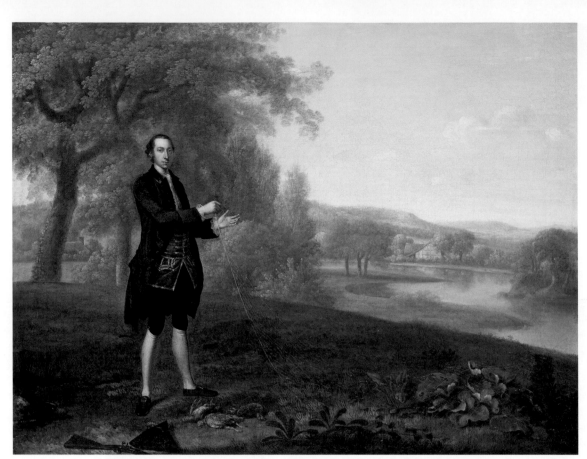

Arthur Holdsworth Conversing with Thomas Taylor
and Captain Stancombe by the River Dart
Painters like Devis served the great demand for portraits
of landowners and middle-class merchants. Depictions of
informal outdoor gatherings like this belong to the genre of
the "conversation piece".

Arthur Holdsworth conversant avec Thomas Taylor
et le capitaine Stancombe près de la rivière Dart
Les peintres comme Devis pourvoyaient à la forte demande de
portraits parmi les propriétaires et les marchands de la classe
moyenne. Les conversations informelles en plein air, comme
celle-ci, appartenaient au genre des Conversation Pieces.

Arthur Holdsworth im Gespräch mit Thomas
Taylor und Captain Stancombe am Fluss Dart
Maler wie Devis bedienten die große Nachfrage nach
Porträts durch Landbesitzer und Kaufleute der Mittelschicht.
Zwanglose Gespräch im Freien wie dieses gehörten zur
Bildgattung des Conversation Piece.

Arthur Holdsworth en conversación con Thomas
Taylor y el Capitán Stancombe en el River Dart
Pintores como Devis sirvieron a la gran demanda de retratos
por parte de terratenientes y comerciantes de clase media. Las
conversaciones informales al aire libre como ésta eran parte
del género de imagen de la Conversation Piece.

Arthur Holdsworth in conversazione con Thom
Taylor e il capitano Stancombe sul fiume D
Pittori come Devis sopperivano alla grande richiesta di ritr
da parte di proprietari terrieri e dei commercianti d
classe media. Conversazioni informali all'aperto come que
facevano parte del genere di ritratto della Conversation Pie

Arthur Holdsworth in gesprek met Thom
Taylor en kapitein Stancombe aan de D
Schilders als Devis voorzagen in de grote vraag naar portret
van grondbezitters en kooplieden uit de middenkla
Informele gesprekken buiten zoals hier behoorden tot
genre van de conversation pie

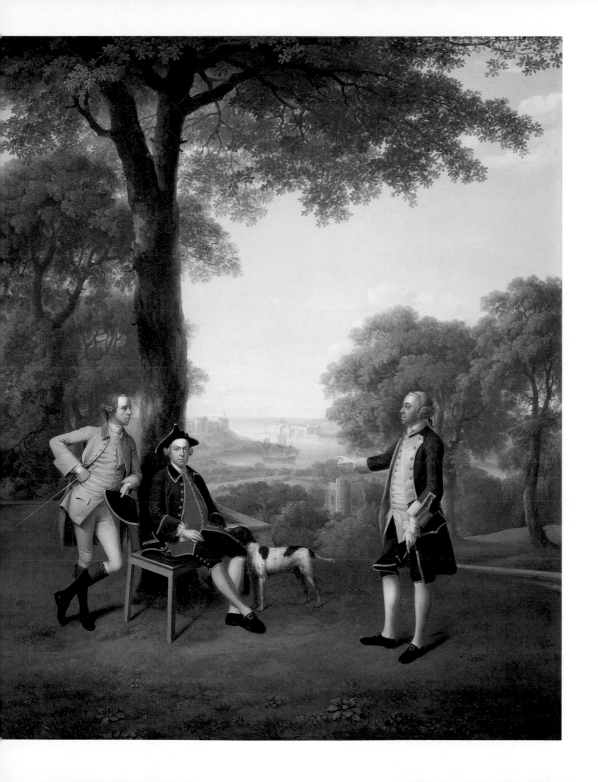

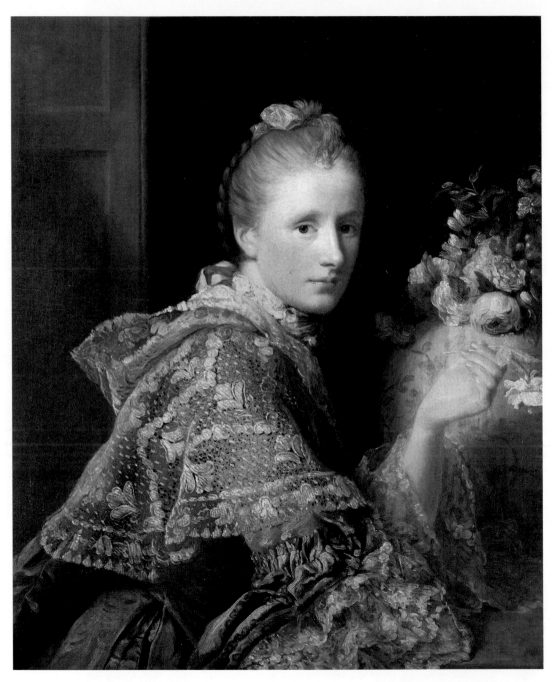

The Artist's Wife: Margar[et]
Lindsay of Evelick

Portrait de Margaret
Lindsay of Evelick,
femme du peintre

Margaret Lindsay
of Evelick, die Frau
des Künstlers

Margaret Lindsay de
Evelick, la esposa del art[ista]

Margaret Lindsay di
Evelick, moglie dell'artist[a]

Margaret Lindsay of Evel[ick]
de vrouw van de kunsten[aar]

ALLAN RAMSAY (1713–84)
1758–60, Oil on canvas/Huile [sur]
toile, 74,3 × 61,9 cm,
Scottish National Portrait
Gallery, Edinburgh

David Hume, Historian and Philosopher
The Scotsman Ramsay enjoyed success in London with his excellent portraits and became court painter to George III. He often returned to Edinburgh, where he painted prominent nobles and intellectuals.

Portrait de l'historien et philosophe David Hume
Originaire d'Écosse, Ramsay rencontra le succès à Londres avec ses portraits mêlant talent et originalité, et devint peintre à la cour de George III. Il rentrait régulièrement à Édimbourg, où il peignait les grands esprits et les nobles.

David Hume, Historiker und Philosoph
Der Schotte Ramsay feierte mit seinen vorzüglichen und individuellen Porträts in London Erfolge und wurde Hofmaler von George III. Häufig kehrte er nach Edinburgh zurück, wo er Geistesgrößen und Adlige malte.

David Hume, historiador y filósofo
El escocés Ramsay celebró el éxito en Londres con sus excelentes retratos individuales y se convirtió en pintor de la corte de Jorge III. A menudo regresaba a Edimburgo, donde pintaba grandes mentes y nobles.

David Hume, storico e filosofo
Lo scozzese Ramsay celebrò il suo trionfo a Londra con gli eccellenti e individuali ritratti e divenne pittore di corte di Giorgio III. Tornò spesso a Edimburgo, dove dipinse intellettuali e nobili.

David Hume, historicus en filosoof
De Schot Ramsay was in Londen zeer succesvol met zijn uitstekende en individuele portretten en werd hofschilder van George III. Hij keerde vaak terug naar Edinburgh, waar hij grote geesten en edelen schilderde.

ALLAN RAMSAY (1713–84)
1766, Oil on canvas/Huile sur toile, 76,2 × 63,5 cm, Scottish National Portrait Gallery, Edinburgh

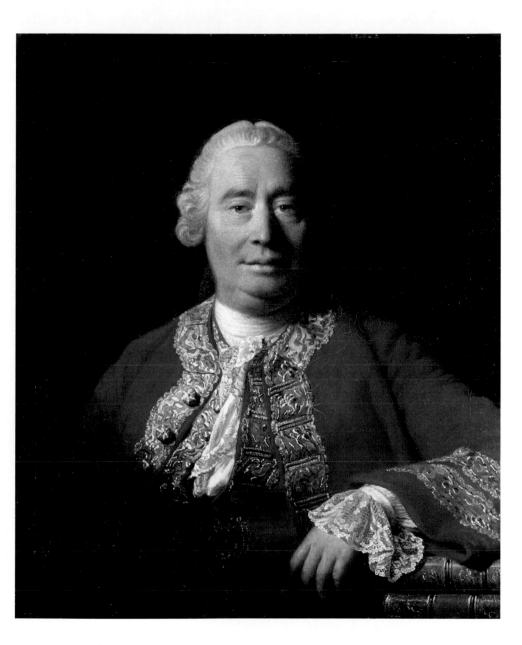

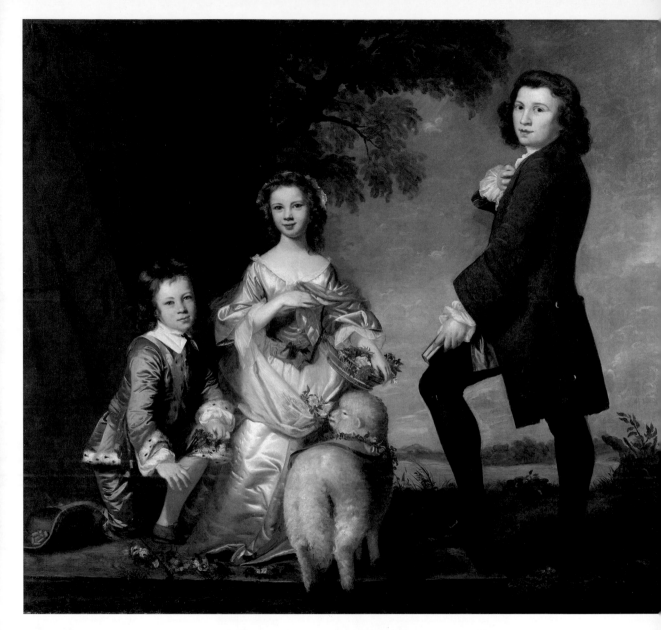

Thomas and Martha Neate with
His Tutor, Thomas Needham

Portrait de Thomas et Martha Neat
avec leur tuteur Thomas Needham

Thomas und Martha Neate mit
dem Tutor Thomas Needham

Thomas y Martha Neate con
el tutor Thomas Needham

Thomas e Martha Neate
con Thomas Needham

Thomas en Martha Neate met
tutor Thomas Needham

SIR JOSHUA REYNOLDS (1723–92)

1748, Oil on canvas/Huile sur toile, 168 × 180,3 cm, Metropolitan Museum of Art, New York

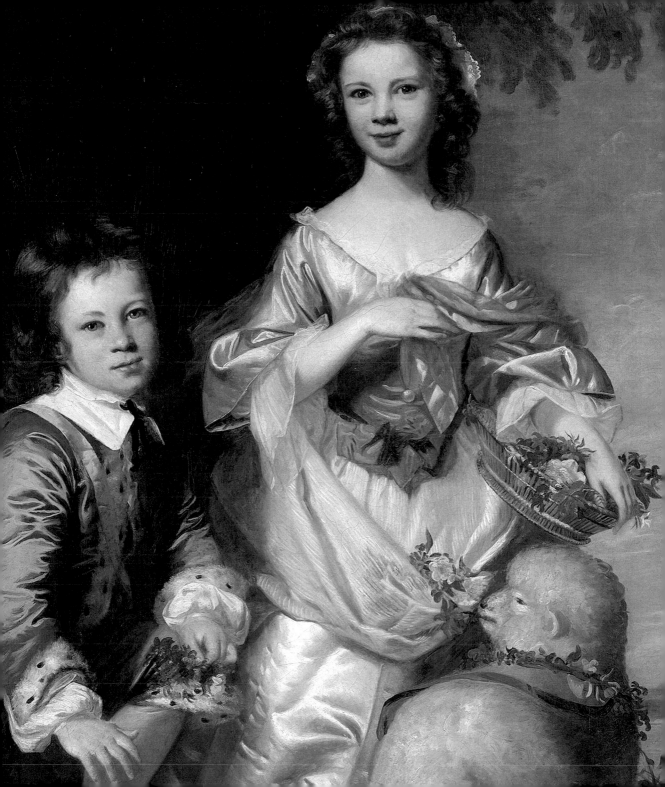

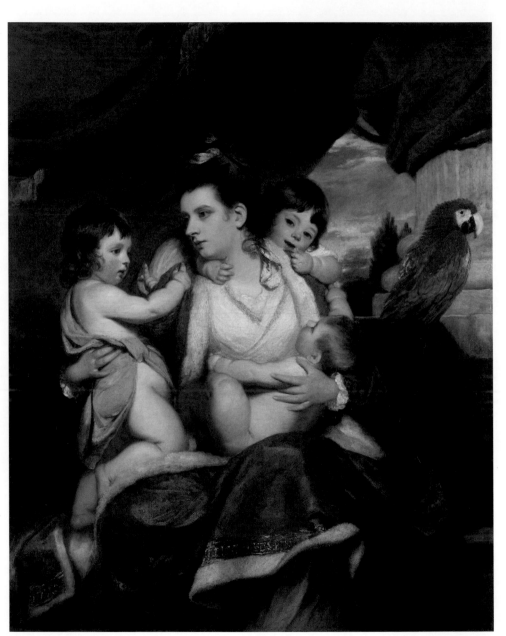

Lady Cockburn and Her Three Eldest Sons

Reynolds cultivated a learned and idealizing style of painting based on antiq and Renaissance models (which he calle the "Grand Manner"). This composition, however, is based on works by van Dyck and Velázquez.

Portrait de Lady Cockburn et ses trois fils aînés

Reynolds cultivait un style érudit et idéalisé, dans la lignée des maîtres de l'Antiquité et de la Renaissance, qu'il qualifiait de « Grand Manner ». Cette composition fait référence aux œuvres d van Dyck et de Vélasquez.

Lady Cockburn und ihre drei ältesten Söhne

Reynolds pflegte einen gelehrten und idealisierenden Malstil nach Vorbildern aus Antike und Renaissance (den er „Gra Manner" nannte). Diese Komposition basiert aber auf Werken van Dycks und Velázquez'.

Lady Cockburn y sus tres hijos mayore

Reynolds cultivó un estilo de pintura erudito e idealizador basado en modelos la antigüedad y del Renacimiento (a los llamó "Grand Manner"). Sin embargo, e composición se basa en obras de van Dy y Velázquez.

Lady Cockburn e i suoi tre figli maggio

Reynolds coltivò una pittura colta e idealizzante, basata su modelli dell'antic e del Rinascimento (che chiamò "Grand Manner"). Tuttavia, questa composizior basa su opere di van Dyck e di Velázque

Lady Cockburn en haar drie oudste zo

Reynolds cultiveerde een geleerde en idealiserende schilderstijl naar voorbeel uit de klassieke oudheid en de renaissan (die hij 'Grand Manner' noemde). Deze compositie is echter gebaseerd op werke van Van Dyck en Velázquez.

SIR JOSHUA REYNOLDS (1723–92)
1773, Oil on canvas/Huile sur toile,
141,5 × 113 cm, The National Gallery, London

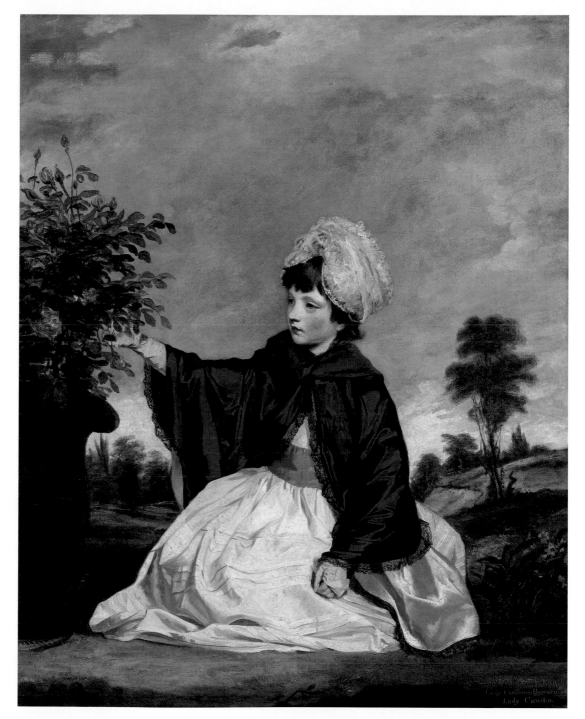

Lady Caroline Howard

SIR JOSHUA REYNOLDS
(1723–92)

1778, Oil on canvas/Huile
sur toile, 143 × 113 cm,
National Gallery of Art,
Washington, D.C.

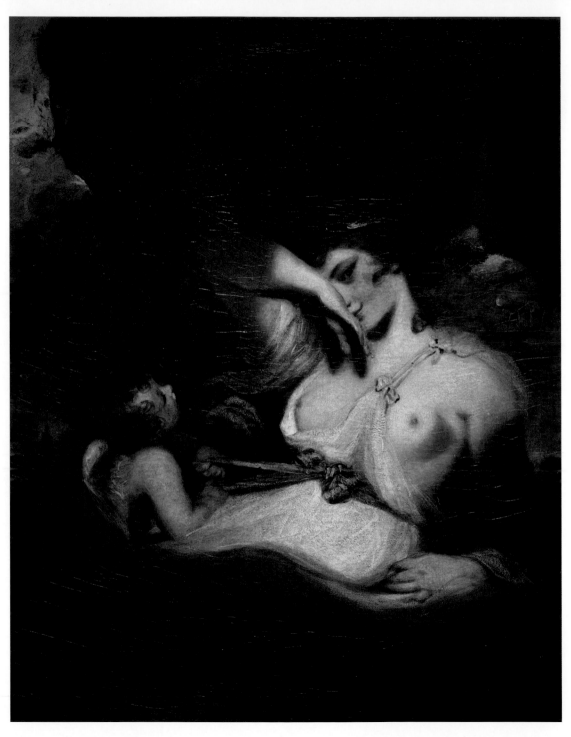

Cupid Unfastening
the Girdle of Venus

Amour dénouant
le lien de Vénus

Amor löst den
Gürtel der Venus

Cupido desatando
el cinto de Venus

Cupido che slaccia
la cintura di Venere

Amor maakt de
gordel van Venus los

SIR JOSHUA REYNOLDS
(1723–92)
1788, Oil on canvas/Huile
sur toile, 127,5 × 101 cm
State Hermitage
Museum, St. Petersburg

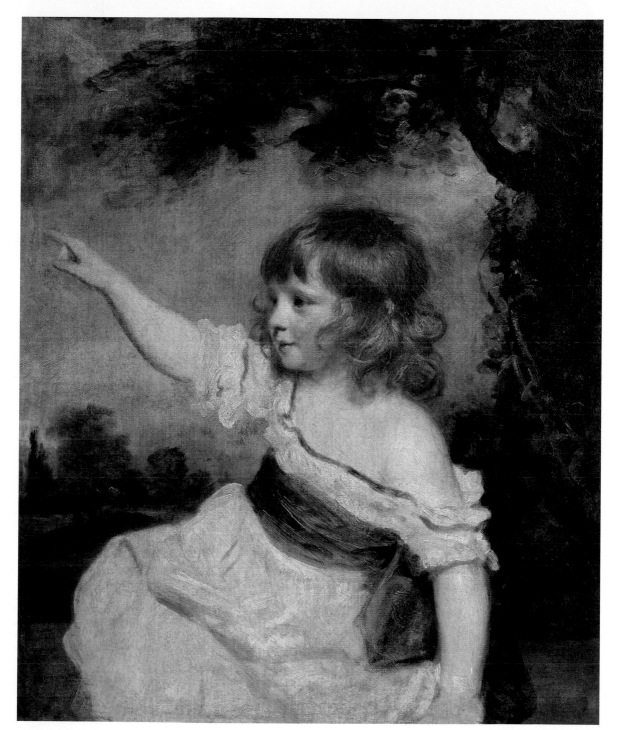

er Hare

**JOSHUA
REYNOLDS
(1723-92)**
3/89, Oil
canvas/
sur toile,
× 64 cm,
usée du
re, Paris

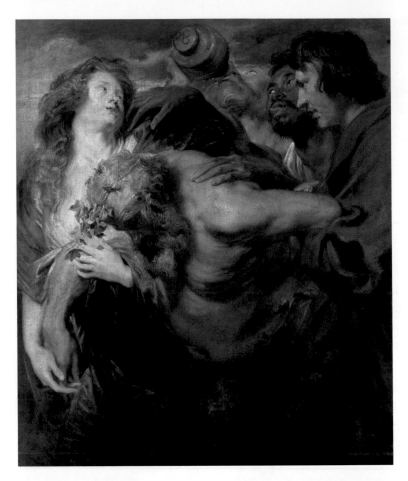

The Drunken Silenus Supported by Satyrs

Silène ivre

Der trunkene Silen

Sileno borracho

Sileno ebbro

De dronken silene

ANTHONIS VAN DYCK (1599–1641)
c. 1619/20, Oil on canvas/Huile sur toile, 107 × 91,5 cm,
Gemäldegalerie Alte Meister, Dresden

The Painter Frans Snyders and His V

Portrait du peintre Frans Snyders et de sa femme Margaretha de

Der Maler Frans Snyders und seine

El pintor Frans Snyders y su es

Ritratto di Frans Snyders e di sua moglie Margareta de

De schilder Frans Snyders en zijn vr

ANTHONIS VAN DYCK (1599–1

c. 1621, Oil on canvas/Huile sur toile, 83 × 110 cm, Gemäldegalerie Alte Meister, K

Anthonis van Dyck: Portrait Art as Personal Image-Building

At the age of 20, Anthonis van dyck was already one of the leading painters in Peter Paul Rubens's workshop in his native Antwerp. From 1621 to 1627, he lived in Italy, where he began his career as a portraitist in Genoa, producing full-figure paintings of the nobles of the city in the style of Titian and Veronese. He also worked as a portraitist in Antwerp and painted religious pictures for Isabella Clara Eugenia, governor of the Spanish Netherlands. In 1632, King Charles I of Britain appointed him court painter. The royal family—Charles I was well aware of the image-building power of art—sat almost exclusively for him. In numerous idealizing portraits of the English court, van Dyck combined the highest grace and elegance with the enormous self-confidence of the depicted – an irresistible formula that shaped British portrait art up to the end of the 18th century.

Antoine Van Dyck : une renommée fondée sur l'art du portrait

Dans sa ville natale d'Anvers, Antoine Van Dyck était l'un des principaux collaborateurs de l'atelier de Pierre Paul Rubens alors qu'il n'était âgé que d'une vingtaine d'années. Il vécut en Italie de 1621 à 1627, où il débuta, à Gênes, sa carrière de portraitiste – en réalisant, à la manière de Titien et Véronèse, des portraits de plain-pied de nobles génois. De retour à Anvers, il continua son activité de portraitiste, tout en peignant aussi des œuvres religieuses pour Isabelle d'Espagne. En 1632, le roi Charles Ier d'Angleterre l'appela à la cour. Les membres de la famille royale (Charles Ier était bien conscient du rôle que pouvait jouer l'art pour son image) étaient ses principaux modèles. Dans ses nombreux portraits de la cour d'Angleterre, Van Dyck sut mettre en avant à la fois la grâce, l'élégance et l'incroyable assurance des personnages qu'il peignait, une combinaison parfaite qui allait influencer l'art britannique du portrait jusqu'à la fin du XVIIIe siècle.

Anthonis van Dyck: Porträtkunst als Imagebildung

Anthonis van Dyck war in seiner Geburtsstadt Antwe schon mit etwa 20 Jahren einer der führenden Mitarb in der Werkstatt von Peter Paul Rubens. Von 1621 bis 1627 lebte er in Italien, wo in Genua seine Karriere als Porträtist begann: Adlige der Stadt stellte er nach Tizian und Veronese im höfischen Ganzfigurenporträ dar. Auch in Antwerpen war er danach vor allem als Porträtist tätig, malte für Statthalterin Isabella von Spanien aber auch religiöse Bilder. 1632 berief ihn der britische König Charles I. zum Hofmaler. Die königlic Familie – Charles I. war sich der imagebildenden Wir von Kunst wohl bewusst – saß fast ausschließlich ihm Modell. In zahlreichen idealisierenden Bildnissen des englischen Hofes kombinierte van Dyck höchste Anm und Eleganz mit dem ungeheuren Selbstbewusstsein der Dargestellten – eine unwiderstehliche Bildformel, welche die britische Porträtkunst bis zum Ende des 18 Jahrhunderts prägte.

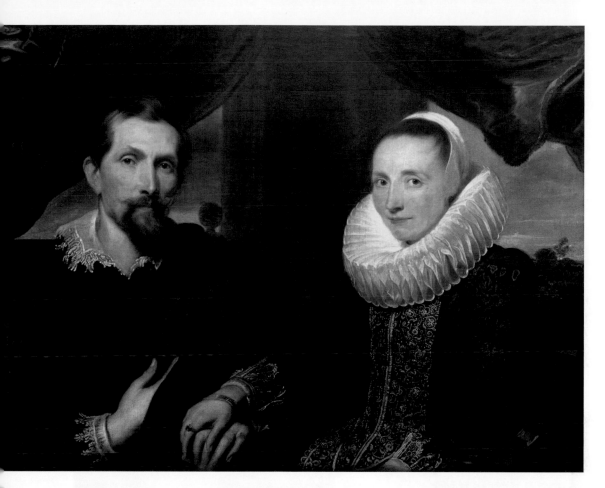

honis van Dyck: el arte del retrato
o formación de la imagen

onis van Dyck era uno de los empleados líderes
taller de Peter Paul Rubens y en su Amberes natal
la edad de 20 años. De 1621 a 1627 vivió en Italia,
le comenzó su carrera como retratista en Génova:
tó a la aristocraciade la ciudad siguiendo el estilo de
no y Veronese en los retratos de la cortede figura
pleta. También trabajó como retratista en Amberesy
cuadros religiosos para la gobernadoraIsabel de
ña. En 1632 el rey Carlos I de Inglaterra lo nombró
r de la corte. La familia real –Carlos I era muy
ciente del efecto de la creación de una buena imagen
vés del arte– posaba casi exclusivamente para él. En
erosos retratos idealizadores de la corte inglesa, van
combinó la mayor gracia y elegancia con la enorme
anza en sí mismo de los representados - una fórmula
agen irresistible que dio forma al arte del retrato
nico hasta finales del siglo XVIII.

Anthonis van Dyck: Ritratto d'arte
come formazione dell'immagine

Già a 20 anni, Anthonis van Dyck era uno dei
collaboratori principali della bottega di Peter Paul Rubens,
nella sua città natale di Anversa. Dal 1621 al 1627 vive in
Italia, dove inizia la sua carriera di ritrattista a Genova:
dopo Tiziano e Veronese dipinse i nobili della città nei
ritratti a figura intera. Ha lavorato anche come ritrattista
ad Anversa, ma ha anche dipinto opere religiose per la
governatrice Isabella di Spagna. Nel 1632 il re Carlo I lo
nominò pittore di corte. La famiglia reale – Carlo I era
ben consapevole dell'effetto dell'immagine dell'arte –
posò quasi esclusivamente per lui. In numerosi ritratti
idealizzanti della corte inglese, van Dyck ha accostato la
massima grazia ed eleganza con la smisurata fiducia in
sé stesso del soggetto ritratto - una formula di immagine
irresistibile che ha plasmato l'arte ritrattistica britannica
fino alla fine del XVIII secolo.

Anthonis van Dyck: portretkunst
voor een beter imago

Anthonis van Dyck was in zijn geboortestad Antwerpen al
op ongeveer 20-jarige leeftijd een van de toonaangevende
medewerkers in het atelier van Peter Paul Rubens. Van
1621 tot 1627 woonde hij in Italië, waar zijn carrière
als portretschilder in Genua begon: edelen uit de stad
portretteerde hij naar Titiaan en Veronese als hoofse
figuren ten voeten uit. Ook in Antwerpen werkte hij
later vooral als portretschilder, maar voor stadhouderes
Isabella van Spanje schilderde hij ook religieuze
schilderijen. In 1632 stelde de Britse koning Karel I hem
aan als hofschilder. De koninklijke familie – Karel I was
zich terdege bewust van de beeldvormende werking
van kunst – zat bijna uitsluitend voor hem model. In
talrijke idealiserende portretten van het Engelse hof
combineerde Van Dyck de grootste gratie en elegantie
met het enorme zelfbewustzijn van de geportretteerden –
een onweerstaanbare formule, die tot het einde van de 18e
eeuw de Britse portretkunst zou kenmerken.

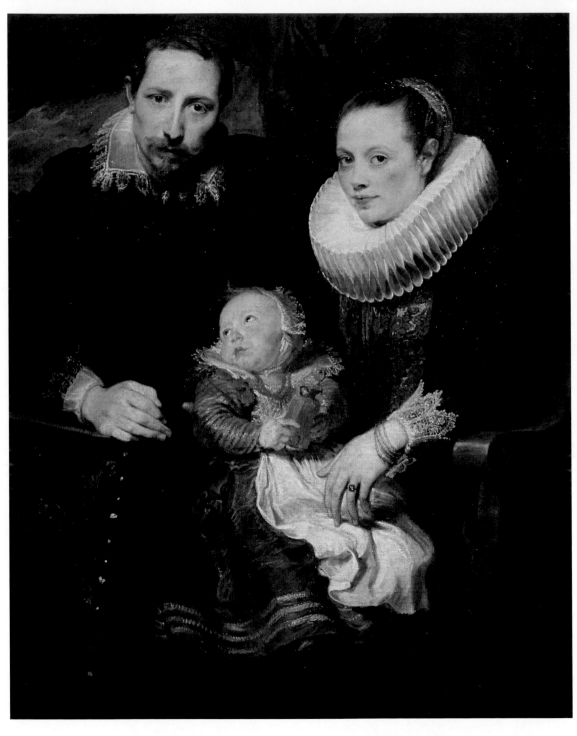

Portrait of
a Family

Portrait de fam[

Porträt einer
Familie

Retrato de
una familia

Ritratto di una
famiglia

Portret van
een familie

ANTHONIS VAN
DYCK (1599-16[
1621, Oil on canv[
Huile sur toile,
113,5 × 93,5 cm, S[
Hermitage Muse[
St. Petersburg

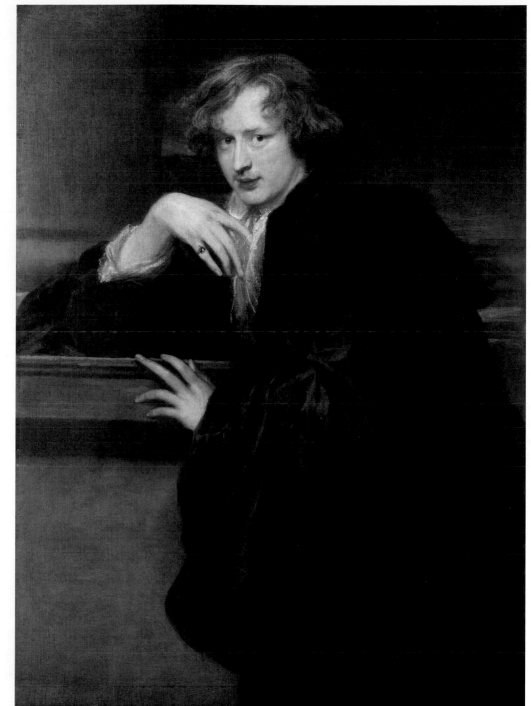

Self-Portrait

Autoportrait

Selbstbildnis

Autorretrato

Autoritratto

Zelfportret

'HONIS VAN DYCK (1599–1641)
c. 1620/21, Oil on canvas/Huile sur
toile, 119,7 × 87,9 cm, Metropolitan
Museum of Art, New York

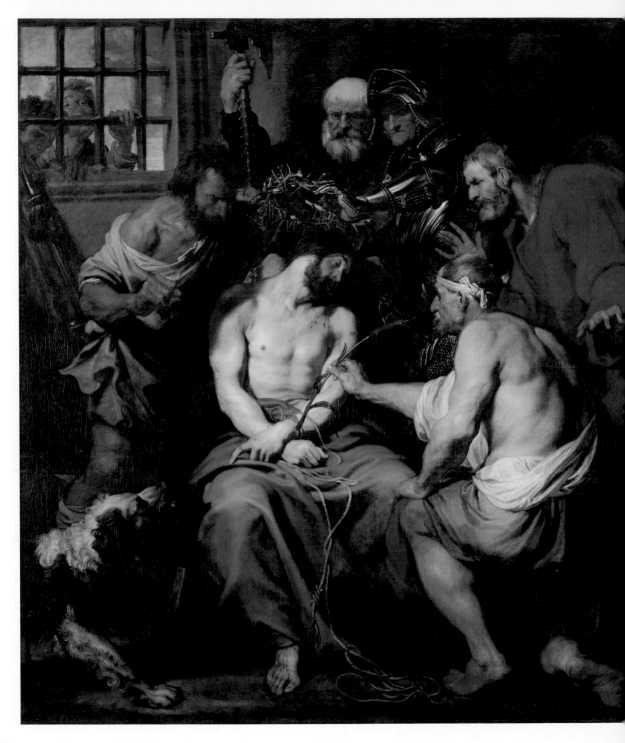

rist with the Crown of Thorns

e Christ figure in this early work recalls Titian, while the
nposition and chiaroscuro evoke Rubens, in whose workshop van
ck worked and to whom he gifted this painting.

Couronnement d'épines

ns cette œuvre de jeunesse, la figure du Christ rappelle Titien ; et
omposition de l'image et le clair-obscur font ouvertement écho
ubens, dans l'atelier duquel Van Dyck travaillait à l'époque – et
quel il offrit ce tableau.

rnenkrönung Christi

Christusfigur in diesem frühen Werk geht auf Tizian zurück, die
mposition und das Hell-Dunkel offenbaren Anklänge an Rubens, in
sen Werkstatt van Dyck arbeitete und dem er dieses Bild schenkte.

Coronación de espinas

figura de Cristo en esta obra temprana se remonta a Tiziano, la
mposición y el claroscuro revelan ecos de Rubens, en cuyo taller
pajó Van Dyck y a quien regaló esta pintura.

oronazione di spine

figura di Cristo in questo primo lavoro rievoca Tiziano, la
mposizione e il chiaroscuro rivelano echi di Rubens, nel cui
oratorio van Dyck ha lavorato e al quale ha donato questo dipinto.

ornenkroning van Christus

Christusfiguur in dit vroege werk gaat terug op Titiaan, terwijl de
mpositie en het clair-obscur overeenkomsten met Rubens vertonen,
viens atelier Van Dyck werkte en aan wie hij dit schilderij schonk.

THONIS VAN DYCK (1599-1641)
8–20, Oil on canvas/Huile sur toile, 225 × 197 cm, Museo del Prado, Madrid

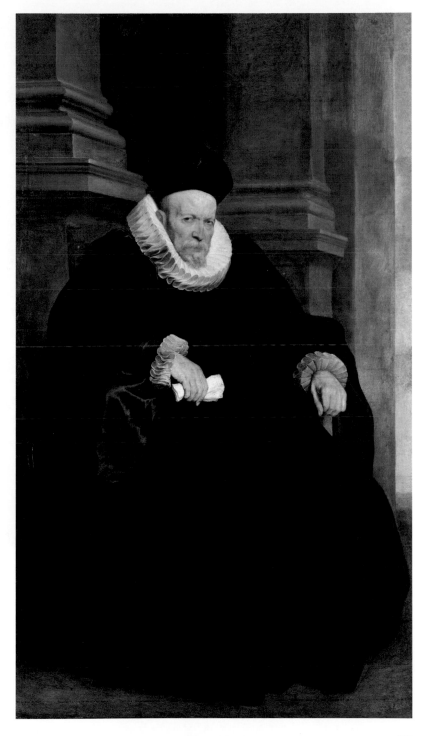

Alessandro Giustiniani-Longo

ANTHONIS VAN DYCK (1599–1641)

622/23, Oil on canvas/Huile sur toile, 203 × 117,3 cm, Gemäldegalerie, Berlin

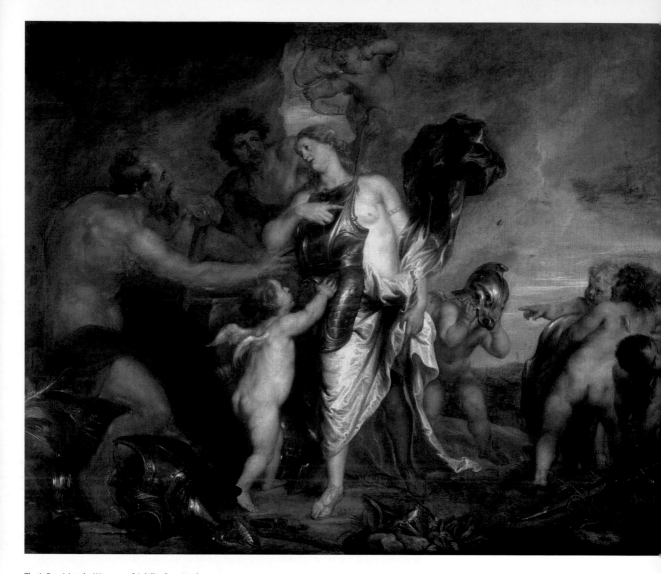

Thetis Receiving the Weapons of Achilles from Hephaestus

Thétis demandant à Héphaïstos de forger des armes pour Achille

Thetis empfängt von Hephaistos die Waffen für Achill

Thetis recibe las armas para Aquiles de Hefistos

Venere nella fucina di Vulcano

Thetis ontvangt van Hephaistos de wapens voor Achilles

ANTHONIS VAN DYCK (1599–1641)
c. 1630–32, Oil on canvas/Huile sur toile, 117 × 156 cm, Kunsthistorisches Museum, Wien

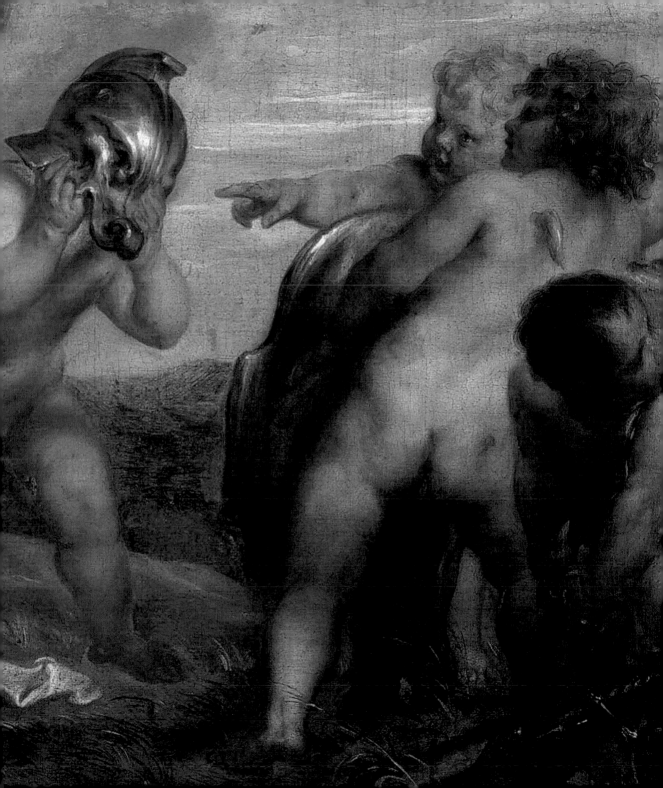

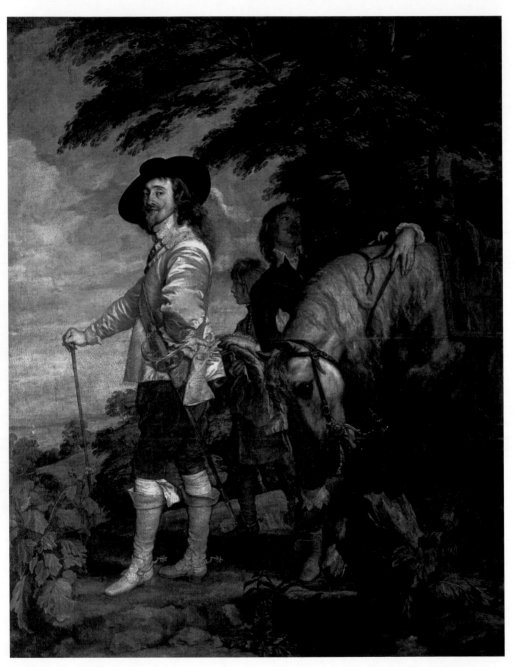

Charles I at the Hunt

Even today, van Dyck's portrait of th[e]
controversial king seduces the viewe[r]
whom Charles I turns: dressed in sim[ple]
hunting clothes, free of royal insignia
he nevertheless brims with authority
and elegance.

Charles I^{er}, roi d'Angleterre dit
Portrait du roi à la chasse

Aujourd'hui encore, les portraits
réalisés par Van Dyck de ce souverai[n]
contesté séduisent le spectateur, vers
lequel Charles I^{er} se tourne : tenue d[e]
chasse simple, sans insignes royaux,
mais pourtant empreint d'autorité
et d'élégance.

Charles I. von Großbritannien
(Der König auf der Jagd)

Noch heute verführen van Dycks
Porträts des umstrittenen Königs de[n]
Betrachter, dem sich Charles I. hier
zuwendet: in einfacher Jagdkleidung
ohne königliche Insignien – doch vo[ll]
Autorität und Eleganz.

Carlos I. de Gran Bretaña
(El Rey a la caza)

Aún siguen seduciendo al espectado[r]
en la actualidad, los retratos de van
Dyck del controvertido rey, a quien
aquí Carlos I se dirige aquí: con sim[ple]
ropas de caza, sin insignias reales, p[ero]
lleno de autoridad y elegancia.

Carlo I d'Inghilterra (Il Re a caccia)

Ancora oggi, i ritratti del controvers[o]
re di Van Dyck seducono lo spettato[re]
al quale Charles I si rivolge: in abiti [da]
caccia semplici, senza vessilli reali -
pieni di autorevolezza ed eleganza.

Karel I van Groot-Brittannië
(De koning tijdens de jacht)

Nog altijd bekoren Van Dycks
portretten van de omstreden konin[g]
de toeschouwer, tot wie Karel I zich
hier richt: in eenvoudige jachtkledin[g]
zonder koninklijkeinsignes, maar vo[l]
gezag en elegantie.

ANTHONIS VAN DYCK (1599-1641)

c. 1635, Oil on canvas/Huile sur toile,
266 × 207 cm, Musée du Louvre, Paris

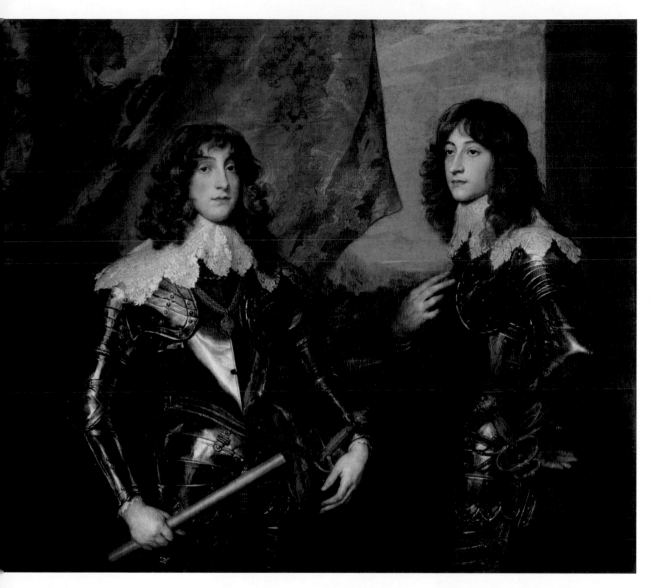

Ludwig of the Palatinate and His Brother Ruprecht

rait des princes palatins

rles-Louis I^{er} et son frère Robert

Karl Ludwig von der Pfalz und sein Bruder Ruprecht

Karl Ludwig del Palatinado y su hermano Ruprecht

Ritratto di Carlo Ludovico e Rupert, principi palatini

Karel Lodewijk van de Palts en zijn broer Ruprecht

HONIS VAN DYCK (1599–1641)

, Oil on canvas/Huile sur toile, 132 × 152 cm, Musée du Louvre, Paris

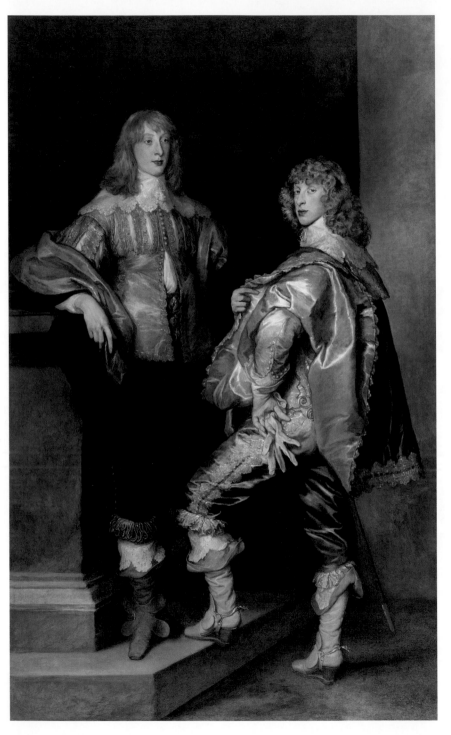

Lord John Stuart and His Brother Lord Bernard Stuart

This late work is typical of van Dyck. The effortlessly confident elegance of the people portrayed shows the grea[..] interest the painter, the son of a silk merchant, had in the representation of fabrics.

Lord John Stuart et son frère Lord Bernard Stuart

Cette œuvre tardive, typique de Van Dyck en ce qui conce[..] l'élégance décontractée des personnages, montre bien l'intérêt que portait ce fils d'un marchand de soieries au rendu des étoffes.

Lord John Stuart und sein Bruder Lord Bernard Stuart

Dieses späte, in der selbstbewusst-mühelosen Eleganz der [..] Porträtierten für van Dyck typische Werk zeigt, welch gro[..] Interesse der Sohn eines Seidenhändlers der Wiedergabe [..] Stoffen entgegenbrachte.

Lord John Stuart y su hermano Lord Bernard Stuart

Esta obra tardía, en la que se muestra la elegancia segura [..] sí misma y sin esfuerzo de la gente retratada, el hijo de un mercader de seda muestra gran interés por la reproducció[..] de tejidos.

Lord John Stuart e suo fratello Lord Bernard Stuart

Quest'opera tarda, in cui l'eleganza sicura di sé e senza sfo[..] delle persone ritratte mostra il grande interesse da parte d[..] figlio di un commerciante di seta per la produzione di tess[..]

Lord John Stuart en zijn broer Lord Bernard Stuart

Dit late werk, met de voor Van Dyck typerende moeiteloo[..] zelfverzekerde elegantie van de geportretteerden, toont de[..] grote belangstelling die deze zoon van een zijdehandelaar voor de weergave van stoffen had.

ANTHONIS VAN DYCK (1599–1641)
c. 1638, Oil on canvas/Huile sur toile, 237,5 × 146,1 cm,
The National Gallery, London

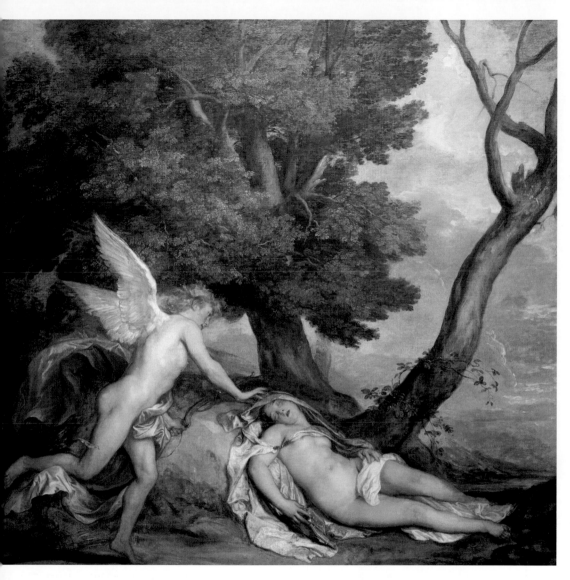

...pid and Psyche

...usually for a court painter, van Dyck worked almost ...usively as a portraitist. This is the only preserved ...chological picture he created for Charles I.

...mour et Psyché

...: rare pour un peintre de cour, Van Dyck travaillait presque ...lusivement comme portraitiste. Ce tableau est la seule ...vre mythologique qu'il ait réalisée pour Charles Ier et qui ...s soit parvenue.

Amor und Psyche

Van Dyck arbeitete, für einen Hofmaler ungewöhnlich, fast nur als Porträtist. Dies ist das einzige erhaltene mythologische Bild, das er für Charles I. schuf.

Cupido y Psique

Van Dyck trabajó, inusual para un pintor de la corte, casi exclusivamente como retratista. Este es el único cuadro mitológico conservado que creó para Carlos I.

Amore e Psiche

Van Dyck lavorò, insolito per un pittore di corte, quasi esclusivamente come ritrattista. Questo è l'unico quadro mitologico che ha creato per Carlo I.

Amor en Psyche

Van Dyck werkte, heel ongebruikelijk voor een hofschilder, bijna uitsluitend als portretschilder. Dit is het enige bewaard gebleven mythologische schilderij dat hij voor Karel I maakte.

...THONIS VAN DYCK (1599–1641)

...9/40, Oil on canvas/Huile sur toile, 200,2 × 192,6 cm, Royal Collection, London

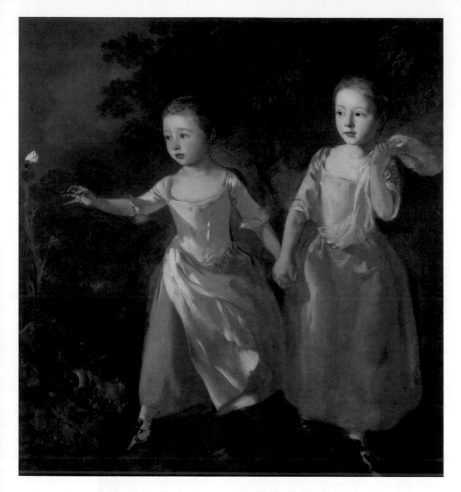

Thomas Gainsborough: Pictures of Man and Nature

Thomas Gainsborough was born the son of a wool merchant in Sudbury, Suffolk, in 1727. His artistic talent was already evident at a young age; an unprecedented career in Bath and London followed from the 1760s. While his fame and merit as a painter were mainly based on his portraits of English society, his real passion was landscape painting. Gainsborough's works possess a sensitive modernity that was entirely in keeping with the spirit of the Enlightenment in 18th-century England. He painted by feeling and did not let himself be guided by academic rules, which earned him the admiration, if not the friendship, of England's second great portraitist, Sir Joshua Reynolds (1732–92). Gainsborough's landscapes and portraits continue to shape our image of England at that time.

Thomas Gainsborough : portraitiste et paysagiste

Fils d'un marchand de laine, Thomas Gainsborough vit le jour en 1727 à Sudbury, dans le Suffolk. Son talent artistique se révéla dès son adolescence, débouchant sur une carrière incroyable à Bath et à Londres à partir des années 1760. S'il devait surtout sa réputation et ses revenus à ses portraits de la société anglaise, les paysages étaient sa véritable passion. Les œuvres de Gainsborough sont d'une modernité empreinte de sensibilité, qui correspondait tout à fait à l'état d'esprit de l'Angleterre des Lumières du XVIIIᵉ siècle. Il peignait de manière plutôt intuitive, sans suivre de trop près les règles académiques. Cela ne lui valut pas l'amitié, certes, mais bien l'estime de l'autre grand portraitiste de l'époque : Sir Joshua Reynolds (1732–1792). C'est aux paysages et aux portraits de Gainsborough que nous devons aujourd'hui notre image de l'Angleterre d'alors.

Thomas Gainsborough: Bilder von Mensch und Natur

1727 wurde Thomas Gainsborough in Sudbury, Suffolk, als Sohn eines Wollhändlers geboren. Sein künstlerisches Talent zeigte sich bereits in jungen Jahren; eine beispiellose Karriere in Bath und London folgte ab den 1760ern. Während sich sein Ruhm und Verdienst als Maler vor allem auf Porträts der englischen Gesellschaft gründeten, galt der Landschaftsmalerei seine eigentliche Leidenschaft. Gainsboroughs Werke besitzen eine sensible Modernität, die ganz dem Zeitgeist des aufklärerischen Englands des 18. Jahrhunderts entsprach. Er malte nach dem Gefühl und ließ sich nicht von akademischen Regeln leiten, was ihm zeitlebens zwar nie die Freundschaft, aber stets die künstlerische Wertschätzung des zweiten großen Porträtisten, Sir Joshua Reynolds (1732–92), einbrachte. Es sind die Landschaften und Porträts Gainsboroughs, die unser Bild des Englands seiner Epoche bis heute prägen.

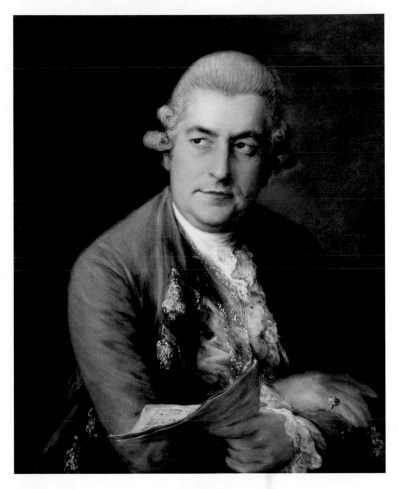

Johann Christian Bach

THOMAS GAINSBOROUGH (1727–88)

c. 1776, Oil on canvas/Huile sur toile, 75,5 × 62 cm, National Portrait Gallery, London

Thomas Gainsborough:
tos del hombre y la naturaleza

omas Gainsborough nació en 1727 en Sudbury, Suffolk,
o de un comerciante de lana. Su talento artístico ya era
dente a una edad temprana; a partir de la década de
o inició una carrera sin precedentes en Bath y Londres.
entras que su fama y mérito como pintor se basaban
ncipalmente en retratos de la sociedad inglesa, su
dadera pasión era la pintura de paisajes. Las obras de
insborough poseen una modernidad sensible que
aba totalmente en consonancia con el espíritu de la
stración en la Inglaterra del siglo XVIII. Pintaba
el sentimiento y no se dejaba guiar por las reglas
démicas, que nunca le hicieron merecedor de la
istad, sino siempre de la apreciación artística del
undo gran retratista, Sir Joshua Reynolds (1732–92).
s paisajes y retratos de Gainsborough todavía
acterizan nuestra imagen de Inglaterra en esa época.

Thomas Gainsborough:
Immagini dell'uomo e della natura

Thomas Gainsborough nacque nel 1727 a Sudbury, nel
Suffolk, figlio di un mercante di lana. Il suo talento
artistico era già evidente in giovane età. Una carriera
senza precedenti proseguì a Bath e a Londra a partire
dal 1760. Mentre la sua fama e il suo merito di pittore
si basavano principalmente sui ritratti della società
inglese, la sua vera passione era la pittura paesaggistica.
Le opere di Gainsborough possiedono una modernità
sensibile del tutto in linea con lo spirito dell'Illuminismo
nell'Inghilterra del XVIII secolo. Dipinge in base
al sentimento e non si lascia guidare dalle regole
accademiche, che non gli valgono mai l'amicizia, ma
di sicuro l'apprezzamento artistico del secondo grande
ritrattista, Sir Joshua Reynolds (1732–92). I paesaggi e i
ritratti di Gainsborough caratterizzano ancora oggi la
nostra immagine dell'Inghilterra di allora.

Thomas Gainsborough:
schilderijen van mens en natuur

Thomas Gainsborough werd in 1727 in Sudbury,
Suffolk, geboren als zoon van een wolhandelaar. Zijn
artistieke talent was al op jonge leeftijd zichtbaar;
een onvergelijkbare carrière in Bath en Londen
volgde vanaf 1760. Terwijl zijn roem en verdienste als
schilder voornamelijk gebaseerd waren op portretten
van de Engelse society, lag zijn echte passie bij de
landschapschilderkunst. Gainsboroughs werken
bezitten een gevoelige moderniteit die volledig in
overeenstemming was met de geest van de verlichting in
het 18e-eeuwse Engeland. Hij schilderde op het gevoel
en liet zich niet leiden door academische regels, wat
hem weliswaar nooit de vriendschap, maar altijd wel
de artistieke waardering van de tweede grote Engelse
portrettist, Sir Joshua Reynolds (1732–1792), opleverde. De
landschappen en portretten van Gainsborough zijn nog
steeds bepalend voor ons beeld van Engeland uit die tijd.

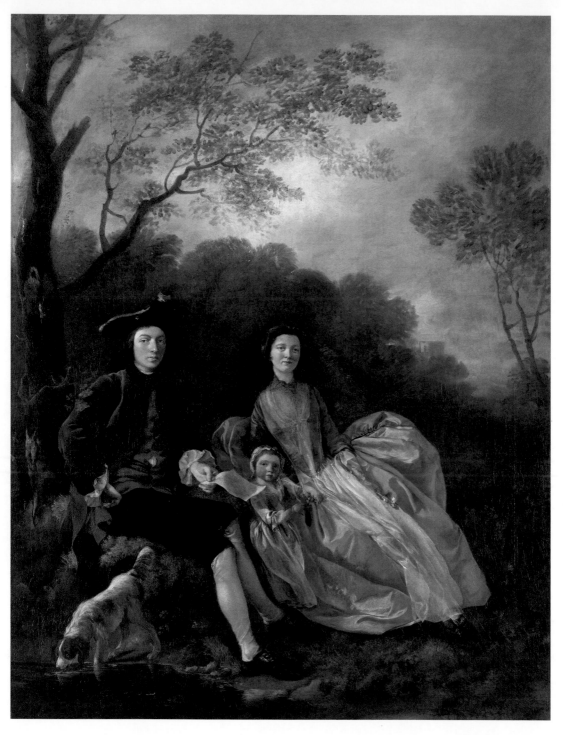

Portrait of the Artist with
His Wife and Daughter

Autoportrait du peintre
avec sa femme et sa fille

Die Familie des Künstlers

La familia del artista

La famiglia dell'artista

Het gezin van de
kunstenaar

THOMAS GAINSBOROUGH
(1727–88)

c. 1748, Oil on canvas/Huile
sur toile, 92,1 × 70,5 cm, The
National Gallery, London

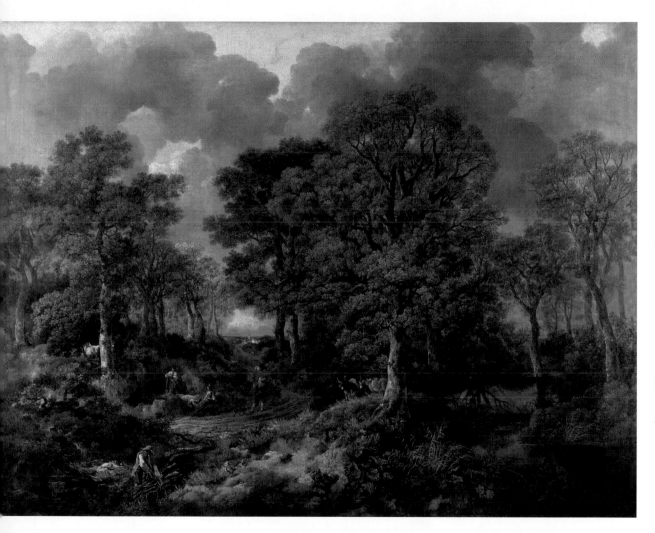

rnard Wood, near Sudbury, Suffolk

nsborough's early landscapes were inspired by the Dutch of the 17th century, which was highly admired at the time, which Gainsborough could study in private collections.

Bois de Cornard

ns ses premiers paysages, Gainsborough s'inspirait de l'art rlandais du XVIIᵉ siècle, qui était très prisé à l'époque et pouvait donc étudier dans des collections privées.

Cornard Wood bei Sudbury

Gainsborough orientierte sich in seinen frühen Landschaften an der niederländischen Kunst des 17. Jahrhunderts. Diese wurde zu seiner Zeit sehr geschätzt und er konnte sie in privaten Sammlungen studieren.

Cornard Wood cerca de Sudbury

Los primeros paisajes de Gainsborough se inspiraron en el arte holandés del siglo XVII. Esto fue muy apreciado en su época y pudo estudiarlo en colecciones privadas.

Cornard Wood presso Sudbury

I primi paesaggi di Gainsborough furono ispirati dall'arte olandese del XVII secolo. Molto apprezzata al suo tempo, ha potuto studiarla nelle collezioni private.

Cornard Wood bij Sudbury

De vroege landschappen van Gainsborough zijn geïnspireerd op de Nederlandse kunst van de 17e eeuw. Deze werden zeer gewaardeerd in zijn tijd en hij kon ze bestuderen in particuliere collecties.

OMAS GAINSBOROUGH (1727–88)

3, Oil on canvas/Huile sur toile, 122 × 155 cm, The National Gallery, London

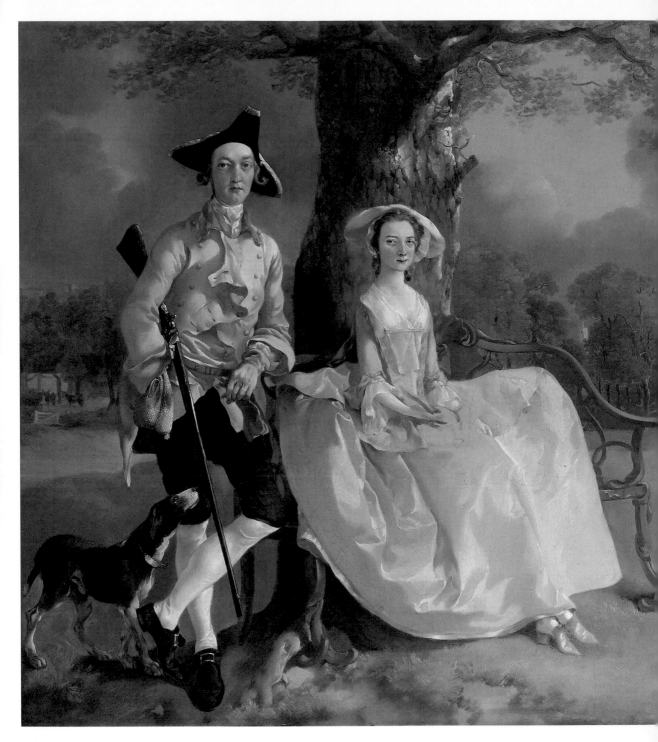

Mr and Mrs Andrews

THOMAS GAINSBOROUGH (1727-88)

c. 1750, Oil on canvas/Huile sur toile,
69,8 × 119,4 cm, The National Gallery, London

The Painter's
Daughters
with a Cat

Les Filles du
peintre avec
un chat

Die Töchter
des Malers
mit Katze La
hijas del pint
con un gato

Le figlie del
pittore con
il gatto

De dochters
van de schild
met een kat

**THOMAS
GAINSBOROU
(1727–88)**
c. 1760, Oil
on canvas/
Huile sur toile,
75,6 × 62,9 cm,
The National
Gallery, Londo

The Blue Boy

Gainsborough's Blue Boy is dressed in a typical van Dyck costume. The visual language of this grandmaster of English portraiture had been very much en vogue since the 1730s.

L'Enfant bleu

L'Enfant bleu de Gainsborough arbore un costume typique de Van Dyck. Les codes visuels de ce grand maître de l'art du portrait britannique des années 1630 talent de nouveau très en vogue dans les années 1730.

The Blue Boy

Gainsboroughs *The Blue Boy* präsentiert sich in der Maskerade eines typischen n-Dyck-Kostüms. Die Bildsprache dieses roßmeisters der englischen Porträtkunst ar seit den 1730ern wieder sehr en vogue.

El joven azul

joven azul de Gainsborough se presenta en la máscara de un disfraz típico de Van Dyck. El lenguaje visual de este gran estro del retrato inglés volvió a estar muy de moda a partir de la década de 1730.

Ragazzo in blu

he Blue Boy di Gainsborough si presenta lla maschera di un tipico costume di Van Dyck. Il linguaggio visivo di questo gran maestro dell'arte ritrattistica inglese fu di nuovo molto in voga a partire dal 1730.

The Blue Boy

Gainsboroughs Blue Boy presenteert zich in de maskerade van een typisch Van Dyck-kostuum. De beeldspraak van deze rootmeester van de Engelse portretkunst was vanaf 1730 weer erg in zwang.

THOMAS GAINSBOROUGH (1727–88)
c. 1770, Oil on canvas/Huile sur toile,
,4 × 123,8 cm, The Huntington, San Marino CA

Woman in B[lue]

La Femme
en bleu

Frau in Blau

Mujer de azu[l]

Donna in blu

Vrouw in bla[uw]

**THOMAS
GAINSBOROU[GH]
(1727–88)**
c. 1775–85, Oil
on canvas/
Huile sur toile,
76,5 × 63,5 cm,
State Hermitag[e]
Museum,
St Petersburg

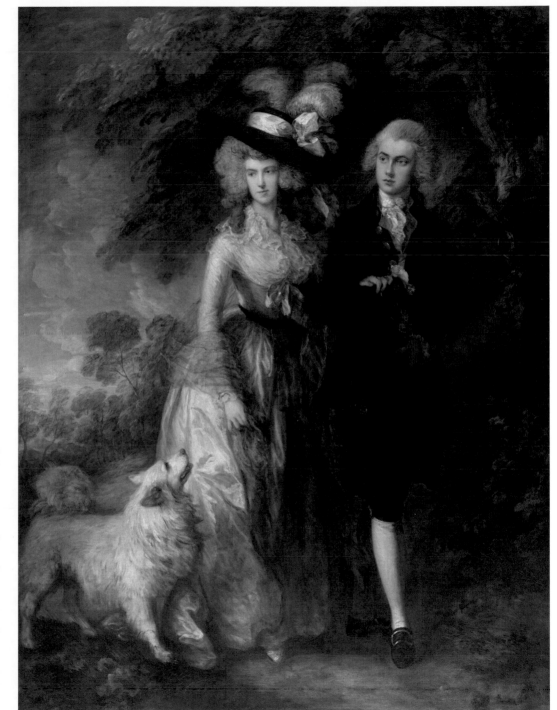

Mr and Mrs William Hallet
(The Morning Walk)

William Hallett et son
épouse Elizabeth,
née Stephen ou
Promenade matinale

Mr and Mrs William Hallet
(Der Morgenspaziergang)

Sr. y Sra. William Hallet
(The Morning Walk)

Mr e Mrs William Hallet (La
passeggiata mattutina)

Mr en Mrs William Hallet
(De ochtendwandeling)

THOMAS GAINSBOROUGH
(1727–88)

1785, Oil on canvas/Huile sur
toile, 236,2 × 179,1 cm,
The National Gallery, London

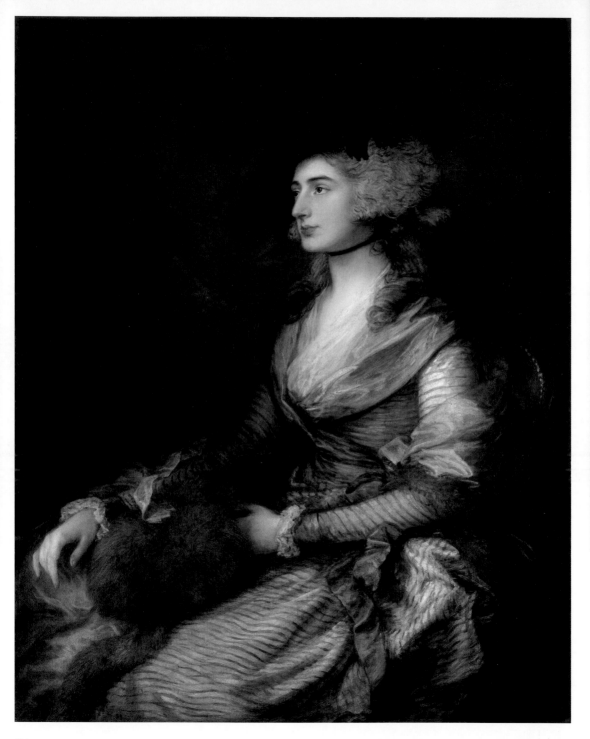

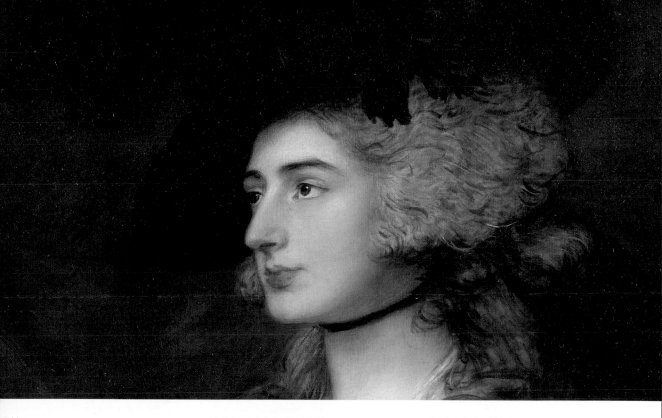

Siddons

ntrary to academic convention, this portrait lacks any
rence to the actress's profession. Gainsborough is said to
e merely asked that Mrs Siddons put on her best hat.

Sarah Siddons

références à sa profession de comédienne sont
lement absentes du tableau, ce qui contrevient aux règles
démiques. Gainsborough se serait contenté de dire à cette
rice de mettre son plus beau chapeau.

MAS GAINSBOROUGH (1727–88)
, Oil on canvas/Huile sur toile, 126 × 99,5 cm, The National Gallery, London

Die Schaupielerin Mrs Sarah Siddons

Hinweise auf die Profession der Schauspielerin fehlen –
entgegen der akademischen Regeln – in diesem Porträt
gänzlich. Gainsborough soll die Aktrice lediglich gebeten
haben, ihren besten Hut aufzusetzen.

La señora Sarah Siddons, actriz de teatro

Contrariamente a las reglas académicas, este retrato carece
por completo de referencias a la profesión de actriz. Se dice
que Gainsborough se limitó a pedirle a la actriz que se pusiera
su mejor sombrero.

L'attrice Mrs. Sarah Siddons

Contrariamente alle regole accademiche, questo ritratto
manca completamente di riferimenti alla professione
dell'attrice. Si dice che Gainsborough si sia limitato a chiedere
all'attrice di indossare il suo cappello migliore.

De toneelspeelster Mrs Sarah Siddons

Tegen de academische regels in wordt in dit portret nergens
verwezen naar het beroep van toneelspeelster. Gainsborough
zou de actrice alleen hebben gevraagd om haar beste hoed op
te zetten.

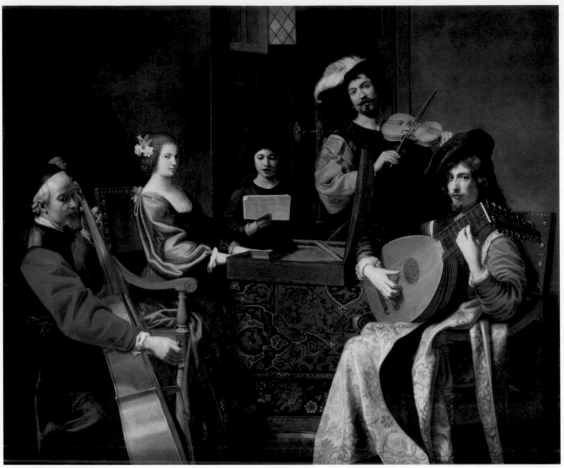

The Concert

Le Concert

Das Konzert

El concierto

Concerto

Het concert

NICOLAS TOURNIE[
(1590–1638/39)

1630–35, Oil on
canvas/Huile sur to
188 × 226 cm, Musé
du Louvre, Paris

Baroque Painting in France:
Classicism, Pomp, Rococo

The 17th century is often referred to as France's golden
century: many outstanding artists and, from the
second half of the century, the splendour of the Sun
King Louis XIV ensured that French art shone brightly
in Europe. Initially, classical themes dominated the
sublime landscapes and mythological scenes of Nicolas
Poussin and Claude Lorrain. Later, art served primarily
as representation: court painter Charles Le Brun and
portraitists such as Pierre Mignard and Hyacinthe Rigaud
ensured that royal power was displayed in monumental
paintings and in the homogeneous decoration of entire,
magnificent palaces. After the death of Louis XIV at the
beginning of the following century, focus shifted to the
private, the pleasant, and the playful, reflected in typically
rococo pictures by Boucher, Watteau, and Fragonard.

La peinture baroque en France :
classicisme, faste et rococo

Le XVIIᵉ siècle est souvent désigné comme le « Siècle
d'or » français, car de nombreux artistes remarquables
et, dans la seconde moitié du siècle, l'éclat du Roi-Soleil
Louis XIV contribuèrent à faire rayonner l'art français
dans toute l'Europe. Dans un premier temps, les thèmes
classiques restèrent dominants, comme en témoignent
les paysages grandioses et les scènes mythologiques de
Nicolas Poussin et de Claude Lorrain. Plus tard, l'art servit
surtout à rehausser le prestige : Charles Le Brun, peintre à
la cour, ou encore des portraitistes comme Pierre Mignard
et Hyacinthe Rigaud contribuèrent à mettre en valeur le
pouvoir royal dans leurs tableaux gigantesques et dans
la décoration somptueuse des châteaux. Après la mort
de Louis XIV, au début du siècle suivant, l'attention fut
davantage concentrée sur la sphère privée, les plaisirs
et la frivolité, typiques des tableaux rococo de Boucher,
Watteau et Fragonard.

Barockmalerei in Frankreich:
Klassizismus, Pomp, Rokoko

Das 17. wird oft als Frankreichs „goldenes" Jahrhundert
bezeichnet, denn viele hervorragende Künstler und ab
zweiten Jahrhunderthälfte der Glanz des Sonnenkönig
Ludwig XIV. sorgten dafür, dass die französische Kuns
in Europa hell strahlte. Zunächst dominierten klassisc
Themen, die in den erhabenen Landschaften und
mythologischen Szenen Nicolas Poussins und Claude
Lorrains ihren Ausdruck fanden. Später diente die
Kunst vor allem der Repräsentation: Hofmaler Charle
Le Brun und Porträtisten wie Pierre Mignard und
Hyacinthe Rigaud sorgten dafür, dass die royale Mach
auf monumentalen Gemälden und in der homogenen
Ausstattung ganzer Prunkschlösser zur Schau gestellt
wurde. Nach dem Tod Ludwigs XIV. lag der Fokus zu
Beginn des folgenden Jahrhunderts eher auf dem Priva
Angenehmen, Verspielten, was sich in den typischen
Rokokobildern Bouchers, Watteaus und Fragonards z[

The Penitent Magdalen

La Madeleine aux deux flammes ou Madeleine Wrightsman

Maria Magdalena als Büßerin

La Magdalena penitente

Maddalena penitente

Maria Magdalena als boetelinge

GEORGES DE LA TOUR (1593-1652)

c. 1640, Oil on canvas/Huile sur toile, 133,4 × 102,2 cm, Metropolitan Museum of Art, New York

pintura barroca en Francia: sicismo, pompa, rococó

iglo XVII se conoce a menudo como el siglo "dorado" Francia, para muchos artistas destacados y, a partir a segunda mitad del siglo, el esplendor del Rey Sol s XIV hizo que el arte francés brillara en Europa. cialmente, los temas clásicos dominaron los paisajes limes y las escenas mitológicas de Nicolas Poussin laude Lorrain. Más tarde, el arte sirvió sobre todo a la representación: el pintor de la corte Charles Le n y retratistas como Pierre Mignard y Hyacinthe aud aseguraron que el poder real se desplegara en turas monumentales y en la decoración homogénea magníficos palacios enteros. Después de la muerte Luis XIV a principios del siglo siguiente, la atención centró más en lo privado, lo agradable, lo lúdico, que refleja en las típicas imágenes rococó de Bouchers, tteau y Fragonard.

Pittura barocca in Francia: classicismo, sfarzo, rococò

Il XVII secolo è spesso definito come il secolo "d'oro" della Francia, molti artisti di spicco e dalla seconda metà del secolo lo splendore del re Sole Luigi XIV hanno fatto sì che l'arte francese brillasse in Europa. Inizialmente, i temi classici dominavano i paesaggi sublimi e le scene mitologiche di Nicolas Poussin e Claude Lorrain. Più tardi, l'arte servì soprattutto per la rappresentazione: il pittore di corte Charles Le Brun e ritrattisti come Pierre Mignard e Hyacinthe Rigaud fecero in modo che il potere monarchico si rivelasse nei dipinti monumentali e nella decorazione omogenea di interi magnifici palazzi. Dopo la morte di Luigi XIV, all'inizio del secolo successivo, l'attenzione si è concentrata più sul privato, sul frivolo, che si riflette nelle immagini tipiche rococò di Bouchers, Watteau e Fragonard.

Barokke schilderkunst in Frankrijk: classicisme, 'pompe' en rococo

De 17e eeuw wordt vaak aangemerkt als de 'gouden' eeuw van Frankrijk, want door de vele uitstekende kunstenaars en vanaf de tweede helft van de eeuw alle pracht van de Zonnekoning Lodewijk XIV straalde de Franse kunst helder in Europa. Aanvankelijk domineerden klassieke thema's, die in de verheven landschappen en mythologische taferelen van Nicolas Poussin en Claude Lorrain tot uitdrukking kwamen. Later diende de kunst vooral als representatie: hofschilder Charles Le Brun en portretschilders als Pierre Mignard en Hyacinthe Rigaud zorgden ervoor dat de koninklijke macht in monumentale schilderijen en in de homogene decoratie van volledige pronkpaleizen te zien was. Na de dood van Lodewijk XIV lag aan het begin van de volgende eeuw de focus meer op het private, het aangename, het speelse, wat terug te zien is in de typische rococoschilderijen van Boucher, Watteau en Fragonard.

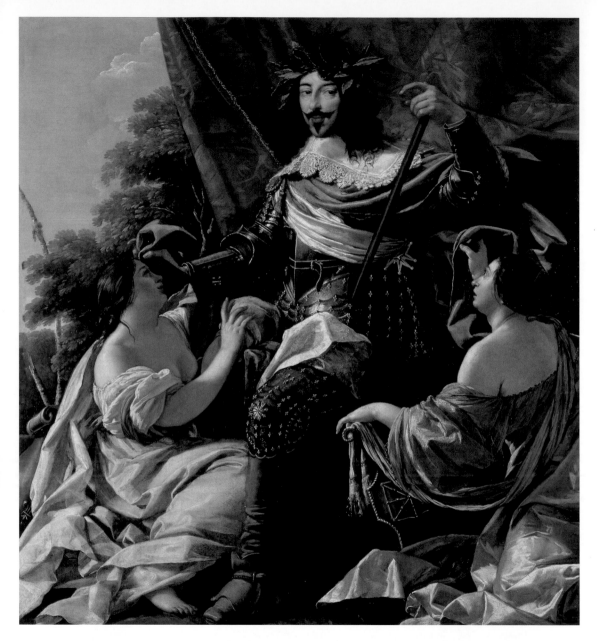

Louis XIII Between Personifications
of France and Navarre

Louis XIII entre deux figures de femmes
symbolisant la France et la Navarre

Ludwig XIII. zwischen den Personifikationen
Frankreichs und Navarras

Luis XIII entre las personificaciones
de Francia y Navarra

Luigi XIII tra le personificazioni di
Francia e Navarra

Lodewijk XIII tussen de personificaties
van Frankrijk en Navarra

SIMON VOUET (1590–1649)

n.d., Oil on canvas/Huile sur toile, 163 × 154 cm, Musée du Louvre, Paris

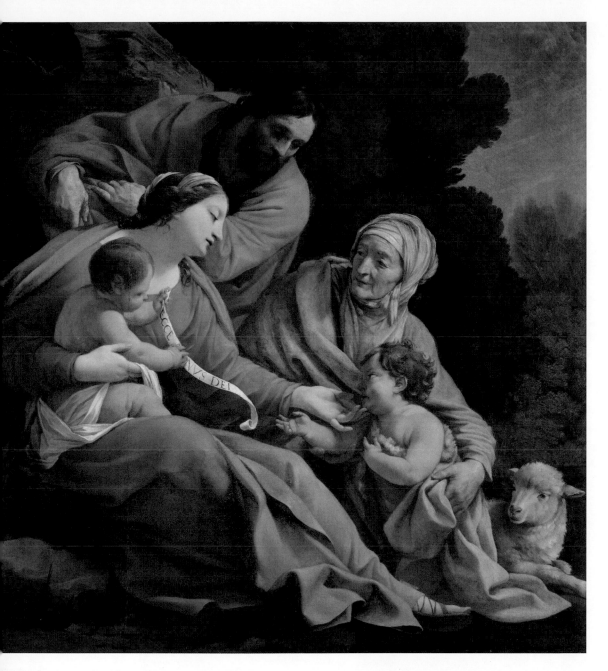

Holy Family Die Heilige Familie *La Sacra Famiglia*

ainte Famille La Sagrada Familia De Heilige Familie

ON VOUET (1590–1649)

41/42, Oil on canvas/Huile sur toile, 132 × 125 cm, Musée du Louvre, Paris

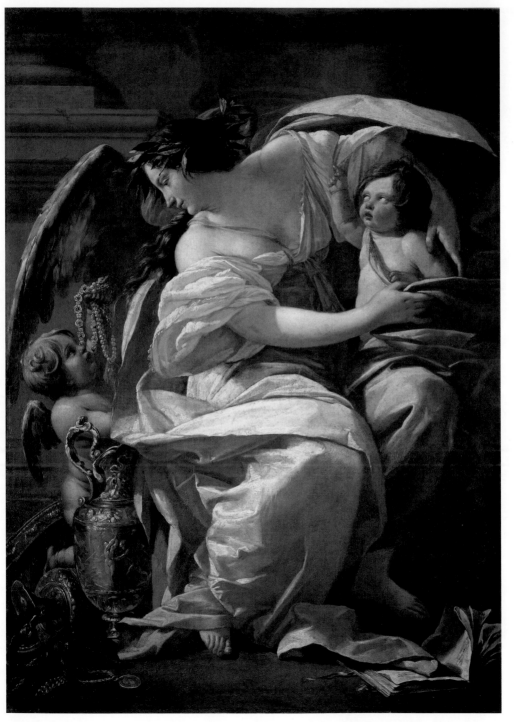

Wealth

A personification of wealth: spiritual child points toward heaven), material (the jewellery) and intellectual (the open book). Vouet imported this style of painting from Italy.

La Richesse

Une personnification de la richesse, à la fois spirituelle (l'enfant qui montre le ciel), matérielle (le bijou) et intellectuelle (le livre tombé au sol). Vouet avait importé ce style pictural d'Italie.

Der Reichtum

Eine Personifikation des Reichtums: an Spirituellem (ein Kind zeigt zum Himmel), an Materiellem (der Schmuck) und an Wissen (das aufgeschlagene Buch). Den Malstil hat Vouet aus Italien importiert.

Alegoría de la riqueza

Una personificación de la riqueza: lo espiritual (un niño señala el cielo), lo material (las joyas) y el conocimiento (libro abierto). Vouet había importado estilo de pintura de Italia.

La ricchezza

Una personificazione della ricchezza spirituale (un bambino indica il cielo), materiale (i gioielli) e conoscenza (il libro aperto). Il Vouet importò lo stile del dipinto dall'Italia.

De rijkdom

Een personificatie van rijkdom: aan spiritualiteit (een kind wijst naar de hemel), aan materie (de sieraden) en aan kennis (het opengeslagen boek). Vouet had de schilderstijl meegenomen uit Italië.

SIMON VOUET (1590–1649)

c. 1640, Oil on canvas/Huile sur toile, 170 × 124 cm, Musée du Louvre, Paris

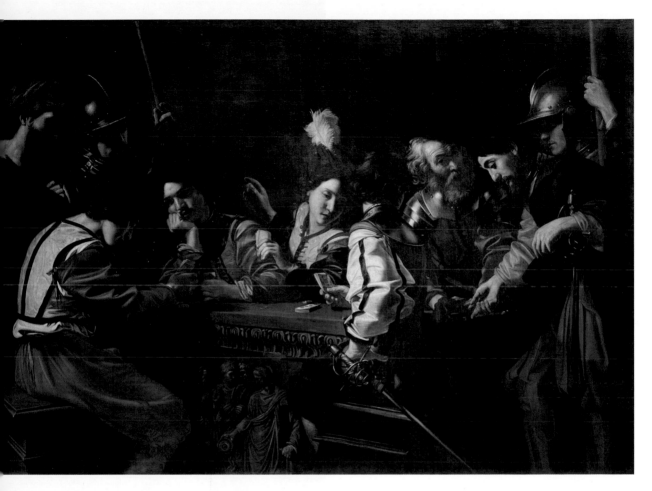

Guardroom

card players on the left are thoughtful, while one on
right is excited by a roll of the dice. Contrasts, a tight
position, and realistic figures recall Caravaggio and draw
viewer into the action.

os de garde

uche, les joueurs de cartes sont pensifs, tandis qu'à droite
énerve en jouant aux dés. Contrastes, cadre resserré et
onnages réalistes renvoient au Caravage et plongent le
tateur dans l'action.

Die Wachstube

Die Kartenspieler links sind nachdenklich, während man sich
rechts beim Würfeln aufregt. Kontraste, enger Bildausschnitt
und realistische Figuren verweisen auf Caravaggio und ziehen
den Betrachter ins Geschehen.

La sala de guardia

Los jugadores de cartas de la izquierda están pensativos,
mientras que los de la derecha se enfadan cuando tiran los
dados. Contrastes, detalles estrechos y figuras realistas hacen
referencia a Caravaggio y atraen al espectador a la acción.

Guardiano

I giocatori di carte a sinistra sono pensierosi, mentre a destra
qualcuno si adira tirando ai dadi. Contrasti, dettagli circoscritti
e figure realistiche si riferiscono a Caravaggio e coinvolgono lo
spettatore nell'azione.

Het wachtlokaal

De kaartspelers aan de linkerkant zijn in gedachten verzonken,
terwijl men zich rechts drukt maakt bij het dobbelspel.
Contrasten, smalle beelduitsneden en realistische figuren
verwijzen naar Caravaggio en betrekken de toeschouwer bij de
situatie.

LAS TOURNIER (1590-C. 1638/39)

25, Oil on canvas/Huile sur toile, 169 × 239 cm, Staatliche Kunstsammlungen Dresden, Dresden

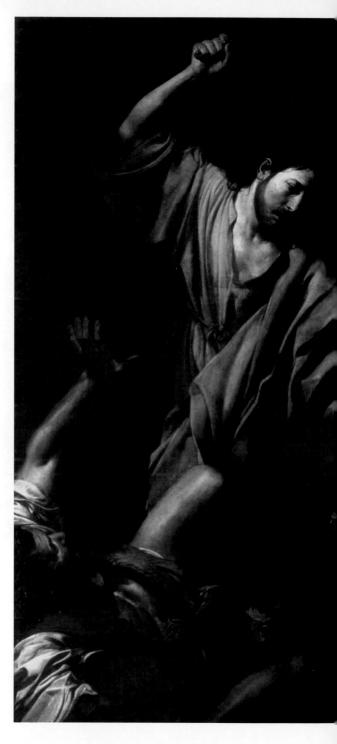

Expulsion of the Money-Changers from the Temple

A religious scene in the style of Caravaggio: according to the Gospels, Jesus chased the money-changers out of the Temple of Jerusalem because no business was to be done in a house of prayer.

Le Christ chassant les marchands du Temple

Une scène religieuse qui s'inscrit dans la droite ligne du Caravage : les Évangiles racontent que Jésus chassa les marchands du Temple de Jérusalem, arguant qu'il ne fallait pas faire d'affaires dans un lieu de prière.

Austreibung der Wechsler aus dem Tempel

Eine religiöse Szene in der Nachfolge Caravaggios: Wie die Evangelien berichten, soll Jesus die Geldwechsler aus dem Jerusalemer Tempel gejagt haben, weil dieser ein Gebetshaus sei, in dem man keine Geschäfte mache.

La expulsión de los comerciantes del templo

Una escena religiosa tras las huellas de Caravaggio: según los evangelios, Jesús persiguió a los comerciantes fuera del templo de Jerusalén porque era una casa de oración en la que no se hacían negocios.

Espulsione dei Cambiavalute dal Tempio

Una scena religiosa sulle orme di Caravaggio: secondo i Vangeli, Gesù scacciò i mercanti dal tempio di Gerusalemme perché era una casa di preghiera e non un luogo di mercato.

Verdrijving van de geldwisselaars uit de tempel

Een religieus tafereel in navolging van Caravaggio: volgens de evangeliën verjoeg Jezus de geldwisselaars uit de tempel van Jeruzalem omdat het een gebedshuis was waarin men geen zaken mocht doen.

VALENTIN DE BOULOGNE (1591–1632)
c. 1618, Oil on canvas/Huile sur toile, 195 × 260 cm, Palazzo Barberini, Roma

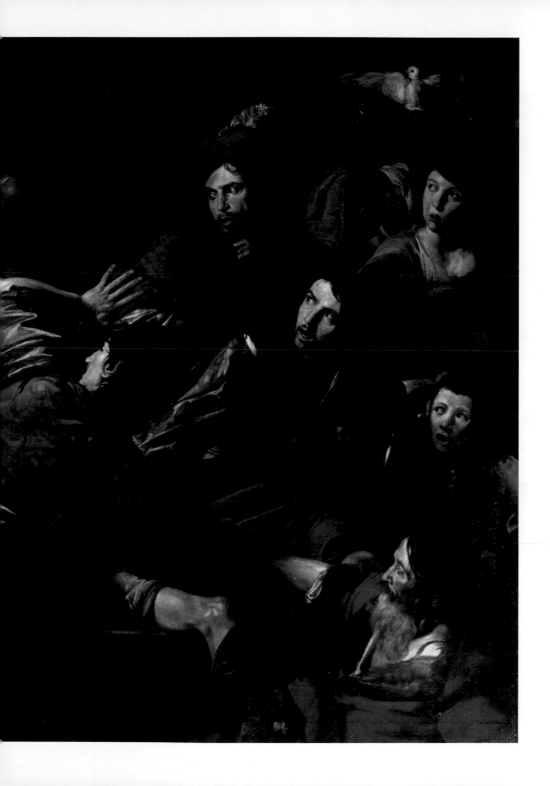

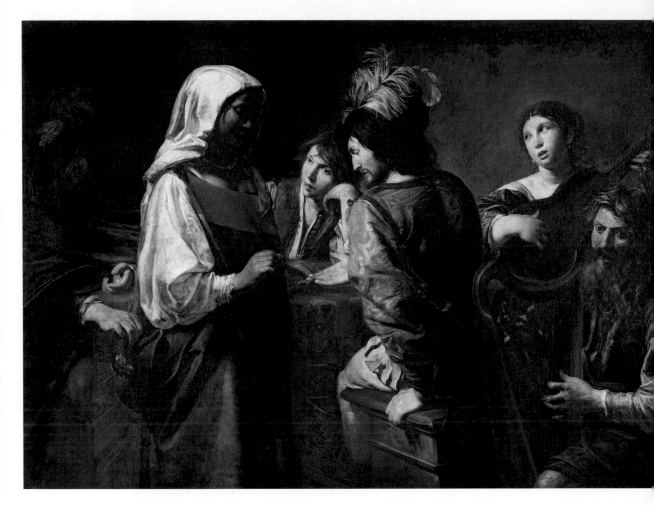

The Fortune Teller

La Diseuse de bonne aventure

Die Wahrsagerin

La adivina

la veggente

De waarzegster

VALENTIN DE BOULOGNE (1591–1632)
c. 1628, Oil on canvas/Huile sur toile, 125 × 175 cm, Musée du Louvre, Paris

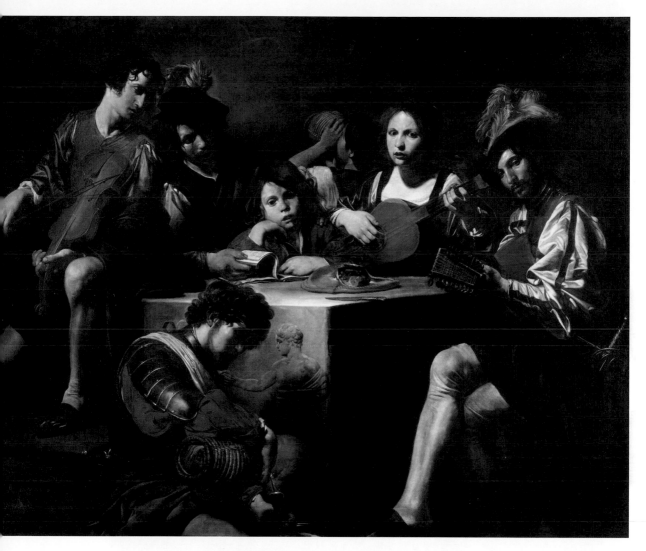

...ert with a Bas-Relief

...ontrasts between light and dark immediately reveal the ...nce of Caravaggio. Although the musicians are playing ...nging, their faces seem strangely sad. What could have ...eded this moment?

...ncert au bas-relief

...ontrastes entre l'ombre et la lumière montrent clairement ...ence du Caravage. Bien que les musiciens soient en train ...er et de chanter, ils arborent une bien triste mine. Qu'a-...en pu se passer ?

Das Konzert am Stein mit dem Relief

In den Kontrasten zwischen Hell und Dunkel wird sofort der Einfluss Caravaggios deutlich. Obwohl die Musikanten gerade spielen und singen, wirken ihre Mienen seltsam traurig. Was ist zuvor wohl geschehen?

Concierto sobre piedra con bajo relieve

Los contrastes entre la luz y la oscuridad revelan inmediatamente la influencia de Caravaggio. Aunque los músicos están tocando y cantando, sus caras parecen extrañamente tristes. ¿Qué crees que pasó antes?

Concerto

I contrasti tra chiaro e scuro rivelano immediatamente l'influenza di Caravaggio. Anche se i musicisti stanno suonando e cantando, i loro volti sembrano stranamente tristi. Cosa sarà successo prima?

Het concert rond de steen met reliëf

De contrasten tussen licht en donker onthullen meteen de invloed van Caravaggio. Hoewel de muzikanten spelen en zingen, staan hun gezichten merkwaardig triest. Wat zou er gebeurd zijn?

...TIN DE BOULOGNE (1591–1632)

...–25, Oil on canvas/Huile sur toile, 173 × 214 cm, Musée du Louvre, Paris

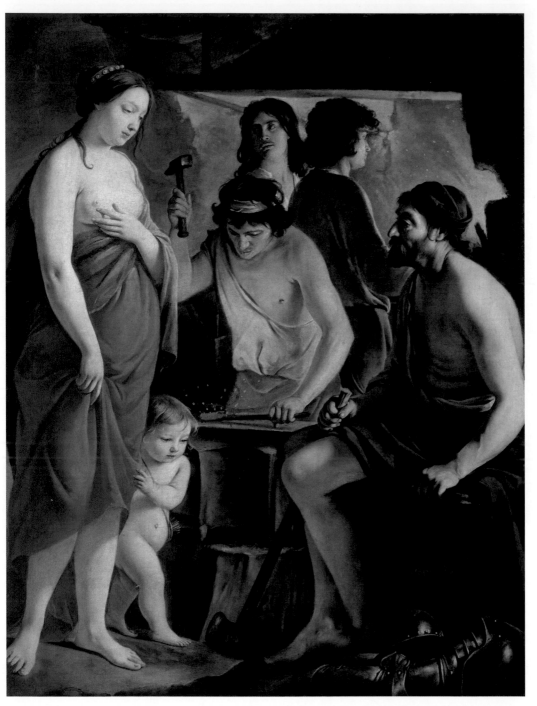

Venus at the Forge of Vulc[...]

Venus (with Cupid at her fe[...] enters the smithy of her hus[...] Vulcan (shown on the right [...] his attribute, the hammer) t[...] collect the weapons ordere[...] her son Aeneas.

Vénus dans la forge de Vu[...]

Vénus (avec Cupidon à ses [...] pieds) entre dans la forge de[...] son époux Vulcain (à droite[...] représenté avec un marteau[...] attribut) pour venir cherch[...] armes commandées pour s[...] fils Énée.

Venus in der Schmiede des Vulkan

Venus (mit Amor zu ihren Füßen) betritt die Schmiede[...] ihres Gatten Vulkan (rechts[...] seinem Attribut dem Hamr[...] dargestellt), um die für ihre[...] Sohn Aeneas bestellten Wa[...] abzuholen.

Venus en la herrería de Vulcano

Venus (con Cupido a sus pi[...] entra en la herrería de su m[...] Vulcano (que se muestra a [...] la derecha con su atributo e[...] martillo) para recoger las a[...] encargadas para su hijo Ene[...]

Venere nella fucina di Vul[...]

Venere (con Cupido ai suoi [...] piedi) entra nella fucina del[...] sposo Vulcano (mostrato su[...] destra con il martello, il suc[...] simbolo) per andare a pren[...] le armi commissionate per [...] figlio Enea.

Venus in de smederij van Vulcanus

Venus (met Amor aan haar [...] voeten) gaat de smederij va[...] haar man Vulcanus binnen [...] (rechts te zien met zijn attr[...] de hamer) om de wapens v[...] haar zoon Aeneas op te hal[...]

LOUIS LE NAIN (1593-1648)
1641, Oil on canvas/
Huile sur toile, 150 × 116,8 cm,
Musée des Beaux-Arts, Reims

...ant Family in an Interior

...e painting of a poor, but dignified peasant family. The ...Le Nain brothers commonly employed this motif, ...h often had religious undertones or was intended to ...olise virtues.

...lle de paysans dans un intérieur

...e de genre représentant une famille de paysans pauvres ...dignes. Ce motif, souvent utilisé par les trois frères Le ..., avait souvent des implications religieuses ou symbolisait ...tu et l'honnêteté.

...$ LE NAIN (1593-1648)

...2, Oil on canvas/Huile sur toile, 113 × 159 cm, Musée du Louvre, Paris

Bauernfamilie

Genrebild einer Bauernfamilie, die arm, aber würdevoll dargestellt ist. Das von den drei Malerbrüdern Le Nain häufig verwendete Motiv hatte oft religiöse Untertöne oder sollte Tugenden symbolisieren.

Familia de campesinos

Pintura de género de una familia campesina pobre pero digna. El motivo utilizado a menudo por los tres hermanos Le Nain tenía a menudo un trasfondo religioso o simbolizaba virtudes.

Famiglia di contadini

Pittura di genere di una famiglia contadina povera ma dignitosa. Il motivo spesso usato dai tre fratelli Le Nain aveva spesso sfumature religiose o era inteso a simboleggiare le virtù.

Boerenfamilie

Genreschilderij van een arm, maar waardig weergegeven boerengezin. Het motief dat de drie broers Le Nain vaak gebruikten, had veelal religieuze ondertonen of was bedoeld om deugden te symboliseren.

The Disciples at Emmaus

Les Pèlerins d'Emmaüs

Jünger in Emmaus

Los discípulos de Emaús

Discepoli a Emmaus

De discipelen in Emmaüs

LOUIS LE NAIN (1593–1648)

c. 1645, Oil on canvas/Huile sur toile, 75 × 92 cm, Musée du Louvre, Paris

Fortune Teller

[ir]ritated young man has a gypsy woman read his palm
[whil]e her companions stealthily pick his pockets. Theatrical
[moti]fs like this were very popular with the Caravaggisti.

[D]iseuse de bonne aventure

[...] eune homme à la mine irritée se fait prédire l'avenir par
[une] vieille gitane, alors que ses complices en profitent pour le
[voler]. Les scènes théâtrales de ce genre étaient très prisées par
[les c]aravagistes.

Die Wahrsagerin

Ein irritiert wirkender Jüngling lässt sich von einer Zigeunerin
die Zukunft weissagen. Ihre Gefährtinnen bestehlen ihn
derweil. Theatralische Motive wie dieses waren bei den
Caravaggisten sehr beliebt.

La adivina

Un joven irritado deja que una gitana le profetice el futuro.
Mientras tanto, sus compañeros le roban. Motivos teatrales
como este eran muy populares entre los caravaggistas.

Il veggente

Un giovane apparentemente irritato lascia che una zingara
predica il futuro. Nel frattempo, i suoi compagni lo derubano.
Motivi teatrali come questo erano molto popolari tra i
caravaggisti.

De waarzegster

Een geïrriteerde jonge man laat een zigeunerin zijn toekomst
voorspellen. Ondertussen bestelen haar metgezellinnen
hem. Theatrale motieven als deze waren erg geliefd bij de
caravaggisten.

[GEO]RGES DE LA TOUR (1593-1652)
[163]0-40, Oil on canvas/Huile sur toile, 101,9 × 123,5 cm, Metropolitan Museum of Art, New York

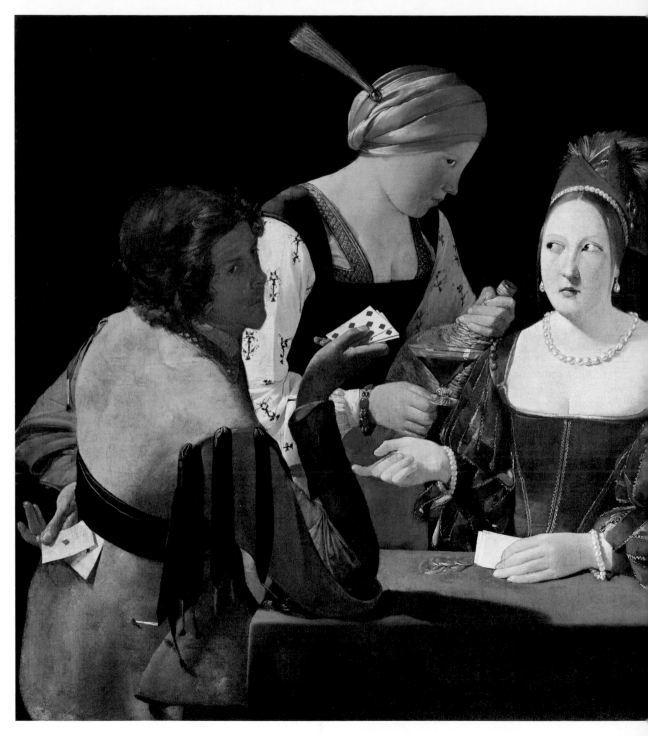

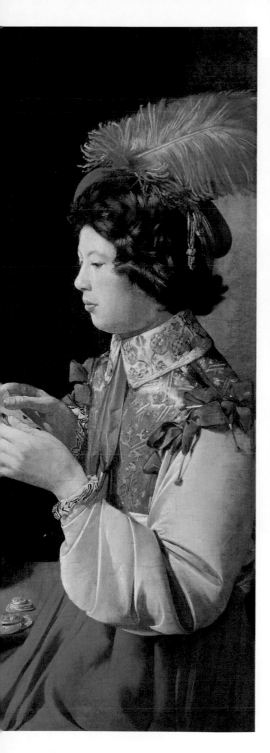

The Cheat with the Ace of Diamonds

Le Tricheur à l'as de carreau

Der Falschspieler mit dem Karo-Ass

El tramposo con el as de diamantes

Il baro con l'asso di quadri

De valsspeler met de ruitenaas

GEORGES DE LA TOUR (1593–1652)

c. 1635–38, Oil on canvas/Huile sur toile, 106 × 146 cm, Musée du Louvre, Paris

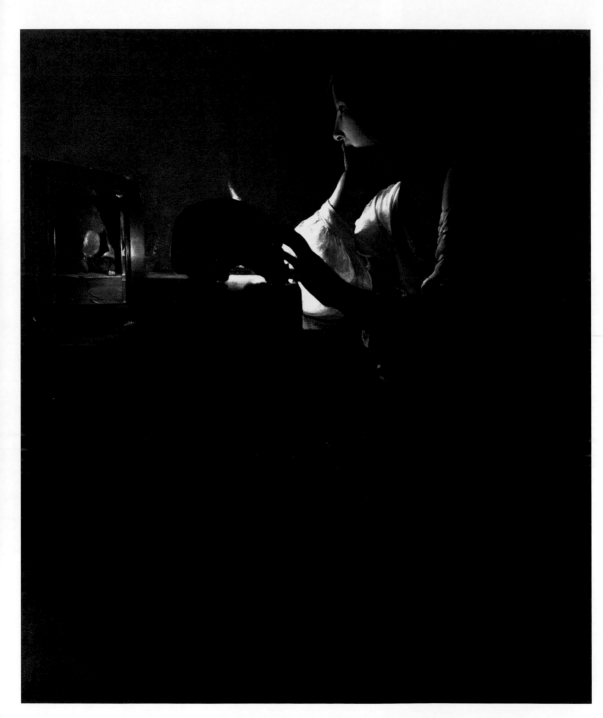

St Joseph the Carpenter
The veneration of Joseph increased in the 17th century, as did the taste for devotional pictures depicting the Holy Family in everyday situations as close to the life of the viewer as possible.

Saint Joseph charpentier
Le culte de Joseph prit de l'ampleur au XVIIᵉ siècle, de même que le goût pour les tableaux de dévotion représentant la Sainte Famille dans des situations du quotidien, c'est-à-dire aussi proche que possible de la vie du spectateur.

Josef als Zimmermann
Die Verehrung Josefs nahm im 17. Jahrhundert zu, ebenso die Vorliebe für Andachtsbilder, in denen die Heilige Familie in Alltagssituationen dargestellt war – möglichst nah am Leben der Betrachter.

San José, carpintero
La veneración de José aumentó en el siglo XVII, al igual que la preferencia por las imágenes devocionales que representan a la Sagrada Familia en situaciones cotidianas, lo más cercanas posible a la vida del espectador.

San Giuseppe il falegname
La venerazione per San Giuseppe aumentò nel XVII secolo, così come la preferenza per le immagini devozionali che ritraggono la Sacra Famiglia in situazioni quotidiane - il più vicino possibile alla vita dello spettatore.

Jozef als timmerman
De verering van Jozef nam in de 17e eeuw toe, net als de voorkeur voor devotiebeelden van de Heilige Familie in alledaagse situaties – zo dicht mogelijk bij het leven van de toeschouwer.

GEORGES DE LA TOUR (1593-1652)
c. 1642, Oil on canvas/Huile sur toile,
137 × 102 cm, Musée du Louvre, Paris

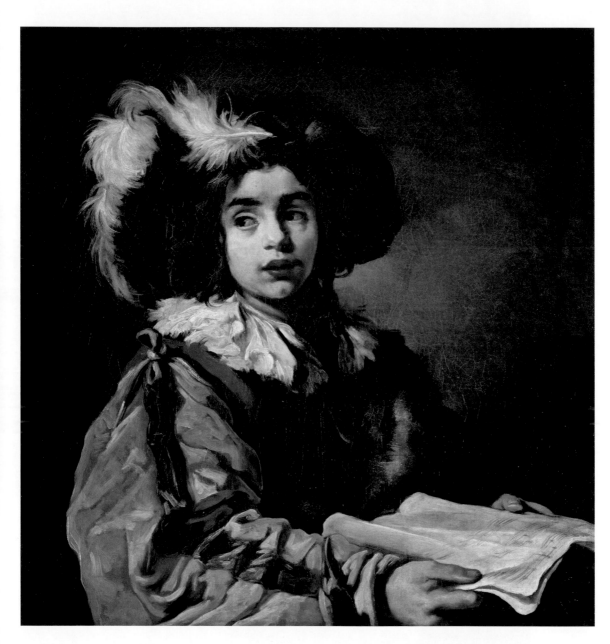

The Young
Singer

Le Jeune
Chanteur

Der junge
Sänger

El joven
cantante

Il giovane
cantante

De jonge
zanger

CLAUDE VIGN
(1593-1670
c. 1622/23, Oil
canvas/Huile s
toile, 95 × 90 c
Musée du
Louvre, Paris

Flora

The goddess of blossoms and spring is not presented here realistically, but rather in flawless youth. Her elegant posture is framed by flowers and fruits.

Flora

La déesse des fleurs et du printemps est représentée ici, en vertu des goûts de l'époque, non pas de manière réaliste donc mais à la jeunesse immaculée, dans une posture très élégante, elle est entourée de fleurs et de fruits.

Flora

Die Göttin der Blüte und des Frühlings wird hier ganz nach dem Geschmack der Zeit nicht realistisch, sondern in eleganter Haltung sowie makelloser Jugendlichkeit inmitten von Blüten und Früchten dargestellt.

Flora

diosa de las flores y la primavera se presenta aquí no de forma alista según el gusto de la época, o en una postura elegante y una mpecable juventud en medio de flores y frutas.

Flora

dea dei fiori e della primavera è presentata non realisticamente, ma in una posizione elegante e iovanile impeccabile in mezzo a fiori e a frutti.

Flora

De godin van de bloesems en de te wordt hier overeenkomstig de maak van die tijd niet realistisch oorgesteld, maar in een elegante ading en onberispelijk jeugdig te dden van bloemen en vruchten.

CLAUDE VIGNON (1593-1670)
c. 1630-40, Oil on canvas/
Huile sur toile, 89,4 × 76,5 cm,
Residenzgalerie, Salzburg

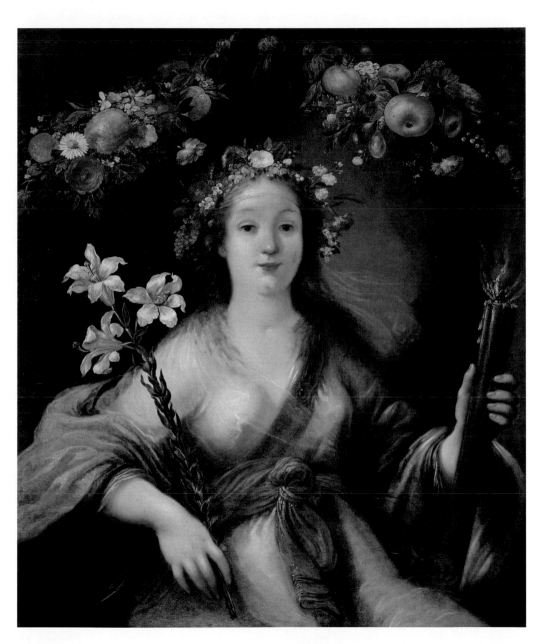

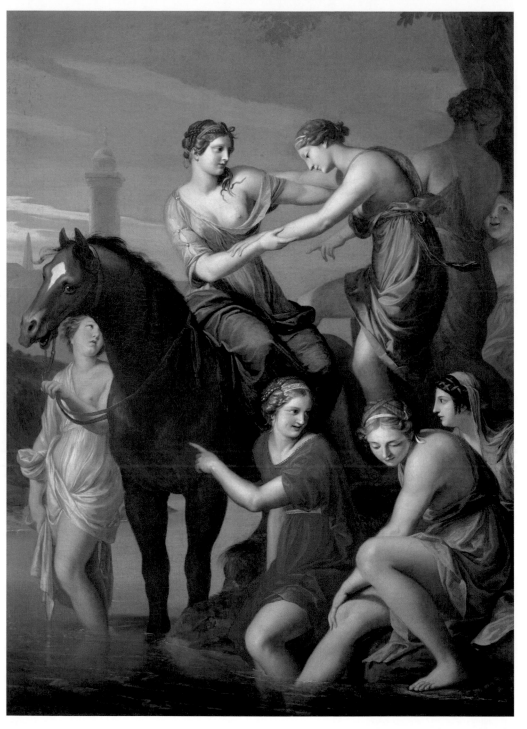

Cloelia Crossing the Tiber

Plutarch's story of Cloelia fleeing with fellow hostages from the Etruscans, is presented by Stella elegantly and in bright colors. Ma[]Antoinette had the painting hung[]the Palace of Versailles.

Clélie passant le Tibre

Stella représenta avec élégance l'histoire de Plutarque dans laque[]Clélie fuit devant les Étrusques a[]d'autres otages. Marie-Antoinette[]fit accrocher ce tableau aux couleurs lumineuses dans le châte[]de Versailles.

Cloelia überquert den Tiber

Die Geschichte von Plutarch, in der Cloelia mit anderen Geiseln vor den Etruskern flieht, wird vo[]Stella elegant und in leuchtenden[]Farben dargestellt. Marie-Antoinette ließ das Bild im Schlo[]Versailles aufhängen.

Cloelia cruza el Tíber

La historia de Plutarco, en la que Cloelia huye con otros rehenes de los etruscos, es presentada por Stella con elegancia y colores brillantes. María Antonieta hizo colgar el cuadro en el Palacio de Versalles.

Clelia attraversa il Tevere

La storia di Plutarco, in cui Clelia[]fugge insieme ad altri ostaggi dag[]Etruschi, è presentata da Stella con eleganza e colori vivaci. Mar[]Antonietta fece appendere il dipi[]al Castello di Versailles.

Cloelia steekt de Tiber over

Het verhaal van Plutarchus, waar[]Cloelia samen met andere gijzela[]de Etrusken ontvlucht, wordt doo[]Stella elegant en in felle kleuren geschilderd. Marie-Antoinette lie[]het schilderij ophangen in het pa[]van Versailles.

JACQUES STELLA (1596–1657)

c. 1635–45, Oil on canvas/Huile sur to[]137 × 101 cm, Musée du Louvre, Paris

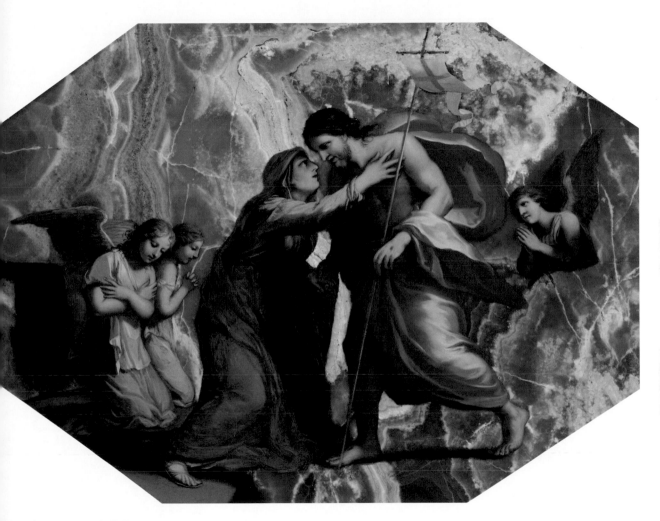

The Risen Christ Appearing to the Virgin

Jésus-Christ réssuscité apparaissant à la Vierge

Der auferstandene Jesus Christus erscheint der Jungfrau

Jesucristo resucitado se aparece a la Virgen

Gesù Cristo risorto appare alla Vergine

De opgestane Jezus verschijnt aan Maria

JACQUES STELLA (1596–1657)

1640, Oil on alabaster, reinforced with a slate plate/Huile sur albâtre renforcé d'une plaque d'ardoise, 31 × 40 cm, Musée du Louvre, Paris

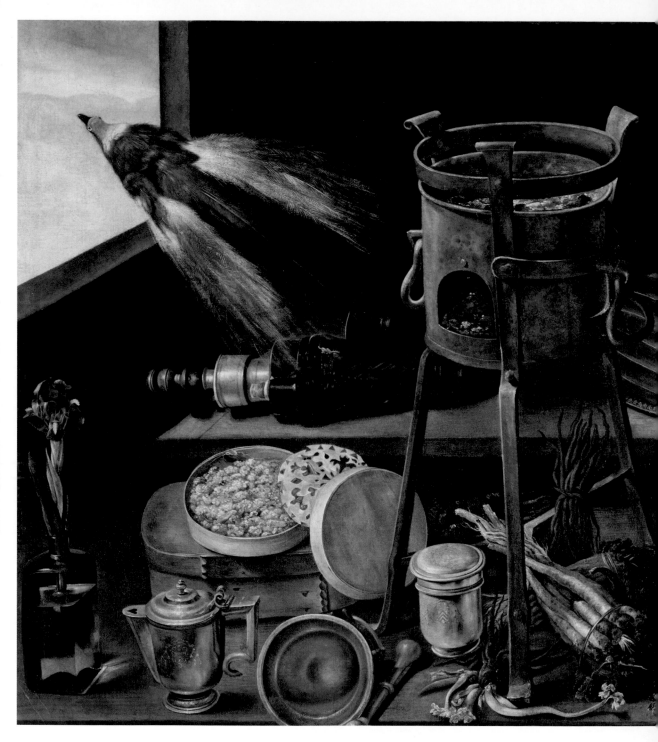

The Five Senses and the Four Elements

A typical theme of the era: mirrors, musical instruments, flowers, fruit, and playing cards stand for the five senses; the bird, the coal basin, the water jug, and root vegetables represent the four elements.

Les Cinq Sens et les quatre éléments

Un sujet typique de l'époque : les cinq sens sont représentés entre autres par un miroir, un instrument, des fleurs, des fruits et un jeu de cartes, tandis que les quatre éléments sont symbolisés par l'oiseau, le brasero, la cruche d'eau et les légumes-racines.

Die fünf Sinne und die vier Elemente

Ein typisches Thema der Zeit: Für die fünf Sinne stehen Spiegel, Instrument, Blumen, Obst und Kartenspiel, für die vier Elemente der Vogel, das Kohlebecken, das Wasserkännchen und Wurzelgemüse.

Los cinco sentidos y los cuatro elementos

Un tema típico de la época: espejos, instrumentos, flores, frutas y cartas representan los cinco sentidos, los cuatro elementos son el pájaro, la cuenca de carbón, la jarra de agua y los ubérculos.

I cinque sensi e i quattro elementi

Un tema tipico dell'epoca: specchi, strumenti, fiori, frutta e carte da gioco rappresentano i cinque sensi, i quattro elementi naturali sono l'uccello, la conca di carbone, la brocca d'acqua e gli ortaggi da radice.

De vijf zintuigen en de vier elementen

Een typisch thema van die tijd: spiegels, instrumenten, bloemen, fruit en speelkaarten staan voor de vijf zintuigen; de vier elementen zijn de vogel, de kolenkit, de waterkan en de wortelgroenten.

JACQUES LINARD (1597–1645)
1627, Oil on canvas/Huile sur toile, 105 × 153 cm, Musée du Louvre, Paris

Basket of Pomegranate, Peaches, and Grapes

Panier de grenades, pêches et raisins

Korb mit Granatapfel, Pfirsichen und Trauben

Cesta con granadas, melocotones y uvas

Cesto con melograni, pesche e uva

Mand met granaatappels, perziken en druiven

JACQUES LINARD (1597–1645)

c. 1635, Oil on canvas/Huile sur toile, 46 × 61 cm, Musée du Louvre, Paris

Cardinal Richelieu

Le Cardinal de Richelieu

Kardinal Richelieu

Cardenal Richelieu

Il Cardinale Richelieu

Kardinaal Richelieu

PHILIPPE DE CHAMPAIGNE (1602–74)
c. 1639, Oil on canvas/Huile sur toile,
222 × 155 cm, Musée du Louvre, Paris

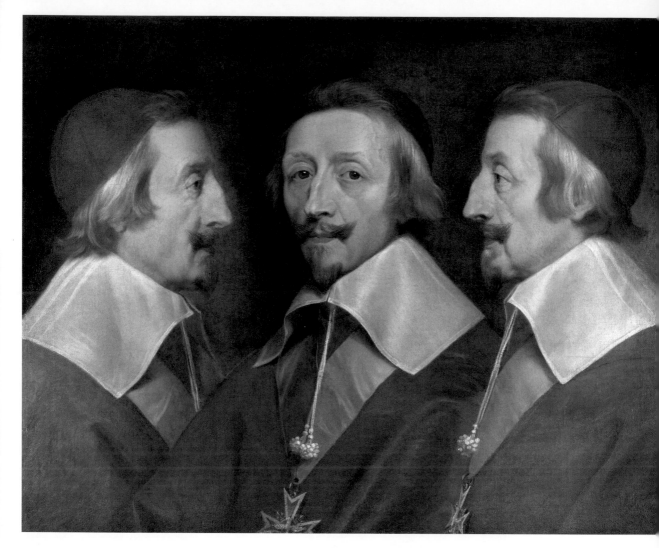

Triple Portrait of Cardinal Richelieu

This portrait, which shows the then 60-year-old cardinal from the front and both sides, served as a model for a sculpture. The inscription above the right profile picture reads: "This is the better one."

Triple Portrait du cardinal de Richelieu

On y voit le cardinal, alors âgé de près de 60 ans, de face et de profil. Ce portrait devait servir de modèle à une sculpture. En haut à droite, on peut lire : « de ces deux profils, cecy [sic] est le meilleur ».

Dreifachporträt des Kardinals Richelieu

Der damals knapp 60-jährige Kardinal wird von vorn sowie von beiden Seiten gezeigt. Das Porträt diente als Vorlage für eine Skulptur. Die Inschrift über dem rechten Profilbild besagt: „Dies ist das bessere".

Triple retrato del Cardenal Richelieu

El entonces cardenal de casi 60 años se muestra de frente y de ambos lados. El retrato sirvió de modelo para una escultura. La inscripción sobre la foto del perfil de la derecha dice: "Esta es la mejor".

Triplo ritratto del cardinale Richelieu

Il cardinale, allora quasi sessantenne, è raffigurato sia frontalmente sia da entrambi i lati. L'iscrizione sopra l'immagine del profilo destro dice: "Questo è il migliore".

Drievoudig portret van kardinaal Richelieu

De toen bijna 60 jaar oude kardinaal wordt van voren en va beide zijden getoond. Het portret diende als voorbeeld voo een sculptuur. Op de tekst boven het rechterprofiel staat: 'I is de betere kant.'

PHILIPPE DE CHAMPAIGNE (1602–74)

c. 1642, Oil on canvas/Huile sur toile, 58,7 × 72,8 cm, The National Gallery, London

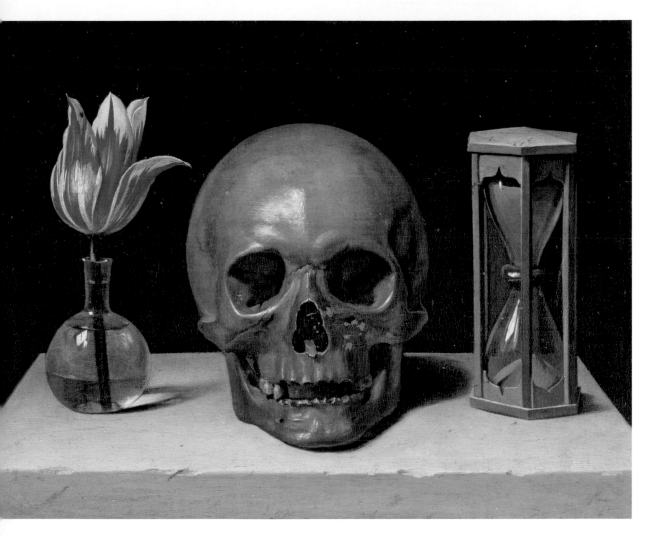

Vanitas or Allegory of Human Life

... ry clear memento mori still life. Tulip, skull, and hourglass ... onish the viewer: "Remember you are mortal!" The ... ne dates back to antiquity, but was also popular with ... stian painters.

...té ou Allégorie de la Vie humaine

... nature morte Memento mori très explicite – la tulipe, ... âne et le sablier le rappellent : « Souviens-toi que tu ... mourir ! ». Cette idée remonte à l'Antiquité, mais était ... ement répandue chez les peintres chrétiens.

...IPPE DE CHAMPAIGNE (1602–74)

... Oil on canvas/Huile sur toile, 28,8 × 37,5 cm, Musée de Tessé, Le Mans

Vanitas oder Allegorie auf das menschliche Leben

Ein sehr deutliches Memento-mori-Stillleben – Tulpe, Totenschädel und Sanduhr mahnen: „Bedenke, dass du sterblich bist!" Der Gedanke stammt aus der Antike, war aber auch bei christlichen Malern populär.

Vanitas o alegoría de la vida humana

Un recuerdo muy claro del bodegón mori –tulipán, calavera y reloj de arena– advierte: "¡Recuerda que eres mortal!" La idea se remonta a la antigüedad, pero también fue popular entre los pintores cristianos.

Vanitas o allegoria della vita umana

Una natura morta con un memento mori molto chiaro: il tulipano, il teschio e la clessidra ammoniscono: "Ricordati che sei mortale!" L'idea risale all'antichità, ma era anche popolare tra i pittori cristiani.

Vanitas of allegorie van het menselijk leven

Een heel duidelijk memento mori-stilleven – tulp, schedel en zandloper waarschuwen: vergeet niet dat je sterfelijk bent! Het idee stamt uit de klassieke oudheid, maar was ook populair bij christelijke schilders.

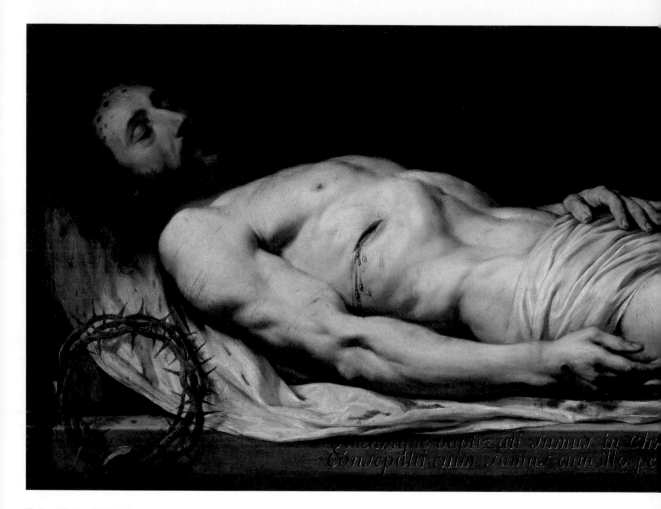

The Dead Christ on His Shroud

Le Christ mort couché sur son linceul

Der tote Christus, auf dem Leichentuch liegend

Cristo muerto, tendido en la mortaja

Il Cristo morto

Dode Christus liggend op de lijkwade

PHILIPPE DE CHAMPAIGNE (1602–74)

c. 1654, Oil on canvas/Huile sur toile, 68 × 197 cm, Musée du Louvre, Paris

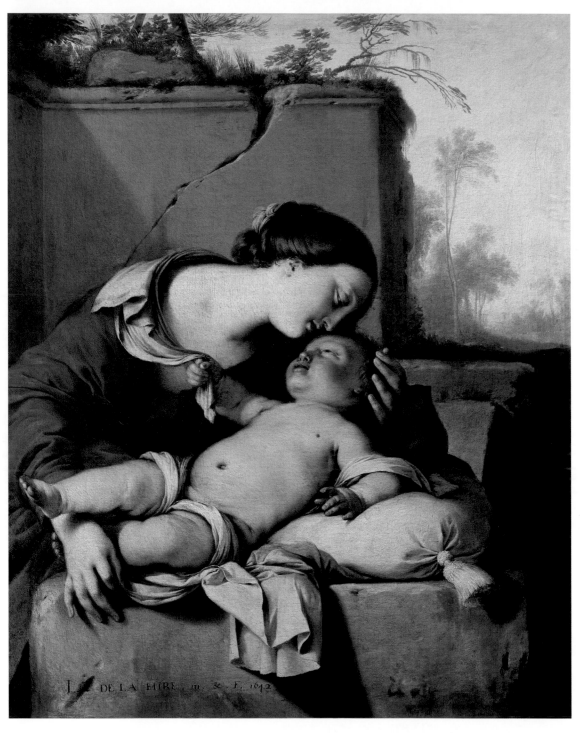

Virgin and Ch

La Vierge à
l'Enfant

Jungfrau mit K

Virgen con niñ

Vergine con
Bambino

Maagd met K

LAURENT DE LA
HYRE (1606-5

1642, Oil on can
Huile sur toile,
114 × 92 cm, Mus
du Louvre, Paris

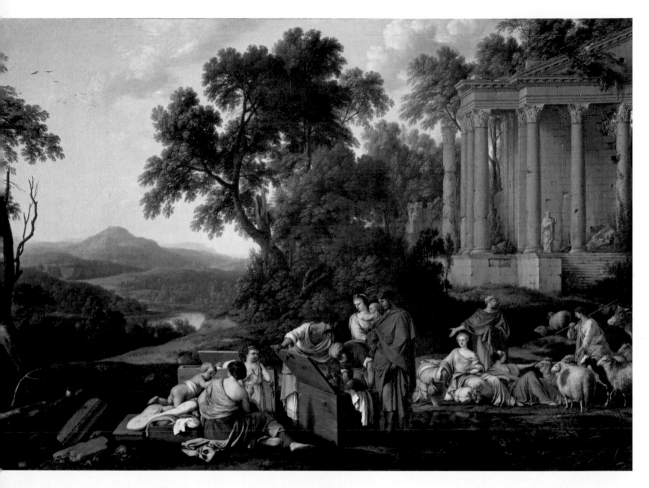

an Searching Jacob's Baggage for the Stolen Idols
Old Testament scene in a classical landscape: Jacob has
etly fled his uncle Laban with the latter's daughters and
ly idols. Laban has tracked them down, but searches for
pictures in vain.

an cherchant ses idoles dans les bagages de Jacob
scène de l'Ancien Testament dans un paysage classique :
b quitta en douce son oncle Laban avec les filles de
ernier et ses idoles. Laban réussit à les rattraper, mais
cha en vain les idoles.

Laban sucht Götterbilder im Gepäck Jakobs
Eine alttestamentarische Szene in klassischer Landschaft:
Jakob verließ seinen Onkel Laban heimlich mit dessen
Töchtern und Götterbildern. Laban hat sie aufgespürt, sucht
aber vergeblich nach den Bildern.

Labán busca cuadros de dioses en el equipaje de Jakob.
Una escena del Antiguo Testamento en un paisaje clásico:
Jacob dejó en secreto a su tío Labán con sus hijas y sus
pinturas de dioses. Labán rastrea las pinturas, pero las busca
en vano.

Labano cerca i suoi idoli nei bagagli di Giacobbe
Una scena dell'Antico Testamento in un paesaggio classico:
Giacobbe lasciò in segreto lo zio Labano con le sue figlie e gli
idoli. Labano li rintraccia, ma cerca gli idoli invano.

Laban zoekt naar afgodsbeelden in de bagage van Jacob
Een scène uit het Oude Testament in een klassiek landschap:
Jacob verliet stiekem zijn oom Laban met diens dochters
en afgodsbeelden. Laban heeft ze opgespoord, maar zoekt
tevergeefs naar de beelden.

RENT DE LA HYRE (1606-56)
Oil on canvas/Huile sur toile, 95 × 133 cm, Musée du Louvre, Paris

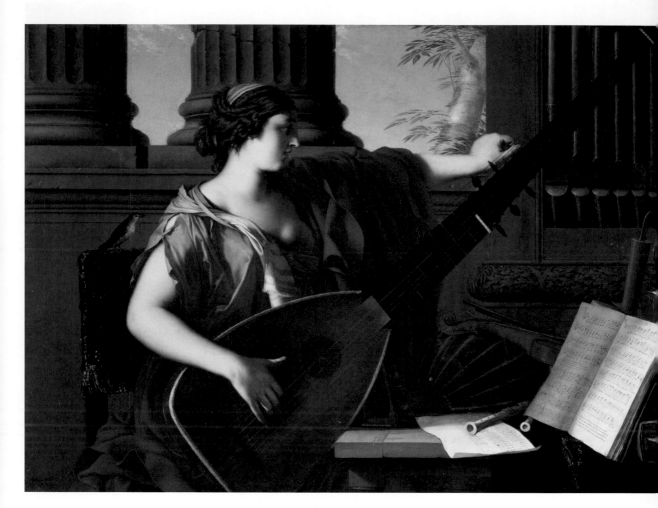

Allegory of Music

Allégorie de la Musique

Allegorie der Musik

Alegoría de la música

Allegoria della musica

Allegorie van de muziek

LAURENT DE LA HYRE (1606-56)

1649, Oil on canvas/Huile sur toile, 105,7 × 144,1 cm, Metropolitan Museum of Art, New York

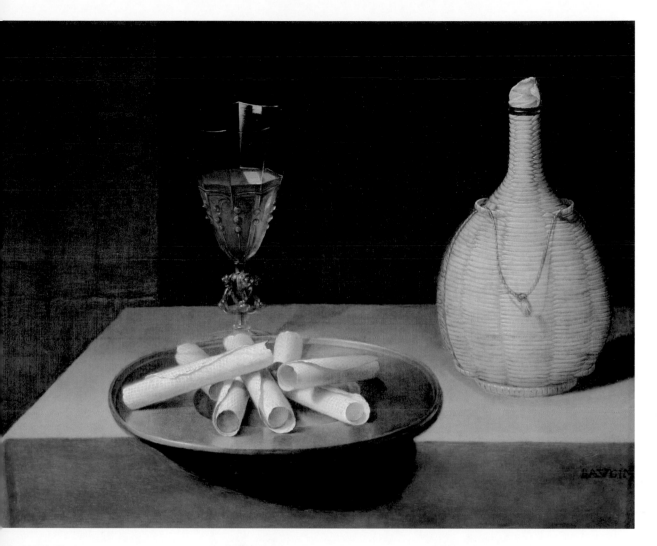

Life with Wafer-Biscuits

austere still life: nothing but a plate with wafer
, a glass of wine, and a bast bottle. Still lifes did not
ays carry a deeper message, but were sometimes
ly decorative.

Dessert de gaufrettes

nature morte austère : rien d'autre qu'un plat garni de
rettes, un verre de vin et une fiasque recouverte d'osier.
natures mortes ne recélaient pas toujours un sens caché,
avaient parfois une visée purement décorative, comme
le cas de celle-ci.

Das Waffeldessert

Ein karges Stillleben: nichts als ein Teller mit Waffelröllchen,
ein Glas Wein und eine Bastflasche. Nicht immer bargen
Stillleben eine tiefere Botschaft, sondern waren manchmal
einfach nur dekorativ.

El postre de obleas

Una naturaleza muerta estéril: nada más que un plato con
rollos de obleas, una copa de vino y una botella de líber. Las
naturalezas muertas no siempre transmiten un mensaje
profundo, sino que a veces son simplemente decorativas.

Il dessert wafer

Una natura morta povera: nient'altro che un piatto con cialde,
un bicchiere di vino e fiasco di vino. Le nature morte non
sempre portavano un messaggio più profondo, a volte erano
semplicemente decorative.

Het wafeldessert

Een sober stilleven: niets meer dan een bord met
wafelrolletjes, een glas wijn en een bastvezelfles. Stillevens
droegen niet altijd een diepere boodschap over, maar waren
soms gewoon decoratief.

N BAUGIN (C. 1610–63)
51, Oil on wood/Huile sur bois, 41 × 52 cm, Musée du Louvre, Paris

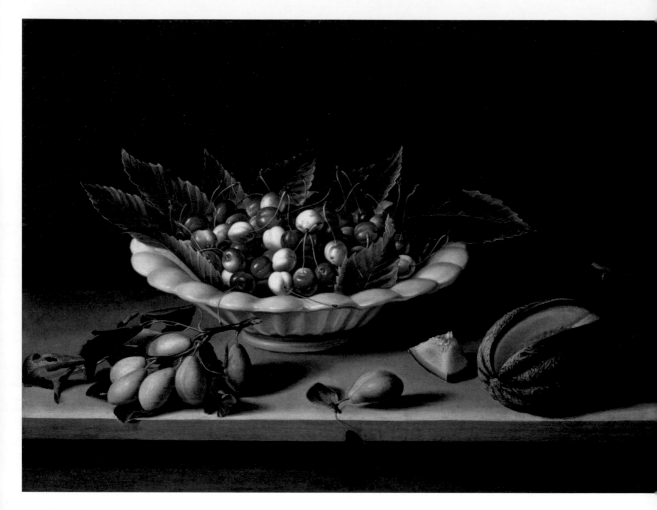

Bowl of Cherries, Plums, and Melon

Coupe de cerises, prunes et melon

Schale mit Kirschen, Pflaumen und Melone

Recipiente con cerezas, ciruelas y melón

Ciotola di ciliegie, prugne e meloni

Schaaltje met kersen, pruimen en een meloen

LOUISE MOILLON (1610–96)
1633, Oil on wood/Huile sur bois, 48 × 65 cm, Musée du Louvre, Paris

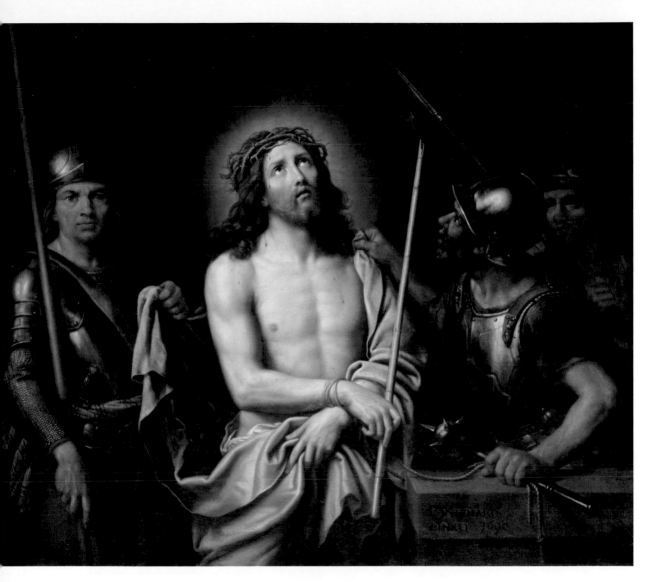

Ecce Homo

PIERRE MIGNARD (1612–95)

Ecce Homo, Oil on canvas/Huile sur toile, 138 × 163,5 cm, Musée des Beaux-Arts, Rouen

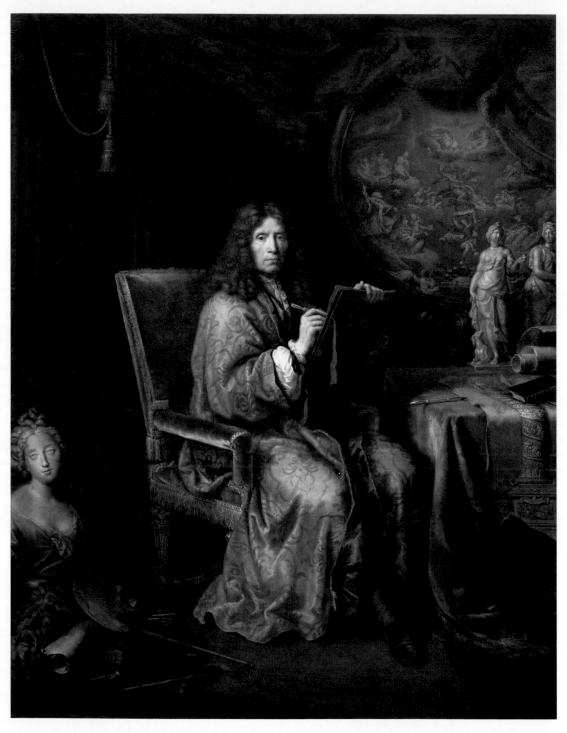

Self-Portrait

Autoportrait

Selbstbildnis

Autorretrato

Autoritratto

Zelfportret

**PIERRE MIGNARD
(1612–95)**
1690, Oil on canvas/Hu
sur toile, 235 × 188 cm,
Musée du Louvre, Paris

Pan and Syrinx

A scene from Ovid's *Metamorphoses:* the nymph Syrinx flees from the advances of the shepherd god Pan to a river god. Soon after this moment, she will be turned into a reed.

Pan et Syrinx

Il s'agit d'une scène des *Métamorphoses* d'Ovide : la nymphe Syrinx (représentée dans les couleurs claires de l'innocence) fuit les avances de Pan, le dieu des bergers, se réfugiant auprès d'un dieu du fleuve. Elle se changera peu après en roseaux.

Pan und Syrinx

Eine Szene aus Ovids *Metamorphosen:* Die Nymphe Syrinx flieht vor den Avancen des Schäfergottes Pan zu einem Flussgott. Nur kurz darauf wird sie sich in ein Schilfrohr verwandeln.

Pan y Siringa

Una escena de las *Metamorfosis* de Ovidio: la ninfa Siringa huye de los avances del dios pastor Pan hacia un dios del río. Poco tiempo después se convertirá en una caña.

Pan e Siringa

Una scena dalle *Metamorfosi* di Ovidio: la ninfa Siringa fugge dalle adulazioni del dio pastore Pan verso il fiume. Ma poco tempo dopo verrà mutata in canne palustri.

Pan en Syrinx

Een scène uit Ovidius' *Metamorfosen:* de nimf Syrinx vlucht voor de avances van de herdersgod Pan naar een riviergod. Niet lang daarna zal zij veranderen in een rietstengel.

PIERRE MIGNARD (1612-95)
c. 1690, Oil on canvas/
Huile sur toile, 113 × 89 cm,
Musée du Louvre, Paris

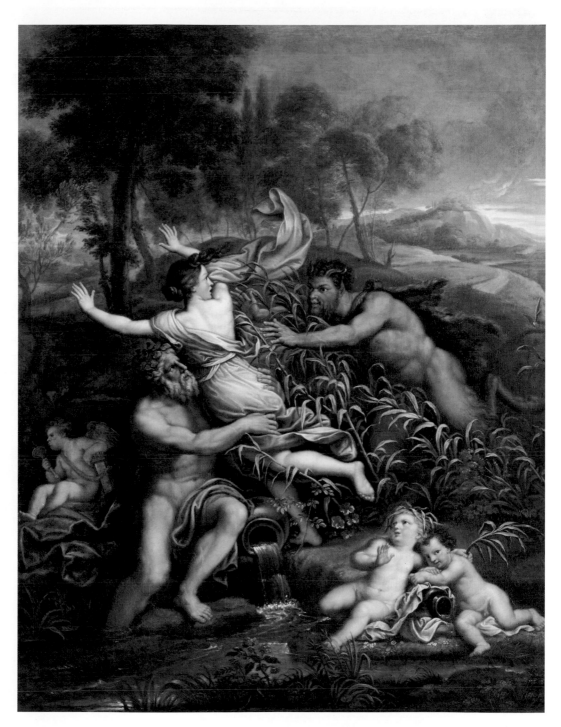

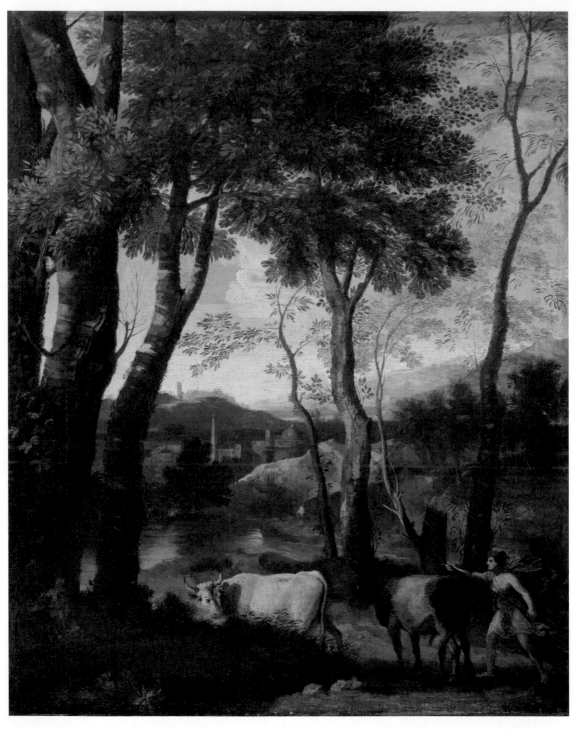

Landscape with
Cattle and a
Horseman

Paysage avec
un vacher

Landschaft mit
Viehherde

Paisaje con reb
de ganado

Paesaggio con
mandria di bov

Landschap met
kudde rundere

GASPARD DUGHE
(1615–75)
c. 1637/38, Oil on
canvas/Huile sur
toile, 54,2 × 43,5 c
The National
Gallery, London

Landscape
Wate

Paysage
case

Landschaf
Wasse

Paisaje
case

Paesa
con cas

Landschap
wate

GASPARD DU
(1615
1650–60, O
canvas/Huile sur
30 × 26 cm, M
del Prado, M

257

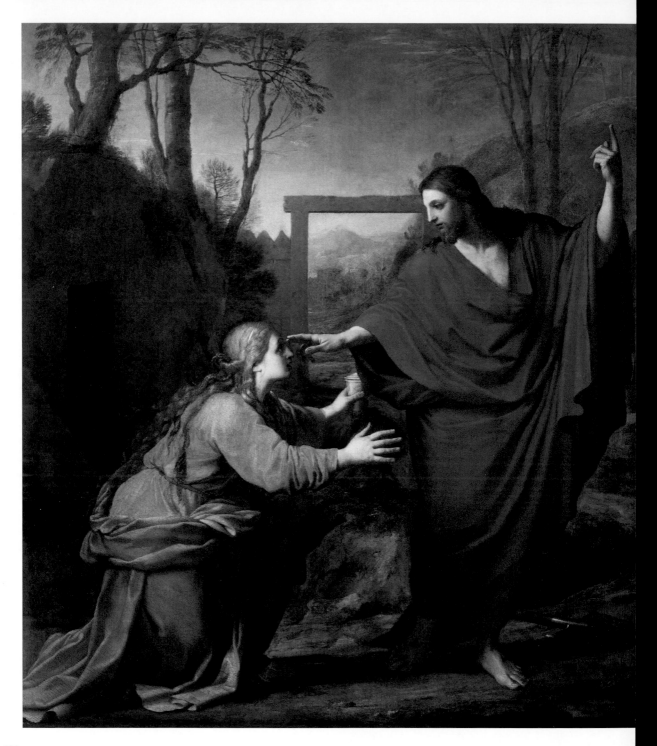

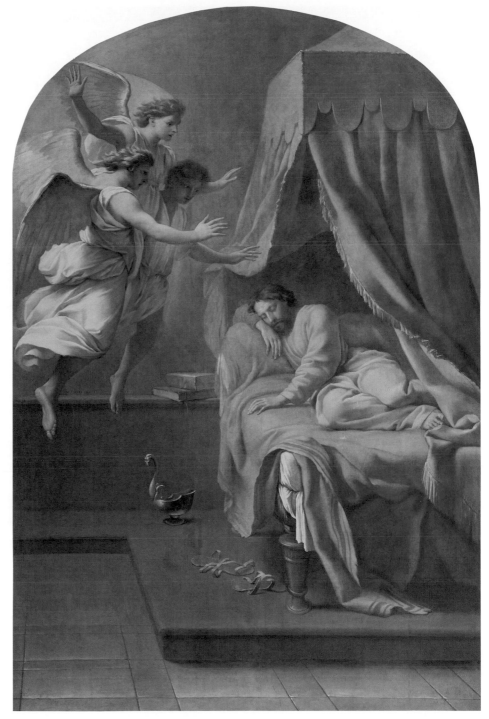

The Dream of St Bruno

Le Songe de saint Bruno

Der Traum des Heiligen Bruno

El sueño de San Bruno

Il sogno di san Bruno

De droom van de heilige Bruno

EUSTACHE LE SUEUR (1616–55)

1645-48, Oil on canvas/Huile sur toile,
193 × 130 cm, Musée du Louvre, Paris

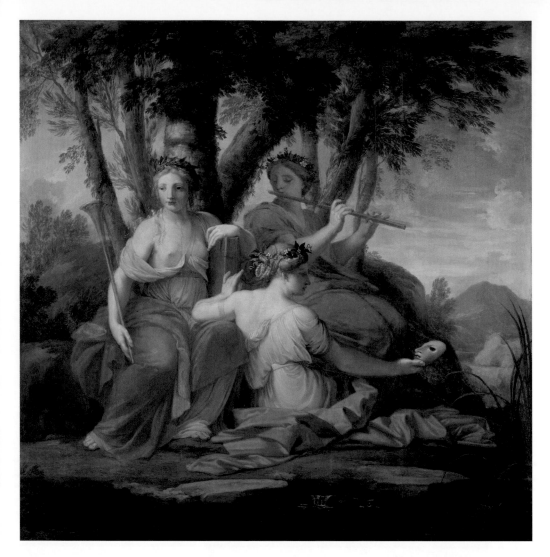

The Muses Clio, Euterpe, and Thalia
Three of the nine muses, daughters of Zeus: Clio
(trumpet and book proclaim the great achievements
of humankind), Euterpe (muse of music, with flute)
and Thalia (with a mask for the theatre).

Les Muses Clio, Euterpe et Thalie
On voit ici trois des neuf muses, filles de Zeus : Clio
(la trompette et le livre font référence aux grands
accomplissements de l'humanité), Euterpe (la muse
de la musique, avec sa flûte) et Thalia (avec son
masque symbolisant le théâtre).

Die Musen Klio, Euterpe und Thalia
Drei der neun Musen, Töchter des Zeus: Klio (Buch
und Trompete künden von großen Errungenschaften
der Menschheit), Euterpe (Muse der Musik mit
Flöte) und Thalia (mit einer Maske für das Theater).

Las Musas Clío, Euterpe y Talía Klio
Tres de las nueve musas, hijas de Zeus: Clío
(trompeta y libro anuncian grandes logros de la
humanidad), Euterpe (musa de la música con flauta)
y Talía (con una máscara para el teatro).

Le Muse Clio, Euterpe e Talia
Tre delle nove muse, figlie di Zeus: Clio (tromba e
libro annunciano i grandi progressi dell'umanità),
Euterpe (musa della musica con il flauto) e Talia
(con la maschera per il teatro).

De muzen Clio, Euterpe en Thalia
Drie van de negen muzen, dochters van Zeus: Clio
(trompet en boek kondigen grote verworvenheden
van de mensheid aan), Euterpe (de muze van de
muziek met fluit) en Thalia (met een masker voor
het theater).

EUSTACHE LE SUEUR (1616–55)
c. 1652–55, Oil on canvas/Huile sur toile, 130 × 130 cm, Musée du Louvre, Paris

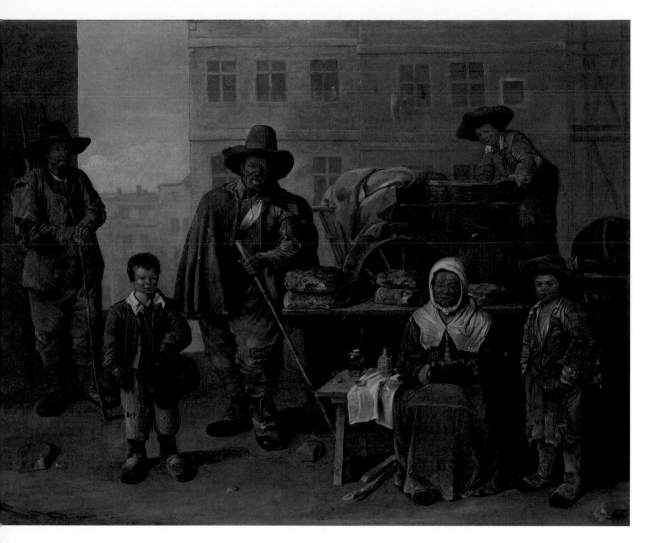

Baker's Cart

harrette du boulanger

Bäckerkarren

rro del panadero

retto del panettiere

akkerskar

MICHELIN (1616–70)

Oil on canvas/Huile sur toile, 98,4 × 125,4 cm, Metropolitan Museum of Art, New York

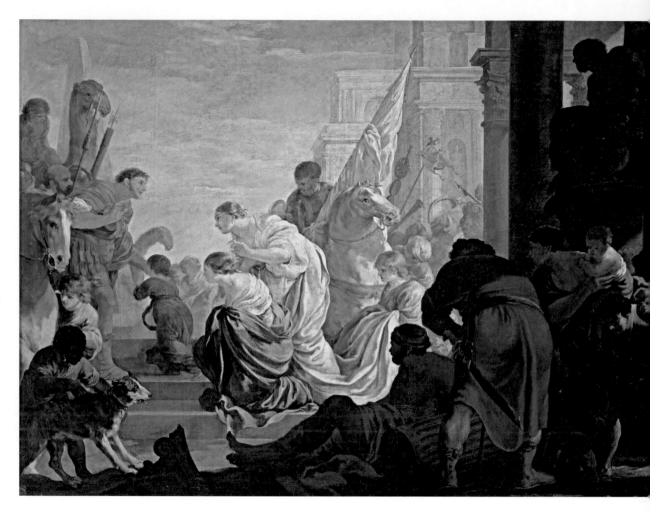

The Meeting of Antony and Cleopatra

La Rencontre d'Antoine et de Cléopâtre

Die Begegnung zwischen Marcus Antonius und Kleopatra

El encuentro entre Marco Antonio y Cleopatra

L'incontro tra Marco Antonio e Cleopatra

De ontmoeting tussen Marcus Antonius en Cleopatra

SÉBASTIEN BOURDON (1616-71)

c. 1645, Oil on canvas/Huile sur toile, 145 × 197 cm, Musée du Louvre, Paris

King Charles X Gu

Le Roi Charles X Gus

König Karl X. Gu

Rey Carlos X Gus

Re Carlo X Gus

Koning Karel X Gustaaf van Zwe

SÉBASTIEN BOURDON (161

c. 1652/53, Oil on canvas/Huile sur toile, 102 × 82 cm, Nationalmuseum, Stock

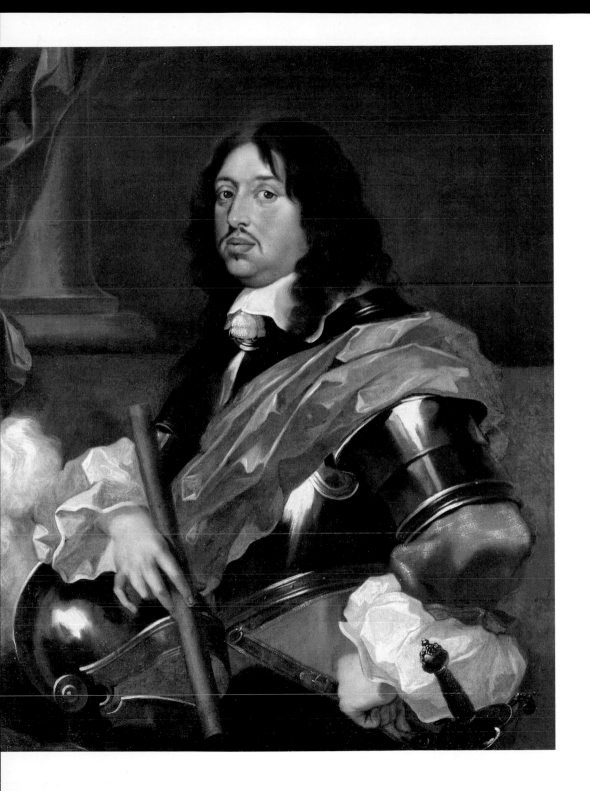

The Bronze Snake
A classical-dramatic representation of a biblical scene: Moses (in red) points to the bronze snake, which can heal repentant sinners of snake bites. In the foreground, sick people beg for forgiveness.

Le Serpent d'airain
Une représentation classique et dramatique d'une scène biblique : Moïse, en rouge, montre le serpent d'airain, qui peut guérir des morsures de serpent les pécheurs repentants. Au premier plan, des malades implorent le pardon.

Die bronzene Schlange
Klassisch-dramatische Darstellung einer biblischen Szene: Moses (in Rot) zeigt auf die bronzene Schlange, die reuige Sünder von Schlangenbissen zu heilen vermag. Vorn erkrankte Menschen, um Vergebung bettelnd.

La Serpiente de Bronce
Representación clásico-dramática de una escena bíblica: Moisés (en rojo) señala a la serpiente de bronce, que puede curar a los pecadores arrepentidos de las mordeduras de serpiente. Delante de gente enferma pidiendo perdón.

Il serpente di bronzo
Rappresentazione classico-drammatica di una scena biblica: Mosè (in rosso) indica il serpente di bronzo, che può guarire i peccatori pentiti dai morsi di serpente. Davanti, malati che chiedono perdono.

De bronzen slang
Klassiek-dramatische voorstelling van een Bijbels tafereel: Mozes (in het rood) wijst naar de bronzen slang, die berouwvolle zondaars van slangenbeten zou kunnen genezen. Vooraan zieke mensen die om vergeving smeken.

SÉBASTIEN BOURDON (1616–71)
c. 1650–60, Oil on canvas/Huile sur toile, 113 × 151 cm, Museo del Prado, Madrid

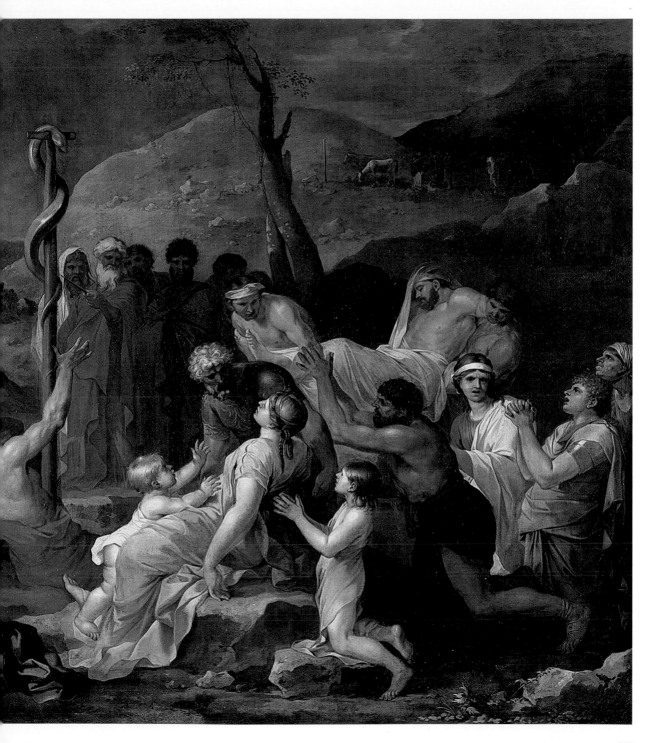

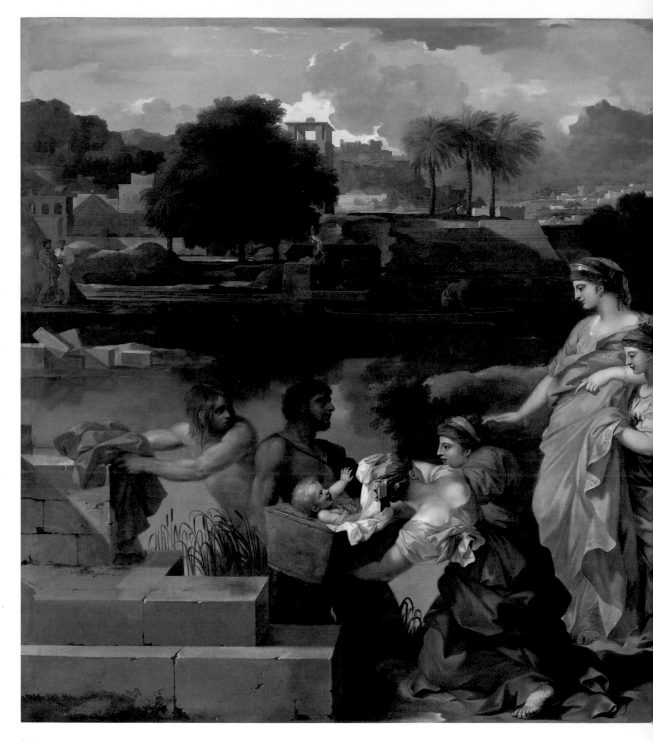

The Finding of Moses

An academic scene recalling Poussin's style. The quiet, statuesque, symmetrical figures look like an antique frieze: the Pharaoh's daughter, in yellow, and her ladies in waiting have just found Moses in his basket.

Moïse sauvé des eaux

À la manière de Poussin et de l'Académie, ces personnages calmes et symétriques, semblables à des statues, rappellent une frise antique : la fille du pharaon, en jaune, et ses suivantes viennent de trouver Moïse dans sa corbeille.

Die Auffindung des Moses

Ganz akademisch, in der Manier Poussins wirken die ruhigen, statuesken, symmetrischen Figuren wie ein antiker Fries: Die Tochter des Pharaos in Gelb und ihre Hofdamen finden soeben Moses in seinem Körbchen.

El hallazgo de Moisés

Académicamente, a la manera de Poussin, las figuras silenciosas, esculturales y simétricas parecen un friso antiguo: la hija del Faraón vestida de amarillo y sus damas de la corte encuentran a Moisés en su pequeña canasta.

Il ritrovamento di Mosè

Dal punto di vista accademico, alla maniera di Poussin, le figure silenziose, statuarie e simmetriche appaiono ad un antico fregio: la figlia del Faraone in giallo e le sue ancelle trovano Mosè nella cesta.

De vondst van Mozes

Heel academisch, op de manier van Poussin, zien de rustige, statueske, symmetrische figuren eruit als een antieke fries: de dochter van de farao in het geel en haar hofdames hebben Mozes net gevonden in zijn mandje.

SÉBASTIEN BOURDON (1616-71)

c. 1655-60, Oil on canvas/Huile sur toile, 119,6 × 172,8 cm, National Gallery of Art, Washington, D.C.

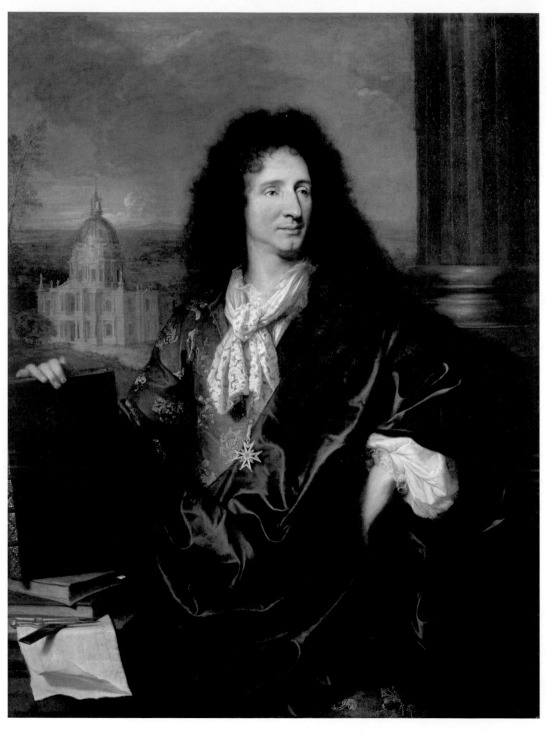

Portrait of Jules
Hardouin-Mansart

Portrait de Jules Hardo...
Mansart, premier
architecte et surintend...
des Bâtiments du roi

Bildnis des Jules
Hardouin-Mansart

Retrato de Jules
Hardouin-Mansart

Ritratto di Jules
Hardouin-Mansart

Portret van Jules
Hardouin-Mansart

HYACINTHE RIGAUD
(1659-1743)
1685, Oil on canvas/Huile
sur toile, 139 × 106 cm,
Musée du Louvre, Paris

Louis XIV

[M]asterly epitome of the royal portrait: [p]roud pose, haughty facial expression, [the] same voluptuous folds in curtain and [c]oat, which is adorned with the same [bro]cade Bourbon lilies as the armchair.

Louis XIV, roi de France

Un exemple magistral de portrait de souverain : pose fière, expression [ina]ccessible, le drapé du rideau rappelant [c]elui du manteau, lui-même orné des mêmes fleurs de lys que le fauteuil.

Ludwig XIV.

Meisterlicher Inbegriff des Herrscherporträts: stolze Pose, unnahbarer Gesichtsausdruck, der [g]leiche üppige Faltenwurf in Vorhang [un]d Mantel, den dieselben brokatenen [Bo]urbonen-Lilien zieren wie den Sessel.

Luis XIV.

Maestra personificación del retrato del gobernante: pose orgullosa, [exp]resión facial inaccesible, los mismos [] exuberantes pliegues en cortina y [ab]igo, adornados con los mismos lirios borbónicos brocados que el sillón.

Luigi XIV

Massima espressione del ritratto del [s]ovrano: posa orgogliosa, espressione [fa]cciale impenetrabile, le stesse ricche [c]he nella tenda e nel mantello, ornate [d]a gli stessi gigli borbonici in broccato come la poltrona.

Lodewijk XIV

Meesterlijk toonbeeld van een vorstenportret: trotse houding, onbenaderbare gezichtsuitdrukking, [zel]fde weelderige plooien in gordijn en [ver]sierd met dezelfde brokaten fleurs de lis als de fauteuil.

HYACINTHE RIGAUD (1659–1743)
1701, Oil on canvas/Huile sur toile,
277 × 194 cm, Musée du Louvre, Paris

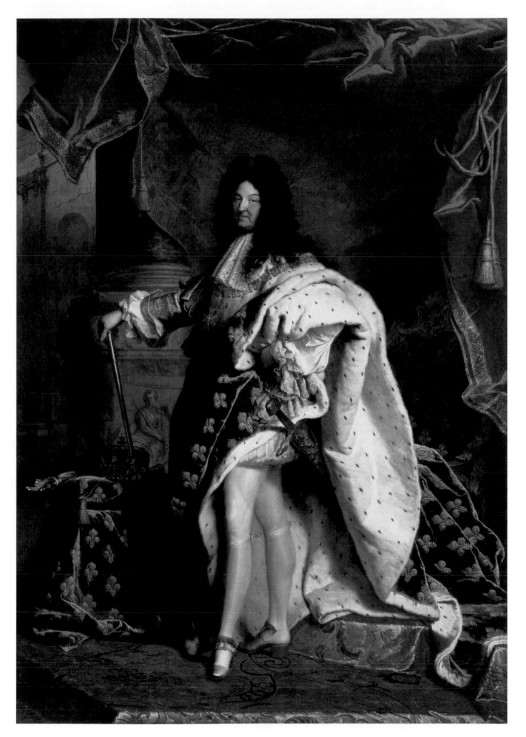

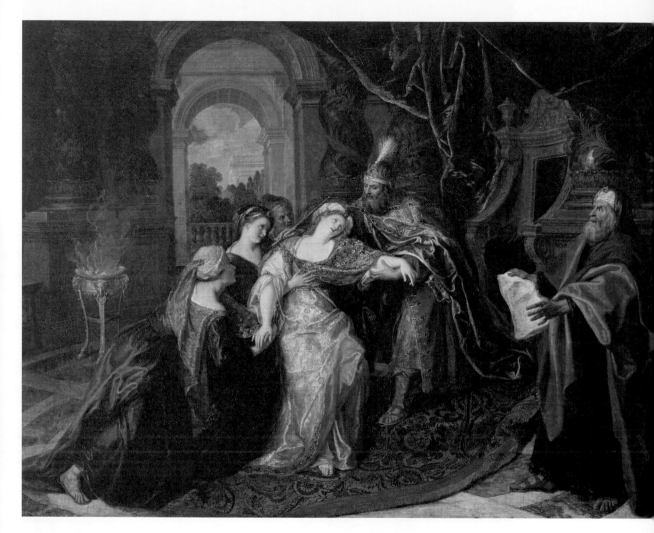

The Swooning of Esther

L'Évanouissement d'Esther

Esthers Ohnmacht

El desmayo de Ester

Lo svenimento di Ester

Esters flauwte

ANTOINE COYPEL (1661–1722)

c. 1696/97, Oil on canvas/Huile sur toile, 105 × 137 cm, Musée du Louvre, Paris

The Faux Pas

"Faux pas" could be interpreted ambiguously here: the gentleman seems to want to get closer to the lady, but she fends him off with her hand. A little psychological scene.

Le Faux-pas

La dame a-t-elle trébuché ? « Faux pas » peut s'entendre ici de deux manières différentes, car le monsieur semble vouloir absolument se rapprocher de la dame, qui le repousse pourtant de la main. Une scène psychologique.

Der Fehltritt

"Fehltritt" ließe sich hier durchaus zweideutig auffassen, denn der Herr scheint der Dame unbedingt näherkommen zu wollen, sie aber wehrt ihn mit der Hand ab. Eine kleine psychologische Szene.

El paso en falso

El paso en falso" podría interpretarse aquí de forma ambigua, porque el caballero parece querer acercarse a la dama, pero ella lo rechaza con la mano. Una pequeña escena psicológica

Il passo falso

"Il passo falso" potrebbe essere interpretato qui in modo ambiguo, perché l'uomo sembra voler avvicinarsi alla donna, ma lei lo rifiuta con la mano. Una piccola scena psicologica.

De misstap

'Misstap' zou hier dubbelzinnig geïnterpreteerd kunnen worden, dat de heer dichter bij de dame lijkt te willen komen, maar zij hem afweert met haar hand. Een klein psychologisch tafereel.

JEAN-ANTOINE WATTEAU (1684–1721)
c. 1716–18. Oil on canvas/
Huile sur toile, 40 × 31 cm,
Musée du Louvre, Paris

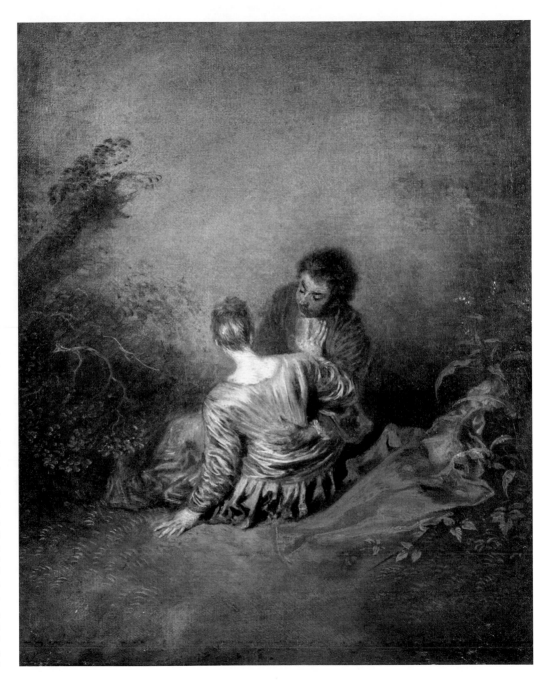

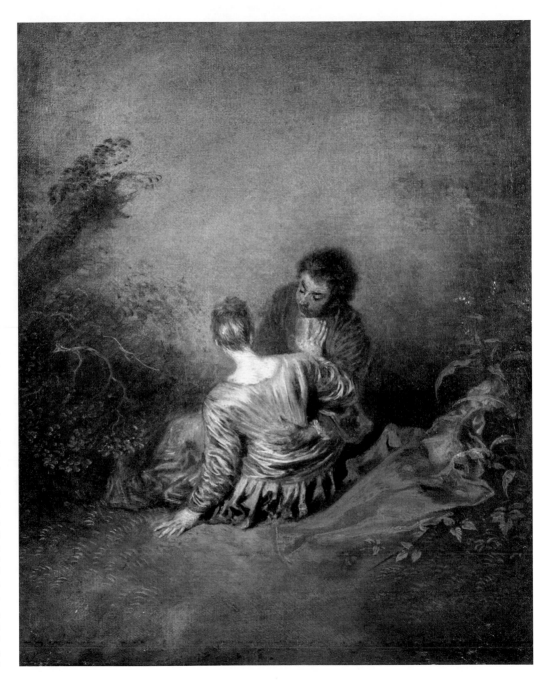

271

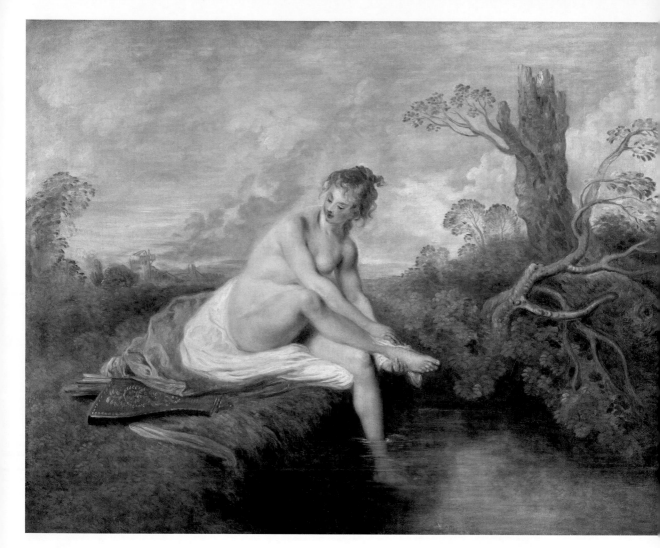

Diana at Her Bath

Diane au bain

Diana im Bade

El baño de Diana

Diana nel bagno

Badende Diana

JEAN-ANTOINE WATTEAU (1684–1721)

c. 1715/16, Oil on canvas/Huile sur toile, 80 × 101 cm, Musée du Louvre, Paris

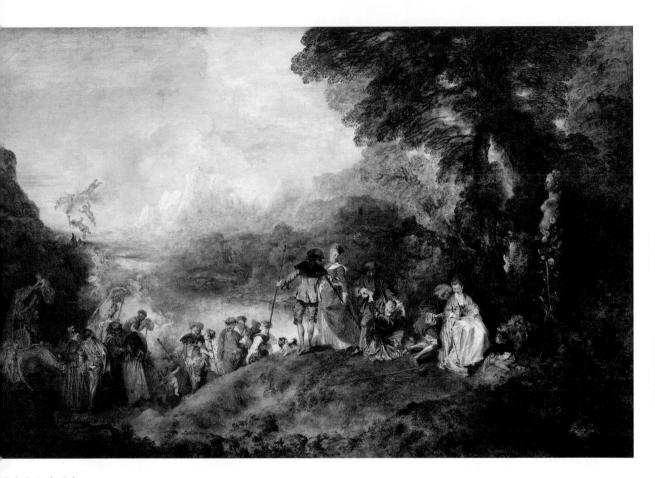

Embarkation for Cythera

erinage à l'île de Cythère

schiffung nach Kythira

egrinación a la isla de Citera

arco per Citera

inscheping naar Cythera

N-ANTOINE WATTEAU (1684–1721)

Oil on canvas/Huile sur toile, 129 × 194 cm, Musée du Louvre, Paris

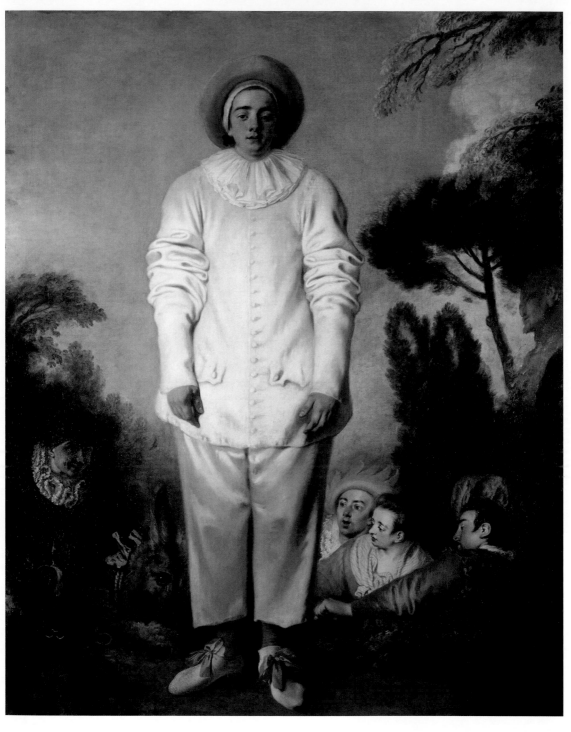

Pierrot, *formerly known as* Gilles

Pierrot, *dit autrefois* Gilles

Pierrot, *auch:* Gil[...]

Pierrot, *tambièn:* Gilles

Pierrot, *anche:* Gilles

Pierrot, *ook:* Gill[...]

JEAN-ANTOINE WATTEAU (1684–1721)

c. 1718/19, Oil on canvas/Huile sur to[...]

185 × 150 cm, Musé[...]

du Louvre, Paris

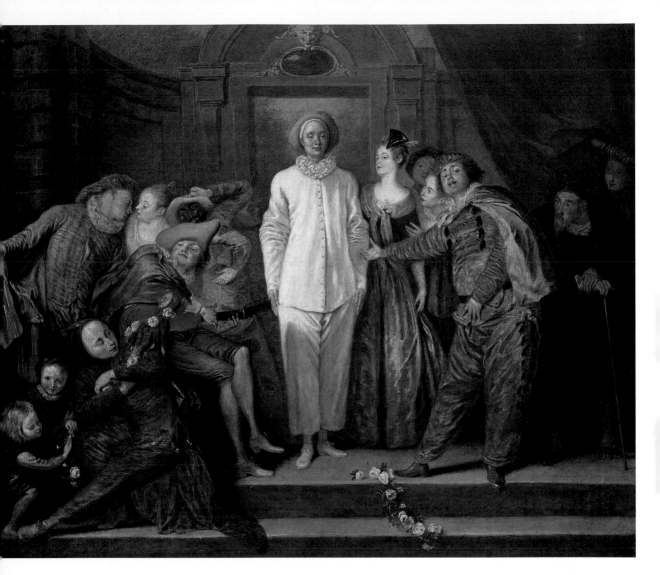

Italian Comedians

...figures of the commedia dell'arte were known to all: in the ...dle, the naive Pierrot; next to him, Flaminia, Scaramouche, ...presents them to the audience; and, on the left with a ...k face, the harlequin.

Comédiens italiens

...personnages de la Commedia dell'Arte étaient alors ...nus de tous : au centre, le candide Pierrot, à ses côtés ...minia, Scaramouche qui les présente au public, et à gauche, ...le masque noir, Arlequin.

Italienische Komödianten

Die Figuren der Commedia dell'Arte waren damals jedem bekannt: in der Mitte der naive Pierrot, daneben Flaminia, Scaramouche, der sie dem Publikum präsentiert, und – mit schwarzem Gesicht links – der Harlekin.

Cómicos italianos

Las figuras de la Commedia dell'Arte eran conocidas por todos en aquella época: en el centro, el ingenuo Pierrot, junto a Flaminia, Scaramouche, que las presenta al público, y –con una cara negra a la izquierda– el arlequín.

Commedianti italiani

Le figure della Commedia dell'Arte erano note a tutti in quel periodo: al centro l'ingenuo Pierrot, accanto a lui Flaminia, Scaramuccia, che li presentava al pubblico, e – con un volto nero a sinistra – l'arlecchino.

Italiaanse comedianten

De figuren van de Commedia dell'Arte waren destijds bij iedereen bekend: in het midden de naïeve Pierrot, daarnaast Flaminia, Scaramouche, die ze aan het publiek presenteert, en – met een zwart gezicht links – Harlekijn.

...N-ANTOINE WATTEAU (1684–1721)

...20, Oil on canvas/Huile sur toile, 63,8 × 76,2 cm, National Gallery of Art, Washington, D.C.

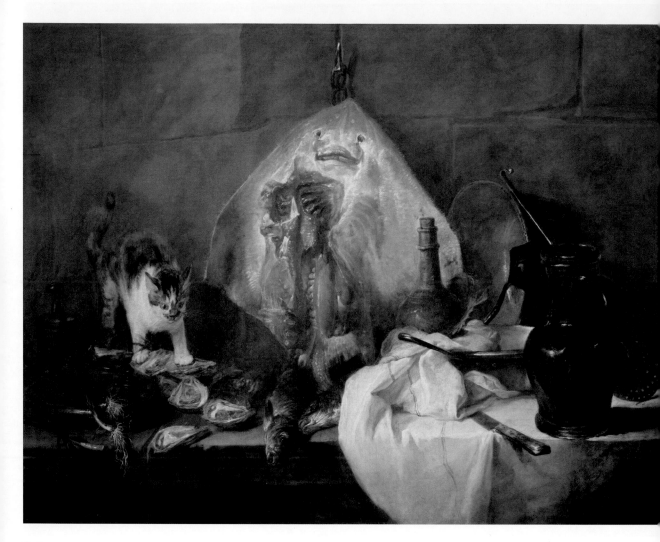

The Ray

La Raie

Der Rochen

El rayo

La razza

De rog

JEAN SIMÉON CHARDIN (1699–1779)

c. 1725/26, Oil on canvas/Huile sur toile, 114 × 146 cm, Musée du Louvre, Paris

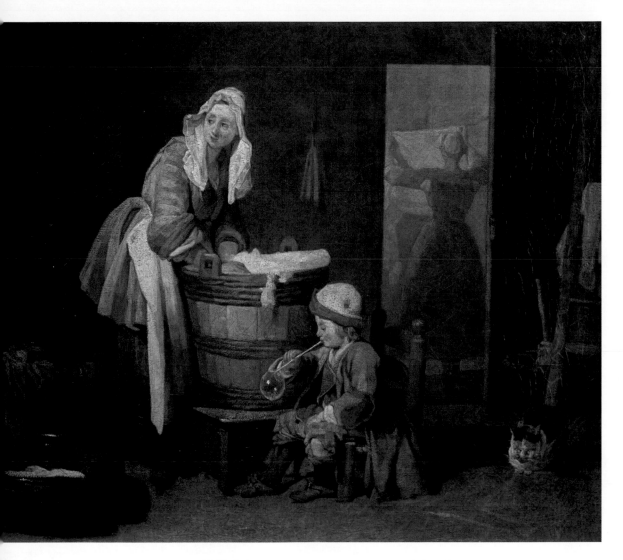

The Washerwoman

At first glance, Chardin's genre scenes and still lifes resemble Flemish paintings, but they are in fact simpler, more harmonious, and less symbolic, distinguishing Chardin as an individualist.

Die Wäscherin

Genreszenen und Stillleben Chardins ähneln auf den ersten Blick flämischen Gemälden, doch sind sie schlichter, harmonischer und nicht auf Symbolwirkung bedacht, was Chardin als einen Individualisten auszeichnet.

La lavandaia

A prima vista, le scene di genere e le nature morte di Chardin assomigliano ai dipinti fiamminghi, ma sono più sobrie, più armoniose e meno simboliche, il che distingue Chardin come individualista.

La Blanchisseuse ou Une Petite Dame s'occupant à savonner

De prime abord, les scènes de genre et les natures mortes de Chardin ressemblent aux tableaux flamands, mais sont plus sobres, plus harmonieuses et moins attachées aux symboles, ce qui prouve l'individualité de Chardin.

La lavandera

A primera vista, las escenas de género y los bodegones de Chardin se asemejan a la pintura flamenca, pero son más sencillos, más armoniosos y menos simbólicos, lo que distingue a Chardin como individualista.

De wasvrouw

Op het eerste gezicht lijken Chardins genrestukken en stillevens op Vlaamse schilderijen, maar ze zijn eenvoudiger, harmonieuzer en minder symbolisch, waardoor Chardin zich als individualist onderscheidt.

JEAN SIMÉON CHARDIN (1699-1779)

1730s, Oil on canvas/Huile sur toile, 37,5 × 42,7 cm, State Hermitage Museum, St. Petersburg

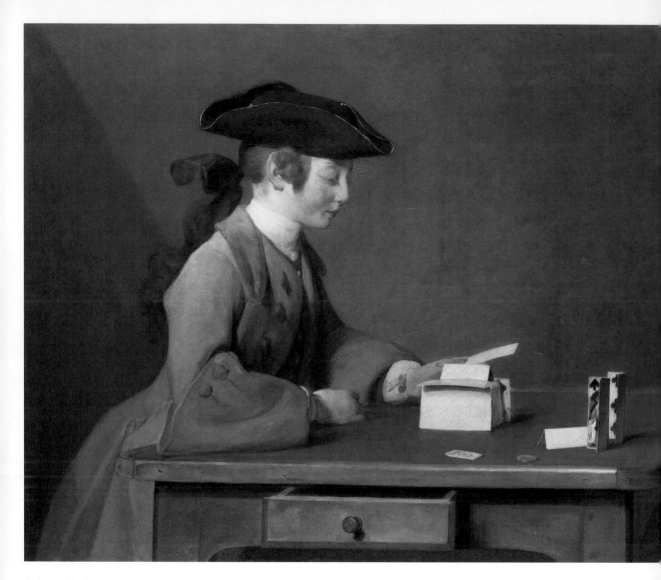

The House of Cards

Le Château de cartes

Das Kartenhaus

El castillo de naipes

Castello di carte

Het kaartenhuis

JEAN SIMÉON CHARDIN (1699–1779)
c. 1736/37, Oil on canvas/Huile sur toile, 60,3 × 71,8 cm, The National Gallery, London

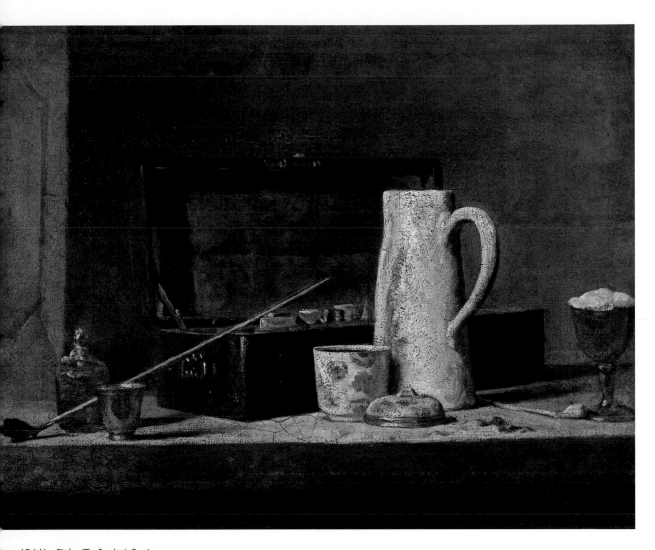

es and Drinking Pitcher (The Smoker's Case)

es et vases à boire *dit aussi* La Tabagie

fen und Trinkgeschirr *auch:* Rauchnecessaire

as y vasijas para beber. El estuche del fumador

a e brocca per bere

en drinkgerei

N SIMÉON CHARDIN (1699-1779)

37, Oil on canvas/Huile sur toile, 32 × 42 cm, Musée du Louvre, Paris

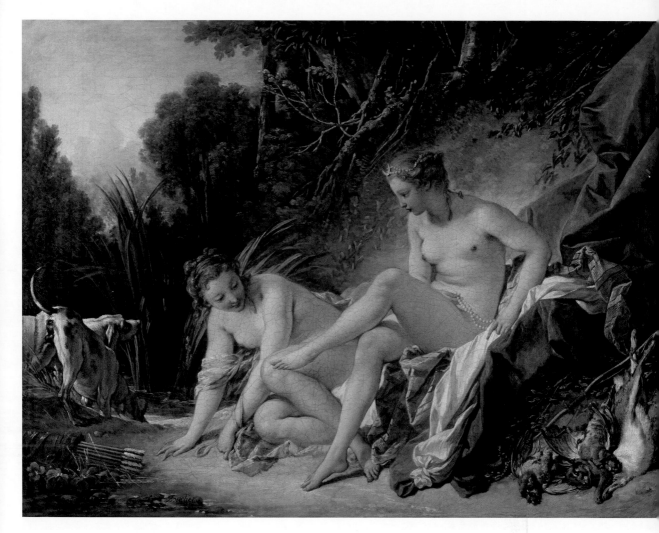

Diana Leaving Her Bath

Diane sortant du bain

Diana entsteigt dem Bade

Diana saliendo del baño

Diana emerge dal bagno

Diana die uit bad komt

FRANÇOIS BOUCHER (1703-70)
1742, Oil on canvas/Huile sur toile, 57 × 73 cm, Musée du Louvre, Paris

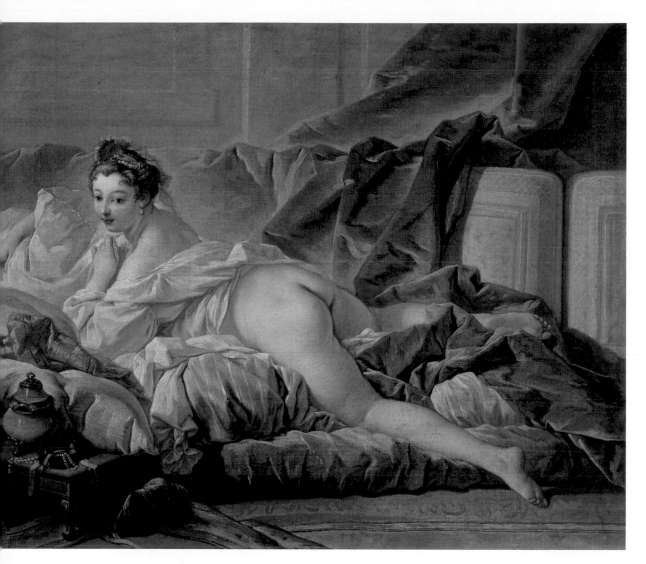

Odalisque

alisque

Odaliske

dalisca

alisca

sque

ÇOIS BOUCHER (1703-70)

, Oil on canvas/Huile sur toile, 53 × 64 cm, Musée du Louvre, Paris

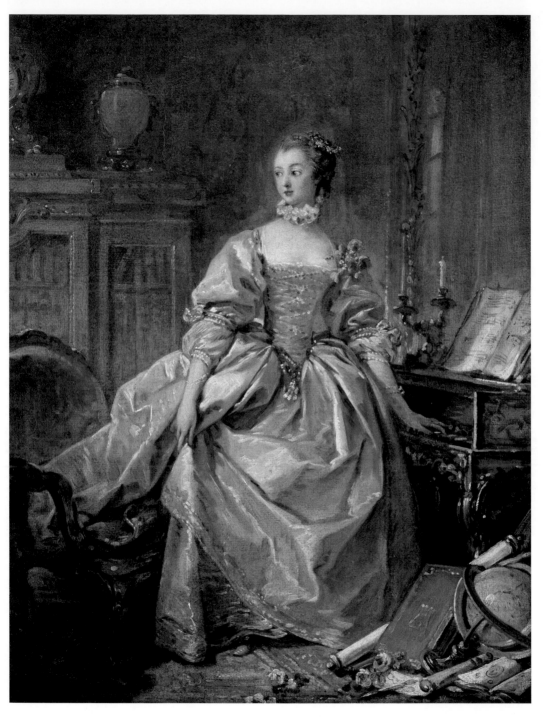

The Marquise de Pompad

One of many depictions of
Louis XV's famous mistress
The marquise was not only
beautiful, but also educated
in the arts, as the instrume
and the other objects in the
picture indicate.

La Marquise de Pompado

C'est l'une des nombreuses
représentations de la maîtr
du roi Louis XV. Outre sa
beauté, elle jouissait égalem
d'une solide éducation
artistique, comme l'indique
l'instrument et d'autres obj
du tableau.

Die Marquise de Pompad

Eine der vielen Darstellung
der Mätresse König
Ludwigs XV. Sie war nicht
schön, sondern zugleich in
den Künsten gebildet, wie
Instrument und die andere
Gegenstände im Bild beleg

La marquesa de Pompado

Una de las muchas
representaciones de la ama
del rey Luis XV, no sólo
hermosa, sino también edu
en las artes, como demuest
el instrumento y los otros
objetos de la imagen.

La Marchesa di Pompado

Una delle tante raffigurazio
della favorita da Re Luigi X
Non solo bella, ma anche
educata alle arti, come
dimostrano lo strumento e
altri oggetti del dipinto.

De markiezin van Pompa

Een van de vele weergaven
van de maîtresse van konin
Lodewijk XV. Ze was niet
mooi, maar ook onderlegd
kunsten, zoals het instrume
en de andere voorwerpen
het schilderij aantonen.

FRANÇOIS BOUCHER (1703–
c. 1750–52, Oil on paper, mour
on canvas/Huile sur papier
marouflé sur toile, 60 × 45,5 cr
Musée du Louvre, Paris

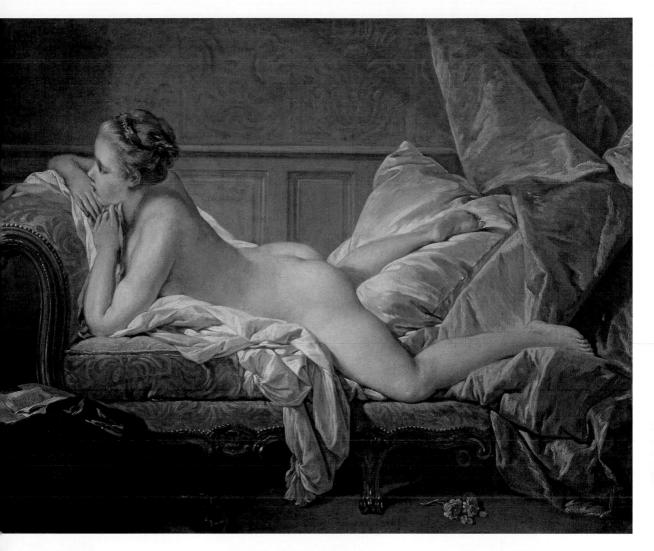

...ng Girl (Louise O'Murphy)

...pretty, coquettish seamstress Louise, discovered as a ...el by Boucher, poses here on a rich chaise longue. She ...caught the eye of King Louis XV, who made her one of ...mistresses.

...e Fille allongée ou L'Odalisque blonde

...lie et coquette couturière Louise fut découverte par ...cher et pose ici sur une chaise longue. Elle plut également ...u Louis XV, qui en fit une de ses maitresses.

...ÇOIS BOUCHER (1703–70)

...Oil on canvas/Huile sur toile, 59,5 × 73,5 cm, Wallraf-Richartz-Museum & Fondation Corboud, Köln

Ruhendes Mädchen (Louise O'Murphy)

Die hübsche, kokette Näherin Louise war von Boucher als Modell entdeckt worden und posiert hier auf einer edlen Chaiselongue. Sie gefiel auch König Ludwig XV., der sie zu einer seiner Mätressen machte.

Niña descansando (Louise O'Murphy)

La guapa y coqueta costurera Louise fue descubierta por Boucher como modelo y posa aquí en una noble chaise longue. También le gustaba el rey Luis XV, que la convirtió en una de sus amantes.

Ragazza distesa (Louise O'Murphy)

La graziosa e civetta sarta Louise fu scoperta da Boucher come modella e posa qui su una signorile chaise longue. Piaceva anche al re Luigi XV, che ne fece una delle sue amanti.

Rustend meisje (Louise O'Murphy)

De mooie, kokette naaister Louise werd door Boucher ontdekt als model en poseert hier op een nobele chaise longue. Ze bekoorde koning Lodewijk XV ook, die haar tot een van zijn minnaressen maakte.

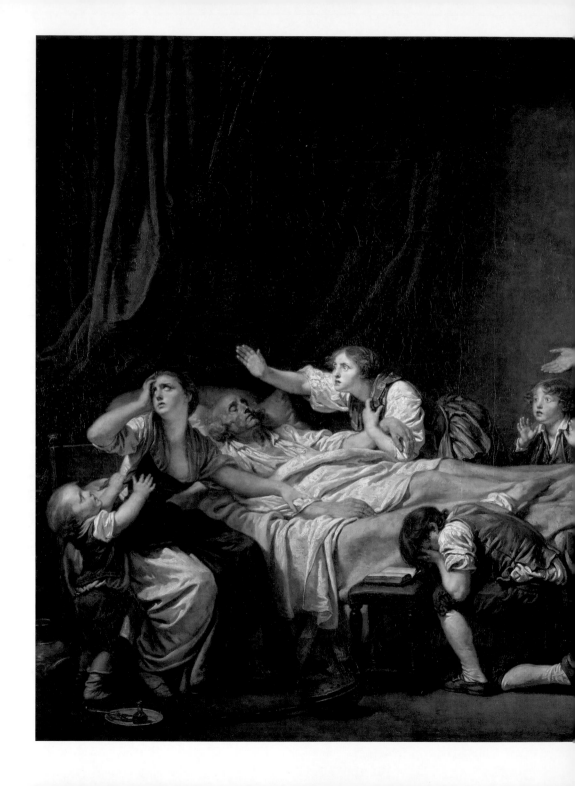

The Father's Curse: The Ungrateful Son

La Malédiction paternelle. Le fils puni

Der väterliche Fluch: Der bestrafte Sohn

La maldición del padre: el hijo castigado

La punizione del figlio

De vaderlijke vloek: de gestrafte zoon

JEAN-BAPTISTE GREUZE (1725–1805)

1778, Oil on canvas/Huile sur toile, 130 × 163 cm, Musée du Louvre, Paris

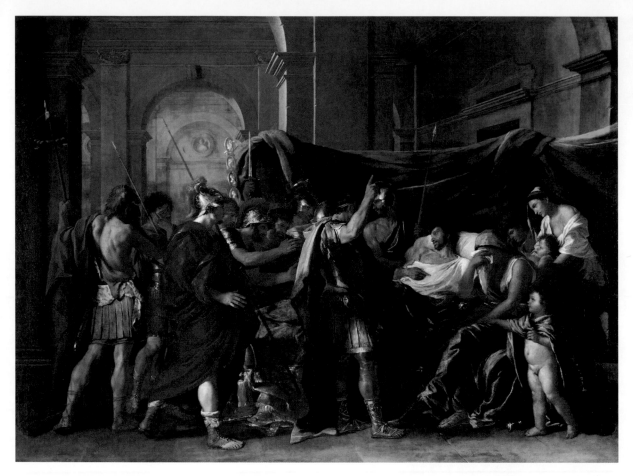

Nicolas Poussin:
Classical Stories in Sublime Nature

Nicolas Poussin, born in Normandy, was a major exponent of classicist baroque painting. His interest in mythology led him to Rome in 1624. In that city, antiquity and Christianity, the two worlds most significant to Poussin's art, met, providing the artist with an ideal working environment. He created paintings of intense colour, endowing his figures with extraordinary luminosity through the so-called "blond tone". He also found educated clients in Rome, whom he preferred to his king: Poussin produced no portraits of rulers. His stay at the French court in 1641, to which he had been entreated by King Louis XIII and Cardinal Richelieu, was therefore ultimately unsuccessful. After both the king and the cardinal had died, Poussin continued working undisturbed in Rome from 1643 on his favourite themes, which he increasingly embedded in heroically charged landscapes.

Nicolas Poussin :
histoires classiques dans une nature grandiose

Né en Normandie, Nicolas Poussin fut le principal représentant de la peinture baroque classique. Son intérêt pour la mythologie le conduisit en 1624 à Rome, où il trouva un environnement de travail idéal : à la croisée des mondes antique et chrétien, que Poussin utilisait à parts égales dans son travail. Des tableaux aux couleurs intenses virent le jour, avec des personnages qu'il rendait lumineux grâce à ses « teintes blondes ». À Rome, il trouva aussi des commanditaires autres que le roi et pour lesquels il avait envie de travailler : on ne trouve pas de portraits de souverains chez Poussin. Son séjour à la cour de France, à la demande du roi Louis XIII et du cardinal Richelieu, en 1641, ne fut donc pas un succès. En 1643, après la mort des deux hommes, Poussin put retourner tranquillement à Rome et continuer à travailler à ses thèmes de prédilection, qu'il intégra de plus en plus souvent dans des paysages chargés d'héroïsme.

Nicolas Poussin:
Klassische Geschichten in erhabener Natur

Nicolas Poussin, geboren in der Normandie, war ein Hauptvertreter der klassizistischen Barockmalerei. Sein Interesse an der Mythologie führte ihn 1624 nach Rom: Hier fand er ein ideales Arbeitsumfeld; es trafen sich die Welten der Antike und des Christentums, die Poussin in seinen Werken stets gleichwertig behandelte. Es entstanden farbintensive Gemälde, deren Figuren er durch den sogenannten „blonden To[n]" eine intensive Leuchtkraft verlieh. Auch fanden sich in Rom kundige Auftraggeber, die er gern belieferte – anders als seinen König: Herrscherporträts findet man bei Poussin nicht. So war sein Aufenthalt am französischen Hof, zu dem ihn König Ludwig XIII. und Kardinal Richelieu 1641 überredeten, kein Erfolg. Nachdem beide verstorben waren, konnte Poussin ab 1643 in Rom ungestört an seinen bevorzugten Theme[n] weiterarbeiten, die er zunehmend in heroisch aufgela[de] Landschaften einbettete.

NICOLAS POUSSIN (1594-1665)
Oil on canvas/Huile sur toile, 147,96 × 198,12 cm, Minneapolis Institute of Art, Minneapolis

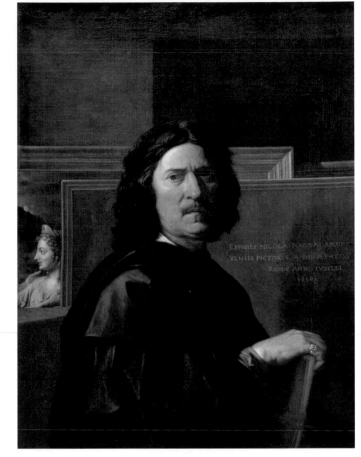

Self-Portrait
Portrait de l'artiste
Selbstbildnis
Autorretrato
Autoritratto
Zelfportret

NICOLAS POUSSIN (1594-1665)
1650, Oil on canvas/Huile sur toile, 98 × 74 cm, Musée du Louvre, Paris

Nicolas Poussin:
entos clásicos de naturaleza sublime

las Poussin, nacido en Normandía, fue un gran
mente de la pintura barroca clasicista. Su interés por
tología le llevó a Roma en 1624: aquí encontró un
ente de trabajo ideal; los mundos de la antigüedad y
stianismo se encontraron, los cuales Poussin siempre
por igual en sus obras. Realiza pinturas de colores
sos, a cuyas figuras les da una intensa luminosidad
vés del llamado "tono rubio". También encontró en
a clientes entendidos en pintura, para los cuales le
aba hacer encargagos, a diferencia de para su rey:
sin no realizaba retratos de gobernantes. Así pues, su
cia en la corte francesa, a la que el rey Luis XIII y el
enal Richelieu le persuadieron en 1641, no tuvo éxito.
ués de la muerte de ambos, Poussin pudo seguir
jando sin problemas en Roma a partir de 1643 sobre
mas preferidos, que cada vez centró más en paisajes
dos de heroísmo.

Nicolas Poussin:
Storie classiche nella natura sublime

Nicolas Poussin, nato in Normandia, fu uno dei maggiori
esponenti della pittura classicista barocca. L'interesse
per la mitologia lo porta a Roma nel 1624: qui trova un
ambiente di lavoro ideale; qui si incontrano i mondi
dell'antichità e del cristianesimo, che Poussin tratta
sempre similmente nelle sue opere. Realizzò dipinti
dai colori vivaci, le cui figure diedero una luminosità
intensa attraverso il cosiddetto "tono biondo". A Roma
trovò anche compratori esperti, che amava rifornire, a
differenza del re: tra le opere di Poussin non troviamo
ritratti di governanti. Il suo soggiorno alla corte francese,
persuaso da re Luigi XIII e dal cardinale Richelieu nel
1641, non ebbe successo. Dopo la morte di entrambi,
Poussin riuscì a continuare a lavorare indisturbato a
Roma, a partire dal 1643, sui suoi temi preferiti, che
sempre più si inseriva in paesaggi carichi di eroismo.

Nicolas Poussin:
klassieke verhalen in een verheven natuur

Nicolas Poussin, geboren in Normandië, was een
belangrijke vertegenwoordiger van de classicistische
barokschilderkunst. Zijn interesse in mythologie
bracht hem in 1624 naar Rome: hier vond hij een ideale
werkomgeving. Hier ontmoeten de werelden van de
klassieke oudheid en het christendom elkaar, die Poussin
in zijn werken altijd gelijkwaardig behandelde. Hij
maakte intens gekl014gede schilderijen met figuren die hij
door middel van de zogenaamde blonde toon intensief
belichtte. In Rome trof hij ook deskundige klanten aan,
aan wie hij – in tegenstelling tot aan zijn koning – graag
wilde leveren: Poussin schilderde geen vorstenportretten.
Zijn verblijf aan het Franse hof, waartoe koning Lodewijk
XIII en kardinaal Richelieu hem in 1641 overhaalden,
was dus geen succes. Toen beiden dood waren, kon Poussin
vanaf 1643 in Rome ongestoord verder werken aan zijn
favoriete thema's, die hij steeds meer in heroïsch geladen
landschappen liet afspelen.

The Empire of Flora

Flora, the goddess of flowers, is surrounded by figures from Ovid's *Metamorphoses,* who turn into flowers as they die. Since they will live on as plants, the atmosphere is nevertheless bright and merry.

L'Empire de Flore

La déesse des fleurs, Flore, est entourée de personnages des *Métamorphoses* d'Ovide, qui en mourant se transforment en fleurs. Comme ils peuvent continuer à vivre sous forme de plantes, l'atmosphère du tableau reste claire et sereine.

Das Reich der Flora

Die Blumengöttin Flora ist umgeben von Figuren aus Ovids *Metamorphosen,* die sich im Sterben in Blumen verwandeln. Da sie als Pflanzen weiterleben werden, wirkt die Stimmung trotzdem hell und freundlich.

El reino de Flora

Flora, la diosa de las flores, está rodeada de figuras de las *Metamorfosis* de Ovidio, que se convierten en flores al morir. Sin embargo, el ambiente es brillante y amistoso, ya que segirán en vida como plantas.

Il regno di Flora

Flora, la dea dei fiori, è circondata da figure delle *Metamorfosi* di Ovidio, che si trasformano in fiori alla loro morte. Poiché vivranno come piante, l'atmosfera è comunque luminosa e gradevole.

Het rijk van Flora

Flora, de bloemengodin, is omringd door figuren uit Ovidius' *Metamorfosen,* die tijdens het sterven veranderen in bloemen. Omdat ze als planten verder zullen leven, is de sfeer toch licht en vriendelijk.

NICOLAS POUSSIN (1594-1665)
1631, Oil on canvas/Huile sur toile, 132 × 181,4 cm, Staatliche Kunstsammlungen Dresden, Dresden

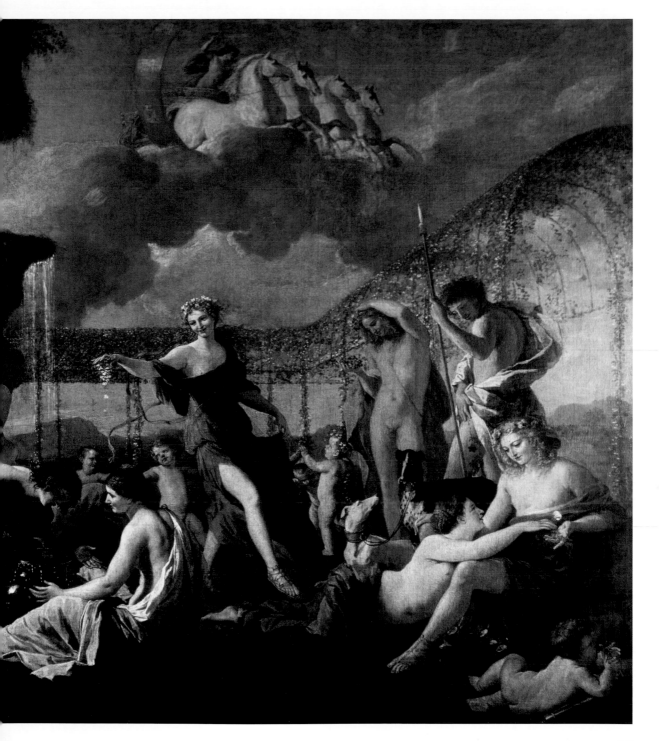

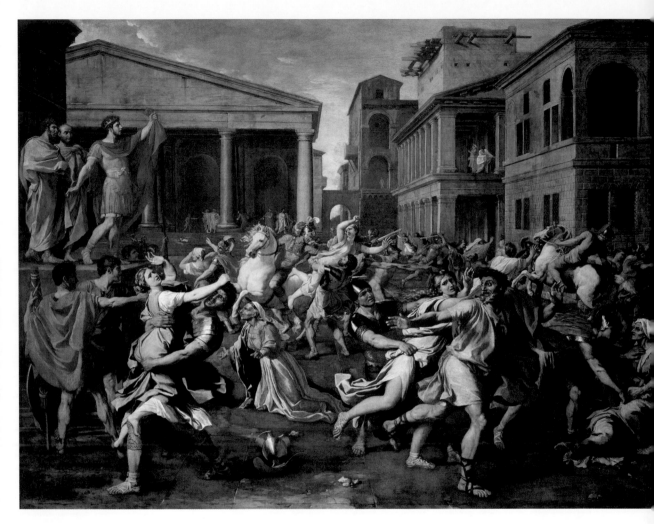

The Rape of the Sabines

L'Enlèvement des Sabines

Der Raub der Sabinerinnen

El rapto de las sabinas

Il ratto delle Sabine

De Sabijnse maagdenroof

NICOLAS POUSSIN (1594–1665)

c. 1637/38, Oil on canvas/Huile sur toile, 159 × 206 cm, Musée du Louvre, Paris

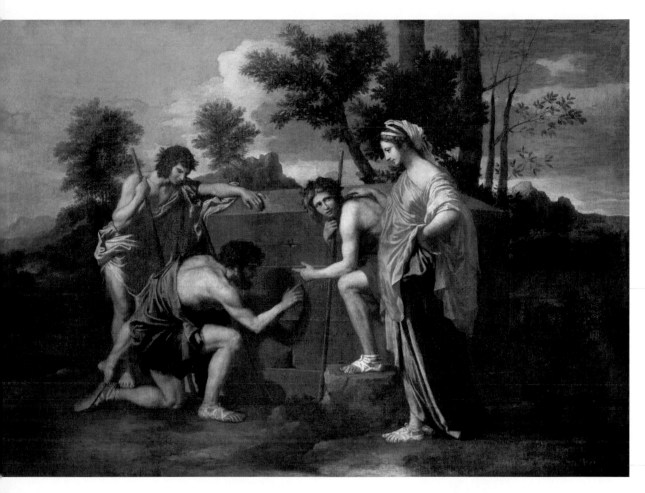

Arcadia ego

…n in Arcadia, I am": a group of shepherds find this
…ence on a sarcophagus. With this popular painting's
…monious arrangement, Poussin shows that death is
…ipresent, even in idyllic moments.

…Bergers d'Arcadie ou Et in Arcadia ego

…suis aussi en Arcadie » : telle est la phrase que les bergers
…vent sur un sarcophage. Sur ce tableau très connu, Poussin
…tre dans une composition harmonieuse que la mort est
…out présente, même dans les moments idylliques.

…LAS POUSSIN (1594-1665)

…8-40, Oil on canvas/Huile sur toile, 85 × 121 cm, Musée du Louvre, Paris

Die Hirten von Arkadien auch: Et in Arcadia ego

„Auch ich in Arkadien": Diesen Satz finden die Hirten auf
einem Sarkophag. In harmonischer Anordnung zeigt Poussin
auf diesem populären Gemälde, dass der Tod selbst in
idyllischen Momenten allgegenwärtig ist.

Los pastores de Arcadia también: Et in Arcadia ego

Yo también en Arcadia": los pastores encuentran esta frase en
un sarcófago. En un arreglo armonioso, Poussin muestra en
esta popular pintura que la muerte es omnipresente incluso en
momentos idílicos

Pastori dell'Arcadia : Et in Arcadia ego

"Anch'io ero in Arcadia": i pastori trovano questa frase su un
sarcofago. In un arrangiamento armonioso, Poussin mostra in
questo quadro popolare che la morte è onnipresente anche nei
momenti idilliaci.

De herders van Arcadië ook: Et in Arcadië ego

Ook ik in Arcadië: de herders treffen deze zin aan op een
sarcofaag. In een harmonieuze compositie toont Poussin met
dit populaire schilderij dat de dood alomtegenwoordig is, zelfs
op idyllische momenten.

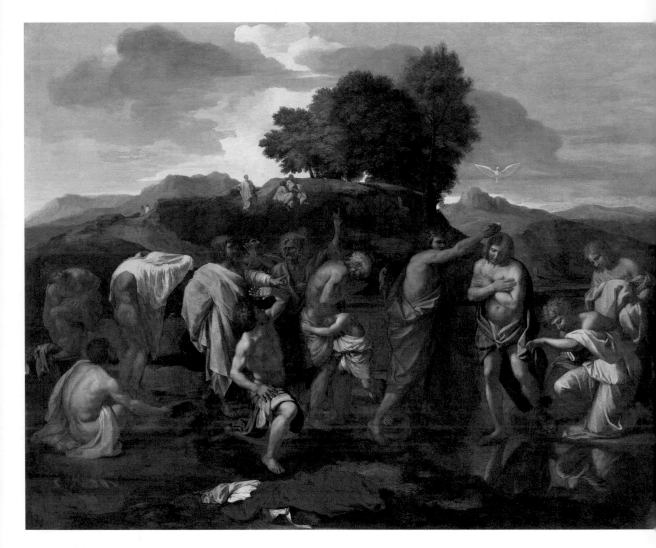

The Baptism of Christ

Les Sept Sacrements, 1. Le Baptême du Christ

Die Taufe Christi

El Bautismo de Cristo

Il Battesimo di Cristo

De doop van Christus

NICOLAS POUSSIN (1594-1665)

1641/42, Oil on canvas/Huile sur toile, 95,5 × 121 cm, National Gallery of Art, Washington, D.C.

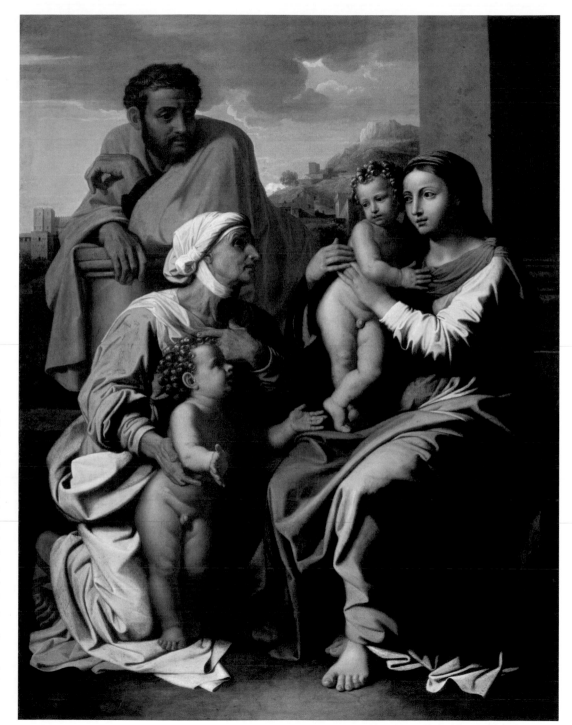

Holy Family with
St Elizabeth and
St John the Baptist

Sainte Famille dite
« aux cinq figures »

lige Familie mit der
ligen Elisabeth und
ohannes dem Täufer

La Sagrada Familia
con Santa Isabel y
Juan Bautista

Sacra Famiglia con
Santa Elisabetta e
Giovanni Battista

lige Familie met de
eiligen Elizabeth en
Johannes de Doper

NICOLAS POUSSIN
(1594–1665)

1644–55, Oil on canvas/
sur toile, 172 × 133,5 cm,
te Hermitage Museum,
St. Petersburg

Landscape during a Thunderstorm with Pyramus and Thisbe

The thunderstorm dramatically shaking the trees reflects the despair of Thisbe, a character in Ovid's *Metamorphoses*, whose lover Pyramus committed suicide as a result of a tragic misunderstanding.

Paysage orageux avec Pyrame et Thisbé

L'orage, qui agite ici les arbres de manière dramatique, reflète le désespoir de la Thisbé des *Métamorphoses* d'Ovide, dont l'amant Pyrame s'est suicidé suite à un malentendu tragique.

Gewitterlandschaft mit Pyramus und Thisbe

Der Gewittersturm, der die Bäume hier dramatisch bewegt, spiegelt die Verzweiflung Thisbes aus Ovids *Metamorphosen* wider, deren Geliebter Pyramus infolge eines tragischen Missverständnisses Selbstmord beging.

Paisaje tormentoso con Píramo y Tisbe

La tormenta que mueve aquí dramáticamente los árboles refleja la desesperación de Tebas por las *Metamorfosis* de Ovidio, cuyo amante Píramo se suicidó como resultado de un trágico malentendido.

Paesaggio tempestoso con piramidi e Thisbe

Il temporale che drammaticamente muove gli alberi riflette qui la disperazione di Tisbe dalle *Metamorfosi* di Ovidio, il cui amante Priamo commette il suicidio a causa di un tragico malinteso.

Onweerslandschap met Pyramus en Thisbe

De onweersbui die de bomen hier dramatisch laat bewegen, weerspiegelt de wanhoop van Thisbe uit Ovidius' *Metamorfosen*, wier geliefde Pyramus zelfmoord had gepleegd als gevolg van een tragisch misverstand.

NICOLAS POUSSIN (1594-1665)
1651, Oil on canvas/Huile sur toile, 191 × 274 cm, Städel Museum, Frankfurt am Main

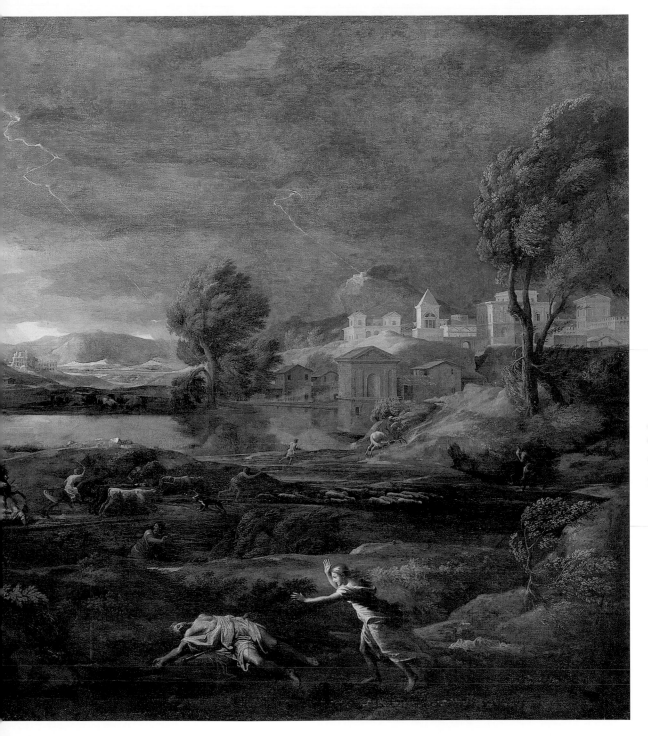

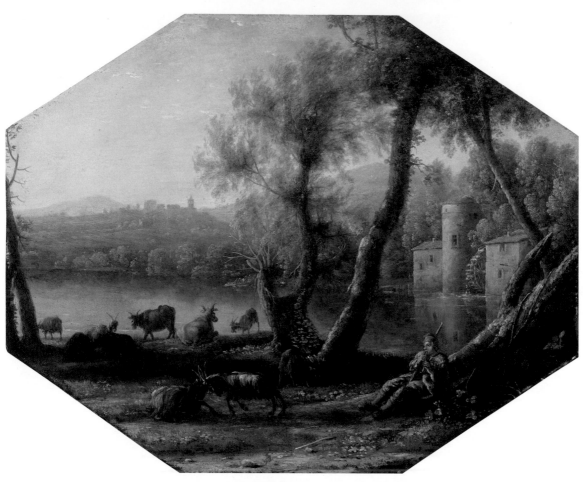

Pastoral
Landscape

Paysage
pastoral

Pastorale
Landschaft

Paisaje Pas

Paesaggio
pastorale

Pastoraal
landschap

**CLAUDE
LORRAIN**
(1600–82)
1636/37, Oil
copper/Huile
plaque de cu
27,9 × 34,7 cr
Art Gallery o
New South
Wales, Sydne

**Claude Lorrain:
Idyllic Landscapes in the Sunlight**

Like his contemporary Nicolas Poussin, Claude Lorrain
(born Claude Gellée) had moved his residence from
France to Rome. Unlike Poussin, however, Lorrain's
overriding passion was for nature. Though most of his
paintings show people, he was not very interested in
them, sometimes even leaving them to be painted by
his apprentices. His figures serve merely to enliven the
foreground, acting as accessories to the vast landscape
unfolding behind them. A cheerful peace lies over these
scenes; there are no storms, as in Poussin. The ancient
temples or ruins frequently found in the landscapes
further contribute to this dreamy atmosphere. Lorrain
also sought to make the sunlight and sky as natural as
possible; this made him a role model for later artists such
as William Turner.

**Claude Lorrain :
paysages idylliques au soleil**

Comme Nicolas Poussin, qu'il connaissait, Claude Lorrain
(de son vrai nom Claude Gellée) avait quitté la France
pour s'installer et peindre à Rome. Contrairement au cas
de Poussin chez Lorrain la nature joua toujours un rôle
essentiel. Si des gens apparaissent sur la plupart de ses
tableaux, il leur porte néanmoins un intérêt limité, laissant
même parfois à ses collaborateurs le soin de les peindre.
Ils habitent en fait le premier plan et jouent un rôle de
figuration, tandis que la vaste nature se déploie derrière
eux. Un calme serein plane au-dessus de ces scènes ; il
n'y a pas non plus de tempêtes comme chez Poussin. Les
temples ou les ruines antiques qui émaillent souvent les
paysages contribuent encore à cette atmosphère onirique.
Lorrain mettait beaucoup de soin à peindre la lumière
du soleil et le ciel de manière aussi fidèle que possible.
Il inspira ainsi des artistes des générations suivantes,
notamment William Turner.

**Claude Lorrain:
Idyllische Landschaften im Sonnenlicht**

Wie Nicolas Poussin, mit dem er bekannt war, hatte au
Claude Lorrain (eigentlich Claude Gellée) seinen Wohn
von Frankreich nach Rom verlegt, um dort zu malen.
Anders als für Poussin spielte für Lorrain immer die
Natur die größte Rolle. Zwar sind auf den meisten sein
Bilder Personen zu sehen, doch interessierten sie ihn
nicht sehr – manchmal ließ er sie sogar von Mitarbeit
malen. Sie beleben lediglich den Vordergrund und
dienen als Staffage für die weite Natur, die sich hinter
ihnen entfaltet. Eine heitere Ruhe liegt über diesen
Szenen; auch gibt es keine Unwetter wie bei Poussin.
Die häufig zu findenden antiken Tempel oder Ruinen
den Landschaften tragen noch zu dieser träumerische
Stimmung bei. Lorrain lag außerdem viel daran, das
Sonnenlicht und den Himmel so naturgetreu wie mög
darzustellen. Dies ließ ihn zum Vorbild späterer Künst
wie zum Beispiel William Turner werden.

The Village
Festival

La Fête
villageoise

Das Dorffest

la fiesta del
pueblo

la festa del
villaggio

Het
dorpsfeest

**CLAUDE
LORRAIN**
(1600-82)
1639, Oil on
canvas/Huile
sur toile,
103 × 135 cm,
Musée du
Louvre, Paris

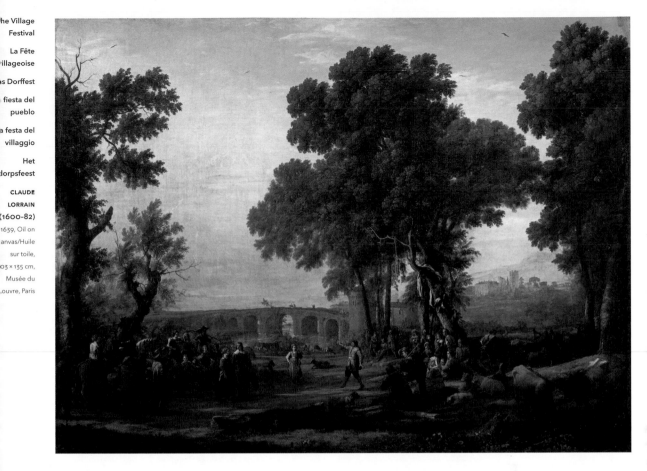

Claude Lorrain:
sajes idílicos a la luz del sol

no Nicolas Poussin, con quien era conocido, Claude
rain trasladósu residencia de Francia a Roma para
ar allí. A diferencia de Poussin, para Lorrain la
uraleza siempre fue lo más importante. La mayoría
us pinturas muestran a la gente, pero él no estaba
y interesado en ellas– a veces incluso encargaba estas
uras a sus compañeros de trabajo. Simplemente
man el primer plano y sirven como ornamentopara la
a naturaleza que se despliega detrás de ellos. Un alegre
ncio yace sobre estas escenas; tampoco hay tormentas
no con Poussin. Los templos antiguos o ruinas que se
s a esta atmósfera de ensueño. Lorrain también quería
la luz del sol y el cielo fueran lo más naturales posible.
lo convirtió en un modelo a seguir para artistas
teriores como William Turner.

Claude Lorrain:
Paesaggi idilliaci alla luce del sole

Come Nicolas Poussin, che conosceva, anche Claude
Gellée detto Lorrain trasferì la sua residenza dalla Francia
a Roma per dipingere. A differenza di Poussin, la natura
ha sempre giocato un ruolo importante per Lorrain. La
maggior parte dei suoi dipinti raffigura persone, ma non
era molto interessato a loro – a volte li ha anche fatti
dipingere dagli allievi. Essi semplicemente animano il
primo piano e servono come figure accessorie per la vasta
natura che si dispiega dietro di loro. Sopra queste scene
si nasconde una serenità allegra, non ci sono tempeste
come in quelle di Poussin. I templi antichi o le rovine nei
paesaggi contribuiscono a questa atmosfera sognante.
Anche Lorrain voleva rendere la luce del sole e il cielo il
più naturale possibile. Questo ha fatto i lui un modello per
artisti a venire come William Turner.

Claude Lorrain:
idyllische landschappen in het zonlicht

Net als Nicolas Poussin, met wie hij bekend was, was
Claude Lorrain van Frankrijk verhuisd naar Rome om
daar te schilderen. Anders dan bij Poussin speelde de
natuur voor Lorrain altijd de grootste rol. Op de meeste
van zijn schilderijen zijn mensen te zien, maar hij was
niet erg in ze geïnteresseerd – soms liet hij ze zelfs
door collega's schilderen. Ze verlevendigen slechts de
voorgrond en dienen als stoffering voor de uitgestrekte
natuur die zich achter hen ontvouwt. Op deze taferelen
rust een vrolijke stilte; er is ook geen noodweer, zoals
bij Poussin. De oude tempels of ruïnes die vaak in de
landschappen aan te treffen zijn, dragen nog verder bij aan
deze dromerige sfeer. Er was Lorrain ook veel aan gelegen
om het zonlicht en de lucht zo natuurlijk mogelijk weer
te geven. Hierdoor werd hij een voorbeeld voor latere
kunstenaars zoals William Turner.

297

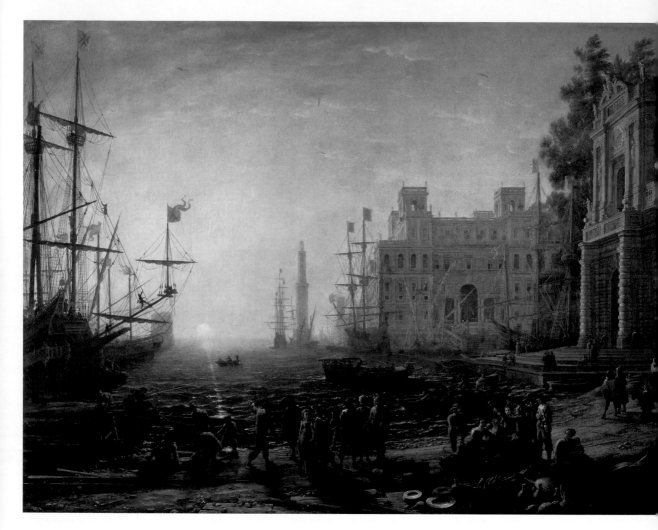

Seaport with the Villa Medici

Port de mer avec la Villa Médicis

Hafenansicht mit der Villa Medici

Vista del puerto con la Villa Medici

Vista dal porto con Villa Medici

Havenzicht met de Villa Medici

CLAUDE LORRAIN (1600–82)

1637, Oil on canvas/Huile sur toile, 102 × 133 cm, Galleria degli Uffizi, Firenze

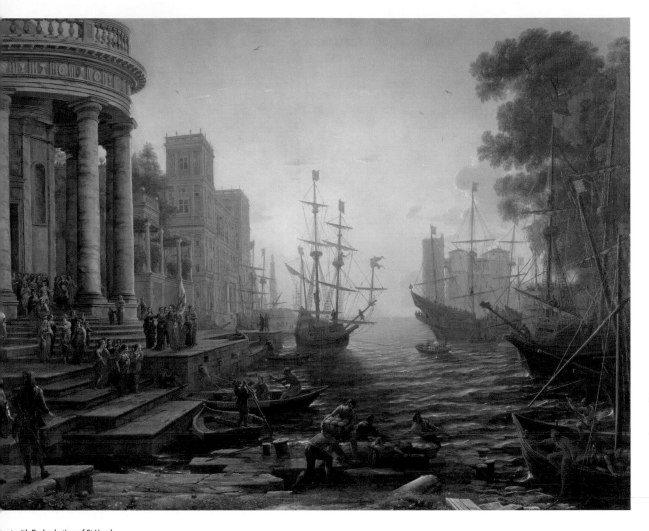

ort with Embarkation of St Ursula

avec l'embarquement de sainte Ursule

n mit Einschiffung der Heiligen Ursula

to con el embarque de Santa Úrsula

o con imbarco di Sant'Orsola

en met inscheping van de heilige Ursula

DE LORRAIN (1600–82)
Oil on canvas/Huile sur toile, 112,9 × 149 cm, The National Gallery, London

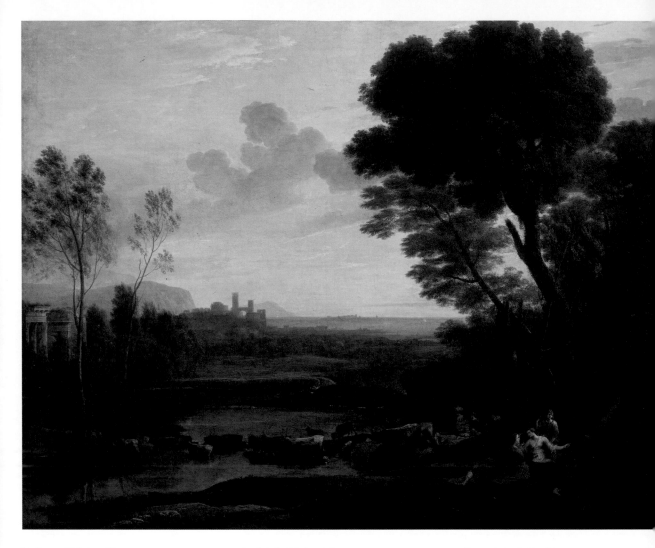

Landscape with Paris and Oenone

The nymph Oenone shows her husband Paris the oath of love he has carved into a tree. The evocative romantic, antique setting served as inspiration for landscape gardeners.

Paysage avec Pâris et Œnone *ou* Le Gué

La nymphe Œnone montre à son mari Pâris le serment d'amour qu'il a gravé sur un arbre. Le décor romantique d'inspiration antique éveille la mélancolie et a souvent servi d'inspiration aux paysagistes.

CLAUDE LORRAIN (1600–82)

1648, Oil on canvas/Huile sur toile, 118 × 150 cm, Musée du Louvre, Paris

Landschaft mit Paris und Oenone

Die Nymphe Oenone zeigt ihrem Mann Paris den Liebesschwur, den er in einen Baum geritzt hat. Die romantisch-antikisierende Kulisse weckte Sehnsüchte und diente Landschaftsgärtnern als Inspiration.

Paisaje con París y Oenone

La ninfa Oenone muestra a su marido París el voto de amor que ha tallado en un árbol. El ambiente romántico y antiguo despertó anhelos y sirvió de inspiración a los paisajistas.

Paesaggio con Paride ed Enone

La ninfa Enone mostra a suo marito Paride il voto d'amore che ha scolpito in un albero. L'ambiente romantico e antico suscitava nostalgia e serviva da ispirazione per i paesaggis

Landschap met Paris en Oenone

De nimf Oenone toont haar man Paris de liefdesgelofte die hij in een boom heeft gekerfd. Het romantische, klassiek aandoende decor wekte heftige verlangens op en diende landschapsarchitecten als bron van inspiratie.

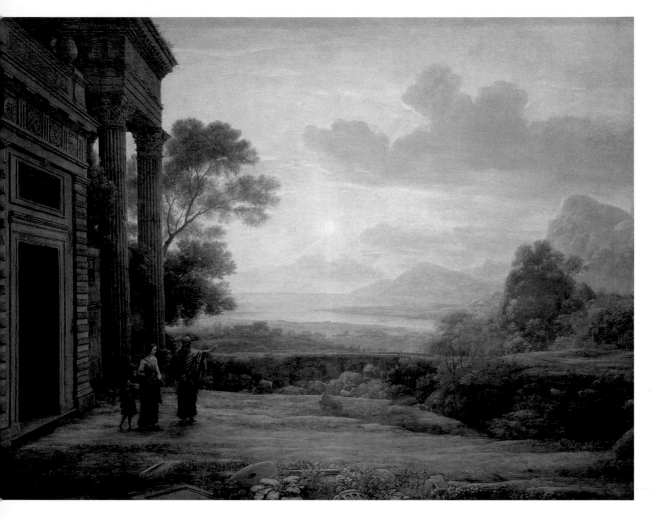

Expulsion of Hagar

Biblical scene: Abraham sends his maid Hagar and their
Ishmael into the desert. Next to the ancient architecture
the landscape that extends to the horizon, the figures all
small.

sage avec Abraham chassant Agar et Ismaël

scène biblique : Abraham envoie sa servante Agar et leur
smaël dans le désert. À côté de l'architecture antique et
aysage, qui s'étend jusqu'à l'horizon, ils semblent tous
petits.

Die Verstoßung der Hagar

Eine biblische Szene: Abraham schickt seine Magd Hagar
und den gemeinsamen Sohn Ismael in die Wüste. Neben der
antiken Architektur und der Landschaft, die sich bis zum
Horizont erstreckt, wirken sie alle klein.

La expulsión de Agar

Una escena bíblica: Abraham envía a su criada Agar y a su
hijo Ismael al desierto. Exceptuando a la arquitectura antigua
y al paisaje que se extiende hasta el horizonte, todos parecen
pequeños.

Cacciata di Agar

Una scena biblica: Abramo allontana la serva Agar e il figlio
Ismaele nel deserto. Oltre all'architettura antica e al paesaggio
che si estende fino all'orizzonte, tutti appaiono piccoli.

De verstoting van Hagar

Een Bijbels tafereel: Abraham stuurt zijn dienstmeisje Hagar
en hun gezamenlijke zoon Ismaël de woestijn in. Naast de
klassieke architectuur en het landschap dat zich tot aan de
horizon uitstrekt, lijken ze allemaal klein.

JDE LORRAIN (1600-82)
» Oil on canvas/Huile sur toile, 106,5 × 140,3 cm, Alte Pinakothek, München

301

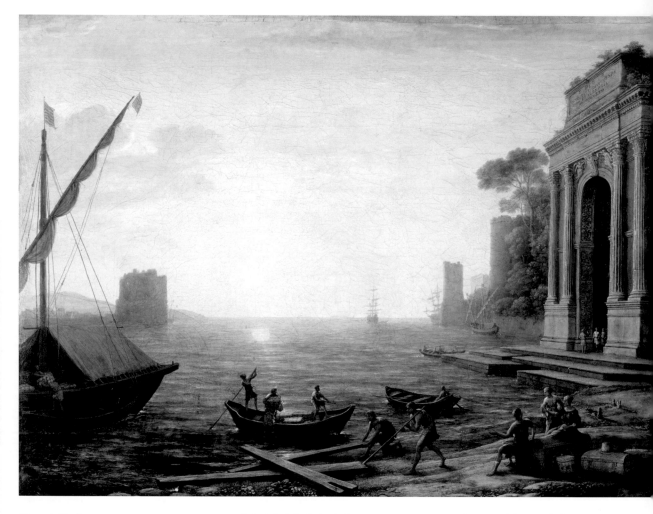

A Seaport at Sunrise

The dock workers who carry goods from a barge to the shore are only accessories: Lorrain emphasises the light of the morning sun, which he paints here for the first time in this way. The Roman triumphal arch recalls times past.

Port maritime à l'aube

Les hommes qui transportent la marchandise du bateau à la rive ne sont qu'accessoires : ce qui est important, c'est la lumière du soleil levant, que Lorrain peint pour la première fois ainsi. L'arc de triomphe romain rappelle les temps anciens.

Ein Seehafen bei aufgehender Sonne

Die Hafenarbeiter, die Waren von einem Kahn ans Ufer bringen, sind nur Beiwerk: Wichtiger ist das Licht der Morgensonne, von Lorrain erstmals so gemalt. Der römische Triumphbogen erinnert an vergangene Zeiten.

Puerto de mar con sol naciente

Los estibadores que llevan mercancías desde una barcaza a la costa son sólo secundarios: más importante es la luz del sol de la mañana, pintada así por primera vez por Lorrain. El arco triunfal romano recuerda tiempos pasados.

Un porto marittimo sotto il sole nascente

I portuali che trasportano merci da una chiatta a riva sono solo accessori: più importante è la luce del sole del mattino, così dipinto per la prima volta dai Lorrain. L'arco di trionfo romano ricorda i tempi passati.

Zeehaven bij opgaande zon

De havenarbeiders die goederen van een schuit naar de wal brengen, zijn slechts bijzaak: belangrijker is het licht van de ochtendzon, dat Lorrain voor het eerst op deze manier schilderde. De Romeinse triomfboog herinnert aan tijden van weleer.

CLAUDE LORRAIN (1600–82)

1674, Oil on canvas/Huile sur toile, 73 × 97,5 cm, Alte Pinakothek, München

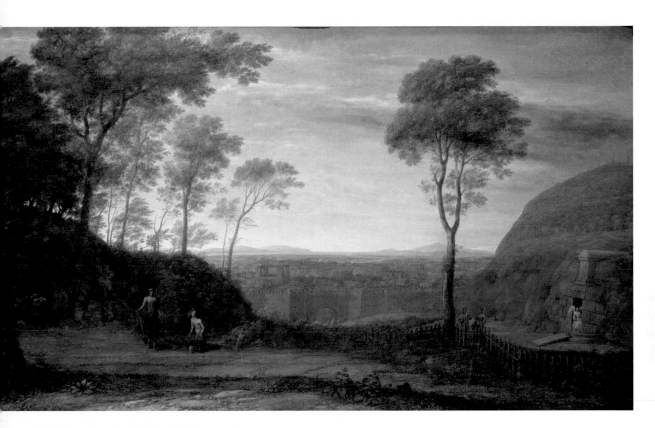

Landscape with Christ Appearing to Mary Magdalene ("Noli me tangere")

Christ apparaît à Marie-Madeleine *ou* Noli me tangere

Landschaft mit Christus, der Maria Magdalena erscheint ("Noli me tangere")

Paisaje con Cristo apareciéndose a María Magdalena ("Noli me tangere")

Paesaggio con Cristo che appare a Maria Maddalena ("Noli me tangere")

Landschap met Christus die aan Maria Magdalena verschijnt ('Noli me tangere')

CLAUDE LORRAIN (1600–82)

Oil on canvas/Huile sur toile, 84,9 × 141,1 cm, Städel Museum, Frankfurt am Main

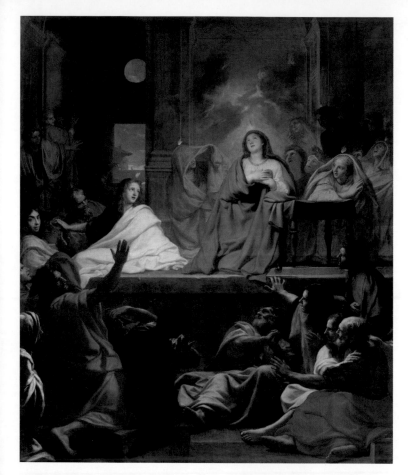

Charles Le Brun:
Court Artist to the Sun King

The son of a sculptor, Charles Le Brun was supported early on by important patrons, including Cardinal de Richelieu. In 1648, after studying painting in Rome with Nicolas Poussin, he co-founded the Académie royale de peinture et de sculpture, which influenced French art significantly from then on and whose successor institution still exists today. In 1662, Le Brun was appointed court artist to Louis XIV. As such, he not only created portraits of rulers and other paintings of monumental size, but was also responsible for the production of tapestries, furniture, and the painting of entire palaces (the Apollo Gallery in the Louvre in Paris, for example). Many of the figures in his classically composed paintings radiate something stately and dignified – even when they are experiencing strong emotions, as is often the case in Le Brun's religious scenes.

Charles Le Brun :
peintre à la cour du Roi-Soleil

Fils d'un sculpteur, Charles Le Brun bénéficia très jeune du soutien de personnages importants, notamment le cardinal de Richelieu. Il étudia la peinture à Rome auprès de Nicolas Poussin. Il fit partie en 1648 des fondateurs de l'Académie royale de peinture et de sculpture (ancêtre de l'Académie des beaux-arts), qui influença durablement l'art français. En 1662, il fut nommé peintre officiel à la cour de Louis XIV. Outre les portraits du souverain et d'autres tableaux d'une taille colossale, il était également responsable de la Manufacture des Gobelins, directeur du Mobilier royal et chargé de la décoration de nombreux châteaux (par exemple la galerie d'Apollon, au Louvre). Dans ses tableaux à la composition classique, les personnages rayonnent de dignité et d'autorité étatique, y compris quand ils sont en train de vivre des émotions intenses, comme c'est souvent le cas dans ses scènes religieuses.

Charles Le Brun:
Hofkünstler des Sonnenkönigs

Charles Le Brun, Sohn eines Bildhauers, wurde schon früh von wichtigen Persönlichkeiten, darunter Kardinal de Richelieu, gefördert. In Rom studierte er Malerei bei Nicolas Poussin. 1648 war er Mitbegründer der Kunstakademie, der Académie royale de peinture et de sculpture, die die französische Kunst fortan maßgeblich beeinflusste und deren Nachfolgerin bis heute existiert. 1662 wurde Le Brun offiziell zum Hofkünstler Ludwigs XIV. ernannt. Als solcher schuf er nicht nur Herrscherporträts und andere Gemälde monumentaler Größe, sondern war zugleich für die Herstellung von Gobelins, Möbeln sowie die Ausmalung ganzer Schlösser (zum Beispiel die Apollogalerie im Pariser Louvre) verantwortlich. Viele Figuren auf seinen klassisch komponierten Gemälden strahlen etwas Staatstragend-Würdevolles aus – selbst wenn sie gerade starke Emotionen durchleben, wie es oft in Le Bruns religiösen Szenen der Fall ist.

The Chancellor Séguier
The Entry of Louis XIV
in Paris in 1660

Portrait équestre
de Pierre Séguier,
chancelier de France

Der Kanzler Séguier
beim Einzug
Ludwigs XIV. in
Paris 1660

Il Canciller Séguier a
la llegada de Luis XIV
a París en 1660

Cancelliere Séguier
all'arrivo di Luigi XIV
a Parigi nel 1660

Kanselier Séguier bij de
Intocht van Lodewijk XIV
in Parijs in 1660

CHARLES LE BRUN
(1619–90)
c. 1660, Oil on canvas/
Huile sur toile, 295 × 357 cm,
Musée du Louvre, Paris

Charles Le Brun:
pintor de la cortedel Rey Sol

Charles Le Brun, hijo de un escultor, fue apoyado desde muy temprano por importantes personalidades, entre ellas el cardenal de Richelieu. Estudió pintura en Roma con Nicolas Poussin. En 1648 fue cofundador de la Académie royale de peinture et de sculpture (Academia Real de Pintura y Escultura), que influyó significativamente en el arte francés a partir de entonces y cuyo sucesor sigue existiendo en la actualidad. En 1662 Le Brun fue nombrado oficialmente pintorde la corte de Luis XIV. Como tal, no sólo creó retratos de gobernantes y otras pinturas de tamaño monumental, sino que también fue responsable de la producción de tapices, muebles y la pintura de castillos enteros (por ejemplo, la Galería Apolo en el Louvre en París). Muchas de las figuras de sus cuadros de composición clásica irradian algo majestuoso y digno, incluso cuando experimentan emociones fuertes, como sucede a menudo en las escenas religiosas de Le Brun.

Charles Le Brun:
artista di corte del re Sole

Charles Le Brun, figlio di uno scultore, fu incoraggiato presto da importanti personalità, tra cui il cardinale de Richelieu. Studiò pittura a Roma con Nicolas Poussin. Nel 1648 fu co-fondatore dell'Académie royale de peinture et de sculpture, influenzando significativamente l'arte francese a partire da quel momento e che rinominata esiste ancora oggi. Nel 1662 Le Brun divenne ufficialmente artista di corte di Luigi XIV. Come tale, non solo ha creato ritratti di regnanti e altri dipinti di dimensioni monumentali, ma è stato anche responsabile della produzione di arazzi, mobili e della pittura di interi castelli (per esempio la Galleria Apollo al Louvre di Parigi). Molte delle figure dei suoi dipinti classici irradiano qualcosa di maestoso e di dignitoso, anche quando provano forti emozioni, come spesso accade nelle scene religiose di Le Brun.

Charles Le Brun:
hofkunstenaar van de Zonnekoning

Charles Le Brun, de zoon van een beeldhouwer, werd al vroeg gesteund door belangrijke personen, onder wie kardinaal de Richelieu. Hij studeerde schilderkunst bij Nicolas Poussin in Rome. In 1648 was hij medeoprichter van de Académie royale de peinture et de sculpture, die de Franse kunst vanaf die tijd sterk beïnvloedde en waarvan de opvolger nog steeds bestaat. In 1662 werd Le Brun officieel benoemd tot hofkunstenaar van Lodewijk XIV. In die hoedanigheid maakte hij niet alleen portretten van vorsten en andere schilderijen van monumentaal formaat, maar was hij ook verantwoordelijk voor de productie van wandtapijten, meubels en de beschildering van volledige kastelen (bijvoorbeeld de Apollogalerij in het Louvre in Parijs). Veel van de figuren in zijn klassiek gecomponeerde schilderijen stralen iets statigs en waardigs uit – zelfs als ze sterke emoties ervaren, zoals vaak het geval is in Le Bruns religieuze scènes.

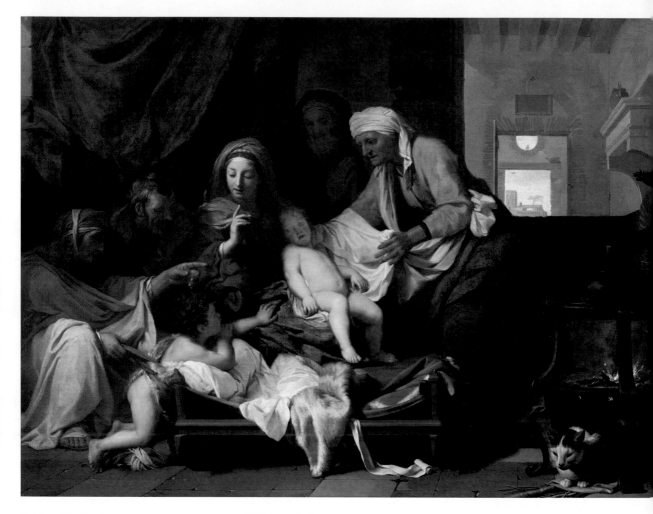

The Sleep of the Infant Jesus

Le Brun frames the sleeping child as if on a stage with figures of the Holy Family. The scene seems domestic and peaceful, but the way the child lies on the cloth already foreshadows the Passion.

Le Sommeil de l'Enfant Jésus ou Le Silence

Le Brun a entouré l'enfant endormi, comme au théâtre, des membres de la Sainte Famille. La scène semble calme et domestique, mais la manière dont l'enfant repose sur le drap renvoie déjà à la Passion de Jésus.

CHARLES LE BRUN (1619–90)

1655, Oil on canvas/Huile sur toile, 87 × 118 cm, Musée du Louvre, Paris

Schlaf des Jesusknaben

Le Brun umrahmte das schlafende Kind wie auf einer Bühne mit Figuren der Heiligen Familie. Die Szene wirkt ruhig und häuslich, doch die Art, wie das Kind auf dem Tuch liegt, verweist bereits auf die Passion Jesu.

Sueño del niño Jesús

Le Brun enmarcó al niño dormido como si estuviera en un escenario con figuras de la Sagrada Familia. La escena parece tranquila y hogareña, pero la forma en que el niño se acuesta en la tela ya se refiere a la pasión de Jesús.

Riposo del Cristo bambino

Le Brun incornicia il Bambino addormentato come su un palco con figure della Sacra Famiglia. La scena sembra cal e accogliente, ma il modo in cui il Bambino giace sul telo rimanda già alla passione di Gesù.

Slapen van de jongen Jezus

Le Brun omkaderde het slapende kind als op een toneel, m personen uit de Heilige Familie. Het tafereel oogt rustig huiselijk, maar de manier waarop het kind op het doek lig verwijst al naar het lijden van Jezus.

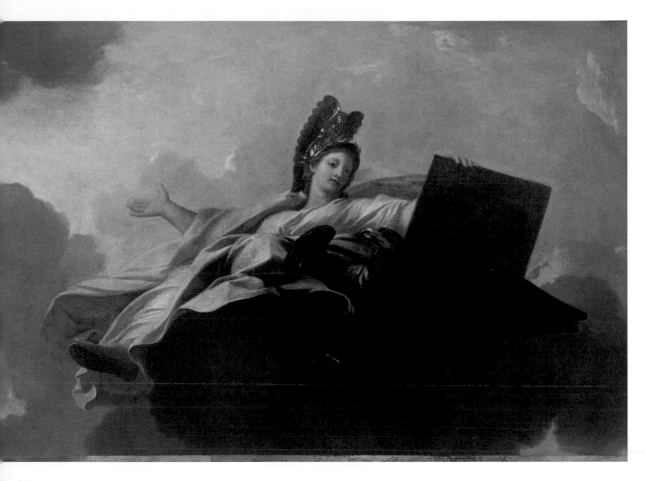

ES LE BRUN (1619–90)

il on canvas/Huile sur toile, 104 × 153 cm, Musée des beaux-arts et d'archéologie, Besançon

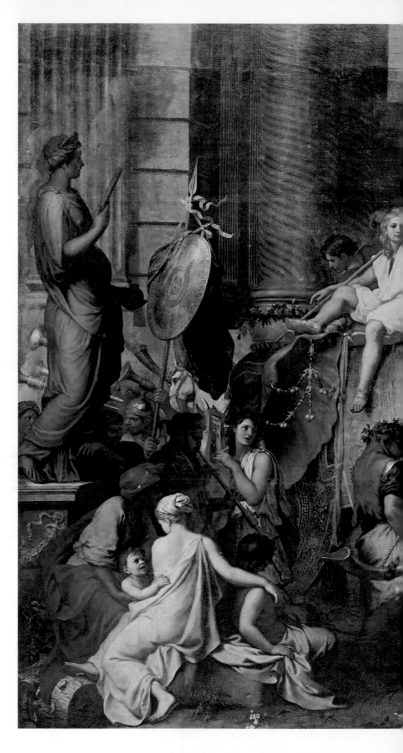

Alexander the Great in Babylon
Alexander arrives victorious in Babylon (the Hanging Gardens of the city behind him). The painting, part of a cycle, alludes to Louis XIV—himself a powerful king.

Entrée d'Alexandre à Babylone ou Le Triomphe d'Alexandre
Victorieux, Alexandre entre dans Babylone dans un char tiré par des éléphants (on aperçoit derrière lui les jardins suspendus de Sémiramis). Ce tableau appartient à un cycle et fait allusion à Louis XIV, un roi très puissant lui aussi.

Einzug Alexanders des Großen in Babylon
Der siegreiche Alexander fährt in Babylon ein (hinter ihm die Hängenden Gärten der Semiramis). Das Bild, Teil eines Zyklus, spielt auf Ludwig XIV. an – auch er ein mächtiger König.

Entrada de Alejandro Magno en Babilonia
El victorioso Alejandro llega a Babilonia (detrás de él los Jardines Colgantes de los Semiramis). La pintura, parte de un ciclo, alude a Luis XIV, también un poderoso rey.

Ingresso di Alessandro Magno a Babilonia
Il vittorioso Alessandro arriva a Babilonia (dietro di lui i giardini pensili di Semiramide). Il dipinto, parte di un ciclo, allude a Luigi XIV – anche lui un potente regnante.

Intocht van Alexander de Grote in Babylon
De zegevierende Alexander komt Babylon binnen (achter hem de hangende tuinen van Semirami). Het schilderij, dat deel uitmaakt van een cyclus, verwijst naar Lodewijk XIV – ook een machtige koning.

CHARLES LE BRUN (1619–90)
1665, Oil on canvas/Huile sur toile, 450 × 707 cm, Musée du Louvre, Paris

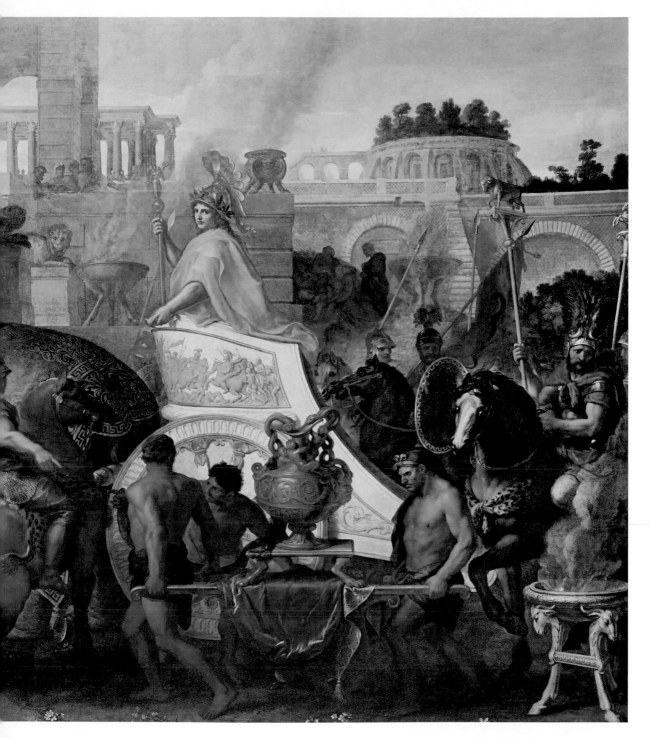

Portrait of Louis XIV

This picture shows the milita[r] power of Louis XIV, seen in armour before a battlefield. The rearing horse with terrif[ic] eyes underlines the young regent's calm.

Portrait équestre de Louis X[IV]

Ce tableau montre le pouvoi[r] militaire de Louis XIV, qui apparaît en armure devant u[n] champ de bataille. Le cheval se cabre avec un regard d'eff[roi] met en valeur la sérénité du jeune souverain.

Reiterbildnis Ludwigs XIV.

Das Bild zeigt die militärisch[e] Macht Ludwigs XIV., zu sehen in einer Rüstung vor einem Schlachtfeld. Das sich aufbäumende Pferd mit schreckgeweiteten Augen unterstreicht die Ruhe des jungen Regenten.

Retrato de Luis XIV.

El cuadro muestra el poder militar de Luis XIV, visto co[n] armadura frente a un camp[o de] batalla. El caballo rebelde de[ojos] aterrorizados subraya la cal[ma] del joven regente.

Ritratto equestre di Luigi X[IV]

Il dipinto mostra la potenza militare di Luigi XIV, raffigu[rato] nell'armatura di fronte a un campo di battaglia. Il cavall[o] ribelle dagli occhi terrorizza[ti] sottolinea la calma del giovane reggente.

Portret van Lodewijk XIV te paard

Het schilderij toont de milit[aire] macht van Lodewijk XIV, w[aar] te zien is aan zijn wapenrust[ing] voor het slagveld. Het steige[rende] paard met doodsangst in de ogen onderstreept de rust va[n de] jonge regent.

CHARLES LE BRUN (1619–90)
1668, Oil on canvas/
Huile sur toile, 329 × 257 cm,
Musée de la Chartreuse, Douai

Carrying of the Cross

rtement de Croix

Kreuztragung

 llevando la cruz

 al Calvario

ruisdraging

LES LE BRUN (1619–90)

Oil on canvas/Huile sur toile, 153 × 214 cm, Musée du Louvre, Paris

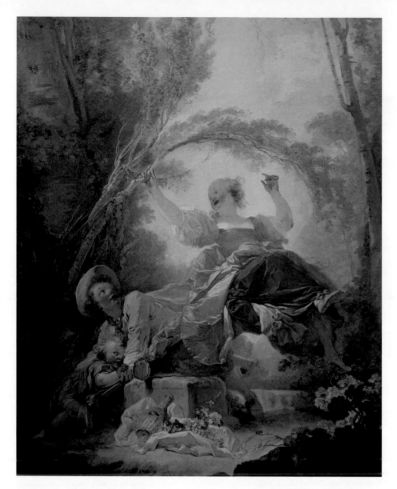

The See-Saw

La Bascule

Die Wippe

El balancín

L'altalena a bilico

De wip

JEAN-HONORÉ FRAGONARD (1732–1806)

c. 1750–52, Oil on canvas/Huile sur toile, 120 × 94,5 cm,
Museo Nacional Thyssen-Bornemisza, Madrid

Jean-Honoré Fragonard: Painter of Sensual, Gallant Life

Along with Jean-Antoine Watteau and François Boucher, Fragonard was a major figure in rococo painting. After the severe pathos of baroque art in the era of Louis XIV, people longed for more light-hearted themes and brighter colours. Fragonard embodies the height of this trend: his paintings almost exclusively show frivolous love scenes or playful activities in nature. Gentlemen and (especially) rosy-cheeked ladies enjoy bathing or idyllic shepherd games with erotic undertones. This cheerful, informal atmosphere captures Fragonard perfectly: fluidly applied pastel shades give the impression that 18th-century life in France was one unending delight. In fact, the country was on the threshold of the French Revolution, which Fragonard's career did not survive: he died forgotten and impoverished in 1806.

Jean-Honoré Fragonard : le peintre de la vie libertine et galante

Avec Jean-Antoine Watteau et François Boucher, Fragonard fut l'un des principaux représentants de la peinture rococo. Après le pathos solennel des tableaux baroques du règne de Louis XIV, on aspirait à présent à des thèmes plus légers et à des couleurs pastel. Fragonard représente l'apogée de ce style : ses tableaux montrent presque exclusivement des scènes d'amour frivoles ou des activités ludiques en pleine nature. Les messieurs et (surtout) les dames bien en chair aimaient à se distraire en se baignant ou en jouant des scènes de bergers aux accents résolument érotiques. Fragonard rendit parfaitement cette ambiance gaie et insouciante : ses tons pastel floconneux donnent l'impression que la vie dans la France du XVIIIᵉ siècle n'était qu'un grand cri de joie. On se trouvait pourtant alors au seuil de la Révolution française, qui marqua la fin du succès de Fragonard : il mourut en 1806, pauvre et oublié.

Jean-Honoré Fragonard: Maler des sinnlich-galanten Lebens

Mit Jean-Antoine Watteau und François Boucher war Fragonard ein Hauptvertreter der Rokokomalerei. Nac dem schweren Pathos barocker Darstellungen, das mi Ära Ludwigs XIV. einherging, sehnte man sich nun na unbeschwerten Themen und helleren Farben. Fragona verkörpert den Höhepunkt dieses Trends: Seine Gem zeigen fast ausschließlich frivole Liebesszenen oder spielerisches Treiben in der Natur. Die Herren und (v allem) die rosigen Damen verlustierten sich damals gern beim Baden oder bei idyllischen Schäferspielen, durchaus mit erotischen Untertönen. Diese heiter-zwanglose Stimmung fängt Fragonard perfekt ein: Flo aufgetragene Pastelltöne vermitteln den Eindruck, das Leben im Frankreich des 18. Jahrhunderts sei ein einzi Frohlocken gewesen. Dabei stand man an der Schwell zur Französischen Revolution, die Fragonard selbst ni gut überstand: 1806 starb er vergessen und verarmt.

Waterfalls at Tivoli

Cascatelles de Tivoli

Wasserfälle bei Tivoli

Cascadas cerca de Tivoli

Cascate vicino a Tivoli

Waterval bij Tivoli

JEAN-HONORÉ FRAGONARD (1732-1806)

1761/62, Oil on canvas/Huile sur toile, 73 × 61 cm, Musée du Louvre, Paris

n-Honoré Fragonard:
tor de la vida sensual-galante

o con Jean-Antoine Watteau y François Boucher,
,onard fue una figura importante de la pintura rococó.
pués del severo patetismo de las representaciones
ocas que acompañaron la época de Luis XIV, la
e anhelaba temas desenfadados y colores más
antes. Fragonard encarna el clímax de esta tendencia:
pinturas muestran casi exclusivamente escenas de
r frívolas o actividades lúdicas en la naturaleza.
caballeros y (especialmente) las damas rosadas
utaban del baño o de los idílicos juegos de los
ores, con matices eróticos. Este ambiente alegre e
rmal captura perfectamente a Fragonard: los tonos
el en escamas dan la impresión de que la vida en
cia en el siglo XVIII era un simple regocijo. Estaban
l umbral de la Revolución Francesa, a la que el propio
,onard no sobrevivió bien: en 1806 murió olvidado
pobrecido.

Jean-Honoré Fragonard:
pittore della vita sensuale-galante

Insieme a Jean-Antoine Watteau e François Boucher,
Fragonard fu una figura di spicco nella pittura rococò.
Dopo il rigido pathos delle raffigurazioni barocche
che accompagnò l'epoca di Luigi XIV, si anelava a temi
spensierati e colori più vivaci. Fragonard incarna il
culmine di questa tendenza: i suoi dipinti mostrano scene
d'amore quasi esclusivamente frivole o attività ludiche
nella natura. I signori e (soprattutto) le belle signore si
divertivano a fare il bagno o nei giochi idilliaci pastorali,
con sfumature erotiche. Fragonard cattura alla perfezione
questa atmosfera allegra e informale: i toni pastello in
fiocchi danno l'impressione che la vita nella Francia
nel XVIII secolo fosse un unico gioire. Si era alle soglie
della Rivoluzione Francese, che lo stesso Fragonard non
sopravvisse bene: nel 1806 morì dimenticato e impoverito.

Jean-Honoré Fragonard:
schilder van een sensueel-galant leven

Samen met Jean-Antoine Watteau en François Boucher
was Fragonard een belangrijke vertegenwoordiger
van de rococoschilderkunst. Na het zware pathos van
barokke afbeeldingen, die verbonden zijn met het
tijdperk van Lodewijk XIV, verlangde men naar luchtige
thema's en lichtere kleuren. Fragonard belichaamt het
hoogtepunt van deze trend: zijn schilderijen tonen
bijna uitsluitend frivole liefdestaferelen of speelse
drukte in de natuur. De heren en (vooral) de blozende
dames vermaakten zich destijds graag met zwemmen
of idyllische herdersspelletjes, die beslist een erotische
ondertoon hadden. Deze vrolijke, ongedwongen sfeer
geeft Fragonard perfect weer: vlokkerig aangebrachte
pasteltinten wekken de indruk dat het leven in Frankrijk
in de 18e eeuw een groot feest was. Men stond aan de
vooravond van de Franse Revolutie, die Fragonard zelf
niet goed doorstond: in 1806 stierf hij arm en vergeten.

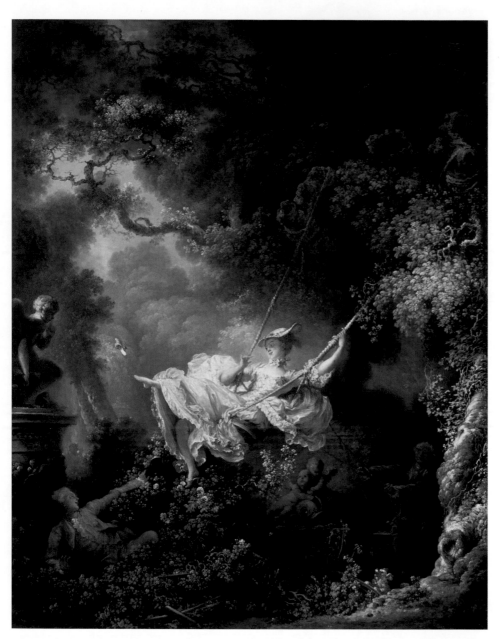

The Swing

In what is probably the most famous roco[o] painting, a boisterous lady rocks on a swin[g] not minding that one of her companions i[s] peeking up her skirt. The coquettish scene shows how distant the elite had become fr[om] the suffering of the people.

Les Hasards heureux de l'escarpolette

Sur ce tableau, le plus célèbre de la périod[e] rococo, une jeune femme pétulante fait de la balançoire. Le fait que l'un de ses accompagnateurs regarde sous sa jupe ne semble pas la déranger. Cette scène coque[tte] montre combien la haute société s'était éloignée du peuple et de ses souffrances.

Die Schaukel

Auf dem wohl berühmtesten Rokokobild schaukelt eine übermütige Dame. Es stört sie nicht, dass einer der Begleiter unter ih[ren] Rock schaut. Die kokette Szene zeigt, wie sich die Elite vom leidenden Volk entfernt hatte.

El columpio

En lo que probablemente sea la pintura ro[cocó] más famosa, una mujer bulliciosa se balan[cea.] No le importa que una de las compañeras [esté] mirando bajo su falda. La escena de la coq[uetería] muestra hasta qué punto la élite se había alejado de la gente que sufría.

L'Altalena

In quello che è probabilmente il più famos[o] dipinto rococò, una baldanzosa signora si dondola sull'altalena. Non le dispiace che [uno] dei suoi accompagnatori stia sbirciando so[tto] la sua gonna. La scena di civetteria mostra quanto l'élite si sia allontanata dal popolo sofferente.

De schommel

Op wat waarschijnlijk het beroemdste rococoschilderij is, schommelt een overmoedige dame. Ze vindt het niet erg [dat] een van de begeleiders onder haar rok kijk[t]. De kokette scène laat zien hoe ver de elite [van] het lijdende volk afstond.

JEAN-HONORÉ FRAGONARD (1732–1806)

1767/68, Oil on canvas/Huile sur toile,
81 × 64,2 cm, Wallace Collection, London

Girl with a Dog

A playfully erotic scene of the type popular with Fragonard's clients, which today seems a bit indecent: a girl amuses herself with a small dog on a lush four-poster bed.

Jeune Fille faisant danser son chien sur son lit

Une des scènes fantaisistes et érotiques que les commanditaires de Fragonard appréciaient tout particulièrement mais qui aujourd'hui paraissent quelque peu choquantes : un lit à baldaquin plantureux, une jeune fille s'amuse avec un petit chien.

Mädchen mit Hund

Eine der verspielt-erotisierenden Szenen, die bei Fragonards Auftraggebern sehr beliebt waren, heute aber etwas anstößig wirken: Auf einem üppigen Himmelbett vergnügt sich ein Mädchen mit einem kleinen Hund.

Niña con su perro

Una de las escenas eróticas lúdicas, muy populares entre los clientes de Fragonard, pero que hoy parecen un poco ofensivas: una niña se divierte con un perrito en una exuberante cama de cuatro pilares.

Giovinetta con cane

Una delle scene erotizzanti e giocose, molto popolari tra i clienti di Fragonard, ma che oggi sembrano un po' offensive: una giovinetta si diverte con un cagnolino su un rigoglioso letto a baldacchino.

Meisje met hond

Een van de speelse, erotiserende scènes die erg populair waren bij de klanten van Fragonard, maar nu een beetje aanstootgevend werken: op een weelderig hemelbed vermaakt een meisje zich met een hondje.

**JEAN-HONORÉ FRAGONARD
(1732–1806)**

c. 1770, Oil on canvas/Huile sur toile, 89 × 70 cm, Alte Pinakothek, München

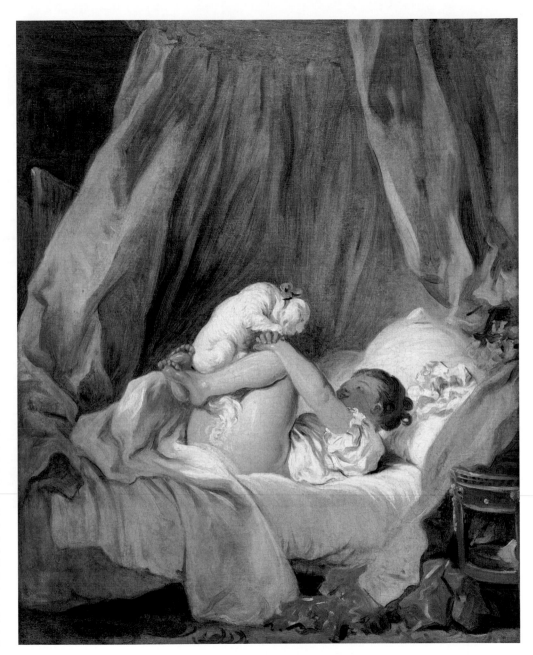

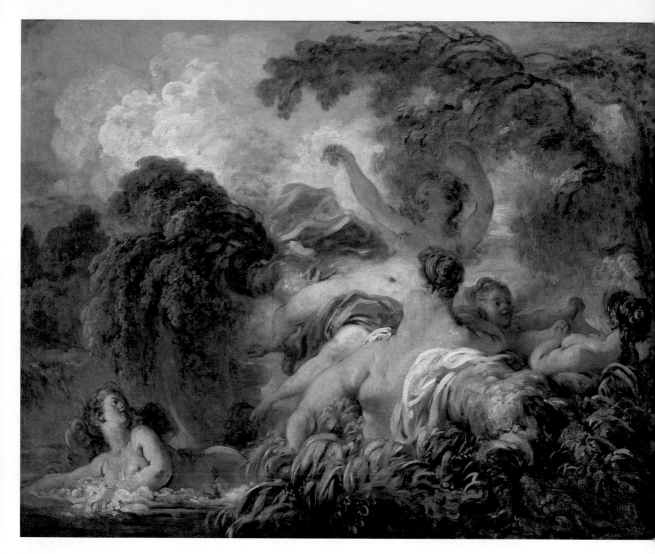

The Bathers

Les Baigneuses

Die Badenden

Los bañistas

Le bagnanti

De baadsters

JEAN-HONORÉ FRAGONARD (1732–1806)

1763/64, Oil on canvas/Huile sur toile, 64 × 80 cm, Musée du Louvre, Paris

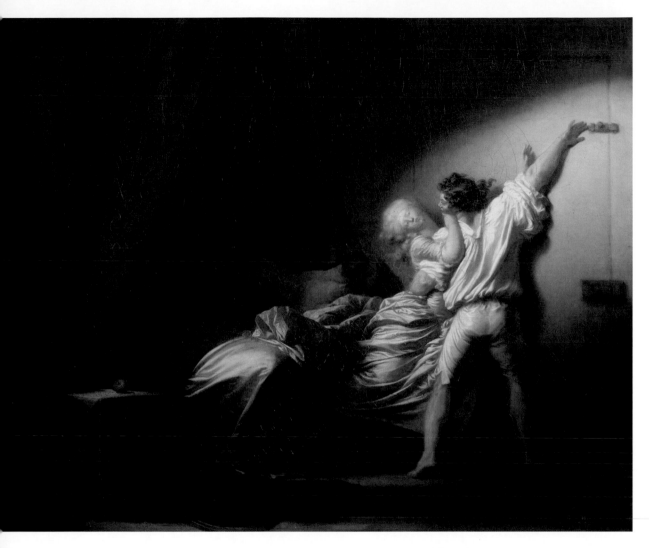

Bolt

Bolt

e work by Fragonard in darker colors. The bed is in
rder, as are the lovers' clothes: has something already
ened here, or is this a scene of seduction? The apple could
k for the latter.

errou

œuvre tardive de Fragonard, aux couleurs plus sombres.
est en désordre, la toilette des amants également : s'est-
à passé quelque chose, ou est-ce juste la tentation qui
e ? La pomme semble plaider pour la deuxième possibilité.

Der Riegel

Ein Spätwerk Fragonards in dunkleren Farben. Das Bett ist
in Unordnung, die Kleidung der Liebenden ebenfalls: Hat
hier schon etwas stattgefunden oder geht es um Versuchung?
Dafür könnte der Apfel sprechen.

El cerrojo

Una obra tardía de Fragonard en colores más oscuros. La
cama está desordenada, al igual que la ropa de los amantes:
¿ha pasado algo aquí o se trata de tentaciones? La manzana
podría hablar a cerca de eso.

Il chiavistello

Un'opera tardiva di Fragonard dai colori più scuri. Il letto è
in disordine, così come i vestiti degli innamorati: è successo
qualcosa qui o si tratta di tentazione? La mela potrebbe essere
un chiaro riferimento.

De grendel

Een laat werk van Fragonard in donkerdere kleuren. Het bed
is een warboel, net als de kleren van de geliefden. Is hier al
iets gebeurd of gaat het om verleiding? De appel zou voor die
interpretatie kunnen spreken.

-HONORÉ FRAGONARD (1732–1806)
7, Oil on canvas/Huile sur toile, 74 × 94 cm, Musée du Louvre, Paris

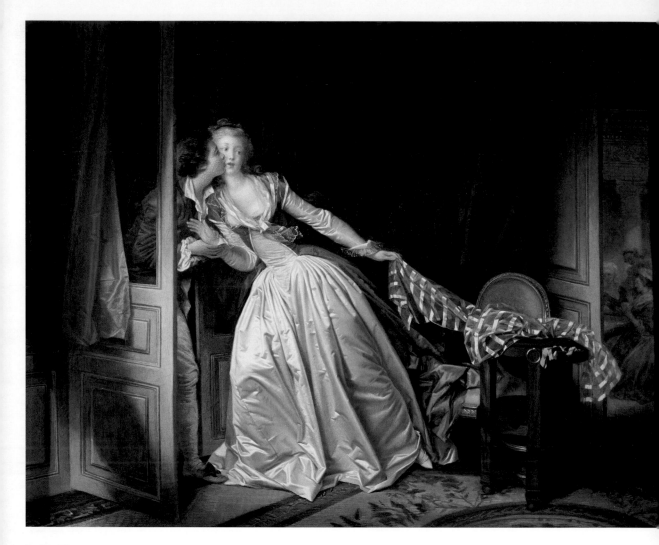

The Secret Kiss

Le Baiser à la dérobée

Der heimliche Kuss

El beso secreto

Il bacio furtivo

De heimelijke kus

JEAN-HONORÉ FRAGONARD (1732–1806) & MARGUERITE GÉRARD (1761–1837)

c. 1785–89, Oil on canvas/Huile sur toile, 45 × 55 cm, State Hermitage Museum, St. Petersburg

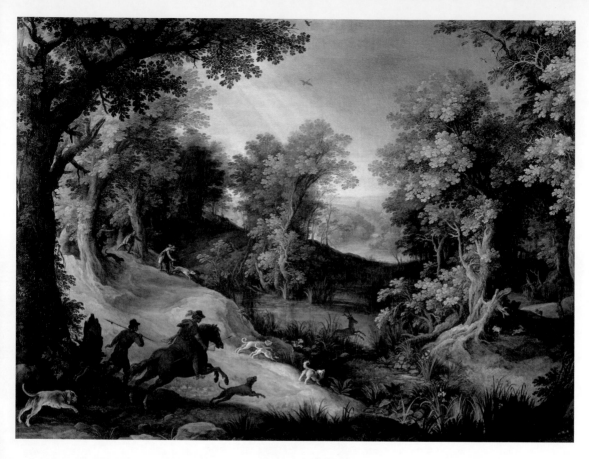

Flemish Painting in the 17th Century

Like their French colleagues, Flemish painters in the 17th century travelled to Rome, capital of the baroque, to study the Italian masters. This was even truer for Flanders than for the northern part of the Netherlands, since although the north had finally broken with Spain and become Protestant with the Peace of Westphalia in 1648, Flanders remained Spanish and Catholic. Flemish painters created monumental works full of dynamism, bridges to the heavenly world. The greatest artist of the time was Peter Paul Rubens, who frequently painted for the church.

At the same time, new genres flourished. Painters like Adriaen Brouwer showed snapshots of the life of the common people, while Frans Snyders, Pieter Boel, and Clara Peeters, among others, created masterful still lifes, often referring to the idea of vanitas: everything earthly is transient.

La peinture flamande du XVIIᵉ siècle

À l'instar de leurs homologues français, les peintres flamands du XVIIᵉ siècle voyageaient eux aussi à Rome, capitale du baroque, pour y étudier les maîtres italiens. C'était plus net encore pour la Flandre que pour la partie nord des Pays-Bas, car si le nord avait définitivement coupé les ponts avec l'Espagne en 1648 (avec la paix de Westphalie) et était devenu protestant, la Flandre en revanche était restée espagnole et catholique. Des tableaux monumentaux virent le jour, caractérisés par une forte dynamique, comme des ponts vers le monde céleste. Le plus grand maître de cette époque fut Pierre Paul Rubens, qui peignit beaucoup pour l'Église. Au même moment, de nouveaux styles fleurirent : les scènes de genre d'Adriaen Brouwer par exemple, sorte d'instantanés montrant la vie de gens simples. Des natures mortes magistrales se multiplièrent, sous le pinceau notamment de Frans Snyders, Pieter Boel et Clara Peeters, faisant souvent référence à l'idée de vanité : tout ce qui est terrestre est éphémère.

Die flämische Malerei des 17. Jahrhunderts

Wie ihre französischen Kollegen reisten auch flämische Maler im 17. Jahrhundert nach Rom, in die Hauptstadt Barocks, um dort die italienischen Meister zu studieren Dies galt noch stärker für Flandern als für den nördlich Teil der Niederlande, denn während sich der Norden 1648 (mit dem Westfälischen Frieden) endgültig von Spanien losgesagt hatte und protestantisch geworden w blieb Flandern spanisch und katholisch. Hier entstande monumentale Gemälde voller Dynamik, eine Brücke zur himmlischen Welt. Der Größte jener Zeit war Peter Paul Rubens, der viel für die Kirche malte. Gleichzeitig florierten neue Gattungen: Genrebilder wie von Adriae Brouwer zeigen Momentaufnahmen aus dem Leben einfacher Menschen. Meisterhafte Stillleben wurden unter anderem von Frans Snyders, Pieter Boel und Clar Peeters geschaffen, häufig verweisen sie auf den Vanitas Gedanken: Alles Irdische ist vergänglich.

tura flamenca del siglo XVII

no sus colegas franceses, los pintores flamencos
ron a Roma, la capital del Barroco, en el siglo XVII
estudiar a los maestros italianos. Esto se notó más
landes que en la parte norte de los Países Bajos, ya
mientras que en 1648 (con la Paz de Westfalia) el
e había renunciado finalmente a España y se había
ertido en protestante, Flandes seguía siendo española
ólica. Aquí creó pinturas monumentales llenas de
mismo, un puente hacia el mundo celestial. El más
de de ese tiempo fue Peter Paul Rubens, quien pintó
ho para la iglesia. Al mismo tiempo, los nuevos
ros florecieron: imágenes de género como las de
aen Brouwer muestran instantáneas de la vida de la
e sencilla. Frans Snyders, Pieter Boel y Clara Peeters,
e otros, crearon bodegones magistrales, refiriéndose
nudo a la idea de las vanitas: todo lo terrenal
asajero.

Pittura fiamminga del XVII secolo

Come i loro colleghi francesi, anche i pittori fiamminghi
si recarono a Roma, capitale del barocco, nel XVII secolo
per studiare i maestri italiani. Ciò valeva per i fiamminghi
più che per la parte settentrionale dei Paesi Bassi, perché
mentre nel 1648 (con la Pace di Vestfalia) il nord aveva
finalmente rinunciato alla Spagna ed era diventato
protestante, le Fiandre rimasero spagnole e cattoliche. Qui
furono creati dipinti monumentali pieni di dinamismo, un
ponte verso il regno dei cieli. Il più grande di quel periodo
fu Peter Paul Rubens, che dipinse molto per la Chiesa.
Allo stesso tempo fiorirono nuovi generi: immagini di
genere come di Adriaen Brouwer mostrano una fotografia
della vita di persone semplici. Magistrali nature dipinte tra
l'altro da Frans Snyders, Pieter Boel e Clara Peeters, fanno
spesso riferimento riferendosi all'idea della vanitas: tutto
ciò che è terreno è transitorio.

De Vlaamse schilderkunst van de 17e eeuw

Net als hun Franse collega's reisden Vlaamse schilders
in de 17e eeuw naar Rome, de hoofdstad van de barok,
om daar de Italiaanse meesters te bestuderen. Dit gold
nog meer voor Vlaanderen dan voor het noordelijke deel
van de Nederlanden, want terwijl in 1648 (met de Vrede
van Münster) het noorden uiteindelijk had gebroken met
Spanje en protestants werd, bleef Vlaanderen Spaans en
katholiek. Hier ontstonden monumentale schilderijen vol
dynamiek, een brug naar de hemelse wereld. De grootste
schilder van die tijd was Peter Paul Rubens, die veel voor
de kerk schilderde. Tegelijkertijd kwamen nieuwe genres
tot bloei: genrestukken zoals die van Adriaen Brouwer
tonen momentopnamen uit het leven van eenvoudige
mensen. Meesterlijke stillevens werden onder andere
gemaakt door Frans Snyders, Pieter Boel en Clara Peeters,
die vaak verwezen naar de vanitasgedachte: al het aardse
is vergankelijk.

Nocturnal Landscape with Harbour and Lighthouse

Paysage nocturne avec un port et un phare

Nächtliche Hafenlandschaft mit Leuchtturm

Paisaje portuario nocturno con faro

Paesaggio notturno del porto con faro

Nachtelijk havenlandschap met vuurtoren

PAUL BRIL (1554–1626)

1601, Oil on copper/Huile sur cuivre, 22 × 29,5 cm, Kunsthistorisches Museum, Wien

[Mou]ntain Landscape

[A fa]ntasy landscape of the type for which Momper was [reno]wned. The decorative figures seem insignificant in view [of th]e grandiose, dramatic scenery with rocks, dark trees, and [a wa]terfall.

[Pays]age de montagne

[Un] des paysages fantastiques typiques de l'époque et pour [lesqu]els Momper était célèbre. Les personnages semblent [acce]ssoires comparés au décor grandiose et dramatique, avec [ses f]alaises, sa chute d'eau et ses arbres sombres.

Gebirgslandschaft

Eine typische Fantasielandschaft der Zeit, für die Momper berühmt war. Die Staffagefiguren wirken unbedeutend angesichts der grandiosen, dramatischen Szenerie mit Felsen, dunklen Bäumen und Wasserfall.

Paisaje de montaña

Un paisaje de fantasía típico de la época en la que Momper era famoso. Las cifras del personal parecen insignificantes en vista del grandioso y dramático paisaje con rocas, árboles oscuros y cascadas.

Maesaggio di montagna

Un tipico paesaggio fantastico dell'epoca per cui Momper era famosa. Le figure ornamentali sembrano insignificanti di fronte al grandioso e drammatico scenario con rocce, alberi scuri e cascate.

Berglandschap

Een typisch fantasielandschap uit die tijd, waar Momper bekend om stond. De decoratieve figuurtjes ogen nietig in het grandioze, dramatische landschap met rotsen, donkere bomen en een waterval.

[JOO]S DE MOMPER THE YOUNGER (1564–1635)

[...]s, Oil on wood/Huile sur bois, 77 × 122 cm, Nationalmuseum, Stockholm

Landscape with the Flight into Egypt

In this alpine fantasy landscape with ruins, one could almost overlook the Holy Family under the arch in the background – were it not for the mysterious bright light that illuminates the centre of the picture.

Paysage avec la Fuite en Égypte

Dans ce paysage de montagne fantastique émaillé de ruines, on remarque à peine la Sainte Famille, à l'arrière-plan, sous l'arche – mais une mystérieuse lumière attire notre attention vers le centre de l'image.

Landschaft mit Flucht nach Ägypten

Fast übersieht man in dieser alpinen Fantasielandschaft mit Ruinen die Heilige Familie unter dem Bogen im Hintergrund – wäre da nicht das mysteriöse helle Licht, das die Bildmitte erstrahlen lässt.

Paisaje con huída a Egipto

En este paisaje de fantasía alpina con ruinas, uno casi pasa por alto a la Sagrada Familia bajo el arco del fondo - si no fuera por la misteriosa luz brillante que ilumina el centro de la imagen.

Paesaggio con fuga in Egitto

In questo paesaggio di fantasia alpino con rovine, ci si affaccia quasi sulla Sacra Famiglia sotto l'arco sullo sfondo, se non fosse per la misteriosa luce che illumina il centro dell'immagine.

Landschap met de vlucht naar Egypte

In dit alpine fantasielandschap met ruïnes zie je de Heilige Familie onder de boog op de achtergrond bijna over het ho Ware het niet dat het mysterieuze heldere licht het midder van het beeld verlicht.

ROELANDT SAVERY (1576/78-1639)

1624, Oil on wood/Huile sur bois, 54,3 × 91,5 cm, National Gallery of Art, Washington, D.C.

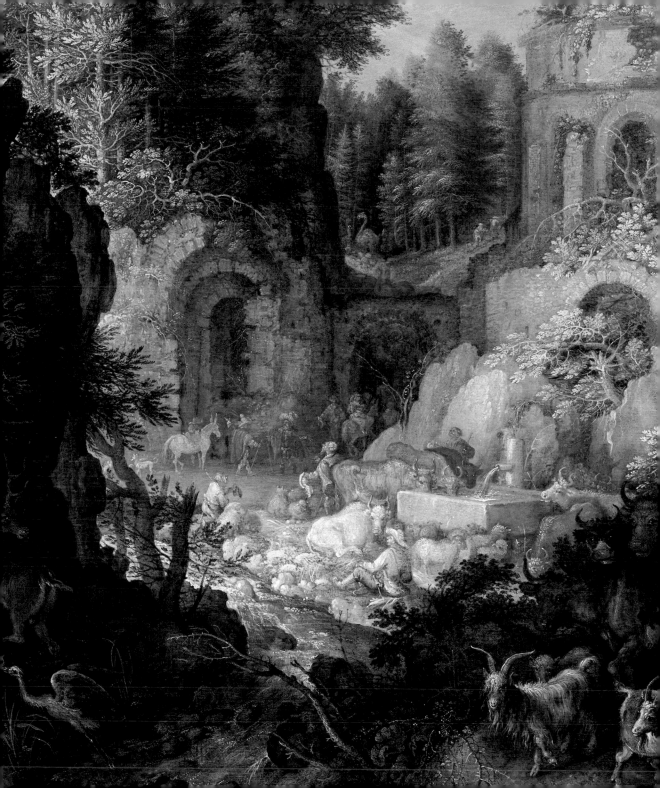

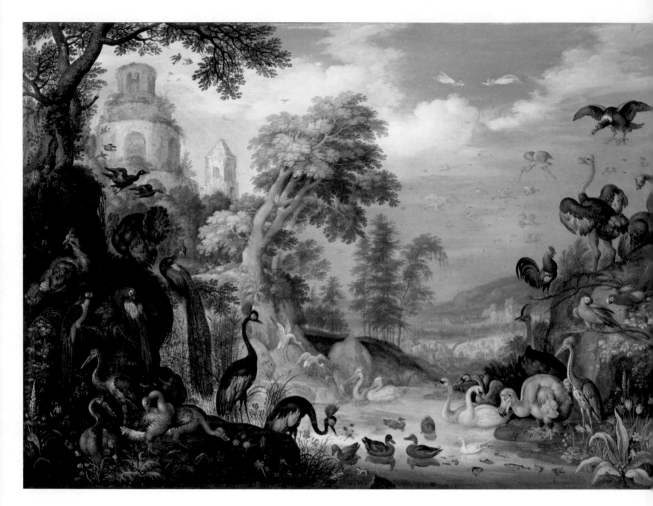

Landscape with Birds

Paysage avec oiseaux

Landschaft mit Vögeln

Paisaje con pájaros

Paesaggio con uccelli

Landschap met vogels

ROELANDT SAVERY (1576 /78–1639)
1628, Oil on copper/Huile sur plaque de cuivre, 42 × 58,5 cm, Kunsthistorisches Museum, Wien

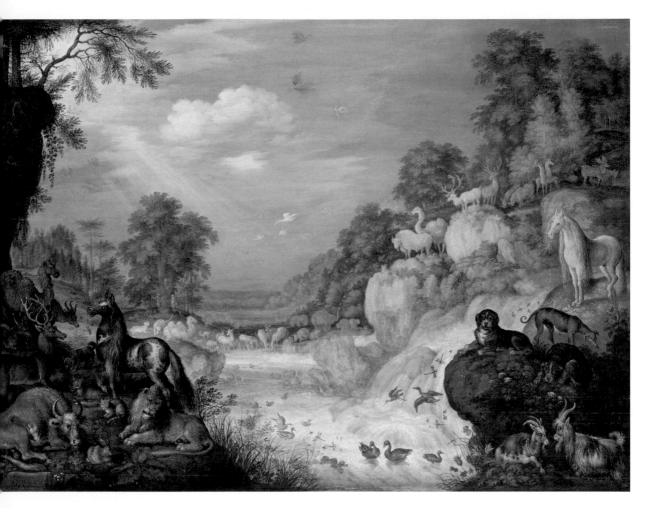

... n and Eve in Paradise (The Fall of Man)

...radis avec, en arrière-plan, le Péché originel

...dies (Im Hintergrund: Der Sündenfall)

...so (al fondo: la Caída)

...diso (Sullo sfondo: il peccato originale)

...dijs (op de achtergrond: De zondeval van de mens)

...ANDT SAVERY (1576/78–1639)

...Oil on copper/Huile sur plaque de cuivre, 41 × 57,3 cm, Kunsthistorisches Museum, Wien

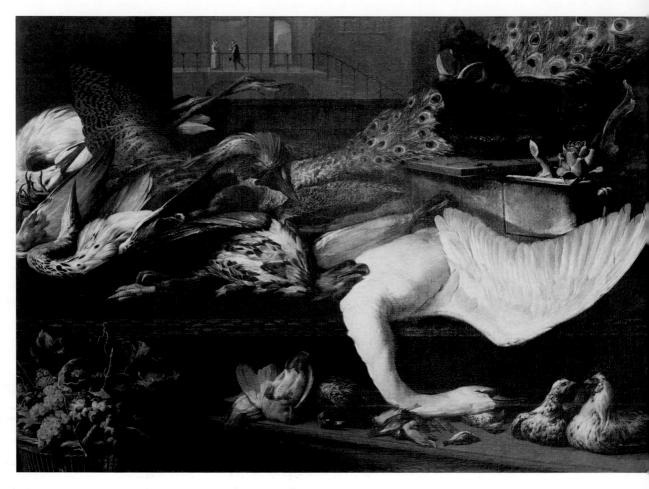

Still Life with Poultry and Venison

Snyders is considered the "inventor" of the hunting and animal still life. Various carcasses of wild animals seem to await preparation; the peacock feathers symbolise vanity, the swan transient beauty.

Nature morte au gibier et à la volaille

Snyders est considéré comme « l'inventeur » des natures mortes montrant des animaux ou des scènes de chasse. Différents animaux sauvages semblent ici attendre d'être cuisinés ; les plumes de paon symbolisent la coquetterie et le cygne la beauté éphémère.

Stillleben mit Geflügel und Wildbret

Snyders gilt als „Erfinder" des Jagd- und Tierstilllebens. Diverse erlegte Wildtiere scheinen auf ihre Zubereitung zu warten; die Pfauenfedern künden von Eitelkeit, der Schwan von vergänglicher Schönheit.

Naturaleza muerta con aves de corral y caza

Snyders es considerado el "inventor" de la caza y de la naturaleza muerta animal. Varios animales salvajes muertos parecen esperar su preparación; las plumas de pavo real anuncian la vanidad, el cisne la belleza pasajera.

Natura morta con pollame e selvaggina

Snyders è considerato l'"inventore" della natura morta di caccia e con animali. Diversi animali selvatici morti sembr[ano] attendere di essere cucinati; le piume di pavone annuncia[no] vanità e il cigno, la bellezza transitoria.

Stilleven met gevogelte en wild

Snyders wordt beschouwd als de 'uitvinder' van de jacht- [en] dierenstillevens. Diverse gedode wilde dieren lijken te wa[chten] op hun bereiding; de pauwenveren getuigen van ijdelheid, [de] zwaan van vergankelijke schoonheid.

FRANS SNYDERS (1579-1657)

1614, Oil on canvas/Huile sur toile, 156 × 218 cm, Wallraf-Richartz-Museum & Fondation Corboud, Köln

Ceres and Two Nymphs

es, goddess of agriculture, holds
vo ears of corn in one hand and
n the other a cornucopia, which
r nymphs fill with fruit. Rubens
nted the women, while Snyders
d the fruit, the monkey, and the
birds.

Cérès avec deux nymphes

ès, déesse de l'agriculture, tient
s épis de maïs dans une main et
corne d'abondance dans l'autre,
que les nymphes remplissent de
its. Rubens peignit les femmes,
Snyders les fruits, le singe et les
oiseaux.

Ceres mit zwei Nymphen

eres, Göttin des Ackerbaus, hält
Maiskolben in der einen und ein
lhorn in der anderen Hand, das
Nymphen mit Früchten füllen.
bens malte die Frauen, Snyders
Obst, den Affen und die Vögel.

Ceres con dos ninfas

Ceres, diosa de la agricultura,
sostiene la mazorca de maíz en
na mano y una cornucopia en la
a, que las ninfas llenan de fruta.
ens pintó las mujeres, Snyders,
la fruta, el mono y los pájaros.

Cerere e due ninfe

ere, dea della fertilità dei campi,
ene la pannocchia da una parte
una cornucopia dall'altra, che le
nfe riempiono di frutta. Rubens
inse le donne, Snyders il frutto,
la scimmia e gli uccelli.

Ceres met twee nimfen

eres, de godin van de landbouw,
dt in de ene hand een maiskolf
de andere hand een hoorn des
vervloeds, die de nimfen vullen
met fruit. Rubens schilderde de
uwen, Snyders de vruchten, aap
en vogels.

**FRANS SNYDERS & PETER PAUL
RUBENS (1579–1657)**
1615-17, Oil on canvas/
Huile sur toile, 224,5 × 166 cm,
Museo del Prado, Madrid

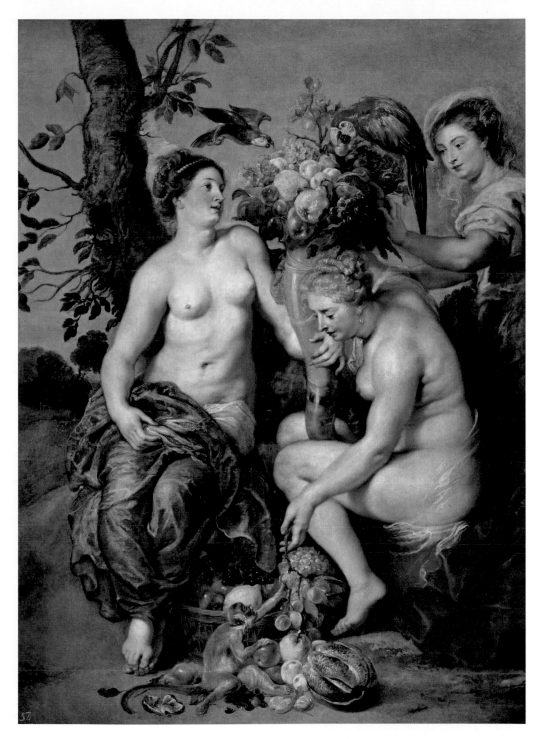

Fish Market

Marchands de poissons à leur étal

Fischmarkt

La lonja de pescado

Mercato del pesce

Vismarkt

FRANS SNYDERS (1579–1657)
c. 1616–21, Oil on canvas/Huile sur toile, 210,5 × 340 cm,
State Hermitage Museum, St. Petersburg

The Hen House

Le Poulailler

Hühnerhaus

El gallinero

Pollaio

Kippenhuis

FRANS SNYDERS (1579–1657)

1600-57, Oil on canvas/Huile sur toile, 99 × 144 cm, Museo del Prado, Madrid

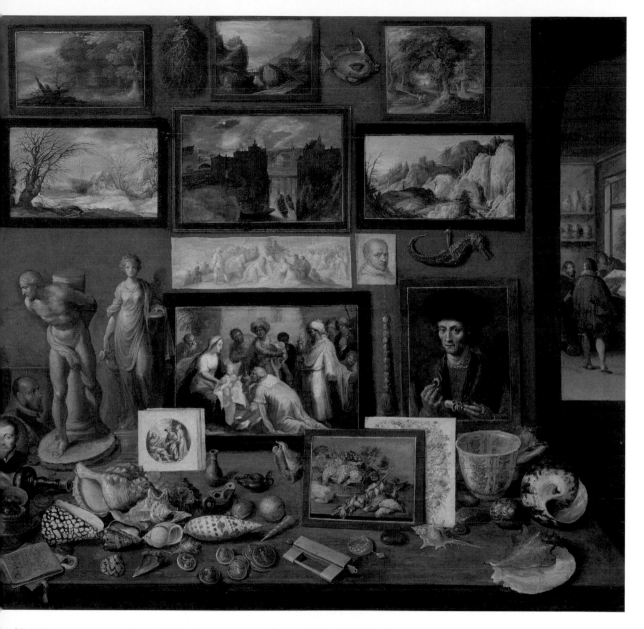

| et of Curiosities | Kunst- und Raritätenkammer | Camera dell'Arte e della Rarità |
| et d'art et de curiosités | Cámara de Arte y Rarezas | Kunst- en rariteitenkamer |

FRANCKEN II. (1581–1642)

s, Oil on wood/Huile sur bois, 74 × 78 cm, Kunsthistorisches Museum, Wien

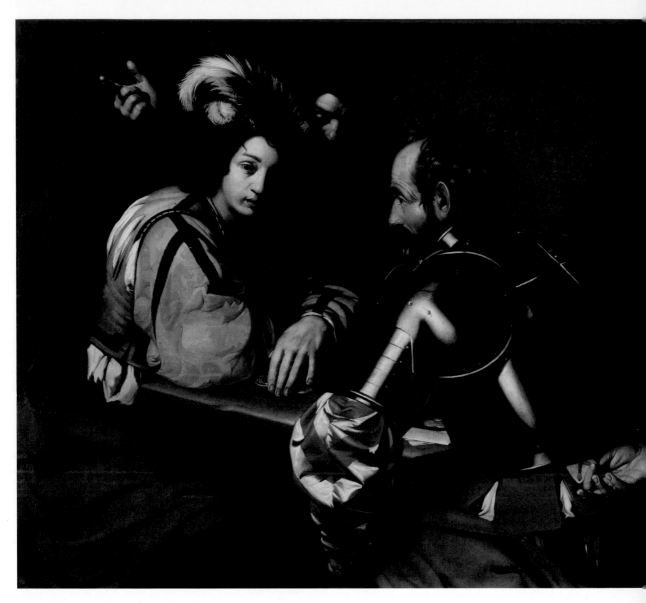

The Cardsharps Die Falschspieler Il baro con l'asso di quadri

Le Tricheur Jugadores de cartas De valsspeler

NICOLAS RÉGNIER (1588-1667)

1620, Oil on canvas/Huile sur toile, 117 × 133 cm, Gallerie dell'Accademia, Venezia

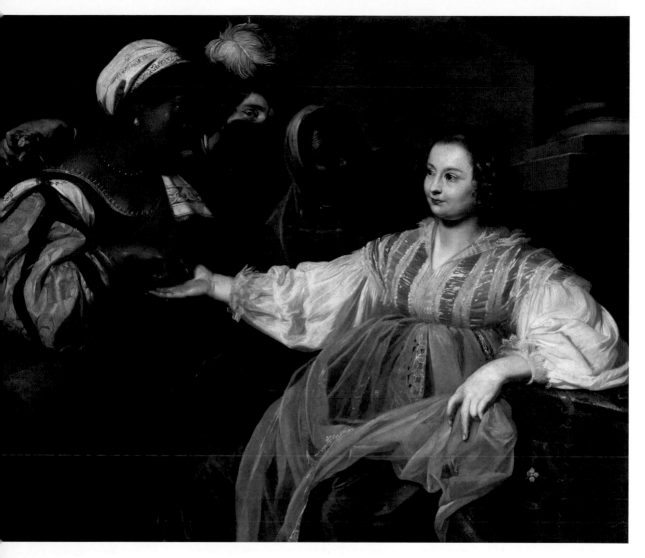

harps and Fortune Teller

le lady innocently lets a fortune teller read her palm
an accomplice steals her purse. The gentleman in the
round, in turn, robs the fortune teller.

euse de bonne aventure

dame blafarde et crédule laisse une diseuse de bonne
ure lire dans les lignes de sa main, tandis que sa complice
e sa bourse. L'homme situé à l'arrière-plan, quant à lui,
asse la diseuse de bonne aventure.

Die Wahrsagerin

Die blasse, gutgläubig aussehende Dame lässt sich von einer
Wahrsagerin aus der Hand lesen, während deren Komplizin
ihre Geldbörse entwendet. Der Herr im Hintergrund
wiederum bestiehlt die Wahrsagerin.

La adivina

La pálida y auténtica dama deja que una adivina le lea la
mano mientras su cómplice le roba el bolso. Por otra parte, el
caballero del fondo roba a la adivina.

La veggente

La signora pallida e in buona fede lascia che una veggente
le legga la mano mentre il suo complice le ruba la borsa. Il
signore sullo sfondo deruba la veggente.

De waarzegster

De bleke, goedgelovig uitziende dame laat een waarzegster
haar hand lezen terwijl dier medeplichtige haar portemonnee
steelt. De heer op de achtergrond steelt weer van de
waarzegster.

AS RÉGNIER (1588-1667)
Oil on canvas/Huile sur toile, 127 × 150 cm, Musée du Louvre, Paris

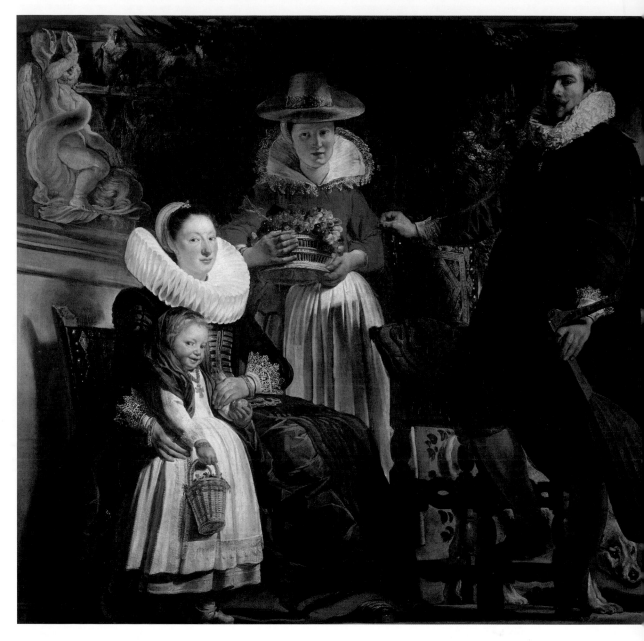

The Painter's Family

Autoportrait avec sa femme, Catharina Van
Noort, leur fille Elisabeth et une servante

Die Familie des Malers

La familia del pintor

La famiglia del pittore

De familie van de schilder

JACOB JORDAENS (1593-1678)
1621/22, Oil on canvas/Huile sur toile, 181 × 187 cm, Museo del Prado, Madrid

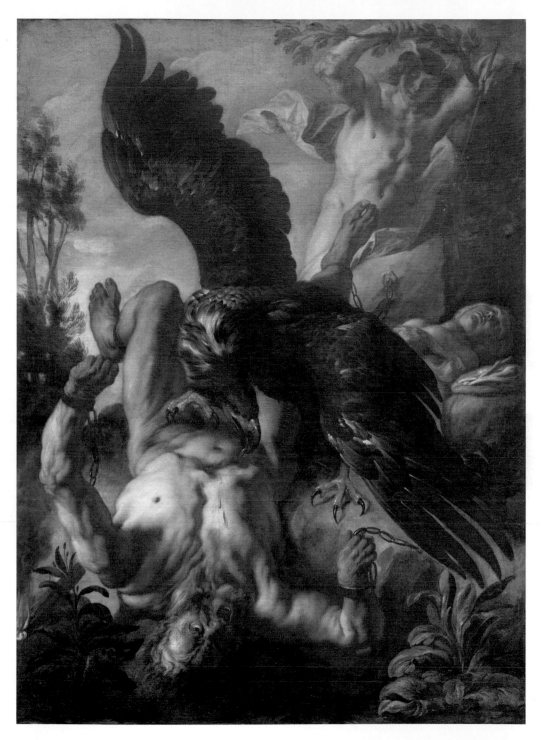

Prometheus Bound

...picture, influenced by Rubens, ...ts Prometheus, who stole fire ...n the gods and as punishment ...s chained on a rock where an ...ate his liver. Jordaens portrays ...the moment of greatest pain.

Prométhée enchaîné

...ableau, où l'on sent l'influence ...e Rubens, montre Prométhée ...qui vola le feu aux dieux et, en ...e de punition, fut condamné à ...nchaîné à un rocher et à avoir ...e mangé par un aigle. On voit ...le moment où la douleur est à ...son paroxysme.

Der gefesselte Prometheus

... von Rubens beeinflusste Bild ...Prometheus, der den Göttern ...Feuer stahl und zur Strafe an ...en Felsen geschmiedet wurde, ...vo ein Adler seine Leber fraß. ...gestellt ist der Augenblick des ...größten Schmerzes.

Prometeo encadenado

...La imagen, influenciada por ...Rubens, muestra a Prometeo, ...ue robó el fuego a los dioses y ...e forjado como castigo en una ...a donde un águila se comió su ...do. Se representa el momento ...de mayor dolor.

Prometeo incatenato

...ratto, influenzato da Rubens, ...ostra Prometeo, che ha rubato ...uoco agli dei ed è incatenato a ...a rupe dove un'aquila mangia ...suo fegato. Viene raffigurato il ...momento di maggior dolore.

De geketende Prometheus

...Het door Rubens beïnvloede ...hilderij toont Prometheus, die ...uur van de goden stal en voor ...f aan een rots werd geketend, ...ar een adelaar zijn lever opat. ...oment van de hevigste pijn is ...afgebeeld.

ACOB JORDAENS (1593-1678)

...c. 1640, Oil on canvas/Huile sur ...ile, 245 × 178 cm, Wallraf-Richartz- ...eum & Fondation Corboud, Köln

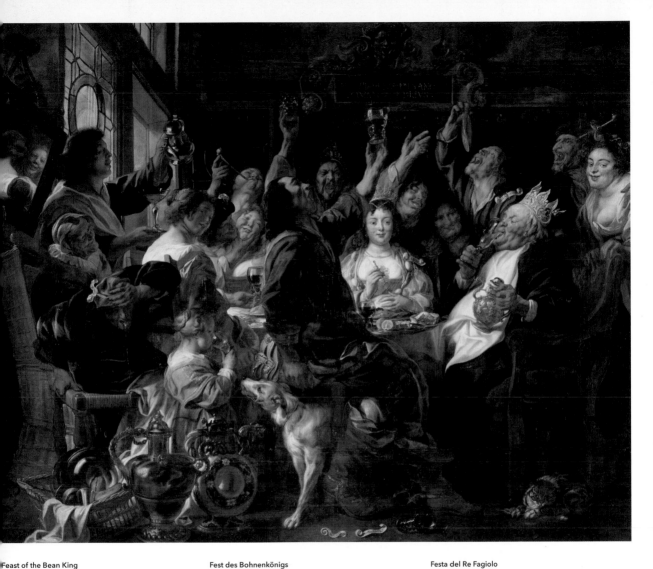

Feast of the Bean King

...anders, whoever finds the bean baked into the Epiphany ... becomes "king". But the Latin inscription warns: "No one ... close to the fool as the drunk."

...oi boit

...ableau fait référence à la tradition de la galette de ...phanie, où celui qui tire la fève devient roi. C'est à sa santé ... compagnie lève son verre, mais l'inscription en latin ...et en garde : « Rien ne ressemble plus à un fou qu'un ...me ivre ».

Fest des Bohnenkönigs

In Flandern wird am Dreikönigstag derjenige, der die eingebackene Bohne findet, zum König. Dabei geht es hoch her, doch die lateinische Inschrift mahnt: „Keiner ist dem Narren so ähnlich wie der Betrunkene".

La fiesta del Rey de los frijoles

En Flandes, en Epifanía, el que encuentra el grano cocido se convierte en rey. Pero la inscripción latina advierte: "Nadie se parece tanto al necio como el borracho".

Festa del Re Fagiolo

Nelle Fiandre, durante l'Epifania, colui che trova il fagiolo diventa re. Ma l'iscrizione latina avverte: "Nessuno è simile allo stolto come l'ubriaco".

De koning drinkt

In Vlaanderen wordt op Driekoningen degene die een meegebakken boon vindt koning. Daarbij wordt flink gefeest, maar de Latijnse inscriptie waarschuwt: 'Niemand lijkt zo op de dwaas als de dronkaard.'

...B JORDAENS (1593–1678)

...0–45, Oil on canvas/Huile sur toile, 242 × 300 cm, Kunsthistorisches Museum, Wien

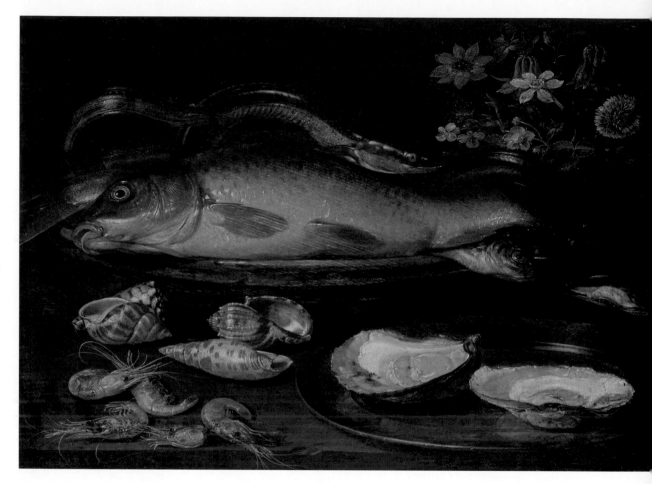

Still Life with Fish, Oysters, and Shrimps

Nature morte aux poissons, huîtres et crevettes

Stillleben mit Fisch, Austern und Garnelen

Naturaleza muerta con pescado, ostras y camarones

Natura morta con pesci, ostriche e gamberi

Stilleven met vis, oesters en garnalen

CLARA PEETERS (1594–1658)

c. 1607–50, Oil on wood/Huile sur bois, 25 × 34,8 cm, Rijksmuseum, Amsterdam

**...e with a Cloth, Salt Cellar, Gilt Tazza, Pie, Jug,
...elain Dish with Olives, and Roast Fowl**

...ough more realistic than others, this still life nevertheless
...rays luxury: the dishes and tablecloth, the imported olives
...orange, as well as the salt (then very expensive) indicate a
...household.

...e avec oranges, olives et tartes

...qu'elle soit plus réaliste que d'autres, cette nature morte
...ime elle aussi le luxe : la vaisselle et la nappe, les olives et
...ranges importées et le sel à l'époque très cher montre qu'il
...d'un riche foyer.

**Tisch mit Salzgefäß, Pastete, Porzellanteller
mit Oliven und gekochtem Geflügel**

Obwohl realistischer als andere, stellt auch dieses Stillleben
Luxus dar: Geschirr und Tischdecke, die importierten Oliven
und die Orange sowie das damals sehr teure Salz deuten auf
einen reichen Haushalt hin.

**Mesa con salero, paté, plato de porcelana
con aceitunas y pollo cocido**

Aunque más realista que otros, esta naturaleza muerta
es también un lujo: los platos y el mantel, las aceitunas
importadas y la naranja, así como la sal, entonces muy cara,
indican un hogar rico.

**Tavolo con saliera, paté, piatto in porcellana
con olive e pollame cucinato**

Anche se più realistica di altre, anche questa natura morta
rappresenta il lusso: i piatti e la tovaglia, le olive importate e le
arance, come anche il sale, allora molto costoso, denotano una
ricca famiglia.

**Tafel met zoutvaatje, pastei, porseleinen bord
met olijven en gebraden gevogelte**

Hoewel dit stilleven realistischer is dan andere, geeft ook dit
luxe weer: serviesgoed en tafelkleed, de geïmporteerde olijven
en sinaasappel en het toen zeer dure zout wijzen op een
rijk huishouden.

...A PEETERS (1594–1658)
...1, Oil on wood/Huile sur bois, 55 × 73 cm, Museo del Prado, Madrid

Peasant Brawling Over Cards

Rixe paysanne autour d'un jeu de cartes

Bauernrauferei beim Kartenspiel

Pelea de campesinos jugando a las cartas

Rissa nella bettola

Boerenvechtpartij bij het kaarten

ADRIAEN BROUWER (1605–1638)

p. 1630, Oil on wood/Huile sur bois, 26,5 × 34,5 cm, Staatliche Kunstsammlungen Dresden, Dresden

The Smokers

...aen Brouwer was a master ...vern scenes and the comic ...ragic faces that accompany them. Here, the painter himself can be seen as the central figure.

Les Fumeurs

...artiste, qui ne vécut que 33 ...tait particulièrement doué ...r les scènes de tavernes ou ...berges, peuplées de visages ...ôles ou tragiques. On peut ...oir ici lui-même, au centre de l'image.

Die Raucher

...Adriaen Brouwer war ein ...er darin, Wirtshausszenen und die entsprechenden lustigen oder tragischen ...esichter darzustellen. Hier ...er selbst als zentrale Figur zu sehen.

Los fumadores

...Adriaen Brouwer fue un ...aestro en la representación de escenas de posada y los correspondientes rostros ...vertidos o trágicos. Aquí él ...smo debe ser visto como la figura central.

Gruppo di fumatori

...Adriaen Brouwer è stato ...un maestro nel ritrarre le ...cene delle locande i volti ...tenti o tragici. Qui si vede ...lui stesso raffigurato come figura centrale.

De rokers

...Adriaen Brouwer was een meester in het schilderen ...van herbergtaferelen en de ...vereenkomstige vrolijke of ...sche gezichten. Hier moet ...j zelf gezien worden als de centrale figuur.

ADRIAEN BROUWER
(1605-1638)

...c. 1636, Oil on wood/Huile sur ...46,4 × 36,8 cm, Metropolitan Museum of Art, New York

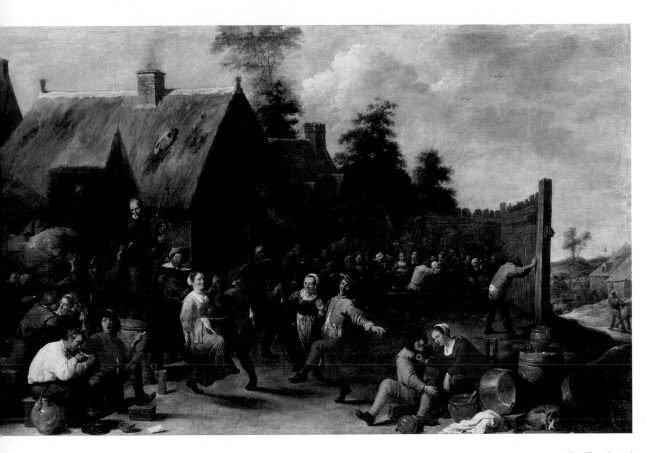

arist in Fruit Wreath

charistie entourée d'une guirlande de fruits

aristie, von Fruchtgirlanden umgeben

ristía, rodeada de guirnaldas de frutas

landa di fiori con Santo Sacramento

elk en hostie omringd door fruitslingers

DAVIDZ. DE HEEM (1606-83/84)

Oil on canvas/Huile sur toile, 138 × 125,5 cm, Kunsthistorisches Museum, Wien

The Village Festival

Fête villageoise

Dorffest

Fiesta campestre

Festa del villaggio

Dorpsfeest

DAVID TENIERS THE YOUNGER/LE JEUNE (1610-90)

1637, Oil on canvas/Huile sur toile, 120 × 188 cm, Museo del Prado, Madrid

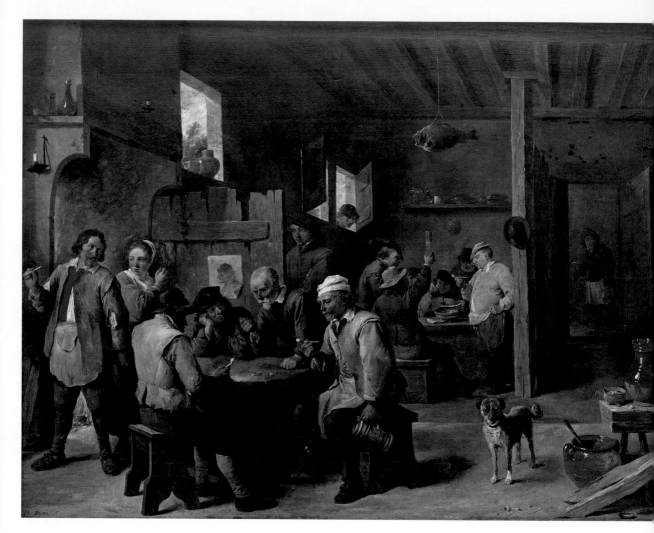

Tavern Scene

Intérieur d'auberge

Zechstube

Oficina del propietario

Osteria

Gelagkamer

DAVID TENIERS THE YOUNGER/LE JEUNE (1610–90)
1643, Oil on wood/Huile sur bois, 55,9 × 73,6 cm, Alte Pinakothek, München

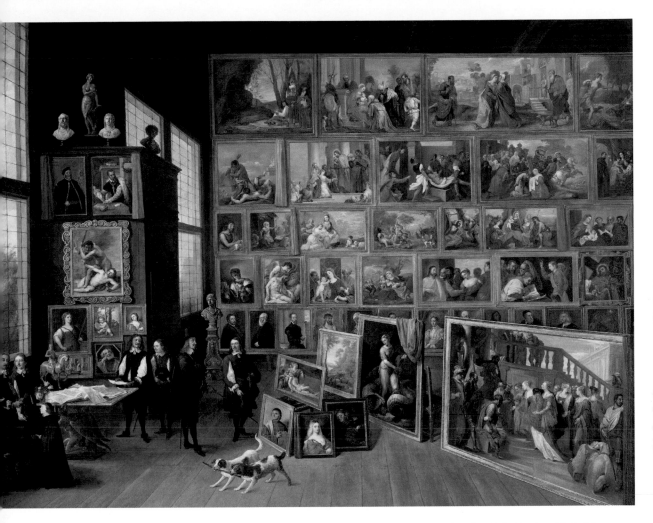

hduke Leopold Wilhelm in his Picture Gallery
t to Leopold Wilhelm, governor of the Spanish
herlands and art collector, stands the painter Teniers
self. They look at newly acquired Italian paintings—which
still be seen in Vienna today.

Gouverneur Léopold-Guillaume et sa
ection de tableaux à Bruxelles
ôté de Léopold Guillaume, gouverneur des Pays-Bas
agnols et collectionneur d'art, on peut voir Teniers lui-
me. Ils regardent des tableaux italiens récemment acquis,
leaux que l'on peut aujourd'hui voir à Vienne.

VID TENIERS THE YOUNGER/LE JEUNE (1610-90)
150, Oil on canvas/Huile sur toile, 124 × 165 cm, Kunsthistorisches Museum, Wien

Erzherzog Leopold Wilhelm in seiner Gemäldegalerie
Neben Leopold Wilhelm, Statthalter der spanischen
Niederlande und Kunstsammler, steht der Maler Teniers
selbst. Sie betrachten neu erworbene italienische Gemälde –
die man in Wien noch heute sehen kann.

Archiduque Leopold Wilhelm en su galería de cuadros
Junto a Leopold Wilhelm, gobernador de los Países Bajos
españoles y coleccionista de arte, se encuentra el pintor
Teniers. Miran las pinturas italianas recientemente adquiridas,
que todavía se pueden ver en Viena hoy en día.

La galleria d'arte dell'arciduca Leopoldo Guglielmo
Accanto a Leopold Guglielmo, governatore dei Paesi Bassi e
collezionista d'arte spagnolo, si trova lo stesso pittore Teniers.
Osservano dipinti italiani di recente acquisizione, che sono
ancora oggi a Vienna.

Aartshertog Leopold Willem in zijn schilderijengalerij
Naast Leopold Willem, gouverneur van de Spaanse
Nederlanden en kunstverzamelaar, staat de schilder Teniers
zelf. Ze kijken naar net aangekochte Italiaanse schilderijen –
die nog steeds te zien zijn in Wenen.

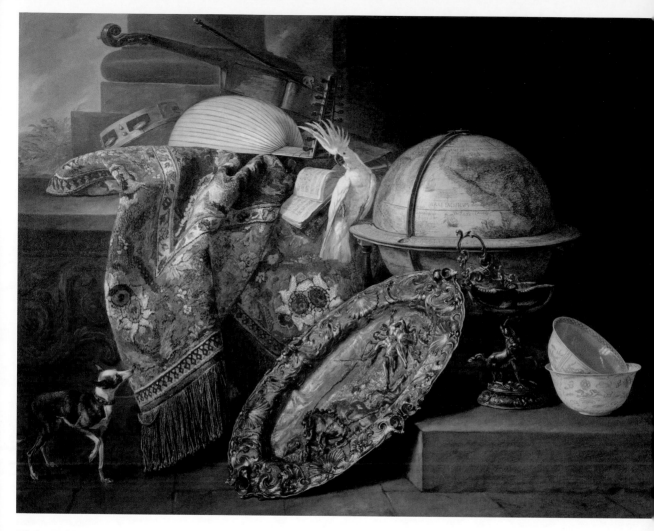

Still Life with Globe and Cockatoo

Nature morte au globe et au cacatoès

Stillleben mit Globus, Prunkgarnitur und Kakadu

Naturaleza muerta con globo y cacatúa

Natura morta con mappamondo, tappeto e cacatua

Stilleven met globe, pronkgarnituur en kaketoe

PIETER BOEL (1626–74)

c. 1658, Oil on canvas/Huile sur toile, 130 × 168 cm, Akademie der Bildenden Künste, Wien

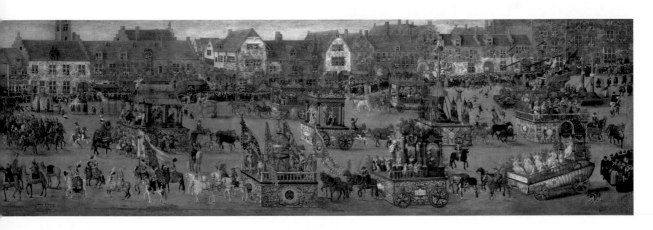

Ommegang in Brussels on 31 May 1615:
Triumph of Archduchess Isabella

Ommegang was a parade in honour of the crossbowmen's
d. On this day, Archduchess Isabella, who commissioned
painting, managed to shoot down a bird that had been tied
church tower.

mmegang de Bruxelles, le 31 mai 1615.
riomphe de l'archiduchesse Isabelle

mmegang était un défilé avec des chars richement ornés,
honneur des arbalétriers. L'archiduchesse Isabelle,
amandataire de ce tableau, réussit ce jour-là à abattre un
au qui était accroché au clocher de l'église.

Der Ommegang in Brüssel am 31. Mai 1615:
Der Triumph der Erzherzogin Isabella

Der Ommegang war ein Umzug zu Ehren der
Armbrustschützengilde. Erzherzogin Isabella, Auftraggeberin
des Bildes, schaffte es an jenem Tag, einen Vogel
abzuschießen, der an einem Kirchturm befestigt war.

El Ommegang en Bruselas el 31 de mayo de 1615:
el triunfo de la Archiduquesa Isabel

El Ommegang era un desfile en honor al gremio de ballesteros.
La archiduquesa Isabel, que encargó el cuadro, logró derribar
un pájaro atado a una torre de la iglesia ese día.

L'Ommegang a Bruxelles il 31 maggio 1615:
il trionfo dell'arciduchessa Isabella

L'Ommegang era una sfilata in onore della corporazione dei
balestrieri. L'arciduchessa Isabella, che commissionò il dipinto,
riuscì a abbattere quello stesso giorno un uccello attaccato a
un campanile della chiesa.

De Ommegang in Brussel op 31 mei 1615:
de triomf van aartshertogin Isabella

De Ommegang was een optocht ter ere van het
kruisboogschuttersgilde. Aartshertogin Isabella, die het
schilderij in opdracht gaf, slaagde er die dag in een vogel neer
te schieten die aan een kerktoren was vastgemaakt.

IS VAN ALSLOOT (C. 1570–C. 1626)
, Oil on canvas/Huile sur toile, 117 × 381 cm, Victoria & Albert Museum, London

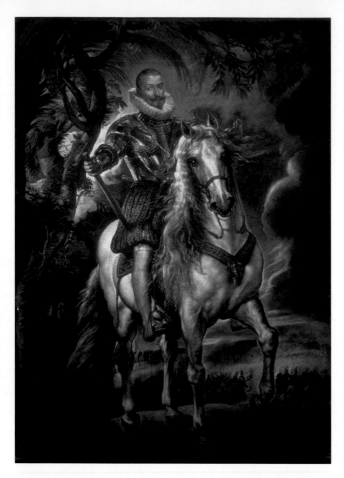

Portrait of the Duke of Lerma

Portrait équestre du duc de Lerme

Reiterbildnis des Herzogs von Lerma

Retrato del Duque de Lerma

Ritratto del duca di Lerma

Portret van de hertog van Lerma te paard

PETER PAUL RUBENS (1577–1640)

1603, Oil on canvas/Huile sur toile, 290,5 × 207,5 cm, Museo del Prado, Madrid

Peter Paul Rubens: Prince of Painters of his Generation

Although he lived "only" 63 years, Peter Paul Rubens led a rich and extraordinarily accomplished life. He travelled (to Italy and elsewhere) and created many works for wealthy Antwerp citizens and the Catholic Church. He served as a diplomat in Madrid and London, where he contributed to the peace between Spain and England in 1630. Even on his travels, he painted incessantly. The artist ran his studio like a company: students and assistants carried out his designs, to which the master only added the finishing touches. This process resulted in a massive oeuvre: around 1500 pictures over the course of Rubens's life. He also worked with copper engravers and printers. A lively sensuality characterises his paintings: allegories offered him the opportunity to depict voluptuous women in glowing nudity. His religious pictures are full of colour and drama, and even inanimate objects seem to vibrate with movement.

Pierre Paul Rubens : le prince de sa génération

Bien qu'il n'ait vécu « que » 63 ans, Pierre Paul Rubens eut une vie très riche et accomplit des choses incroyables. Il commença par voyager (lui aussi en Italie) et réalisa de nombreuses œuvres pour des Anversois fortunés et pour l'Église catholique. Il devint ensuite diplomate et séjourna à Madrid et à Londres, où il contribua en 1630 à la paix entre l'Espagne et l'Angleterre. Même en voyage, il peignait sans cesse. Cet artiste menait son atelier comme une entreprise : ses élèves et ses assistants peignaient à partir de ses esquisses et il apportait ensuite les dernières finitions aux tableaux. Il réalisa ainsi une œuvre monumentale de plus de 1500 pièces. Il travailla également avec des graveurs sur cuivre et des imprimeurs. Ses tableaux sont caractérisés par une sensualité pleine de vie : les allégories offrent la possibilité de peindre des femmes plantureuses d'une nudité éclatante ; les œuvres religieuses mêlent couleurs et tension dramatique, où les objets mêmes semblent animés.

Peter Paul Rubens: Malerfürst seiner Generation

Obwohl er „nur" 63 Jahre alt wurde, hat Peter Paul Rubens ein reiches Leben geführt und Unglaubliches vollbracht. Zunächst reiste er (auch nach Italien) und schuf viele Werke für vermögende Antwerpener Bürger sowie die katholische Kirche. Als Diplomat weilte er in Madrid und London, wo er 1630 zum Frieden zwischen Spanien und England beitrug. Selbst auf Reisen malte er unaufhörlich. Der Künstler betrieb sein Atelier wie ein Unternehmen: Schüler und Assistenten führten seine Entwürfe aus, denen er dann nur mehr den letzten Schliff gab. So entstand ein gewaltiges Lebenswerk von etwa 1500 Bildern. Auch arbeitete er mit Kupferstechern und Druckern zusammen. Charakteristisch für seine Gemälde ist eine lebhafte Sinnlichkeit: Allegorien boten Gelegenheit, üppige Frauen in leuchtender Nacktheit darzustellen; die religiösen Bilder sind voller Farbe und Dramatik, selbst Gegenstände wirken bewegt.

The Crown of Thorns (Ecce Homo)

Le Couronnement d'épines ou Ecce Homo

Die Dornenkrone (Ecce Homo)

Corona de espinas (Ecce Homo)

La corona di spine (Ecce Homo)

De doornenkroon (Ecce homo)

PETER PAUL RUBENS (1577-1640)

a. 1612, Oil on wood/Huile sur bois, 125,7 × 96,5 cm, State Hermitage Museum, St. Petersburg

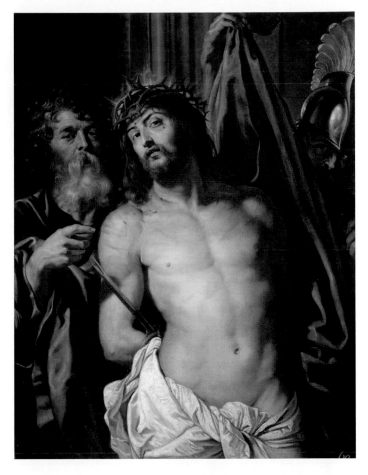

ter Paul Rubens:
íncipe de los pintores de su generación

esar de que "solamente" llegó a los 63 años, Peter Paul bens llevó una vida rica y logró cosas increíbles. Al ncipio viajó (también a Italia) y creó muchas obras para dadanos ricos de Amberes y para la Iglesia Católica. e diplomático en Madrid y Londres, donde contribuyó a paz entre España e Inglaterra en 1630. Incluso en s viajes pintaba incesantemente. El artista dirigía estudio como una empresa: alumnos y ayudantes varon a cabo sus diseños, a los que sólo dio los últimos oques. De esta manera se creó una enorme obra de a de alrededor de 1500 pinturas. También trabajó con badores e impresores de cobre. Una sensualidad viva característica de sus pinturas: las alegorías ofrecían la ortunidad de representar a mujeres exuberantes en una nudez brillante; los cuadros religiosos están llenos de or y drama, incluso los objetos parecen conmovedores.

Peter Paul Rubens:
Principe dei pittori della sua generazione

Anche se morì "solo" 63 anni, Peter Paul Rubens condusse una vita ricca e compì cose incredibili. Inizialmente viaggiò (anche in Italia) e creò molte opere per ricchi cittadini di Anversa e per la Chiesa Cattolica. Fu diplomatico a Madrid e a Londra, dove contribuì alla pace tra la Spagna e l'Inghilterra nel 1630. Dipingeva incessantemente anche durante i suoi viaggi. L'artista gestiva il suo studio come un'azienda: allievi e assistenti realizzarono i suoi progetti, ai quali poi diede solo gli ultimi ritocchi. Così creò un enorme lavoro di tutta una vita di circa 1500 opere. Ha lavorato anche con calcografi e tipografi. Una vivace sensualità è caratteristica dei suoi dipinti: allegorie che offrono l'opportunità di rappresentare donne lussureggianti in una nudità brillante; immagini religiose piene di colore e drammaticità, anche gli oggetti sembrano emozionati.

Peter Paul Rubens:
vorst onder de schilders van zijn generatie

Hoewel hij 'slechts' 63 jaar oud werd, had Peter Paul Rubens een rijk leven gehad en ongelooflijke dingen volbracht. Aanvankelijk reisde hij (ook naar Italië) en maakte hij veel werken voor rijke Antwerpenaren en de katholieke kerk. Als diplomaat verbleef hij in Madrid en Londen, waar hij in 1630 bijdroeg aan de vrede tussen Spanje en Engeland. Zelfs op zijn reizen schilderde hij onophoudelijk. De kunstenaar leidde zijn atelier als een bedrijf: leerlingen en assistenten voerden zijn ontwerpen uit, waaraan hij vervolgens alleen nog maar de laatste hand legde. Zo ontstond een enorm levenswerk van ongeveer 1500 schilderijen. Hij werkte ook samen met kopergraveurs en drukkers. Kenmerkend voor zijn schilderijen is een levendige zinnelijkheid: allegorieën boden de gelegenheid om weelderige vrouwen in briljante naaktheid af te beelden; de religieuze doeken zijn vol kleur en dramatiek, zelfs objecten roepen ontroering op.

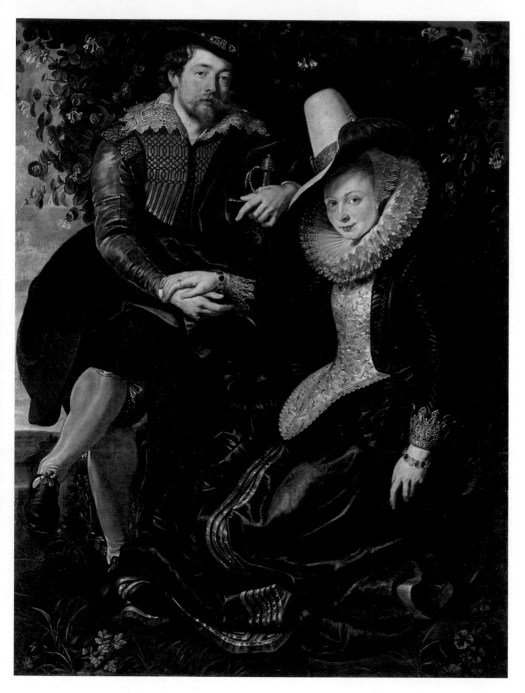

The Honeysuckle Bower

In 1609, Rubens married Isabella Brand, the daughter of a patrician. Th they were doing very well can be seen from their elegant, exquisitely painted clothes and their confident posture. Honeysuckle stands for constancy.

Sous la tonnelle de chèvrefeuille

En 1609, Rubens épousa une fille de patricien, Isabella. On voit bien, à leurs vêtements richement ornés, minutieusement peints, et à leur attitude pleine d'aplomb, que la vie leur sourit. Le chèvrefeuille symbolise la stabilité.

Rubens und Isabella Brant in der Geißblattlaube

1609 heiratete Rubens die Patriziertochter Isabella. Dass es ihnen sehr gut ging, sieht man an der schmucken, akkurat gemalten Kleidu und ihrer selbstbewussten Haltung. Geißblatt steht für Beständigkeit.

Autorretrato con su esposa Isabel Brant

En 1609 Rubens se casó con la hija patricia Isabel. Que les iba muy bien s puede ver en la ropa bonita, pintada c precisión y su postura de confianza er sí mismos. La madreselva es sinónimo de durabilidad.

Autoritratto con la moglie Isabella Brant

Nel 1609 Rubens sposò la nobile Isabella. Che cose andassero loro molto bene si può vedere dai bei vestiti, accuratamente dipinti e dalla loro postura orgogliosa. Il caprifoglio sinonimo di durata nel tempo.

Rubens en Isabella Brant in het kamperfoelieprieel

In 1609 trouwde Rubens met de patriciërsdochter Isabella. Dat ze het erg goed hadden, blijkt uit de mooie, nauwkeurig geschilderde kleding en h zelfverzekerde houding. Kamperfoelie staat voor bestendigheid.

PETER PAUL RUBENS (1577–1640)
c. 1609/10, Oil on canvas, mounted on wood/Huile sur toile marouflée sur chêne, 178 × 136,5 cm, Alte Pinakothek, München

Venus at a Mirror

Following Titian's example, Venus appears as the epitome of beauty. The dark background makes her skin and silky hair shine. In the mirror, which looks like a portrait, we encounter her gaze.

La Toilette de Vénus

Comme chez Titien, Vénus apparaît ici comme incarnation la beauté. L'arrière-plan obscur fait étinceler sa peau claire et ses cheveux soyeux. Nous croisons son regard dans le miroir, qui fait l'effet d'un portrait.

Venus vor dem Spiegel

Nach dem Vorbild Tizians erscheint Venus als Inbegriff der Schönheit. Der dunkle Hintergrund lässt ihre Haut und das seidige Haar strahlen. Im Spiegel, der wie ein Porträtbildnis wirkt, begegnen wir ihrem Blick.

La Venus del espejo

Siguiendo el ejemplo de Tiziano, Venus aparece como el epítome de la belleza. El fondo oscuro hace brillar su piel y su cabello sedoso. En el espejo, que parece un retrato, nos encontramos con su mirada.

Venere davanti allo specchio

Seguendo l'esempio di Tiziano, Venere appare come la quintessenza della bellezza. Lo sfondo scuro fa risplendere la pelle e i capelli setosi. Nello specchio, che sembra un ritratto, incontriamo il suo sguardo.

Venus voor de spiegel

Venus verschijnt naar het voorbeeld van Titiaan als het toonbeeld van schoonheid. De donkere achtergrond laat haar huid en zijdezachte haren stralen. In de spiegel, die eruitziet als een portret, ontmoeten we haar blik.

PETER PAUL RUBENS (1577–1640)
1614/15, Oil on wood/
Huile sur bois, 123 × 98 cm,
Liechtenstein Museum, Wien

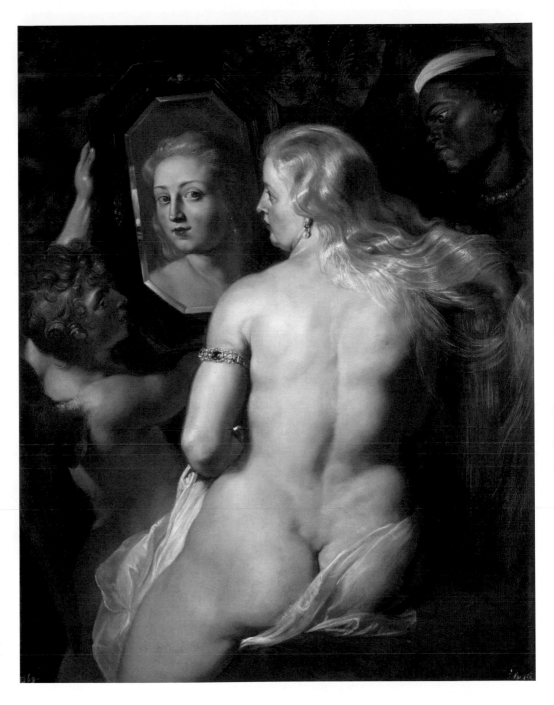

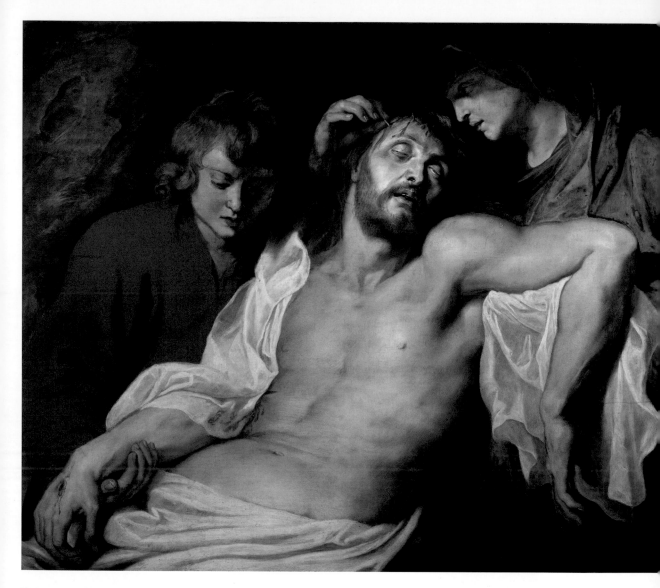

The Lamentation of Christ

Déploration du Christ par la Vierge et saint Jean

Beweinung Christi durch Maria und Johannes

Lamentación por Cristo de María y Juan

Compianto di Maria e Giovanni

Bewening van Christus door Maria en Johannes

PETER PAUL RUBENS (1577–1640)

c. 1614/15, Oil on wood/Huile sur bois, 107,5 × 115,5 cm, Kunsthistorisches Museum, Wien

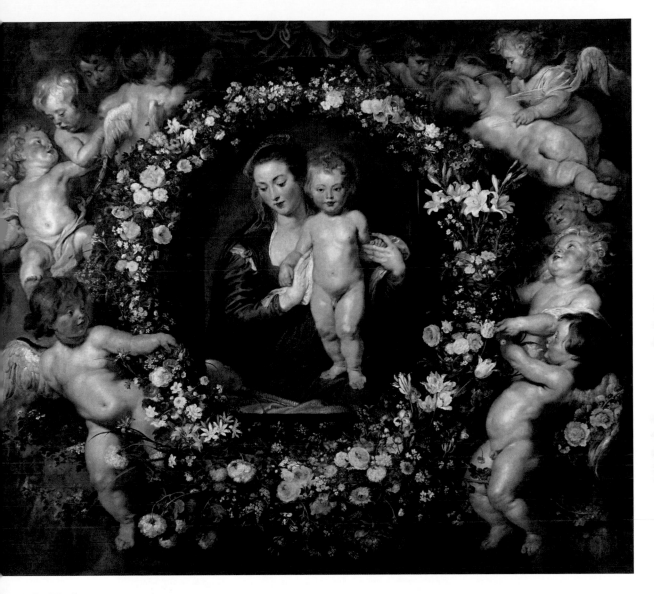

donna in Floral Wreath

rge à l'Enfant entourée d'une couronne de fleurs

donna im Blumenkranz

dona con corona de flores

donna nella corona di fiori

Madonna in een bloemenkrans

ER PAUL RUBENS (1577–1640) & JAN BRUEGHEL THE ELDER (1568–1625)
16–18, Oil on wood/Huile sur bois, 185 × 209,8 cm, Alte Pinakothek, München

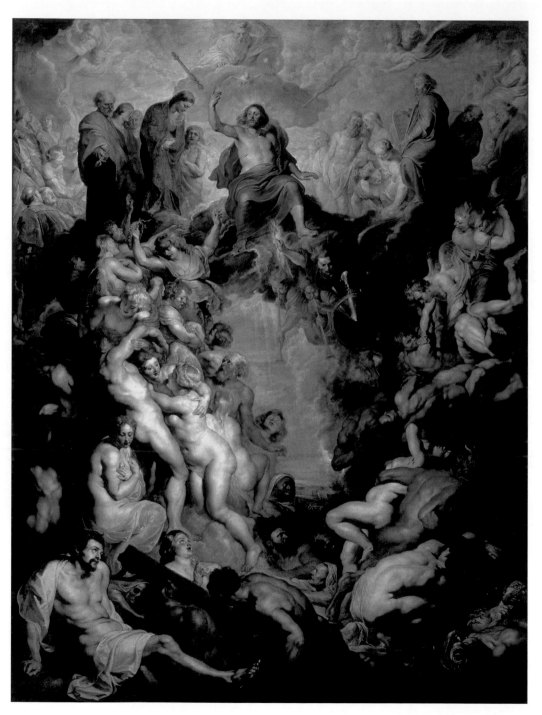

The Great Last Judgement

Rubens's largest painting depa
Christ as judge, flanked by M
and Moses, with characteristi
dynamism. The people on the
rise to heaven, while those on
right fall to hell.

Le Grand Jugement dernier

Le plus grand tableau que
Rubens ait jamais peint
montre, avec une dynamique
caractéristique, le Christ juge
accompagné de Marie et de
Moïse. Les hommes situés à
gauche montent au ciel, ceux
droite sont précipités vers l'en

Das Große Jüngste Gericht

Das größte Bild, das Rubens
gemalt hat, zeigt mit
charakteristischer Dynamik d
richtenden Christus, flankiert
von Maria und Moses. Die
Menschen links steigen in der
Himmel auf, die rechts stürze
die Hölle.

El Gran Juicio Final

La pintura más grande que
Rubens pintó muestra con
dinamismo característico al
Cristo juzgador, flanqueado pe
María y Moisés. La gente de la
izquierda sube al cielo, la de la
derecha cae al infierno.

Il Grande Giudizio Universal

Il dipinto più grande di Ruber
mostra con caratteristico
dinamismo il Cristo che giudi
affiancato da Maria e da Mosè
popolo a sinistra sale al cielo,
popolo a destra cade all'infern

Het grote laatste oordeel

Het grootste schilderij dat
Rubens schilderde, toont met
karakteristieke dynamiek de
rechtsprekende Christus,
geflankeerd door Maria en
Mozes. De mensen links stijge
op naar de hemel, de mensen
rechts storten neer in de hel.

PETER PAUL RUBENS (1577–164
c. 1617, Oil on canvas/Huile
sur toile, 608,5 × 463,5 cm,
Alte Pinakothek, München

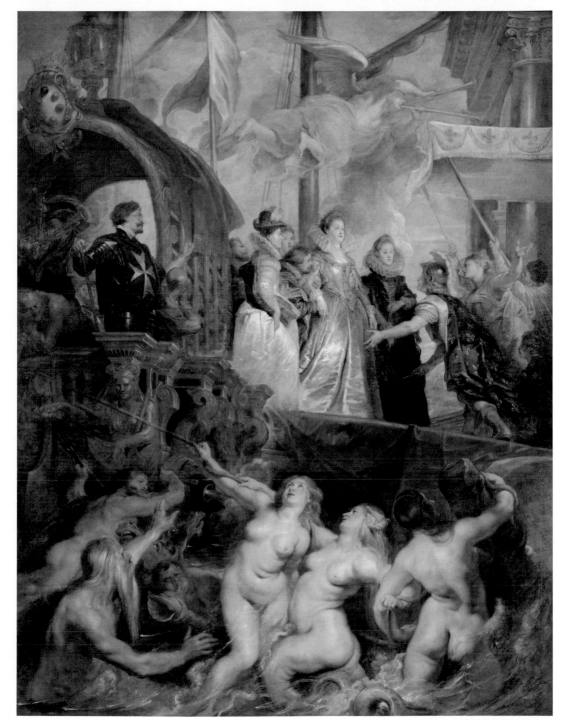

The Landing of Marie
e' Medici in Marseille,
November 3, 1600

Le Débarquement de
la reine à Marseille, le
3 novembre 1600

ie Landung der Maria
on Medici in Marseille,
3. November 1600

desembarco de María
e Médicis en Marsella,
e noviembre de 1600

Lo sbarco di Maria dei
Medici a Marsiglia,
3 novembre 1600

e aankomst van Maria
de Medici in Marseille,
3 november 1600

PETER PAUL RUBENS
(1577-1640)

c. 1623-25, Oil on canvas/
ile sur toile, 394 × 295 cm,
Musée du Louvre, Paris

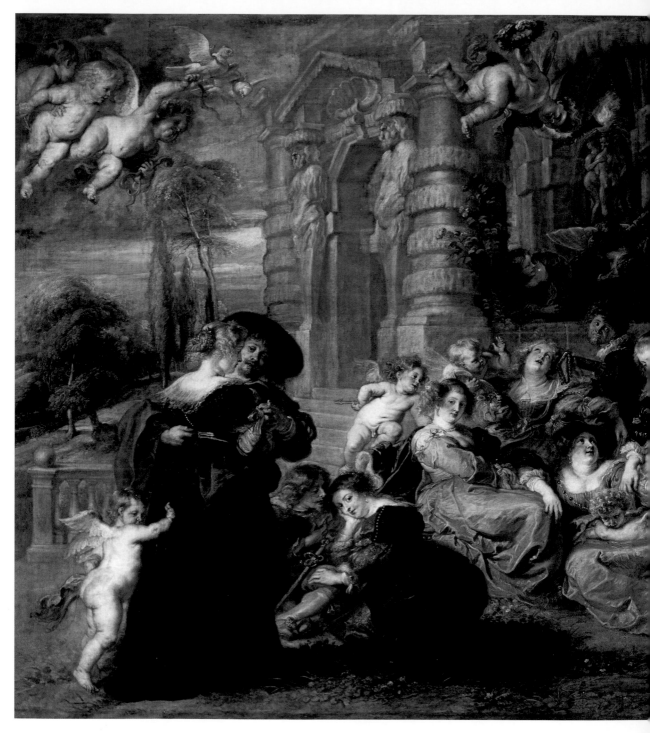

The Garden of Love

Le Jardin de l'Amour

Der Liebesgarten

El Jardín del Amor

Il Giardino dell'Amore

De liefdestuin

PETER PAUL RUBENS (1577–1640)
1630–35, Oil on canvas/Huile sur toile, 199 × 286 cm, Museo del Prado, Madrid

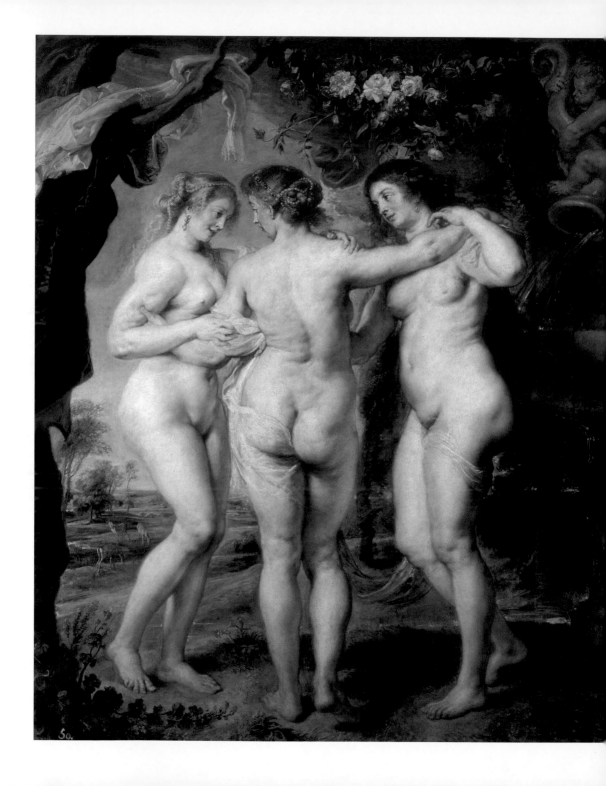

Three Graces

Trois Grâces

drei Grazien

tres Gracias

re Grazie

drie Gratiën

ER PAUL RUBENS (1577–1640)

35, Oil on wood/Huile sur chêne, 220,5 × 182 cm, Museo del Prado, Madrid

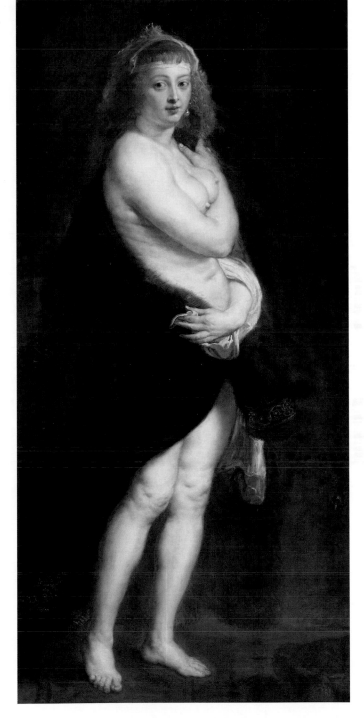

Helena Fourment (The Fur)

Hélène Fourment sortant du bain *ou* La Petite Pelisse

Helena Fourment ("Das Pelzchen")

Helena Fourment ("La pequeña piel")

Helena Fourment ("La pelliccetta")

Helena Fourment (Het pelsken)

PETER PAUL RUBENS (1577–1640)

1636–38, Oil on wood/Huile sur bois, 178,7 × 86,2 cm, Kunsthistorisches Museum, Wien

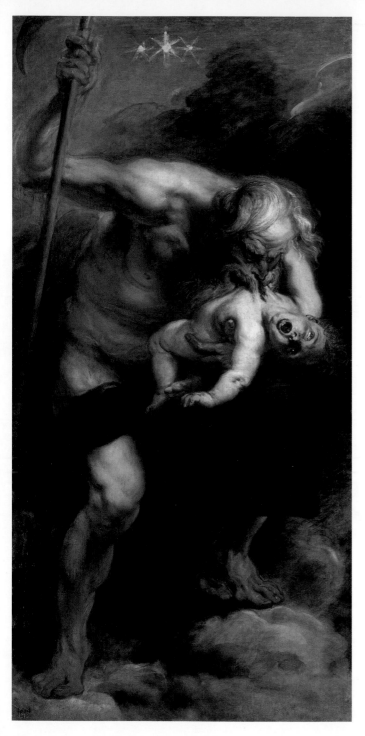

Saturn Devouring His Son

The god Saturn, a fearsome, dynamic old man realistically executed by Rubens, devoured all his sons to protect his throne. Only Zeus escaped, by trickery.

Saturne dévorant un de ses fils

Le dieu Saturne, représenté par Rubens avec le plus grand réalisme sous les traits d'un vieil homme effrayant, dévora tous ses fils pour qu'ils ne puissent pas le détrôner. Seul Zeus réussit à s'échapper grâce à une ruse.

Saturn verschlingt einen Sohn

Der Gott Saturn, als furchterregender, dynamischer alter Mann von Rubens realistisch ausgeführt, verschlang alle seine Söhne, damit sie ihn nicht entthronen konnten. Nur Zeus entkam durch eine List.

Saturno devorando a su hijo

El dios Saturno, un anciano temible y dinámico conseguido de forma realista por Rubens, devoró a todos sus hijos para que no pudieran destronarlo. Sólo Zeus escapó por engaño.

Saturno divora un figlio

Il dio Saturno, un vecchio temibile, dinamico, realisticamente rappresentato da Rubens divorò tutti i suoi figli perché non potessero detronizzarlo. Solo Zeus gli sfugge grazie ad un'astuzia.

Saturnus verslindt een zoon

De god Saturnus, een angstaanjagende, dynamische oude man, realistisch uitgevoerd door Rubens, verslond al zijn zonen zodat ze hem niet konden onttronen. Alleen Zeus ontsnapte door een list.

PETER PAUL RUBENS (1577-1640)

1636–38, Oil on canvas/Huile sur toile, 182,5 × 87 cm, Museo del Prado, Madrid

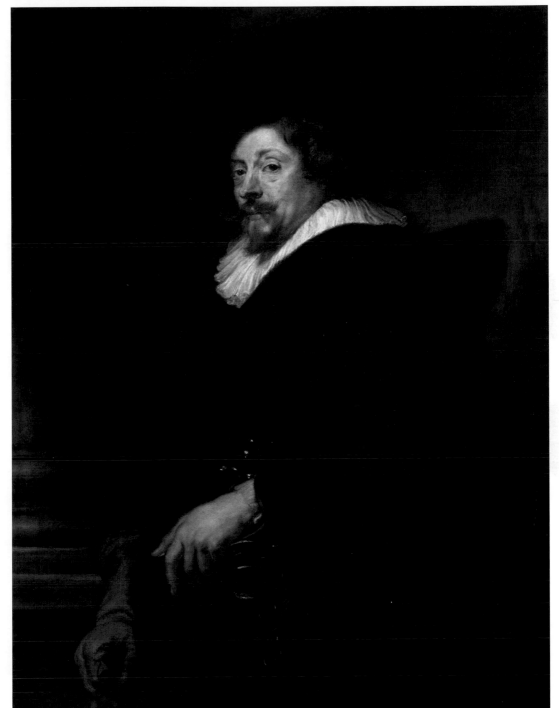

Self-Portrait

Autoportrait

Selbstbildnis

Autorretrato

Autoritratto

Zelfportret

PETER PAUL RUBENS
(1577–1640)

c. 1638, Oil on canvas/
uile sur toile, 110 × 85,5 cm,
Kunsthistorisches
Museum, Wien

The Judgement of Paris

This popular theme offered Rubens the opportunity to depict beautiful female nudes—as well as the possible consequences of love. Paris's choice of Venus as the fairest sparked the Trojan War.

Le Jugement de Pâris

Ce thème souvent représenté offre à Rubens la possibilité de montrer la beauté de la nudité féminine – et les conséquences possibles de l'amour : c'est en choisissant Vénus comme étant la plus belle que Pâris déclenche la guerre de Troie.

Das Urteil des Paris

Das oft dargestellte Thema bot Rubens Gelegenheit, weibliche Schönheit nackt zu zeigen – und mögliche Konsequenzen der Liebe: Weil er Venus als Schönste erwählt, löst Paris den Trojanischen Krieg aus.

El juicio de París

El tema a menudo representado le ofreció a Rubens la oportunidad de mostrar la belleza femenina desnuda– y las posibles consecuencias del amor: al elegir a Venus como la más bella, París desencadenó la Guerra de Troya.

Giudizio di Paride

Il tema, spesso rappresentato, offre a Rubens l'opportunità di mostrare la bellezza della nudità femminile e le possibili conseguenze dell'amore: perché sceglie Venere come la più bella, Paride scatena la guerra di Troia.

Het oordeel van Paris

Het vaak afgebeelde thema bood Rubens de kans om het vrouwelijk schoon naakt te tonen, evenals de mogelijke gevolgen van de liefde. Doordat hij Venus koos als mooiste, veroorzaakte Paris de Trojaanse Oorlog.

PETER PAUL RUBENS (1577–1640)

c. 1638, Oil on canvas/Huile sur toile, 199 × 381 cm, Museo del Prado, Madrid

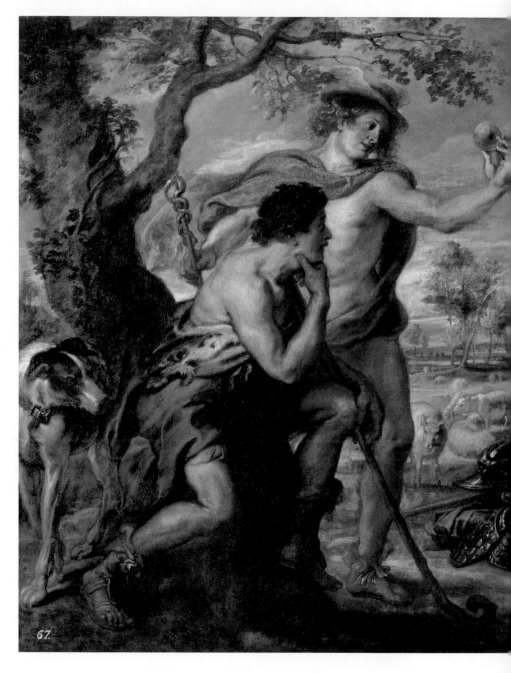

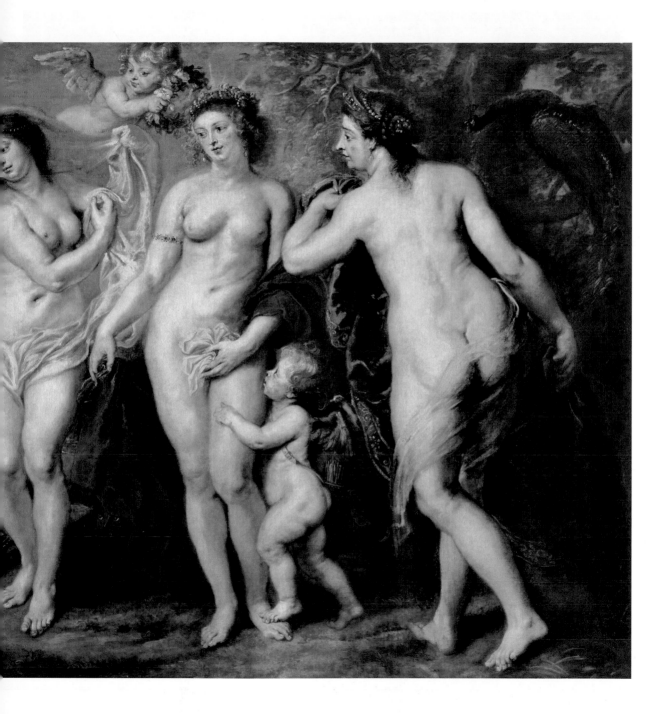

Sight Das Sehen Allegoria della vista

L'Allégorie de la Vue Alegoría de la vista Het zien

JAN BRUEGHEL THE ELDER (1568–1625) & PETER PAUL RUBENS (1577–1640)
1617, Oil on wood/Huile sur bois, 64,7 × 109,5 cm, Museo del Prado, Madrid

Jan Brueghel the Elder: Master of Flowers

Jan Brueghel the Elder, contemporary and friend of Rubens, came from a famous painting dynasty: his father and brother were Pieter Brueghel the Elder and the Younger; Jan Brueghel the Younger was his son. Like many painters of his time, he specialised in a certain genre: he was called "Velvet Brueghel" or "Flower Brueghel" because of his captivatingly beautiful flowers. He also sometimes added these to Rubens's paintings—a "division of labour" typical of Rubens and other artists at the time. Brueghel often painted landscapes with small figures or animals in the foreground, as well as allegorical paintings. He received many of his commissions from the regents of the Spanish Netherlands, Albert VII and Isabella, who wished to strengthen the Spanish-Catholic element in the country, not least through the fine arts.

Jan Brueghel l'Ancien : le maître des fleurs

Jan Brueghel l'Ancien, contemporain et ami de Rubens, était issu d'une célèbre famille de peintres : Pieter Brueghel l'Ancien et le Jeune étaient respectivement son père et son frère, et son fils n'était autre que Jan Brueghel le Jeune. Comme beaucoup de peintres de son époque, il était « spécialiste » d'un certain genre : on l'appelait aussi le « Brueghel de Velours » ou le « peintre des fleurs », car il était capable de représenter la flore avec beauté. Il en peignit d'ailleurs aussi sur des tableaux de Rubens, une « division du travail » typique de ce dernier, qui collabora à l'époque avec un certain nombre de collègues. Brueghel peignait également souvent des paysages, avec quelques personnages ou animaux jouant au premier plan un rôle secondaire, ainsi que des tableaux allégoriques. Il reçut beaucoup de commandes des souverains des Pays-Bas espagnols, Albert d'Autriche et Isabelle, qui voulaient renforcer l'élément catholique espagnol dans le royaume, notamment grâce aux beaux-arts.

Jan Brueghel der Ältere: Der meisterhafte Blumenmaler

Jan Brueghel der Ältere, Zeitgenosse und Freund von Rubens, entstammte einer berühmten Malerdynastie: Vater und Bruder waren Pieter Brueghel der Ältere und der Jüngere; Jan Brueghel der Jüngere war sein Sohn. Wie viele Maler seiner Zeit war er „Spezialist" für ein bestimmtes Genre: Man nannte ihn auch „Samtbrueghel" oder „Blumenbrueghel", weil er bestechend schöne Blumen malen konnte. Diese durfte er auch auf Gemälden von Rubens anbringen – eine Rubens-typische „Arbeitsteilung", wie sie in jenen Jahren auch mit anderen Kollegen praktiziert wurde. Häufig malte Brueghel ebenfalls Landschaftsdarstellungen mit klein Staffagefiguren oder -tieren im Vordergrund sowie allegorische Gemälde. Viele seiner Aufträge erhielt er den Regenten der spanischen Niederlande Albrecht V und Isabella, denn diese wollten das spanisch-katholis Element im Land nicht zuletzt durch die schönen Künste festigen.

Fish Market
before a City
by the Sea

Marché aux
ssons dans une
ville portuaire

Fischmarkt vor
einer Stadt
am Meer

Mercado de
escado frente
a una ciudad
junto al mar

Mercato del
pesce in una
città di mare

Vismarkt voor
n stad aan zee

BRUEGHEL THE
R (1568-1625)
c. 1620, Oil on
copper/Huile sur
e, 17,6 × 27,5 cm,
tliches Museum,
Schwerin

Brueghel el Viejo: intor especialista en flores

Brueghel el Viejo, contemporáneo y amigo de Rubens, enía de una famosa dinastía de pintores: su padre y ermano eran Pieter Brueghel el Viejo y el Joven; Jan ghel el Joven era su hijo. Como muchos pintores a tiempo, era un "especialista" en un determinado ro: también se le llamaba "Samtbrueghel" o menbrueghel" porque podía pintar flores de una za cautivadora. También se le permitió aplicarlas pinturas de Rubens– una "división del trabajo" a de Rubens, como también hacía con otros colegas quellos años. Brueghel pintaba a menudo paisajes figuras pequeñas o animales en primer plano y ras alegóricas. Recibió muchos de sus encargos de egentes de los Países Bajos españoles Albrecht VII bella, que querían fortalecer el elemento hispano- ico en el país, sobre todo a través de las bellas artes.

Jan Brueghel il Vecchio: il grande artista dei fiori

Jan Brueghel il Vecchio, contemporaneo e amico di Rubens, proveniva da una famosa dinastia pittorica: padre e fratello erano Pieter Brueghel il Vecchio e il Giovane; Jan Brueghel il Giovane era suo figlio. Come molti pittori del suo tempo, era uno "specialista" per un particolare genere: veniva chiamato anche "Samtbrueghel" o "Blumenbrueghel" perché sapeva dipingere fiori con una bellezza accattivante. Gli fu anche permesso di applicarli ai dipinti di Rubens – una "divisione del lavoro" tipica di Rubens, praticata anche con altri colleghi in quegli anni. Brueghel dipinse spesso paesaggi con piccole figure o animali in primo piano e dipinti allegorici. Ricevette molte delle sue commissioni dai reggenti dei Paesi Bassi spagnoli Albrecht VII e Isabella, che volevano rafforzare l'elemento cattolico-spagnolo nel paese anche attraverso le belle arti.

Jan Brueghel de Oude: meesterlijke bloemenschilder

Jan Brueghel de Oude, een tijdgenoot en vriend van Rubens, kwam uit een beroemde schilderdynastie: zijn vader en broer waren Pieter Brueghel de Oude en de Jonge; Jan Brueghel de Jonge was zijn zoon. Net als veel schilders van zijn tijd was hij 'specialist' in een bepaald genre: hij werd ook wel 'Fluwelen Brueghel' of 'Bloemenbrueghel' genoemd omdat hij overtuigend mooie bloemen kon schilderen. Deze mocht hij ook aanbrengen op Rubens' schilderijen – een 'werkverdeling' die typerend was voor Rubens en zoals in die tijd ook met andere collega's werd gepraktiseerd. Brueghel schilderde vaak landschappen met kleine versierende figuren of dieren op de voorgrond en allegorische schilderijen. Veel van zijn opdrachten kreeg hij van Albrecht VII en Isabella, de regenten van de Spaanse Nederlanden, die de Spaans-katholieke invloed in het land niet in de laatste plaats door de beeldende kunst wilden versterken.

Flowers in a Wooden Vessel

With this famous still life, "Flow[...]
Brueghel" lived up to his name:
the picture contains 130 differen[...]
delicate and lifelike flowers. In
reality, this bouquet would prob[...]
not exist.

Grand bouquet de fleurs
dans un baquet de bois

Avec cette célèbre nature morte
florale, le « peintre des fleurs » f[...]
honneur à son nom : il peignit 1[...]
fleurs différentes, toutes plus fin[...]
réalistes les unes que les autres.
bouquet ne pourrait naturelleme[...]
pas exister dans le monde réel.

Großer Blumenstrauß in
einem Holzgefäß

Mit diesem berühmten
Blumenstillleben machte der
„Blumenbrueghel" seinem Nam[...]
alle Ehre: Fein und naturgetreu
malte er 130 unterschiedliche
Blüten. In der Realität würde es
diesen Strauß wohl nicht geben.

Gran ramo de flores en
una vasija de madera

Con este famoso bodegón de flo[...]
el "Bloemenbrueghel" hizo hono[...]
a su nombre: el artista pintó 130
flores diferentes, finas y vivas. E[...]
realidad, este ramo probablemen[...]
no existiría.

Bouquet di fiori in un vaso di le[...]

Con questa famosa natura mort[...]
di fiori, il "Bloemenbrueghel"
ha fatto onore al suo nome: ha
dipinto 130 diversi fiori raffinati
realistici. In realtà, questo bouq[...]
probabilmente non esisterebbe.

Groot boeket bloemen
in houten vaas

Met dit beroemde bloemstillleve[...]
deed 'Bloemenbrueghel' zijn naa[...]
alle eer aan: heel fijn en levense[...]
schilderde hij 130 verschillende
bloemen. In werkelijkheid zou d[...]
boeket waarschijnlijk niet besta[...]

**JAN BRUEGHEL THE ELDER
(1568–1625)**

1606/07, Oil on wood/
Huile sur bois, 97,5 × 73 cm,
Kunsthistorisches Museum, Wien

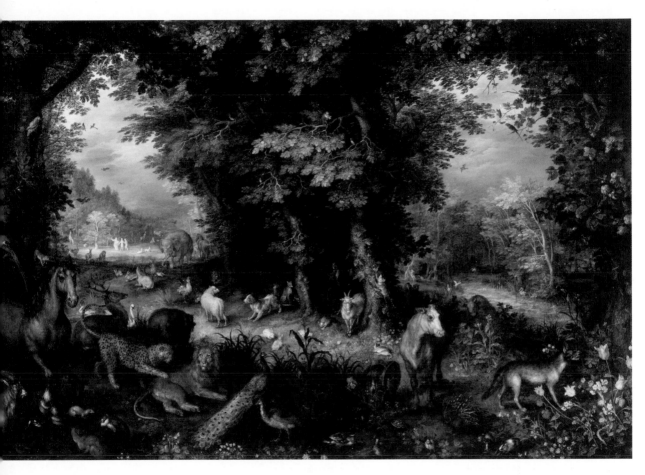

h (The Earthly Paradise)

reation lies before us: flowers, trees, birds, domestic and
animals in peaceful harmony. Only the snake is missing:
ghel was one of the first to paint Eden without the Tree of
wledge.

erre *ou* Le Paradis terrestre

e la Création s'offre à nous : fleurs, arbres, oiseaux,
aux domestiques et sauvages, en parfaite harmonie. Seul
rpent est le grand absent : Brueghel fut l'un des premiers à
dre le paradis sans l'arbre de la connaissance.

Die Erde *oder* Das irdische Paradies

Die ganze Schöpfung liegt vor uns: Blumen, Bäume, Vögel,
Haus- und Wildtiere in friedlicher Eintracht. Was fehlt, ist die
Schlange: Als einer der Ersten malte Brueghel das Paradies
ohne den Baum der Erkenntnis.

La Tierra o Paraíso Terrenal

Toda la creación está ante nosotros: flores, árboles, pájaros,
animales domésticos y animales salvajes en pacífica armonía.
Lo que falta es la serpiente: Brueghel fue uno de los primeros
en pintar el paraíso sin el Árbol del Conocimiento.

La Terra *o* il Paradiso Terrestre

Tutta la creazione si estende ai nostri occhi: fiori, alberi,
uccelli, animali domestici e selvatici in armonia. Quello che
manca è il serpente: Brueghel fu uno dei primi a dipingere il
paradiso senza l'Albero della Conoscenza.

De aarde *of* Het aardse paradijs

De hele schepping ligt voor ons: bloemen, bomen, vogels,
gedomesticeerde en wilde dieren in vredige harmonie. Wat
ontbreekt is de slang: Brueghel was een van de eersten die het
paradijs schilderde zonder de boom van kennis.

BRUEGHEL THE ELDER (1568–1625)
/08, Oil on copper/Huile sur plaque de cuivre, 45 × 65 cm, Musée du Louvre, Paris

Extensive Landscape with View of Mariemont Castle

Mariemont, south of Brussels, was the summer residence of Archduke Albert VII and his wife, the Spanish infanta Isabella. The picture shows the richness of the castle with its extensive grounds.

Vue du château de Mariemont

Mariemont, au sud de Bruxelles, était la résidence d'été de l'archiduc Albert et de son épouse, l'infante d'Espagne Isabella. Ce tableau montre la richesse du château et de ses vastes terres.

Ansicht des Schlosses Mariemont

Mariemont, südlich von Brüssel, war der Sommersitz von Erzherzog Albrecht VII. und seiner Gattin, der spanischen Infantin Isabella. Das Bild zeigt den Reichtum des Schlosses mit seinen weiten Ländereien.

Paisaje con el Castillo de Mariemont

Mariemont, al sur de Bruselas, fue la residencia de verano del Archiduque Albrecht VII y su esposa, la infanta española Isabella. La imagen muestra la riqueza del castillo con sus amplias tierras.

Veduta del Castello di Mariemont

Mariemont, a sud di Bruxelles, era la residenza estiva dell'arciduca Alberto VII e di sua moglie, l'infanta di Spagr Isabella. Il ritratto mostra la ricchezza del castello con le s vaste terre.

Gezicht op het kasteel van Mariemont

Mariemont, ten zuiden van Brussel, was de zomerresident van aartshertog Albrecht VII en diens vrouw, de Spaanse infante Isabella. Het schilderij toont de rijkdom van het ka met zijn uitgestrekte landerijen.

JAN BRUEGHEL THE ELDER (1568–1625)

1612, Oil on canvas/Huile sur toile, 184 × 292 cm, Musée des Beaux-Arts, Dijon

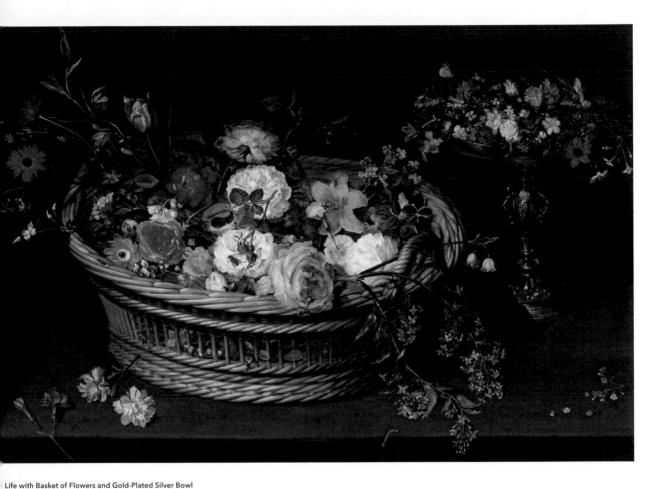

Life with Basket of Flowers and Gold-Plated Silver Bowl

beille de fleurs et coupe en vermeil sur un entablement

leben mit Blumenkorb und vergoldeter Silberschale

degón con cesta de flores y cuenco de plata dorada

ura morta con cesto di fiori e ciotola dorata

even met bloemenmand en vergulde zilveren schaal

BRUEGHEL THE YOUNGER (1601–78)

, Oil on canvas/Huile sur toile, 52 × 82 cm, Private collection

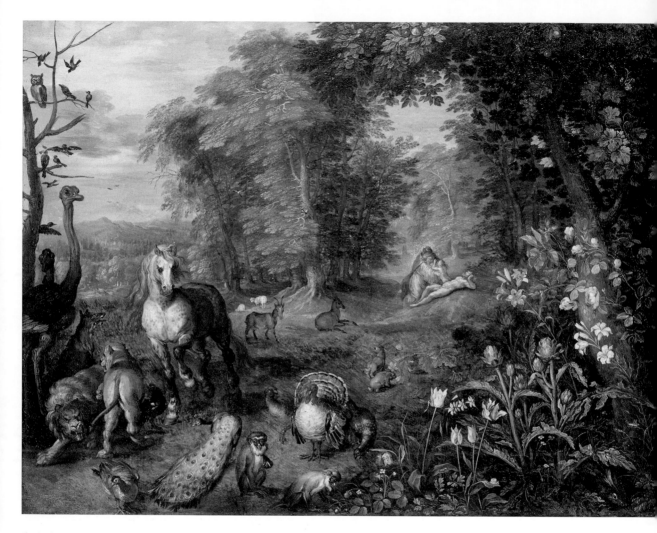

The Garden of Eden with the Creation of Eve

Le Paradis, avec la Création d'Ève

Paradieslandschaft mit der Erschaffung Evas

Paisaje paradisíaco con la creación de Eva

Paradiso con il racconto della creazione di Eva

Paradijslandschap met de schepping van Eva

JAN BRUEGHEL THE YOUNGER (1601–78)

1636–40, Oil on copper/Huile sur plaque de cuivre, 28,8 × 36,6 cm, Städel Museum, Frankfurt am Main

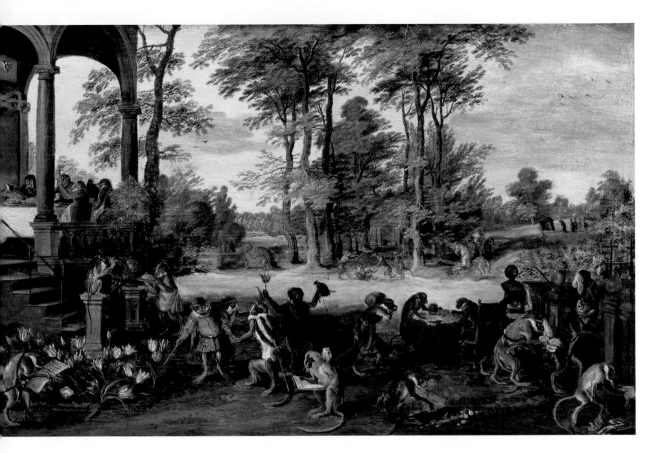

re on Tulip Mania

his satirical picture, which focuses on the then raging "tulip
nia", monkeys (as a symbol of stupidity) take on human
es. For example, one weighs tulip bulbs with gold.

re de la tulipomanie

ce tableau satirique, qui s'attaque à la « folie des tulipes »
sévissait à l'époque, on peut voir des singes (symboles
bêtise) jouer des rôles humains. L'un d'eux par exemple
ange des oignons de tulipe contre de l'or.

Satire auf die Tulipomanie

Auf diesem satirischen Bild, das den damals grassierenden
„Tulpenwahn" aufs Korn nimmt, übernehmen Affen (als
Symbol für Dummheit) menschliche Rollen. Einer wiegt zum
Beispiel Tulpenzwiebeln mit Gold auf.

Sátira de la tulipomanía

En este cuadro satírico, que se centra en la entonces
desenfrenada "manía del tulipán", los monos (como símbolo de
estupidez) asumen roles humanos. Por ejemplo, uno de ellos
compensa bulbos de tulipán con oro.

Satira della tulipomania

In questo quadro satirico, che si concentra sulla "mania
dei tulipani" allora dilagante, le scimmie (come simbolo di
stupidità) assumono ruoli umani. Ad esempio, una di loro
pesa bulbi di tulipano con l'oro.

Satire op de tulpomanie

Op dit satirische schilderij, dat de toen heersende tulpomanie
op de korrel neemt, nemen apen (als symbool van
domheid) menselijke rollen aan. Eén aap weegt bijvoorbeeld
tulpenbollen met goud.

▌ BRUEGHEL THE YOUNGER (1601–78)

o, Oil on wood/Huile sur bois, 31 × 49 cm, Frans Hals Museum, Haarlem

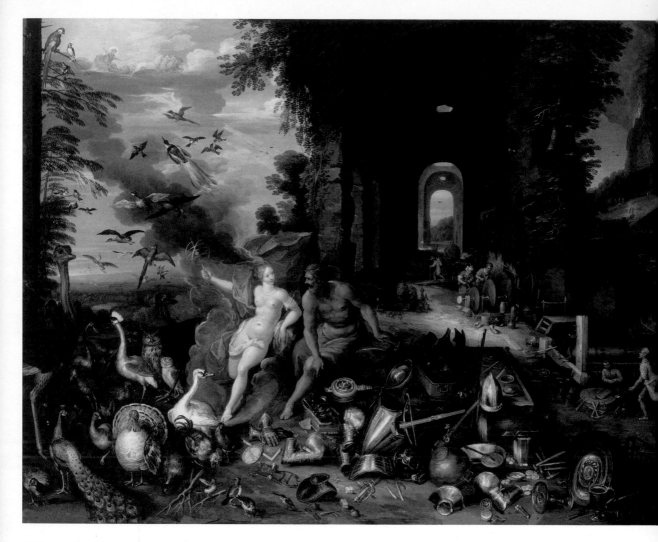

An Allegory of Air and Fire

Allégorie du Feu et de l'Air

Eine Allegorie des Feuers und der Luft mit Venus in der Schmiede des Vulkan

Una alegoría del fuego y el aire con Venus en la forja de Vulcano

Allegoria del fuoco e dell'aria con Venere nella fucina di Vulcano

Een allegorie van vuur en lucht met Venus in de smederij van Vulcanus

JAN BRUEGHEL THE YOUNGER (1601–78) & FRANS FRANCKEN (1581–1642)
1640, Oil on copper/Huile sur plaque de cuivre, 50,8 × 63,5 cm, Private collection

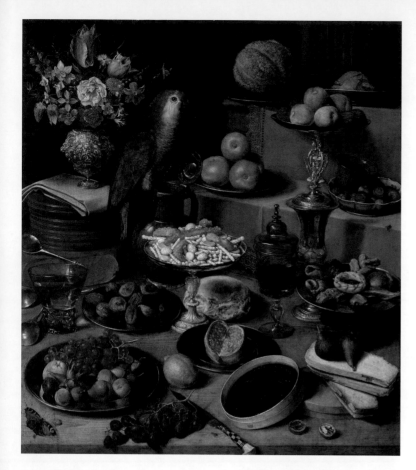

Still Life with Parrot

Nature morte au perroquet et aux desserts

Großes Schauessen mit Papagei

Naturaleza muerta con papagayo

Natura morta con pappagallo

Stilleven met papegaai

GEORG FLEGEL (1563–1638)
c. 1620, Oil on copper/Huile sur plaque de cuivre,
78 × 67 cm, Alte Pinakothek, München

Baroque in Germany:
In the Shadow of the Netherlands

No other European country suffered as much from the
devastation of the Thirty Years War as Germany. Nowhere
in the first half of the 17th century was it possible to
develop a cultural landscape that could compare to that in
the Netherlands or Italy.

 Although there was no shortage of artistic talents in
Germany, they were usually forced to go Amsterdam
or Rome if they wanted to make a living from their art.
This was certainly the case for the two most important
German painters, Adam Elsheimer and Johann Liss, who
moved to Rome and Venice, respectively, and essentially
became part of the Italian baroque.

 Only towards the end of the century, in the late
baroque and subsequent rococo period, did German art
begin to flourish. Particularly in southern Germany and
Austria, painters such as Johann Michael Rottmayr and
Franz Anton Maulbertsch contributed to the country's
artistic revival.

Le baroque allemand :
dans l'ombre des Pays-Bas

Aucun pays d'Europe ne souffrit d'autant de ravages au
cours de la guerre de Trente Ans que le Saint-Empire.
Dans la première moitié du XVIIᵉ siècle, nulle part ne put
se développer une vie culturelle qui soit un tant soit peu
comparable à celle des Pays-Bas ou de l'Italie.

 Les artistes talentueux ne manquaient certes pas, mais
ils partaient en général vers Amsterdam ou vers Rome
pour y vivre de leur art. Ce fut le cas notamment des
peintres allemands probablement les plus importants de
l'époque, Adam Elsheimer et Johann Liss, qui partirent
respectivement à Rome et à Venise et s'intégrèrent plus ou
moins au baroque italien.

 C'est seulement à la fin du siècle, c'est-à-dire à l'époque
du baroque tardif puis du rococo, que démarra un nouvel
essor culturel dans le monde allemand, en particulier dans
les régions du sud et en Autriche, où des peintres comme
Johann Michael Rottmayr ou Franz Anton Maulbertsch
témoignèrent d'un renouveau des arts.

Barock in Deutschland:
Im Schatten der Niederlande

Kein anderes europäische Land litt in ähnlicher Weise
unter den Verwüstungen des Dreißigjährigen Krieges
wie Deutschland. Nirgendwo konnte sich in der ersten
Hälfte des 17. Jahrhunderts eine kulturelle Landschaft
entwickeln, die auch nur in Ansätzen vergleichbar
gewesen wäre mit jener in den Niederlanden oder Italie

 Dabei mangelte es nicht an künstlerischen Talenten,
doch zog es diese zumeist nach Amsterdam oder
Rom, wenn sie von ihrer Kunst leben wollten. Das gilt
vor allem für die damals wohl wichtigsten deutschen
Maler Adam Elsheimer und Johann Liss, die nach Rom
beziehungsweise Venedig zogen und dort mehr oder
weniger Teil des italienischen Barocks wurden.

 Erst gegen Ende des Jahrhunderts, also im Spätbaroc
und darauffolgenden Rokoko, gab es wieder eine echte
kulturelle Blüte, vor allem in Süddeutschland und
Österreich, wo Maler wie Johann Michael Rottmayr
oder Franz Anton Maulbertsch vom Aufschwung der
Künste zeugten.

Judith Slays Holofernes

Judith dans la tente d'Holopherne

Judith tötet Holofernes

Judith mata a Holofernes

Giuditta uccide Oloferne

Judith doodt Holofernes

JOHANN LISS (1597–1631)

c. 1620, Oil on canvas/Huile sur toile, 126 × 102 cm, Kunsthistorisches Museum, Wien

Barroco en Alemania: a la sombra de los Países Bajos

Ningún otro país europeo sufrió tanto la devastación de la guerra de los Treinta Años como Alemania. En ninguna parte fue posible desarrollar durante la la primera mitad del siglo XVII un paisaje cultural que pudiera compararse con el de los Países Bajos o Italia.

No escaseaban los talentos artísticos, pero en su mayoría se sentían atraídos por Ámsterdam o Roma si querían ganarse la vida con su arte. Esto se aplica sobre todo a los entonces probablemente más importantes pintores alemanes Adam Elsheimer y Johann Liss, que se trasladaron a Roma y Venecia y más o menos pasaron a formar parte del barroco italiano.

Sólo hacia finales de siglo, es decir, a finales del Barroco tardío y en el período rococó posterior, se produjo de nuevo un verdadero auge cultural, sobre todo en el sur de Alemania y en Austria, donde pintores como Johann Michael Rottmayr o Franz Anton Maulbertsch fueron testigos del auge de las artes.

Barocco in Germania: all'ombra dei Paesi Bassi

Nessun altro paese europeo ha sofferto tanto della devastazione della Guerra dei trent'anni quanto la Germania. Nella prima metà del XVII secolo non è stato possibile sviluppare un paesaggio culturale paragonabile a quello dei Paesi Bassi o dell'Italia.

Non mancavano i talenti artistici, ma erano per lo più attirati da Amsterdam o da Roma se volevano guadagnarsi da vivere con la loro arti. Questo vale soprattutto per gli allora probabilmente più importanti pittori tedeschi Adam Elsheimer e Johann Liss, che si trasferirono a Roma e a Venezia ed entrarono più o meno a far parte del barocco italiano.

Solo verso la fine del secolo, vale a dire nel tardo barocco e nel successivo periodo rococò, vi fu di nuovo un vero e proprio boom culturale, soprattutto nella Germania meridionale e in Austria, dove pittori come Johann Michael Rottmayr o Franz Anton Maulbertsch assistettero al rilancio delle arti.

Barok in Duitsland: in de schaduw van de Nederlanden

Geen enkel Europees land heeft zo geleden onder de verwoestingen van de Dertigjarige Oorlog als Duitsland. Nergens kon zich in de eerste helft van de 17e eeuw een cultuurlandschap ontwikkelen dat ook maar enigszins vergelijkbaar was met dat in de Nederlanden of Italië. Er was geen tekort aan artistieke talenten, maar die trokken vooral naar Amsterdam of Rome als ze van hun kunst wilden leven. Dat geldt vooral voor de toen waarschijnlijk belangrijkste Duitse schilders Adam Elsheimer en Johann Liss, die naar Rome en Venetië verhuisden en min of meer deel gingen uitmaken van de Italiaanse barok.

Pas tegen het einde van de eeuw, dat wil zeggen in de late barok en de daaropvolgende rococoperiode, was er weer sprake van een echte culturele bloeitijd, vooral in Zuid-Duitsland en Oostenrijk, waar schilders zoals Johann Michael Rottmayr en Franz Anton Maulbertsch getuigden van de opleving van de kunsten.

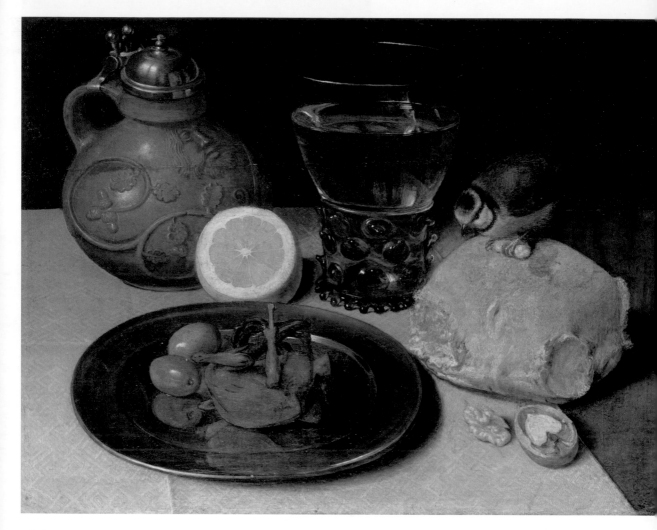

Still Life

Nature morte à la mésange et à la caille rôtie

Stillleben

Naturaleza muerta

Natura morta

Stilleven

GEORG FLEGEL (1566-1638)

c. 1625-30, Oil on wood/Huile sur bois, 27 × 34 cm, Metropolitan Museum of Art, New York

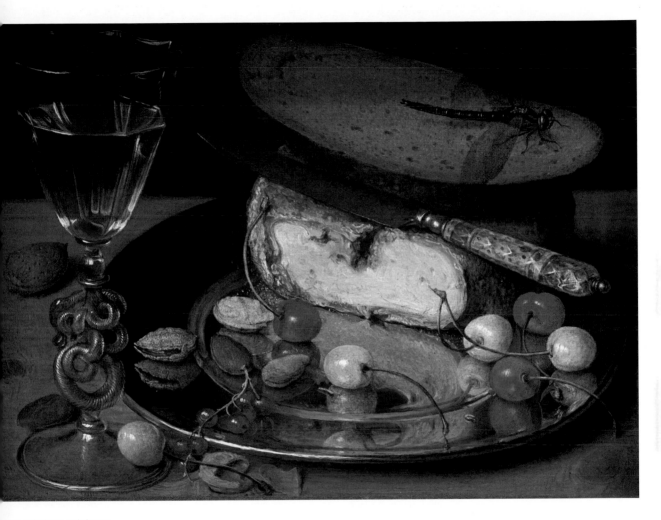

ll Life with Cheese and Cherries

ature morte au fromage et aux cerises

illleben mit Käse und Kirschen

aturaleza muerta con queso y cerezas

atura morta con formaggi e ciliegie

llleven met kaas en kersen

ORG FLEGEL (1566–1638)

35, Oil on beechwood/Huile sur hêtre, 18,4 × 25 cm, Staatsgalerie, Stuttgart

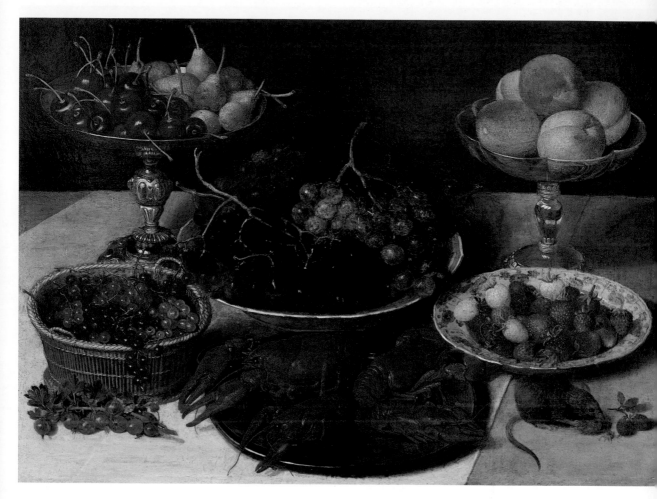

Fruit and Crayfish

Nature morte aux fruits et aux homards

Obst und Krebse

Frutas y cangrejos de río

Frutta e gamberi

Vruchten en kreeften

GEORG FLEGEL (1566–1638)

n.d., Oil on oakwood/Huile sur bois, 35,5 × 48,5 cm, Narodni Galerie, Praha

Nymph and Shephe

La Nymphe et le berg

Nymphe und Schä

Ninfa y past

Ninfa e past

Nimf en herd

JOHANN LISS (1597–163

c. 1625, Oil on canvas/Huile sur toile, 104,5 × 94,9 cm, Metropolitan Museum of Art, New Y

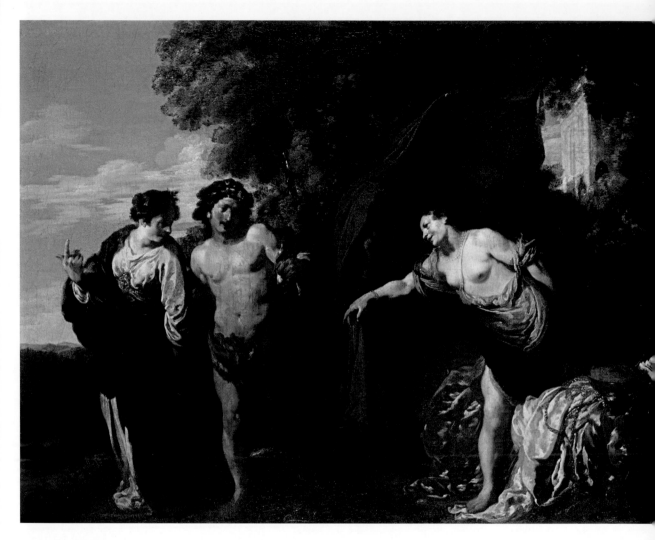

Hercules at the Crossroads

Le Choix d'Hercule

Herkules am Scheidewege

Hércules en la encrucijada

Ercole a un bivio

Hercules op een kruispunt

JOHANN LISS (1597- 1631)

c. 1625, Oil on canvas/Huile sur toile, 61 × 75 cm, Gemäldegalerie Alte Meister, Dresden

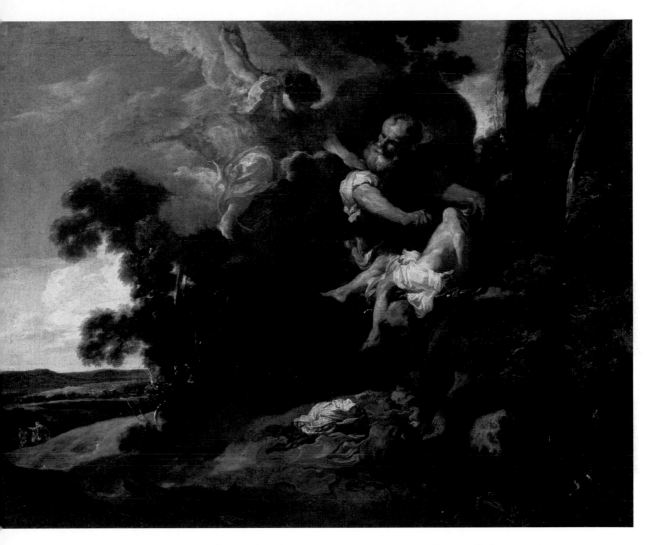

aham Sacrificing Isaac

e many German painters, Liss, a native of Holstein, went to
e after several years in the Netherlands. He soon settled
enice, where he died of the plague at the age of 34.

acrifice d'Isaac

ginaire du Holstein, Liss partit à Rome après quelques
ées aux Pays-Bas, comme beaucoup de peintres allemands
époque. Il s'installa peu après à Venise, où il mourut de la
e alors qu'il n'avait que 34 ans.

Abraham opfert Isaak

Der aus Holstein stammende Liss ging, nach einigen Jahren in
den Niederlanden, wie viele deutsche Maler nach Rom. Er ließ
sich bald in Venedig nieder, wo er mit nur 34 Jahren an der
Pest starb.

El sacrificio de Isaac

Liss, que vino de Holstein, fue a Roma, como muchos pintores
alemanes, después de varios años en los Países Bajos. Pronto
se instaló en Venecia, donde murió a causa de la peste a la
edad de 34 años.

Abramo sacrifica Isacco

Liss, originario di Holstein, si recò a Roma, come molti pittori
tedeschi, dopo diversi anni trascorsi nei Paesi Bassi. Ben
presto si stabilì a Venezia, dove morì di peste a 34 anni.

Abraham offert Izaäk

Liss, die uit Holstein kwam, ging, net als veel Duitse schilders,
naar Rome nadat hij enkele jaren in Nederland was geweest.
Al snel vestigde hij zich in Venetië, waar hij op 34-jarige
leeftijd stierf aan de pest.

ANN LISS (1597-1631)

30, Oil on canvas/Huile sur toile, 66 × 85 cm, Gallerie della Accademia, Venezia

Still Life with Shells and a Chip-Wood Box

Nature morte aux nautile, coquillage et boîte en bois

Stillleben mit Muscheln und einem Spanholz-Kästchen

Naturaleza muerta con conchas y una caja de madera aglomerada

Natura morta con conchiglie e una scatola di legno

Stilleven met schelpen en een spaanhouten doosje

SEBASTIAN STOSKOPFF (1597-1657)

c. 1626-29, Oil on canvas/Huile sur toile, 47 × 59,4 cm, Metropolitan Museum of Art, New York

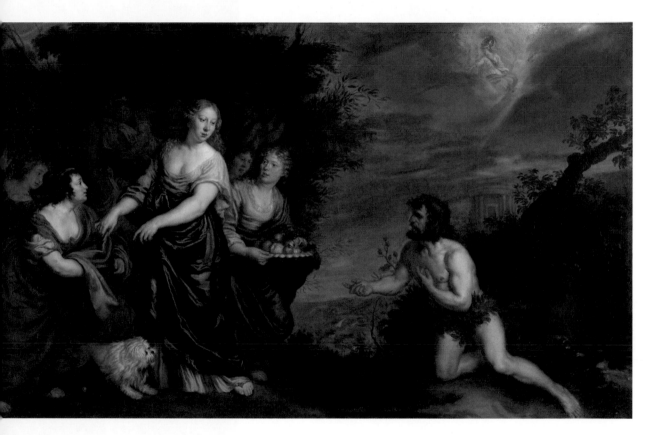

...sseus and Nausicaa

...se et Nausicaa

...sseus und Nausikaa

...es y Nausícaa

...se e Nausicaa

...sseus en Nausikaä

...CHIM VON SANDRART (1606–88)

...80–c. 1688, Oil on canvas/Huile sur toile, 103,5 × 168,5 cm, Rijksmuseum, Amsterdam

Minerva and Saturn Protecting Art and Science from Envy and Lies

Minerve et Saturne protègent l'Art et la Science

Minerva und Saturn beschützen Kunst und Wissenschaft vor Neid und Lüge

Minerva y Saturno protegen el arte y la ciencia de la envidia y la mentira

Minerva e Saturno proteggono l'arte e la scienza dall'invidia e dalla menzogna

Minerva en Saturnus beschermen kunst en wetenschap tegen afgunst en leugens

JOACHIM VON SANDRART (1606–88)

1644, Oil on canvas/Huile sur toile, 146 × 202 cm, Kunsthistorisches Museum, Wien

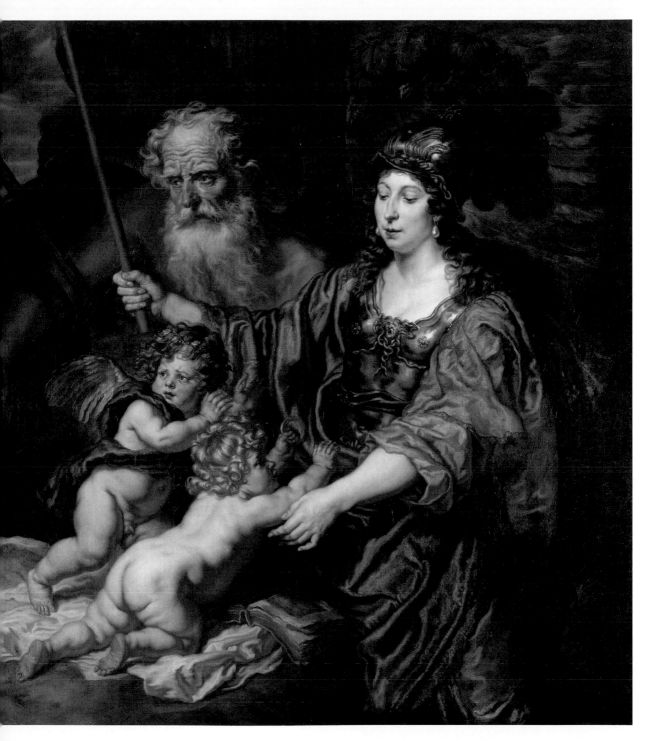

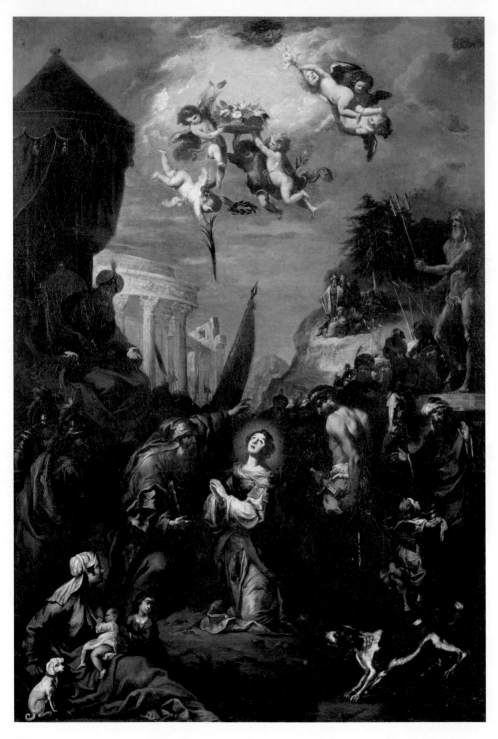

The Martyrdom of St Dorothy

Le Martyre de sainte Dorothée

Die Marter der Heiligen Dorothea

El Martirio de Santa Dorotea

Il martirio di Santa Dorotea

De marteling van Dorothea

TOBIAS POCK (1609–83)

c. 1656, Oil on canvas/Huile sur toile, 98 × 66,8 cr

Kunsthistorisches Museum, Wien

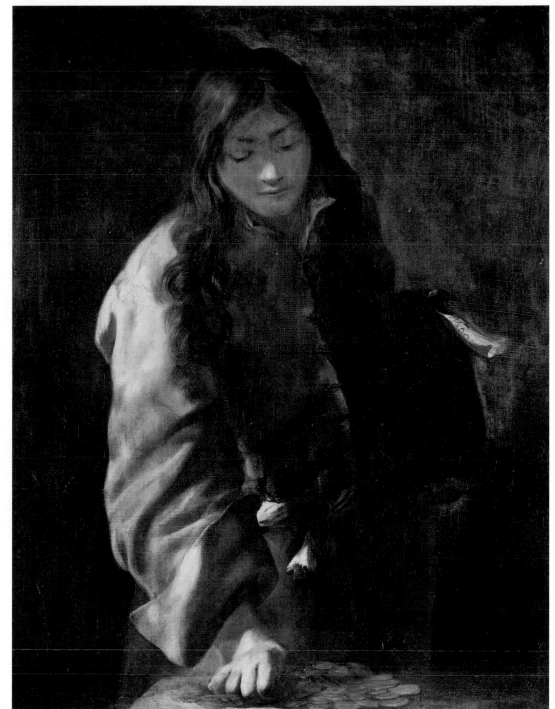

Feeling

Le Sentiment

Gefühl

Sensibilidad

Sensibilità

Het gevoel

**JOHANN HEINRICH
SCHÖNFELD (1609-84)**
c. 1655, Oil on canvas/
Huile sur toile, 99 × 77 cm,
Kunsthistorisches
Museum, Wien

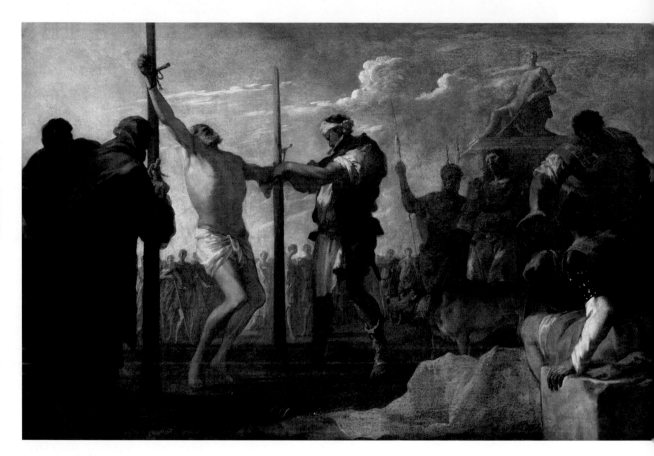

The Flaying of St Bartholomew

Saint Barthélémy écorché

Schindung des Heiligen Bartholomäus

Profanación de San Bartolomé

San Bartolomeo scorticato

Marteling van Bartholomeus

JOHANN HEINRICH SCHÖNFELD (1609–84)

c. 1670, Oil on canvas/Huile sur toile, 83,5 × 127 cm, Staatsgalerie, Stuttgart

aced Italian Landscape with Herdsmen and Herd

sage d'Italie aux vachers et au troupeau

enische Terrassenlandschaft mit Hirten und Herde

aje arcádico con pastores y rebaños

saggio italiano con pastori e mandrie

aans terrassenlandschap met herders en kudde

ANN HEINRICH ROOS (1631–85)

Oil on canvas/Huile sur toile, 75 × 86 cm, Sammlung Schloss Mosigkau, Dessau

Landscape
with Shephe
and Cattle

Paysage
pastoral au
vacher et
au bétail

Landschaft ⊓
Hirten und V

Paisaje con
pastores y
ganado

Paesaggio
con pastori
e bestiame

Landschap ⊓
herders en v

**JOHANN
HEINRICH RO**
(1631–85)
1673, Oil on
canvas/Huile s
toile, 55 × 47 c
Museum der
bildenden
Künste, Leipzi

JOHANN CARL
(1632–98)
1655–60,
Oil on canvas/
Huile sur toile,
5,9 × 99,7 cm,
The National
Gallery, London

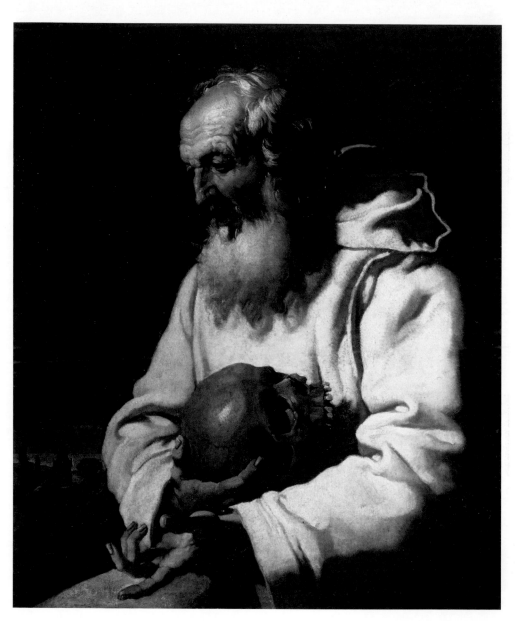

St Romuald

Johann Carl Loth, also known as Carlo[
is considered the leading Venetian pai[
of the late 17th century. His reputation[
was confirmed by numerous commiss[
from royal European courts.

Romuald de Ravenne

Johann Carl Loth, aussi surnommé
Carlotto, était considéré comme un de[
peintres vénitiens majeurs de la fin du
XVIIe siècle. La réputation dont il jouis[
se reflète dans le nombre de command[
qu'il reçut des cours européennes.

Der Heilige Romuald

Johann Carl Loth, auch Carlotto genan[
gilt als führender venezianischer Male[
des ausgehenden 17. Jahrhunderts.
Sein Ansehen äußerte sich auch in der[
zahlreichen Aufträgen europäischer
Fürstenhöfe.

San Romualdo

Johann Carl Loth, también conocido
como Carlotto, es considerado el prin[
pintor veneciano de finales del siglo X[
Su reputación también se reflejó en lo[
numerosos encargos de los tribunales
principescos europeos.

San Romualdo

Johann Carl Loth, detto anche Carlott[
è considerato il principale pittore
veneziano della fine del XVII secolo.
La sua reputazione si rifletteva anche
nelle numerose commissioni delle cor[
principesche europee.

De heilige Romualdus

Johann Carl Loth, ook bekend als
Carlotto, wordt beschouwd als de
toonaangevende Venetiaanse schilder [
het einde van de 17e eeuw. Zijn reputa[
kwam ook tot uiting in de talrijke
opdrachten van Europese vorstenhuiz[

JOHANN CARL LOTH (1632-98)

c. 1660-70, Oil on canvas/Huile sur toile,
101 × 85 cm, Gallerie dell'Accademia, Vene[

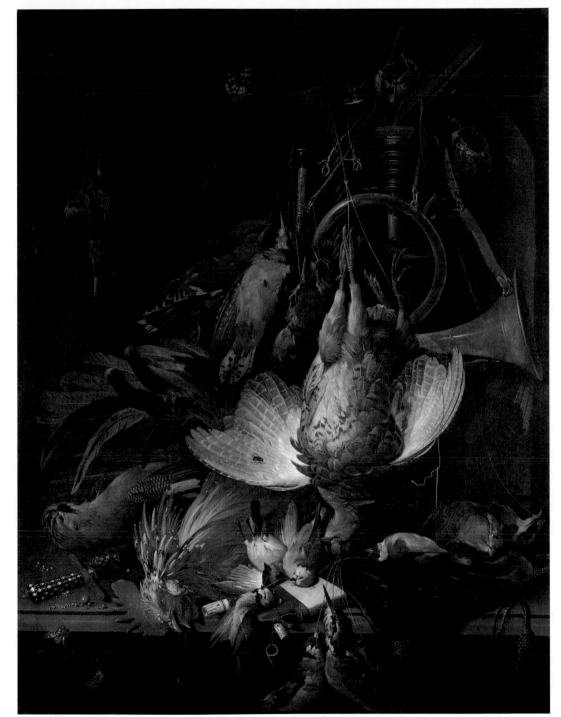

Still Life with Birds
and Hunting Gear

Nature morte de
chasse aux oiseaux

Stillleben mit Vögeln
und Jagdzeug

Naturaleza muerta
con pájaros y
material de caza

ura morta con uccelli
e animali da caccia

Stilleven met vogels
en jachtspullen

**ABRAHAM MIGNON
(1640–79)**

665, Oil on canvas/l'uile
sur toile, 87,5 × 67,5 cm,
Sammlung Schloss
Mosigkau, Dessau

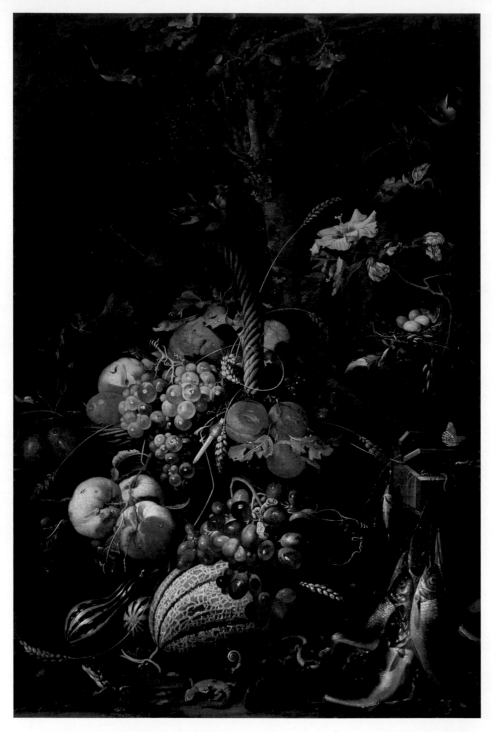

Fruit

Nature morte aux fruits

Obst

Fruta

Frutta

Fruit

ABRAHAM MIGNON (1640–79)

c. 1660–79, Oil on canvas/Huile sur toile, 89 × 70 c

State Hermitage Museum, St. Petersburg

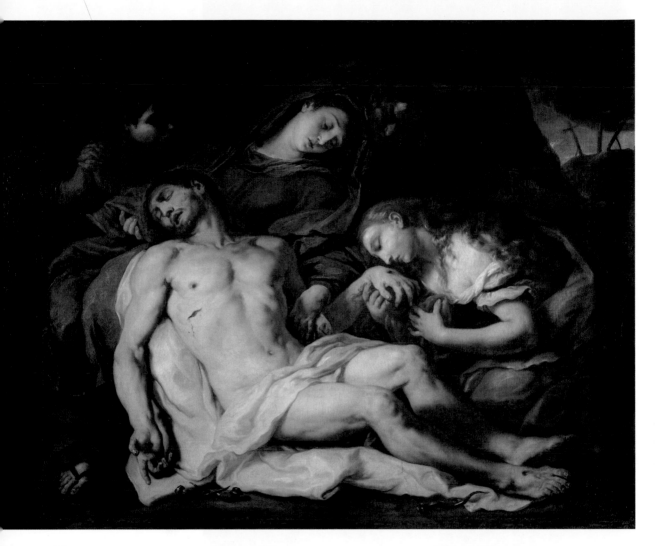

Lamentation of Christ

...mayr's significance lies in his reputation as the first ...trian baroque painter. In his large-format paintings, ...ombined Italian influences with features of the ...nish baroque.

Déploration du Christ

...portance toute particulière de Rottmayr est due au fait ...ce fut le premier peintre baroque autrichien. Dans ses ...vres, généralement de grande taille, il mêlait les influences ...ennes et les traits distinctifs du baroque flamand.

ANN MICHAEL ROTTMAYR (1654-1730)
, Oil on canvas/Huile sur toile, 135 × 169,5 cm, Residenzgalerie, Salzburg

Beweinung Christi

Die besondere Bedeutung Rottmayrs liegt in seinem Ruf als erster österreichischer Barockmaler. In seinen großformatigen Gemälden verband er italienische Einflüsse mit Merkmalen des flämischen Barock.

Llanto por Cristo muerto

El significado especial de Rottmayr radica en su reputación como el primer pintor barroco austríaco. En sus pinturas de gran formato combinó influencias italianas con rasgos del barroco flamenco.

Compianto del Cristo

L'importanza particolare di Rottmayr risiede nella sua fama di primo pittore barocco austriaco. Nei suoi dipinti di grande formato combinò influenze italiane con le caratteristiche del barocco fiammingo.

Bewening van Christus

De bijzondere betekenis van Rottmayr ligt in zijn reputatie van eerste Oostenrijkse barokschilder. In zijn schilderijen op groot formaat verbond hij Italiaanse invloeden met kenmerken van de Vlaamse barok.

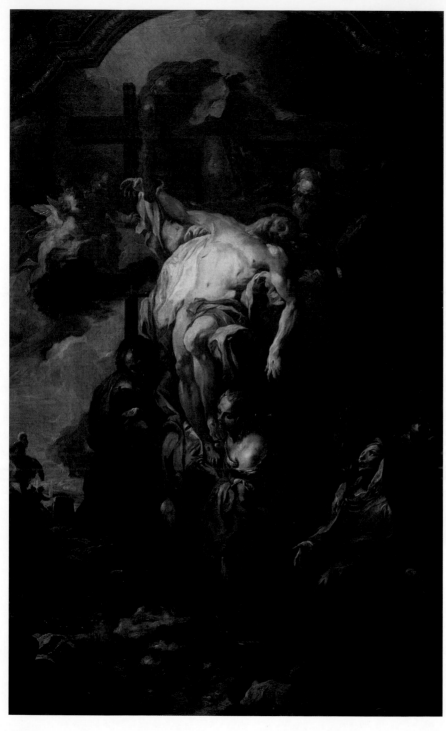

The Descent from the Cross

Descente de croix

Die Kreuzabnahme

El descendimiento

Deposizione dalla croce

Kruisafneming

JOHANN MICHAEL ROTTMAYR (1654–1730)
c. 1704, Oil on canvas/Huile sur toile, 113 × 69 cm,
Muzeum Narodowe, Wrocław

Raising of the Son of the Widow of Nain

La Résurrection du fils de la veuve de Naïm

Christus erweckt den Sohn der Witwe von Nain

Cristo despierta al hijo de la viuda de Naín

Cristo risveglia il Figlio della Vedova di Nain

Christus wekt de zoon van de weduwe van Nain tot leven

MARTINO ALTOMONTE (1657–1745)

1731, Oil on canvas/Huile sur toile, 95 × 50,5 cm, Szépművészeti Múzeum, Budapest

Still Life

Nature morte à la montre à gousset, à la porcelaine et au cristal de Bohème

Stillleben

Naturaleza muerta

Natura morta

Stilleven

CHRISTIAN BERENTZ (1658- 1722)

n.d., Oil on canvas/Huile sur toile, 50 × 65,5 cm, Galleria Nazionale, Roma

Still Life with Flowers and a
Woman with Grapes

Nature morte aux fruits et aux fleurs
avec une femme cueillant du raisin

Stillleben mit Blumen und einer
Trauben lesenden Frau

Bodegón con flores y una mujer
comprobando las uvas

Natura morta con fiori e una
donna che legge l'uva

Stilleven met bloemen en een
druiven lezende vrouw

CHRISTIAN BERENTZ (1658–1722)
6, Oil on canvas/Huile sur toile, 249 × 174 cm,
Galleria Nazionale di Capodimonte, Napoli

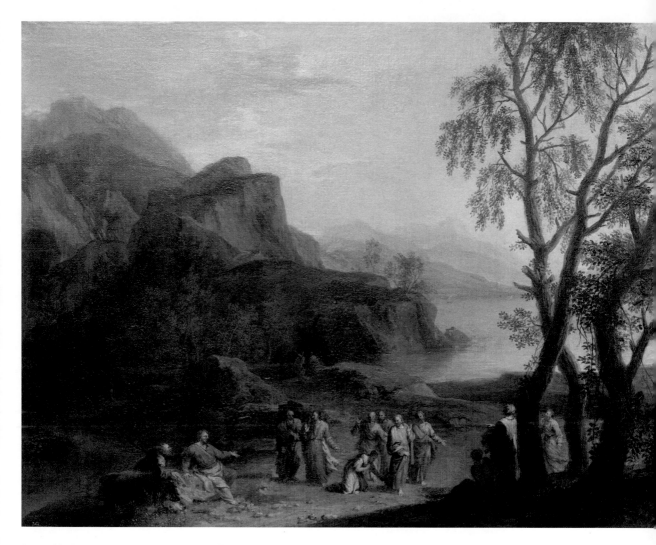

Jesus and the Canaanite Woman

Le Christ et la Cananéenne

Jesus und das kanaanäische Weib

Jesús y la Mujer Cananea

Gesù e la Donna Cananea

Jezus en de Kanaänitische vrouw

FRANZ JOACHIM BEICH (1665-1748)

p. 1720, Oil on canvas/Huile sur toile, 65 × 82 cm, Städtisches Museum, Ravensburg

Portrait of a Flute Player
in High Polish Cap

Portrait du musicien de
cour Josef Lemberger

Bildnis eines
Querflötenbläsers in
hoher polnischer Mütze

Retrato de un flautista
con gorra polaca alta

Ritratto del suonatore
di flauto

Portret van een
dwarsfluitspeler met
een hoge Poolse muts

JOHANN KUPETZKY
(1667–1740)

1709, Oil on canvas/Huile
sur toile, 94,8 × 73,5 cm,
Germanisches
Nationalmuseum, Nürnberg

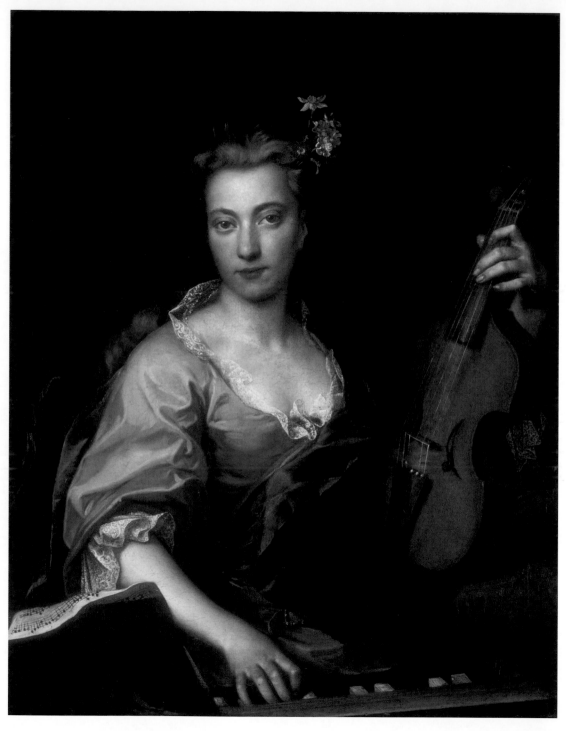

Woman with a
Viola d'Amore

Portrait de femme
à la viole d'amour

Frau mit einer
Viola d'amore

Mujer con viola
d'amore

Donna con viola
d'amore

Vrouw met een
viola d'amore

JOHANN KUPETZKY
(1667–1740)
c. 1720–30, Oil on canv
Huile sur toile, 95 × 74 c
Szépművészeti
Múzeum, Budapest

g Midas Listening to Pan's Song

e many artists of the time, Bergmüller often turned to
nan literature in his search for subjects. Here, it is Ovid's
amorphoses that reflects the baroque spirit.

Roi Midas écoute Pan attentivement

mme beaucoup d'artistes baroques et rococo, Bergmüller
ait aussi aller chercher ses sujets dans la littérature de
ome antique ; on voit ici une scène des *Métamorphoses*
vide, dans laquelle se reflète bien l'esprit du temps.

König Midas lauscht Pans Gesang

Wie vielen Künstlern der Zeit, gefiel es auch Bergmüller auf
der Suche nach Sujets auf römische Literatur zurückzugreifen.
Hier sind es die *Metamorphosen* Ovids, in denen sich der
barocke Zeitgeist gern spiegelte.

El rey Midas escucha el canto de Pan

Como a muchos artistas de la época, a Bergmüller también
le gustaba recurrir a la literatura romana en su búsqueda de
temas. Aquí están las *Metamorfosis* de Ovidio en las que se
reflejaba el espíritu barroco de la época.

Re Mida ascolta il canto di Pan

Come molti artisti dell'epoca, anche Bergmüller amava
fare riferimento alla letteratura romana nella sua ricerca di
soggetti. Qui sono le *Metamorfosi* di Ovidio a riflettere lo
spirito barocco dell'epoca.

Koning Midas luistert naar Pans gezang

Bergmüller greep, net als veel andere kunstenaars uit die tijd,
graag terug op Romeinse literatuur in zijn zoektocht naar
onderwerpen. Hier zijn het Ovidius' *Metamorfosen,* waarin de
barokke tijdgeest zich graag spiegelde.

ANN GEORG BERGMÜLLER (1688–1762)
Oil on canvas/Huile sur toile, 63,5 × 87 cm, Residenzgalerie, Salzburg

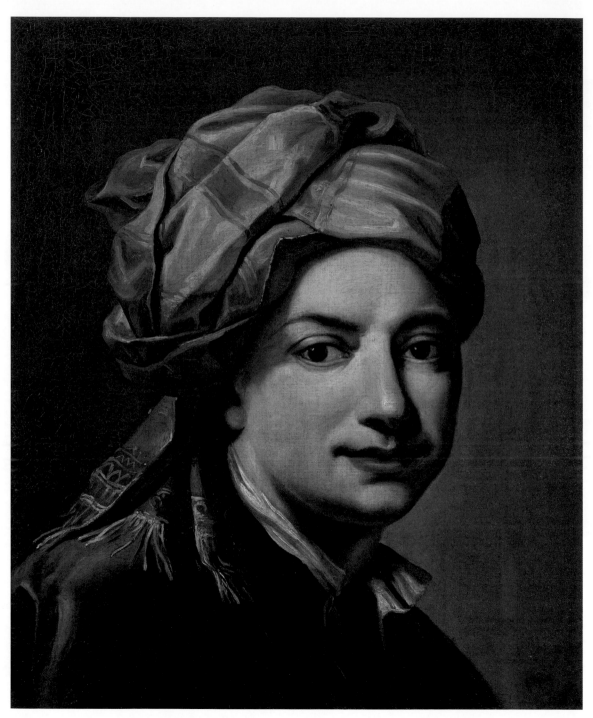

Self-Portrait

Autoportrait

Selbstbildnis

Autorretrato

Autoritratto

Zelfportret

**MARTIN VAN
MEYTENS
(1695-1770)**
n.d., Oil on
canvas/Huile s[u]
toile, 45 × 38 c[m]
Nationalmuse[um]
Stockholm

Portrait of Empress Maria Theresa of Austria

[Eu]ropean artist: born in Sweden, trained in many countries, van [M]eytens brought rococo color to [Aust]ria, whose sensuality, however, [w]as diluted at the strict Viennese court.

Portrait de Marie-Thérèse de Hongrie

[un] artiste qui méritait pleinement [le q]ualificatif de peintre européen : [né] en Suède, il se forma dans de [no]mbreux pays puis introduisit en [Au]triche la palette rococo, dont la [s]ensualité fut toutefois atténuée pour l'austère cour viennoise.

Maria Theresia

Ein europäischer Künstler: In Schweden geboren, in vielen [L]ändern ausgebildet, brachte van [Me]ytens das Rokoko-Kolorit nach Österreich, dessen Sinnlichkeit [j]edoch am strengen Wiener Hof abgeschwächt wurde.

María Teresa

Un artista europeo: nacido en [Sue]cia, formado en muchos países, [va]n Meytens trajo el color rococó [a] Austria, cuya sensualidad, sin [em]bargo, se debilitó en la estricta corte vienesa.

Maria Teresa

Un artista europeo: nato in [S]vezia, formatosi in molti paesi, [v]an Meytens ha portato il colore [roc]ocò in Austria, la cui sensualità si è però indebolita alla severa corte viennese.

Maria Theresia

Een Europese kunstenaar: Van Meytens werd geboren in Zweden en opgeleid in [di]verschillende landen. Hij bracht [r]ococoloriet naar Oostenrijk, waarvan de zinnelijkheid [aan] het strenge Weense hof werd afgezwakt.

[MA]RTIN VAN MEYTENS (1695-1770)

c. 1743, Oil on canvas/Huile sur toile, Musei Civici, Padua

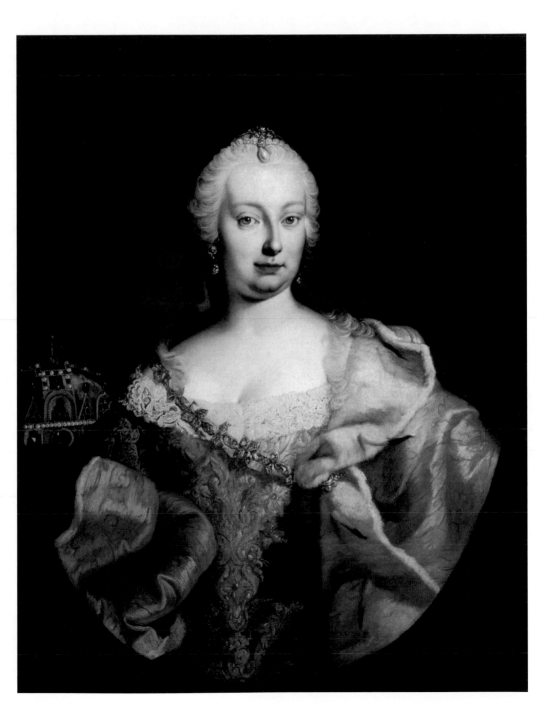

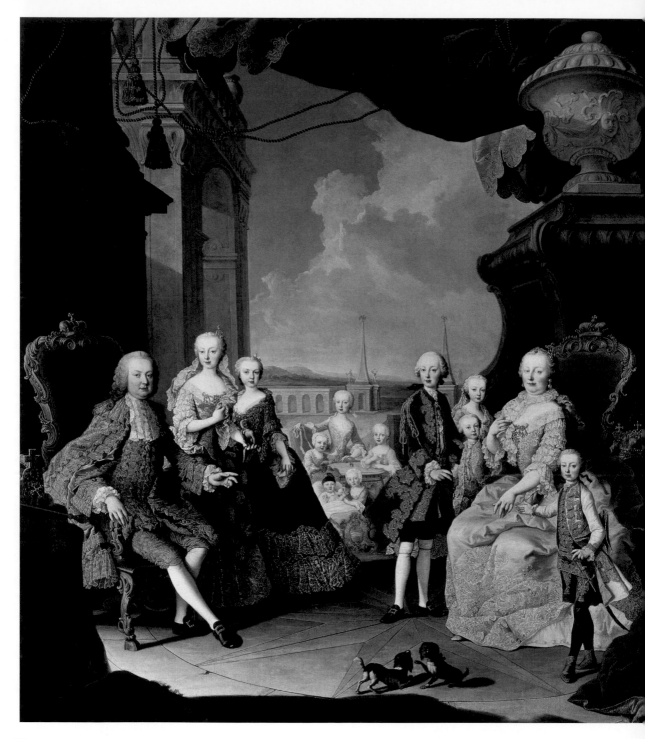

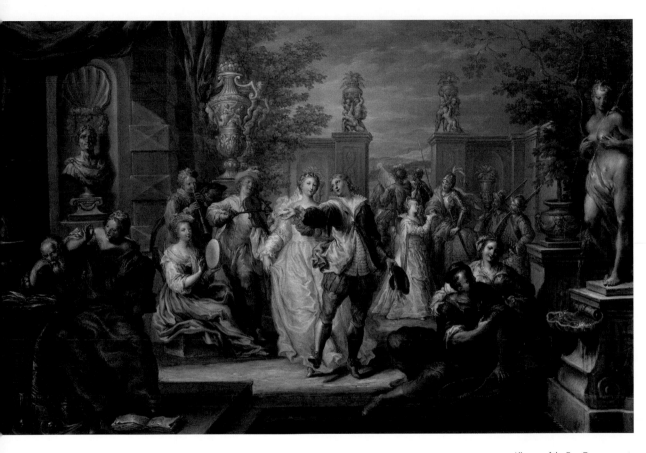

Allegory of the Four Temperaments
Allégorie des quatre tempéraments
Allegorie der vier Temperamente
Alegoría de los cuatro temperamentos
Allegoria dei quattro temperamenti
Allegorie van de vier temperamenten

JOHANN GEORG PLATZER (1704-61)
c. 1730, Oil on copper/Huile sur plaque de cuivre, 37,5 × 57 cm, Muzeum Narodowe, Wrocław

up Portrait of the ImperialFamily

rait de la famille impériale d'Autriche

ppenbildnis der kaiserlichen Familie mit neun Kindern

rato de grupo de la familia imperial del ImperialFamilia con nueve hijos

atto di gruppo della fFamiglia imperiale con nove figli.

epsportret van de keizerlijke familie met negen kinderen

RTIN VAN MEYTENS (1695-1770)

, Oil on canvas/Huile sur toile, 204 × 189 cm, Kunsthistorisches Museum, Wien

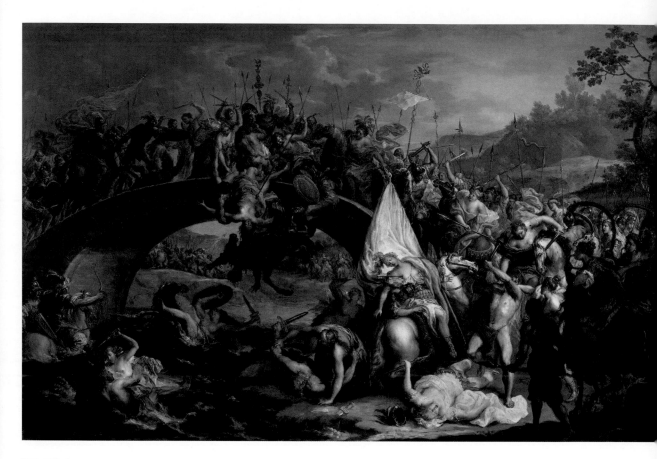

Battle of the Amazons

Le Combat des Amazones

Amazonenschlacht

Batalla amazónica

Battaglia delle amazzoni

Amazonegevecht

JOHANN GEORG PLATZER (1704–61)

n.d., Oil on copper/Huile sur plaque de cuivre, 55,2 × 88,3 cm

The Penitent
Magdalene

Le Repentir
de Marie-
Madeleine

Die büßende
Magdalena

La Magdalena
penitente

Maddalena
penitente

De boetende
Magdalena

ANNA DOROTHE
THERBUSCH
(1721–82)
n.d., Oil on canvas
Huile sur toile,
64 × 51,5 cm,
Staatliches
Museum, Schwer

Self-Portrait

One of eight self-portraits by this important portraitist. It speaks both to Therbusch's great talent and her entrepreneurial spirit that she was able to assert herself internationally as an artist.

Autoportrait au monocle

L'un des huit autoportraits de cette portraitiste de renom : outre son grand talent, il illustre aussi l'esprit d'entreprise de cette femme artiste qui réussit, à cette époque, à être reconnue internationalement.

Selbstbildnis

Eines von acht Selbstporträts der bedeutenden Porträtistin. Es spricht sowohl für ihr großes Talent, als auch für ihren Unternehmungsgeist, dass sie sich in dieser Zeit als Künstlerin international durchsetzen konnte.

Autorretrato

Uno de los ocho autorretratos de la considerada retratista. Habla tanto de su gran talento como de su espíritu emprendedor, siendo capaz de afirmarse internacionalmente como artista durante este tiempo.

Autoritratto

Uno degli otto autoritratti dell'importante ritrattista. Parla sia per il suo grande talento sia per il suo spirito imprenditoriale che ha saputo affermare a livello internazionale come artista in quel periodo.

Zelfportret

Een van acht zelfportretten van de belangrijke portretschilderes. Het spreekt zowel voor haar grote talent als voor haar ondernemersgeest dat zij zich in deze tijd internationaal heeft kunnen manifesteren als kunstenares.

ANNA DOROTHEA THERBUSCH (1721–82)

1782, Oil on canvas/Huile sur toile, 151 × 115 cm, Gemäldegalerie Alte Meister, Berlin

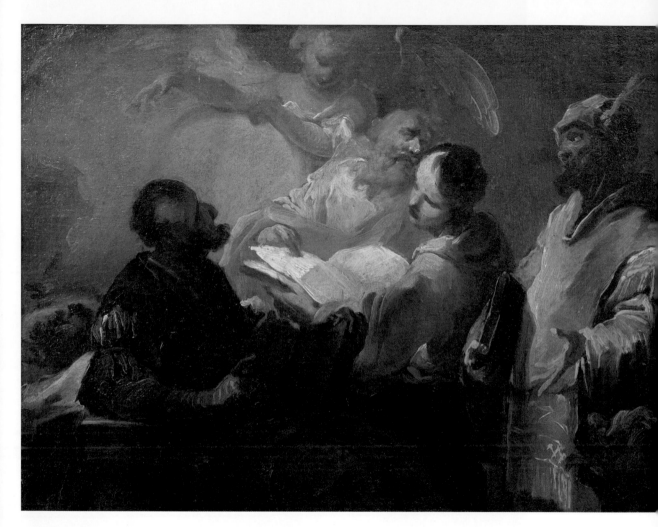

The Four Evangelists

Les Quatre Évangélistes

Die vier Evangelisten

Los cuatro evangelistas

I quattro evangelisti

De vier evangelisten

FRANZ ANTON MAULBERTSCH (1724-96)

c. 1759, Oil on wood/Huile sur bois, 18,5 × 23,5 cm, Barockmuseum, Salzburg

riolanus at the Gates of Rome

riolan aux portes de Rome

riolan vor Rom

riolan ante Roma

riolano prima di Roma

riolanus voor Rome

ANZ ANTON MAULBERTSCH (1724-96)

1794/95, Oil on fir door/Huile sur bois, 35 × 45,5 cm, Staatsgalerie, Stuttgart

Adam Elsheimer:
A Great Artist's Life at Top Speed

Adam Elsheimer, who was born in Frankfurt am Main, belongs to the early baroque period; he died several years before the beginning of the Thirty Years War. All the more astonishing, then, is the enormous influence he exerted on European painting of the 17th century in the only two decades that he was active as a painter.

Like many of his contemporaries, Elsheimer was attracted to Rome at a young age, where he studied the works of Michelangelo and Raphael, as well as those of Annibale Carracci. But it was Caravaggio who became most important to him. Elsheimer primarily painted landscapes, which at that time still served almost exclusively as backgrounds for various biblical scenes. It is striking how enormously spacious Elsheimer's works appear, despite their generally small formats. His gifts as a colourist are particularly evident in atmospheric nocturnal pieces.

Adam Elsheimer :
une grande vie d'artiste en accéléré

Chronologiquement, Adam Elsheimer doit être rattaché au baroque primitif, car il naquit à Francfort-sur-le-Main quelques années avant le début de la guerre de Trente Ans. Il est d'autant plus étonnant de voir quelle influence énorme il eut, au cours des deux décennies de son activité, sur la peinture européenne du XVIIᵉ siècle.

Comme beaucoup de ses contemporains, il partit très tôt à Rome, où il étudia les œuvres de Michel-Ange et de Raphaël au même titre que celles d'Annibale Carrache. C'était pourtant le Caravage qui allait devenir pour lui le plus important. Sur le plan thématique, il se consacra surtout aux paysages, qui à son époque servaient encore essentiellement d'arrière-fond à diverses scènes bibliques. Il est impressionnant de voir la profondeur de l'espace qui règne dans ses œuvres, qui sont pourtant majoritairement de petit format. Son talent exceptionnel pour les couleurs ressort particulièrement dans ses scènes de nuit.

Adam Elsheimer:
Ein großes Künstlerleben im Schnelldurchlauf

Zeitlich muss der in Frankfurt am Main geborene Adam Elsheimer dem frühen Barock zugerechnet werden, er starb bereits einige Jahre vor Beginn des Dreißigjährigen Krieges. Umso erstaunlicher ist, welch enormen Einfluss er in den nur zwei Jahrzehnten, die er als Maler tätig war, auf die europäische Malerei des 17. Jahrhunderts ausübte.

Wie viele seiner Zeitgenossen zog es ihn bereits in jungen Jahren nach Rom, wo er die Werke Michelangelos und Raffaels ebenso studierte wie jene Annibale Carraccis. Am wichtigsten aber sollte auch für ihn Caravaggio werden. Thematisch wandte er sich vor allem Landschaftsdarstellungen zu, die seinerzeit noch fast ausschließlich als Hintergrund für diverse biblische Szenen dienten. Auffallend ist, wie enorm weiträumig seine Werke trotz ihrer meist kleinen Formate wirken. Seine Stärke als begnadeter Kolorist kam vor allem in atmosphärischen Nachtstücken zur Geltung.

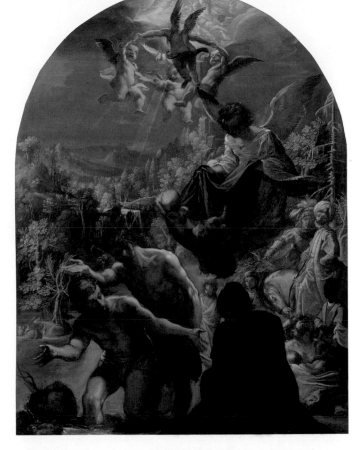

The Baptism of Christ

Le Baptême du Christ

Die Taufe Christi

El Bautismo de Cristo

Il Battesimo di Cristo

De doop van Christus

ADAM ELSHEIMER (1578-1610)

c. 1599, Oil on copper/Huile sur plaque de cuivre, 28,1 × 21 cm, The National Gallery, London

dam Elsheimer:
vida de un gran artista de avance rápido

lam Elsheimer, nacido en Fráncfort del Meno, debe
rtenecer al barroco temprano por la época en la que
vió; murió varios años antes del comienzo de la Guerra
los Treinta Años. Lo más sorprendente, pues, es la
orme influencia que ejerció en la pintura europea del
glo XVII en las dos únicas décadas que estuvo activo
mo pintor.

Como muchos de sus contemporáneos, se sintió atraído
r Roma desde muy joven, donde estudió las obras de
iguel Ángel y Rafael, así como la de Annibale Carracci.
ro Caravaggio debió ser para él el más importante.
máticamente se dedicó sobre todo a las representaciones
paisajes, que en aquel entonces todavía servían casi
clusivamente como telón de fondo para varias escenas
blicas. Llama la atención la enorme amplitud de sus
ras a pesar de sus formatos, en su mayoría pequeños. Su
erza como colorista dotado era particularmente evidente
piezas atmosféricas nocturnas.

Adam Elsheimer:
Una vita da grande artista in rapida successione

Adam Elsheimer, nato a Francoforte sul Meno, è da
attribuire al primo periodo barocco; morì diversi anni
prima dell'inizio della Guerra dei Trent'anni. Ancora
più sorprendente, quindi, è l'enorme influenza che ha
esercitato sulla pittura europea del XVII secolo negli
ultimi due decenni in cui fu attivo come pittore.

Come molti dei suoi contemporanei, fu attratto
da Roma in giovane età, dove studiò le opere di
Michelangelo e di Raffaello e quelle di Annibale
Carracci. Ma soprattutto il Caravaggio divenne per lui
di enorme importanza. Dal punto di vista tematico, si
dedicò principalmente alle raffigurazioni dei paesaggi,
che all'epoca servivano ancora quasi esclusivamente
da sfondo per diverse scene bibliche. Colpisce
l'enorme spaziosità delle sue opere, nonostante i loro
formati per lo più piccoli. La sua forza di colorista
di talento è particolarmente evidente nelle opere di
atmosfera notturna.

Adam Elsheimer:
een groots kunstenaarsleven in korte tijd

De in Frankfurt am Main geboren Adam Elsheimer
moet qua tijd gerekend worden tot de vroege barok; hij
overleed enkele jaren voor het begin van de Dertigjarige
Oorlog. Des te verbazender is de enorme invloed die hij
in de slechts twintig jaar dat hij als schilder actief was,
heeft uitgeoefend op de Europese schilderkunst van de
17e eeuw.

Net als veel van zijn tijdgenoten trok hij al op jonge
leeftijd naar Rome, waar hij zowel de werken van
Michelangelo en Rafaël als die van Annibale Carracci
bestudeerde. Maar het allerbelangrijkst voor hem zou
Caravaggio worden. Qua thematiek richtte hij zich vooral
op landschappen, die destijds nog vrijwel uitsluitend
als achtergrond dienden voor allerlei Bijbelse taferelen.
Opvallend is hoe weids zijn werken ondanks hun meestal
kleine formaat lijken te zijn. Zijn kracht als begenadigd
colorist kwam vooral tot uiting in sfeervolle nachtstukken.

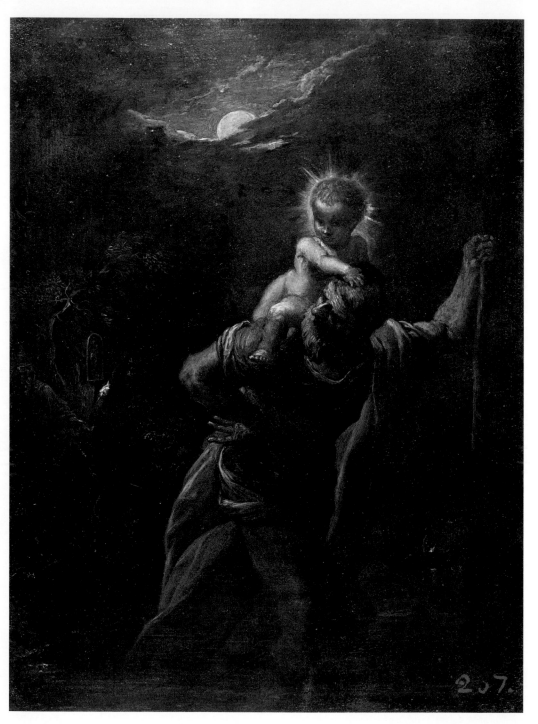

St Christopher

A beautiful, mysterious nocturnal atmosphere. The panel probably attracted attention in Rome shortly after its completion. For the head of the boy Jesus, Elsheimer copied an example by Rubens, who lived in the city at the time.

Saint Christophe

Un véritable joyau, en particulier pour son atmosphère nocturne pleine de mystère. Il était probablement déjà connu à Rome peu après avoir été achevé, car Rubens, qui vivait là-bas à l'époque, copia la tête de l'enfant Jésus.

Der Heilige Christophorus

Eine wunderschöne, geheimnisvolle Nachtstimmung. Schon kurz nach Fertigstellung muss die Tafel in Rom bekannt gewesen sein. Denn der Kopf des Jesusknaben wurde von dem zu dieser Zeit dort lebenden Rubens kopiert.

San Cristóforo

Una hermosa y misteriosa atmósfera nocturna. El cuadro debió haber sido conocido en Roma poco después de su finalización, pues la cabeza del niño Jesús fue copiada de Rubens quien vivía allí en esa época.

San Cristoforo

Una bella e misteriosa atmosfera notturna. Il dipinto doveva essere noto a Roma poco dopo il suo completamento. Per la testa di Gesù si è rifatto a Rubens, che viveva lì in quel periodo.

De heilige Christoffel

Een prachtige, mysterieuze nachtelijke sfeer. De plaquette moet kort na de voltooiing ervan in Rome bekend zijn geweest. H hoofd van de jonge Jezus werd namelijk gekopieerd door Ruben die daar op dat moment woonde

ADAM ELSHEIMER (1578–1610)
c. 1598/99, Oil on copper/Huile sur plaque de cuivre, 22,5 × 16,7 cm, Sta Hermitage Museum, St. Petersburg

Glorification of the Cross

La Vénération de la Croix

Verherrlichung des Kreuzes

Glorificación de la Cruz

La glorificazione della Croce

Verheerlijking van het kruis

ADAM ELSHEIMER (1578–1610)

1603–05, Oil on copper/Huile sur
plaque de cuivre, 48,8 × 36,2 cm,
Städel Museum, Frankfurt am Main

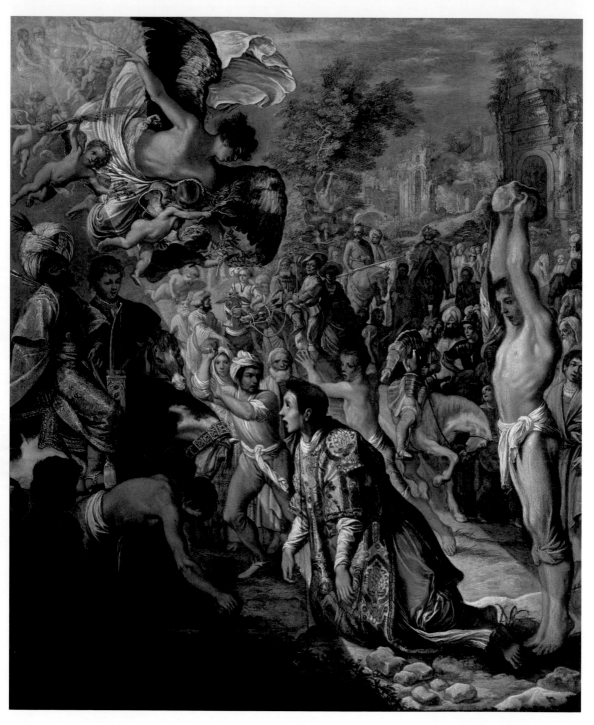

The Stoning
of St Stephen

Lapidation d
saint Étienne

Steinigung d
Stephanus

La lapidación
de San Esteb

Lapidazione
Santo Stefan

De steniging
van Stefanus

**ADAM
ELSHEIMER
(1578-1610)**
c. 1603/04, Oil
on silver-plated
copper/Huile
sur plaque de
cuivre étamé,
34,7 × 28,6 cm,
Scottish
National Galler
Edinburgh

Morning Landscape (Aurora)

Paysage du matin *ou* Aurora

Morgenlandschaft (Aurora)

La Aurora

Paesaggio mattutino (Aurora)

Ochtendlandschap (Aurora)

ADAM ELSHEIMER (1578–1610)

c. 1606, Oil on copper/Huile sur plaque de cuivre, 17 × 22,5 cm, Herzog Anton Ulrich-Museum, Braunschweig

Jupiter and Mercury with Philemon and Baucis
...ork from Elsheimer's time in Rome, which shows
... he was able to bring a complex scene to life in the
...allest of spaces with refined means such as lighting and
...re composition.

Jupiter et Mercure hébergés par Philémon et Baucis
...ci une autre œuvre de la période romaine d'Elsheimer où il
...ssit à donner vie à un décor complexe dans un espace très
...reint, en jouant notamment sur la lumière et la position
... personnages.

Jupiter und Merkur bei Philemon und Baucis
Ein Werk aus Elsheimers Zeit in Rom, das zeigt, wie
er mit raffinierten Gestaltungsmitteln wie Licht und
Figurenkomposition auf kleinstem Raum eine komplexe
Szenerie lebendig machen konnte.

Júpiter y Mercurio en la casa de Filemón y Baucis
Una obra de la época de Elsheimer en Roma que muestra
cómo fue capaz de dar vida a un paisaje complejo en los
espacios más pequeños con medios de diseño refinados, tales
como la composición de luz y figura.

Giove e Mercurio presso Filemone e Bauci
Un'opera del periodo romano di Elsheimer che mostra come
sia riuscito a far rivivere uno scenario complesso, come la
luce e la composizione di figure, nei più piccoli spazi dal
design raffinato.

Jupiter en Mercurius bij Philemon en Baucis
Een werk uit Elsheimers tijd in Rome, dat laat zien hoe
hij met verfijnde middelen als licht en figurencompositie
een complexe scenerie in de kleinste ruimten tot leven
kon brengen.

AM ELSHEIMER (1578–1610)
...08/09, Oil on copper/Huile sur plaque de cuivre, 16,5 × 22,5 cm, Gemäldegalerie Alte Meister, Dresden

The Flight into Egypt

A moonlit night unprecedented in art: the newly invented telescope now allowed artists to depict the sky with astronomical accuracy – and this without divesting the scene of its magic.

La Fuite en Égypte

Une nuit de pleine lune comme les arts n'en avaient encore jamais connu : la lunette astronomique, qui venait d'être inventée, permettait à présent de représenter le firmament avec davantage d'exactitude astronomique. Cela n'enlève rien au charme de la scène.

Die Flucht nach Ägypten

Eine Mondnacht, wie es sie noch nie gab in der Kunst: Mit dem gerade erfundenen Teleskop war es nun möglich, das Firmament astronomisch korrekte abzubilden. Und das, ohne der Szene etwas von ihrem Zauber zu nehmen.

La Huida a Egipto

Una noche de luna como nunca antes en el arte: con el telescopio recién inventado ahora era posible representar el cielo astronómicamente correcto. Y esto sin quitar nada de su magia de la escena.

Fuga in Egitto

Una notte di luna come mai prima d'ora nell'arte: con il telescopio di nuova invenzione era ora possibile raffigurare il cielo in modo astronomicamente corretto. E questo senza togliere nulla alla magia dalla scena.

De vlucht naar Egypte

Een nacht met maan als nooit tevoren in de kunst: met de nieuw uitgevonden telescoop was het nu mogelijk om het firmament astronomisch correct weer te geven. En dat zonder de scène iets van zijn magie te ontnemen.

ADAM ELSHEIMER (1578-1610)

1609, Oil on copper/Huile sur plaque de cuivre, 30,6 × 41,5 cm, Alte Pinakothek, München

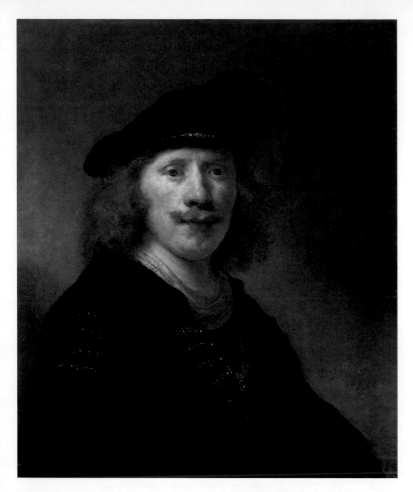

Holland:
New Pictures for a New Company

The Protestant Dutch provinces split off from the Spanish Netherlands during the Eighty Years War. In the 17th century, its golden age, Holland acquired enormous wealth through sea trade. The self-assured bourgeois society demanded images of itself and its surroundings, and an enormous art market emerged. Painters often specialised in one genre of painting, depicting rich merchants in portraits; Dutch rivers, dunes, and the sea in landscapes; and the bourgeois and peasant milieu in genre pictures. Last but not least, still lifes reminded their viewers that all earthly wealth is transient. Thus, not only did the naturalism of Dutch painting flourish in the 17th century, but the genres of landscape, genre painting, and portraiture also significantly developed.

La Hollande :
de nouvelles images pour une société nouvelle

Au terme de la guerre de Quatre-Vingts Ans, les provinces protestantes néerlandaises se séparèrent des Pays-Bas espagnols. Au XVIIᵉ siècle, véritable âge d'or pour la région, la Hollande s'enrichit considérablement grâce au commerce maritime. Cette société bourgeoise fière de sa réussite voulut des tableaux la représentant dans son environnement, donnant naissance à un nouveau marché. Les peintres, qui se spécialisaient souvent dans un genre particulier, peignirent des portraits des commerçants aisés, des paysages montrant les rivières, les dunes et la mer hollandaises, et des scènes de genre illustrant les milieux bourgeois ou paysans. Sans oublier les natures mortes, qui rappelaient que toute richesse terrestre est éphémère. Le XVIIᵉ siècle hollandais vit ainsi l'essor sans précédent du naturalisme, tout en continuant à développer le paysage, le portrait et la peinture de genre.

Holland:
Neue Bilder für eine neue Gesellschaft

Die protestantischen niederländischen Provinzen spalteten sich im Achtzigjährigen Krieg von den spanischen Niederlanden ab. Im 17. Jahrhundert, dem dortigen Goldenen Zeitalter, erlangte Holland durch de Seehandel ungeheuren Reichtum. Die selbstbewusste bürgerliche Gesellschaft verlangte nach Bildern von sic selbst und ihrer Umgebung – ein enormer Kunstmarkt entstand. Häufig auf eine Bildgattung spezialisierte Ma stellten etwa in repräsentativen Porträts reiche Kaufleu dar, in Landschaften die holländischen Flüsse, Dünen un das Meer, in Genrebildern das bürgerliche wie bäuerlich Milieu. Nicht zuletzt erinnerten Stillleben daran, dass aller irdische Reichtum vergänglich ist. So gelangte im 17. Jahrhundert nicht nur der Naturalismus der niederländischen Malerei zu einer nie dagewesenen Blü auch die Bildgattungen Landschaft, Genrebild und Por wurden wesentlich weiterentwickelt.

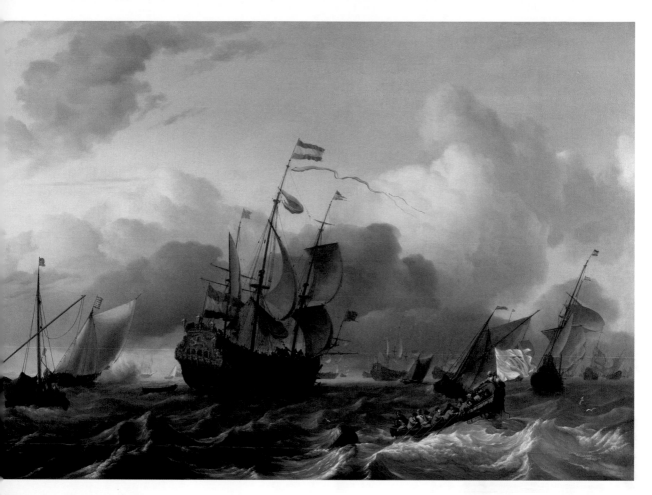

Olanda:
Nuove immagini per una nuova società

Le province protestanti olandesi si sono separate dai
Paesi Bassi spagnoli durante la Guerra degli ottant'anni.
Nel XVII secolo, l'età dell'oro, l'Olanda acquisì un'enorme
ricchezza attraverso il commercio marittimo. L'orgogliosa
società borghese richiedeva autoritratti e del proprio
ambiente: ne scaturì un enorme mercato dell'arte. I
pittori, spesso specializzati in un genere di pittura
rappresentativo, raffigurano ricchi mercanti, paesaggi di
fiumi olandesi, di dune e del mare, e nei dipinti di genere
l'ambiente borghese e contadino. Infine, le nature morte ci
ricordano che tutta la ricchezza terrena è transitoria. Così,
non solo fiorì il naturalismo della pittura olandese nel
XVII secolo, ma anche i generi del paesaggio, la pittura di
genere e i ritratti si svilupparono in modo significativo.

Olanda:
Nuevas pinturas para una nueva sociedad

Las provincias protestantes holandesas se separaron
de los Países Bajos españoles durante la Guerra de los
Treinta Años. En el siglo XVII, la Edad de Oro, Holanda
adquirió una enorme riqueza a través del comercio
marítimo. La sociedad burguesa segura de sí misma
quería pinturas de sí misma y de su entorno: surgió
un enorme mercado del arte. Los pintores, a menudo
especializados en un género de pintura, retrataban a ricos
comerciantes en retratos representativos, ríos holandeses,
dunas y el mar en pinturas de paisajes, y el medio
burgués y campesino en pinturas de género. Por último,
pero no por ello menos importante, las naturalezas
muertas nos recordaron que toda la riqueza terrenal
es transitoria. Así, no sólo el naturalismo de la pintura
holandesa floreció en el siglo XVII, sino que los géneros
de paisaje, la pintura de género y el retrato también se
desarrollaron significativamente.

Nederland: nieuwe schilderijen
voor een nieuwe samenleving

Tijdens de Tachtigjarige Oorlog splitsten de protestantse
Nederlandse provincies zich af van de Spaanse
Nederlanden. In de 17e eeuw, de Nederlandse Gouden
Eeuw, verwierf Nederland enorme rijkdom door de
overzeese handel. De zelfbewuste burgerlijke samenleving
wenste schilderijen van zichzelf en de eigen omgeving,
waardoor er een enorme kunstmarkt ontstond. Schilders,
die vaak in één genre gespecialiseerd waren, schilderden
representatieve portretten van rijke kooplieden,
Nederlandse rivieren, duinen en de zee in landschappen
en de burgerlijke en boerenmilieus in genreschilderijen.
Niet in de laatste plaats herinnerden stillevens ons eraan
dat alle aardse rijkdom vergankelijk was. Zo bloeide in de
17e eeuw niet alleen het naturalisme van de Nederlandse
schilderkunst op, maar werden ook de genres landschap,
genrestuk en portret wezenlijk verder ontwikkeld.

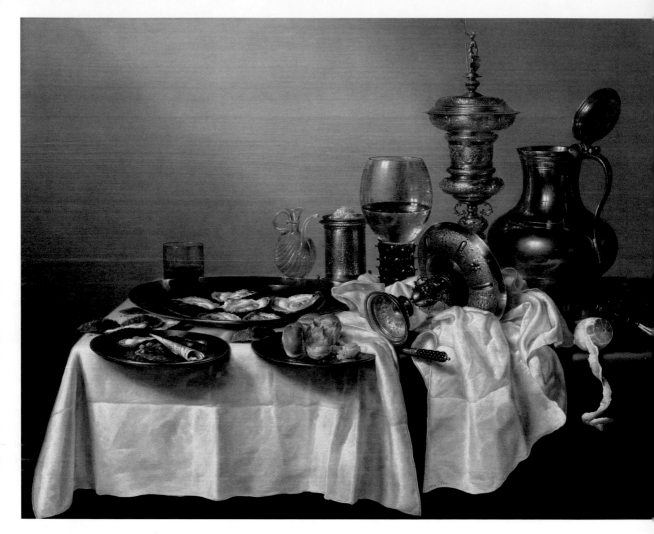

Still Life with Gilded Goblet

Nature morte à la coupe d'or

Stillleben mit vergoldetem Pokal

Bodegón con copa dorada

Natura morta con calice dorato

Stilleven met vergulde bokaal

WILLEM CLAESZ. HEDA (1594–1680)

1635, Oil on wood/Huile sur bois, 88 × 113 cm, Rijksmuseum, Amsterdam

Woman Peeling A

La Peleuse de pom

Die Apfelschä

La peladora de manz

La sbucciatrice di r

De appelschi

GERARD TER BORCH (1617

c. 1660, Oil on canvas on wood/Huile sur toile marouflée sur bois, 36,5 × 30,5 cm, Kunsthistorisches Museum,

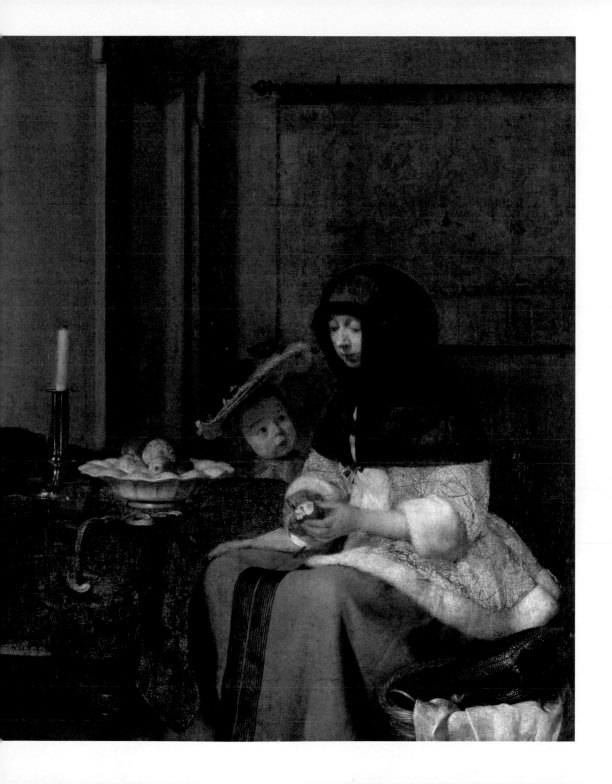

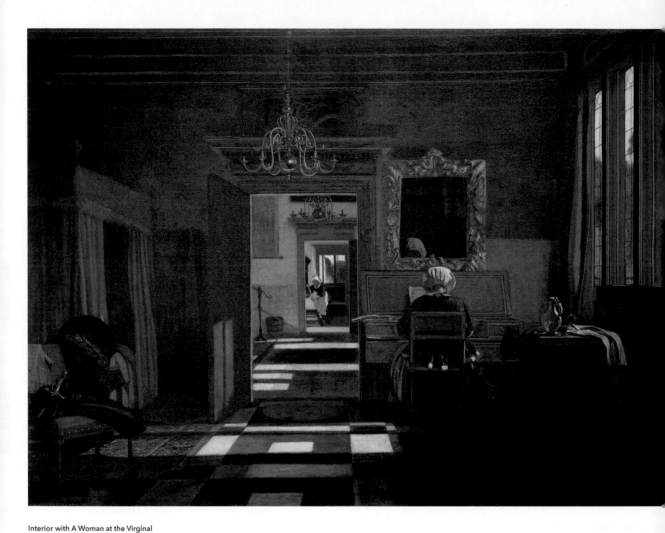

Interior with A Woman at the Virginal

Intérieur avec une femme au virginal

Interieur mit Frau am Virginal

Interior con una mujer en el virginal

Interni con donna al virginale

Interieur met vrouw aan het virginaal

EMANUEL DE WITTE (1617-92)

1665-70, Oil on canvas/Huile sur toile, 77,5 × 104,5 cm, Museum Boijmans van Beuningen, Rotterdam

o Discovering Jupiter with Io

on découvrant Jupiter avec Io

o entdeckt Jupiter mit Io

o descubriendo a Júpiter con Io

none scopre Giove con Io

o ontdekt Jupiter met Io

ER LASTMAN (1583–1633)

, Oil on wood/Huile sur chêne, 54,3 × 77,8 cm, The National Gallery, London

The Descent from the Cross

Descente de croix

Die Kreuzabnahme

El descendimiento de la cruz

La discesa dalla croce

Kruisafneming

REMBRANDT HARMENSZ. VAN RIJN (1609-69)

1634, Oil on canvas/Huile sur toile, 158 × 117 cm, State Hermitage Museum, St. Petersburg

Rembrandt: Between Tradition and Innovation

Rembrandt was the most important baroque artist of the northern Netherlands, and is to this day considered one of the greatest painters, etchers, and draughtsmen of all time. In the 1630s, he was celebrated by the rich citizens of Amsterdam for his portraits and dramatic biblical and mythological images, which featured chiaroscuro techniques learned from Dutch Caravaggisti. In the decade that followed, his paintings achieved new psychological depth, not least due to personal misfortune. This applies above all to the self-portraits and numerous biblical scenes in which Rembrandt continually found new themes and ways of representation. In the last years of his life, his brushstrokes and colours developed a life of their own; nevertheless, Rembrandt's work after the 1640s was less and less in keeping with the tastes of rich clients, who now preferred fine painting, and the great artist died in poverty.

Rembrandt : entre tradition et innovation

Rembrandt fut le peintre le plus important du baroque hollandais et on le considère aujourd'hui encore comme l'un des plus grands peintres, graveurs et dessinateurs de l'histoire des arts. Dans les années 1630, les riches bourgeois d'Amsterdam chantaient les louanges de ses portraits et de ses tableaux représentant des scènes bibliques et mythologiques dans le style des caravagistes hollandais. Au cours de la décennie suivante, ses œuvres gagnèrent en profondeur psychologique, notamment à cause de différents revers de fortune de sa vie personnelle. Cela ressort particulièrement dans ses autoportraits et dans les nombreuses scènes bibliques dans lesquelles il explorait sans cesse de nouveaux thèmes et de nouveaux styles. Dans les dernières années de sa vie, ses coups de pinceaux et sa palette de couleur acquièrent pour ainsi dire une vie propre. Pourtant, à partir des années 1640, les œuvres de Rembrandt furent de moins en moins du goût des riches commanditaires, qui préféraient à présent la « peinture fine », tant et si bien qu'il mourut dans la pauvreté.

Rembrandt: Zwischen Tradition und Innovation

Rembrandt war der bedeutendste barocke Künstler der nördlichen Niederlande; bis heute gilt er als einer der größten Maler, Radierer und Zeichner überhaupt. In den 1630er-Jahren feierten ihn die reichen Bürger Amsterdams für seine repräsentativen Porträts sowie sein an holländischen Caravaggisten geschultes Hell-Dunkel in dramatischen biblischen und mythologischen Bildern. Im Jahrzehnt danach gewannen seine Gemälde – nicht zuletzt aufgrund persönlicher Schicksalsschläge – an psychologischer Tiefe. Dies gilt vor allem für die Selbstporträts und zahlreiche biblische Szenen, in denen Rembrandt immer wieder neue Themen und Darstellungsweisen fand. In den letzten Lebensjahren entfalteten Pinselstrich und Farbe geradezu ein Eigenleben. Dennoch entsprach Rembrandts Schaffen seit den 1640er-Jahren immer weniger dem Geschmack reicher Auftraggeber, die nun die Feinmalerei bevorzugten, was dazu beitrug, dass er in Armut starb.

Belshazzar's Feast

Le Festin de
Balthazar

Das Gastmahl
des Belsazar

El festín de
Baltasar

Il banchetto
del Belsazar

Het feestmaal
van de Belsazar

**REMBRANDT
HARMENSZ. VAN
RIJN (1609–69)**
c. 1636–38, Oil on
canvas/Huile sur toile,
167,6 × 209,2 cm,
The National
Gallery, London

Rembrandt: entre tradición e innovación

Rembrandt fue el artista barroco más importante
del norte de los Países Bajos; hasta el día de hoy es
considerado uno de los más grandes pintores, grabadores
y dibujantes de todos los tiempos. En la década de 1630,
los ciudadanos ricos de Ámsterdam admiraban sus
retratos representativos y sus claroscuros, formados
por caravaggistas holandeses, en imágenes bíblicas y
mitológicas dramáticas. En la década siguiente, sus
pinturas ganaron profundidad psicológica, sobre todo
debido a los golpes personales del destino. Esto se aplica
sobre todo a los autorretratos y a las numerosas escenas
bíblicas en las que Rembrandt encontró repetidamente
nuevos temas y formas de representación. En los últimos
años de su vida, las pinceladas y la pintura desarrollaron
una vida propia. Sin embargo, el trabajo de Rembrandt
desde la década de 1640 se ajustaba cada vez menos
a los gustos de los clientes ricos que en ese momento
preferían la pintura fina, lo que contribuyó a su muerte
en la pobreza.

Rembrandt: Tra tradizione e innovazione

Rembrandt è stato il più importante artista barocco dei
Paesi Bassi settentrionali; ad oggi è considerato uno dei
più grandi pittori, incisori e disegnatori di tutti i tempi.
Negli anni '30, i ricchi cittadini di Amsterdam lo celebrano
per i suoi ritratti rappresentativi e per il suo caravaggesco
chiaroscuro olandese, con immagini drammatiche,
bibliche e mitologiche. Nel decennio successivo, i suoi
dipinti acquistano profondità psicologica, non da ultimo
a causa di sventure personali. Questo vale soprattutto
per gli autoritratti e per le numerose scene bibliche in cui
Rembrandt ha ripetutamente trovato nuovi temi e modi
di rappresentazione. Negli ultimi anni della sua vita, le
pennellate e i colori hanno sviluppato una vita propria.
Tuttavia, l'opera di Rembrandt a partire dagli anni '40 è
sempre meno in sintonia con i gusti di una clientela ricca
che preferisce la pittura fine, che contribuì alla sua morte
in povertà.

Rembrandt: tussen traditie en vernieuwing

Rembrandt was de belangrijkste barokkunstenaar van
Noord-Nederland; tot op heden wordt hij beschouwd
als een van de grootste schilders, etsers en tekenaars
aller tijden. Tussen 1630 en 1640 waardeerden de rijke
Amsterdamse burgers hem om zijn representatieve
portretten en zijn aan de hand van Nederlandse
caravaggisten bekwaamde clair-obscur in dramatische
Bijbelse en mythologische schilderijen. In de
daaropvolgende tien jaar wonnen zijn schilderijen aan
psychologische diepgang, niet in de laatste plaats door
persoonlijke tegenslagen van het lot. Dat geldt vooral
voor de zelfportretten en talrijke Bijbelse taferelen,
waarin Rembrandt steeds weer nieuwe thema's en
manieren van weergeven vond. In de laatste jaren van
zijn leven gingen penseelstreken en verf een eigen leven
leiden. Rembrandts werk sloot vanaf 1640 steeds minder
aan bij de smaak van rijke klanten, die nu de voorkeur
gaven aan fijnschilderkunst, wat ertoe bijdroeg dat hij in
armoede stierf.

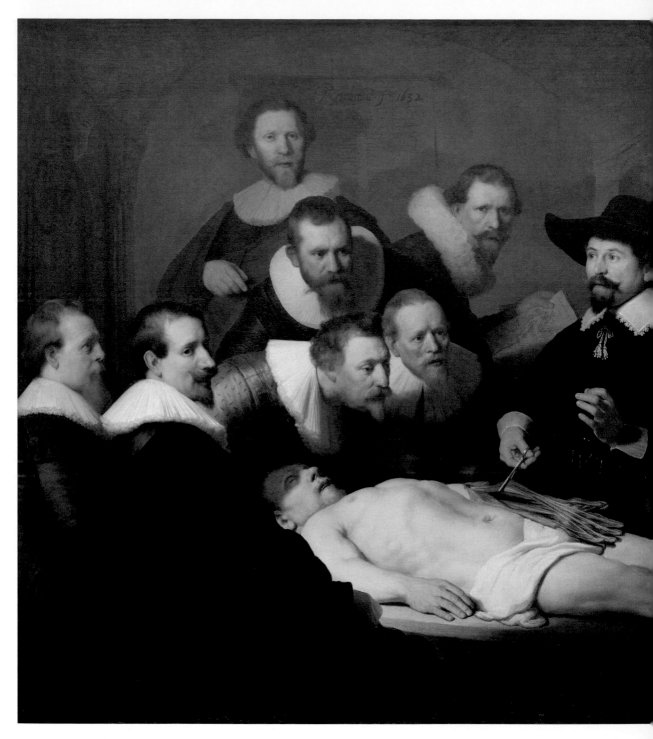

The Anatomy Lesson of Dr Tulp

Rembrandt completed this portrait of members of the Amsterdam Guild of Barbers and Surgeons at the age of 25. Such anatomical presentations were then public and social events.

La Leçon d'anatomie du docteur Tulp

Rembrandt avait 25 ans lorsqu'il réalisa ce portrait d'un membre de la guilde amstellodamoise des barbiers et des chirurgiens. Les leçons d'anatomie de ce genre étaient à l'époque des évènements publics et mondains.

Die Anatomiestunde des Dr. Tulp

Der 25-jährige Rembrandt porträtierte Mitglieder der Amsterdamer Gilde der Barbiere und Chirurgen. Solch eine anatomische Präsentation war damals ein öffentliches und gesellschaftliches Ereignis.

Lección de anatomía del Dr. Nicolaes Tulp

Rembrandt, de 25 años, retrató a miembros del Gremio de Barberos y Cirujanos de Ámsterdam. Tal presentación anatómica fue entonces un evento público y social.

La lezione di anatomia del dottor Tulp

Il venticinquenne Rembrandt ritrasse i membri dell'Associazione Barbieri e Chirurghi di Amsterdam. Tale rappresentazione anatomica era allora un evento pubblico e sociale.

De anatomische les van dr. Nicolaes Tulp

De 25-jarige Rembrandt schilderde leden van het Amsterdamse gilde van barbiers en chirurgijns. Zo'n anatomische presentatie was destijds een openbare en maatschappelijke gebeurtenis.

REMBRANDT HARMENSZ. VAN RIJN (1609-69)

1632, Oil on canvas/Huile sur toile, 169,5 × 216,5 cm, Mauritshuis, Den Haag

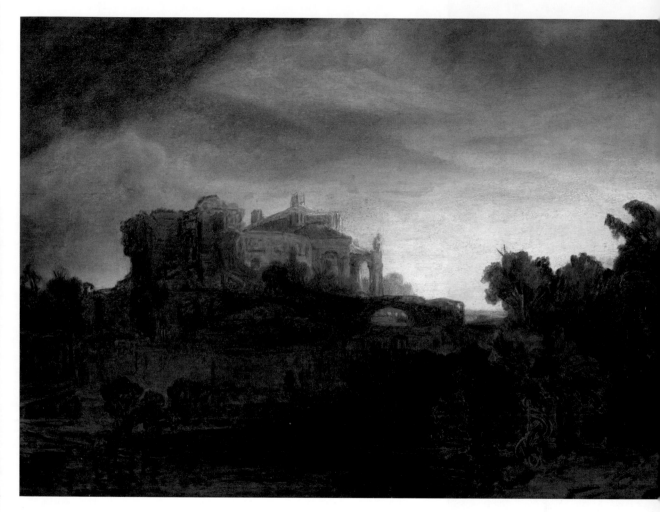

Landscape with Castle

Paysage au château, vue imaginaire

Landschaft mit Schloss

Paisaje con castillo

Paesaggio con castello

Landschap met kasteel

REMBRANDT HARMENSZ. VAN RIJN (1609-69)

c. 1640-42, Oil on canvas/Huile sur toile, 44 × 60 cm, Musée du Louvre, Paris

Saskia as Flora

Rembrandt's wife, Saskia van Uylenburgh, niece of a rich art dealer, appears here as Flora. They married in 1634 and enjoyed a spell of happiness, both privately and professionally, until Saskia's death in 1642.

Flora ou Saskia en Flora

Rembrandt représenta sa femme Saskia van Uylenburgh, nièce d'un riche marchand d'art, sous les traits de Flora. Leur mariage, en 1634, marqua pour lui une époque heureuse tant sur le plan personnel que professionnel, qui prit fin en 1642 avec la mort de Saskia.

Saskia als Flora

Rembrandt malte seine Frau Saskia van Uylenburgh, Nichte eines reichen Kunsthändlers, als Flora. Die Heirat 1634 fiel in eine privat und beruflich glückliche Phase, die mit Saskias Tod 1642 endete.

Saskia como Flora

Rembrandt pintó a su esposa Saskia van Uylenburgh, sobrina de un rico comerciante de arte, como Flora. El matrimonio en 1634 entró en una fase feliz, tanto privada como profesionalmente, la cual terminó con la muerte de Saska en 1642.

Saskia in veste di flora

Rembrandt dipinse sua moglie Saskia van Uylenburgh, nipote di un ricco mercante arte, come Flora. Il matrimonio nel 1634 entrò in una fase felice, sia privatamente a professionalmente, che si concluse con la morte di Saska nel 1642.

Saskia als Flora

Rembrandt schilderde zijn vrouw Saskia van Uylenburgh, nicht van een rijke kunsthandelaar, als Flora. Het huwelijk in 1634 viel zowel privé als professioneel in een gelukkige fase, die eindigde met Saska's dood in 1642.

REMBRANDT HARMENSZ. VAN RIJN (1609-69)

1634, Oil on canvas/Huile sur toile, 124,7 × 100,4 cm, State Hermitage Museum, St. Petersburg

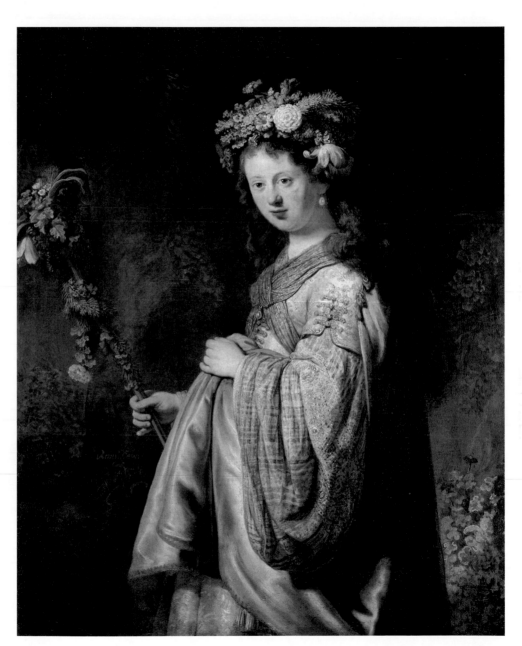

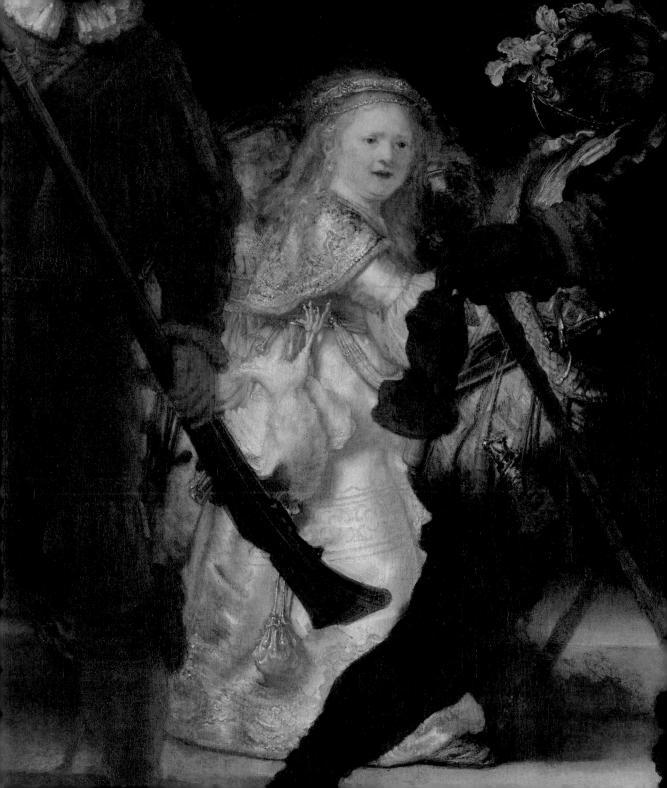

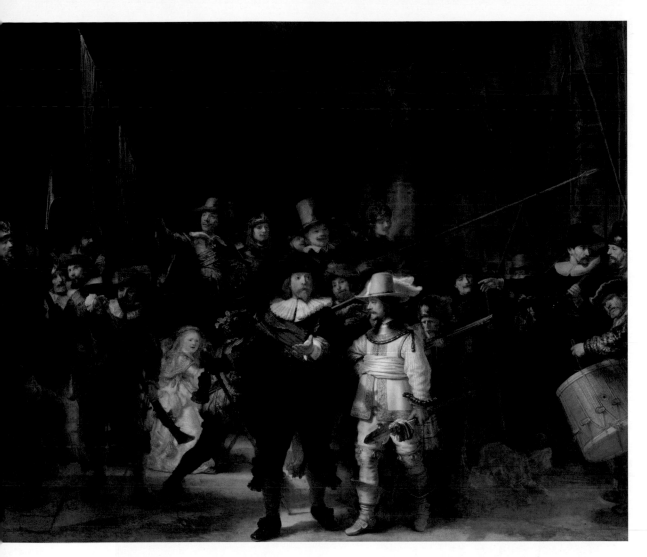

Militia Company of District II under the Command of Captain Frans Banninck Cocq (The Night Watch)
Rembrandt's painting for the Rifle Guild Festival Hall in Amsterdam stages a dramatic plot amid in a group portrait of militia.

Ronde de nuit
Le tableau de Rembrandt, destiné à orner la salle des fêtes de la compagnie des arquebusiers d'Amsterdam, a la spécificité de mettre en scène une action, fait rare pour le portrait de groupe d'une milice (un genre hollandais typique).

Die Kompanie des Frans Banning Cocq (Die Nachtwache)
Rembrandts Bild für den Festsaal der Schützengilde in Amsterdam zeichnet sich dadurch aus, dass er in dem Gruppenporträt einer Bürgerwehr eine dramatische Handlung inszenierte.

La Compañía del capitán Frans Banning Cocq (La Ronda Nocturna)
La pintura de Rembrandt para la sala de fiestas del gremio de los guardias en Amsterdam se caracteriza por la dramática trama que escenificó en el retrato de grupo de una milicia.

La compagnia di Frans Banning Cocq (La ronda di notte)
Il dipinto di Rembrandt per il salone delle feste della Corporazione die tiratori di Amsterdam è caratterizzato dalla trama drammatica che ha messo in scena nel ritratto di gruppo di una ronda notturna.

De Nachtwacht (De compagnie van kapitein Frans Banning Cocq en luitenant Willem van Ruytenburgh maakt zich gereed om te marcheren)
Rembrandts schilderij voor de feestzaal van de Amsterdamse schutterij kenmerkt zich door de dramatische handelwijze die hij in het groepsportret van een burgerwacht ensceneerde.

REMBRANDT HARMENSZ. VAN RIJN (1609-69)
1642, Oil on canvas/Huile sur toile, 379,4 × 453,5 cm, Rijksmuseum, Amsterdam

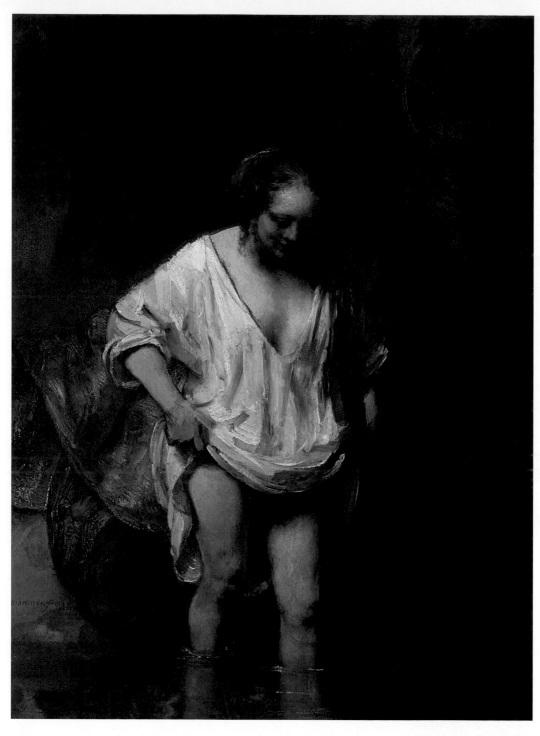

Woman Bathing in the River
(Hendrickje Stoffels?)

Femme se baignant
dans une rivière

Im Fluss badende Frau
(Hendrickje Stoffels?)

Mujer bañándose en el río
(Hendrickje Stoffels?)

Giovane donna al
bagno in un ruscello

Vrouw, badend in een rivier
(Hendrickje Stoffels?)

**REMBRANDT HARMENSZ. VAN
RIJN (1609–69)**
1654, Oil on oak/Huile
sur chêne, 61,8 × 47 cm,
The National Gallery, London

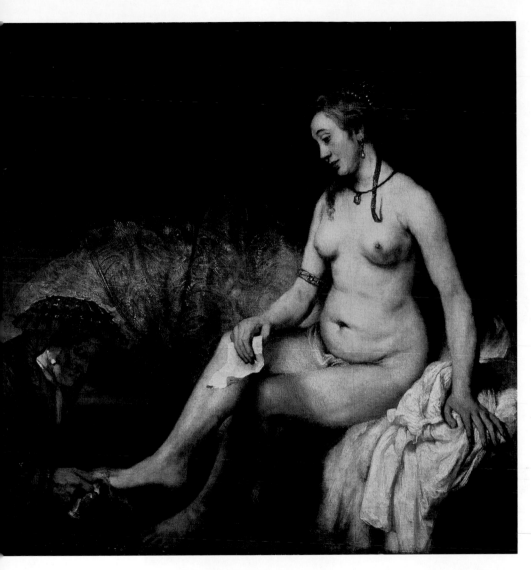

thsheba at Her Bath

s Bathsheba not only receives King David's letter,
has already read it. She is not pleased to have
used the king's interest, and seems to anticipate the
ure disaster.

thsabée au bain tenant la lettre de David

te Bethsabée ne vient pas de recevoir la lettre du
elle l'a déjà lue. Elle ne se réjouit pas d'avoir attiré
térêt du souverain, semblant plutôt pressentir le
lheur qui s'annonce.

Bathseba im Bade mit dem Brief Davids

Diese Batsheba erhält den Brief des Königs nicht
erst, sie hat ihn schon gelesen. Sie ist nicht erfreut,
das Interesse des Königs geweckt zu haben, sondern
scheint das künftige Unheil vorauszuahnen.

Betsabé con la carta de David

Esta Batsabé no sólo recibe la carta del rey, sino que
ya la ha leído. No está contenta de haber despertado el
interés del Rey, sino que más bien parece anticipar el
futuro desastre.

Bagno in vasca con la lettera di Davide

Questa Betsabea non solo riceve la lettera del re,
ma l'ha già letta. Non è contenta di aver suscitato
l'interesse del re, bensì sembra anticipare il disastro
futuro.

Bathseba met de brief van koning David

Deze Bathseba heeft de brief van de koning niet alleen
net ontvangen, maar heeft hem ook al gelezen. Ze is
niet blij dat ze de interesse van de koning heeft gewekt,
maar lijkt het aanstaande onheil al te voorvoelen.

MBRANDT HARMENSZ. VAN RIJN (1609-69)

4, Oil on canvas/Huile sur toile, 142 × 142 cm, Musée du Louvre, Paris

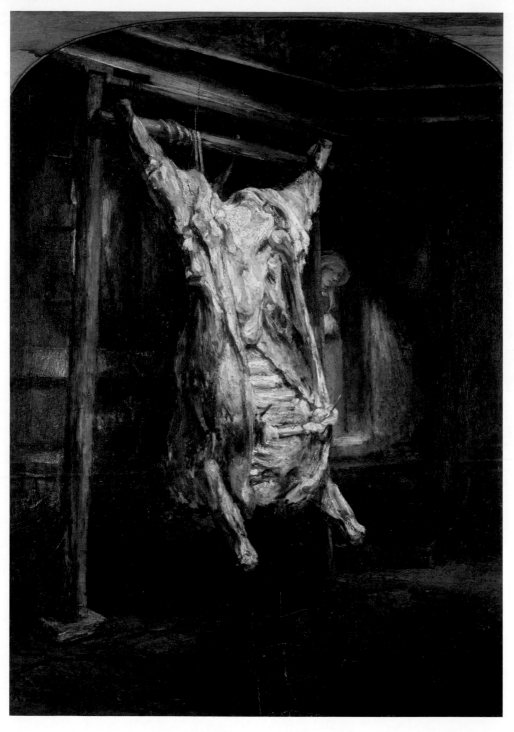

The Slaughtered Ox

Le Bœuf écorché

Der geschlachtete Ochse

El buey desollado

Il bue macellato

De geslachte os

**REMBRANDT HARMENSZ. VAN RIJN
(1609-69)**
1655, Oil on canvas/Huile sur toile,
94 × 69 cm, Musée du Louvre, Paris

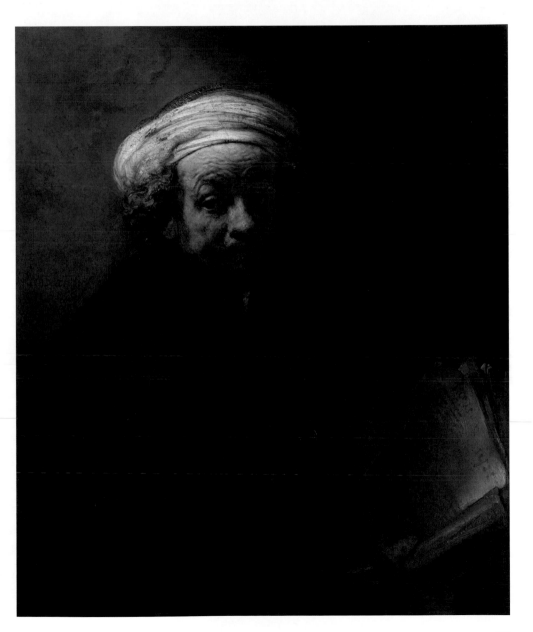

Self-Portrait as the Apostle Paul

This is the only one of his approximately 90 self-portraits in which Rembrandt portrays himself as a biblical figure. The materiality of color typical of the artist's late self-portraits becomes apparent here.

Autoportrait en apôtre Paul

Il s'agit du seul de ses 90 autoportraits dans lequel Rembrandt se représente sous les traits d'une figure biblique. Au niveau du style pictural, il annonce la matérialité de la couleur typique des autoportraits tardifs de l'artiste.

Selbstbildnis als Paulus

Dies ist das einzige seiner etwa 90 Selbstporträts, in dem sich Rembrandt als biblische Figur darstellte. In der Malweise kündigt sich die für die späten Selbstbildnisse typische Materialität der Farbe an.

Autorretrato como San Pablo

Éste es el único de sus aproximadamente 90 autorretratos en los que Rembrandt se retrató a sí mismo como una figura bíblica. En el estilo pictórico se hace evidente la materialidad del color, típica de los autorretratos tardíos.

Autoritratto come Paul

Questo è l'unico dei suoi circa 90 autoritratti in cui Rembrandt si raffigurò come una figura biblica. Nella pittura, la materialità del colore, tipica dei tardivi autoritratti, diventa evidente.

Zelfportret als Paulus

Dit is het enige van zijn circa 90 zelfportretten waarop Rembrandt zichzelf als Bijbelse figuur afbeeldde. In de schilderstijl wordt de voor zijn late zelfportretten kenmerkende stoffelijkheid al aangekondigd.

REMBRANDT HARMENSZ. VAN RIJN (1609-69)

1661, Oil on canvas/Huile sur toile, 91 × 77 cm, Rijksmuseum, Amsterdam

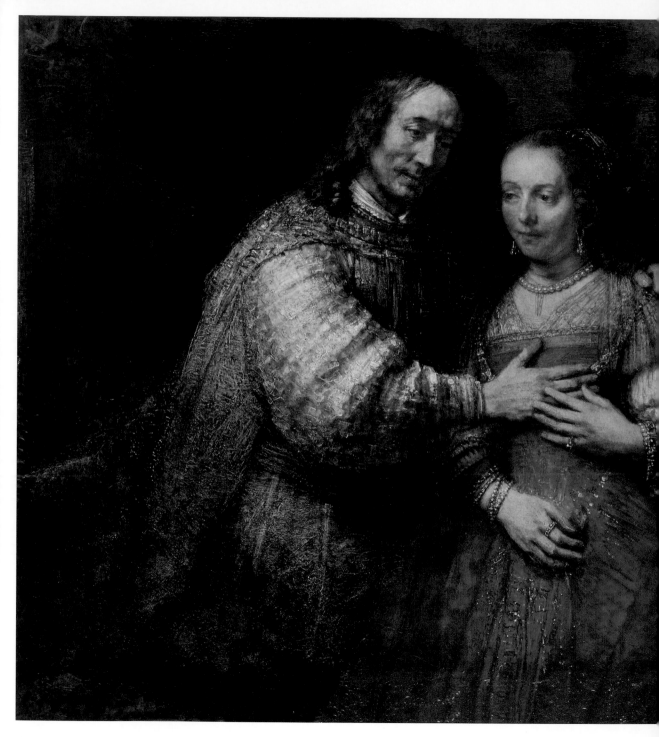

Portrait of a Couple as Isaac and Rebecca (The Jewish Bride)

A gesture of affection is at the centre of this painting, in which two Amsterdam citizens are portrayed as an Old Testament couple – presumably Isaac and Rebecca, as a drawing by Rembrandt suggests.

La Fiancée juive

Un geste d'affection occupe le centre de ce tableau, dans lequel un couple de bourgeois d'Amsterdam s'est fait peindre sous les traits d'un couple de l'Ancien Testament – probablement Isaac et Rebecca, comme le laisse supposer un dessin de Rembrandt.

Bildnis eines Paares als Isaak und Rebekka (Die Judenbraut)

Eine Geste der Zuneigung steht im Zentrum dieses Bildes, in dem sich Amsterdamer Bürger als Paar des Alten Testaments malen ließen – vermutlich als Isaak und Rebekka, wie eine Zeichnung Rembrandts nahelegt.

Retrato de una pareja, probablemente como Isaac y Rebeca (La Novia Judía)

Un gesto de afecto aparece en el centro de esta pintura, en la que los ciudadanos de Ámsterdam fueron pintados como una pareja del Antiguo Testamento - presumiblemente como Isaac y Rebeca, como sugiere un dibujo de Rembrandt.

Ritratto di coppia come Isacco e Rebecca (La sposa degli ebrei)

Un gesto di affetto è al centro di questo dipinto, in cui i cittadini di Amsterdam sono stati dipinti come una coppia dell'Antico Testamento - presumibilmente come Isacco e Rebecca, come suggerisce un disegno di Rembrandt.

Portret van een paar als Izaäk en Rebekka (Het joodse bruidje)

Centraal in dit schilderij staat een gebaar van genegenheid, waarop Amsterdamse burgers werden geschilderd als een paar uit het Oude Testament – vermoedelijk als Izaäk en Rebekka, zoals een tekening van Rembrandt aannemelijk maakt.

REMBRANDT HARMENSZ. VAN RIJN (1609-69)

c. 1665-69, Oil on canvas/Huile sur toile, 121,5 × 166,5 cm, Rijksmuseum, Amsterdam

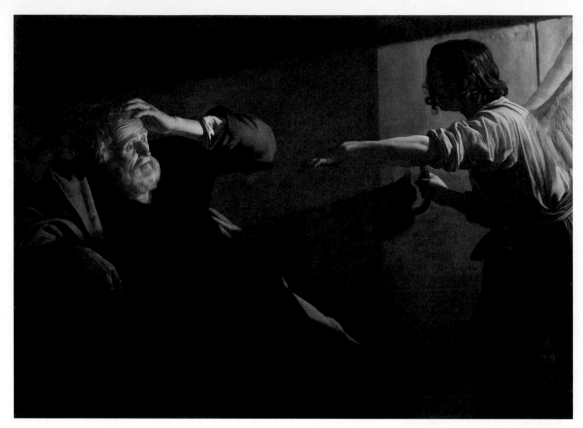

The Liberation
of St Peter

La Délivrance
de saint Pierre

Die Befreiung Pe▮

La liberación
de San Pedro

La liberazione
di San Pietro

De bevrijding
van Petrus

**GERRIT VAN
HONTHORST**
(1592–1656)
c. 1616–18, Oil on
canvas/Huile sur
toile, 131 × 181 cm,
Gemäldegalerie,
Berlin

Dutch History Painting:
Paintings for Private Collectors

Until the 19th century, history painting was considered
the most important genre in art. It comprised themes and
motifs from ancient mythology, religion, and literature, as
well as historical events, often focusing on an aspect that
could claim universal validity. Large cycles of paintings
to justify the power of absolutist rulers—such as those by
the Flemish Rubens, for example—were the exception in
Holland. Here, the bourgeois "ruling class" was usually
depicted in group portraits. Since Dutch Protestantism
rejected religious images in churches, small- or medium-
format history paintings instead found their way into
the town and country houses of private individuals,
reflecting (in the case of religious images) their owners'
personal convictions.

La peinture d'histoire hollandaise : des
tableaux destinés aux collectionneurs privés

Jusqu'au xixᵉ siècle, la peinture d'histoire fut considérée
comme le genre le plus important. Elle puisait ses thèmes
et ses motifs dans la mythologie antique, la religion
et la littérature, ou encore dans des évènements de
l'histoire ancienne ou récente, en se focalisant sur un
aspect à la valeur intemporelle. Les grands cycles de
tableaux visant à justifier la monarchie absolue (comme
ceux du Flamand Rubens) faisaient en Hollande figure
d'exception. La « classe dominante » bourgeoise aimait
se faire peindre sous forme de portraits de groupe. De
plus, le protestantisme néerlandais désapprouvait les
images religieuses dans les églises. C'est ainsi que virent
le jour des tableaux d'histoire de petit ou de moyen
format, qui souvent prenaient place dans les maisons
privées, à la ville comme à la campagne, et (dans le cas de
représentations religieuses) reflétaient les convictions de
leurs propriétaires.

Die holländische Historienmalerei:
Bilder für Privatsammler

Die Historienmalerei galt bis ins 19. Jahrhundert als
die wichtigste Kunstgattung. In ihr wurden Themen
und Motive aus der antiken Mythologie, der Religion
und Literatur sowie Ereignisse der älteren und neueren
Geschichte dargestellt – häufig auf einen Aspekt
konzentriert, der überzeitliche Gültigkeit beanspruchen
konnte. Große Gemäldezyklen zur Rechtfertigung
der Macht absolutistischer Herrscher – wie sie zum
Beispiel der Flame Rubens schuf – waren in Holland die
Ausnahme. Hier ließ sich die bürgerliche „herrschende
Klasse" vor allem in Gruppenporträts darstellen. Der
niederländische Protestantismus lehnte außerdem
religiöse Bilder in Kirchen ab. Deshalb entstanden klein-
oder mittelformatige Historienbilder, die nun Einzug in
die Stadt- und Landhäuser von Privatpersonen hielten
und (im Fall von religiösen Darstellungen) auch deren
persönliche Überzeugungen widerspiegelten.

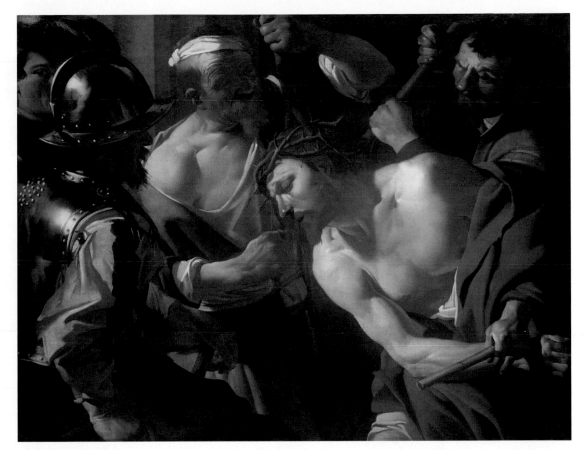

The Crowning with Thorns

Le Couronnement d'épines

Dornenkrönung Christi

Coronación de espinas

Incoronazione di spine

Doornenkroning van Christus

DIRCK VAN BABUREN
(C. 1594-1624)
1622/23, Oil on canvas/Huile sur toile, 106 × 136 cm, Museum Catharijneconvent, Utrecht

Pintura de historia holandesa: pinturas para coleccionistas privados

Hasta el siglo XIX, la pintura histórica era considerada la forma de arte más importante. En ella se presentaron temas y motivos de la mitología, la religión y la literatura antiguas, así como acontecimientos de la historia más antigua y más reciente, que a menudo se centran en un aspecto que podría reivindicar una validez supracorpórea. Grandes ciclos de pinturas para justificar el poder de los gobernantes absolutistas –como creó el flamencoRubens, por ejemplo– fueron la excepción en Holanda. Aquí, la "clase dominante" burguesa fue representada principalmente en retratos de grupo. El protestantismo holandés también rechazó las imágenes religiosas en las iglesias. Por esta razón, se crearon pinturas históricas de pequeño o mediano formato, que se introdujeron en la ciudad y en las casas de campo de particulares y que (en el caso de las representaciones religiosas) también reflejaban sus convicciones personales.

Pittura storica olandese: dipinti per collezionisti privati

Fino al XIX secolo, la pittura storica era considerata la forma d'arte più importante. In essa sono stati presentati temi e motivi della mitologia, della religione e della letteratura antica, nonché eventi della storia antica e più recente, spesso focalizzati su un aspetto che potrebbe rivendicare la validità nel tempo. Grandi cicli di dipinti per giustificare il potere dei governanti assolutisti – come ad esempio il fiammingo Rubens- sono stati l'eccezione in Olanda. Qui, la "classe dirigente" borghese era rappresentata principalmente in ritratti di gruppo. Anche il protestantesimo olandese ha rifiutato le immagini religiose nelle chiese. Per questo motivo, sono stati realizzati dipinti di storia di piccolo o medio formato, che fecero il loro ingresso nelle case di città e di campagna di privati e che (nel caso delle rappresentazioni religiose) riflettono anche le loro convinzioni personali.

Nederlandse historieschilderkunst: schilderijen voor privéverzamelaars

Tot in de 19e eeuw werd de historieschilderkunst beschouwd als het belangrijkste kunstgenre. Hierin werden thema's en motieven uit de klassieke mythologie, religie en literatuur gepresenteerd, maar ook gebeurtenissen uit de oudere en recentere geschiedenis – vaak gefocust op één aspect dat kon claimen van alle tijden te zijn. Grote schilderijencycli ter rechtvaardiging van de macht van absolute vorsten – zoals de Vlaming Rubens bijvoorbeeld maakte – waren uitzonderlijk in Nederland. Hier liet de burgerlijke 'heersende klasse' zich vooral in groepsportretten afbeelden. Het Nederlandse protestantisme wees religieuze schilderijen in kerken bovendien af. Daarom ontstonden kleine of middelgrote historiestukken, die nu hun weg vonden naar de stadshuizen en buitenverblijven van particulieren en (in het geval van religieuze voorstellingen) ook hun persoonlijke overtuigingen weerspiegelden.

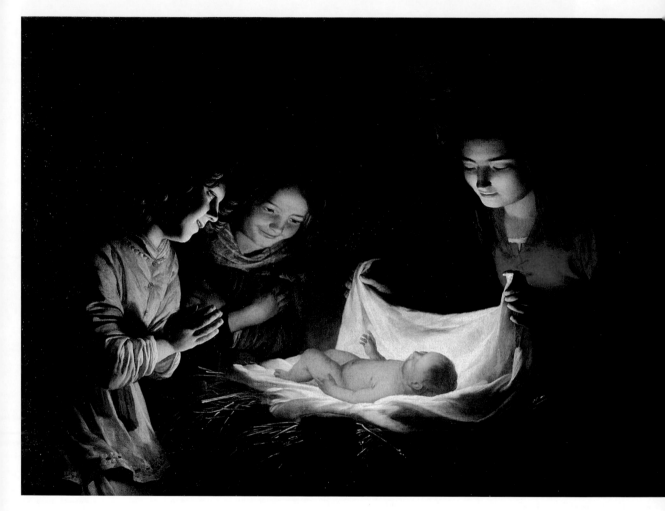

Adoration of the Child

Honthorst, one of the Utrecht Caravaggisti, spent many years in Italy. He borrowed Caravaggio's pronounced chiaroscuro for many night scenes. Here, all light seems to emanate from the Christ child.

Adoration de l'Enfant

Honthorst, l'un des caravagistes de la ville d'Utrecht, vécut des années durant en Italie. Il reprit les clairs-obscurs prononcés du Caravage pour de nombreuses scènes de nuit. Ici, toute la lumière semble irradier de l'enfant Jésus.

Die Anbetung des Kindes

Honthorst, einer der Utrechter Caravaggisten, lebte jahrelang in Italien. Von Caravaggio übernahm er das ausgeprägte Hell-Dunkel für viele Nachtszenen. Hier scheint alles Licht vom Christuskind auszugehen.

Adoración del Niño

Honthorst, uno de los caravagantes de Utrecht, vivió en Italia durante años. De Caravaggio se hizo cargo de los pronunciados claroscuros de muchas escenas nocturnas. Aquí toda la luz parece emanar del Niño Jesús.

Adorazione del bambino

Honthorst, uno dei caravaggisti di Utrecht, ha vissuto per ann in Italia. Di Caravaggio adotta l'evidente chiaroscuro per molt scene notturne. Qui tutta la luce sembra venga emanata dal Cristo Bambino.

Aanbidding van het kind

Honthorst, een van de Utrechtse caravaggisten, woonde jarenlang in Italië. Van Caravaggio nam hij het uitgesproken chiaroscuro over voor veel nachtelijke taferelen. Hier lijkt al het licht van het Christuskind uit te gaan.

GERRIT VAN HONTHORST (1592–1656)

c. 1620, Oil on canvas/Huile sur toile, 95,5 × 131 cm, Galleria degli Uffizi, Firenze

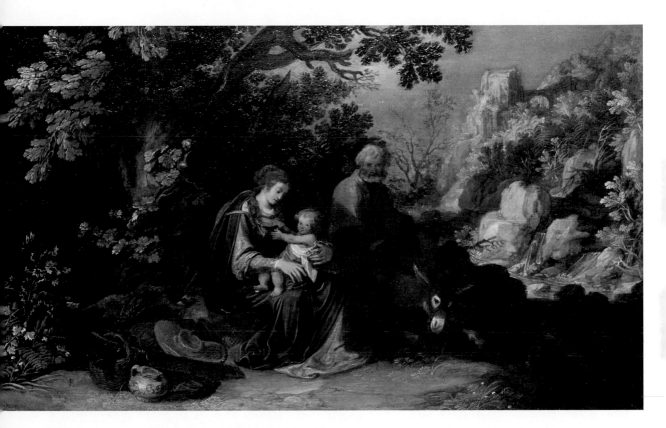

The Rest on the Flight into Egypt

...astman was one of the most important historical painters of the early baroque period, preferring mythological and biblical ...otifs in scenic settings. Rembrandt was among his students.

...e Repos de la Sainte Famille pendant la fuite en Égypte

...astman fut l'un des peintres d'histoire majeurs du baroque ...rimitif et peignait principalement des scènes mythologiques ...u bibliques entourées de paysages. Rembrandt fit partie de ...es élèves.

...IETER LASTMAN (1583-1633)

..., 1608, Oil on oak/Huile sur chêne, 31,8 × 52 cm, Gemäldegalerie, Berlin

Die Ruhe auf der Flucht nach Ägypten

Lastman war einer der wichtigsten Historienmaler des frühen Barocks und widmete sich vorzugsweise mythologischen und biblischen Szenen in landschaftlicher Kulisse. Zu seinen Schülern gehörte Rembrandt.

La calma en la huida a Egipto

Lastman fue uno de los pintores históricos más importantes de la primera época del Barroco y se dedicó preferentemente a escenas mitológicas y bíblicas en un entorno escénico. Entre sus alumnos estaba Rembrandt.

Riposo durante la fuga in Egitto

Lastman fu uno dei più importanti pittori storici del primo barocco e si dedicò preferibilmente a scene mitologiche e bibliche in un contesto scenografico. Tra i suoi studenti si conta Rembrandt.

De rust tijdens de vlucht naar Egypte

Lastman was een van de belangrijkste schilders van historiestukken uit de vroege barok en wijdde zich bij voorkeur aan mythologische en Bijbelse taferelen in een landschappelijk decor. Rembrandt was een van zijn leerlingen.

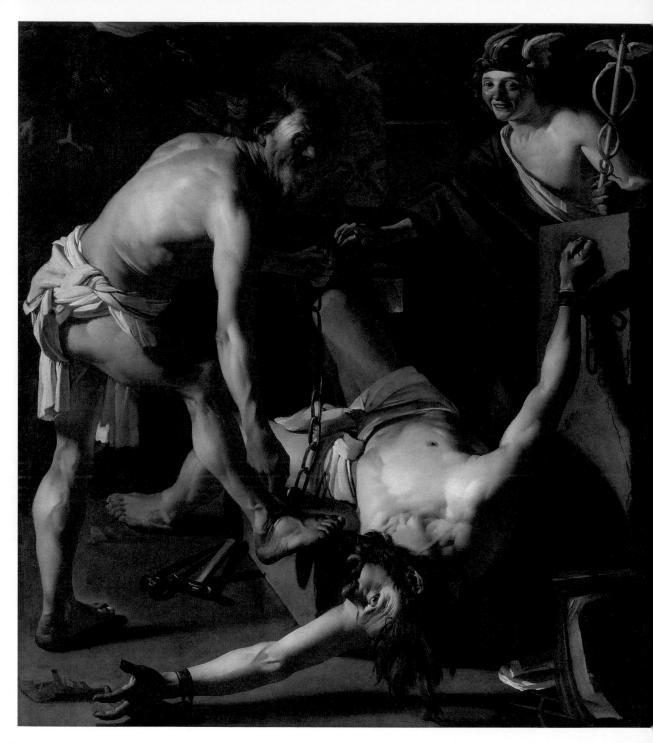

Venus and Adonis

Venus begs her lover Adonis not to go on the hunt (where he will be killed). Bol was a very successful painter, and presented the popular theme from Ovid's *Metamorphoses* in an elegant and colorful way.

Vénus et Adonis

Vénus implore son amant Adonis de ne pas partir à la chasse (où il trouvera la mort). Peintre très renommé, Bol représenta ce motif prisé des *Métamorphoses* d'Ovide avec élégance et dans des couleurs gaies.

Venus und Adonis

Venus fleht ihren Geliebten Adonis an, nicht auf die Jagd zu gehen (bei der er getötet wird). Der sehr erfolgreiche Maler Bol stellte das beliebte Thema aus Ovids *Metamorphosen* elegant und farbenfroh dar.

Venus y Adonis

Venus le ruega a su amante Adonis que no vaya a cazar (donde lo matan). El exitoso pintor Bol presentó el tema popular de las *Metamorfosis* de Ovidio de una manera elegante y colorida.

Venere e Adone

Venere prega il suo amante Adone di non andare a caccia (dove verrà ucciso). Il pittore di grande successo Bol ha rappresentato il tema popolare delle *Metamorfosi* di Ovidio in modo elegante e vivace nei colori.

Venus en Adonis

Venus smeekt haar geliefde Adonis niet te gaan jagen (waarbij hij gedood wordt). De zeer succesvolle schilder Bol gaf het populaire thema uit Ovidius' *Metamorfosen* elegant en kleurig weer.

FERDINAND BOL (1616–80)

1657–60, Oil on canvas/Huile sur toile, 168 × 230 cm, Rijksmuseum, Amsterdam

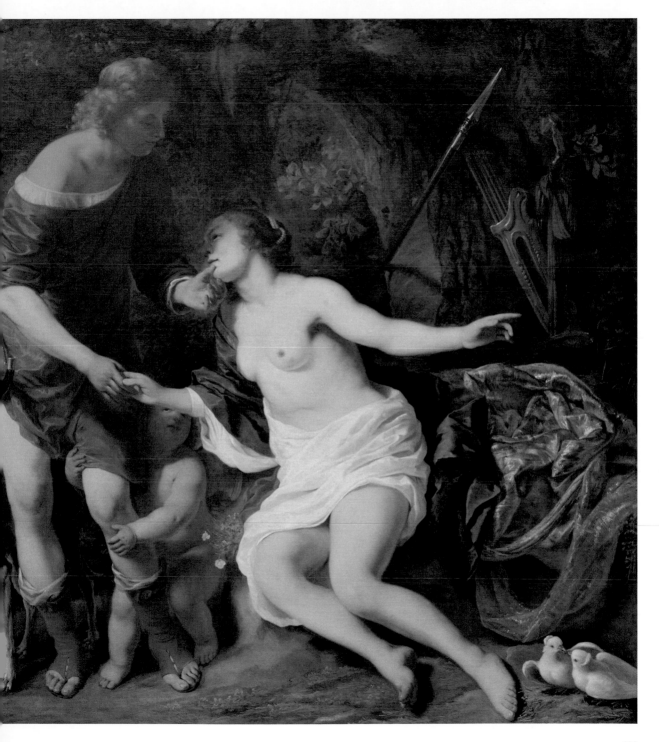

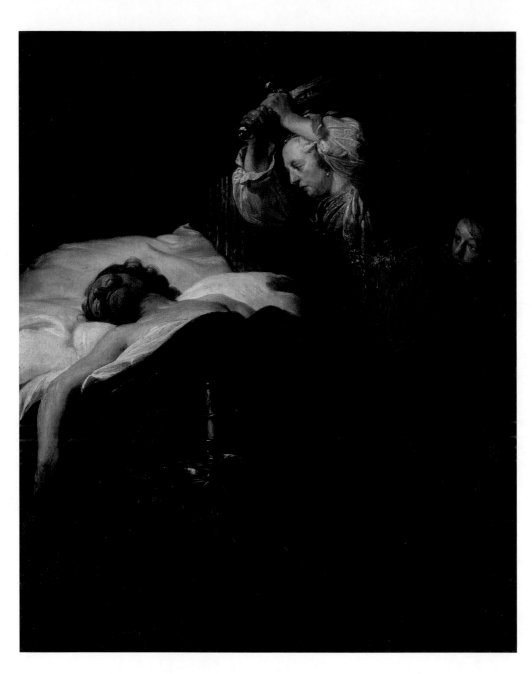

Judith and Holofernes

By slaying the Assyrian general Holofernes in his sleep, Judith saves the Jewish people – for religious-political reasons, this subject was portrayed often in the baroque period, usually more dramatically than here.

Judith et Holopherne

En tuant dans son sommeil le général assyrien Holopherne, Judith sauve le peuple juif – un motif qui pour des raisons religieuses et politiques fut beaucoup représenté à l'époque baroque, souvent de manière plus dramatique qu'ici.

Judith und Holofernes

Indem Judith den assyrischen Feldherren Holofernes im Schlaf tötet, rettet sie das jüdische Volk – ein Thema, das auch aus religionspolitischen Motiven im Barock häufig dargestellt wurde, oft dramatischer als hier.

Judith y Holofernes

Al matar al general asirio Holofernes mientras dormía, Judith salva al pueblo judío - un tema que a menudo fue retratado en motivos religiosos-políticos barrocos, normalmente más dramáticamente que aquí.

Giuditta e Oloferne

Uccidendo nel sonno il generale assiro Oloferne, Giuditta salva il popolo ebraico, un soggetto spesso rappresentato durante il barocco con motivazioni politico-religiose, spesso più drammatiche rispetto a questo ritratto.

Judith en Holofernes

Door de Assyrische generaal Holofernes in zijn slaap te vermoorden, redt Judith het Joodse volk – een onderwerp dat in de barok vaak, meestal dramatischer dan hier, om religieus-politieke redenen werd afgebeeld.

JAN DE BRAY (C. 1627–97)
1659, Oil on wood/Huile sur bois,
40 × 32,5 cm, Rijksmuseum, Amsterdam

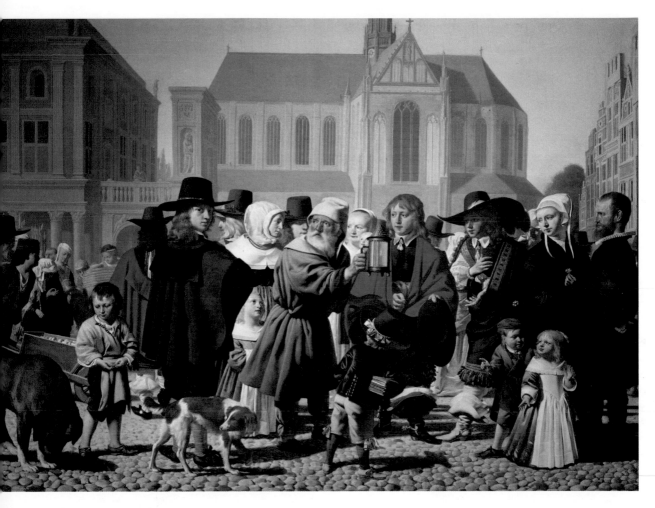

ogenes Looking for an Honest Man (Historical Portrait of the Steyn Family)

ogène recherchant un honnête homme ou Portrait historié de la famille du grand-pensionnaire Pieter Steyn

ogenes sucht einen ehrlichen Menschen (Historisierendes Porträt der Familie Steyn)

ógenes busca una persona honesta (Retrato histórico de la familia Steyn)

ogene cerca un vero uomo (Ritratto storico della famiglia Steyn)

ogenes zoekt een mens (Portret historié van de familie Steyn)

ESAR BOETIUS VAN EVERDINGEN (1616/17-78)

52, Oil on canvas/Huile sur toile, 75,9 × 103,6 cm, Mauritshuis, Den Haag

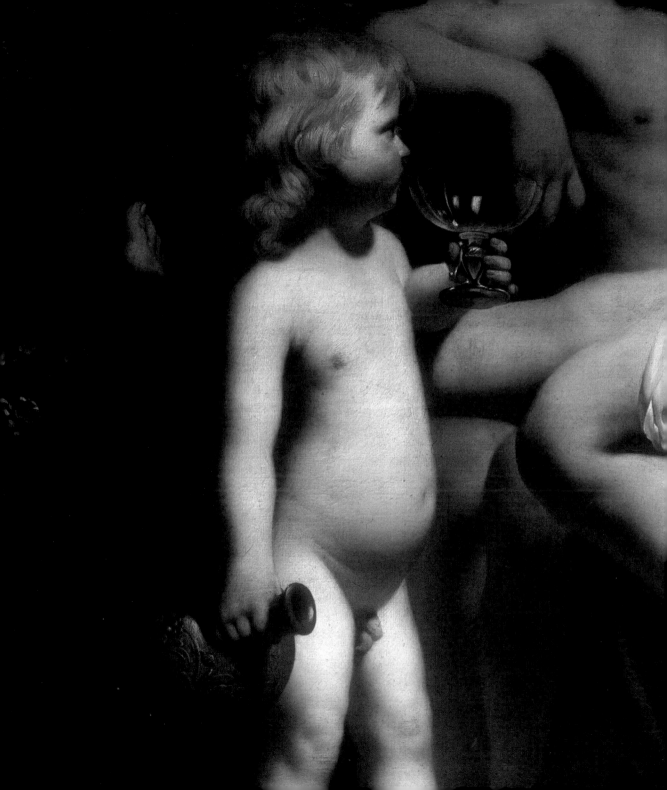

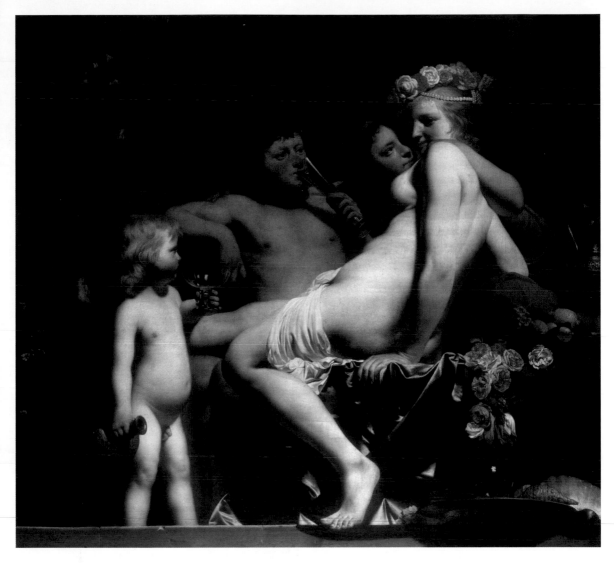

Bacchus and Ariadne on Naxos

The smooth and detailed surface of the picture and its permissive theme in antique costume are well-suited to the tastes of the time and are typical of Dutch baroque classicism.

Bacchus et Ariane à Naxos

Le style souple et détaillé de ce tableau, de même que son sujet osé sur fond antique, étaient sans doute au goût de l'époque, car ils sont typiques du classicisme baroque hollandais.

Bacchus und Ariadne auf Naxos

Die geschmeidige und detaillierte Malweise dieses Bildes und sein freizügiges Thema im antiken Gewand dürften den Geschmack der Zeit getroffen haben und sind typisch für den holländischen Barockklassizismus.

Baco y Ariadna en Naxos

El estilo pictórico liso y detallado de esta pintura y su tema permisivo en una prenda antigua están probablemente en consonancia con el gusto de la época y son típicos del clasicismo barroco holandés.

Bacco e Arianna a Nasso

La pittura setosa e dettagliata di questo dipinto e il suo tema permissivo in un abito antico sono probabilmente in accordo con il gusto del tempo e sono tipici del classicismo barocco olandese.

Bacchus en Ariadne op Naxos

De gladde en gedetailleerde schilderstijl van dit werk en het onbekrompen thema in een antiek gewaad sluiten waarschijnlijk aan bij de smaak van die tijd en zijn kenmerkend voor de Nederlandse classicistische barok.

CAESAR BOETIUS VAN EVERDINGEN (1616/17–78)

c. 1660, Oil on canvas/Huile sur toile, 141 × 161 cm, Gemäldegalerie Alte Meister, Dresden

Banquet at the Crossbowmen's Guild in
Celebration of the Treaty of Münster

Banquet de la guilde des Arbalétriers célébrant
la ratification du traité de Münster

Festmahl der Amsterdamer Armbrustschützen
zur Feier des Westfälischen Friedens

Celebración de la Paz de Westfalia

Festa dei balestrieri di Amsterdam per celebrare la Pace di Westfalia

Schuttersmaaltijd ter viering van de Vrede van Münster

BARTHOLOMEUS VAN DER HELST (1613–70)
1648, Oil on canvas/Huile sur toile, 232 × 547 cm, Rijksmuseum, Amsterdam

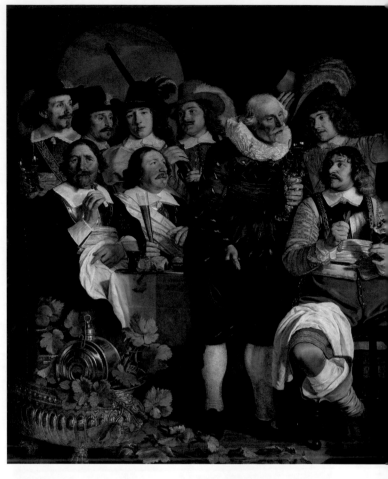

Dutch Portraits:
Between Representation and the Individual

The wealthy citizens of the northern Netherlands
commissioned a huge number of portraits from around
1600 onwards. Many of them contain references to the
wealth of the sitters—in the form of precious clothes,
jewellery, and lace—or symbols that point to their
professions or political convictions. Of great importance
are the group portraits, from depictions of marksmen's
or professional guilds to the directors of philanthropic
establishments such as hospitals and poorhouses, in
which the influential classes presented themselves in
their societal roles. Bartholomeus van der Helst, Govert
Flinck, Nicolaes Maes, and Rembrandt all created elegant
portraits in the 1630s. Frans Hals cultivated an individual,
spontaneous style, while Rembrandt's late self-portraits
are regarded as the pinnacle of the genre.

Les portraits hollandais :
entre représentation et individualité

À partir de 1600, les bourgeois aisés du nord des Pays-
Bas commandèrent un nombre considérable de portraits.
Beaucoup d'entre eux comportaient, via les vêtements
coûteux, les bijoux et les dentelles, des indices de la
richesse de la personne représentée, ou des symboles
indiquant son activité ou son orientation politique.
Les portraits de groupes étaient monnaie courante,
allant des milices et des guildes jusqu'aux responsables
d'institutions caritatives, comme les hospices et les
asiles : les couches les plus influentes de la population se
plaisaient à être représentées avec leur fonction au sein de
la société. Parmi les grands portraitistes des années 1630,
il convient de citer Bartholomeus van der Helst, Govert
Flinck, Nicolaes Maes, ou encore Rembrandt. Frans Hals
développa un style de peinture plus individuel et plus
spontané. Quant à Rembrandt, ses autoportraits tardifs
sont considérés comme l'apogée de l'art du portrait.

Holländische Porträts:
Zwischen Repräsentation und Individuum

Die wohlhabenden Bürger der nördlichen Niederlande
gaben ab etwa 1600 eine riesige Menge Porträts in
Auftrag. Viele von ihnen enthalten – mit kostbarer
Kleidung, Schmuck und Spitze – Hinweise auf den
Reichtum der jeweils Dargestellten oder Symbole, die
auf Tätigkeit oder politische Gesinnung hindeuten. Von
großer Wichtigkeit sind die Gruppenbildnisse, die von
Schützen- oder Berufsgilden bis zu Trägern mildtätiger
Einrichtungen wie Spitälern und Armenhäusern reichen.
Die einflussreichen Bevölkerungsschichten ließen sich mit
Vorliebe in ihrer Funktion für die Bürgerschaft darstellen.
Als Schöpfer eleganter und repräsentativer Porträts sind
Bartholomeus van der Helst, Govert Flinck, Nicolaes
Maes und auch Rembrandt in den 1630er-Jahren zu
nennen. Einen individuellen, spontanen Malstil pflegte
Frans Hals; die späten Selbstporträts Rembrandts gelten
als Höhepunkt der Bildniskunst.

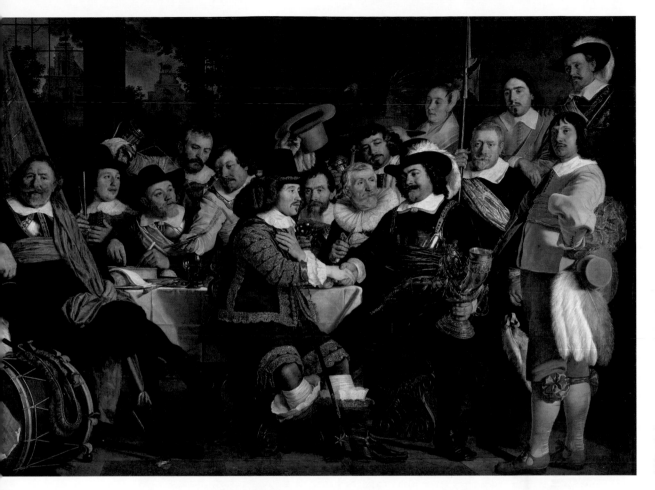

etratos holandeses:
ntre la representación y el individuo

s ciudadanos ricos del norte de los Países Bajos
cargaron un gran número de retratos a partir del 1600.
uchas de ellos contienen –mediante la representación
preciosas vestimentas, joyas y encajes– referencias a
riqueza de lo representado o símbolos que denotanla
ividad o a las convicciones políticas. De gran
portancia son los retratos de grupo, que van desde
adores o gremios profesionales hasta portadores de
tituciones benéficas como hospitales y hospicios: los
ratos influyentes de la población se dejaban retratar
ndo preferencia a su función a favor de la ciudadanía.
la década de 1630, Bartholomeus van der Helst,
vert Flinck, Nicolaes Maes y Rembrandt fueron los
adores de retratos elegantes y representativos. Frans
ls cultivó un estilo pictórico individual y espontáneo;
 autorretratos tardíos de Rembrandt son considerados
mo el clímax del retrato.

Ritratti olandesi:
tra rappresentazione e individuo

I ricchi cittadini dei Paesi Bassi settentrionali
commissionarono un gran numero di ritratti a partire
dal 1600 circa. Molti di essi contengono – con abiti
preziosi, gioielli e pizzi – riferimenti alla ricchezza delle
raffigurazioni o dei simboli che ne determinano l'attività
o le convinzioni politiche. Di grande importanza sono
i ritratti di gruppo, che spaziano dalle corporazioni di
tiratori o di professionisti ai portantini di istituzioni
benefiche come ospedali e ospizi: gli strati influenti della
popolazione si lasciavano rappresentare preferibilmente
nella loro funzione per la cittadinanza. Nel 1630
Bartholomeus van der Helst, Govert Flinck, Nicolaes
Maes e Rembrandt sono annoverati tra gli autori di ritratti
eleganti e rappresentativi. Frans Hals coltivò una pittura
individuale e spontanea; i tardi autoritratti di Rembrandt
sono considerati il culmine dell'arte ritrattistica.

Nederlandse portretten:
tussen representatie en het individu

De welvarende burgers van de noordelijke Nederlanden
gaven vanaf ongeveer 1600 opdracht voor een enorm
aantal portretten. Veel ervan bevatten – met kostbare
kleding, sieraden en kant – verwijzingen naar de
rijkdom van de geportretteerde of symbolen die wijzen
op het beroep of de politieke overtuiging. Van groot
belang zijn de groepsportretten, die variëren van
schutters- of beroepsgilden tot verantwoordelijken
voor liefdadigheidsinstellingen zoals ziekenhuizen en
armenhuizen: de invloedrijke lagen van de bevolking
lieten zich bij voorkeur in hun functie voor de burgerij
afbeelden. Bartholomeus van der Helst, Govert Flinck,
Nicolaes Maes en Rembrandt waren tussen 1630 en 1640
de makers van elegante en representatieve portretten.
Frans Hals bezat een eigen, spontane schilderstijl;
Rembrandts late zelfportretten worden beschouwd als het
hoogtepunt van de portretkunst.

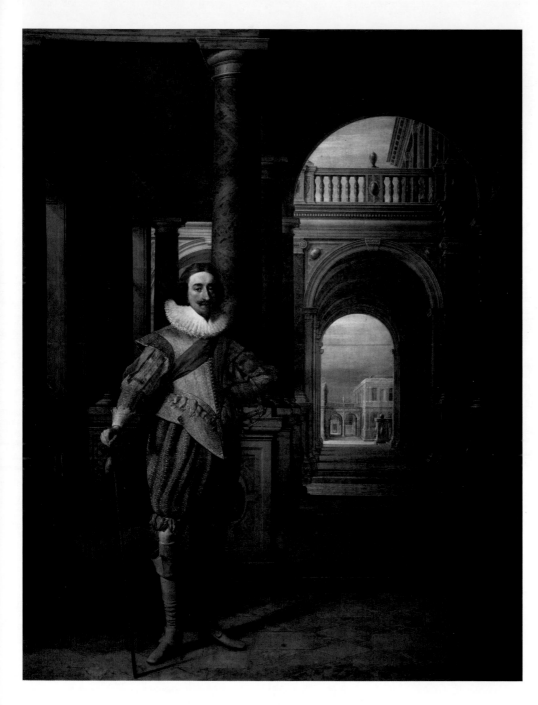

Charles I of Great Britain

Mytens became court painter to the English king in 1625. This picture combines the exacting Dutch representation of textures, the British tradition of the courtly full-figure portrait, and antique architecture.

Portrait de Charles Ier

En 1625, Mytens devint peintre à la cour du roi d'Angleterre. Le rendu exact des textures, de l'école néerlandaise, se marie ici aux portraits de plain-pied de la tradition britannique et à une architecture d'inspiration antique.

Charles I. von Großbritannien

Mytens wurde 1625 Hofmaler des englischen Königs. Hier vereinen sich die niederländische exakte Wiedergabe von Texturen, das höfische Ganzfigurenporträt britischer Tradition und eine antikisierende Architektur.

Carlos I de Gran Bretaña

Mytens se convirtió en pintor de la corte del rey inglés en 1625. Aquí se combinan la reproducción exacta holandesa de texturas, el retrato cortesano de la tradición británica y arquitectura antigua.

Carlo I di Gran Bretagna

Mytens divenne pittore di corte del re d'Inghilterra nel 1625. Qui si combinano l'esatta riproduzione olandese delle texture, il cortese ritratto a figura intera della tradizione britannica e l'architettura antica.

Karel I van Groot-Brittannië

Mytens werd in 1625 hofschilder van de Engelse koning. Hier komen de precieze Nederlandse stofweergave, Britse traditie van het hoofse portret ten voeten uit en een antiquiserende architectuur samen.

DANIEL MYTENS (C. 1590–1647), PORTRAIT / HENDRICK VAN STEENWIJCK THE YOUNGER (C. 1580–1649), ARCHITECTURE

1626/27, Oil on canvas/Huile sur toile, 307 × 240 cm, Galleria Sabauda, Torino

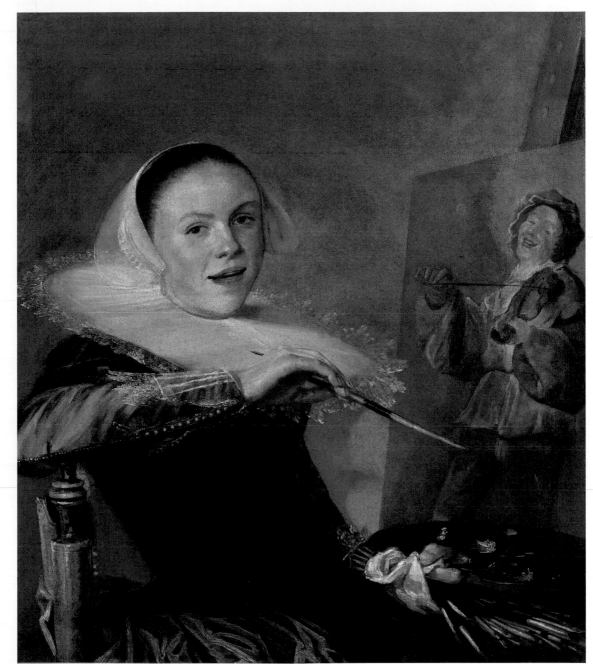

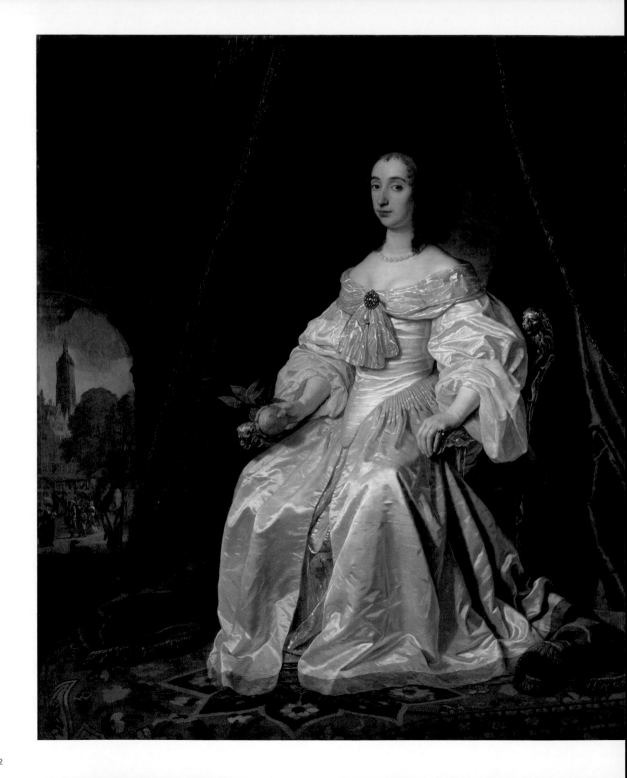

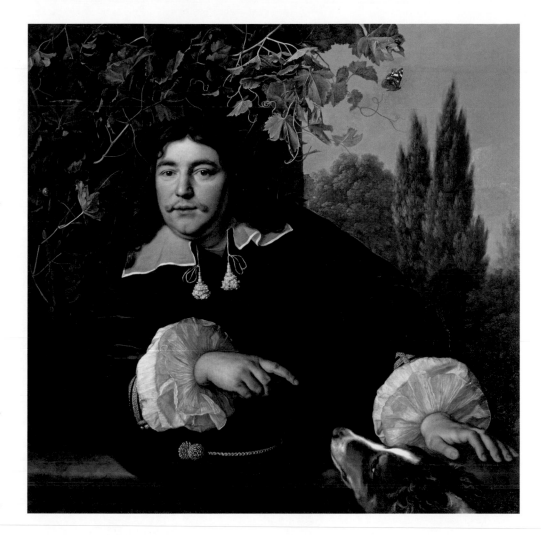

Mary Stuart, Princess of Orange, Widow of William II

...daughter of the English king and ...of the governor William II of ...nge became a widow at the age ...o. White was the royal mourning ...r; the orange refers to Mary's ...nection to the House of Orange.

Mary Stuart, princesse d'Orange, ...ve de Guillaume II

...du roi d'Angleterre et épouse du ...verneur Guillaume II d'Orange, ...ry Stuart devint veuve à 19 ans. Le ...c était la couleur du deuil au sein ...a famille royale, tandis que l'orange ...voie aux liens de Mary avec la ...ille d'Orange.

Mary Stuart, Prinzessin von ...nien, als Witwe von Willem II.

...Tochter des englischen Königs ...Gattin des Statthalters Willem ...on Oranien wurde mit 19 Jahren ...we. Weiß war die königliche ...uerfarbe; die Orange verweist ...Marys Verbindung zum ...s Oranien.

...ía Estuardo, princesa de ...nge, viuda de Willem II.

...ija del rey inglés y esposa del ...ernador Willem II de Orange, ...udó a la edad de 19 años. El blanco ...el color de luto real; el naranja se ...re a la conexión de María con la ...a de Orange.

...ía Stuarda, principessa ...range, vedova di Guglielmo II

...glia del re d'Inghilterra e moglie ...governatore Guglielmo II d'Orange ...nne vedova a 19 anni. Il bianco ...l colore reale del lutto; l'arancione ...ferisce al legame di Maria con la ...dei d'Orange.

...ía Stuart als weduwe ...Willem II

...ochter van de Engelse koning en ...genote van stadhouder Willem II ...Oranje werd op 19-jarige leeftijd ...uwe. Wit was de koninklijke ...wkleur; het oranje verwijst naar ...ia's band met het Huis ...Oranje.

...THOLOMEUS VAN DER HELST ...3-70)

...Oil on canvas/Huile sur toile, ...5 × 170 cm, Rijksmuseum, Amsterdam

Self-Portrait

The most sought-after portraitist of his time portrays himself as a gentleman: the clothes are the latest fashion, the balustrade and trees indicate a country estate, and the dog refers to hunting – a privilege of the nobility.

Autoportrait

Le portraitiste le plus demandé de son époque s'est représenté ici en gentleman : ses vêtements sont à la dernière mode, la balustrade et les arbres suggèrent un grand domaine, et le chien renvoie à la chasse, un privilège de la noblesse.

Selbstbildnis

Der gefragteste Porträtist seiner Zeit malte sich als Gentleman: Die Kleidung entspricht der neuesten Mode, Balustrade und Bäume deuten einen Landsitz an, der Hund verweist auf die Jagd – ein Vorrecht des Adels.

Autorretrato

El retratista más buscado de su tiempo se pintó a sí mismo como un caballero: la ropa a la última moda, la balaustrada y los árboles indican la posesión de una finca, el perro se refiere a la caza - un privilegio de la nobleza.

Autoritratto

Il ritrattista più ricercato del suo tempo si dipinge come un signore: i vesti sono all'ultima moda, balaustra e alberi indicano una tenuta di campagna, il cane fa riferimento alla caccia - un privilegio della nobiltà.

Zelfportret

De meest gewilde portretschilder van zijn tijd schilderde zichzelf als een gentleman: de kleren zijn naar de laatste mode, balustrade en bomen duiden op een landgoed, de hond verwijst naar de jacht, een voorrecht van de adel.

BARTHOLOMEUS VAN DER HELST (1613-70)

1655, Oil on canvas/Huile sur toile, 96,5 × 99 cm, The Toledo Museum of Art, Toledo, Ohio

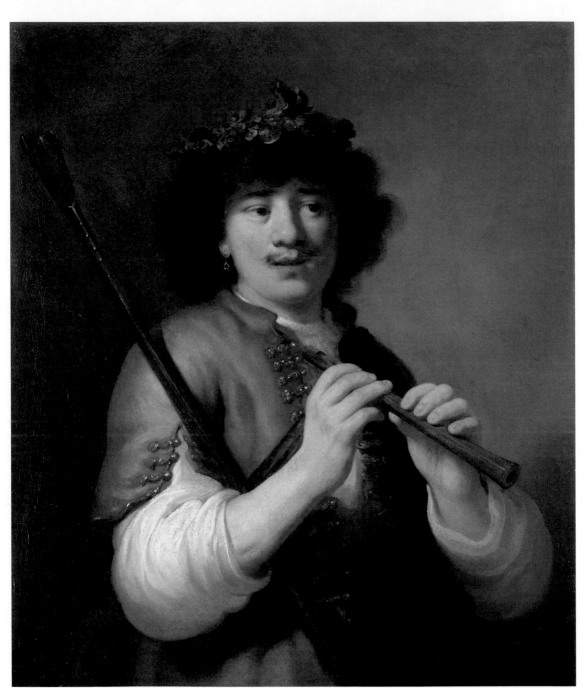

The Company of Captain Bas and Lieutenant Conijn

During the war for independence from Spain, the marksmen's guilds were a militia, later a kind of gentlemen's club. Flinck's group portraits represent a specifically Dutch type of portrait.

La Compagnie du capitaine Albert Bas et son lieutenant Lucas Conijn

Pendant le soulèvement des Pays-Bas contre l'Espagne, les arbalétriers étaient une milice, puis devinrent par la suite une sorte de club réservé aux hommes. Leurs portraits de groupe présentent un genre très spécifique de la peinture hollandaise.

Offiziere und andere Schützen unter Kapitän Bas und Leutnant Conijn

Während des Kriegs um die Unabhängigkeit von Spanien waren die Schützengilden eine Bürgerwehr, später eine Art Herrenklub. Ihre Gruppenbildnisse stellen einen spezifisch holländischen Porträttypus dar.

Oficiales y otros tiradores bajo el mando del Capitán Bas y el Teniente Conijn

Durante la guerra por la independencia de España, los gremios de tiradores eran una milicia, más tarde una especie de club de hombres. Sus retratos de grupo representan un tipo de retrato específicamente holandés.

Officiali e altri tiratori sotto il comando del capitano Bas e del tenente Conijn

Durante la guerra per l'indipendenza la Spagna, le corporazioni dei tiratori erano una milizia, più tardi una sorta di club maschile. I loro ritratti di gruppo rappresentano un tipo di ritratto specificamente olandese.

Officieren en andere schutters van Wijk XVIII in Amsterdam onder leiding van kapitein Albert Bas en luitenant Lucas Conijn

Tijdens de Tachtigjarige Oorlog waren de schutterijen burgerwachten, later werden ze een soort herensociëteiten. Hun groepsportretten vormen een specifiek Nederlands portretgenre.

GOVERT FLINCK (1615–60)
1645, Oil on canvas/Huile sur toile, 347 × 244 cm, Rijksmuseum, Amsterdam

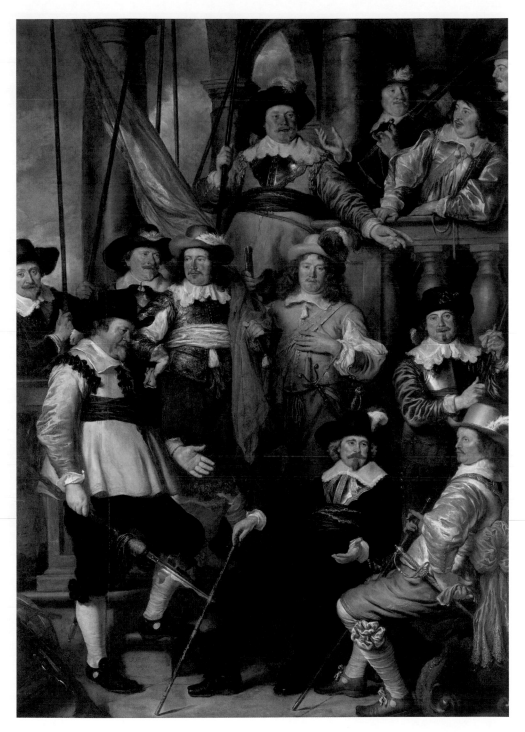

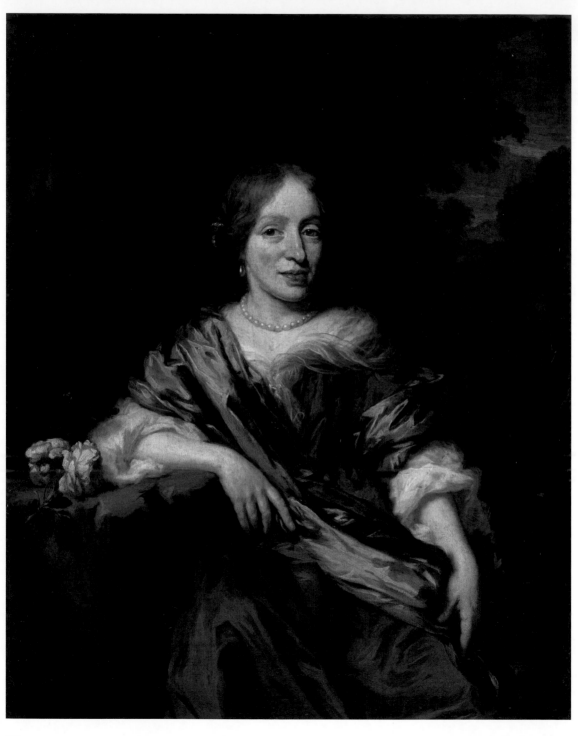

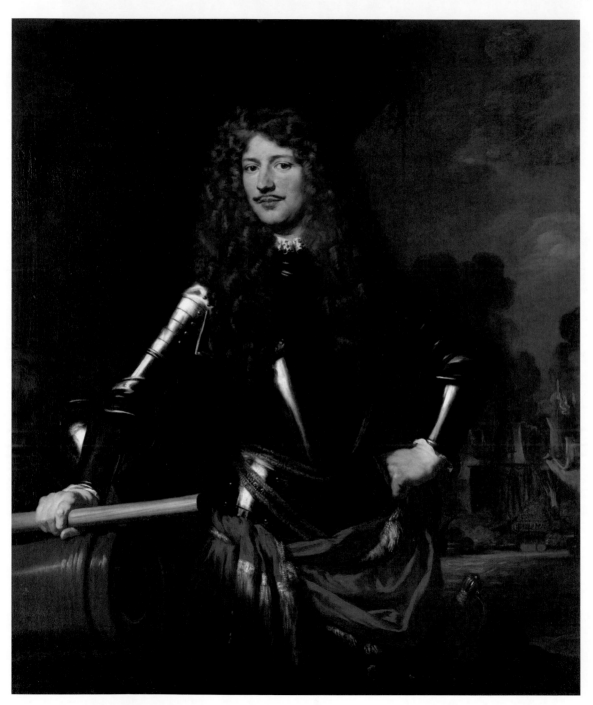

Cornelis Evertsen, Lieutenant-Admiral of Zeeland

Portrait de Cornelis Evertsen, vice-amiral de Zélande

Cornelis Evertsen, Admiralleutnar von Zeeland

Cornelis Evertsen, Almirante Teniente de Zeeland

Cornelis Evertsen, ammiraglio tenente della Zelanda

Cornelis Evertsen, luitenant-admiraal van Zeeland

NICOLAES MAES (1634–93)
1680, Oil on canvas/Huile sur toile, 148 × 124 cm
Rijksmuseum, Amsterdam

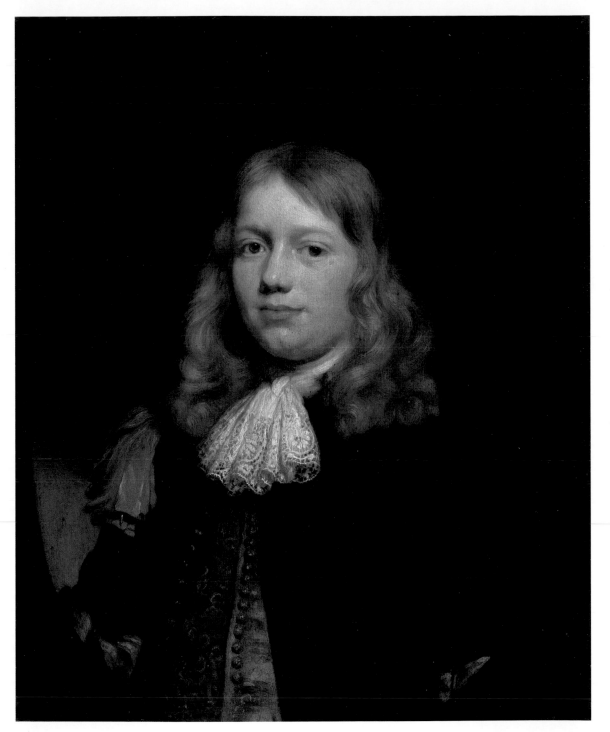

Portrait of a
Young Man

Portrait d'un
eune homme

Bildnis eines
jungen
Mannes

Retrato de
un joven

Ritratto di
ovane uomo

Portret van
een jonge
man

**NICOLAES
MAES (ATTR.)
(1634-93)**
1670-80,
Oil on wood/
Huile sur bois,
36,5 × 31 cm,
Rijksmuseum,
Amsterdam

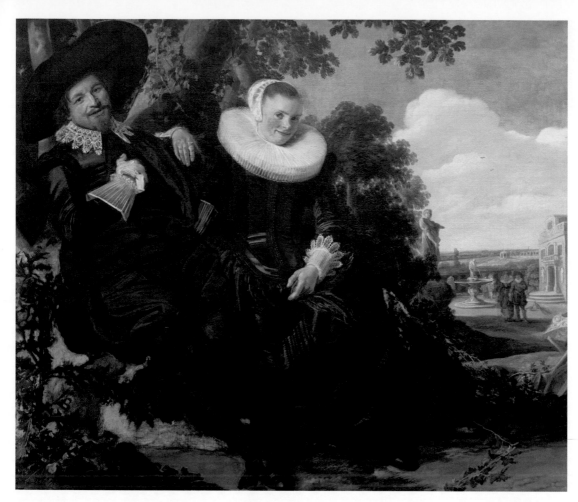

Marriage Portrait
of Isaac Massa and
Beatrix van der Laer

Portrait de mariage
d'Isaac Massa et
Beatrix van der Laer

Hochzeitsporträt
von Isaac Massa und
Beatrix van der Laer

Retrato de boda
de Isaac Massa y
Beatrix van der Laer

Ritratto di nozze
di Isaac Massa e
Beatrix van der Laer

Portret van een stel,
waarschijnlijk Isaac
Abrahamsz Massa en
Beatrix van der Laer

FRANS HALS
(C. 1580–1666)
c. 1622, Oil on
canvas/Huile sur
toile, 140 × 166,5 cm,
Rijksmuseum, Amsterdam

Frans Hals: Near to Life and Spontaneity

Frans Hals, who worked in Haarlem, was mainly a
portrait painter. Even during his lifetime, he was praised
for capturing the personality of those he portrayed.
This talent earned him many commissions for group
portraits – from opulent images of the citizen's militia to
seemingly sober depictions of the boards of charitable
institutions dressed in Protestant black. Hals's paintings
are characterised by a lively, free technique, which
animates the sitters and indicates a quick, spontaneous
way of working. This bold brushwork became more and
more pronounced in his later creative period, so that
parts of some paintings appear almost abstract. For a
long time after his death, Hals was almost forgotten, until
realists and impressionists rediscovered him and his
revolutionary techniques in the mid-19th century.

Frans Hals : réalisme et spontanéité

Installé à Haarlem, Frans Hals était avant tout portraitiste.
De son vivant déjà, on vantait son art de capturer la
personnalité des gens dans ses portraits. Cela lui valut
également de nombreuses commandes de portraits de
groupes, allant des représentations opulentes de milices
à celles, en apparence austères, des régents d'institutions
caritatives, vêtus d'un noir tout protestant. Les tableaux
de Hals se caractérisent par leur technique vive et libre,
qui confère beaucoup de vivacité aux personnages
et qui témoigne d'une manière de travailler rapide et
spontanée. Ce coup de pinceau audacieux se renforça
par la suite, tant et si bien que sur certains tableaux des
parties entières semblent presque abstraites. Après sa
mort, Hals tomba presque dans l'oubli, jusqu'à ce que
les réalistes et les impressionnistes le redécouvrent
au milieu du XIXᵉ siècle à cause de sa technique de
peinture révolutionnaire.

Frans Hals: Lebensnähe und Spontaneität

Der in Haarlem arbeitende Frans Hals war vor allem
Bildnismaler. Schon zu Lebzeiten wurde er dafür
gepriesen, dass er die Persönlichkeit der von ihm
Porträtierten einfange. Dies brachte ihm auch viele
Aufträge von Gruppen ein – von opulenten Bildern der
Bürgerwehren bis zu scheinbar kargen Darstellungen von
in protestantisches Schwarz gekleideten Vorsitzenden
karitativer Einrichtungen. Hals' Gemälde zeichnen
sich durch seine lebhafte und freie Technik aus,
die die Dargestellten mit Leben erfüllt und auf eine
schnelle, spontane Arbeitsweise hindeutet. Diese kühne
Pinselführung wurde in seiner späteren Schaffenszeit
immer ausgeprägter, sodass Partien einiger Bilder nahezu
abstrakt erscheinen. Nach seinem Tod war Hals lange Zeit
fast vergessen, bis ihn Mitte des 19. Jahrhunderts Realisten
und Impressionisten wegen seiner revolutionären
Maltechnik wiederentdeckten.

Young Man Holding a Skull

Jeune Homme tenant un crâne

Junger Mann mit Totenschädel

Joven sosteniendo un cráneo

Giovane con teschio

Portret van een jonge man met schedel

FRANS HALS (C. 1580–1666)
1626–28, Oil on canvas/Huile sur toile, 92,2 × 80,8 cm,
The National Gallery, London

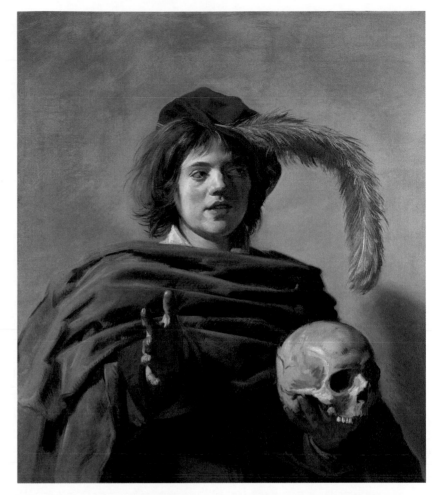

Frans Hals: cercanía a la vida y espontaneidad

Frans Hals, que trabajaba en Haarlem, era principalmente
retratista. Ya durante su vida fue elogiado por capturar
personalidad de aquellos a los que retrató. Esto también
trajo muchas comisiones de grupos – desde imágenes
ulentas de la milicia ciudadana hasta representaciones
arentemente estériles de los presidentes de instituciones
ritativas vestidos de negro protestante. La pintura de
als se caracteriza por su técnica viva y libre, que llena de
da a las personas que están sentadas y señala una forma
ida y espontánea de trabajar. Esta audaz pincelada
hizo cada vez más pronunciada en su última etapa
eativa, por lo que algunas partes de algunas pinturas
recen casi abstractas. Tras su muerte, Hals quedó en el
ido durante mucho tiempo hasta que a mediados del
lo XIX los realistas e impresionistas lo redescubrieron
acias a su revolucionaria técnica pictórica.

Frans Hals: Vicinanza alla vita e spontaneità

Frans Hals, che lavorava ad Haarlem, era principalmente
un pittore di ritratti. Già durante la sua vita fu elogiato
per aver catturato la personalità dei suoi soggetti. Ciò
lo portò anche a molte commissioni di gruppi – da
opulente immagini della milizia cittadina a raffigurazioni
apparentemente brulle dei presidenti di istituzioni
caritative vestite di nero protestante. I dipinti di Hals sono
caratterizzati dalla sua tecnica vivace e libera, che riempie
di vita i personaggi e denota un modo di lavorare rapido
e spontaneo. Questa audace pennellata si fece sempre
più pronunciata nel suo successivo periodo creativo,
tanto che alcune parti di alcuni dipinti apparvero quasi
astratte. Per molto tempo dopo la sua morte, Hals fu quasi
dimenticato fino a quando a metà del XIX secolo i realisti
e gli impressionisti lo riscoprirono grazie alla sua tecnica
pittorica rivoluzionaria.

Frans Hals: realisme en spontaniteit

De in Haarlem werkzame Frans Hals was bovenal
portretschilder. Al tijdens zijn leven werd hij geprezen om
het feit dat hij de persoonlijkheid van de geportretteerde
zo goed kon vastleggen. Dat leverde hem ook veel
opdrachten op van groepen – van weelderige doeken
van de burgerwacht tot schijnbaar sobere afbeeldingen
van de zwartgeklede voorzitters van protestantse
liefdadigheidsinstellingen. Hals' schilderijen kenmerken
zich door een levendige en vrije techniek, die de
geportretteerden tot leven brengt en op een snelle,
spontane manier van werken wijst. Deze gedurfde
penseelvoering werd in zijn latere werken steeds
uitgesprokener, waardoor delen van enkele schilderijen
bijna abstract lijken. Na zijn dood was Hals lange tijd
bijna vergeten, tot realisten en impressionisten hem
halverwege de 19e eeuw opnieuw ontdekten vanwege zijn
revolutionaire schildertechniek.

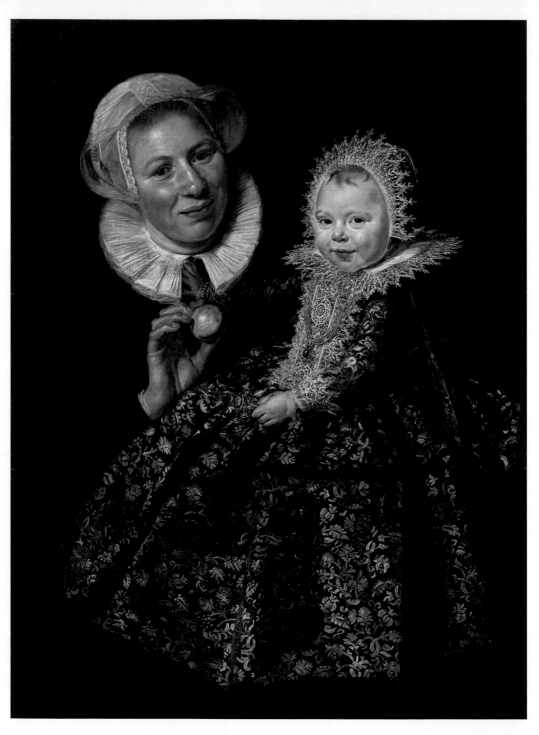

Catharina Hooft with Her Nurs[e]

A little girl in an expensive brocade dress is unusually portrayed with her nurse. The composition and the pear echo images of the Madonna and Christ child.

Portrait de Catharina Hooft et sa nourrice

Cette petite fille dans sa riche robe de brocart est représentée ici avec sa nourrice, de manière très inhabituelle. La disposition du tableau et la présence de la poire rappellent une madone av[ec] l'enfant Jésus.

Catharina Hooft mit ihrer Amm[e]

Ein kleines Mädchen in einem kostbaren Brokatkleid ist ungewöhnlicherweise mit seiner Amme porträtiert. In der Komposition und der Birne klingen Bilder der Madonna mi[t] dem Christuskind nach.

Catharina Hooft con su enfermera

Una niña pequeña con un precioso vestido de brocado es retratada inusualmente con su enfermera. La composición y la pera nos recuerdan a pinturas d[e] la Madonna con el Niño Jesús.

Catharina Hooft con la bambinaia

Una bambina in un prezioso abito di broccato è ritratta insolitamente con la sua bambinaia. La composizione e la pera riecheggiano le immagin[i] della Madonna con il Cristo Bambino.

Portret van Catharina Hooft en haar min

Een klein meisje in een jurk van[?] kostbaar brokaat is ongebruikel[ijk] geportretteerd met haar min. In[?] de compositie en de peer klinke[n] schilderijen door van Onze Liev[e] Vrouwe met het Christuskind.

FRANS HALS (C. 1580–1666)
c. 1619/20, Oil on canvas/
Huile sur toile, 91,8 × 68,3 cm,
Gemäldegalerie, Berlin

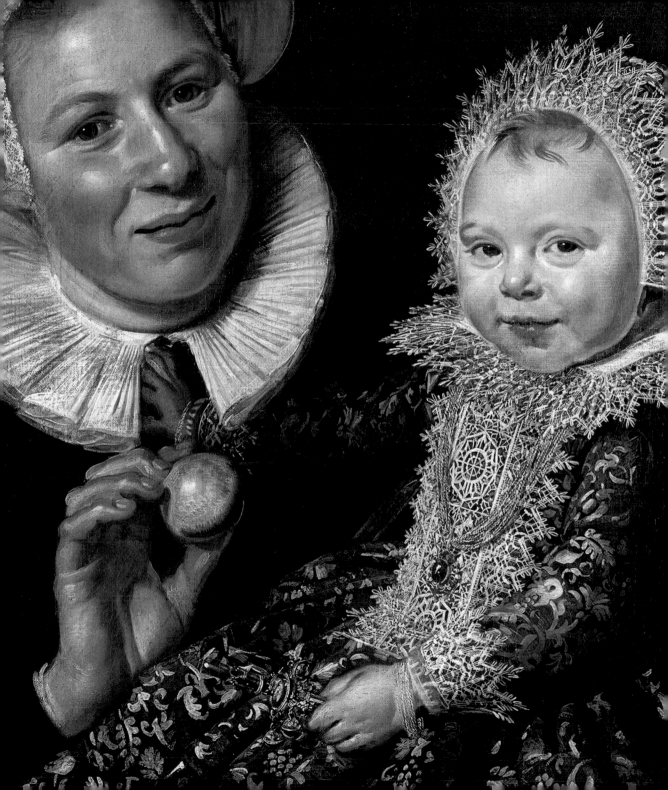

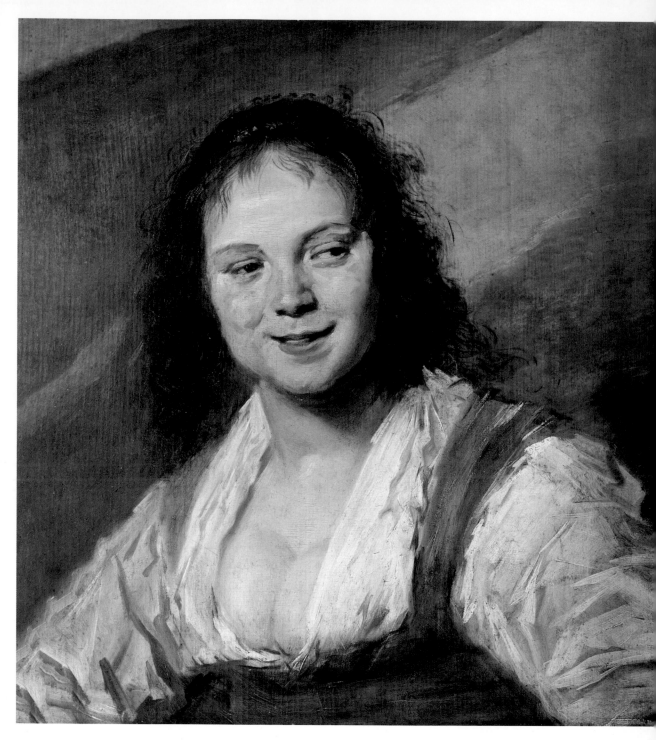

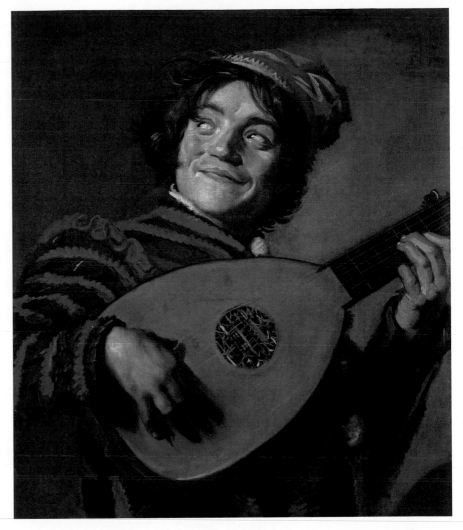

The Lute Player

People of simple classes were often portrayed anonymously in genre portraits. This musician could personify vanity; the picture may be also be also an allegory of hearing.

Le Bouffon au luth

Les gens de milieux modestes étaient souvent représentés anonymement dans les portraits de genre. Ce musicien représente peut-être la coquetterie, à moins que le tableau ne soit une allégorie de l'ouïe.

Der Lautenspieler

Menschen einfacher Schichten wurden häufig anonym in Genreporträts dargestellt. Dieser Musiker könnte die Eitelkeit personifizieren, vielleicht ist das Bild auch eine Allegorie des Hörsinns.

El laudista

Las personas de clases sencillas a menudo eran retratadas anónimamente en retratos de género. Este músico podría personificar la vanidad, quizás la imagen es también una alegoría del oído.

Il suonatore di liuto

Persone di ceti semplici venivano spesso ritratte in forma anonima in ritratti di genere. Questo musicista potrebbe incarnare la vanità, forse l'immagine è anche un'allegoria dell'udito.

Luitspeler

Mensen van eenvoudige afkomst werden in genreportretten vaak anoniem afgebeeld. Deze muzikant zou ijdelheid kunnen personifiëren, maar misschien gaat het om een allegorie van het horen.

FRANS HALS (C. 1580-1666)

1623/24, Oil on canvas/Huile sur toile, 70 × 62 cm, Musée du Louvre, Paris

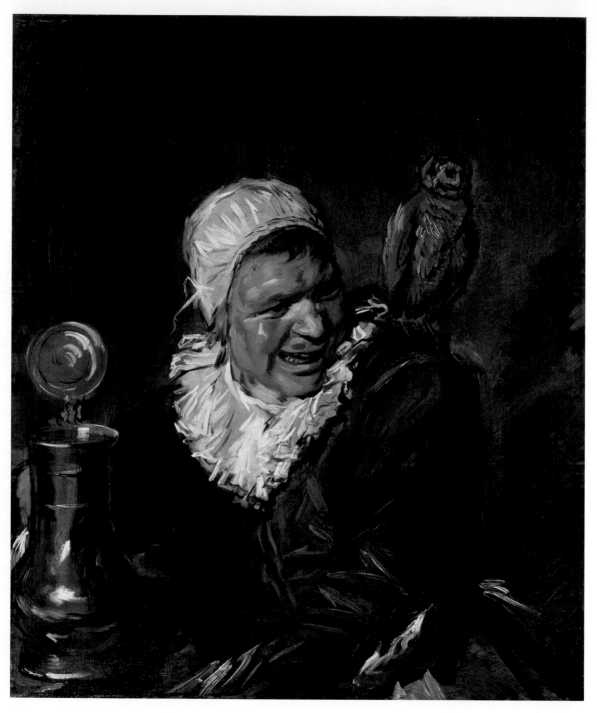

Malle Babbe

La Malle
Babbe *ou*
La Sorcière
de Haarlem

Malle Babbe

Malle Babbe

Babbo Natale
Malle

Malle Babbe

FRANS HALS
(C. 1580–1666)
1633–35, Oil
on canvas/
Huile sur toile,
75,8 × 66,2 cm,
Gemäldegalerie,
Berlin

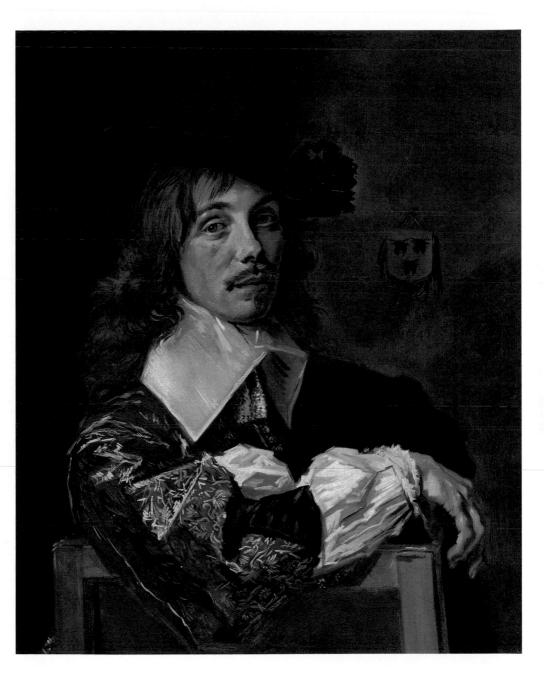

Willem Coymans

Hals captured the dandy-like clothing of this rich merchant with a few, sometimes almost abstract brushstrokes. He was the first to depict sitters informally: Coymans drapes his arm across the chair.

Portrait de Willem Coymans

Hals sut capturer la tenue de dandy de ce riche marchand en quelques coups de pinceau, avec un effet presque abstrait. Il fut le premier à placer son modèle dans une position informelle, le bras appuyé sur le dossier d'une chaise.

Willem Coymans

Hals erfasste die dandyhafte Kleidung dieses reichen Kaufmanns mit wenigen, teils abstrahierenden Pinselstrichen. Als Erster stellte er Porträtierte informell mit dem Arm auf der Rückenlehne eines Stuhls dar.

Hals plasmó la ropa de este rico mercader con unas pocas pinceladas, en parte abstractas. Fue el primero en retratar de manera informal con el brazo en el respaldo de una silla.

Willem Coymans

Hals riassunse l'abbigliamento da dandy di questo ricco mercante con poche pennellate, in parte astratte. Fu il primo a ritrarre in modo informale i dipinti con il braccio sullo schienale di una sedia.

Willem Coymans

Met een paar, deels abstracte penseelstreken legde Hals de dandy-achtige kleding van deze rijke koopman vast. Als eerste gaf hij de geportretteerden informeel weer met een arm op de rugleuning van een stoel.

FRANS HALS (C. 1580–1666)

1645, Oil on canvas/Huile sur toilo, 77 × 64 cm, National Gallery of Art, Washington, D. C.

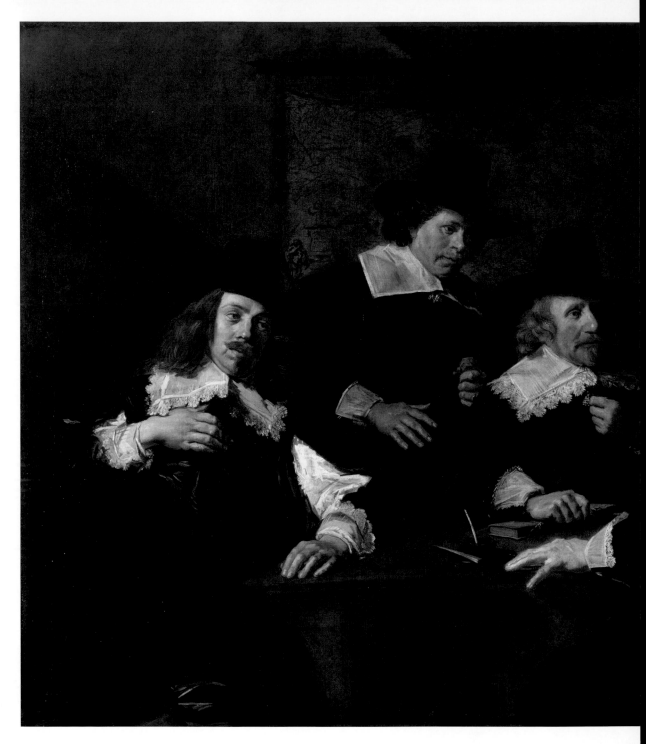

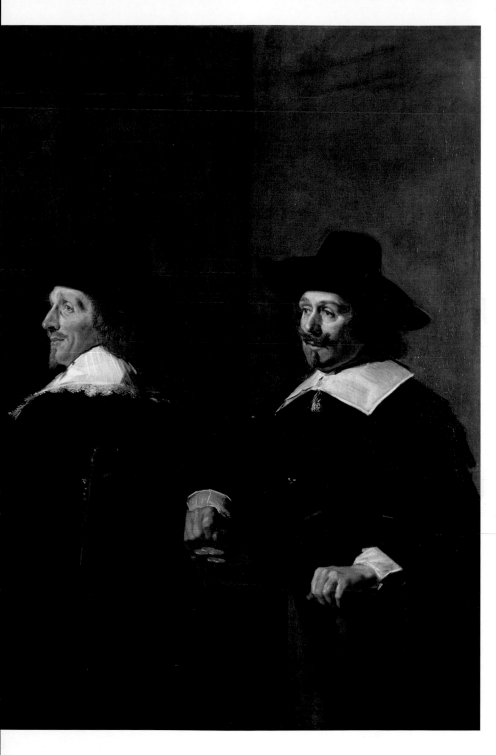

Regents of St Elisabeth's
Hospital in Haarlem

Portrait de groupe des régents de
l'hôpital Sainte-Élisabeth de Haarlem

Die Regenten des St.-Elisabeth-
Krankenhauses in Haarlem

Los regentes del Hospital
St. Elisabeth en Haarlem

I reggenti dell'Ospedale
Sant'Elisabetta di Haarlem

Groepsportret van de regenten
van het St. Elisabeths of Groote
Gasthuis te Haarlem

FRANS HALS (C. 1580–1666)

1641, Oil on canvas/Huile sur toile,
153 × 252 cm, Frans Hals Museum, Haarlem

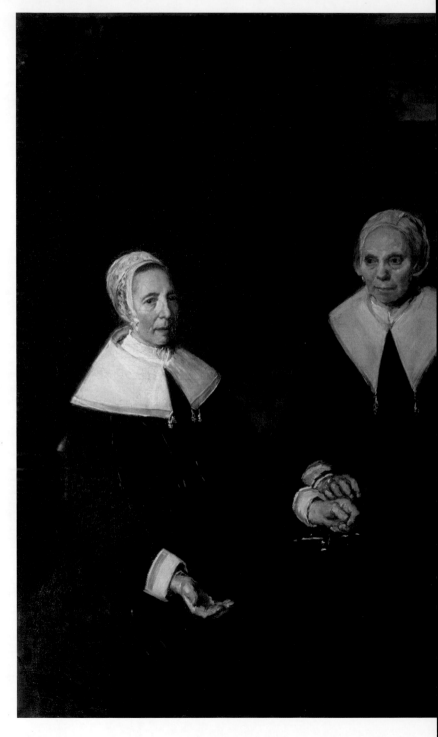

The Regentesses of the Old Men's Almshouse in Haarlem

Portrait de groupe des régentes de l'hospice de vieillards

Die Regentinnen des Altmännerhauses in Haarlem

Las regentes reglas del asilo de ancianos en Haarlem

Le reggenti dell'Ospizio dei vecchi da Haarlem

Regentessen van het Oudemannenhuis

FRANS HALS (C. 1580–1666)

c. 1664, Oil on canvas/Huile sur toile, 170,5 × 249,4 cm,
Frans Hals Museum, Haarlem

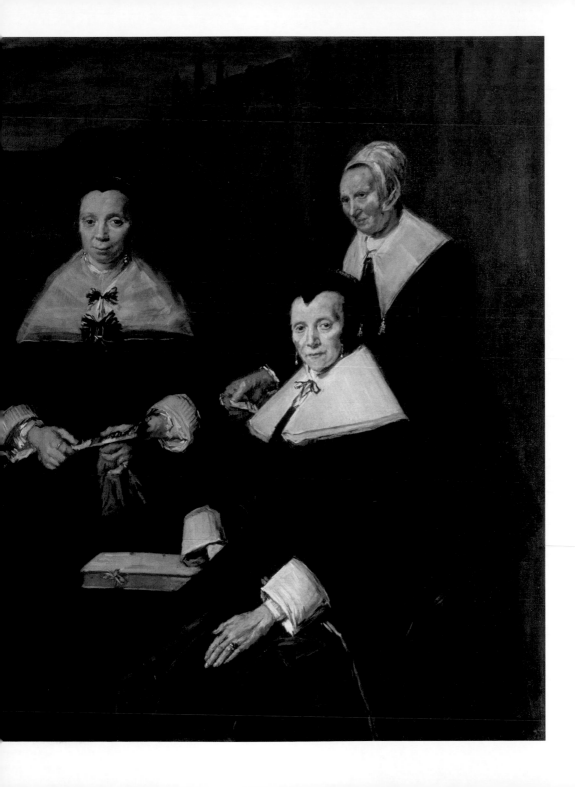

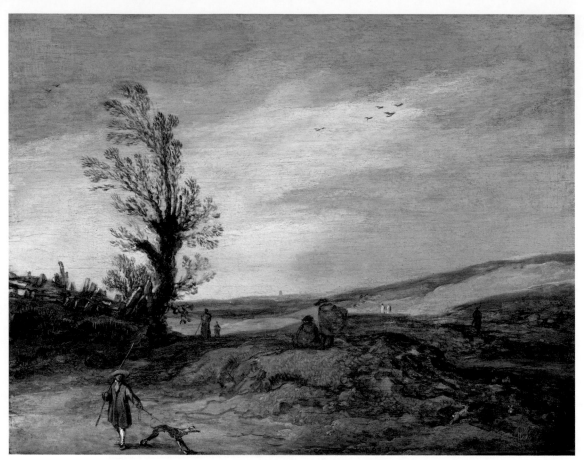

A View in
the Dunes

Vue des dunes

Dünenlandschaft

Paisaje con
dunas

Panorama
con dune

Duinlandschap

**ESAIAS VAN
DE VELDE
(1587–1630)**
1629, Oil on wood/
Huile sur bois,
17,7 × 22,7 cm,
Rijksmuseum,
Amsterdam

Land- and Cityscape:
Scenes of Dutch Life

In the 17th century, landscape painting became an
independent artistic genre, liberated from biblical or
mythological details. As of about 1630, landscapes
by northern Dutch painters in particular show a
detailed realism that offers a window into the reality of
contemporary life: ferries filled with people and cows sail
down rivers in front of city silhouettes; trees line a dusty
country road or bend in the wind; ships glide across the
sea in all kinds of weather. The cityscape also developed as
a genre; paintings of Amsterdam, ever expanding through
its rings of canals, depict new buildings in the style of
baroque classicism. Architectural painting also flourished
with perspectively exact pictures of church interiors.

Paysages ruraux et urbains :
les différents univers hollandais

Au XVIIe siècle, la peinture de paysages, libérée de ses
éléments bibliques ou mythologiques, devint un genre à
part entière. Les paysages du nord des Pays-Bas, surtout,
font preuve à partir de 1630 d'un réalisme très détaillé, qui
nous en dit long sur la réalité de la vie de l'époque : sur un
fleuve, un bac fait traverser les gens et les vaches, avec la
silhouette d'une ville en arrière-plan ; des arbres bordent
une route de campagne poussiéreuse, ou ploient dans
le vent ; dans les marines, différents bateaux affrontent
toutes sortes de conditions climatiques. En outre, le genre
du paysage urbain se développa à son tour. Les tableaux
d'Amsterdam, surtout, agrandie de manière méthodique
par plusieurs ceintures de canaux, montrent les nouvelles
constructions dans le style baroque classique. Enfin, la
peinture architecturale connut elle aussi son essor, avec
notamment des intérieurs d'églises rendus avec une
perspective parfaite.

Landschaft und Stadtlandschaft:
Holländische Lebenswelten

Im 17. Jahrhundert wurde die Landschaftsmalerei,
befreit von biblischen oder mythologischen Details,
zu einer eigenständigen Kunstgattung. Insbesondere
in den Landschaftsbildern der nördlichen Niederlande
zeigt sich seit etwa 1630 ein detailgetreuer Realismus,
der vieles über die damalige Lebenswirklichkeit aussagt:
In Flusslandschaften verkehren Fähren mit Menschen
und Kühen vor einer Stadtsilhouette; Bäume säumen
eine staubige Landstraße oder biegen sich im Wind; in
Seestücken befinden sich unterschiedliche Schiffe in einer
Vielzahl von Wetterlagen. Zudem entwickelte sich der
Bildtypus der Stadtlandschaft. Vor allem Gemälde von
Amsterdam, das durch den Grachtengürtel planmäßig
erweitert wurde, zeigen neue Bauten im Stil eines
barocken Klassizismus. Die Architekturmalerei gelangte
auch mit perspektivisch exakten Kircheninterieurs
zur Blüte.

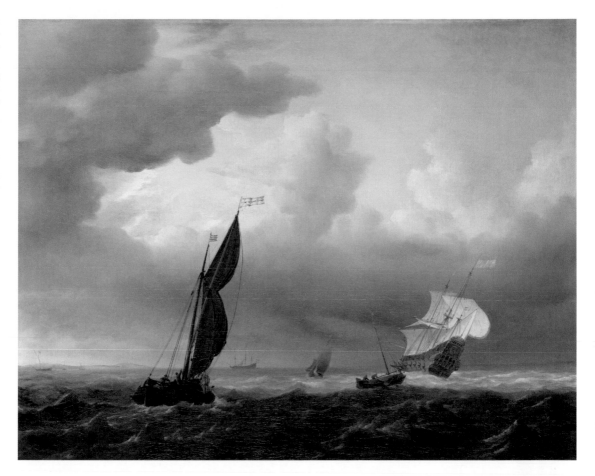

Paisaje natural y paisaje urbano: stilos de vida holandeses

n el siglo XVII, la pintura paisajística, liberada de los etalles bíblicos o mitológicos, se convirtió en una orma de arte independiente. Desde alrededor de 1630, os paisajes del norte de los Países Bajos en particular muestran un realismo detallado que dice mucho sobre realidad de la vida en aquellos días: en los paisajes uviales, los ferrys transitan con pasajeros y las vacas parecen frente a la silueta de una ciudad; los árboles ordean una polvorienta carretera rural o se doblan con viento; en las partes marinas hay diferentes barcos n una variedad de condiciones climáticas. Además, se esarrolló el tipo de imagen del paisaje urbano. Sobre do, las pinturas de Ámsterdam, que fueron ampliadas egún lo planeado por el cinturón del canal, muestran uevos edificios en el estilo del clasicismo barroco. La intura arquitectónica también floreció con los interiores erspectivamente exactos de la iglesia.

Panorama e paesaggio urbano: lo stile di vita olandese

Nel XVII secolo la pittura paesaggistica, svincolata dai dettagli biblici o mitologici, divenne una forma d'arte indipendente. Dal 1630 circa, i paesaggi dei Paesi Bassi settentrionali in particolare mostrano un realismo dettagliato che esprime la realtà della vita di quei tempi: nei paesaggi fluviali, i traghetti corrono con persone e mucche di fronte alla sagoma di una città, gli alberi fiancheggiano una strada di campagna polverosa o piegati dal vento, in scorci di mare si vedono sono diverse navi in una varietà di condizioni atmosferiche. Inoltre, si sviluppò il tipo di dipinto del paesaggio urbano. Soprattutto i dipinti di Amsterdam, ampliata secondo i piani nel sistema dei canali, mostrano nuovi edifici in stile classico barocco. Il dipinto architettonico fiorì anche con interni di chiesa con prospettive esatte.

Landschap en stadsbeeld: de Nederlandse levensstijl

In de 17e eeuw werd de landschapschilderkunst, bevrijd van Bijbelse of mythologische details, een zelfstandig kunstgenre. Vanaf omstreeks 1630 vertonen met name de landschappen uit de noordelijke Nederlanden een gedetailleerd realisme dat veel zegt over het werkelijke leven van die tijd: in rivierlandschappen varen veerboten met mensen en koeien voor een stadssilhouet; bomen omzomen een stoffige landweg of buigen mee met de wind; in zeestukken bevinden zich verschillende schepen onder uiteenlopende weersomstandigheden. Daarnaast kwam het stadslandschap als genre tot ontwikkeling. Vooral schilderijen van Amsterdam, dat met de grachtengordel planmatig werd uitgebreid, tonen nieuwe gebouwen in de stijl van het barokke classicisme. Het architectuurschilderij floreerde ook met perspectivisch exacte kerkinterieurs.

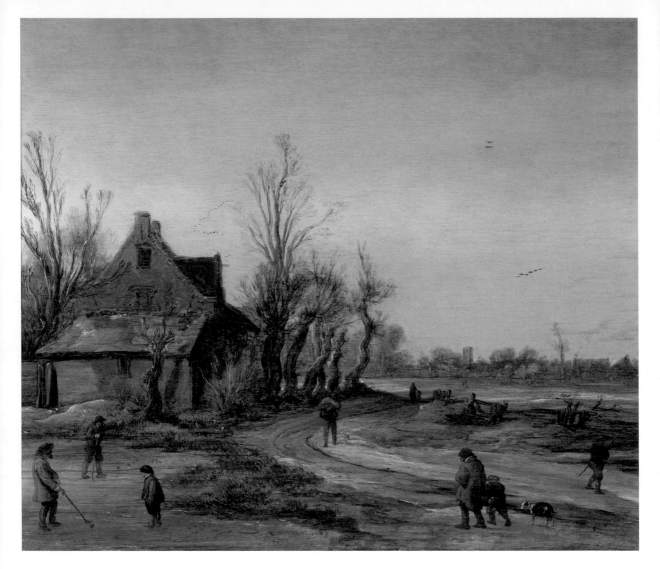

A Winter Landscape

A representative of the Haarlem School, van de Velde was an early realistic landscape painter. In addition to greater realism, he also introduced a low horizon into Dutch painting.

Paysage d'hiver

Van de Velde fut l'un des pionniers de la peinture de paysage réaliste, ainsi qu'un représentant de l'école de Haarlem. Outre sa grande précision, il introduisit dans ses tableaux l'horizon bas.

Eine Winterlandschaft

Van de Velde ist ein Protagonist der frühen realistischen Landschaftsmalerei Hollands und ein Vertreter der Haarlemer Schule. Neben größerem Realismus führte er einen niedrigen Horizont in die Gemälde ein.

Un paisaje invernal

Van de Velde es uno de los protagonistas de los primeros paisajes realistas de Holanda y un representante de la Escuela Haarlem. Además de un mayor realismo, introdujo un horizonte bajo en las pinturas.

Un paesaggio invernale

Van de Velde è un protagonista della prima pittura paesaggistica realistica dell'Olanda e un rappresentante della scuola di Haarlem. Oltre a un maggiore realismo, introdusse nei dipinti un orizzonte basso.

Winterlandschap

Van de Velde is een wegbereider van de vroege realistische Hollandse landschapschilderkunst en vertegenwoordiger van de Haarlemse school. Naast meer realisme introduceerde hij een lage horizon in de schilderijen.

ESAIAS VAN DE VELDE (1587-1630)
1623, Oil on oak/Huile sur chêne, 25,9 × 30,4 cm, The National Gallery, London

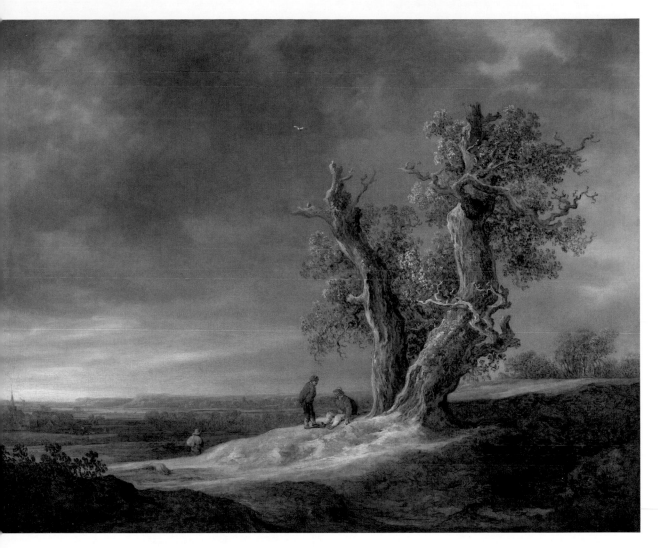

Landscape with Two Oaks

...completely ordinary motif—a rest by two old oaks under ...n ominous sky—becomes worthy of representation in the ...aturalistic landscape tradition of the northern Netherlands.

...aysage avec deux chênes

...e motif tout à fait quotidien – une pause au pied de deux ...hênes, sous un ciel menaçant – devint digne d'être peint dans ... peinture de paysage naturaliste du nord des Pays-Bas.

...N VAN GOYEN (1595–1656)
...41, Oil on canvas/Huile sur toile, 88,5 × 110,5 cm, Rijksmuseum, Amsterdam

Landschaft mit zwei Eichen

Ein völlig alltägliches Motiv – eine Rast an zwei alten Eichen unter dräuendem Himmel – ist in der naturalistischen Landschaftsmalerei der nördlichen Niederlande nun darstellungswürdig geworden.

Paisaje con dos robles

Un motivo completamente cotidiano –un descanso a los pies de dos robles viejos bajo un cielo agotador– se ha convertido ahora en digno de representación en la pintura paisajística naturalista del norte de los Países Bajos.

Paesaggio con due querce

Un motivo assolutamente quotidiano – il riposo tra due vecchie querce sotto un cielo scuro – è diventato oggi degno di essere rappresentato nella pittura di paesaggio naturalistico dei Paesi Bassi settentrionali.

Landschap met twee eiken

Een heel alledaags motief – een rustpauze bij twee oude eiken onder een dreigende hemel – is in de naturalistische landschapschilderkunst van de noordelijke Nederlanden de moeite van het afbeelden waard geworden.

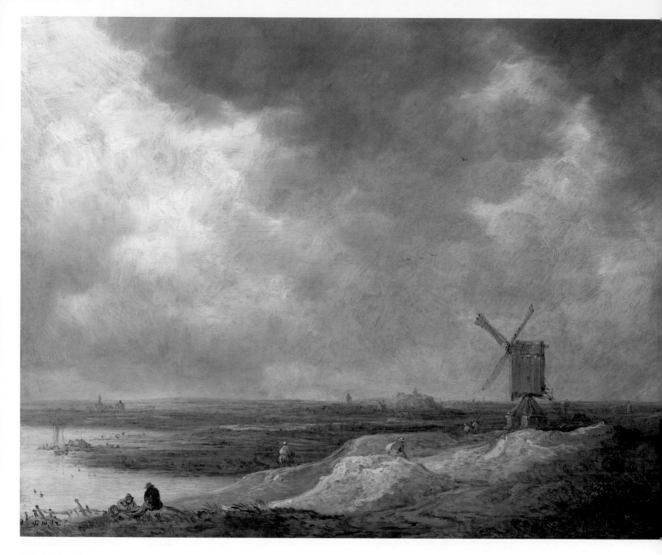

A Windmill by a River
This painting is an example of the tonal phase of Dutch landscape painting. The colors have been reduced almost entirely to greys and ochres, which dominate the flat, wide country and the sky.

Paysage fluvial avec moulin
Ce tableau est un exemple de la « phase tonale » de la peinture de paysage hollandaise. Les couleurs sont réduites à des nuances de gris et d'ocre, le vaste et plat pays ainsi que le ciel dominent l'image.

Eine Windmühle an einem Fluss
Dieses Gemälde ist ein Beispiel für die tonale Phase der holländischen Landschaftsmalerei. Die Farben wurden fast ganz auf Grau- und Ockertöne reduziert, es dominieren das flache, weite Land und der Himmel.

Un molino de viento en un río
Esta pintura es un ejemplo de la fase tonal de la pintura paisajística holandesa. Los colores se han reducido casi en su totalidad a tonos grises y ocres, dominando la llanura, la amplitud del paisaje y el cielo.

Mulino a vento su un fiume
Questo dipinto è un esempio della fase tonale della pittura paesaggistica olandese. I colori sono stati ridotti quasi interamente ai toni del grigio e dell'ocra, dominando la campagna, ampia e pianeggiante e il cielo.

Windmolen bij een rivier
Dit schilderij is een voorbeeld van de tonale fase van de Nederlandse landschapschilderkunst. De kleuren zijn bijna volledig teruggebracht tot grijs- en okertinten, die het vlakke, weidse landschap en de lucht domineren.

JAN VAN GOYEN (1596-1656)
1642, Oil on oak/Huile sur chêne, 29,4 × 36,3 cm, The National Gallery, London

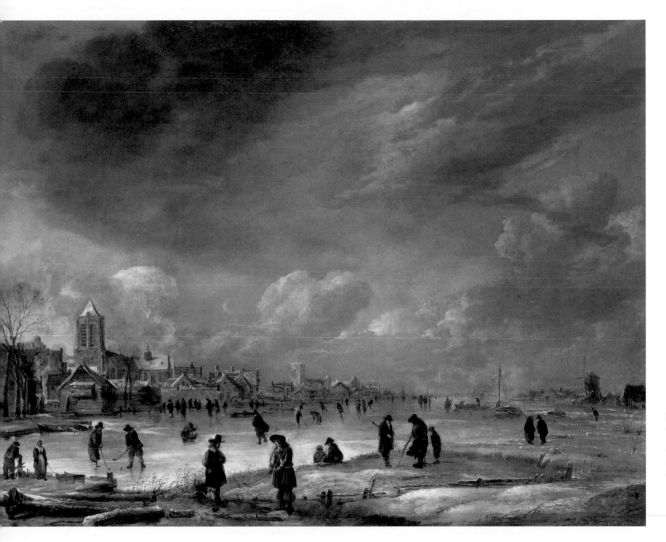

River View in Winter

Like many Dutch painters, van der Neer had specialised: he painted winter and night landscapes. Since, like many of his colleagues, he was unable to make a living from painting, he also ran a wine tavern.

Vue d'une rivière en hiver

Comme de nombreux autres peintres hollandais, van der Neer s'était spécialisé : il peignait des paysages nocturnes et hivernaux. Et comme beaucoup de ses collègues, il ne réussit pas à vivre de sa peinture et gagna sa vie grâce à une taverne.

Blick auf einen Fluss im Winter

Wie viele holländische Maler hatte sich van der Neer spezialisiert: Er malte Winter- und Nachtlandschaften. Und wie viele Kollegen konnte er von der Malerei nicht leben, weshalb er eine Weinschenke betrieb.

Vista de un río en invierno

Como muchos pintores holandeses, van der Neer se había especializado: pintaba paisajes de invierno y de noche. Y como muchos de sus colegas, no podía vivir de la pintura, por lo que dirigía una taberna de vinos.

Vista su un fiume in inverno

Come molti pittori olandesi, van der Neer si era specializzato: dipingeva paesaggi invernali e notturni. E come molti dei suoi colleghi, non riusciva a guadagnarsi da vivere dipingendo, ed è per questo che gestiva un'osteria.

Riviergezicht bij winter

Net als veel Nederlandse schilders had Van der Neer zich gespecialiseerd: hij schilderde winter- en nachtlandschappen. En net als veel van zijn collega's kon hij niet van de schilderkunst leven, zodat hij er een kroeg naast had.

AERT VAN DER NEER (1603/04-77)

1655-60, Oil on wood/Huile sur bois, 50,5 × 66 cm, Rijksmuseum, Amsterdam

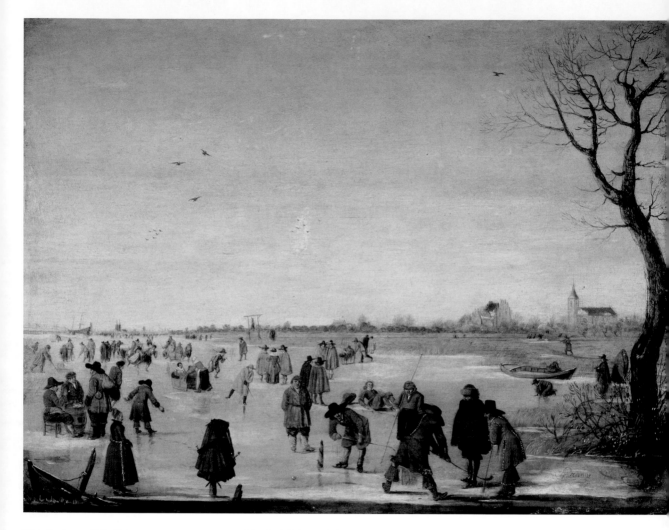

Winter Landscape with Ice Skaters
Avercamp specialised in ice-skating and winter scenes, a popular genre of Dutch painting. The 17th century coincided with the "Little Ice Age", when rivers and lakes often froze over.

Paysage d'hiver avec des patineurs
Avercamp se spécialisa dans les scènes d'hiver avec des patineurs, un genre prisé dans la peinture hollandaise. Le XVIIᵉ siècle se trouvait en plein dans le « petit âge de glace », les fleuves et les lacs étaient donc souvent gelés.

Winterlandschaft mit Eisläufern
Avercamp hatte sich auf Eislauf- und Winterszenen spezialisiert – ein beliebtes Genre der holländischen Malerei. Das 17. Jahrhundert fiel in die „Kleine Eiszeit", Flüsse und Seen waren häufig zugefroren.

Paisaje invernal con patinadores sobre hielo
Avercamp se había especializado en el patinaje sobre hielo y en escenas de invierno, un género popular de la pintura holandesa. El siglo XVII entró en la "Pequeña Edad de Hielo", los ríos y lagos a menudo se congelaban.

Paesaggio invernale con pattinatori su ghiaccio
Avercamp si era specializzata in pattinaggio su ghiaccio e scene invernali - un genere popolare della pittura olandese. Il XVII secolo cadde nella "Piccola Era Glaciale", fiumi e laghi erano spesso ghiacciati.

Winterlandschap met schaatsers
Avercamp had zich gespecialiseerd in schaatstafeleren en winterlandschappen, een populair genre in de Nederlandse schilderkunst. De 17e eeuw viel in de Kleine IJstijd, waardoor rivieren en meren vaak bevroren waren.

BARENT AVERCAMP (1612/13-79)
1632-79, Oil on wood/Huile sur bois, 38,5 × 50 cm, Groninger Museum, Groningen

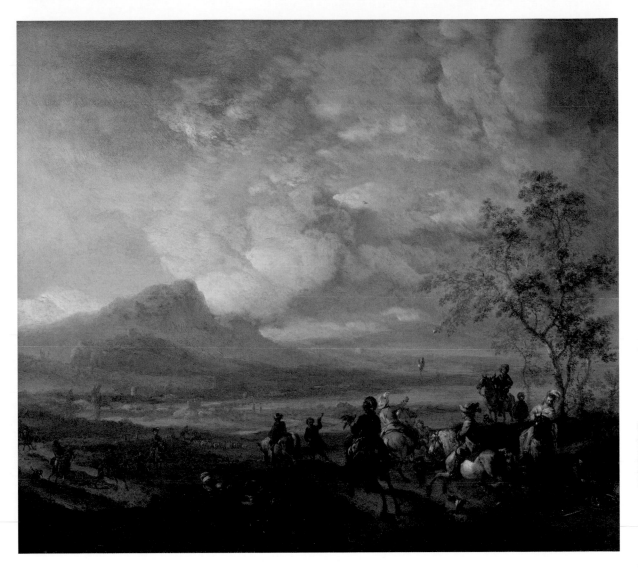

The Heron Hunt

La Chasse au héron

Reiherjagd

Caza de garzas

Caccia all'airone

Reigerjacht

PHILIPS WOUWERMAN (1619-68)

1650-68, Oil on copper/Huile sur cuivre, 26 × 30 cm, Rijksmuseum, Amsterdam

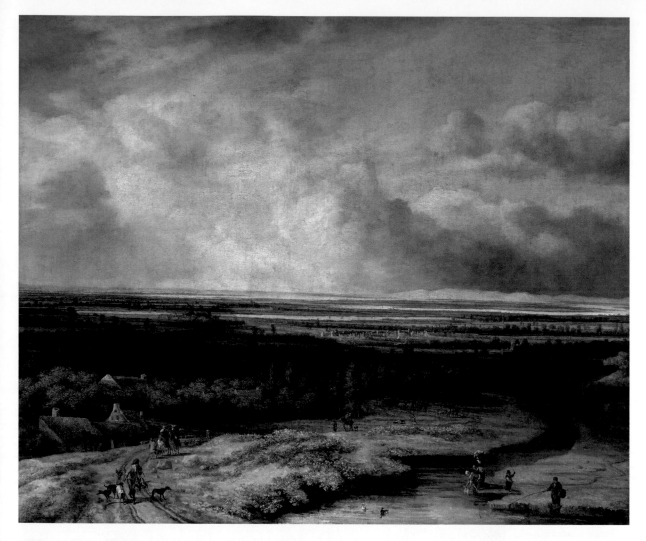

An Extensive Landscape with a Hawking Party
As of about 1650, Koninck painted wide landscapes whose horizon lines are rather high for Dutch pictures of the time. Other motifs can be found in the areas dedicated to the land and sky.

Paysage avec une partie de chasse au faucon
À partir de 1650 environ, Koninck peignit de larges paysages, où la ligne d'horizon était encore relativement haute pour la peinture hollandaise. Les autres motifs étaient subordonnés à l'espace consacré à la terre et au ciel.

Eine weite Landschaft mit einer Gesellschaft auf der Falkenjagd
Koninck malte seit etwa 1650 weite Landschaften, deren Horizontlinien für holländische Bilder der Zeit eher hoch liegt. Den Land und Himmel gewidmeten Bildbereichen ordnen sich weitere Motive unter.

Un paisaje amplio con una reunión en una cacería de halcones
Desde aproximadamente 1650 Koninck pintó amplios paisajes cuyas líneas de horizonte eran bastante altas para las imágenes holandesas de la época. Otros motivos se subdividen en zonas dedicadas a la tierra y al cielo.

Un vasto paesaggio con gruppo a caccia col falco
Dal 1650 circa Koninck dipinse ampi paesaggi le cui linee d'orizzonte per le immagini olandesi dell'epoca sono piuttosto alte. Altri motivi sono suddivisi in aree dedicate alla terra e al cielo.

Een weids landschap met een gezelschap op valkenjacht
Sinds ongeveer 1650 schilderde Koninck weidse landschappen waarvan de horizon voor Nederlandse schilderijen uit die tijd vrij hoog ligt. In de aan land en hemel gewijde vlakken zijn verdere motieven ondergeschikt gemaakt.

PHILIPS KONINCK (1619–88)
c. 1670, Oil on canvas/Huile sur toile, 132,5 × 160,5 cm, The National Gallery, London

Cattle and Cheep in a Stormy Landscape
Potter almost exclusively painted pictures of animals, which he often endowed with great personality. The dramatic lighting and the cattle placed against the sky make this small picture look almost monumental.

Bétail dans un paysage d'orage
Potter ne peignit presque que des animaux, auxquels il attribuait souvent une personnalité. Avec son éclairage inquiétant et son bœuf qui se dresse devant le ciel, ce tableau, pourtant de taille modeste, semble immense.

Rinder und Schafe in stürmischer Landschaft
Potter malte fast nur Bilder von Tieren, denen er häufig eine Persönlichkeit gab. Dieses nicht große Bild wirkt durch die dramatische Lichtführung und das vor dem Himmel stehende Rind geradezu monumental.

Ganado bovino y ovino en un paisaje tormentoso
Potter pintaba casi exclusivamente cuadros de animales a los que a menudo daba personalidad. La dramática iluminación y el ganado parado frente al cielo hacen que este pequeño cuadro parezca casi monumental.

Bovini e pecore in un paesaggio tempestoso
Potter dipingeva quasi esclusivamente quadri di animali ai quali spesso dava personalità. L'illuminazione spettacolare e il bovino in piedi di fronte al cielo rendono questo piccolo quadro quasi monumentale.

Runderen en schapen in een stormachtig landschap
Potter maakte bijna uitsluitend schilderijen van dieren, die hij vaak een persoonlijkheid gaf. De dramatische lichtvoering en het rund dat voor de hemel staat, maken dit kleine doek bijna monumentaal.

PAULUS POTTER (1625-54)
1647, Oil on oak/Huile sur chêne, 46,3 × 37,8 cm, The National Gallery, London

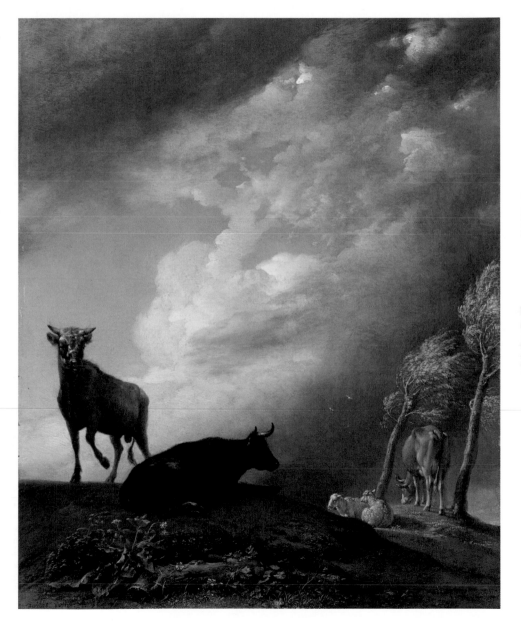

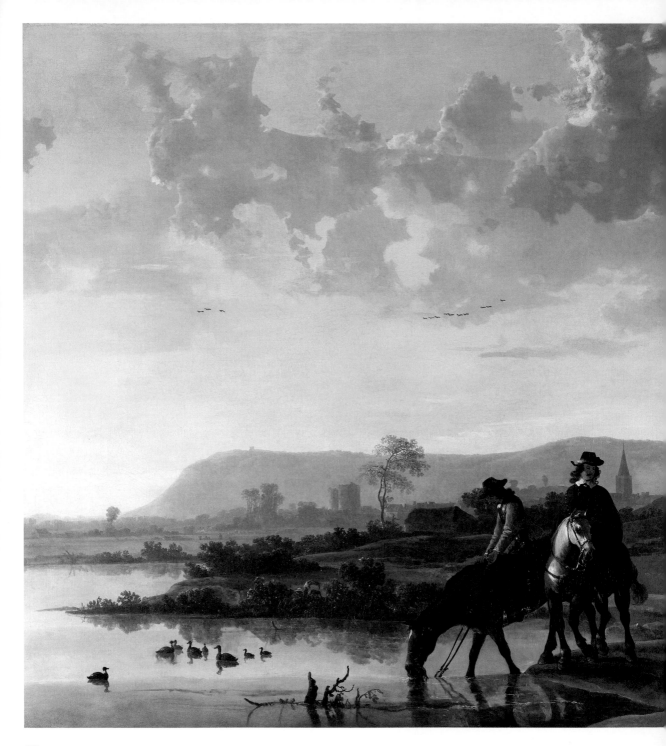

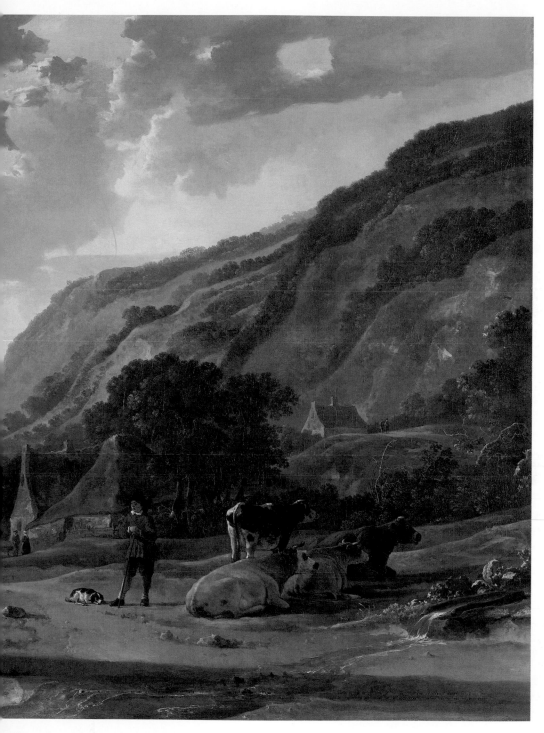

River Landscape
with Riders

Paysage fluvial
aux cavaliers

Flusslandschaft mit Reitern

Paisaje fluvial con jinetes

Paesaggio fluviale
con cavalieri

Rivierlandschap met ruiters

AELBERT CUYP (1620–91)
1653-57, Oil on canvas/Huile
sur toile, 128 × 227,5 cm,
Rijksmuseum, Amsterdam

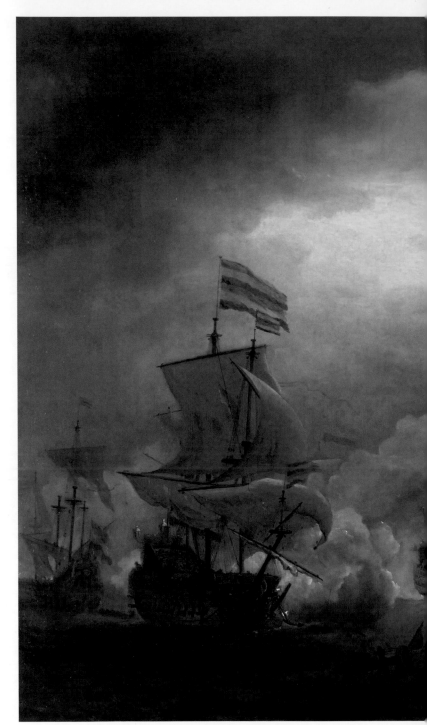

Encounter during the Battle of Kijkduin (The Nocturnal Battle)
The seascape as historical painting: in 1673, the Dutch victory
in the naval battle at Kijkduin prevented the English and French
from landing in Holland. The clouds of smoke give the impression
of a night scene.

La Bataille de Kijkduin ou Combat nocturne
À la fois une marine et une peinture d'histoire : en 1673, la victoire
des Pays-Bas lors de la bataille du Kijkduin empêcha les Anglais et
les Français d'accoster en Hollande. Les nuages de fumée donnent
l'impression d'une scène de nuit.

**Begegnung während der Seeschlacht vor
Kijkduin (Die nächtliche Schlacht)**
Das Seestück als Historienbild: 1673 verhinderte der Sieg der
Niederländer in der Seeschlacht bei Kijkduin, dass Engländer und
Franzosen in Holland landeten. Die Rauchwolken erwecken den
Eindruck einer Nachtszene.

**Encuentro durante la batalla naval frente
a Kijkduin (La batalla nocturna)**
El paisaje marino como pintura histórica: en 1673, la victoria de los
holandeses en la batalla naval de Kijkduin impidió a los ingleses
y franceses desembarcar en Holanda. Las nubes de humo dan la
impresión de una escena nocturna.

**Incontro durante la battaglia navale al largo
di Kijkduin (La battaglia notturna)**
Il paesaggio marino come quadro storico: nel 1673, la vittoria
degli olandesi nella battaglia navale di Kijkduin impedì agli inglesi
e ai francesi di sbarcare in Olanda. Le nuvole di fumo danno
l'impressione di una scena notturna.

Gevecht tijdens de zeeslag bij Kijkduin (Het nachtelijk gevecht)
Het zeegezicht als historisch schilderij: in 1673 voorkwam de
overwinning van de Nederlanders in de zeeslag bij Kijkduin de
landing van Engelsen en Fransen in Nederland. De rookwolken
wekken de indruk van een nachttafereel.

WILLEM VAN DE VELDE THE YOUNGER (1633–1707)
c. 1675, Oil on canvas/Huile sur toile, 114 × 183 cm,
Rijksmuseum, Amsterdam

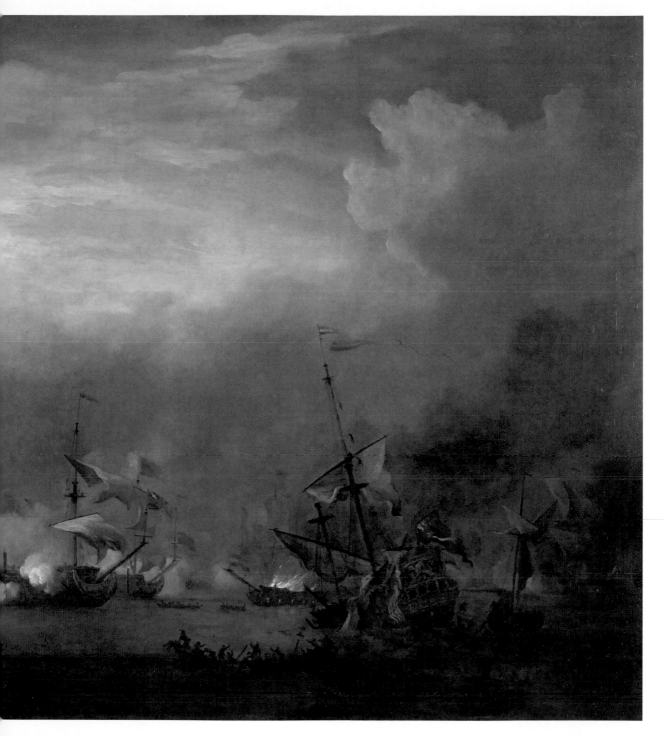

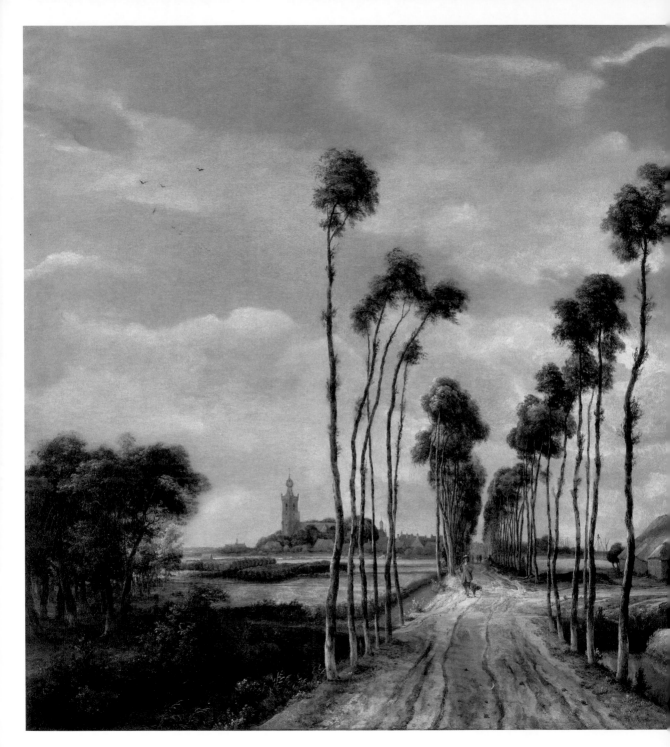

The Avenue at Middelharnis

Spotlight and symmetry lend something monumental to this simple street. The avenue, the planting of trees on the right, and the drainage ditches illustrate man's conquest of nature.

L'Allée de Middelharnis

Le point de vue et la symétrie confèrent à cette simple rue un caractère monumental. Cette allée, bordée d'arbres à gauche et d'un fossé de drainage à droite, montre comment l'homme a dompté la nature.

Allee in Middelharnis

Blickpunkt und Symmetrie verleihen einer einfachen Straße etwas Monumentales. Die Allee, die Baumpflanzung rechts und die Entwässerungsgräben veranschaulichen, wie sich der Mensch die Natur untertan machte.

La Avenida de Middelharnis

Los focos y la simetría le confieren a una simple calle algo monumental. La avenida, la plantación de árboles a la derecha y las acequias de drenaje ilustran cómo el hombre se sometió a la naturaleza.

Viale di Middelharnis

Punto prospettico e simmetria conferiscono a una semplice strada un aspetto monumentale. Il viale, gli alberi a destra e i fossati illustrano come l'uomo si sia sottomesso alla natura.

Het laantje van Middelharnis

Gezichtspunt en symmetrie verlenen een eenvoudig laantje iets monumentaal. De laan, de boomkwekerij rechts en de sloten illustreren hoe de mens de natuur aan zichzelf ondergeschikt maakte.

MEINDERT HOBBEMA (1638-1709)

1689, Oil on canvas/Huile sur toile, 103,5 × 141 cm, The National Gallery, London

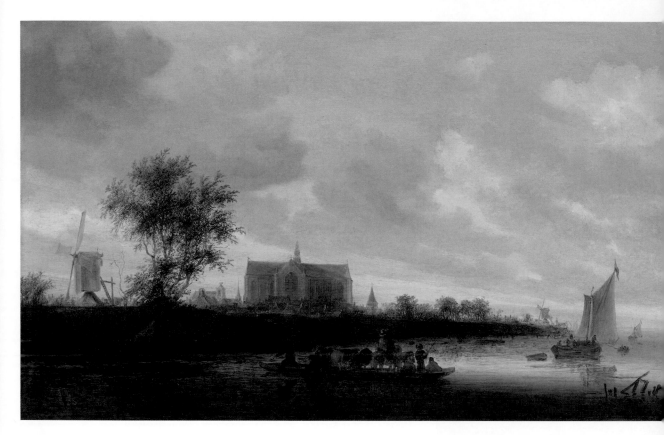

View of Alkmaar

Vue d'Alkmaar

Blick auf Alkmaar

Vista de Alkmaar

Vista su Alkmaar

Blik op Alkmaar

SALOMON VAN RUYSDAEL (C. 1600–70)

c. 1650–55, Oil on wood/Huile sur bois, 51,4 × 83,8 cm, Metropolitan Museum of Art, New York

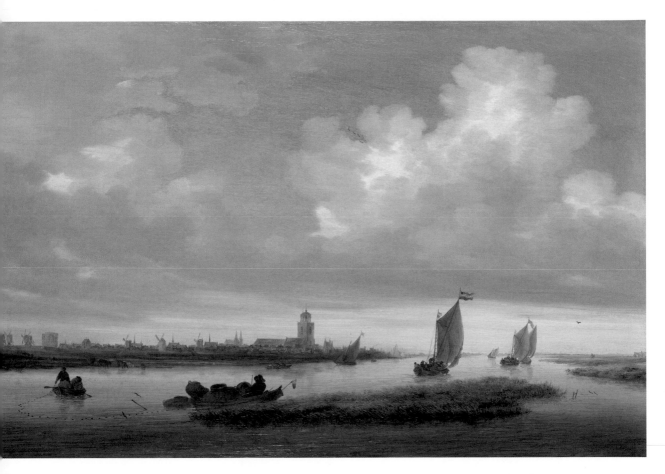

View of Deventer from the Northwest
Ruysdael, who worked in Haarlem, was the leading painter of water landscapes. Here, ships sail towards Deventer on the IJssel. The city is not represented in detail, though its main churches can be recognised.

Deventer vu du nord-ouest
Installé à Haarlem, Ruysdael fut l'un des fers de lance des marines. On voit ici des bateaux se diriger vers Deventer sur l'IJssel. La ville n'est pas rendue avec beaucoup d'exactitude, mais on reconnaît ses principales églises.

Blick auf Deventer von Nordwesten
Der in Haarlem arbeitende Ruysdael war der führende Maler von Wasserlandschaften. Hier segeln Schiffe auf der IJssel auf Deventer zu. Die Stadt ist nicht exakt wiedergegeben, doch sind ihre Hauptkirchen zu erkennen.

Vista de Deventer desde el noroeste
Ruysdael, que trabajaba en Haarlem, fue el principal pintor de paisajes acuáticos. Aquí los barcos navegan hacia Deventer en el IJssel. La ciudad no está exactamente representada, pero se pueden ver sus principales iglesias.

Vista su Deventer da nord-ovest
Ruysdael, che lavorò ad Haarlem, fu il principale pittore di paesaggi marini. Qui le navi navigano verso Deventer sull'IJssel. La città non è esattamente rappresentata, ma si possono riconoscere le chiese principali.

Gezicht op Deventer vanuit het noordwesten
De in Haarlem werkzame Van Ruysdael was de toonaangevende schilder van waterlandschappen. Hier varen schepen over de IJssel richting Deventer. De stad is niet precies weergegeven, maar de belangrijkste kerken zijn te zien.

SALOMON VAN RUYSDAEL (C. 1600-70)
1657, Oil on oak/Huile sur chêne, 51,8 × 76,5 cm, The National Gallery, London

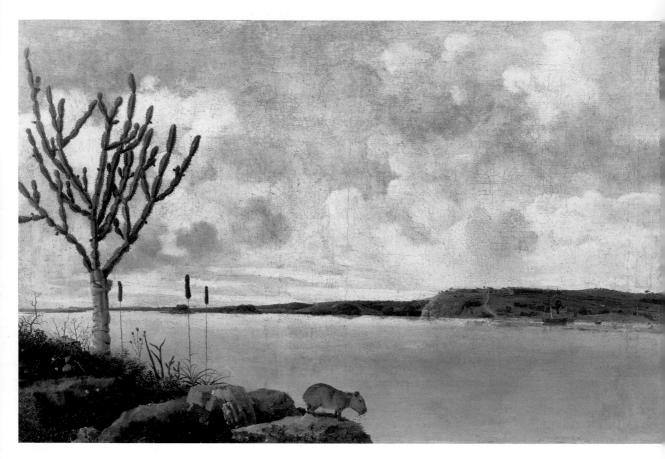

Rio São Francisco and Fort Maurits in Brazil

As part of an expedition to Brazil, Post painted realistic pictures of the Dutch colony there between 1636 and 1644. His later decorative-exotic paintings suited his customers' taste.

Le Rio São Francisco et le fort Maurice

Entre 1636 et 1644, Post prit part à une expédition vers le Brésil et y peignit des tableaux réalistes des colonies hollandaises. Ses tableaux tardifs, aussi décoratifs qu'exotiques, rencontraient le succès chez ses clients.

FRANS POST (C. 1612–80)

1639, Oil on canvas/Huile sur toile, 62 × 95 cm, Musée du Louvre, Paris

Rio São Francisco und Fort Maurits in Brasilien

Post malte von 1636 bis 1644 als Teilnehmer einer Expedition nach Brasilien realistische Bilder der dortigen holländischen Kolonie. Seine späteren dekorativ-exotischen Gemälde trafen den Kundengeschmack.

Río São Francisco y Fort Maurits en Brasil

Post pintó cuadros realistas de la colonia holandesa de 1636 a 1644 como parte de una expedición a Brasil. Sus pinturas decorativas-exóticas posteriores satisfacen el gusto del cliente.

Rio São Francisco e Fort Maurits in Brasile

Post dipinse ritratti realistici della colonia olandese lì 1636-1644 come parte di una spedizione in Brasile. I tardi dipinti decorativo-esotici hanno incontrato il gusto del cliente.

Rio São Francisco en Fort Maurits in Brazilië

Als lid van een expeditie naar Brazilië schilderde Post tussen 1636 en 1644 realistische doeken van de Nederlandse kolonie daar. Zijn latere decoratief-exotische schilderijen vielen erg in de smaak van klanten.

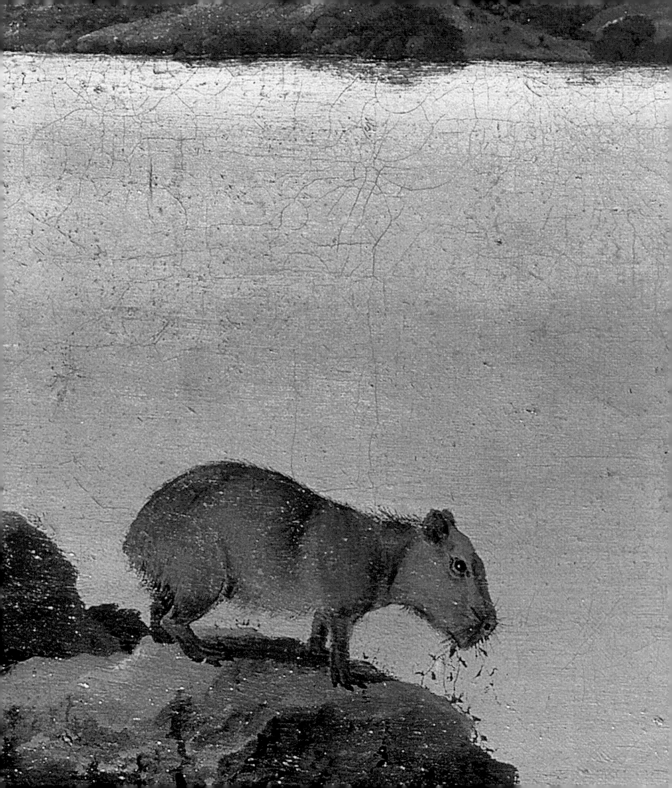

A Waterfall in a Rocky Landscape
Waterfalls exerted a great fascination on Ruisdael, though he never experienced them himself, and only knew them from drawings by a colleague from Amsterdam who had travelled through Scandinavia.

Paysage rocailleux avec une cascade
Les chutes d'eau exerçaient une grande fascination sur Ruisdael, alors qu'il n'en avait vu aucune de ses propres yeux et ne les connaissait que par les dessins d'un collègue amstellodamois qui avait voyagé en Scandinavie.

Wasserfall in felsiger Landschaft
Wasserfälle übten auf Ruisdael eine große Faszination aus – doch kannte er sie nicht aus eigener Anschauung, sondern nur aus Zeichnungen eines Amsterdamer Kollegen, der Skandinavien bereist hatte.

Cascada en un paisaje rocoso
Las cascadas ejercían una gran fascinación sobre Ruisdael, pero él no las conocía por su propia experiencia, sino sólo por los dibujos de un colega de Ámsterdam que había viajado por Escandinavia.

Cascata in un paesaggio roccioso
Le cascate hanno esercitato un grande fascino su Ruisdael – eppure le conosceva non per esperienza personale, ma solo grazie ai disegni di un collega di Amsterdam che aveva viaggiato attraverso la Scandinavia.

Waterval in een rotsachtig landschap
De watervallen oefenden een grote aantrekkingskracht uit op Van Ruisdael, maar hij kende ze niet uit eigen ervaring – alleen van tekeningen van een Amsterdamse collega die door Scandinavië gereisd had.

JACOB VAN RUISDAEL (C. 1628/29–82)
c. 1660–70, Oil on canvas/Huile sur toile, 98,5 × 85 cm, The National Gallery, London

Windmill at Wijk bij Duurstede | Die Mühle in Wijk bei Duurstede | Il mulino di Wijk vicino a Duurstede

Moulin de Wijk près de Duurstede | La fábrica en Wijk, cerca de Duurstede | De molen bij Wijk bij Duurstede

JACOB VAN RUISDAEL (C. 1628/29–82) c. 1668–70, Oil on canvas/Huile sur toile, 83 × 101 cm, Rijksmuseum, Amsterdam

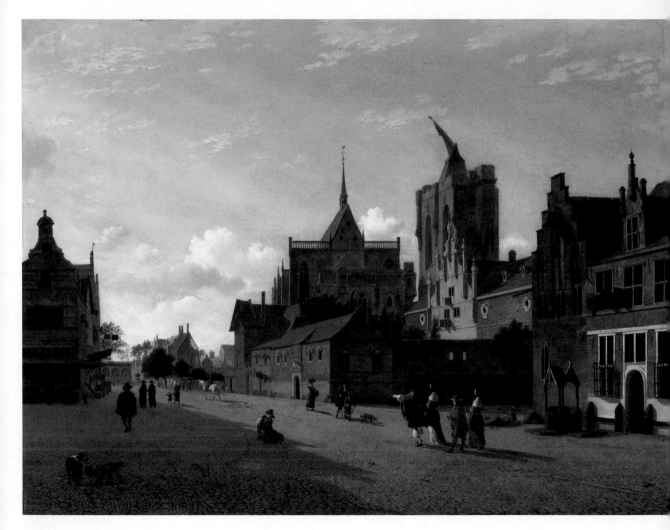

View of Cologne

Une vue de Cologne

Ansicht von Köln

Vista de la ciudad de Colonia

Vista di Colonia

Gezicht op Keulen

JAN VAN DER HEYDEN (1637–1712)

c. 1660-65, Oil on oak/Huile sur chêne, 33,1 × 42,9 cm, The National Gallery, London

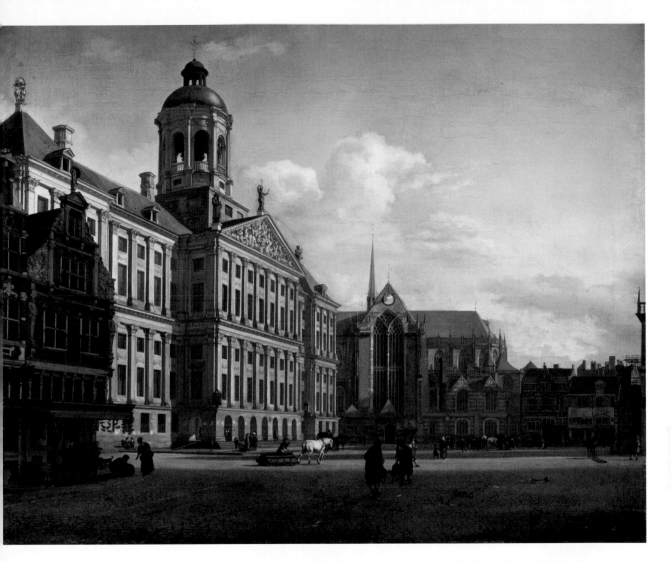

The Dam in Amsterdam with the New Town Hall
Construction of the magnificent New Town Hall of
Amsterdam began in 1648 in the modern classicist style,
according to the plans of Jacob van Campen—a monument to
the citizens' confidence.

Le Dam avec le nouvel hôtel de Ville à Amsterdam
Le nouvel hôtel de ville somptueux fut construit d'après les
plans de Jacob van Campens, à partir de 1648, dans un style
classique – un monument qui illustre bien l'assurance dont
faisait preuve la bourgeoisie.

JAN VAN DER HEYDEN (1637-1712)
1668, Oil on canvas/Huile sur toile, 73 × 86 cm, Musée du Louvre, Paris

Der Dam in Amsterdam mit dem Neuen Rathaus
Das prachtvolle Neue Rathaus von Amsterdam wurde
ab 1648 nach Plänen Jacob van Campens im modernen
klassizisistischen Stil errichtet – ein Monument des
Selbstbewusstseins der Bürgerschaft.

La presa en Amsterdam con el nuevo Ayuntamiento
El magnífico Ayuntamiento Nuevo de Ámsterdam fue
construido a partir de 1648 según los planos de Jacob van
Campen en el estilo clasicista moderno– un monumento de la
autoconfianza de los ciudadanos.

La diga di Amsterdam con il Municipio Nuovo
Il magnifico Municipio Nuovo di Amsterdam è stato
costruito dal 1648 secondo i piani di Jacob van Campen in
stile classicista moderno – un monumento della fierezza dei
cittadini.

De Dam in Amsterdam met het Nieuwe Stadhuis
Het prachtige Nieuwe Stadhuis van Amsterdam werd vanaf
1648 in de moderne classicistische stijl gebouwd naar een
ontwerp van Jacob van Campen – een monument van het
zelfvertrouwen van de burgerij.

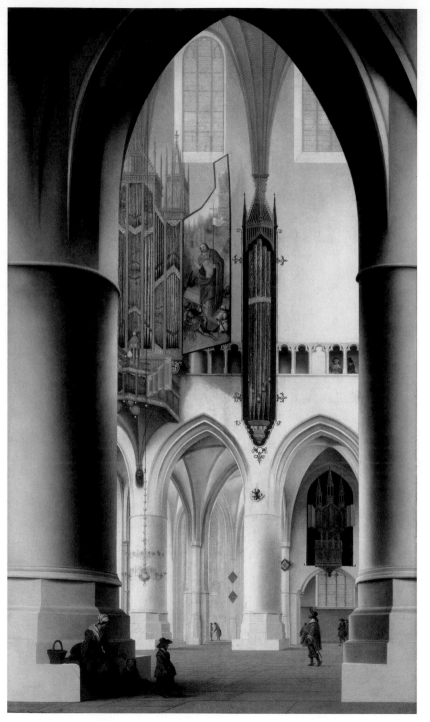

The Interior of St Bavo in Haarlem
The architectural painter Saenredam has chosen the perspective of a visitor to the church. His gaze falls on the richly painted organ, left over from Catholic times, which contrasts with the otherwise Protestant lack of adornment.

Intérieur de l'église Saint-Bavon de Haarlem
Saenredam, peintre d'architecture, a choisi la perspective d'une personne qui entre dans l'église : le regard se pose sur les orgues richement peintes, datant de l'époque catholique, qui contrastent avec le dépouillement protestant.

Das Innere der St.-Bavo-Kirche in Haarlem
Der Architekturmaler Saenredam wählte die Perspektive eines Besuchers der Kirche. Dessen Blick fällt auf die reich bemalte Orgel aus katholischen Zeiten, die mit der protestantischen Schmucklosigkeit kontrastiert.

El interior de la iglesia de San Bavo en Haarlem
El pintor arquitectónico Saenredam eligió la perspectiva de un visitante de la iglesia. Su mirada se fija en el órgano ricamente pintado de la época católica, que contrasta con la desnudez protestante.

L'interno della chiesa di St. Bavo ad Haarlem
Il pittore di architettura Saenredam ha scelto la prospettiva di un visitatore della chiesa. Il suo sguardo cade sull'organo riccamente dipinto dell'epoca cattolica, che contrasta con l'austerità protestante.

Interieur van de Sint-Bavokerk in Haarlem
De architectuurschilder Saenredam koos voor het perspectief van een bezoeker van de kerk. Diens blik valt op het rijk beschilderde orgel uit de katholieke tijd, dat contrasteert met de protestantse soberheid.

PIETER JANSZ. SAENREDAM (1597–1665)
1636, Oil on wood/Huile sur bois, 94 × 55 cm, Rijksmuseum, Amsterdam

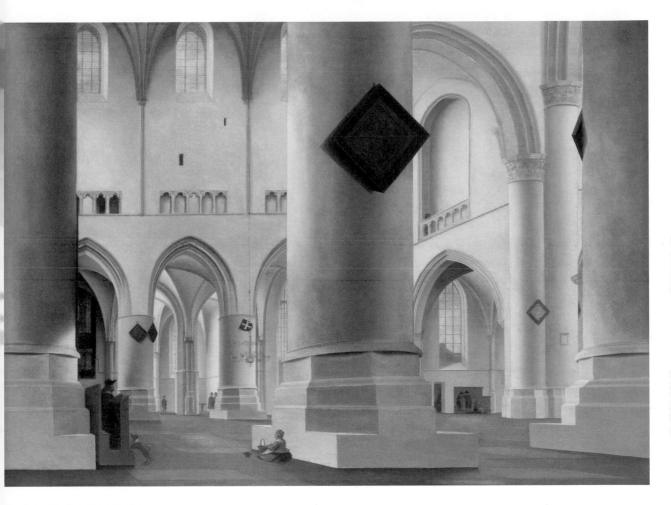

The Interior of the Grote Kerk at Haarlem

Intérieur de l'église Saint-Bavon de Haarlem

Das Innere der Grote Kerk in Haarlem

El interior de la Grote Kerk en Haarlem

L'interno del Grote Kerk a Haarlem

Het interieur van de Grote Kerk te Haarlem

PIETER JANSZ. SAENREDAM (1597–1665)

1636/37, Oil on oak/Huile sur chêne, 59,5 × 81,7 cm, The National Gallery, London

**View of the Tomb of William the Silent
in the New Church in Delft**

De Witte was a painter of church interiors and figures. Here,
in a scene reminiscent of genre painting, a guided tour pauses
by the tomb of a Dutch national hero murdered in the struggle
for independence.

**Intérieur de la Nieuwe Kerk de Delft, avec vue
de la tombe de Guillaume le Taciturne**

De Witte était spécialisé dans les intérieurs d'églises et les
personnages. On peut voir ici une visite guidée qui rappelle
la peinture de genre, devant la tombe du héros national
hollandais, mort pendant la guerre d'indépendance.

**Das Grabmal von Wilhelm dem Schweiger
in der Nieuw Kerk in Delft**

De Witte war Maler von Kircheninterieurs und auch
Figurenmaler. Hier findet eine an die Genremalerei erinnernde
Führung vor dem Grabmal des im Unabhängigkeitskampf
ermordeten holländischen Nationalhelden statt.

**Interior de la Nieuwe Kerk, en Delft,
con la tumba de Guillermo el Silencioso.**

De Witte fue pintor de interiores de iglesias y también pintor
de figuras. Aquí, frente a la tumba del héroe nacional holandés
asesinado en la lucha por la independencia, tiene lugar una
visita guiada que recuerda a la pintura de género.

**Nuova chiesa in Delft con tomba di William
il silenzioso**

De Witte era un pittore di interni di chiese e anche un
ritrattista di figure. Qui, una visita guidata che ricorda
la pittura di genere si svolge davanti alla tomba dell'eroe
nazionale olandese ucciso nella lotta per l'indipendenza.

**Grafmonument van Willem de Zwijger
in de Nieuwe Kerk in Delft**

De Witte was naast schilder van kerkinterieurs ook
figurenschilder. Hier vindt een aan de genreschilderkunst
herinnerende rondleiding plaats voor het grafmonument
van de in de Tachtigjarige Oorlog vermoorde held van het
Nederlandse volk.

EMANUEL DE WITTE (1617–92)

1656, Oil on canvas/Huile sur toile, 97 × 85 cm, Palais des Beaux-Arts, Lille

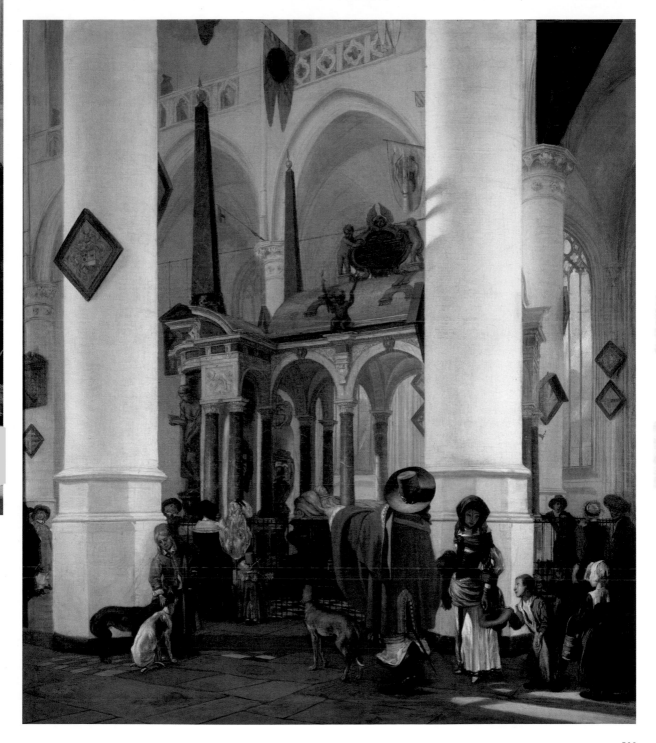

The "Golden Bend" in the Herengracht, Amsterdam, Seen from the West
Berckheyde was one of the most important painters of urban landscapes, which developed into an independent genre after 1650. The "Golden Bend" is the richest part of the Herengracht in Amsterdam.

Le Virage du Herengracht, vu de l'ouest
Berckheyde fut l'un des plus grands peintres de paysages urbains, qu'il développa après 1650 pour en faire un genre à part entière. La « courbure d'or » est le tronçon le plus chic du Herengracht, qui fait partie des élargissements d'Amsterdam.

Die Gouden Bocht in der Herengracht von Westen
Berckheyde war einer der wichtigsten Maler von Stadtlandschaften, die sich nach 1650 als eigenes Genre entwickelten. Die „Goldene Biegung" ist der vornehmste Teil der Herengracht in Amsterdam

El Gouden Bocht en el Herengracht del oeste
Berckheyde fue uno de los pintores más importantes de paisajes urbanos que se desarrollaron como género propio después de 1650. El "Golden Bend" es la parte más noble del Herengracht en Amsterdam.

Il Gouden Bocht nell'Herengracht da ovest
Berckheyde fu uno dei più importanti pittori di paesaggi urbani, che si sviluppò come genere a sé stante dopo il 1650. La "Golden Bend" è la parte più nobile dell'Herengracht di Amsterdam.

Gezicht op de Gouden Bocht in de Herengracht
Berckheyde was een van de belangrijkste schilders van stadslandschappen, die zich na 1650 ontwikkelden tot een apart genre. De Gouden Bocht is het voornaamste deel van de Herengracht in Amsterdam.

GERRIT BERCKHEYDE (1638–98)
1672, Oil on wood/Huile sur bois, 40,5 × 63 cm, Rijksmuseum, Amsterdam

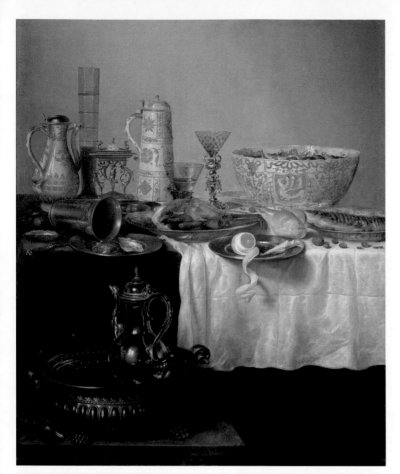

WILLEM CLAESZ. HEDA (1594–1680)

1638, Oil on canvas/Huile sur toile, 118,4 × 97,5 cm, Hamburger Kunsthalle

PIETER CLAESZ (C. 1597–1660)

1656, Oil on oak/Huile sur chêne, 39,5 × 60,5 cm, Kunsthistorisches Museum, Wien

Dutch Still Lifes: Splendour and Transience

Especially in the 17th century, still life in the northern (and southern) Netherlands developed into a popular genre in whose many subgenres painters often specialised. Various, often exquisite objects are apparently presented incidentally, as if after a meal: tropical fruits and dishes with exotic spices, gold vessels and goblets with nautilus shells, oriental carpets and porcelain brought to the country by the Dutch East India Company. In many still lifes, enjoyment in the sumptuous or pleasurable dominates; in some, withered leaves or insects quietly remind the viewer that everything earthly is transient. This is the message of vanitas still lifes, in which sheet music and instruments refer to fading melodies, clocks to the passage of time, or skulls to the finitude of life.

Les natures mortes hollandaises : entre le cossu et l'éphémère

Au XVIIᵉ siècle surtout, la nature morte connut un véritable essor dans le nord et le sud des Pays-Bas, devenant un genre très prisé aux multiples sous-catégories, dans lesquelles se spécialisaient les peintres. Les objets les plus divers, généralement raffinés, y apparaissaient comme par hasard, comme laissés là après un repas : fruits venus d'ailleurs et mets aux épices exotiques, coupelles en or et coupes nautilus, tapis orientaux et porcelaine, qui avaient fait leur entrée dans le pays via les échanges commerciaux de la Compagnie néerlandaise des Indes orientales. Dans nombre de natures mortes, la joie des richesses et des délices dominait, mais dans d'autres, feuilles mortes et insectes faisaient figure de mise en garde, rappelant que tout sur Terre est éphémère. Tel était le principal message des vanités, où les notes et instruments rappelaient que la musique s'estompe peu à peu, les horloges que le temps passe, et les crânes que la vie n'est pas éternelle.

Holländische Stillleben: Pracht und Vergänglichkeit

Vor allem im 17. Jahrhundert entwickelte sich das Stillleben in den nördlichen (und südlichen) Niederlanden zu einer populären Bildgattung mit vielen Untertypen, auf die sich Maler spezialisierten. Verschiedenste, oft erlesene Objekte werden scheinbar beiläufig, wie nach einer Mahlzeit, präsentiert: Südfrüchte und Speisen mit exotischen Gewürzen, Goldgefäße und Pokale mit Nautilusmuscheln, Orientteppiche und Porzellane, die durch den Handel der Niederländischen Ostindien-Kompanie ins Land gelangt waren. In vielen Stillleben dominiert die Freude am Kostbaren oder Genussbringenden, in manchen gesellt sich mit verwelkten Blättern oder Insekten die leise Mahnung dazu, dass alles Irdische vergänglich ist. Dies ist die Hauptbotschaft der Vanitas-Stillleben, in denen Noten und Instrumente auf verklungene Musik, Uhren auf die verrinnende Zeit oder Totenschädel auf die Endlichkeit des Lebens verweisen.

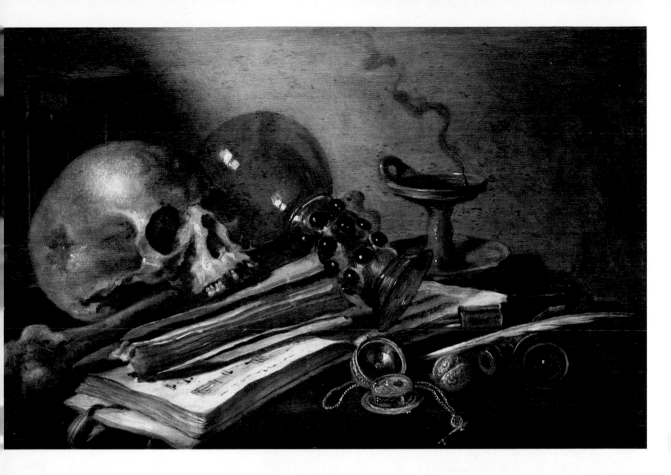

Naturaleza muerta holandesa: esplendor y fugacidad

Especialmente en el siglo XVII, las naturalezas muertas del norte (y del sur) de los Países Bajos se convirtieron en un género popular con muchos subtipos en los que los pintores se especializaron. Varios objetos, a menudo exquisitos, se presentan de paso, como después de una comida: frutas tropicales y comida con especias exóticas, vasijas de oro y tazas con conchas de nautilo, alfombras orientales y porcelana, que llegaron al país a través del comercio de la Compañía Holandesa de las Indias Orientales. En muchos bodegones domina la alegría de lo precioso o placentero; en algunos, con hojas marchitas o insectos, se acompaña de un silencioso recordatorio de que todo lo terrenal es pasajero. Este es el mensaje principal de los bodegones de vanitas, en los que las notas y los instrumentos se refieren a la música que se desvanece, los relojes al paso del tiempo o los cráneos a la finitud de la vida.

Nature morte olandesi: Splendore e transitorietà

Soprattutto nel XVII secolo, le nature morte nei Paesi Bassi settentrionali (e meridionali) si svilupparono in un genere popolare con molti sottotipi in cui si specializzarono i pittori. Diversi oggetti, spesso squisiti, sono esibiti in modo casuale, come dopo un pasto: frutti tropicali e cibo con spezie esotiche, vasi d'oro e tazze con gusci di nautilus, tappeti orientali e porcellane, importati nel paese attraverso il commercio della Compagnia Olandese delle Indie Orientali. In molte nature morte domina la gaiezza del prezioso o il godimento delle cose, in alcune, con foglie appassite o insetti, è accompagnata da un quieto monito che tutto ciò che è terreno è transitorio. Questo è il messaggio principale delle vanitas, in cui note e strumenti musicali rimandano alla musica che si smorza, orologi al passare del tempo o teschi alla finitezza della vita.

Nederlandse stillevens: pracht en vergankelijkheid

Vooral in de 17e eeuw groeide het stilleven in de noordelijke (en zuidelijke) Nederlanden uit tot een populair genre met allerlei subtypen, waar schilders zich in specialiseerden. Verschillende, vaak prachtige objecten worden schijnbaar terloops gepresenteerd, bijvoorbeeld na een maaltijd: zuidvruchten en voedsel met exotische specerijen, gouden vaatwerk en bokalen van nautilusschelpen, oosterse tapijten en porselein, die via de handel van de Nederlandse Oost-Indische Compagnie het land binnenkwamen. In veel stillevens domineert de vreugde van het kostbare of aangename; in sommige, met verdorde bladeren of insecten, gaat die gepaard met een stille herinnering aan het feit dat al het aardse van voorbijgaande aard is. Dit is de belangrijkste boodschap van vanitas-stillevens, waarin noten en instrumenten verwijzen naar wegebbende muziek, klokken naar het verstrijken van de tijd of schedels naar de eindigheid van het leven.

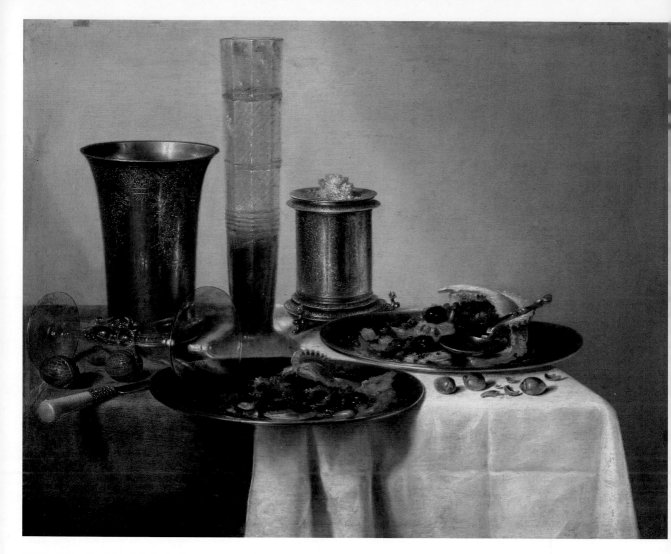

Still Life with Silver Vessels (The End of the Meal)
Heda's speciality were still lifes in a reduced color palette, called tonal "banketjes". The predominant shades of grey or brown are only sparingly combined with other colors.

Fin de collation *ou* Un dessert
Heda était spécialisé dans les natures mortes à la palette de couleurs réduite, qualifiées de « banketjes » monochromes. Les tons gris et bruns dominent largement, les autres couleurs ne sont utilisées qu'avec parcimonie.

WILLEM CLAESZ. HEDA (1594–1680)
1637, Oil on wood/Huile sur bois, 44 × 55 cm, Musée du Louvre, Paris

Stillleben mit Silbergefäßen (Das Ende des Mahls)
Hedas Spezialität waren Stillleben in einer reduzierten Farbpalette, die als tonale „banketjes" bezeichnet werden. Die vorherrschenden Grau- oder Brauntöne sind nur sparsam mit anderen Farben kombiniert.

Bodegón con Vasos de Plata (El Fin del Molino)
La especialidad de Heda eran los bodegones en una paleta de colores reducida, llamados "banketjes" tonales. Los tonos predominantes de gris o marrón sólo se combinan escasamente con otros colores.

Natura morta con recipienti d'argento (la fine del pasto)
La specialità di Heda erano le nature morte in una scelta di colori ridotta, chiamate "banketjes" tonali. Le tonalità predominanti di grigio o marrone si combinano solo con parsimonia con altri colori.

Stilleven met zilveren kannen (Het einde van de maaltijd)
Heda's specialiteit waren stillevens in een gereduceerd kleurenpalet, die tonale 'banketgens' werden genoemd. De overheersende grijs- of bruintinten worden slechts miniem gecombineerd met andere kleuren.

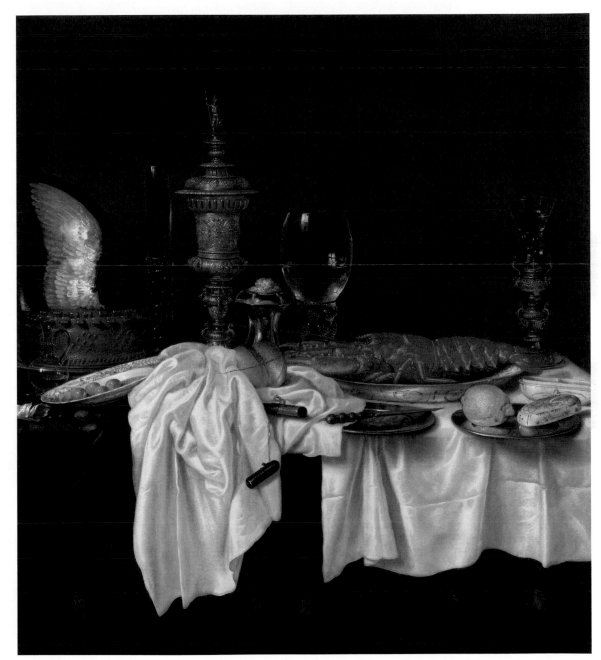

Still Life with
Lobster

Nature morte
au homard

Stillleben mit
Hummer

Naturaleza
muerta con
langosta

Natura morta
con aragosta

Stilleven
met kreeft

**WILLEM
CLAESZ. HEDA
(1594-1680)**
1650-59,
Oil on canvas/
Huile sur toile,
114 × 103 cm,
The National
Gallery, London

Still Life with Turkey Pâté

The contemporary observer of this food still life ("banketje" or "ontbijtje") would have immediately noticed the costliness of everything depicted – in addition to the wealth of the piece's owner.

Nature morte à la tourte et à la dinde

Le caractère précieux de tous les éléments de cette nature morte représentant un repas (en néerlandais « banketje » ou « ontbijtje ») devait sauter aux yeux des spectateurs de l'époque, au même titre que la richesse du propriétaire de cette œuvre.

Stillleben mit Truthahnpastete

Dem zeitgenössischen Betrachter dieses Mahlzeiten-Stilllebens („banketje" oder „ontbijtje") dürfte die Kostbarkeit alles Dargestellten sofort aufgefallen sein – wie wohl auch der Reichtum des Besitzers des Kunstwerks.

Bodegón con paté de pavo

El observador contemporáneo de este bodegón ("banketje" u "ontbijtje") puede haber notado inmediatamente la preciosidad de todo lo representado - como probablemente también la riqueza del propietario de la obra de arte.

Natura morta con tacchino

L'osservatore contemporaneo di questa natura morta con banchetto ("banketje" o "ontbijtje") può aver notato immediatamente la preziosità di tutto ciò che viene raffigurato - come probabilmente anche la ricchezza del proprietario dell'opera d'arte.

Stilleven met kalkoenpastei

De hedendaagse toeschouwer van dit maaltijdstilleven ('banketgen' of 'ontbijtgen') heeft mogelijk meteen de kostbaarheid van alles opgemerkt – en waarschijnlijk ook de rijkdom van de eigenaar van het doek.

PIETER CLAESZ (C. 1597–1660)

1627, Oil on wood/Huile sur bois, 75 × 132 cm, Rijksmuseum, Amsterdam

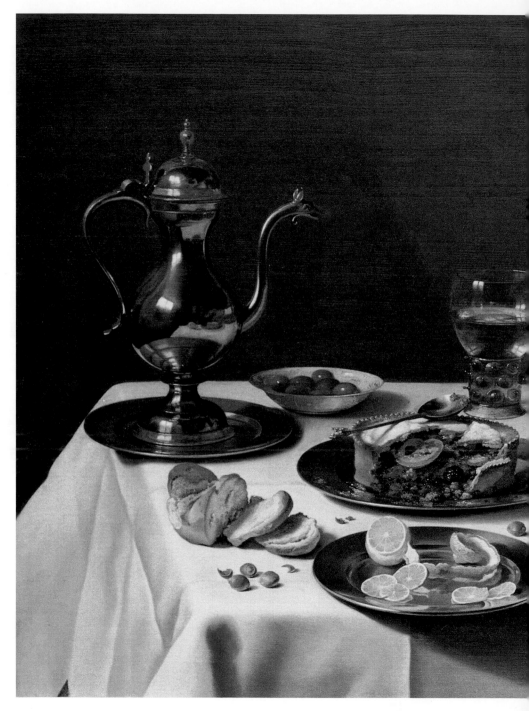

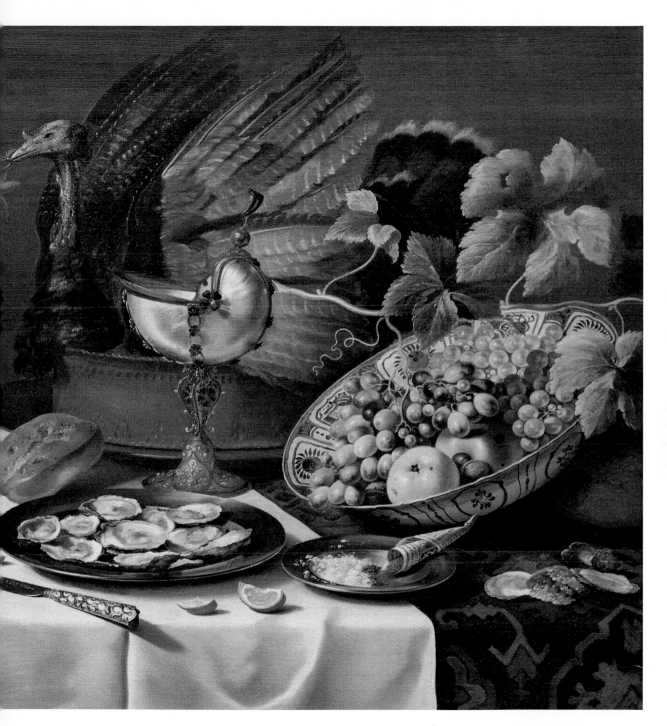

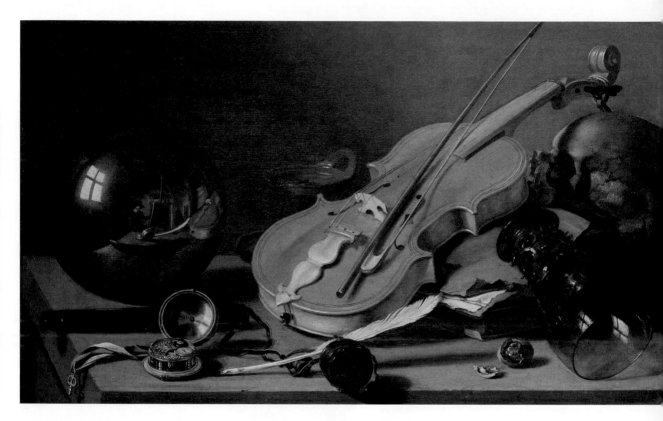

Vanitas Still Life with Self-Portrait

This picture is the epitome of a vanitas still life: the light has gone out, the glass has been emptied, time has elapsed, the music has faded away. Will the art whose origin the sphere reflects endure?

Vanité ou Nature morte au globe de verre avec autoportrait

Ce tableau semble l'incarnation même de la vanité : la lampe est éteinte, le verre vide, le temps écoulé et la musique terminée. L'art, dont on voit la genèse se refléter dans la bille de verre, sera-t-il plus pérenne ?

Vanitas-Stillleben mit Selbstbildnis

Das Bild ist der Inbegriff eines Vanitas-Stillleben: Das Licht ist erloschen, das Glas geleert, die Zeit verronnen, die Musik verklungen. Wird die Kunst, deren Entstehung die Kugel spiegelt, Bestand haben?

Naturaleza muerta de vanitas con autorretrato

El cuadro es el epítome de un bodegón de vanitas: la luz se ha apagado, el vaso se ha vaciado, el tiempo ha pasado, la música se ha desvanecido. ¿Durará el arte, cuyo origen refleja la esfera?

Vanitas con autoritratto

Il quadro è la quintessenza di una vanitas: la luce si è spenta, il bicchiere è stato svuotato, il tempo è trascorso, la musica è finita. L'arte, l'origine della quale riflette la sfera, durerà nel tempo?

Vanitas-stilleven met zelfportret

Het schilderij is een toonbeeld van het vanitas-stilleven: het licht is gedoofd, het glas is leeg, de tijd is voorbij, de muziek weggestorven. Zal de kunst, waarvan de bol het ontstaan weerspiegelt, blijven bestaan?

PIETER CLAESZ (C. 1597–1660)

c. 1628, Oil on wood/Huile sur bois, 35,9 × 60,5 cm, Germanisches Nationalmuseum, Nürnberg

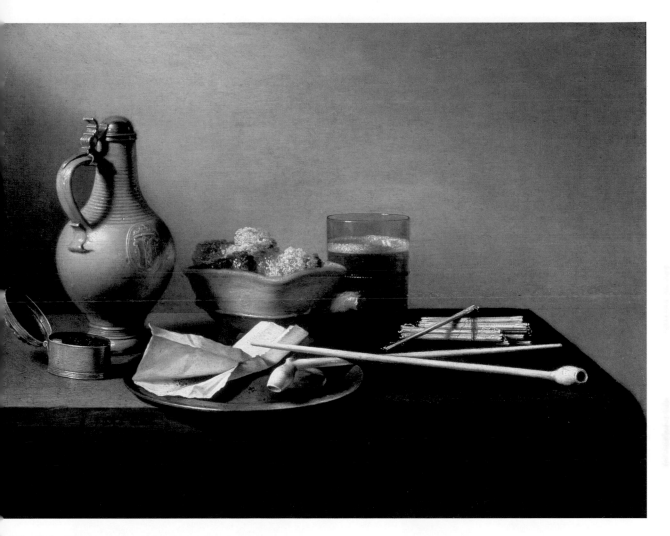

Still Life with Clay Pipes

Nature morte aux pipes

Stillleben mit Tonpfeifen

Naturaleza muerta con tubos de arcilla

Natura morta con pipe, boccale di birra e braciere

Stilleven met kleipijpen

PIETER CLAESZ (C. 1597–1660)

1636, Oil on wood/Huile sur bois, 49 × 63,5 cm, State Hermitage Museum, St. Petersburg

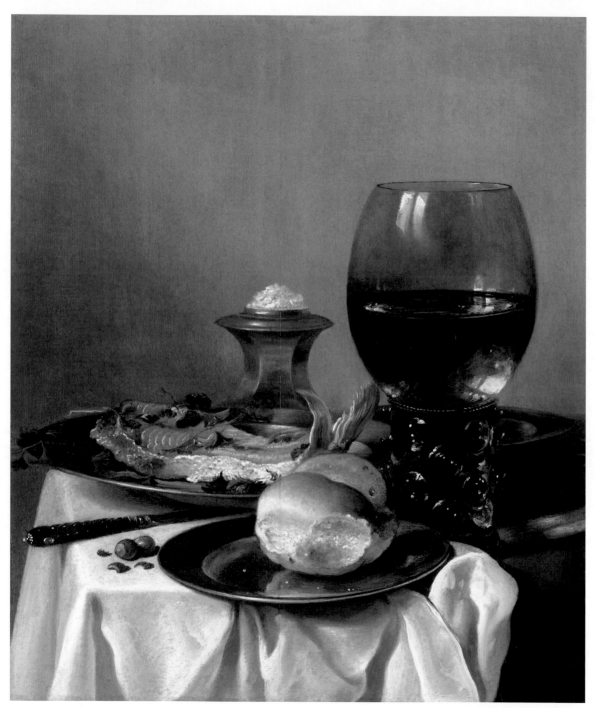

Still Life with
a Salt Cellar

Nature morte
au sel

Stillleben mit
Salzgefäß

Naturaleza
muerta con
recipiente
de sal

Natura morta
con saliera

Stilleven met
een zoutvat

PIETER CLAESZ
(C. 1597-1660
c. 1640-45,
Oil on wood/
Huile sur bois,
52,8 × 44 cm,
Rijksmuseum,
Amsterdam

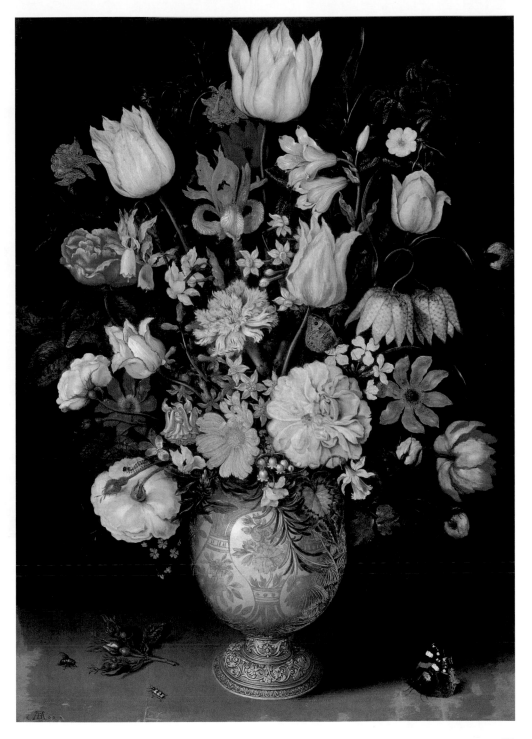

Bouquet of Flowers

An early type of still-life is the flower picture, which originated in Antwerp. An exquisite variety of species, which would not necessarily have been in bloom at the same time, is presented in a precious vase.

Bouquet de fleurs

La nature morte florale est l'un des types de natures mortes les plus anciens, originaire d'Anvers (tout comme l'auteur de ce tableau). On y admire en général des variétés de fleurs raffinées, dont la floraison n'intervient pas forcément en même temps.

Blumenstrauß

Ein früher Stilllebentypus ist das Blumenstillleben, das aus Antwerpen stammt. Nicht unbedingt gleichzeitig blühende und oft erlesene Sorten wurden in kostbaren Vasen präsentiert.

Ramo de flores

Un tipo de bodegón temprano es el bodegón de flores, que proviene de Amberes. A menudo se presentaban variedades exquisitas en floreros preciosos, no necesariamente floreciendo simultáneamente.

Bouquet di fiori

Un primo tipo di natura morta è la natura morta con i fiori, che proviene da Anversa. Non necessariamente con fioritura e con spesso squisite varietà, venivano presentate in vasi preziosi.

Vaas met bloemen

Een vroeger stilleventype is het bloemstilleven, dat uit Antwerpen komt. Niet per se gelijktijdig bloeiende en vaak exquise variëteiten werden gepresenteerd in kostbare vazen.

AMBROSIUS BOSSCHAERT THE ELDER (C. 1597–1660)
1609, Oil on mahogany/Huile sur bois d'acajou, 51 × 36,5 cm, Kunsthistorisches Museum, Wien

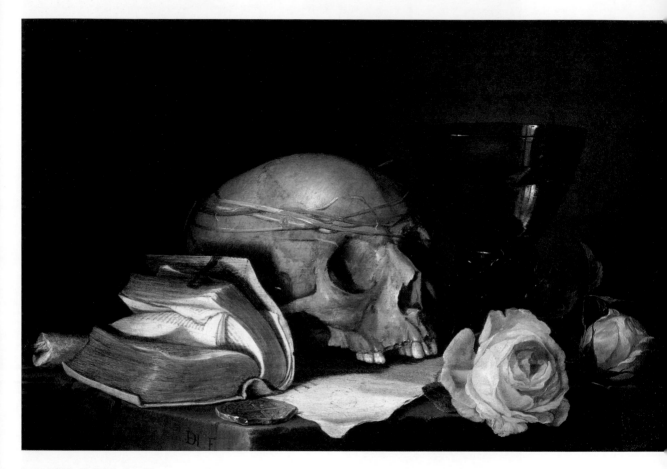

Vanitas Still Life with Skull, Book, and Roses

Vanité ou Nature morte au crâne, au livre et à la rose

Vanitas-Stillleben mit Totenschädel, Buch und Rosen

Naturaleza muerta de vanitas con un cráneo, un libro y rosas

Vanitas Natura morta con teschio, libro e rose

Vanitas-stilleven met schedel, boek en rozen

JAN DAVIDSZ. DE HEEM (1606–83/84)

c. 1630, Oil on wood/Huile sur bois, 23,2 × 34,6 cm, Nationalmuseum, Stockholm

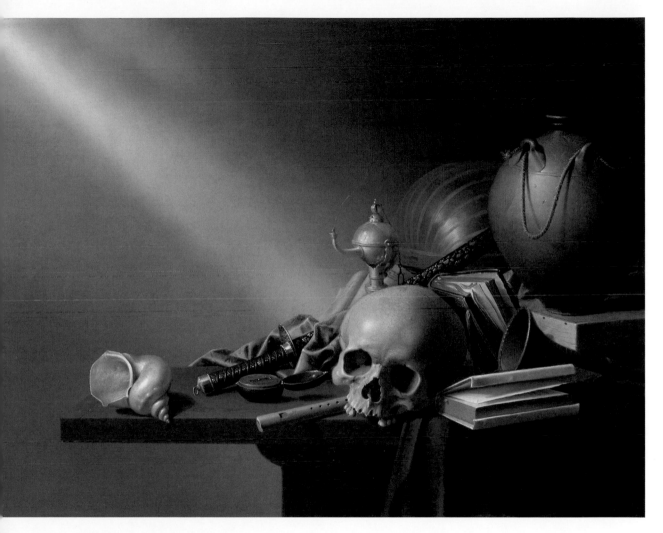

Still Life: An Allegory of the Vanities of Human Life

Une allégorie des vanités de la vie humaine

Stillleben: Eine Allegorie der Eitelkeiten des menschlichen Lebens

Bodegón: una alegoría de las vanidades de la vida humana

Natura morta: un'allegoria delle vanità della vita umana

Stilleven: een allegorie van de ijdelheden van het menselijk leven

HARMEN STEENWYCK (1612–56)
. 1640, Oil on oak/Huile sur chêne, 39,2 × 50,7 cm, The National Gallery, London

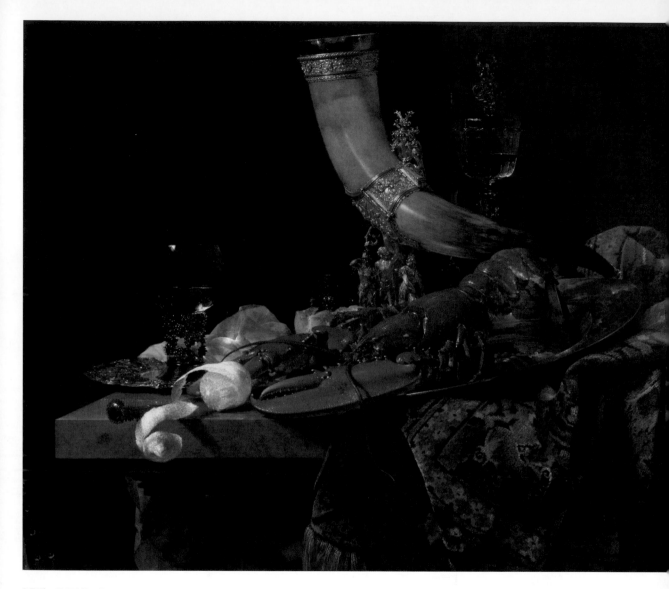

Still Life with Drinking-Horn

Nature morte avec homard et cor à boire

Stillleben mit Trinkhorn der Amsterdamer St.-Sebastians-Schützengilde, Hummer und Gläsern

Bodegón con cuerno para beber de la Asociación de Tiro de San Sebastian de Amsterdam, langostas y vasos.

Natura morta con corno della Corporazione die tiratori di Amsterdam, aragoste e bicchieri

Stilleven met drinkhoorn van het Amsterdamse Sint-Sebastiaansgilde, kreeft en glazen

WILLEM KALF (1619–93)

c. 1653, Oil on canvas/Huile sur toile, 86,4 × 102,2 cm, The National Gallery, London

Still Life with Porcelain Jug, Bowl and Nautilus Goblet

Relatively few, but extremely exquisite objects—gold-mounted Chinese porcelain, an oriental carpet, and a nautilus cup—are arranged in Kalf's elegant, sumptuous still life.

Nature morte à l'aquamanile, au fruit et au nautilus

Les objets sont peu nombreux et donc bien choisis : de la porcelaine chinoise garnie d'or, un tapis oriental et une coupe nautilus, disposés par Kalf en une élégante nature morte d'apparat.

Stillleben mit Porzellankanne, Schüssel und Nautiluspokal

Relativ wenige, dafür überaus erlesene Objekte – goldmontierte chinesische Porzellane, ein Orientteppich und ein Nautiluspokal – wurden von Kalf zu einem eleganten Prunkstillleben arrangiert.

Naturaleza muerta con jarra de porcelana, cuenco y copa Nautilus

Relativamente pocos, pero extremadamente exquisitos objetos —porcelana china montada en oro, una alfombra oriental y una copa de nautilus— fueron colocados por Kalf en un elegante bodegón de esplendor.

Natura morta con brocca in porcellana, ciotola e coppa di Nautilus

Pochi ma squisiti oggetti – porcellane cinesi montate in oro, un tappeto orientale e una coppa di nautilus – sono stati disposti da Kalf in un'elegante natura morta di grande splendore.

Stilleven met porseleinen kan, schaal en nautilusbeker

Relatief weinig, maar wel zeer verfijnde objecten – Chinees porselein met goud, een oosterse tapijt en een nautilusbeker – werden door Kalf gerangschikt tot een elegant pronkstilleven.

WILLEM KALF (1619–93)
c. 1660, Oil on canvas/Huile sur toile, 111 × 84 cm, Museo Nacional Thyssen-Bornemisza, Madrid

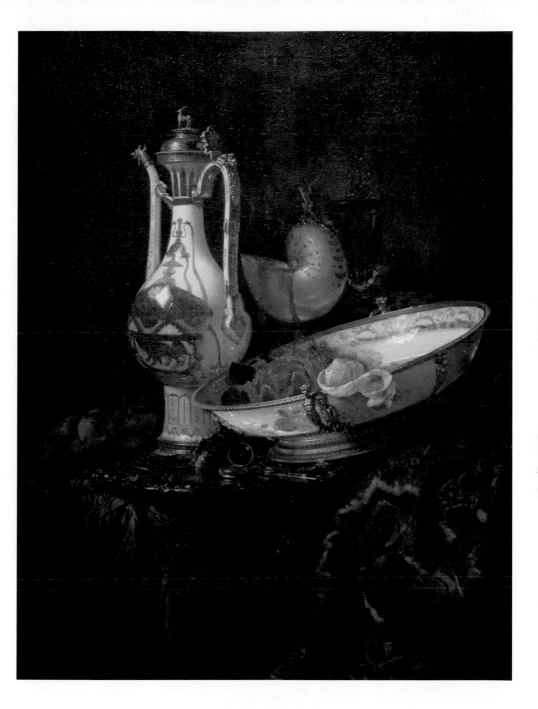

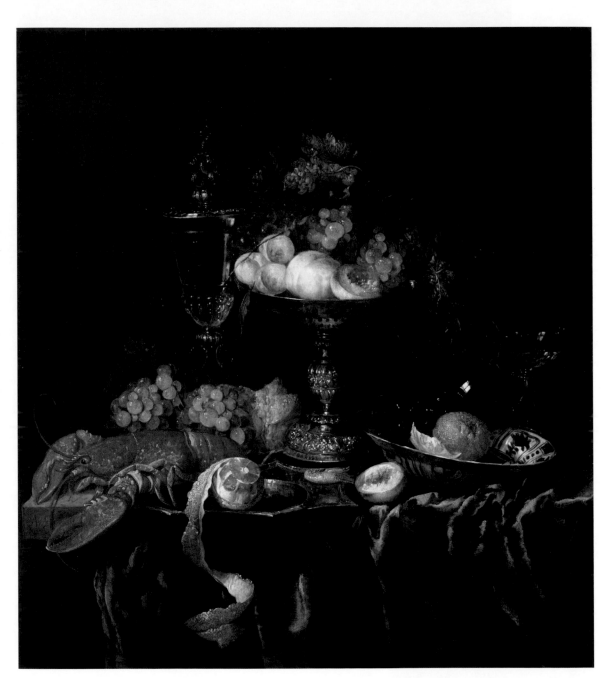

Still Life with
Fruits and
Lobster

**Nature morte
avec des
fruits et un
homard**

**Stillleben mit
Früchten und
Hummer**

**Naturaleza
muerta con
frutas y
langosta**

**Natura morta
con frutta e
aragosta**

**Stilleven met
vruchten
en kreeft**

**ABRAHAM
VAN BEYEREN
(1620/21–90)**
c. 1660,
Oil on wood/
Huile sur bois,
85,2 × 75,2 cm,
Museum der
bildenden
Künste, Leipzig

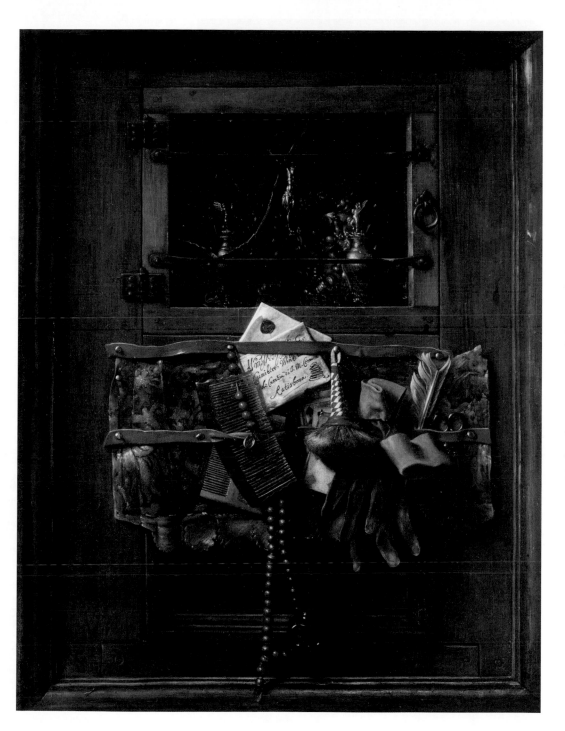

Still Life with Letter

Van Hoogstraten, a pioneer of trompe l'œil still life, paints pin boards with letters and other utensils that deceive the eye with their life-size, Illusionistic rendering.

Nature morte à la lettre

Pionnier des natures mortes en trompe-l'œil, van Hoogstraten aimait peindre ce genre de tablettes portant des lettres et d'autres ustensiles, qui grâce à leur format réaliste faisaient parfaitement illusion.

Stillleben mit Brief

Van Hoogstraten, ein Pionier des Trompe-l'œil-Stilllebens, malte Steckbretter mit Briefen und anderen Utensilien, die durch ihre reale Größe und die illusionistische Wiedergabe das Auge täuschen.

Bodegón con un escrito

Van Hoogstraten, pionero del trompe l'œil still life, pintó tablones de anuncios con letras y otros utensilios que engañan al ojo con su tamaño real y su representación ilusionista.

Natura morta con lettera

Van Hoogstraten, un pioniere della natura morta trompe l'œil, dipinse tavole di sughero con lettere e altri utensili che ingannano l'occhio con le loro dimensioni reali e la loro resa illusionistica.

Stilleven met brief

Van Hoogstraten, een pionier van het trompe l'œil-stilleven, schilderde houten rekken met brieven en andere huishoudelijk gerei die door hun ware grootte en illusionistische weergave het oog bedriegen.

SAMUEL VAN HOOGSTRATEN (1627-78)

c. 1654, Oil on canvas/Huile sur toile, 90 × 71 cm, Museum der bildenden Künste, Leipzig

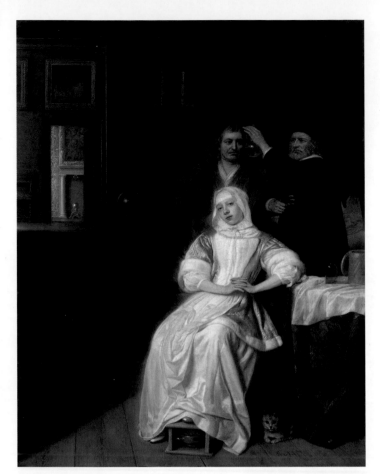

The Anemic Lady

Femme consultant un docteur

Die Bleichsüchtige

La dama anémica

Ragazza anemica

De bleekzuchtige dame

SAMUEL VAN HOOGSTRATEN (1627–78)

1660–78, Oil on canvas/Huile sur toile, 69,5 × 55 cm, Rijksmuseum, Amsterdam

Dutch Genre Pictures:
Realism and Moralism

Although painters have always depicted scenes from
everyday life, genre painting did not develop into a
fully independent genre until the 17th century, where
it flourished especially in the northern and southern
Netherlands. Genre scenes often have two aspects: On
the one hand, they reflect the life of the painter's time
down to the last detail; on the other, they often convey a
moral message (with varying degrees of subtlety). Only
at second glance do we notice, for example, that a pair
of slippers is lying around carelessly in a stately room, or
that a boy, absorbed in delousing his dog, has forgotten
his school books. Genre scenes are set in the most diverse
environments, from the elegant interiors of Vermeer
or Metsu to the farmers' taverns of Ostades, with their
drinking, brawling guests. Finally, there are rooms that
seem bourgeois at first, but are in fact brothels.

La peinture de genre hollandaise :
réalisme et moralisme

Si les scènes de la vie quotidienne furent représentées tout
au cours de l'histoire de la peinture, c'est au XVIIᵉ siècle et
surtout dans le nord et le sud des Pays-Bas que la peinture
de genre devint réellement un genre à part entière. Les
scènes de genre revêtent souvent deux aspects : d'une
part, elles reflètent en détail la vie de l'époque, et d'autre
part elles véhiculent souvent un message moral, de
manière tantôt claire, tantôt plus subtile. Ce n'est qu'au
deuxième coup d'œil que l'on découvre par exemple
que des pantoufles traînent dans un recoin de la pièce
d'une maison bourgeoise ou qu'un jeune garçon oublie
ses cahiers, tout occupé qu'il est à épouiller son chien.
Les scènes de genre peuvent se jouer dans les milieux
les plus divers : dans les intérieurs élégants de Vermeer
ou Metsu, tout comme dans les tavernes de campagne
de van Ostade – dont les clients s'enivrent et se battent.
Sans oublier les demeures qui semblent bourgeoises mais
s'avèrent être des maisons closes.

Holländische Genrebilder:
Realismus und Moralismus

Auch wenn Szenen des täglichen Lebens eigentlich
schon immer gemalt wurden, entwickelte sich die
Genremalerei im 17. Jahrhundert vor allem in den
nördlichen und südlichen Niederlanden zu einer
eigenständigen Bildgattung. Genreszenen haben häufig
zwei Aspekte: Einerseits geben sie das damalige Leben
bis ins Detail wieder, andererseits übermitteln sie häufig
eine moralische Botschaft, auf die mal deutlicher, mal
subtiler hingewiesen wird. Erst auf den zweiten Blick
bemerken wir etwa, dass Pantoffeln nachlässig in einem
herrschaftlichen Zimmer herumliegen oder ein Junge
beim Lausen seines Hundes die Schulhefte vergisst.
Genreszenen können in den unterschiedlichsten Milieus
spielen: in den eleganten Interieurs von Vermeer
oder Metsu ebenso wie in den Bauernschenken von
Ostades, deren Gäste raufen und trinken. Nicht zuletzt
gibt es Räume, die zwar gutbürgerlich scheinen, aber
Bordelle darstellen.

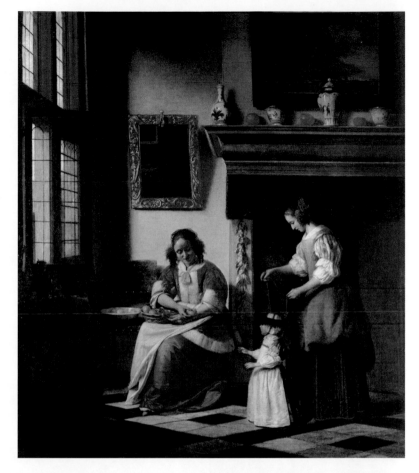

Fotos de género holandés: realismo y moralismo

Aunque siempre se han pintado escenas de la vida cotidiana, la pintura de género se convirtió en un género independiente en el siglo XVII, especialmente en el norte y el sur de los Países Bajos. Las escenas de género a menudo tienen dos aspectos: por un lado, reflejan la vida de aquella época hasta el último detalle; por otro, transmiten a menudo un mensaje moral a veces más claro, a veces más sutilmente señalado. Sólo a primera vista nos damos cuenta, por ejemplo, de que las pantuflas yacen descuidadas en una habitación señorial o de que un niño se olvida de leer los libros de ejercicios mientras espulga a superro. Las escenas de género se pueden representar en los entornos más diversos: en los elegantes interiores de Vermeer o Metsu, así como en las tabernas de Ostades, cuyos huéspedes se pelean y beben. Por último, pero no menos importante, hay habitaciones que pueden parecer burguesas, pero son burdeles.

Pittura di genere olandese: Realismo e Moralismo

Anche se le scene di vita quotidiana sono sempre state rappresentate nei dipinti, la pittura di genere si è sviluppata in un genere indipendente nel XVII secolo, soprattutto nel nord e nel sud dei Paesi Bassi. Le scene di genere hanno spesso due aspetti: da un lato, riflettono la vita di quel tempo fino all'ultimo dettaglio, dall'altro, trasmettono spesso un messaggio morale che a volte è più chiaro, a volte più acutamente sottolineato. Solo a una seconda occhiata notiamo, per esempio, che le pantofole sono posizionate con disattenzione in una stanza signorile o un ragazzo dimentica i quaderni per togliere le pulci al suo cane. Le scene di genere possono essere rappresentate negli ambienti più diversi: negli eleganti interni di Vermeer o di Metsu e nelle taverne dei contadini di Ostades, i cui ospiti si azzuffano e bevono. Ultimo ma non meno importante, sono le stanze che possono sembrare borghesi, ma che raffigurano bordelli.

Nederlandse genrebeelden: realisme en moralisme

Hoewel scènes uit het dagelijks leven eigenlijk altijd al geschilderd zijn, ontwikkelde de genreschilderkunst zich in de 17e eeuw vooral in Noord- en Zuid-Nederland tot een zelfstandig genre. Genrestukken hebben vaak twee aspecten: aan de ene kant geven ze het leven van die tijd tot in de kleinste details weer, aan de andere kant brengen ze vaak een morele boodschap over waarnaar soms duidelijker, soms subtieler wordt verwezen. Pas op het tweede gezicht zien we bijvoorbeeld dat pantoffels slordig in een statige kamer liggen of dat een jongen bij het vlooien van een hond zijn schoolschriften vergeet. Genretaferelen kunnen zich in de meest uiteenlopende milieus afspelen: in de elegante interieurs van Vermeer of Metsu en in de boerencafés van Van Ostade, waar de gasten vechten en drinken. Niet in de laatste plaats zijn er kamers die er fatsoenlijk uitzien, maar eigenlijk bordelen zijn.

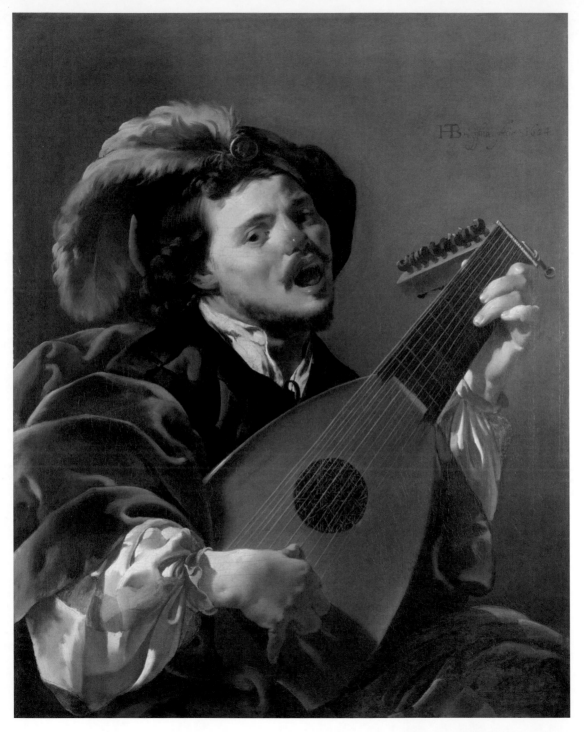

The Lute Player

Chanteur
s'accompagnant
au luth

Der Lautenspieler

El laudista

Suonatore di liuto

De luitspeler

**HENDRICK TER
BRUGGHEN**
(1588-1629)
1624, Oil on canvas/
Huile sur toile,
100,5 × 78,7 cm,
The National
Gallery, London

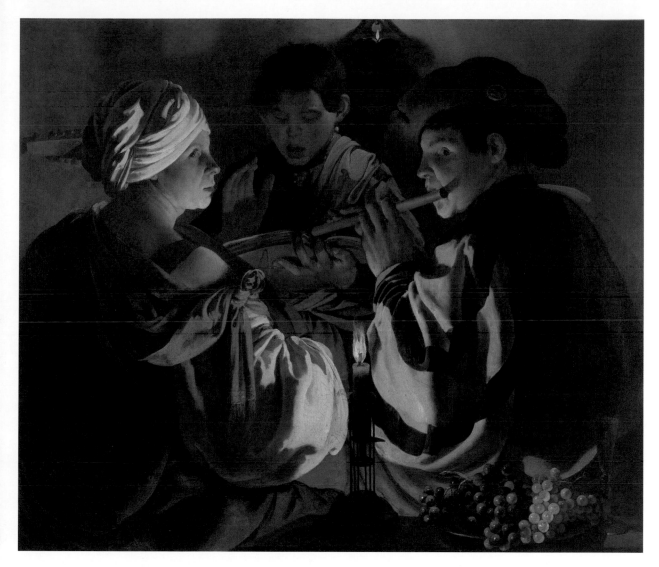

The Concert

The theme and composition, along with the figures' clothing and chiaroscuro, betray Caravaggio's influence. Ter Brugghen, one of the Utrecht Caravaggisti, had lived in Italy from 1604 to 1614.

Le Concert

Le thème, la composition mais également l'habillement des personnages et le clair-obscur trahissent l'influence du Caravage. Ter Brugghen, l'un des caravagistes d'Utrecht, vécut en Italie entre 1604 et 1614.

Das Konzert

Thema und Komposition, aber auch die Kleidung der Figuren und das Hell-Dunkel verraten den Einfluss Caravaggios. Ter Brugghen, einer der Utrechter Caravaggisten, hatte von 1604 bis 1614 in Italien gelebt.

El concierto

El tema y la composición, pero también la vestimenta de las figuras y el claroscuro traicionan la influencia de Caravaggio. Ter Brugghen, uno de los caravagantes de Utrecht, vivió en Italia de 1604 a 1614.

Il Concerto

Il tema e la composizione, ma anche l'abbigliamento delle figure e il chiaroscuro tradiscono l'influenza di Caravaggio. Ter Brugghen, uno dei caravaggisti di Utrecht, aveva vissuto in Italia dal 1604 al 1614.

Het concert

Het thema en de compositie, maar ook de kleding en het chiaroscuro van de figuren verraden de invloed van Caravaggio. Ter Brugghen, een Utrechtse caravaggist, had van 1604 tot 1614 in Italië gewoond.

HENDRICK TER BRUGGHEN (1588–1629)
c. 1626, Oil on canvas/Huile sur toile, 99,1 × 116,8 cm, The National Gallery, London

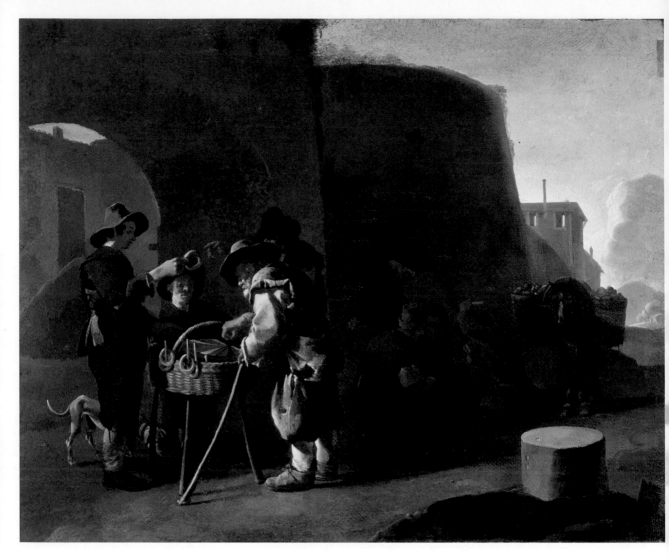

The Cake Seller

A group of Dutch painters formed in Rome around van Laerin, who called themselves Bamboccianti (after the artist's nickname, Bamboccio – rag doll). They painted scenes from the life of the common people.

Le Vendeur de beignets

À Rome, tout un groupe de peintres néerlandais se forma autour de van Laer, prenant le nom de « Bamboccianti » (à cause de son propre surnom : « Bamboccio », marionnette). Ils peignaient des scènes illustrant la vie des gens simples.

Der Kringelverkäufer

Um van Laer bildete sich in Rom eine Gruppe niederländischer Maler, die sich (nach seinem Spitznamen Bamboccio – Lumpenpuppe) Bamboccianti nannten. Sie malten Szenen aus dem Leben des einfachen Volkes.

El vendedor de Kringle

Alrededor de van Laer se formó en Roma un grupo de pintores holandeses que (por su apodo Bamboccio - muñeca de trapo) se llamaban a sí mismos Bamboccianti. Pintaron escenas de la vida de la gente común.

Il venditore di dolci

Intorno a van Laer si formò a Roma un gruppo di pittori olandesi che (dal soprannome di Bamboccio) si chiamarono Bamboccianti. Hanno dipinto scene della vita della gente comune.

De krakelingverkoper

Rondom Van Laer vormde zich in Rome een groep Nederlandse schilders die zich (naar zijn bijnaam Bamboccio, lappenpop) bamboccianti noemden. Ze schilderden taferelen uit het leven van gewone mensen.

PIETER VAN LAER (IL BAMBOCCIO) (C. 1595-1642)
c. 1630, Oil on canvas/Huile sur toile, 32 × 42 cm, Galleria Nazionale d'Arte Antica, Roma

A Boy and a Girl with a Cat and an Eel
Judith Leyster was one of many Dutch women painters. This scene has a moral message: the cat, lured by the eel and then pulled in by its tail, extends its claws!

Un garçon et une fille avec un chat et une anguille
Judith Leyster fut l'une des – relativement nombreuses – femmes peintres hollandaises. Ce tableau a une visée moralisatrice, car un chat que l'on attire avec une anguille, pour ensuite lui tirer la queue, sort les griffes !

Junge und Mädchen mit Katze und Aal
Judith Leyster war eine der nicht wenigen holländischen Malerinnen. Diese Szene hat eine moralische Botschaft, denn die mit dem Aal angelockte und dann am Schwanz gezogene Katze fährt ihre Krallen aus!

Chico y chica con un gato y una anguila
Judith Leyster fue una de las muchas pintoras holandesas. Esta escena contiene un mensaje moral: porque el gato por un lado se siente atraído por la anguila pero por otro eriza la cola. ¡Por ello saca sus garras!

Giovinetto e giovinetta con gatto e anguilla
Judith Leyster è stata una delle non poche pittrici olandesi. Questa scena ha un messaggio morale, perché il gatto è attratto dall'anguilla e poi tiratogli la coda caccia gli artigli!

Jongen en meisje met kat en paling
Judith Leyster was een van de niet weinige Nederlandse schilderessen. Deze scène heeft een morele boodschap, omdat de met de paling gelokte kat die aan haar staart getrokken wordt haar klauwen uitslaat!

JUDITH LEYSTER (1609-69)
c. 1635, Oil on oak/Huile sur chêne, 59,4 × 48,8 cm, The National Gallery, London

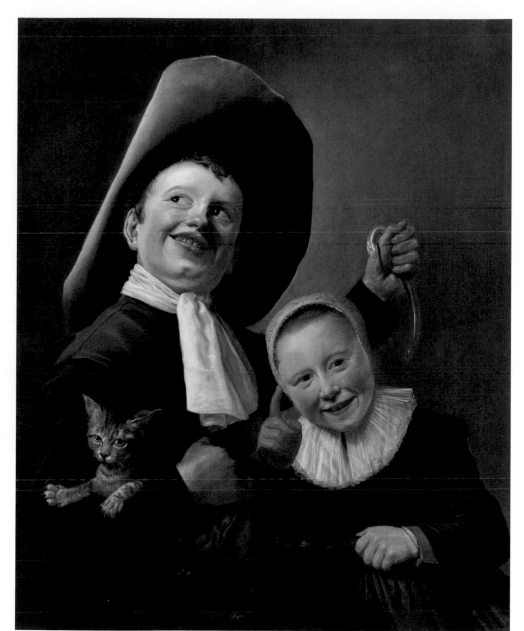

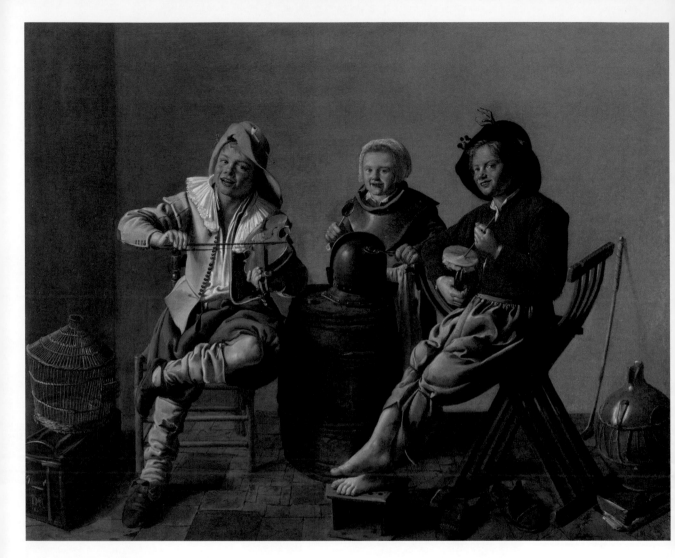

Two Boys and a Girl Making Music

Deux garçons et une fille jouant de la musique

Zwei Jungen und ein Mädchen beim Musizieren

Dos chicos y una chica haciendo música

Due giovani e una giovinetta che fanno musica

Twee jongens en een meisje die muziek maken

JAN MIENSE MOLENAER (C. 1610–68)
1629, Oil on canvas/Huile sur toile, 68,3 × 84,5 cm, The National Gallery, London

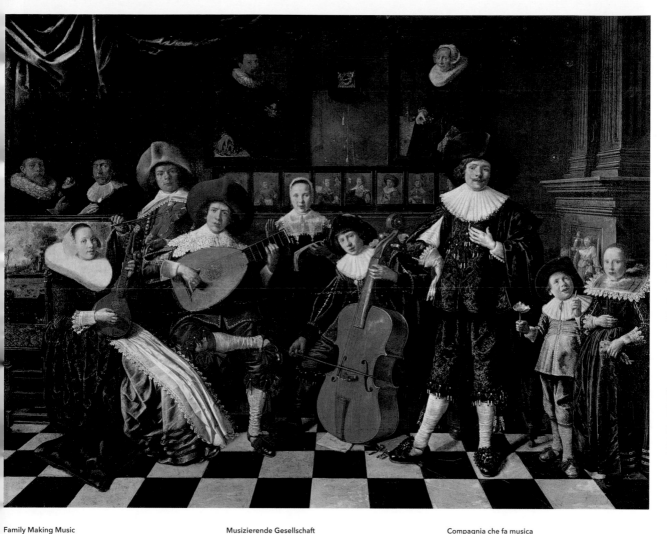

Family Making Music

The painter depicts himself with his brothers and sisters in this representative genre painting. Their shared music-making symbolises the family's harmonious relationship.

Autoportrait en famille ou Une famille de musicien

Dans cette scène de genre, le peintre s'est représenté avec ses frères et sœurs. L'harmonie des musiciens jouant ensemble symbolise celle qui doit régner dans une vie de famille.

Musizierende Gesellschaft

Der Maler stellte sich in diesem repräsentativen Genrebild mit seinen Brüdern und Schwestern dar. Die Harmonien des gemeinsamen Musizierens sind Sinnbild für ein ebensolches Familienleben.

Sociedad Musical

El pintor se presentó en esta representativa pintura de género con sus hermanos y hermanas. La armonía de hacer música juntos es un símbolo de tal vida familiar.

Compagnia che fa musica

Il pittore si presenta con i suoi fratelli e le sue sorelle in questo quadro di genere rappresentativo. L'armonia di fare musica insieme è il simbolo per una vita familiare di questo tipo.

Zelfportret met familieleden

In dit representatieve genreschilderij presenteerde de schilder zich samen met zijn broers en zussen. De harmonieën van het gezamenlijk musiceren staan symbool voor een harmonieus gezinsleven.

JAN MIENSE MOLENAER (C. 1610–68)

1635, Oil on wood/Huile sur bois, 62,3 × 81,3 cm, Frans Hals Museum, Haarlem

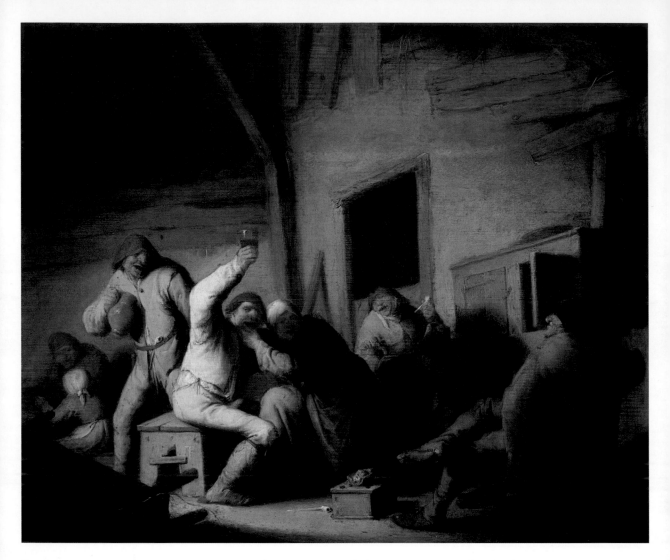

Merry Farmers in a Tavern
Ostade is one of the main representatives of the farmers' genre. Images of drinking or brawling country people were moralizing on the one hand, but appealing and sought-after on the other due to their comic, uncouth nature.

Paysans faisant la fête dans une taverne
Ostade fut l'un des principaux peintres de scènes de genre paysannes. Ses tableaux de campagnards avaient une visée moralisatrice, mais étaient aussi convoités pour leur côté comique, rude et mal dégrossi.

Ausgelassene Bauern in einer Schenke
Ostade ist einer der Hauptvertreter des Bauerngenres. Bilder von trinkenden oder raufenden Landleuten waren einerseits moralisierend, aber auch aufgrund des Komischen und Ungehobelten reizvoll und begehrt.

Agricultores alegres en una taberna
Ostade es uno de los principales representantes del género campesino. Las imágenes de gente del campo que bebía o que se peleaba eran moralizantes por un lado, pero también atractivas y codiciadas debido a lo cómico y grosero.

Allegri contadini in un'osteria
Ostade è uno dei principali rappresentanti del genere contadino. Le immagini di gente di campagna che beveva o che si azzuffava erano moralizzanti da un lato, ma anche attraenti e ricercate per la loro comicità e ingenuità.

Vrolijke boeren in een herberg
Van Ostade is een van de hoofdvertegenwoordigers van het boerengenre. Schilderijen van drinkende of vechtende dorpelingen waren weliswaar moraliserend, maar ook aantrekkelijk en gewild vanwege het komische en onbeschaafde element.

ADRIAEN VAN OSTADE (1610–85)
c. 1635, Oil on oak/Huile sur chêne, 28,8 × 36,3 cm, Alte Pinakothek, München

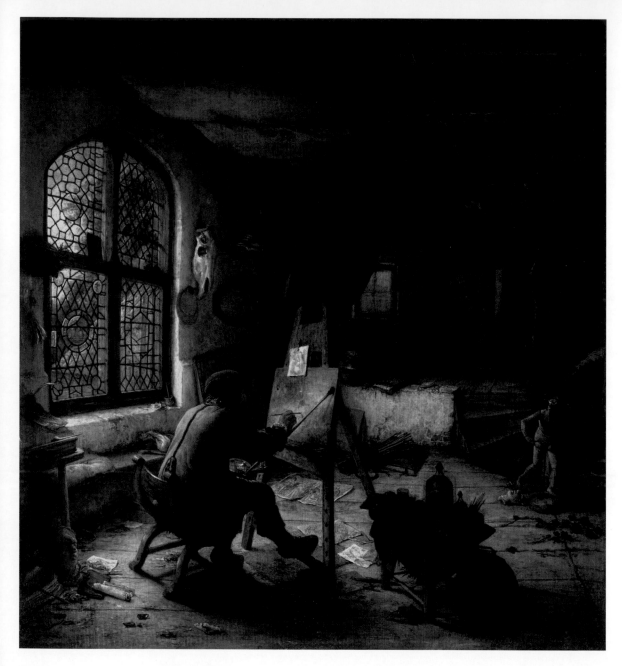

The Painter in His Studio Der Maler in seiner Werkstatt Il pittore nella sua bottega

L'Artiste dans son atelier El pintor en su taller De schilder in zijn atelier

ADRIAEN VAN OSTADE (1610–85)

1663, Oil on oak/Huile sur chêne, 38 × 35,5 cm, Gemäldegalerie Alte Meister, Dresden

The Grocer's Shop
Dou was one of the "fine painters" of Leiden who mainly created small, but detailed and almost illusionistic paintings. He often depicted his objects behind a curtain or in a niche.

L'Épicière de village
Représentant de l'école de Leyde de « peinture fine », Dou peignit surtout des tableaux de petit format, très détaillés et presque illusionnistes. Il plaçait souvent l'objet de son tableau dans une niche ou derrière un rideau.

Der Krämerladen
Dou war einer der Leidener Feinmaler, die meist kleine, aber detailreiche und schon fast illusionistische Gemälde schufen. Oft stellte er seine Bildgegenstände hinter einem Vorhang oder in einer Nische dar.

La tienda de ultramarinos
Dou fue uno de los mejores pintores de Leiden, que en su mayoría crearon pinturas pequeñas, pero detalladas y casi ilusionistas. A menudo representaba sus objetos pictóricos detrás de una cortina o en un nicho.

Negozio di alimentari
Dou fu uno dei pittori di Leida, che creò soprattutto dipinti piccoli, ma dettagliati e quasi illusionistici. Spesso ritraeva i suoi oggetti pittorici dietro una tenda o in una nicchia.

De kruidenierswinkel
Dou was een Leidse fijnschilder die vooral kleine, maar uiterst gedetailleerde en bijna illusionistische schilderijen maakte. Vaak schilderde hij de objecten achter een gordijn of in een nis.

GERARD DOU (1613–75)
1647, Oil on wood/Huile sur bois, 38 × 29 cm, Musée du Louvre, Paris

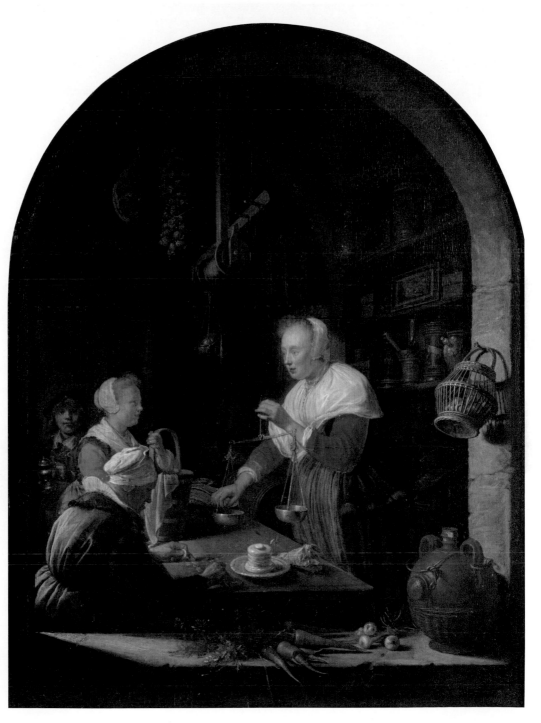

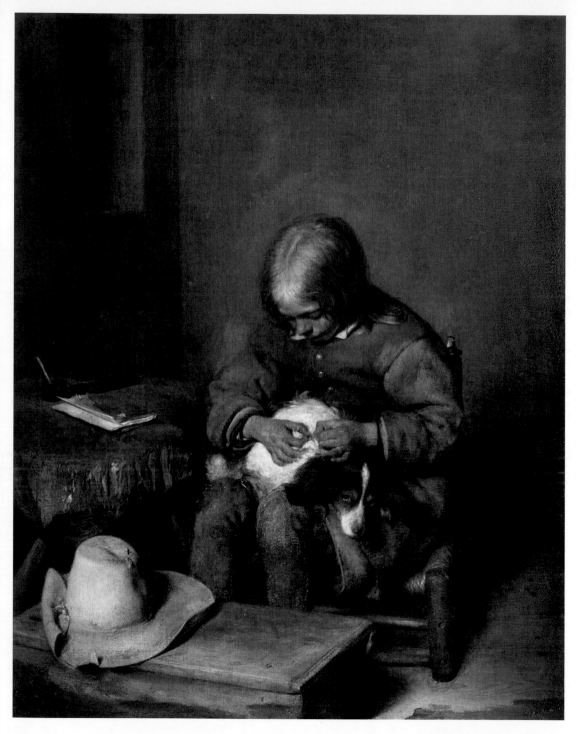

The Flea-Catcher
(Boy with His Dog)

Garçon épouillant
son chien

Ein Knabe floht
seinen Hund

Un niño huyendo
de su perro

Giovane spulcia
il suo cane

Jongen bezig een
hondje te vlooien

GERARD TER BORCH
(1617–81)
c. 1655, Oil on wood/
Huile sur bois,
34,4 × 27,1 cm, Alte
Pinakothek, München

A Man Offering Money and Coins to a Girl (The Gallant Soldier)

The theme of the painting is love for sale, which appears in a number of Dutch genre pictures – usually in a rather reserved fashion. Another clue is the open bed curtain.

Le Galant militaire ou Jeune femme à laquelle un homme offre de l'argent

Ce tableau a pour thème l'amour vénal, que l'on retrouve dans de nombreuses scènes de genre hollandaises, généralement de manière subtile. Le rideau du lit, ouvert, est un indice supplémentaire.

Ein Mann bietet einem Mädchen Geld an (Der galante Soldat)

Thema des Bildes ist die käufliche Liebe, die in einer ganzen Anzahl holländischer Genrebilder dargestellt wird – zumeist eher zurückhaltend. Ein weiterer Hinweis ist der geöffnete Bettvorhang.

Un hombre ofrece dinero a una niña (El soldado galán)

El tema de la pintura es el amor a la venta, que está representado en una serie de cuadros de género neerlandés - en su mayoría más bien de carácter reservado. Otra pista es la cortina abierta de la cama.

Un uomo offre soldi a una ragazza (Il soldato galante)

Il tema del dipinto è l'amore venale, che è rappresentato in un certo numero di dipinti di genere olandesi - per lo più piuttosto riservato. Un altro indizio è la tenda da letto aperta.

Een man biedt een meisje geld aan (De galante soldaat)

Het thema van het schilderij is de betaalde liefde, die in een flink aantal Nederlandse genreschilderijen wordt afgebeeld – meestal vrij terughoudend. Een andere aanwijzing is het geopende bedgordijn.

GERARD TER BORCH (1617–81)

c. 1660–63, Oil on canvas/Huile sur toile, 68 × 55 cm, Musée du Louvre, Paris

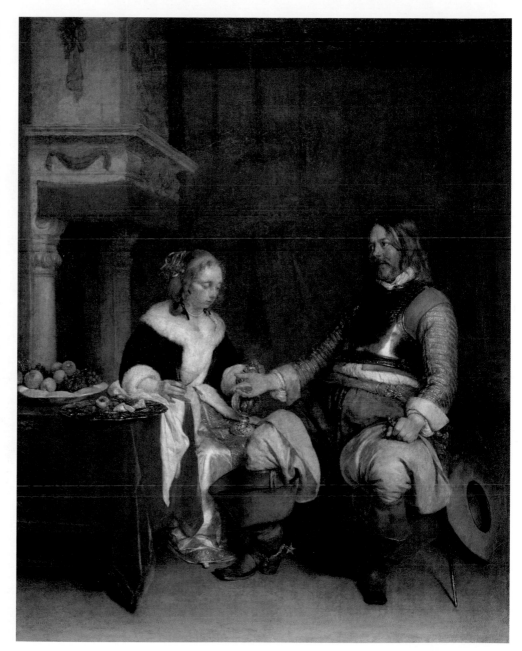

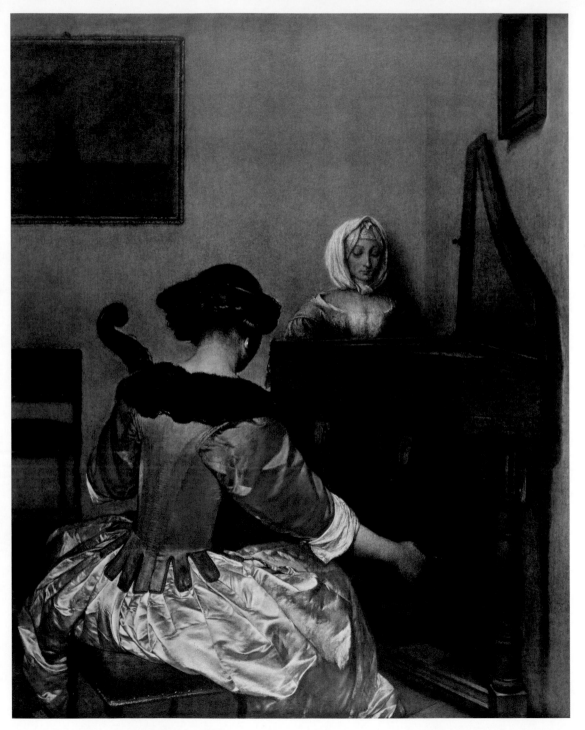

The Concert

Le Concert

Das Konzert

El concierto

Concerto

Het concert

GERARD TER BORCH
(1617–81)
c. 1675, Oil on
oak/Huile sur
chêne, 56 × 44 cm,
Gemäldegalerie, Berlin

The Goldfinch
Sociable goldfinches were kept as pets. This trompe l'œil picture could have hung high on a wall to seem like a living bird.

Le Chardonneret
Le chardonneret, si sociable, était souvent accueilli comme un animal domestique. Accroché bien haut sur un mur, ce trompe-l'œil pouvait vraiment donner l'impression d'un oiseau vivant.

Der Distelfink
Die geselligen Distelfinken wurden als Haustiere gehalten. Dieses Bild, ein Trompe l'œil, könnte recht weit oben an einer Wand gehangen und dort wie ein lebendiger Vogel gewirkt haben.

El jilguero
Los jilgueros sociables eran considerados mascotas. Este cuadro, un trompe l'œil, podría colgarse a lo alto de una pared y parecer un pájaro vivo.

Il cardellino
I cardellini socievoli erano tenuti come animali domestici. Questo dipinto, un trompe l'œil, avrebbe potuto essere appeso abbastanza in alto su una parete e avrebbe dato l'impressione che ci fosse un uccello vivente.

Het puttertje
De gezellige puttertjes werden als huisdier gehouden. Dit schilderijtje, een trompe l'œil, kon vrij hoog aan de muur worden gehangen om daar de indruk te wekken van een levende vogel.

CAREL FABRITIUS (1622–54)
1654, Oil on wood/Huile sur bois,
33,5 × 22,8 cm, Mauritshuis, Den Haag

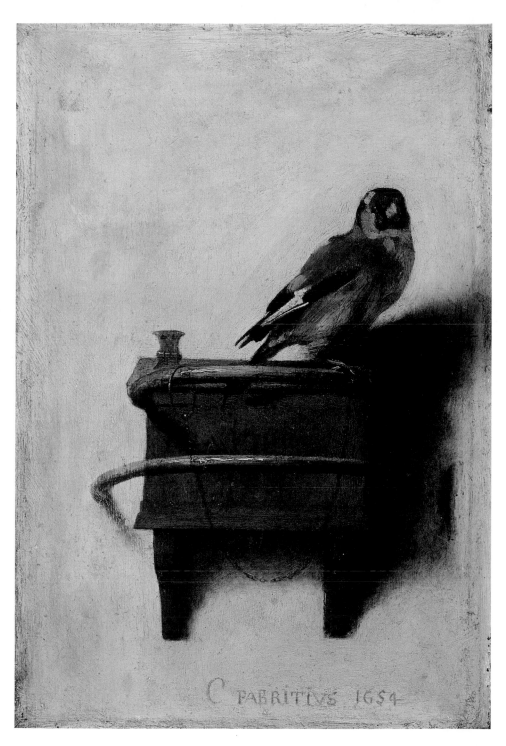

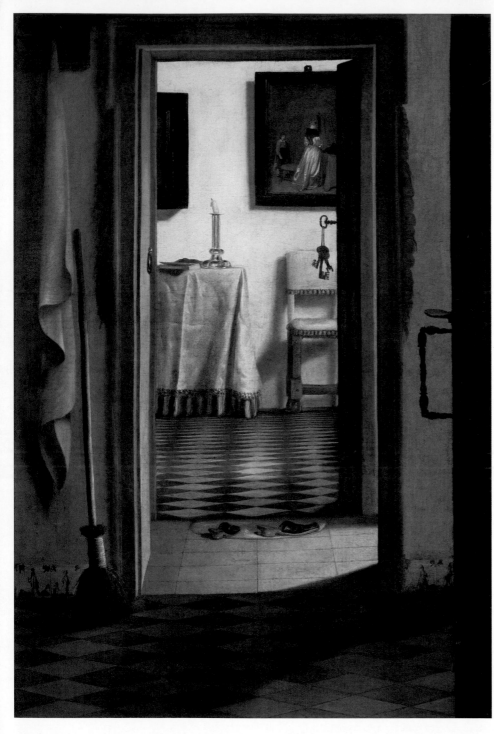

The Slippers

The painting fascinates with its contrast between the room filled with household objects and the front parlour. Through two door frames, one can see a picture of Hoogstraaten's colleague Gerard ter Borch.

Vue d'intérieur ou Les Pantoufles

Dans ce tableau, le contraste entre la pièce contenant des ustensiles de ménage et l'élégant salon est fascinant. À travers les deux encadrements de porte, on peut voir un tableau de Gerard ter Borch, collègue de Hoogstraaten.

Die Pantoffeln

Das Gemälde fasziniert durch den Kontrast zwischen einem Raum mit Haushaltsgegenständen und einer guten Stube. Durch zwei Türrahmen fällt der Blick auf ein Bild von Hoogstraatens Kollegen Gerard ter Borch.

Las zapatillas

La pintura fascina por el contraste entre una habitación con objetos domésticos y una buena sala de estar. A través de dos marcos de puerta se puede ver una foto del colega de Hoogstraaten, Gerard ter Borch.

Le pantofole

Il dipinto affascina per il contrasto tra una stanza con oggetti di uso domestico e una bella stanza. Attraverso due stipiti si può vedere un ritratto del collega di Hoogstraaten, Gerard ter Borch.

De pantoffels

Het schilderij fascineert door het contrast tussen een ruimte met huishoudelijke voorwerpen en de goede woonkamer. Door twee deurkozijnen valt de blik op een schilderij van Van Hoogstratens collega Gerard ter Borch.

SAMUEL VAN HOOGSTRATEN (1627-78)
c. 1658, Oil on canvas/Huile sur toile,
103 × 70 cm, Musée du Louvre, Paris

The Sick Child

When this domestic scene was painted, Amsterdam was still mourning its many victims of the plague. The composition, reminiscent of a pietà, conveys great seriousness.

L'Enfant malade

Cette scène domestique dégage beaucoup de sérieux, quand on sait que peu auparavant la ville d'Amsterdam eut à déplorer de nombreux morts de la peste. Sa composition rappelle une pietà.

Das kranke Kind

Die häusliche Szene birgt vor dem Hintergrund, dass Amsterdam kurz vor Entstehung des Bildes viele Pesttote zu beklagen hatte, sowie durch die an eine Pietà erinnernde Komposition große Ernsthaftigkeit.

El niño enfermo

La escena doméstica se esconde en el trasfondo de que Amsterdam tuvo que lamentar muchas muertes por la peste poco antes de que se creara el cuadro, así como la composición que recuerda a una Pietà con gran seriedad.

Il bambino malato

La scena domestica si nasconde sullo sfondo del fatto che Amsterdam ha dovuto piangere molte morti di peste poco prima che il dipinto fosse realizzato, così come la composizione che ricorda una Pietà di grande serietà.

Het zieke kind

Tegen de achtergrond dat er in Amsterdam kort voor het ontstaan van dit werk veel doden waren gevallen aan de pest en door de Piëta-achtige compositie schuilt er een grote ernst in dit huiselijke tafereel.

GABRIËL METSU (1629–67)

c. 1664–66, Oil on canvas/Huile sur toile, 32,2 × 27,2 cm, Rijksmuseum, Amsterdam

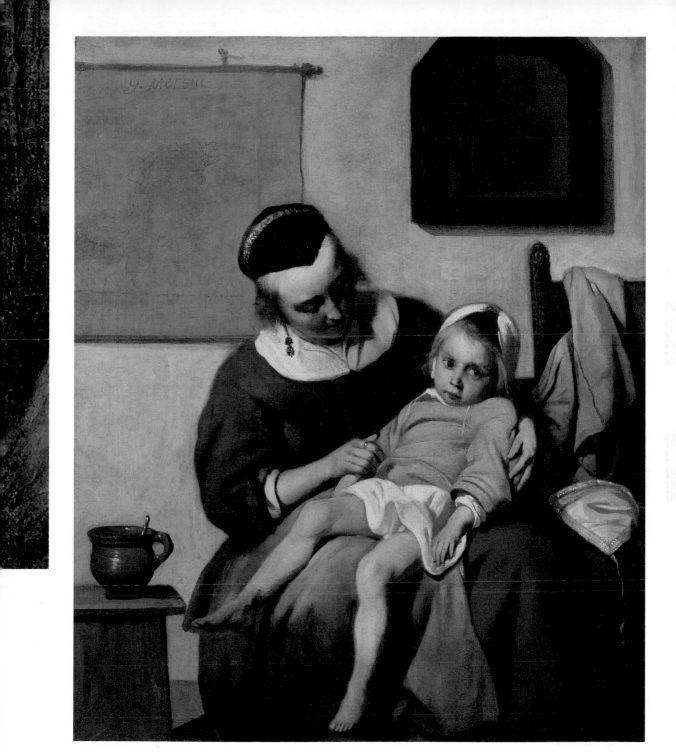

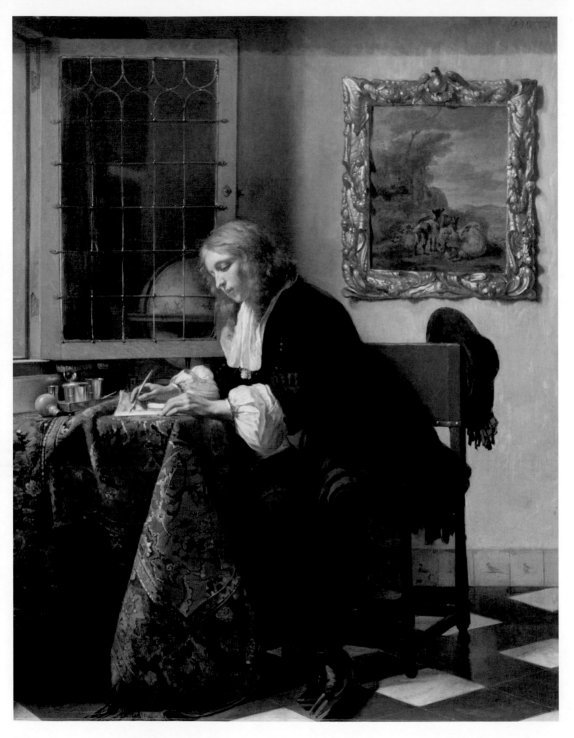

A Gentleman
Writing a Letter

Jeune Homme
écrivant une lettre

Briefschreibender Herr

El escritor de cartas
sorprendido

Gentiluomo cxhe
scrive una lettera

Briefschrijvende heer

GABRIËL METSU
(1629–67)

1664–66, Oil on wood/Huile
sur bois, 52,5 × 40,2 cm,
National Gallery of
Ireland, Dublin

A Woman Reading a Letter

These two genre pictures are pendants. The woman tries to conceal the letter, written by the man, from her servant, who lifts the curtain on a picture of the sea: love is like a voyage on rough waters.

Jeune Femme lisant une lettre

Ces deux scènes de genre sont des pendants l'une de l'autre. La femme cherche à cacher la lettre à sa servante, qui écarte le rideau d'une marine : l'amour est comme un voyage en bateau sur une mer déchaînée.

Brieflesende Frau

Diese beiden Genrebilder sind Pendants. Die Frau sucht den vom Mann geschriebenen Brief vor ihrer Dienerin zu verbergen; diese lüftet den Vorhang eines Seestücks: Die Liebe gleicht einer Schifffahrt auf rauer See.

Mujer leyendo una carta

Estos dos cuadros del género se corresponden. La mujer trata de ocultar la carta escrita por el hombre a su sirvienta, la cual levanta la cortina que cubre un trozo de mar: el amor es como un viaje en barco por mar agitado.

Donna che legge una lettera

Queste due immagini di genere sono in corrispondenza. La donna cerca di nascondere alla sua serva la lettera scritta dall'uomo; questa apre la tenda su un tratto di mare: l'amore è come una gita in barca sul mare agitato.

Brieflezende vrouw

Deze twee genrestukken zijn elkaars tegenhangers. De vrouw probeert de brief van de man voor haar meid te verbergen; die tilt het gordijn voor een zeegezicht op: de liefde is als een boottocht op ruwe zee.

GABRIËL METSU (1629–67)
1664–66, Oil on wood/Huile sur bois, 52,5 × 40,2 cm, National Gallery of Ireland, Dublin

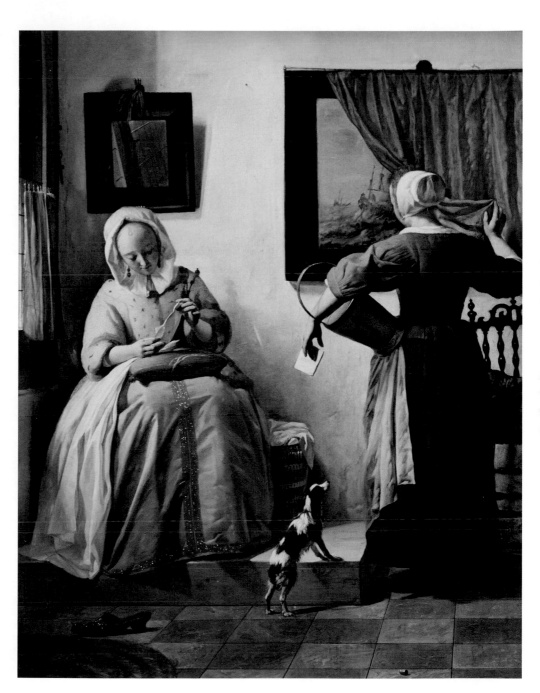

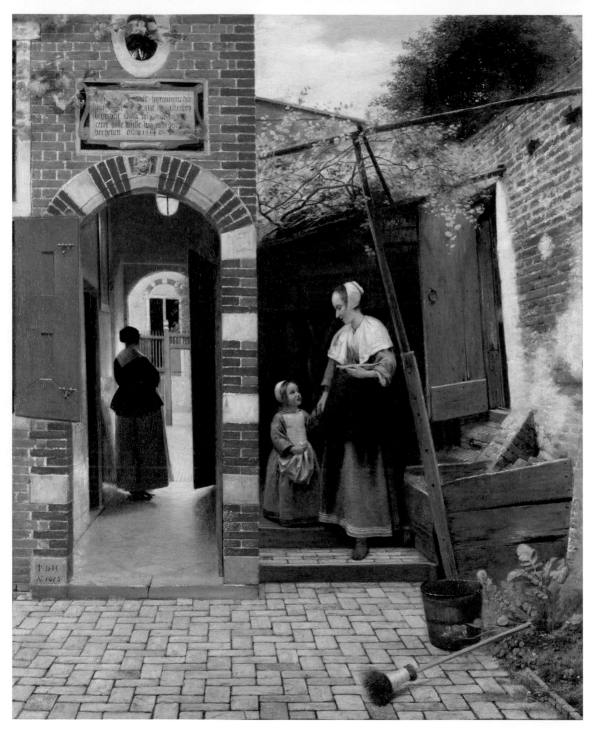

The Courtyard
of a House
in Delft

Cour d'une
maison à Delft

Der Hinterhof
eines Hauses
in Delft

El patio trasero
de una casa
en Delft

Il cortile di una
casa di Delft

Plaatsje achter
een huis in Delft

**PIETER DE
HOOCH**
(1629–84)
1658, Oil on
canvas/Huile sur
toile, 73,5 × 60 cm,
The National
Gallery, London

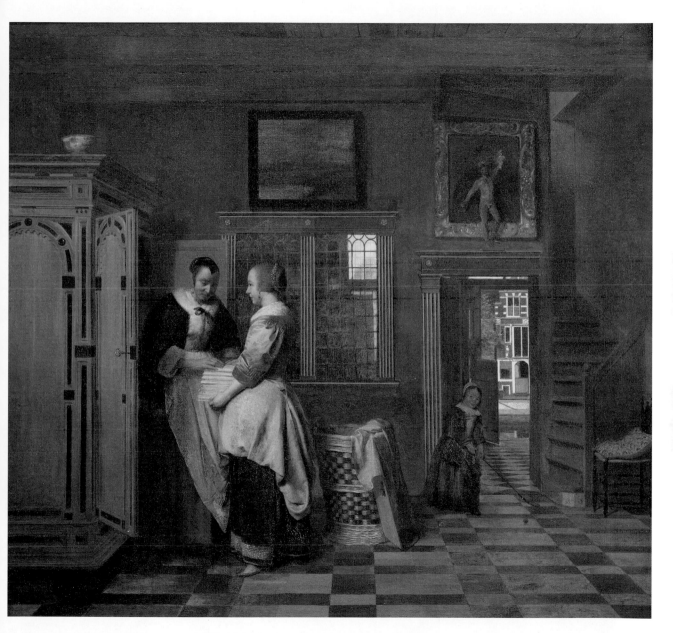

Interior with Women beside a Linen Cupboard

L'Armoire à linge

Am Wäscheschrank

El armario de la ropa blanca

L'armadio della biancheria

Binnenhuis met vrouwen bij een linnenkast

PIETER DE HOOCH (1629–84)

1663, Oil on canvas/Huile sur toile, 70 × 75,5 cm, Rijksmuseum, Amsterdam

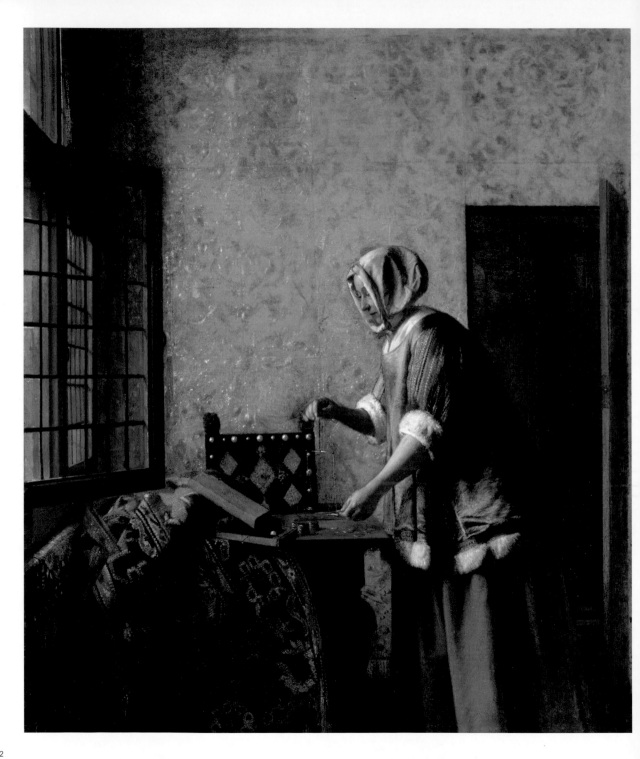

Interior with a Woman Weighing Gold Coin

La Peseuse d'or

Die Goldwägerin

La pesadora de oro

La pesatrice d'oro

De goudweegster

PIETER DE HOOCH (1629–84)

c. 1664, Oil on canvas/Huile sur toile, 61 × 53 cm, Gemäldegalerie, Berlin

A Man Offering Gold and Coins to a Girl

Une scène aux chandelles : un homme offrant une chaîne en or et des pièces à une fille assise sur un lit

Bei Kerzenlicht: Ein Mann bietet einem Mädchen Goldmünzen an

A la luz de las velas: un hombre ofrece monedas de oro a una chica

A lume di candela: un uomo offre monete d'oro a una giovinetta

Bij kaarslicht: een man biedt een meisje gouden munten aan

GODFRIED SCHALCKEN (1643–1706)

c. 1665–70, Oil on copper/Huile sur cuivre, 15,5 × 18,9 cm, The National Gallery, London

Jan Steen: A Moralizing Satirist

Jan Steen is known for his moralizing and satirical genre scenes: People are so disorderly, households so chaotic that they can only serve as negative examples to others (especially children). The artist often illustrated proverbs in this way—a popular pictorial theme in the Netherlands since the 16th century. The theatre had an important influence on Steen's work as well: he had connections to the association of rederrijkers (rhetoricians) from his hometown of Leiden, which regularly staged plays. Many of his pictures therefore look like stage scenes, and rely on means comparable to the then usually crudely moralizing theatre. Steen's more conventional genre and history paintings are less well-known; they resemble his moralizing scenes in structure, but either lack the satirical element entirely or express it more modestly.

Jan Steen : un satiriste moralisateur

Jan Steen est connu pour ses scènes de genre moralisatrices et satiriques : les personnages sont toujours dans l'excès, et les foyers tellement désordonnés qu'ils donnent un exemple effroyable, notamment aux enfants. Souvent, l'artiste illustre des proverbes, un thème déjà très apprécié dans les Pays-Bas du XVIᵉ siècle. Le théâtre eut une influence déterminante sur l'œuvre de Steen : il était en lien avec l'Union des rhétoriciens de Leyde, sa ville, qui montait régulièrement des pièces de théâtre. Ses tableaux font ainsi souvent l'effet de scènes et utilisent des codes comparables à ceux du théâtre souvent grossièrement moralisateur de l'époque. On oublie souvent que Steen pratiqua également la peinture de genre ou d'histoire plus conventionnelle, dont la construction était similaire à celle de ses scènes moralisatrices, mais où l'élément satirique était moindre – ou du moins plus discret.

Jan Steen: Ein moralisierender Satiriker

Bekannt ist Jan Steen für seine moralisierenden und satirischen Genreszenen: Menschen betragen sich so zügellos, Haushalte sind so unordentlich, dass sie für andere (vor allem Kinder) nur als abschreckende Beispiele dienen können. Häufig illustrierte der Künstler auf diese Weise Sprichwörter – ein in den Niederlanden schon im 16. Jahrhundert beliebtes Bildthema. Wichtigen Einfluss auf Steens Werk hatte das Theater: Er stand in Verbindung zur Vereinigung der Rederijkers (Rhetoriker) seiner Heimatstadt Leiden, die regelmäßig Stücke inszenierte. So wirken viele seiner Bilder wie Bühnen und arbeiten mit Mitteln, die dem damaligen, in der Regel derb-moralisierenden Theater vergleichbar sind. Weniger bekannt ist, dass Steen auch konventionellere Genre- und Historienbilder malte, die seinen moralisierenden Szenen im Aufbau ähneln, das satirische Element jedoch nicht oder verhaltener zum Ausdruck bringen.

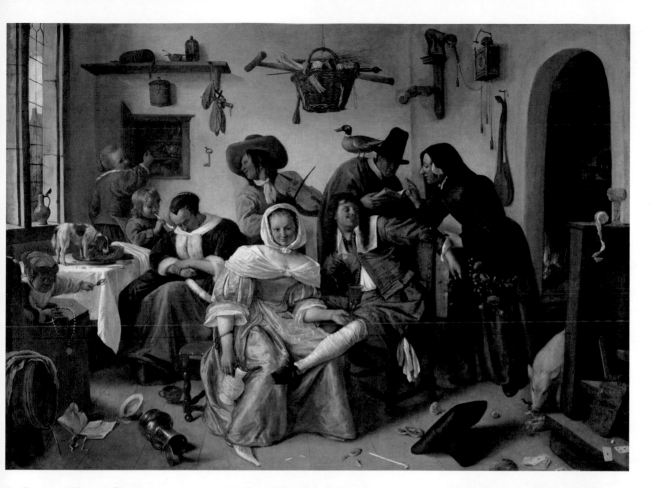

Jan Steen: u satírico moralizante

Jan Steen es conocido por sus escenas de género moralizantes y satíricas: la gente está tan desenfrenada, los hogares están tan desordenados que sólo pueden servir para asustar a los demás (especialmente a los niños). El artista ilustró a menudo los proverbios de esta manera– un tema pictórico popular en los Países Bajos ya en el siglo XVI. El teatro tuvo una influencia importante en la obra de Steen: estaba relacionado con la asociación de los Rederijkers (retóricos) de su ciudad natal, Leiden, que representaba regularmente obras de teatro. Así, muchos de sus cuadros se parecen a escenarios y trabajan con medios comparables a los del teatro, por lo general burdo y moralizante. Menos conocido es que Steen también pintó pinturas de género e historia más convencionales, que se asemejan a sus escenas moralizantes en estructura, pero que no expresan el elemento satírico o lo expresan de forma más modesta.

Jan Steen: Una satira moralizzante

Jan Steen è noto per le sue scene di genere moralistiche e satiriche: le persone si comportano in modo dissoluto, le famiglie sono così disordinate che possono solo fungere da deterrente per gli altri (specialmente per i bambini). L'artista ha illustrato spesso in questo modo i proverbi – un tema popolare pittorico nei Paesi Bassi già nel XVI secolo. Il teatro ebbe un'influenza importante sul lavoro di Steen: egli era in contatto con l'associazione dei Rederijkers (retorici) della sua città natale, Leida, che organizzava regolarmente spettacoli teatrali. Così molti dei suoi quadri sembrano palcoscenici e lavorano con mezzi paragonabili al teatro di allora, solitamente rude e moralizzante. Meno noto è che Steen ha anche dipinto opere di genere e storiche più convenzionali, che assomigliano nella struttura alle sue scene moralizzanti, ma non esprimono, se non in modo contenuto, l'elemento satirico.

Jan Steen: een moraliserende satiricus

Jan Steen staat bekend om zijn moraliserende en satirische genretaferelen: mensen gedragen zich zo ongebreideld, huishoudens zijn zo rommelig dat ze voor anderen (vooral kinderen) alleen maar kunnen dienen als afschrikkend voorbeeld. De kunstenaar illustreerde op deze manier vaak spreekwoorden – een thema dat in Nederland al in de 16e eeuw populair was voor schilderijen. Het theater had een belangrijke invloed op Steens werk: hij was verbonden aan de rederijkersvereniging van zijn woonplaats Leiden, die regelmatig toneelstukken opvoerde. Zo zien veel van zijn schilderijen eruit als podia en werken ze met vergelijkbare middelen als het toen meestal grof-moraliserende theater. Minder bekend is dat Jan Steen ook meer conventionele genre- en historiestukken schilderde, die in opbouw lijken op zijn moraliserende scènes, maar het satirische element niet of meer ingehouden tot uitdrukking brengen.

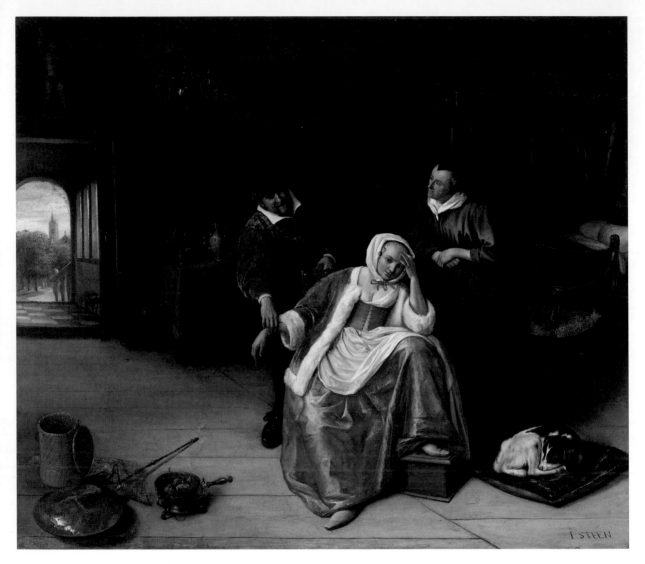

The Lovesick Maiden

The influence of the theatre is obvious in this picture: the doctor is dressed as if in a comedy, and even the the lovesick maiden, identified by the statue of Eros above the door, could be a stage character.

La Maladie d'amour

Dans ce tableau, l'influence du théâtre est évidente : le médecin est habillé comme pour une comédie et la femme malade d'amour (comme le suggère la présence d'Éros au-dessus de la porte) aurait tout à fait sa place sur une scène.

Die liebeskranke Jungfrau

In diesem Bild Steens ist der Einfluss des Theaters offensichtlich: Der Arzt ist wie in einer Komödie gekleidet, und auch die am Eros über der Tür zu identifizierende Liebeskranke könnte eine Bühnenfigur sein.

La enferma de amor

En esta imagen de Steen, la influencia del teatro es obvia: el médico está vestido como si fuera una comedia, y la enferma de amor que se identifica en Eros por encima de la puerta también podría ser un personaje escénico.

La malata d'amore

In questo quadro di Steen, l'influenza del teatro è evidente: il medico è vestito come in una commedia, e la malata d'amore, da identificare con Eros sopra la porta, potrebbe anche rappresentare un personaggio da palcoscenico.

Polsvoelende dokter (Meisje met liefdesverdriet)

Op dit schilderij van Jan Steen is de invloed van het theater overduidelijk: de dokter is gekleed als in een komedie en de ziekte is door Eros boven de deur, die ook een toneelpersonage zou kunnen zijn, te identificeren als liefdesverdriet.

JAN STEEN (1626–79)

c. 1660, Oil on canvas/Huile sur toile, 86,4 × 99,1 cm, Metropolitan Museum of Art, New York

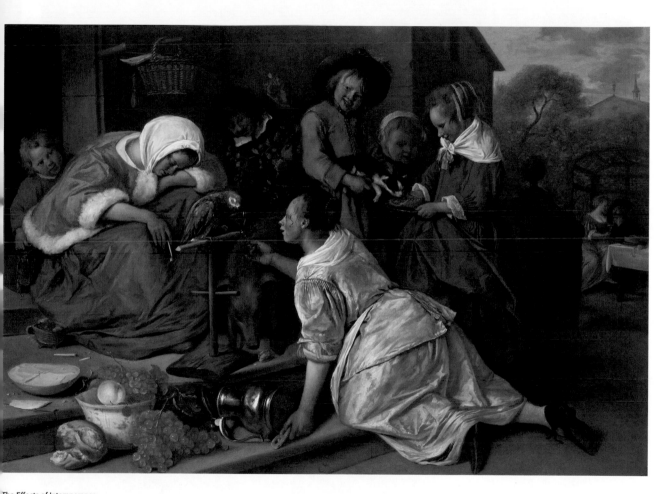

The Effects of Intemperance

Les Effets de l'intempérance

Die Folgen unmäßigen Trinkens

Las consecuencias de beber en exceso

Conseguenze dell'ebbrezza

De gevolgen van onmatigheid

JAN STEEN (1626-79)

c. 1663-65, Oil on wood/Huile sur bois, 76 × 106,5 cm, The National Gallery, London

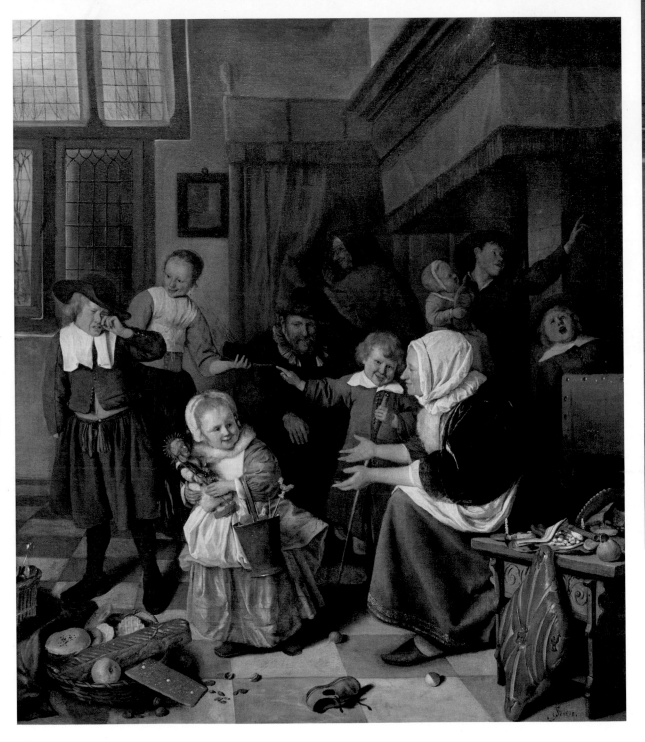

The Feast of St Nicholas

This warm, life-like genre scene shows the festival of St Nicholas, when good children in the Netherlands received gifts, and the less good ones—at least in Steen's day—went away empty-handed.

La Saint-Nicolas

Cette scène de genre chaleureuse et pleine de vie montre la fête de Saint-Nicolas, jour où – aux Pays-Bas – les enfants sages recevaient des cadeaux et ceux qui avaient été moins sages (du moins à l'époque de Steen) repartaient bredouilles.

JAN STEEN (1626–79)

1665–68, Oil on canvas/Huile sur toile, 82 × 70,5 cm, Rijksmuseum, Amsterdam

Nikolausabend

Diese warmherzige und lebensnahe Genreszene zeigt ein Nikolausfest, den Tag, an dem in den Niederlanden brave Kinder Geschenke bekommen und weniger brave – zumindest zu Zeiten Steens – leer ausgingen.

Víspera de San Nicolás

Esta cálida y realista escena de género muestra una festividad de San Nicolás, el día en que los niños buenos de los Países Bajos reciben regalos y los menos buenos –al menos en la época de Steens– se van con las manos vacías.

La festa di San Nicola

Questa scena di genere, calda e realistica, mostra la festa di San Nicola, il giorno in cui i bambini buoni nei Paesi Bassi ricevono regali e quelli meno buoni – almeno al tempo di Steens – sono rimasti a mani vuote.

Het Sint-Nicolaasfeest

In dit warme en levensechte genrestuk is het Sinterklaasfeest te zien, de dag waarop brave kinderen in Nederland cadeaus krijgen en minder brave – althans in de tijd van Steen – met lege handen weggaan.

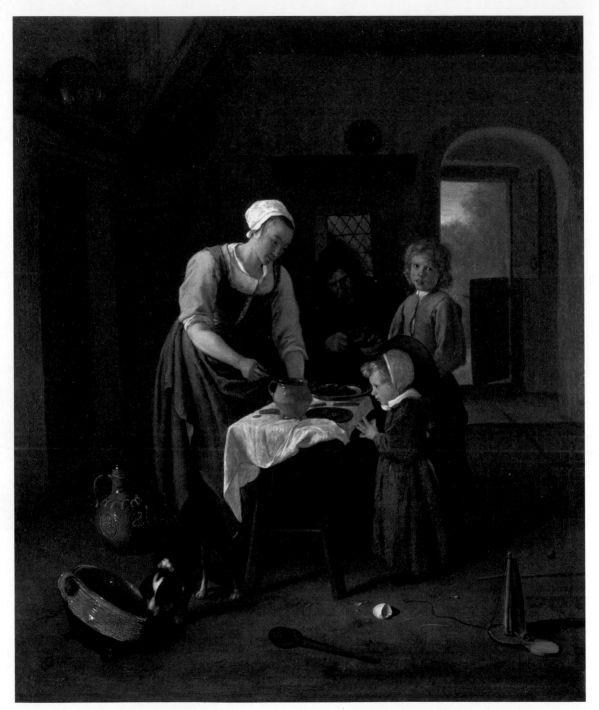

A Peasant
Family at
Meal-Time

Une famille
paysanne à
l'heure du
repas *ou* Le
Bénédicité

Bauernfamilie
bei der
Mahlzeit

Familia
campesina, a la
hora de comer

Famiglia
contadina

Boerenfamilie
bij de maaltijd

JAN STEEN
(1626–79)
c. 1665, Oil
on canvas/
Huile sur toile,
44,8 × 37,5 cm,
The National
Gallery, London

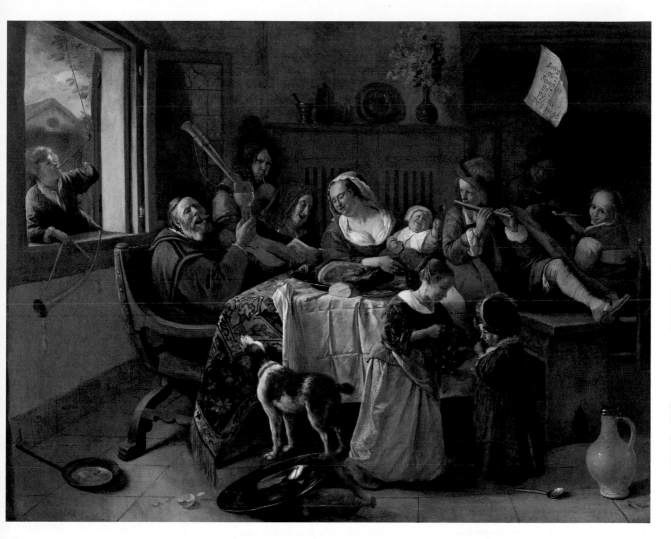

The Happy Family

This family's concert seems to be one thing above all: discordant. The saying above the fireplace explains that the parents are not setting a good example for their children: "The young whistle what the old have sung".

La Famille joyeuse

Le concert de cette famille a l'air pour le moins dissonant. Le fait que les parents ne sont pas de bons exemples pour leur progéniture est confirmé par le proverbe qui apparaît au-dessus de la cheminée : « Ce que chantent les vieux, les petits le fredonnent ».

Die fröhliche Familie

Das Konzert dieser Familie scheint vor allem eines zu sein: misstönend. Dass die Eltern kein gutes Vorbild für ihre Kinder sind, erläutert der Spruch über dem Kamin: „Wie die Alten sungen, pfeifen auch die Jungen".

La familia feliz

El concierto de esta familia parece ser ante todo una cosa: inquietante. El dicho sobre la chimenea explica que los padres no son un buen ejemplo para sus hijos: "Así como el viejo cantaba, los jóvenes tocaban la flauta".

La famiglia felice

Il concerto di questa famiglia sembra essere soprattutto una cosa: inquietante. Il detto sopra il caminetto spiega che i genitori non sono un buon esempio per i loro figli: "Come cantano i vecchi, i giovani fischiano".

Het vrolijke huisgezin

Het concert van deze familie lijkt vooral één ding te zijn: dissonant. Het gezegde boven de open haard verklaart dat ouders geen goed voorbeeld zijn voor hun kinderen: 'Zo de ouden zongen, piepen de jongen.'

JAN STEEN (1626–79)
1668, Oil on canvas/Huile sur toile, 110,5 × 141 cm, Rijksmuseum, Amsterdam

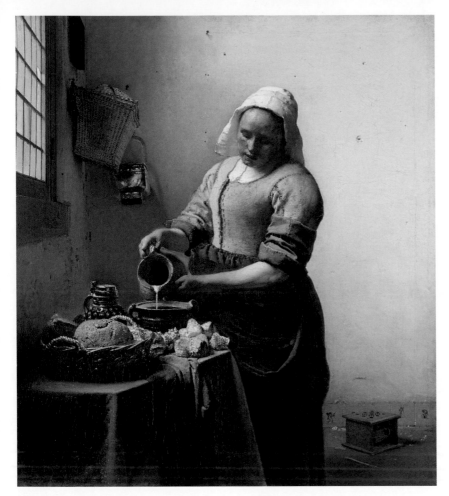

The Milkmaid

La Laitière

Das Milchmädchen (Dienstmagd mit Milchkrug)

La lechera (criada con jarra de leche)

Lattaia (domestica con caraffa di latte)

Het melkmeisje

JOHANNES VERMEER (1632–75)

c. 1660, Oil on canvas/Huile sur toile,
45,5 × 41 cm, Rijksmuseum, Amsterdam

**Johannes Vermeer van Delft:
Magician of Light**

Thanks to his incomparable, almost magical use of light
and perspective, Johannes Vermeer created true icons of
painting. His works have inspired writers and filmmakers;
museums and the rare exhibitions of his work are true
places of pilgrimage for art enthusiasts. Vermeer lived and
worked in Delft during the so-called golden age, a period
of economic and cultural prosperity in the Netherlands.
Like his father, he was an art dealer, but always saw
himself more as an artist. He worked only on commission
and produced no more than one or two works a year—just
enough to support his wife and eleven children. Although
he created only 45 paintings in his life, 35 of which still
exist today, he is one of the most famous painters in
Western art history, alongside Rembrandt and Frans Hals.

**Johannes Vermeer van Delft :
un magicien de la lumière**

Grâce à son rapport incomparable et presque magique à
la lumière et à la perspective, Johannes Vermeer réalisa
de véritables icônes de la peinture. Ses œuvres inspirèrent
les écrivains et les réalisateurs, et représentent dans les
musées et les rares expositions de véritables lieux de
pèlerinage pour les amoureux de l'art. Ce peintre vécut
et travailla à Delft pendant l'époque dite du « siècle
d'or », une phase d'essor économique et culturel aux
Pays-Bas. À l'instar de son père, il était marchand d'art,
mais se considéra toujours plutôt comme un artiste. Il
ne travaillait que sur commande et ne réalisait pas plus
d'un ou deux tableaux par an : juste assez pour nourrir
sa femme et leurs onze enfants. Bien qu'il n'ait peint
que 45 tableaux au cours de sa vie, dont 35 nous sont
parvenus, il fait partie aux côtés de Rembrandt et de Frans
Hals des peintres les plus connus de l'histoire des arts.

**Johannes Vermeer van Delft:
Magier des Lichts**

Dank seines unvergleichlichen, fast zauberhaften
Umgangs mit Licht und Perspektive schuf Johannes
Vermeer wahre Ikonen der Malerei. Seine Werke
inspirierten Schriftsteller wie Filmemacher; Museen und
die seltenen Ausstellungen sind (wahre) Pilgerstätten
für Kunstbegeisterte. Der Maler lebte und arbeitete in
Delft während des sogenannten „Goldenen Zeitalters",
einer Phase wirtschaftlicher und kultureller Blüte in den
Niederlanden. Genau wie sein Vater war er Kunsthändler,
sah sich selbst aber immer eher als Künstler. Er arbeitete
nur im Auftrag und produzierte nicht mehr als ein oder
zwei Arbeiten pro Jahr – gerade genug, um seine Frau
und elf Kinder zu unterstützen. Obwohl er in seinem
Leben nur 45 Gemälde schuf, von denen 35 heute noch
existieren, gehört er neben Rembrandt und Frans Hals zu
den bekanntesten Malern der Kunstgeschichte.

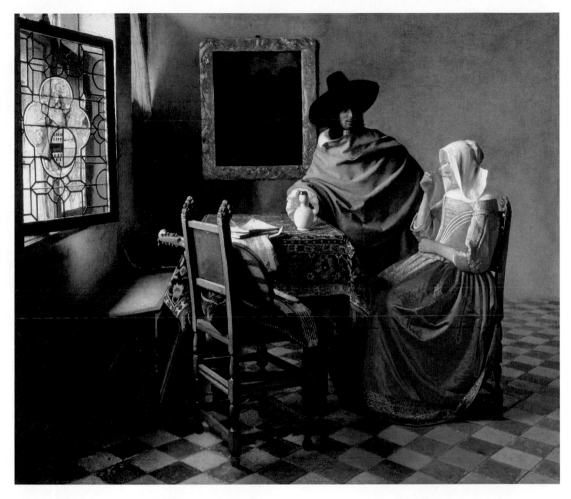

The Wine Glass

Le Verre de vin

Das Glas Wein (Herr und Dame beim Wein)

La copa de vino (caballero y dama con el vino)

Bicchiere di vino (gentiluomo e signora con il vino)

Het glas wijn (Drinkende dame met een heer)

JOHANNES VERMEER (1632–75)
c. 1661/62, Oil on canvas/Huile sur toile, 66,3 × 76,5 cm, Gemäldegalerie, Berlin

Johannes Vermeer van Delft: el mago de la luz

Gracias a su incomparable y casi mágico uso de la luz y la perspectiva, Johannes Vermeer creó verdaderos iconos de la pintura. Sus obras inspiraron a escritores y cineastas; los museos y las raras exposiciones son (verdaderos) lugares de peregrinación para los entusiastas del arte. El pintor vivió y trabajó en Delft durante la llamada "Edad de Oro", un período de prosperidad económica y cultural en los Países Bajos. Al igual que su padre, fue marchante de arte, pero siempre se vio a sí mismo más como un artista. Sólo trabajaba a comisión y no producía más de una o dos obras al año, lo suficiente para mantener a su esposa y once hijos. A pesar de que sólo creó 45 pinturas en su vida, 35 de las cuales aún existen hoy en día, es uno de los pintores más famosos de la historia del arte, junto con Rembrandt y Frans Hals.

Johannes Vermeer van Delft: Mago della luce

Grazie al suo incomparabile, quasi magico, uso della luce e della prospettiva, Johannes Vermeer ha creato vere e proprie icone della pittura. Le sue opere hanno ispirato scrittori e registi, i musei e le rare mostre sono (veri) luoghi di pellegrinaggio per gli appassionati d'arte. Il pittore visse e lavorò a Delft durante la cosiddetta "età dell'oro", un periodo di prosperità economica e culturale nei Paesi Bassi. Come suo padre, era un mercante d'arte, ma si è sempre considerato più come un artista. Ha lavorato solo su commissione e ha prodotto non più di uno o due lavori all'anno – appena sufficiente per sostenere la moglie e gli undici figli. Sebbene abbia realizzato solo 45 dipinti, 35 dei quali esistono ancora oggi, è uno dei pittori più famosi della storia dell'arte, insieme a Rembrandt e Frans Hals.

Johannes Vermeer: lichtval

Dankzij zijn onvergelijkbare, bijna magische gebruik van licht en perspectief creëerde Johannes Vermeer ware iconen van de schilderkunst. Zijn werken inspireerden schrijvers en filmmakers; musea en de zeldzame tentoonstellingen zijn (echte) bedevaartsplaatsen voor kunstliefhebbers. De schilder woonde en werkte in Delft tijdens de zogenaamde Gouden Eeuw, een periode van economische en culturele bloei in Nederland. Net als zijn vader was hij kunsthandelaar, maar hij zag zichzelf altijd meer als kunstenaar. Hij werkte alleen in opdracht en schilderde niet meer dan een of twee werken per jaar – net genoeg om zijn vrouw en elf kinderen te onderhouden. Hoewel hij in zijn leven slechts 45 schilderijen maakte, waarvan er nu nog 35 bestaan, is hij, naast Rembrandt en Frans Hals, een van de beroemdste schilders uit de kunstgeschiedenis.

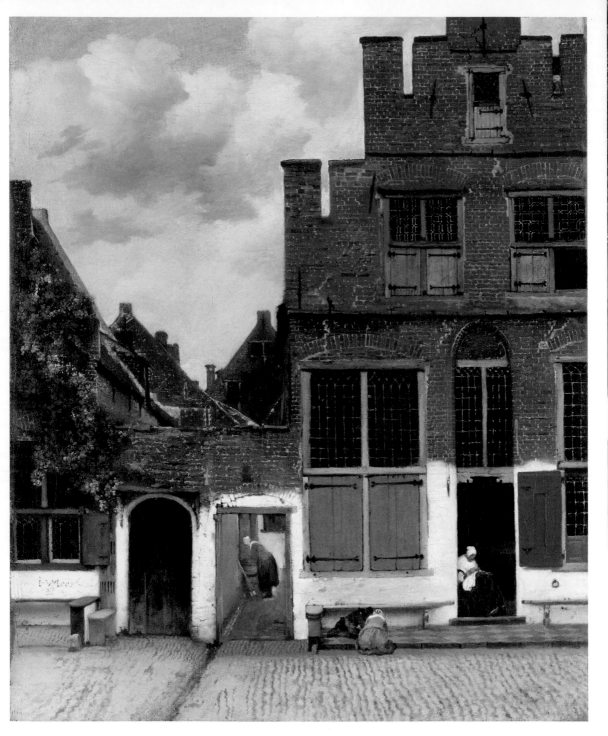

The Little Street

An atmosphere of pure silence. Despite the topographical accuracy of the scene, Vermeer is more interested in capturing a moment, a "snapshot", in this city view – as he also is in his genre pictures.

La Ruelle

Une atmosphère d'un calme absolu. Outre l'exactitude topographique, Vermeer voulait surtout, dans cette vue de la ville, capturer un instant, réaliser un « instantané », comme dans ses peintures de genre.

Die kleine Straße (Het straatje)

Eine Atmosphäre purer Stille. Trotz topografischer Genauigkeit ging es Vermeer in dieser Stadtansicht eher darum, einen Moment, einen „Schnappschuss", festzuhalten – ebenso in seinen Genrebildern.

La calle pequeña (Het straatje)

Una atmósfera de puro silencio. A pesar de la precisión topográfica, Vermeer estaba más interesado en capturar un momento, una "instantánea", en esta vista de la ciudad, también en sus imágenes de género.

La stradina (Het straatje)

Un'atmosfera di puro silenzio. Nonostante la precisione topografica, Vermeer era più interessato a catturare un momento, una "istantanea", nella vista di questa città - anche nelle sue immagini di genere.

Het straatje (Gezicht op huizen in Delft)

Een sfeer van pure stilte. Ondanks de topografische nauwkeurigheid was het Vermeer er bij dit stadsgezicht vooral om te doen een moment vast te leggen, een 'momentopname' te maken – ook in zijn genrestukken.

JOHANNES VERMEER (1632–75)

c. 1658, Oil on canvas/Huile sur toile, 54,3 × 54 cm, Rijksmuseum, Amsterdam

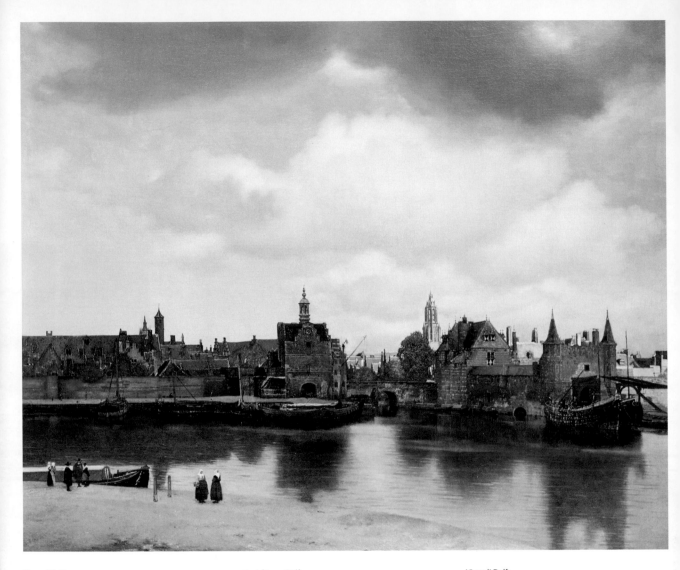

View of Delft

Vermeer's œuvre was forgotten after his death. It was only after 1842 that the French journalist Thoré-Bürger, having seen the view of Delft, helped to make him known again.

Vue de Delft

En 1677, l'héritage de Vermeer fut vendu aux enchères et son œuvre tomba ensuite dans l'oubli. Ce n'est qu'en 1842 que le journaliste et critique d'art français Thoré-Bürger, après avoir vu la Vue de Delft, le ramena à la lumière.

Ansicht von Delft

Vermeers Œuvre geriet nach dessen Tod in Vergessenheit. Erst nach 1842 verhalf der französische Journalist Thoré-Bürger Vermeer, nachdem er die Ansicht von Delft gesehen hatte, wieder zu Bekanntheit.

Vista de Delft

La obra de Vermeer fue olvidada después de su muerte. No fue hasta después de 1842 que el periodista francés Thoré-Bürger ayudó a Vermeer, después de haber visto el punto de vista de Delft, a darse a conocer de nuevo.

Vista di Delft

L'opera di Vermeer è stata dimenticata dopo la sua morte. Fu solo dopo il 1842 che il giornalista francese Thoré-Bürger aiutò Vermeer, dopo aver visto la Veduta di Delft, a riportarlo alla ribalta.

Gezicht op Delft

Vermeers oeuvre raakte na zijn dood in vergetelheid. Pas na 1842 hielp de Franse journalist Thoré-Bürger, na het zien van Gezicht op Delft, Vermeer weer bekendheid te krijgen.

JOHANNES VERMEER (1632–75)
1661, Oil on canvas/Huile sur toile, 98 × 117,8 cm, Mauritshuis, Den Haag

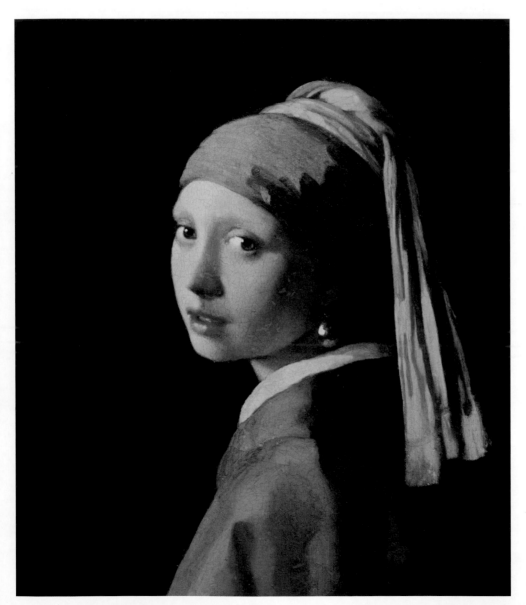

The Girl with the Pearl Earring
Vermeer's famous small-format portrait of an unknown girl in an oriental fantasy costume with a shimmering pearl in her ear is also known as the "Mona Lisa of the Netherlands".

La Jeune Fille à la perle
Ce célèbre instantané de Vermeer, de petit format, représentant une jeune fille inconnue en tenue orientale, avec à l'oreille une perle étincelante, est souvent qualifié de « Mona Lisa des Pays-Bas ».

Das Mädchen mit dem Perlenohrgehänge
Vermeers berühmte kleinformatige Momentaufnahme eines unbekannten Mädchens in orientalischem Fantasiekostüm mit schimmernder Perle am Ohr wird auch als „Mona Lisa der Niederlande" bezeichnet.

La joven de la perla
La famosa instantánea de pequeño formato de Vermeer de una chica desconocida en un disfraz de fantasía oriental con una perla resplandeciente en la oreja también se conoce como la "Mona Lisa de los Países Bajos".

La ragazza con l'orecchino di perla
La famosa immagine di piccolo formato di Vermeer di una sconosciuta ragazza in un costume di fantasia orientale con una perla scintillante all'orecchio è conosciuta anche come la "Gioconda dei Paesi Bassi".

Meisje met de parel
Vermeers beroemde momentopname op klein formaat van een onbekend meisje in een oosterse fantasiekostuum met een glinsterende parel aan haar oor wordt ook wel de 'Mona Lisa van Nederland' genoemd.

JOHANNES VERMEER (1632–75)
c. 1665, Oil on canvas/Huile sur toile, 44,5 × 39 cm, Mauritshuis, Den Haag

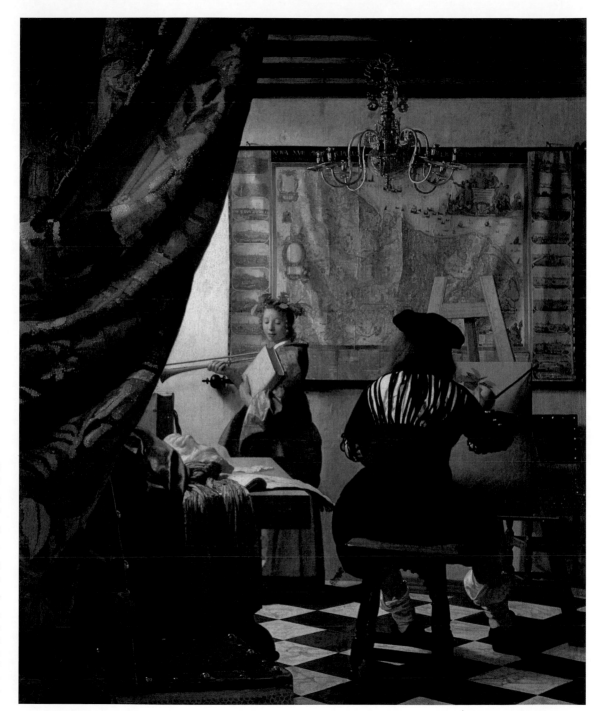

The Art of
Painting

L'Art de la
peinture

Die Malkunst

El arte de pintar

L'arte di
dipingere

De schilderkunst

**JOHANNES
VERMEER**
(1632–75)

c. 1666–68, Oil on
canvas/Huile sur
toile, 120 × 100 cm,
Kunsthistorisches
Museum, Wien

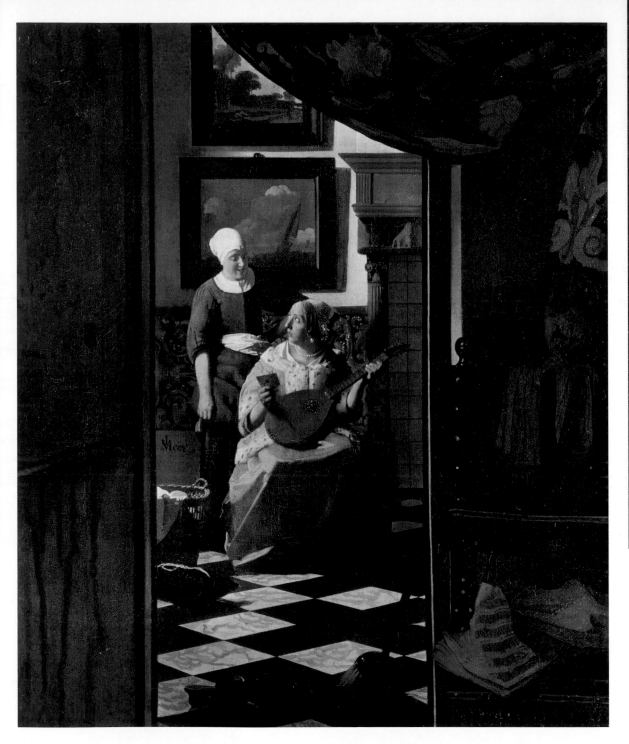

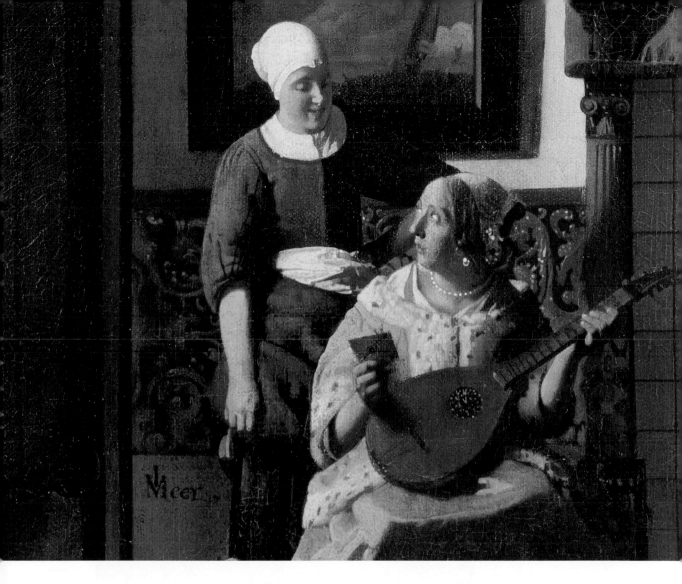

The Love Letter
In Dutch genre painting, receiving, writing, and reading letters often refers to love. The seascape in the background is also a metaphor for love's tempests and risks.

La Lettre d'amour
Dans la peinture de genre hollandaise, le fait de recevoir, d'écrire ou de lire une lettre est souvent synonyme d'amour. La marine située à l'arrière-plan est aussi une métaphore d'émotions et de prise de risques.

Der Liebesbrief
In der holländischen Genremalerei verweist das Empfangen, Schreiben und Lesen von Briefen häufig auf die Liebe. Auch das Seestück im Hintergrund ist eine Metapher für ihre Bewegtheiten und Risiken.

La carta de amor
En la pintura holandesa de género, recibir, escribir y leer cartas a menudo se refiere al amor. El paisaje marino de fondo es también una metáfora de sus movimientos y riesgos.

La lettera d'amore
Nella pittura di genere olandese, ricevere, scrivere e leggere lettere spesso si riferisce all'amore. Il paesaggio marino sullo sfondo è anche una metafora per la commozione e i rischi che ne derivano.

De liefdesbrief
In de Nederlandse genreschilderkunst verwijzen het ontvangen, schrijven en lezen van brieven vaak naar de liefde. Ook het zeegezicht op de achtergrond is een metafoor voor bewogenheden en risico's.

JOHANNES VERMEER (1632–75)
1669/70, Oil on canvas/Huile sur toile, 44 × 38,5 cm, Rijksmuseum, Amsterdam

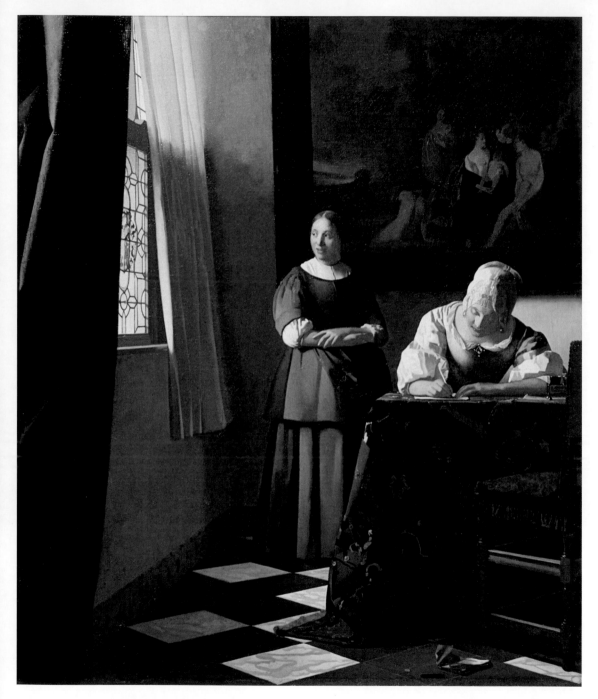

Lady Writing
a Letter with
her Maid

Femme écrivant
une lettre et
sa servante

Briefschreiberin
und Dienstmagd

Redactora y
sirvienta

Donna che scrive
una lettera alla
presenza della
domestica

Schrijvende
vrouw met
dienstbode

**JOHANNES
VERMEER
(1632–75)**
c. 1670, Oil on
canvas/Huile sur
toile, 71,1 × 60,5 cm,
National Gallery of
Ireland, Dublin

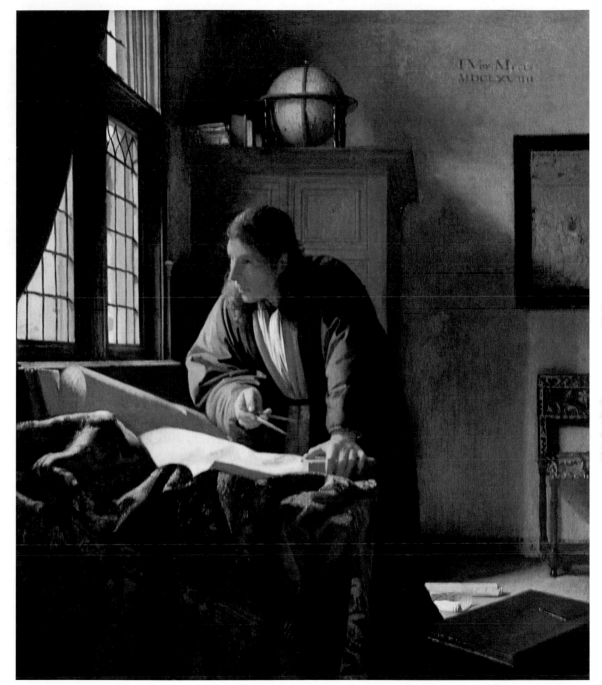

The
Geographer

Le Géographe

Der Geograph

El geógrafo

Il geografo

De geograaf

JOHANNES VERMEER
(1632-75)
1669, Oil
on canvas/
Huile sur toile,
51,6 × 45,4 cm,
Städel Museum,
Frankfurt
am Main

1600

 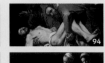 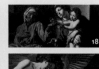

1635

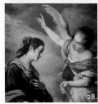

1670

1705

1740

1775

1600

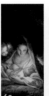
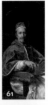

30 34 37 40 46–47 48 52 53

1635

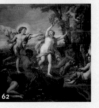

38–39 60 61

1670

62

1705

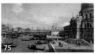

74 75

1740

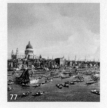

77

1775

EL GRECO	JUSEPE DE	FRANCISCO DE	DIEGO	BARTOLOMÉ	FRANCISCO DE
1541–1614	RIBERA	ZURBARÁN	VELÁZQUEZ	ESTEBAN	GOYA
	1591–1652	1598–1664	1599–1660	MURILLO	1746–1828
				1618–1682	

1600

 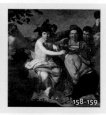

1635

1670

1705

1740

1775

1600

1635

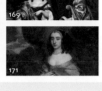

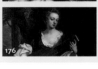

1670

1705

1740

1775

THOMAS **GAINSBOROUGH** 1727–1788	SIMON **VOUET** 1590–1649	VALENTIN **DE BOULOGNE** 1591–1632	LOUIS **LE NAIN** 1593–1648	GEORGES **DE LA TOUR** 1593–1652	NICOLAS **POUSSIN** 1594–1665

1600

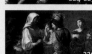

1635

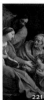
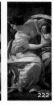

1670

1705

1740

1775

1600

1635

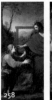

1670

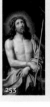
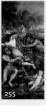

1705

1740

1775

CHARLES **LE BRUN** 1619–1690	JEAN-ANTOINE **WATTEAU** 1684–1721	JEAN SIMÉON **CHARDIN** 1699–1779	FRANÇOIS **BOUCHER** 1703–1770	JEAN-HONORÉ **FRAGONARD** 1732–1806	JAN **BRUEGHEL THE ELDER** 1568–1625

1600

1635

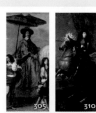

1670

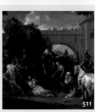

1705

1740

1775

580

1600

1635

1670

1705

1740

1775

ADAM ELSHEIMER 1578–1610	JOHANN LISS 1597–1631	JOACHIM VON SANDRART 1606–1688	MARTIN VAN MEYTENS 1695–1770	ANNA DOROTHEA THERBUSCH 1721–1782	FRANS HALS c. 1580–1666

1600

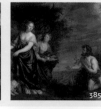

1635

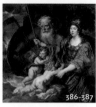

1670

1705

1740

1775

1600

1635

1670

1705

1740

1775

1600

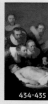

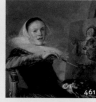

432 · 434–435 · 461

1635

498

499

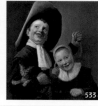

439 · 443 · 533 · 464 · 465 · 451 · 452–453 · 540 · 541

1670

1705

1740

1775

JAN STEEN 1626–1679	SAMUEL VAN HOOGSTRATEN 1627–1678	GABRIËL METSU 1629–1667	PIETER DE HOOCH 1629–1684	JOHANNES VERMEER 1632–1675	NICOLAES MAES 1634–1693

1600

1635

554
555

527

548

549

550
552-553

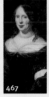
566-567
568

1670

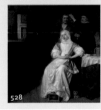
528

467 468

1705

1740

1775

Index